# ALBRECHT DÜRER

## DOCUMENTARY BIOGRAPHY

Designed by Catherine Gaffney
Printed in the United Kingdom

**Library of Congress Cataloging-in-Publication Data**

Ashcroft, Jeffrey, author.
Albrecht Dürer : documentary biography / Jeffrey Ashcroft.
pages cm
Includes bibliographical references and index.
ISBN 978-0-300-21084-2 (cl : alk. paper)
Dürer, Albrecht, 1471–1528. |
Artists – Germany – Biography – Sources.
LCC N6888.D8 A88 2017 | DDC 759.3 – dc23

LC record available at http://lccn.loc.gov/2015044967

A catalogue record for this book is available from the British Library.

# ALBRECHT DÜRER

## DOCUMENTARY BIOGRAPHY

DÜRER'S PERSONAL AND AESTHETIC WRITINGS

WORDS ON PICTURES

FAMILY, LEGAL AND BUSINESS DOCUMENTS

THE ARTIST IN THE WRITINGS OF CONTEMPORARIES

Edition Translation Commentary *by*

Jeffrey Ashcroft

I

YALE UNIVERSITY PRESS · NEW HAVEN AND LONDON

For

I · B · R · I

*…nymmer mer kain spruch zierlich mag auß der andern getolmetscht werden / oder aber ye ser selten / das alle art zierhait und lieplichait in der tolmetschung mitfolge*

(…no phrase can ever be translated elegantly from the other language, or at any rate very rarely, in such a way that all its grace and charm comes across in translation)

Georg Spalatin, apologia for his translation of Erasmus, *Institutio principis Christiani*, from 'elegant Latin into the German vernacular'

*Ich suche zu vergessen, daß lange erwartete Schriften gewöhnlich sich minderer Nachsicht zu erfreuen haben*

(I am trying to forget that long-awaited books tend to enjoy a less lenient reception)

Alexander von Humboldt, preface to *Cosmos*

*Biography…for me it was to become a kind of pursuit, a tracking of the physical trail of someone's path through the past, a following of footsteps. You would never catch them; no, you would never quite catch them. But maybe, if you were lucky, you might write about the pursuit of that fleeting figure in such a way as to bring it alive in the present*

Richard Holmes, *Footsteps. Adventures of a Romantic Biographer*

# Contents

## I

# Contents

## II

# List of Illustrations

# Acknowledgements

This book has deep roots. Frederick Stopp first made me aware more than fifty years ago that Albrecht Dürer was also a writer. More than sixty years ago George Hipwell initiated me into the challenges and satisfactions of translating German texts into English. Translating and interpreting the writings of Dürer was not a feasible undertaking for a university teacher in post under modern constraints on research and funding. This book, long contemplated, had to wait for my retirement, the first ten years of which it has filled and fulfilled.

A seedcorn grant from the Carnegie Trust and the award of an Emeritus Research Fellowship by the Leverhulme Trust financed some of my many visits to Germany and allowed me to engage research assistance. I am grateful to Helen Chambers, John Flood and Martin Kemp for supporting my funding applications and for their continuing encouragement of the project.

I owe a large debt to Adrian Gratwick who vetted my Latin translations and replaced most of them with authoritative drafts. To Ronnie Ferguson I owe the revelation that Dürer spoke and wrote Venetian Italian and the decoding of key passages in his letters.

Three people read and commented on my manuscript at different stages of its genesis. Harry Jackson brought to it his philological knowledge and scholarly rigour, and the good will of a friend of many decades. It benefited from Anne Simon's unmatched knowledge of Nuremberg's history and culture. Isla Ashcroft, my 'common reader', read successive versions with her sharp eye for typographical errors, her instinct for the *mot juste*, her distaste for Germanic tape-worm sentences, and her command of legal concepts and vocabulary.

Four libraries in particular were indispensable to my research. I paid almost annual visits to one or both of the Herzog August Bibliothek in Wolfenbüttel and the Germanisches Nationalmuseum in Nuremberg. The hospitality and the academic community of the HAB were a particular boon to me. In London I made grateful use of the Warburg

Institute and the British Library – though the BL to my chagrin did not allow me direct access to Dürer's autograph papers. I am grateful also to the university libraries in St Andrews, Cambridge and Edinburgh, and to David Roche of St Andrews University's Print and Design Unit.

For specific help and favours I am obliged to Corine Schleif and Volker Schier, especially for pre-publication information on Pirckheimer's *Rechenmeisterin*; to Anja Grebe; to Hugh Morris for a second opinion on Barbara Dürer's terminal illness and Albrecht Dürer's yellow spot; to Ines and Michael Zwanger and to Rosie and Hans Zahn for welcome distractions in Erlangen and Kraftshof; to Rosalind Garton for yoga, and to Ros and Richard Bachelor for geology; to Bill, Anne and Laura, the bouquinistes, for art-historical bargains; to Jude Taylor for setting up my bibliographical database.

Among a host of former students who over forty years stimulated my research and teaching in early modern linguistics and in Renaissance and Reformation culture, I mention in particular Alan Murray, Susan Harvey, Julia Hardiman, Laura Spires, Fiona Campbell and Jo Kershaw. The St Andrews Reformation Studies Institute provided a stimulating research environment. The Special Collections staff of St Andrews University Library made its treasures freely available to me and my students.

Ben Ashcroft gave me an insider's advice on publishing and publishers. To Gillian Malpass, Catherine Gaffney and Yale University Press go my heartfelt thanks for taking on the formidable task of producing this monster of a book.

Too many academic colleagues, friends and EastEnders for me to acknowledge individually have observed my long labours with humour and encouragement. Above all I pay my inadequate thanks to all my family for their unflagging support, tolerance and confidence, without which the book would never have been finished.

*Overleaf* 1. Michael Wolgemut, *Nuremberg*, woodcut for Hartmann Schedel/Georg Alt, *Buch der Chroniken*, Nuremberg: Anton Koberger, 1493, pp. xcix$^v$–c$^r$

NVREMBERGA

S. Lonntus.

S. Sebaldus.

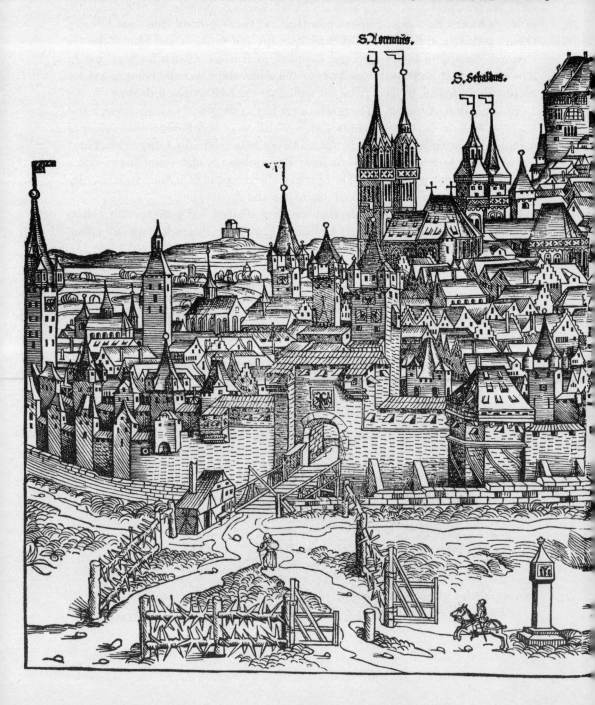

# Nurmberg

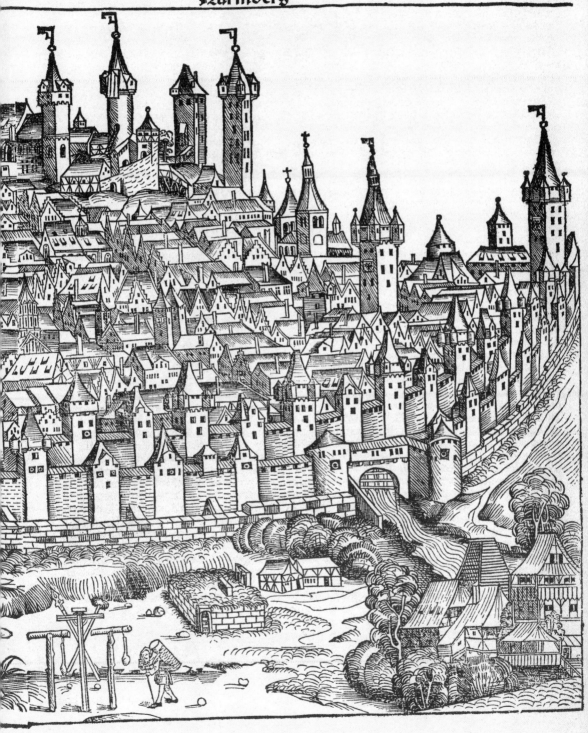

# Introduction

Albrecht Dürer (1471–1528) was the first artist in Europe outside Italy to leave behind a large body of his own writing. His life is also recorded in the writings of contemporaries and in legal and administrative documents. Such ample biographical record remained unparalleled in and long after his lifetime. There is far less written trace of Rembrandt, for example, and little at all of Vermeer. Dürer's huge body of artworks – approaching 200 paintings, almost 300 prints, around 950 drawings and numerous book illustrations – have never ceased to appeal to art lovers and to fascinate art historians across the world. Yet few, even in Germany, who queue to visit exhibitions of Dürer's pictures are aware of his writings, while anglophone art historians who cannot read fifteenth- and sixteenth-century German still rely on William Conway's brief, unreliable, and long since outdated anthology published in 1889.

My book has a threefold aim. It makes available the first ever English translation of a full range of Dürer's writings which have a direct bearing on his life story and which map the evolution of his understanding of art. It supplements his own writings with what his contemporaries wrote about him, and with public records relating to him. It structures this evidence for the first time chronologically as a 'documentary biography', his life as told in written record. It supplies a detailed commentary on more than 600 texts, conceived primarily for non-German-reading users. In this I attempt a synthesis of a representative sample of the vast modern scholarly literature on Dürer and his art for those unable to read or access it in mainly German-language research publications.

The documentary biography is based on Hans Rupprich's comprehensive edition of the writings in their original linguistic form, *Dürer. Schriftlicher Nachlass*, published in three volumes between 1956 and 1969.[1] It does not translate the whole text corpus contained there, but it covers the entire biographical material in Rupprich's first volume and those texts from the second and third volumes in which Dürer over the course of his life articulates his ideas on the theory and practice of art. I have occasion-

ally expanded texts which Rupprich excerpted and added many others which he missed or which have been unearthed since 1969. Only in very rare cases of doubt have I verified Rupprich's transcriptions by recourse to the original manuscript sources. To have attempted a thorough revision of his readings of Dürer's often difficult hand would have been inordinately time-consuming and yielded scant return. Such minor errors and misunderstandings as I have come upon usually proved marginal or irrelevant to the translator and where necessary they are corrected in the commentary. A concordance (pp. 1056–60) allows cross-reference between the Rupprich edition, which is unhelpfully structured by text genres, and the chronological sequence of the documentary biography.

Rupprich's edition and my documentary biography have as their principal common source Dürer's large and now widely scattered 'literary estate' (*Nachlass*) as well as a wide range of writings by his contemporaries. Dürer collected, one might almost say 'hoarded', personal papers – letters, a journal, accounts of his family history, sketches and preparatory drawings for paintings, woodcuts and engravings, also outlines, drafts, figures and diagrams for the books on the theory and practice of art he planned or eventually published. He was evidently reluctant to throw away even small scraps of paper on which he had drawn or written anything remotely significant. Fleeting sketches are reused often years later as source material in finished paintings or prints. Draft formulations of writings, on the nature of beauty or on a problem of perspective, even ones scored out and superseded by second or third thoughts, are not thrown away but carefully 'archived'. It can seem as if Dürer might be consciously looking to document his personal life and record the development of his aesthetic perceptions and his artistic techniques, in some sense even to provide the stuff of a biography. Foreign though the modern notion of a 'documentary biography' would have been to him, he certainly wished posterity to remember him and his art. He donated his last oil paintings, the panels of the *Four Apostles*, to the City Council of Nuremberg as his 'memorial' (*zu einer gedechtnus*). A great deal of his archive remains intact and forms a major part of his 'literary estate' (that too an anachronistic notion). At the same time, much has been lost, like letters written to Dürer or those he must have sent to his parents and his wife during his journeyman travels and his visits to Venice in the 1490s and in 1505–7. This and other personal material may, it seems, have been discarded by his wife Agnes after his death.

Chief credit for the survival of so much of Dürer's writings is due to Willibald Pirckheimer, his intellectual mentor and friend. Pirckheimer was a member of the patrician ruling caste of the city republic of Nuremberg, soldier and diplomat, steeped in classical and Italian literature, art and learning. He was uniquely equipped to further Dürer's education in antique and Renaissance culture, aesthetics and science, to promote his social status, and to win him the recognition – amply evidenced in the documentary biography – of the wider world of humanist scholars and intellectuals. When Dürer died in 1528, he was working together with Pirckheimer on

the proofs of his last printed work, *Four Books of Human Proportion*. It was Pirckheimer who completed the editorial process and saw it into publication. To help him in this work he took charge of Dürer's papers. When Pirckheimer himself died intestate in 1530, his library, papers and artworks passed to his heirs and by marriage to the Imhoff family who administered this patrimony of treasures piously until 1633. Then, with Germany ravaged by the Thirty Years War, Nuremberg's economy – based on long-distance and international commerce – disrupted, and its political independence threatened, the Imhoffs faced bankruptcy and sold up their most valuable assets. In 1633–4 Amsterdam merchants hoovered up the bulk of Pirckheimer's books and Dürer's papers and artworks. Three years later Thomas Howard, Earl of Arundel, came to Germany as the ambassador of Charles I to the Holy Roman Emperor, but with a secondary mission of procuring for himself, a passionate fan of Dürer, and for King Charles, the first great English royal connoisseur and art collector, whatever he could find of Dürer's paintings and Pirckheimer's library.[2] In war-torn Germany and belea-guered Nuremberg he

> found a most myserable Countrye, and nothing by y^e way to be bought of any momente, heere in this towne beinge not one scrach of Alb. Duers paintinge in oyle to be sold, though it were his Countrye…they say within 3 or 4 yeeres great store of good things haue bin carryed out at easy rates.

There were some rich pickings still to be had, however. Arundel bought up what was left of Pirckheimer's books, and the City Council presented him, as a gift for Charles I and to solicit his political support, Dürer's self-portrait and portrait of his father, both done in 1498. For himself he got from the bishop of Würzburg a Madonna and Child. To William Petty, his chaplain and agent who was scouting for treasures in Italy, Arundel wrote:

> I wish y^u sawe the Picture of a Madonna of AD w^ch the Bishoppe of Wirtzberge gaue me last weeke as I passed by that way, & though it were painted at first upon an uneuen board, & is vernished, yet it is more worth then all the toyes I haue gotten in Germanye, & for such I esteeme it, hauinge ever carried it in my owne Coach since I had it.

Back in England Arundel got wind of six books in which the Amsterdam merchant Pieter Spiering Silfvercrona had had bound up the papers of Dürer bought from the Imhoffs. One source suggests Arundel managed to buy them for 500 fl., but if so they must have been resold when, after his death in exile after the Civil War and the execu-tion of Charles I, his own cultural treasures were dispersed. Sir Hans Sloane (1660–1753), physician, Fellow of the Royal Society (and inventor of drinking chocolate) acquired five of the volumes in the Netherlands in 1724. They are now in the shared custody of the British Museum – to which Sloane left them with his collection of curiosities as a founding legacy – and the British Library.

Other important writings of Dürer are preserved in the former Saxon royal library in Dresden, in the Germanisches Nationalmuseum and the Stadtbibliothek in Nuremberg. Despite the attrition of centuries, particularly the near-total destruction of the medieval and Renaissance city in the Second World War, legal and administrative records of Dürer's life survive in Nuremberg's municipal and state archives. In cases where the autograph originals of Dürer's texts have not survived, notably such key sources as his poetry (63)[3], the Family Chronicle (1) and the Account of Travels in the Netherlands (162), the continuing interest in his life and personality and the abiding veneration of his art ensured the making and survival of more or less reliable manuscript copies of now lost first-hand sources by antiquarians of the later sixteenth and seventeenth centuries. Records of Dürer's financial affairs and property transactions, tributes to him in his lifetime, mention of him in contemporary letters, memoirs of him in the decades following his death, and evidence of the early reception of his art and his printed books, have been assembled in more recent times from a wide range of disparate sources.

Quantity and quality of the information the sources afford us are by turns breathtaking, like the letters Dürer writes from Venice (29), and banally meagre, as when Erasmus or Philipp Melanchthon as an afterthought ask their Nuremberg correspondents to pass on their regards to him. The biographer of a subject living from the end of the eighteenth century onwards may expect to construct a more or less seamless record and narrative of a notable life. In Dürer's case there are yawning holes in the documentation of his life, and one dare not miss out even the most trivial passing mention. We should not be surprised to know precious little of his childhood and youth. But there is no more than a handful of sources for the formative journeyman years between 1490 and 1492 – where his travels took him, whom he met and what his contacts may have meant to him for his maturing as an artist. We can only surmise that Dürer must have visited Venice around 1495. In the years from then until 1500 he was laying the aesthetic and commercial foundations for his future success as artist and entrepreneur, transforming the genres of woodcut and engraving, painting innovative altar panels and self-portraits. Yet scarcely a single surviving source traces the motivation and causality of this progression. By 1500, when suddenly the information begins to flow freely, half his life is behind him and that has to be pieced together from no more than forty documents, some of them scraps of a few words.

From 1500 onwards the wealth of material surpasses anything comparable for a Northern European artist in Dürer's lifetime or long after. We can follow his rise to prominence in Nuremberg, the parameters and financial machinations of his service of Emperor Maximilian, his involvement in the first stages of the Lutheran Reformation. Yet still the gaps appear. After 1521 in not one single piece of writing does he mention Martin Luther and we lack a firm basis for judging where his journey of faith, intermittently mapped from his early manhood onwards, had taken him by the time of his death. Over the whole of his adult life there were occasions when he met other

artists and had the opportunity to see great works of late medieval and Renaissance art, most notably in Venice and the Netherlands. Frustratingly for the modern reader, the sources rarely convey Dürer's emotional and critical reactions to artworks, and when they do, he seems to lack a vocabulary and discourse adequate to express his judgements. On the other hand, in his letters from Venice, he shows himself capable of expressing his personality in an inimitably individual idiom which deploys self-irony and multilingual wit. In his later formulations and reformulations of the underlying aesthetics of his artistic theory and practice, we can follow the critical process by which he creates and refines a German discourse to rival and sometimes surpass comparable Renaissance treatises in Latin and Italian. The styles and registers of Dürer's prose, and his transformation of the status and functions of written German around 1500, raise issues for the translator. These are explored in the discussion on translation following this Introduction.

Dürer's literary estate has understandably been eclipsed by the greater cultural legacy of his art. A documentary biography cannot neatly divorce written testimony from the paintings, drawings and prints which tell their own story of the artist's life. However, works of art cannot be 'read' as documents in any straightforward or easily controllable way, for all that late medieval and Renaissance art both have iconographical languages – formal conventions, themes and subjects – which are in some sense 'legible'. A relatively small number of artworks are discussed in the documentary biography: in cases where they carry an inscription, by Dürer or a contemporary; where they are evidently associated with an identifiable written source or stimulus; or where in exceptional cases a contemporary description or critique survives. These criteria mean that my coverage of Dürer's art is necessarily arbitrary and cannot give a coherent, consequential picture of even its biographical significance.

The third dimension of my documentary biography is the commentary, intended to explain and interpret the texts and to place them in the multiple contexts of Dürer's life and the society, culture and economic activity of his time. What he wrote and what his contemporaries wrote document his historical time and place as well as the course and achievement of his individual life. The commentary provides detailed notes on the language and content of documents, and introductory or summarising discussions. Fifteenth- and sixteenth-century texts, their subject-matter and their writers' language, are rarely self-explanatory. It is also the case that Dürer's life and art, and the texts, contexts and artefacts which form the evidence of his biography, have generated a vast corpus of interpretative writing. This began as early as the middle of the sixteenth century, most famously with Giorgio Vasari's *Lives of the Most Excellent Italian Architects, Painters and Sculptors* (2nd edn 1568). By the 500th anniversary of Dürer's birth in 1971, Matthias Mende's comprehensive bibliography numbered 10,271 items. The effect of the anniversary was to give a further fillip to scholarship. The bibliography on the website of the Germanisches Nationalmuseum in Nuremberg (http://duerer.gnm.de/wiki) counts some 1,350 relevant publications in the forty years

from 1971 to 2010. I have not read quite all of these! My commentary attempts to give the reader an overview of research on the themes and concerns of texts and the interpretation of artworks. It is geared to more recent research so that it can reflect the current state of scholarship. I have gratefully drawn, on occasion heavily, on the annotations in Rupprich's *Nachlass*. Particularly relevant publications, including where possible research published in English which the readers of this documentary biography may more readily follow up, are cross-referenced with the bibliography, in notes and at the end of commentaries on texts. Neither bibliography nor commentary aspires to be comprehensive or to give adequate coverage and credit to all that has been written on Dürer. It is likely that despite my best efforts I will have missed important scholarly contributions and possibly even primary texts. I hope that it will be possible to remedy my worst sins of omission by updating an electronic version of the documentary biography.

The point-by-point acknowledgement of bibliographical sources in the commentary does not do justice to more comprehensive, synthesising works on Dürer and his art. It may be helpful to refer the reader to some valuable general works in English. Surveys of Dürer's life and art: Anzelewsky 1971/1981, Hutchison 1990, Panofsky 1948, Silver/Smith 2010, Smith 2012. Extended studies of aspects of Dürer's art and culture: Koerner 1993, Price 2003. Intellectual background: Kraye 1996, Ames-Lewis 2000. Historical context: G. Strauss 1976, Whaley 2012. The Northern Renaissance: Smith 2004, Nash 2008.

# Translating Dürer

In 1869 two books were published, each claiming with equal justification to be the first of its kind. 'That no English book about Albrecht Dürer, no complete translation of his Journal, Letters, and other pieces, no catalogue or critical account of his works, should have yet appeared is somewhat remarkable…We can scarcely help feeling that some express and authentic account of the Master should have been expected', wrote William Bell Scott.[4] To Mrs Charles Heaton (Mary M. Heaton) in her *Life of Albrecht Dürer of Nürnberg* ('revised and enlarged' in 1881), it seemed 'strange that a separate life of the greatest of German artists should never before have been published in England'. 'In themselves', Scott goes on, 'his writings are very interesting, and fully warrant the conclusion to which his designs and pictures lead us, that he was a simple-minded man, profound and strong, viewing life, art, and religion in the same serious spirit.' Heaton found that Dürer's writings 'reflect so vividly the simple loving heart with which his genius was associated, that I thought my readers would far rather have them in their crude, rough, and sometimes ungrammatical form, than any smooth biographical structure that I could build up out of them'. She admits that 'the difficulty of rendering provincial German of the fifteenth century into English of the nineteenth is so great that I have been obliged in some places to own myself conquered by it. In such places I have given the original words in a footnote', rather than venturing 'phrases which Dürer might perhaps or ought to have used, but most assuredly did not.'[5]

Most art historians writing in English, and hence also their readers, still rely for their knowledge of Dürer's writings on William Martin Conway's biography with translated documents, first published in 1889. Introducing the reprint of 1958, Alfred Werner commends Conway's versions for the way they turn 'the rich idiomatic German of Dürer into a melodious, rhythmically balanced, slightly archaic English…that only enhances its antiquated charm'.[6] Jane Campbell Hutchison in 2000 criticises Conway for his translation 'into plummiest Cantabrigian prose – an unfortunate bowdlerisation…of the true

effect of the artist's quite direct and clear writing style'.[7] That Conway's Victorian transla-
tion draws condescending criticism after 125 years is scarcely surprising. It is not simply
a question of the nature of Dürer's German and the style of Conway's English. His texts,
like Scott's and Heaton's, have linguistic, factual and interpretative errors, and knowledge
of the contexts of Dürer's art and writings has been transformed by more than a century
of academic industry.

Translation is not a self-explanatory procedure. It is conditioned by linguistic, stylistic,
and genre-specific factors which are themselves historically and culturally conditioned,
and it requires methodological reflection. In 1907 Everyman's Library published a transla-
tion by Anne Macdonell of the Italian Renaissance goldsmith Benvenuto Cellini's
*Memoirs*, the earliest artist's autobiography (begun in 1558). It replaced a previous
Everyman's edition which used Thomas Roscoe's translation of 1822. Its main contem-
porary rival was John Addison Symond's version of 1887. Reviewing this Victorian
generation of translators (to which Heaton and Conway themselves belonged), Macdonell
credits Roscoe with 'individuality of style, but an individuality which is pedantic and
often unpleasant' and in any case finds he 'does not satisfy the loosest standard of cor-
rectness'. Symonds – best known as a poet – she admires for his 'unsparing conscien-
tiousness, his patient, unremitting zeal for accuracy'. 'His Cellini is Cellini with an added
quality, which makes the autobiography shine as it hardly does in the Italian, and which
at times rather disguises the cruder idiom of the original.' In the first years of the twen-
tieth century, Macdonell complains, the ideal is 'scientific, philological, rather than artistic,
and too often…the work has the air of being done, not so much for the sake of literature,
as under the eye of the examiner'. That requires 'strict justice to each individual clause,
compelling here the choice of archaisms, there of colloquialisms of the day, and again
of foreign idioms, as if to force on the reader that something very difficult is being done
for him – which, in truth, is often the case'.[8]

I have not set out to translate Dürer's writings and associated German and Latin
texts 'for the sake of literature'. My book has passed more than once 'under the eye
of the examiner', read for me by colleagues, and vetted by other experts for my aca-
demic publisher. It tries to keep the needs and expectations of its target readerships
in mind, and it will be for my readers to judge its merits and demerits. What this part
of my introduction aims to do is to set out a more clearly defined approach to the
method of translation. It locates Dürer's writings in the historical context of written
German around 1500, it categorises their linguistic and stylistic range and character-
istics, and it discusses issues and problems inherent in translating a heterogeneous
corpus of 500-year-old texts into contemporary English.

The six decades of Dürer's life, from 1471 to 1528, saw a significant shift in the nature
and status of the German language. Throughout the fifteenth century German had
been competing with, and starting partially to supplant, Latin as the vehicle of written
communication in fields such as administration, law and commerce. By the 1520s, not

least because of the impetus it received from the early Lutheran Reformation, it was emerging as a language of religion, philosophy, learning and literature (a status not fully achieved until the eighteenth century).[9] Though the printing press in its early decades from the 1450s onwards produced more titles in Latin than in German, it also stimulated translations from Latin into German and a limited flow of new books written in the vernacular. In cities like Nuremberg, higher population groups benefited from the spread of education and literacy, and were becoming to a modest extent both readers and writers.[10] Albrecht Dürer, with characteristic enterprise, took advantage of being born into the age of printing, of being the godson of Germany's foremost late fifteenth-century publisher, Anton Koberger, and of coming to know humanist scholars and intellectuals, by perfecting the printed art forms of woodcut and engraving and by publishing three books in the 1520s.[11] The last decade of his life coincided with the first impact of the Lutheran Reformation, which dramatically boosted the status of written German. Dürer avidly bought and read Luther's publications, and was well known to many of the early reformers. Although his formal education was limited, he developed exceptional linguistic talents. His written German can be versatile and nuanced in a range of genres and registers of language. He learnt Italian during his visits to Venice. His cultured friends helped him gain access to ancient and contemporary Latin writing. From around 1500 he amassed manuscript notes and drafts which in the 1520s he shaped into two printed textbooks, intended to open up fundamental techniques of Italian Renaissance art to German craftsmen. These achieved the unusual distinction of being translated into Latin (indeed they won their largest readership in these versions).

Dürer the writer contributed to a shift in the relationship of German and Latin. Around 1500 Germany had in effect two written languages: Latin was the medium of scholarship, of theology and Catholic worship, and of law and administration; German had begun to challenge Latin in these last two areas, but was long hampered by the lack of a nationally valid linguistic norm and by its perceived cultural inferiority. The new humanist learning[12] was focused initially on the revival of classical Latin to replace its corrupt medieval forms. From the mid-fifteenth century onwards, German humanists were discovering long lost Greek and Latin literary, philosophical and scientific texts, and developing out of them the early modern scholarly disciplines of philology and textual science, history, and natural philosophy. Mastery of Latin as a written and, to some extent, spoken medium was the defining mark of the intellectual elite.

Above all it was the rapid expansion of towns in the fourteenth and fifteenth centuries which advanced German as a written language. There German developed new currency and status in areas of secular life where literacy had become more widespread. Towns with populations of up to 50,000, like Cologne and Nuremberg, with early capitalist economies based on manufacture and commerce, demanded efficient government and regulation. In a politically fragmented nation which lacked a strong centralising monarchy, larger and smaller towns won for themselves a substantial measure of

fiscal, legal, social and cultural autonomy. Nuremberg was a *Reichsstadt*, a city-republic, directly responsible to the imperial authority and free of feudal subjection to a territorial prince or bishop. It was governed by an oligarchy of patrician dynasties, with the support of an upper tier of established merchants and craftsmen. It was a regime geared to the maintenance of political and commercial stability, civic order and security. It purchased the obedience and loyalty of its citizens at all levels of its hierarchical society by providing services – justice, healthcare, education, pastoral religious ministry – which gave them a quality of life exceptional in this age.[13]

The German that was written in Nuremberg around 1500, in personal letters, family documents, commercial contracts, business correspondence, property deeds and technical instructions, and in prayers and hymns, poetry and story, was peculiar to the city. In varying degree written language mirrored and refined the spoken language of its inhabitants. Writing in the vernacular was still primarily generated and formed by function and utility. Text-types and genres were geared to the specific concerns of socio-economic groups. Latin had norms and rules of spelling, syntax, grammar and rhetoric, defined by the Renaissance return to classical models and valid wherever and by whomever it was used. Written German around 1500 lacked a prestigious model, typically provided by a royal court or a capital city, which could impose itself as a national standard. How you wrote depended on who you were, on where you wrote, on what and for whom you were writing.[14]

So Albrecht Dürer's German is Nuremberg German in terms of its dialect character. His spelling forms convey local vowels and consonants; his grammar uses local spoken reductions of noun and verb endings which encode information like singular and plural, gender, past or present tense. His vocabulary contains words peculiar to local colloquial speech.[15] His autograph manuscripts have little or no punctuation. It is a language attuned to oral usage and characterised by restricted, dialectal norms, still to some extent speech in written transcription. Within this specifically Nuremberg language system, Dürer's German reflects also his social identity: his origin in a respectable handcraft family, his middling degree of education, increasingly also the cultural achievement which propelled him to the interface of middle- and upper-class society. He exemplifies in his written practice a linguistic dynamic which reflects his socio-cultural upward mobility. This is evident in a gradual recession of dialect features over time – comparable with the shift in language use people show nowadays if they move from speaking local or regional English in their early years to acquiring more standard speech habits through higher education, professional advancement and enhanced social status.[16]

The process by which language, written and spoken, tends to lose its geographical rootedness, to become less marked by dialect features, happens not just in individuals' life experience, but in collective patterns too. Nuremberg merchants and manufacturers developed far-flung trading networks; the city had particularly close political links with the Hapsburg emperors and frequently hosted national diplomatic occasions. Its humanist intelligentsia built up a European reputation for its literary and scientific scholarship.

As it became a major centre of printing it needed to be aware that its own German was not familiar or valid across the German-speaking lands. Such pressures encouraged movement towards more widely accessible, proto-standard forms of the written vernacular. During Dürer's lifetime, regionally valid examples of normative language emerged like the Hanseatic German of the North Sea and Baltic trading nexus. The imperial chancery, the civil service of the Hapsburg emperors in Vienna, had by the end of the fifteenth century a policy of standardising the written German of its scribes according to a south German norm of phonology and orthography. Documents which went from the chancery to governments and authorities through the German Empire began to convey a consistent model of the written language. Printers in southern and central German cities started to purge their publications of crass local linguistic features and to imitate the chancery's model of good practice. These two powerful agencies provided exemplars for official and private writing in cities like Nuremberg. From around 1520 what in the long term became the most powerful of all normative forces emerged – the Lutheran Reformation. Its heartland was East Middle Germany, in medieval times colonial territory, populated by migrants from all quarters of the empire. Here there emerged a compromise dialect which synthesised key features of northern Low German, the central German dialects, and those of southern Upper German. The Reformation effectively hijacked the printing industry in the 1520s and flooded the nation with popular theology and anti-Catholic polemic, most of it in 'Lutheran' East Middle German, much of it written by Martin Luther himself. Albrecht Dürer was versed in Lutheran thought by 1518, and he eagerly bought and read Reformation pamphlets in the following years. We presume that he owned Luther's German translation of the New Testament, first printed in 1522.

Dürer's German, however, is not simply the product of the linguistic, social and cultural influences that acted upon it. It is an idiolect, an individual language variety shaped by his personality, by cultural and linguistic encounters peculiar to his life, and by the uses and intentions of his writings. The conscious expression of his self-awareness in language is apparent to any perceptive reader. The co-existence of such individual self-expression in words with Dürer's numerous self-depictions in drawings and paintings is unparalleled in the Renaissance even by Leonardo da Vinci. This degree of unique identity, conveyed in image and language, is evident in a whole range of written genres, in letters, poetry, accounts of family history, and the insights his technical and aesthetic writings give into the sources and processes of his creativity. In some texts, such as his family chronicle (1) and his verse (63), Dürer is working within the formal and linguistic parameters of conventional genres of early modern secular and religious writing. Even so, the extent to which he has internalised these styles and idioms, for instance in his devotional writings (see 108), is striking. In other texts, most spectacularly his letters from Venice to Willibald Pirckheimer (29), he finds an inimitably individual voice. Within a framework of learnt formulae for starting and ending a letter, he switches codes and even mixes languages as he moves from topic

to topic, from business matters to artistic concerns to coarse joshing. The linguistic virtuosity of macaronic passages of mixed Venetian Italian and German, and of his transference into German of key terms of Renaissance vocabulary, reveal Dürer as a highly aware, sophisticated exponent of language. The culminating evidence of his linguistic ingenuity[17] is his creation, in the surviving drafts and printed editions of his books on geometry, perspective and human proportion for young artists and craftsmen, of an innovative discourse of art theory and technique in the German vernacular, a newly forged vocabulary of the subject, and original visual layouts of his material combining text, diagram and illustration.

A tension will have become apparent in my discussion – between the picture of German as a written medium secondary if not inferior to Latin, still emergent as a language of serious intellectual and cultural discourse, and the claims made for Dürer as an exponent of language in writings whose interest and importance lies in their innovative, ground-breaking nature. But this tension runs through Dürer's writings themselves. He realises himself their potential to bring urgent new impulses to German and northern European artists. However, he is aware also of the limitations of his own knowledge, his lack of direct access to classical sources and to contemporary Italian teaching on the 'science of art'.[18] He acknowledges, too, the limits of his skill as a writer, and of the German language itself as a vehicle for an educational project which hitherto could have been carried out only in Latin: 'being someone gifted with slight intellect and no particular art and skill...who, lacking education and having spent his life with colours and painting, cannot set my work before the public in the fittingly elegant words which need requires'.[19] There becomes apparent in the 1520s a weakening in his linguistic assurance. This may well have had personal grounds – from 1521 until his death in 1528 his health was failing and he was struggling to get his legacy of theory and practical knowledge into print for posterity. It is a crisis in linguistic confidence at variance with the boost he helped bring to the status of German.

The languages of my source texts, Renaissance Latin and early modern German, are not recoverable or reproducible in some equivalent form of pastiche archaic English. Translated texts cannot aim to have an effect on the target readership of my documentary biography that is remotely comparable with the historic impact of Dürer's original texts. There are ineluctable, insuperable obstacles to the replication of linguistic, intellectual and cultural constituents of 500-year-old texts, such as the translator of a modern work into a contemporary version might aim at. What is called 'translation loss' – the fact that no source text can be perfectly replicated, though in some degree this may be controllable and mitigable – is acute here. It is particularly crucial and regrettable in the case of texts in which Dürer is articulating his concepts of artistic theory and practice. There he is creating a vernacular discourse, a vocabulary, a way of writing about art, which belong in a unique historical context and are aimed at a very specific readership. The linguistic, intellectual and cultural historical specificity of

these texts taxes the translator's strategies and stratagems beyond their limits.[20] Much will inevitably be 'lost in translation'.

My translations do not proceed from generalised judgements of Dürer's German as older translators saw it – characterisations like 'crude, rough and sometimes ungrammatical', 'rich and idiomatic', 'direct and clear'. In truth it can be all of these, and my translations do try to convey the variety and range of style and diction in different genres of Dürer's texts. His most significant writing is individual and creative in its use of language and he often strains the limits of what is communicable in the written vernacular of his time. Translation does him most justice, and best serves the reader, not by aping 'antiquated charm', but by bringing to bear the full resources of current English prose. Only in this way can we hope to replicate the impact on their contemporary readers of texts which, quaint to us, were modern and challenging to them.

In some cases texts and their genres have analogues in modern English or in its older but still familiar guises. Language and syntax of early modern legal texts can be – and here are – imitated in pastiche. The lay religious idiom of Dürer's reflections on the deaths of his parents (15, 92), his reception of early Reformation teaching, and his devotional poetry transfer readily into an English coloured by the Book of Common Prayer or William Tyndale's Bible. Efforts by well-meaning ghost-writers to draft humanist-style material for Dürer's books, in verbose Latinate German (84.1–2, 182.1), are similarly easy game for translation marked by calque and exoticism. Other Latin texts cover a range from relaxed or more formal letter-writing to scholarly discourse and neo-Latin poetry in would-be grand manner. My translations look to convey stylistic features of all these. While verse translation as such is never attempted, if only in the interests of stricter accuracy, some effort is made to reproduce the rhythms and ductus of German and Latin poetry.

Language and content of most texts are not self-explanatory to the modern reader, student or art historian. Linguistic aspects like historical change in semantics, morphology and syntax, Dürer's creation of a new German aesthetic and scientific lexis, its sources and connotations, his assimilation of a new artistic persona from antique and Renaissance traditions, the dense nexus of cultural, social and political contexts in which his art and writing are embedded – all these dimensions of his self-depiction in language and his contemporaries' stylisation of him make an extensive scholarly apparatus indispensable. The danger is that the reader has to hack a path through the 'ragged underbrush of marginal notes', the 'thorny hedge' of commentary, to reach the 'sunny uplands' of Dürer's utterances.[21] Annotation will, I hope, not be 'dry bones that do not rise up and dance', but will help to bring dead words to life. As well as clarifying what texts say, how and why they say it, the commentary offers a synoptic guide to the current state of research on the documents and on the artworks covered in the biography, referenced to the extensive bibliography.

In all texts of the documentary biography my translation claims a sounder philological grasp of fifteenth- and sixteenth-century German and Latin than its predecessors, quite

apart from the fact that many texts are here made available in English for the first time. For the linguistic and cultural historical reasons already explained, the translations have to be heavily biased towards the styles and idioms, lexis, tonal and cultural registers of modern English. Close replication or discernible equivalence of source text and target text is confined to simpler factual and denotative documents. Complex discourse, with conceptual and theoretical or personal and emotional content, generates translation which operates with a greater or lesser degree of freedom from constraints imposed by closely tracking the source text. Where the effects of historical change – for example in German and English semantics, in aesthetic categories, in cultural attitudes and assumptions – render the translation of source text elements particularly problematical, recourse is almost always to annotation and commentary rather than to explicatory glossing within the text itself ('exegetic translation'), both where these difficulties are contextual and arise from historical processes and where they are inherent to the text.

Some particular, recurrent examples of issues which arise in the translation of Dürer's discourse and lexis of aesthetics and the production of art merit brief specific discussion. Confronted with the need effectively to create a new language of art in German, Dürer has recourse to three main linguistic strategies. Firstly, he takes vocabulary from Italian. In a letter from Venice in February 1506 (29.2), he complains that Italian artists dismiss his work as *nit antigisch art*, imitating in German (by 'loan translation') the Italian phrase *all'antico* ('in the antique manner'). Reference works list no earlier occurrence of *antik, antigisch* in German. By September 1506 (29.9) he is proud to report that Venetians deem his altar panel of the *Feast of the Rose Garlands* 'erhaben', derived (by 'semantic loan') from Italian *sublime*, again a first occurrence, the word not being used again in this figurative sense in German until the eighteenth century. Most strikingly he coins circa 1523, to denote the revival of the art of Antiquity in the 150 years from circa 1350 to 1500, the word *widererwaxsung* (181.2) – 'regrowth, rebirth' – recorded nowhere else in German and not paralleled even in Italian until Giorgio Vasari's *rinascità* (1550); the modern word Renaissance is a nineteenth-century French coining. Further words are taken, sometimes as direct loan-words, from Latin and Italian theoretical writings on art, for example *figur, modell, proporz/proportion, prospectiva/perspectiva*.

Secondly, Dürer draws on words he has come to know from late medieval mystical theology and devotional literature. It was in these genres that much Christian Latin abstract and conceptual vocabulary was adapted into German (again, especially by loan translation). Dürer develops this lexis by semantic extension to give it key meanings for his discourse on artistic concepts. Examples are: *vergleichung* (Latin *concinnitas*), *geschicklikeit* (Latin *habitudo, commoditas*), *freyikeit* (Latin *libertas, liberalis*), *subtilitet* (Latin *subtilitas*). A third category is semantic extensions of older German vocabulary: examples are *abstehlen, gegengesicht, gegenwurf, angesicht, eingiessen/eingus* (this for the quasi-divine inspiration of the artist, from the religious sense of 'inspiration by the Holy Spirit'). In contrast, Dürer's anatomical lexis, for the measurement of the body in proportional construction, shows a preference for quite earthy demotic and dialect

words: *zagel* ('tail', 'penis'), *vxen* ('armpits'), *einpeissung* ('pits, furrows' in the body – from *beissen*, 'bits bitten out'), *maus* ('mouse' – biceps!), *mollet* ('corpulent'), *muncket* ('fat' or 'broad'), *murret* ('short', 'crooked').

For the translator, Dürer's construction of an aesthetic and technical vocabulary presents acute problems. The precise sense of his terms and their demarcation from each other is often impossible to determine at all accurately. Indeed, the passages in which he deploys them are exploratory, working towards definitions rather than arguing from clear concepts. Modern English deploys a large, fully defined technical vocabulary of art theory and practice. The translator cannot unpick centuries of semantic development but is compelled, variously, to adapt Dürer's terminology to contemporary standard concepts or to rely on annotation and commentary to an even greater degree than usual.

Even words in Dürer's lexis which are immediately familiar can be acutely problematical. Between sixteenth-century and modern German major semantic change has occurred. The total vocabulary has increased exponentially in continuous reflex with forces of social, intellectual, technical-scientific and material change. One major effect of this process is that words with originally broad spans of meaning and connotation have tended to specialise in limited, specific senses. Lexemes in early modern vocabulary are much more likely to have a greater, more complex polysemy – to have a range and variety of meanings, some closely related, some confusingly at variance. Especially at long historical remove it can be far from easy to establish which of its possible senses a word carries in a given context. A classic example of semantic change, and one which is of obviously crucial significance for Dürer's writings, is the noun *kunst* (Latin *ars*, English 'art') and its adjectival forms (for example, *künstlich, kunstvoll, kunstreich, künstlerisch, kunstliebend, kunstverständig*) and noun synonyms and compounds (such as *künstler, kunstner, kunstwerk, kunststück, malkunst, schreibkunst*). Etymologically *kunst* is related to German *können* ('can') and *kennen* ('know', compare northern dialect and Scots 'ken'). Its main sense circa 1500 (as is also the case with *ars* and 'art'), is 'knowledge' and 'ability based on knowledge'. The shift to the principal modern senses of *kunst* and 'art', creative skill and its aesthetic, imaginative products, came about in the eighteenth century.[22] One restricted sense in which Dürer also uses *kunst* is to denote his engraved and woodcut prints, products of particular expertise and applied 'art'. Over the course of his writings about the theory and practice of art, Dürer felt his way towards the threshold of the modern conception of art which combines acquired knowledge (in increasingly theoretical and scientific forms) with creativity and inspiration. In 1513 he wrote:

> To acquire the art of painting properly [*kunst recht zw molen*] is difficult. So anyone who finds he lacks the skill for it should not attempt it. For it comes through inspiration from on high. The art of painting [*kunst des molens*] cannot be well judged except by those who are themselves good painters. In truth it is a mystery to others just like a foreign language is to you. To learn and practise this art would be a noble

thing for intelligent young men free to pursue it. Many centuries ago this great art of painting [*gros kunst der mo009*] was highly esteemed by mighty kings, and they enriched excellent artists [*künstner*] and held them in great worth, for they deemed such ingenuity a creativity in the image of God himself. For a good painter is inwardly teeming with figures, and were it possible that he might live for ever, he would always, from out of these inner ideas of which Plato writes, have new things to pour forth in his works (82.1).

In such passages Dürer reinterprets the concept *kunst*. He does so by associating the noun contextually with other words (*eingiessungen, subtil, sinreichikeit*) which belong to his extended vocabulary of aesthetic discourse sketched above, whose connotations link *kunst* with theologically derived ideas of quasi-divine creativity (here explicitly, *ein geleich formig geschopff noch got*). The tension in this passage, between the received sense of *kunst* as acquired knowledge and its extended sense of art impelled by inspired creativity, is impossible to convey adequately in translation, because the translator has wherever possible to use 'art' for *kunst*, even though the English word is now irrevocably altered by its eighteenth-century redefinition. The polysemy of Dürer's *kunst*, its indeterminacy in any given context, may be mitigated in translation by substituting a synonym or a paraphrase like 'knowledge' or 'acquired skill', where the sense is evidently the traditional one. But since key passages usually raise issues of interpretation, in this respect too the translation is reliant on annotation and commentary.

A final ongoing feature of Dürer's prose which affects translation strategy is the 'orality' of his written style.[23] In common with much early modern German, even when he is writing on a relatively high level of formality and thematic ambition, his persona tends to be that of speaker, using verbs of saying, expounding argument and instruction in the first person singular, and enlisting the reader's co-operation through the first person plural, apostrophising the reader with the familiar *du* pronoun. The translator has to curb the excessive use of cohesion devices (beginning each sentence with conjunctions 'so', 'therefore' 'thus' and so on) and the rhetorical doubling and trebling of synonymous nouns, verbs and adjectives, a feature lay writers imitate from the prolix style of chancery German and humanist Latin.[24] Pruning these features incurs 'translation loss' by favouring target language expectations against the historical character of the original text. The loss is partially compensated by leaving these rhetorical accumulations unchecked in the examples of 'ghost-written' drafts of prefaces and dedicatory epistles written by Dürer's humanist friends (84.1–2, 182.1).

My translations owe much to the vigilance and judgement of my expert readers and my 'common reader'. Ronnie Ferguson helped me make sense of Dürer's Venetian. When it came to the challenging task of translating the ambitious prose and, worse still, verse of Renaissance humanists, my Latin – a year's-worth at a 1950s grammar school and decades-worth paddling in the shallows of medieval poetry, chronicles and Vulgate – was

rapidly out of its depth. I was brought to shore by Adrian Gratwick, emeritus classicist. He corrected my error-strewn efforts and as *my* ghost-writer drafted whole texts which I needed merely to rephrase. He also cast a cold eye on Rupprich's at times faulty transcriptions and contributed glosses and explanations to the commentaries.

NOTES

1   See the comprehensive discussion of the sources in R I, 8–17.

2   For the following see Crowne 1637/2012, Springell 1963, Howarth 1985, MacGregor 1994.

3   Here and throughout the book numbers not otherwise labelled refer the reader to the chronologically ordered texts of the documentary biography (see the full index of texts, pp. 1042–55).

4   Scott 1869, V–VI.

5   Heaton 1869/1881, VI.

6   Conway 1889/1958.

7   *Albrecht Dürer: A Guide to Research*, New York/London: Garland/Hutchison, 2000.

8   *Memoirs of Benvenuto Cellini, A Florentine Artist, Written by Himself*, London: Dent, 1907, VII–VIII.

9   Eric A. Blackall, *The Emergence of German as a Literary Language*, Cambridge: CUP, 1959.

10   'Thomas More thought that something like sixty per cent of Londoners could read and write.' In Nuremberg the proportion may have been even higher, whereas the rural poor were almost entirely illiterate, and even country priests were said to be unable to understand the liturgy they garbled (Hale 1971, 283–4, who also warns that 'literacy in itself, whether it means as little as the ability to sign one's name or as much as to carry on a business correspondence, is little guide to the ability to learn from books, let alone derive ideas from them'). See also Chadwick 2001, 8–11; Moeller/Patze/Stackmann 1983.

11   Ashcroft 2009, 3–18.

12   For the following see Kraye 1996.

13   Strauss 1976.

14   For more comprehensive (and in part more technical) discussion of this and the following, see R. E. Keller, *The German Language*, London: Faber & Faber, 1978 (Chapter 6); Christopher Wells, *German. A Linguistic History to 1945*, Oxford: OUP, 1985 (Chapter 5). On underlying aspects and concepts of language, see David Crystal, *The Cambridge Encyclopaedia of Language*, Cambridge: CUP, 1987.

15   The sounds, grammar, vocabulary and written spellings of Nuremberg's urban dialect reflected its position on the boundary of Bavarian and East Franconian (Steger 1971, Koller 1989).

16   Koller 1989.

17  The allusion to Latin *ingenium* and Italian *ingegno*, the creativity of the Renaissance artist, is deliberate.

18  In Martin Kemp's now indispensable phrase (Kemp 1990).

19  See texts 182.1–9, commentary, Ashcroft 2005, and SMS 3, 325.

20  My approach to translation methodology in this section of the introduction, and some of its terminology, are indebted to Sándor Hervey/Michael Loughridge/Ian Higgins, *Thinking German Translation*, 2nd edn, London: Routledge, 2006. I am particularly grateful to Michael Loughridge.

21  Grafton 1997, 9.

22  Wellmann 1993, Ashcroft 1999.

23  Betten 1990b, 331–3, insists that orality is not a naive feature but a conscious stylistic choice of vernacular writers.

24  See Kästner/Schütz/Schwitalla 1990, 205–20, on the 'linguistic consciousness' underlying the stylistic differences between Latin, Latin-influenced German, and vernacular writing pitched at the 'common man'.

# Money, Coinage and Currency

Dürer's financial affairs are well documented, but given the very complex nature of the monetary systems of early modern Europe, they are not always easy to follow in detail. In Nuremberg, Venice and Antwerp, the main locations of his life, different currencies were used in larger and smaller transactions, and especially in the Netherlands coins of various countries were in circulation. Within the German Empire the fragmentation of political power was a contributory factor in the lack of a standard currency.

We need to distinguish three different, though partially overlapping, aspects of financial calculation and the monetary denominations used in them. For large transactions 'real' coins of high precious metal content were used, in Dürer's lifetime principally gold coins of up to 24 carat: gulden, florin and ducat. These had international currency and validity. In small-scale, everyday commerce local coins were used, such as the *pfennig* (penny) and *heller* (halfpenny) in Germany, the *stuiver* in the Netherlands, the *soldo* in Italy, whose value was essentially transactional though it was defined in relation to the 'real' currency. Local coins were 'white' silver coins, which outside Germany later gave way to 'black money', of copper with a minimal silver content. In book-keeping, as a way of reconciling differing currencies and denominations, standard 'moneys of account' were used which were not necessarily the same as coins in actual circulation. In Germany the pound (*pfund*) served this purpose – a unit of weight which could be translated into different coinages. This system also compensated for the fluctuating metal content of coins from different mints and for the fraudulent practice of clipping and shaving them for their gold and silver.

All three kinds of money appear in the texts of the documentary biography. Payment for Dürer's major artistic commissions, his imperial liferent, his annuity from the Nuremberg Council, and his house transactions, are specified in gulden or florins (see for example 47, 53, 99, 198). Payments recorded in the financial records of Duke Frederick the Wise of Saxony, the bishop of Bamberg and the city of Nuremberg use

moneys of account (see 6, 18, 22, 113). The Nuremberg Council entries sometimes mix gold coins, the accounting *pfund*, and *müntz*, small change (87, 252). The use of local coinage, along with 'real' coins of different provenance, is fully documented in the account of Dürer's travels in the Netherlands (162), in which he painstakingly records trivial everyday expenditure and his relatively cheap sales of woodcuts and engravings.

Conversion of sixteenth-century coinages into present-day currency values is quite meaningless since ways of life, patterns of consumption, scales of wages and income, and overarching economic structures, have so radically changed.

## The large and small denomination coins and moneys of account which occur in Dürer's writings:

### 'Real' coins

**Angel:** English gold coin, copied from French *ange*, minted from 1465 to replace the *noble*. Valued at 6s. 8d. or 2 gulden. Bore the figure of the Archangel Michael slaying the dragon. The *angelot* was a ½ *angel*.

**Ducat:** Venetian gold coin, also called *zechine*. First minted in 1284 and named after the text round its edge: *Sit tibi Christe datus quem tu regis iste ducatus* – 'May this duchy which you rule be devoted to you, O Christ'. Same weight – 3.54 g (24 carat) – as the florin.

**Florin:** The Florentine gold coin *fiorino* first minted in 1252. The *ducat* and the *gulden* were modelled on it. In texts abbreviated to *fl*.

**Gulden:** Literally 'golden [coin]'. From 1346 minted by the Prince Electors of the Rhineland, hence Dürer's term *gulden reinisch* ('Rhenish gulden'), which he also applies to the *gulden* minted in Nuremberg under imperial privilege. In 1386 it had a weight of 3.4 g of gold but by the sixteenth century that had been reduced to under 3 g. When Dürer refers to *goldgulden* or *fl*. he may mean coins of heavier weight, equivalent to 30 rather than 20 shillings, though *gulden* is generally synonymous with *fl*. From 1429 Nuremberg minted two coins named *gulden*, the *Sebaldgulden* or *Stadtwährungsgulden* in 22.5 carat gold, and the *Lorenzgulden* or *Landwährungsgulden* in 19 carat gold. In the documentary biography the *Stadtwährung* is referred to as the 'common' or 'designated currency of Nuremberg'. The *St Philippgulden* was minted by Philip the Fair of Burgundy (1494–1506), with the image of his name saint impressed on it, and was common in the Netherlands. The *Horngulden*, minted by Bishop Johann von Horn of Liège, was only 10 carat gold. Dürer refers also to *schlecht gulden*, 'light' – either *Horngulden* or worn, clipped or defectively minted coins. The *gulden* in Dürer's usage should not be confused with the Netherlandish *guilder*, developed after 1526 from the gold coin introduced by Emperor Charles V, the *Carolus guilder*.

**Krone:** 'Crown'. French (from 1339) and English (from 1526) gold coins, stamped with the royal crown. In England from 1526 until decimalisation in 1971 worth 5s (latterly surviving only in half-crown form). Dürer's unclear mention of the French

coin seems to overvalue it when he makes either 25 or 40 *Cronen* equivalent to 54 *gulden* 8 *stuivers*.

**Nobel:** English *noble*, first coined in 1344, originally valued at 6s. 8d., then at half the *angel*, approximately equivalent to the *gulden*.

**Portuguese great gulden:** Dürer was given 2 *Portigales groß gulden*, one of which weighed 10 *ducats*. These must have been huge coins.

## Smaller and local coins

**Groschen:** Diminutive from Latin *grossus*, see French *gros*, English *groat*. Silver coin worth multiples, commonly 12, of the (originally Roman) *denarius*. In the Netherlands the *grot* was copied from the French *gros tournois*. The smaller nominal of it was the *doppelgrot*, then in Saxony and Meissen the *groschen*. In Saxony the *guldengroschen* was current in the sixteenth century, a heavier silver coin with the value of 20–24 ordinary *groschen*.

**Heller:** Silver coin from the imperial mint at Schwäbisch-Hall. Steadily declined in weight and silver content. Nuremberg minted the *heller* from the fourteenth century, at which time there were 240 to the *gulden*. By the sixteenth century the *heller* was worth a half-*pfennig*. In its small-change function it became the first German copper coin.

**Marcello:** Familiar to Dürer as the silver coin of Venice, worth 10 *solidi* (shillings), half a *ducat*. Named after Niccolo Marcello, Doge in 1473–4.

**Ort:** Silver coin, from *ort* in its sense of 'angle, edge, point', hence 'quarter piece' (two intersecting lines give four angles). *Ortsgulden* was a quarter of a gulden, *örtgen* or *ortje* a quarter of a Netherlands *stuiver*.

**Pfennig:** The oldest word for a coin in the west Germanic languages: Anglo-Saxon *penning, pending*, old High German *phenning, phending*. In the eighth century a silver coin, the equivalent of Latin *denarius, stater*. In the sixteenth century locally minted and valued nominally at 240 to the *gulden*, 12 to the *groschen*, and worth 2 *heller*.

**Stuiver:** Netherlandish double *groschen*, later also minted in north Germany as the *stuber*. In Antwerp, where it is the basic coin for Dürer's purposes in 1520–21, it was set at 120 to the pound or *gulden*.

**Weißpfennig** or **albus:** Rhenish silver (hence 'white') penny minted from the fourteenth century. Originally set at a value of 2 *schilling*/24 pence and weighing 3.9 grams of silver, it was still a reputable coin for Dürer in Antwerp in 1520–21. The rise of the silver *taler* in the later sixteenth century led to a reduction of its silver content, decline to 'small-change' value, and replacement by 'black' copper alloy coins.

## Moneys of account

In some cities 'real' coins were also used as accounting denominations. In Antwerp the florin and gulden stood in a fixed relation to the pound. In Florence the *fiorino* doubled with the pound as money of account as well as a coin in circulation. In Augsburg after 1500 the pound was superseded by the *rechnungsgulden* ('gulden of account'). Traditionally

and still in Nuremberg, however, the standard money of account was the *pfund*. Since the Carolingian Empire in the ninth century, the Roman *pondus* weight of 12 oz of pure silver had been coined into 240 silver pennies. In England Henry VIII issued a gold coin valued at 20 shillings, 1 pound weight, called the *sovereign* from its embossed image of the enthroned king. But generally the *pound/pfund* remained the accounting weight convertible into coinage. It retained its Latin symbols L.s.d (*libra, solidi, denarii*). The Nuremberg *gulden*, like the Roman pound, was reckoned as 20 *schilling* = 240 *pfennig*. The accounting procedure was more complex. In 1500 the *alt pfund* (the 'old pound', set at 8 to the *gulden*) was replaced by the *neu pfund* revalued at 4 *alt pfund* = 120 *denarii*. The *Rhenish gulden* was now calculated as 2 *pfund*, the *florin* and *gold gulden* as 2 *neu pfund* 1 *schilling*.

A further accounting and invoicing money used in some texts of the documentary biography is the *schock*, an ancient Germanic word with the possible original sense of 'armful or sheaf of corn', then 'unspecified quantity of things, animals, people'. On the market place, then in the counting-house, it acquired the precise sense of '60 *groschen*', probably the quantity that could be struck from one mark weight of silver. A *viertel* was a 'quarter' of a *gulden*, that is 60 *pfennig*.

[Engel 1965; Jardine 1996, 99–102; Landau/Parshall 1994, 369–71; North 1994 & 1995; Schrötter 1930; Sprenger 2002; Spufford 1988; Unverfehrt 2007, 226; Welch 2005, 81–9. On Italian currency, Kemp, 1997, index, 302]

*Facing page*  Ehrhard Schön (attributed), *Portrait of Albrecht Dürer in Old Age*, 1528/9. Detail of fig. 74

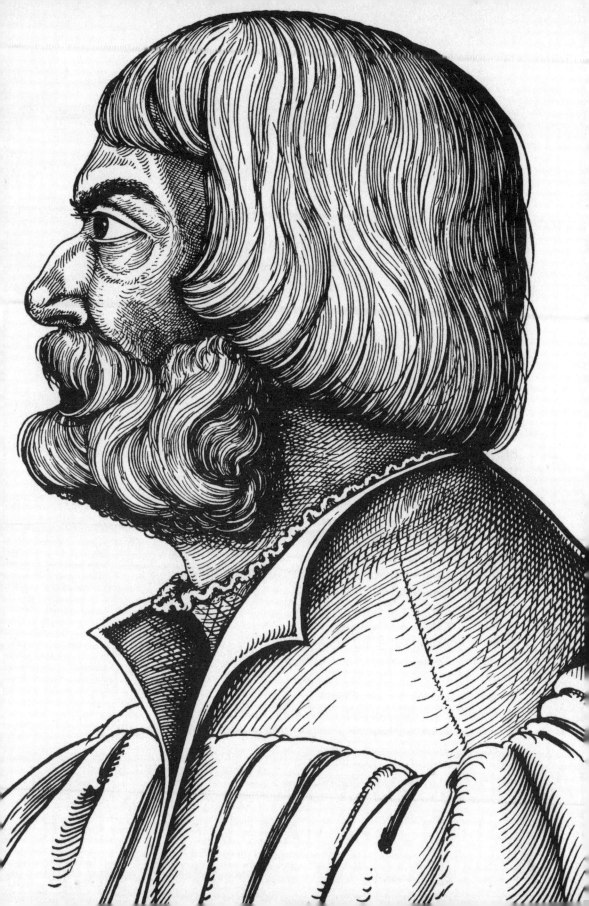

# Abbreviations

| | |
|---|---|
| A | Anzelewsky, *Albrecht Dürer: Das malerische Werk* |
| AD | Albrecht Dürer |
| ASG | Adrian Gratwick |
| Battaglia | *Grande Dizionario della lingua italiana* |
| Baumann | *Kleines frühneuhochdeutsches Wörterbuch* |
| BI | Biographical Index |
| BL | British Library |
| BM | British Museum |
| BSB | Bayerische Staatsbibliothek |
| CSB | *Christoph Scheurl's Briefbuch* |
| DH | *Deutscher Humanismus 1480–1520. Verfasserlexikon* |
| DRwb | *Deutsches Rechtswörterbuch* |
| DWb | *Deutsches Wörterbuch von Jacob und Wilhelm Grimm* |
| EColl | *Erasmus, Collected Works* |
| ECorr | *The Correspondence of Erasmus* |
| Ex. Cat. | Exhibition Catalogue |
| FND | *Frühe Neuzeit in Deutschland* |
| FnhdWb | *Frühneuhochdeutsches Wörterbuch* |
| GNM | Germanisches Nationalmuseum |
| HAB | Herzog August Bibliothek |
| Hampe | *Nürnberger Ratsverlässe über Kunst und Künstler* |
| Hwb | *Handwörterbuch zur deutschen Rechtsgeschichte* |
| Lexer | *Mittelhochdeutsches Handwörterbuch* |
| MBr | *Melanchthons Briefwechsel* |
| NH | Pliny the Elder, *Natural History* |

| | |
|---|---|
| Niermeyer | *Mediae Latinitatis Lexicon Minus* |
| Paul | Hermann Paul, *Deutsches Wörterbuch* |
| PBr | *Pirckheimers Briefwechsel* |
| Pfeifer | *Etymologisches Wörterbuch des Deutschen* |
| QGKN | *Quellen zur Geschichte und Kultur der Stadt Nürnberg* |
| R I/II/III | Rupprich, *Dürer. Schriftlicher Nachlass*, 3 vols |
| Röhrich | *Lexikon der sprichwörtlichen Redensarten* |
| S D | Strauss, *The Complete Drawings of Albrecht Dürer* |
| S E | Strauss, *Albrecht Dürer. Engravings, Etchings and Drypoints* |
| S W | Strauss, *Dürer, Woodcuts and Woodblocks* |
| Shearman | *Raphael in Early Modern Sources* |
| SMS | Schoch, Mende, Scherbaum, *Dürer, Das druckgraphische Werk* |
| SOD | *The New Shorter Oxford English Dictionary* |
| Stupperich | *Reformatorenlexikon* |
| W | Winkler, *Die Zeichnungen Albrecht Dürers* |
| WA | *Luthers Werke* (Weimarer Ausgabe) |

*Overleaf 2.* Matthäus Merian, Bird's-eye view of Nuremberg. *Topographia Franconiae*, Frankfurt 1656, pp. K2–K3

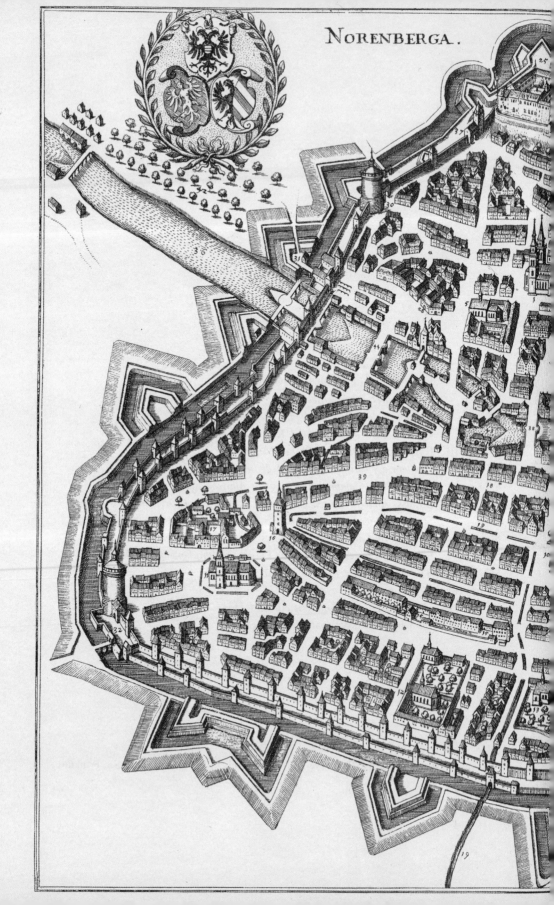

NORENBERGA.

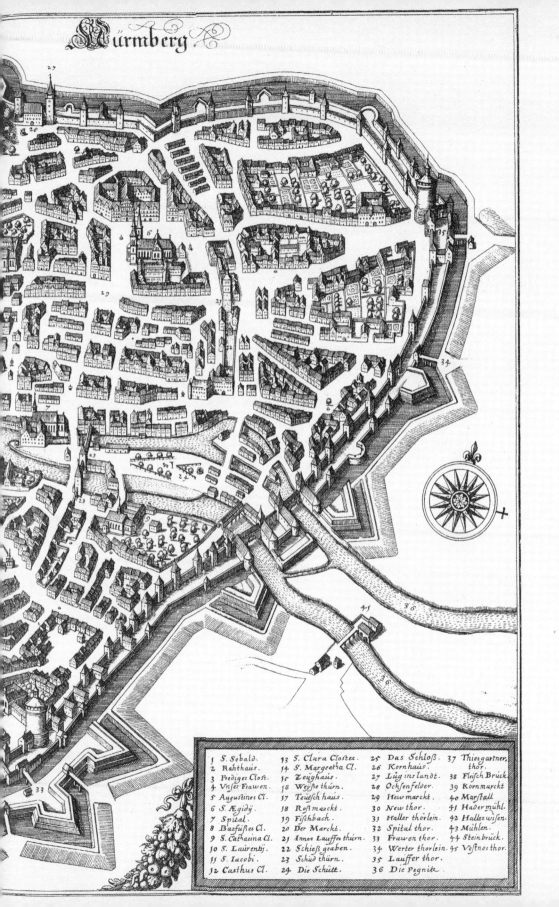

# Nürmberg.

| | | | |
|---|---|---|---|
| 1 S. Sebald. | 13 S. Clara Closter. | 25 Das Schloß. | 37 Thiergartner. thor. |
| 2 Rahthaus. | 14 S. Margretha Cl. | 26 Kornhaus. | |
| 3 Prediger Clost. | 15 Zeughaus. | 27 Lug ins landt. | 38 Fleisch Brück. |
| 4 Vnser Frawen. | 16 Weyße thürn. | 28 Ochsenfelder. | 39 Kornmarckt. |
| 5 Augustiner Cl. | 17 Teütsch haus. | 29 New marckt. | 40 Marstall. |
| 6 S. Ægidÿ. | 18 Roßmarckt. | 30 New thor. | 41 Hader mühl. |
| 7 Spital. | 19 Fischbach. | 31 Haller thörlein. | 42 Haller wisen. |
| 8 Barfüßer Cl. | 20 Der Marckt. | 32 Spital thor. | 43 Mühlen. |
| 9 S. Cathania Cl. | 21 Annee Lauffer thürn. | 33 Frawen thor. | 44 Steinbrück. |
| 10 S. Lairentÿ. | 22 Schieß graben. | 34 Werter thörlein. | 45 Vestner thor. |
| 11 S. Iacobi. | 23 Schüd thürn. | 35 Lauffer thor. | |
| 12 Carthus Cl. | 24 Die Schütt. | 36 Die Pegnitz. | |

# Part I

## 1471–1499

The texts in Part 1 cover the entire first half of AD's life, which is neatly and in a way symbolically balanced on the fulcrum of the semi-millennial year 1500. It is, even in its last decade when AD is emerging as a major artist, the least well documented phase of his life. We lack any written record of his formative years of travel between 1490 and 1494 or of the months he is presumed to have spent in Venice in 1494/5. The Family Chronicle (1) dates in its extant form from 1524, and some of its material relates to events in AD's later life, but its natural place is at the beginning of the documentary biography. Its compilation, from his father's notes and his own memory, just four years before his death in 1528, may stem to some extent from a desire to provide posterity – rather than family as such, for he had no children and few relatives – with the rudiments of a biography.

Unlike much material in all of the following sections, the rest of the texts here owe little to any wish on AD's own or his contemporaries' part to record and memorialise his life. Apart from inscriptions on drawings and paintings, their survival is either a matter of chance, as is the case with his father's letter of 1492 (4), or has to do with function and legal requirement in the case of the property deed and the employment contracts (2, 6, 7–8).

What AD writes on his artworks only occasionally has direct biographical relevance, although overall it represents a by no means negligible aspect of his self-revelation in his writings (3, 5, 9). It is particularly frustrating to the biographer and to the art-historian that so much of AD's artistic output in the first half of his life remains undocumented in his own or others' writings. In particular, we have no primary evidence for his formative years as apprentice and journeyman: what he worked on for Michael Wolgemut, where his travels took him, who his masters were, and what he produced for them. The identification by older scholars of an extensive range of woodcuts as work done by AD in his journeyman years is entirely speculative. We lack

virtually all contextualisation in written sources, by AD himself or by contemporaries, of his first religious paintings, of the early pictures of his parents (3.2, 9.1) and his own self-portraits from 1493 and 1498 (5.2, 9.5). This is equally the case with the first woodcut masterpieces, above all the *Apocalypse*, and with already mature engravings such as the *Four Naked Women* (9.3), *The Dream of the Doctor* (9.4) and the *Sea Monster*. The impact on his art of his first visit to Venice can only be inferred from the artworks themselves.

From 1500 the picture will change abruptly. Extant documentation then begins to span a much wider range of text types and perspectives. AD's letters and those of his contemporaries, tributes to him and his art, professional and legal records, and his theoretical and aesthetic writings, together start to build up a fuller and more continuous narrative of his life.

# After 1467/1524

## 1 Family Chronicle

*Nuremberg, after Christmas in the year 1524*[1]
I, Albrecht Dürer the Younger, have put together from my father's writings this account of where he came from, and how he settled and remained here until he died in the Lord. God have mercy on him and on us. Amen.

*Anno 1524*
Albrecht Dürer the Elder was born[2] of a family in the kingdom of Hungary from a little village with the name of Ajtós, not far from a small town called Gyula, which was an eight-mile journey away beyond Wardein.[3] There his forebears lived from the raising of oxen and horses. But my father's father, who was named Anton Dürer, came as a boy to the aforementioned small town of Gyula to be apprenticed to a goldsmith and he learned this craft from him. Thereafter he married a maiden called Elisabeth with whom he had a daughter Catharina and three sons. The first son, named Albrecht Dürer, was my dear father who also became a goldsmith, a man of high skill and integrity. The second son his father christened Laslen, and he became a saddler. His son is my cousin Nikolaus Dürer, who is established in Cologne and is known as Nikolaus Unger. He too is a goldsmith and learned this craft from my father here in Nuremberg.[4] Anton's third son was christened Johannes, and his father allowed him to pursue his studies. Later he became parish priest at Wardein and stayed there thirty years. My dear father Albrecht Dürer later moved to Germany, spent a long time in the Netherlands learning from the great masters of his craft, and finally came here to Nuremberg in the year numbered 1455 since the birth of Christ, on the feast day of St Eligius.[5] And on that very day Philipp Pirckheimer was celebrating his marriage at the Castle and there was a great dance under the big linden tree.[6] For a long time thereafter, until the year of our Lord 1467, my father was in the service of old Hieronymus Holper, my grandfather.[7] Then my grandfather gave him his daughter, a pretty and upright girl of fifteen named Barbara, and they celebrated their marriage a week before St Vitus's Day.[8] And it should be noted that my grandmother, my mother's mother, was Öllinger's daughter from Weissenburg, called Kunigunde. And my dear father had these following children with his wife, my dear mother. This list I set out as he wrote it in his book, word for word:

1   Item, in the year of Christ's birth 1468, on St Margaret's Eve at the sixth hour of the day,[9] my wife Barbara bore me my first daughter. Old Margarete of Weissenburg[10] became godmother, and by my wish named the child Barbara after its mother.

2   Item, in the year of Christ's birth 1470, on St Marina's Day in Lent,[11] two hours before daybreak, my wife Barbara bore me my second child, a son. Fritz Roth from Bayreuth lifted him from the font and named my son Johannes.

3   Item, in the year of Christ's birth 1471, in the sixth hour on St Prudentius's Day, the Tuesday before Ascension Day, my wife Barbara bore me my second son. Godfather to him was Anton Koberger who named him Albrecht after me.[12]

4   Item, in the year of Christ's birth 1472, in the third hour of St Felix's Day, my wife Barbara bore me my fourth child. Sebald Hölzle became his godfather and named my son Sebald after himself.[13]

5   Item, in the year of Christ's birth 1473, on St Rupert's Day in the sixth hour, my wife Barbara bore me my fifth child. Its godfather was Hans Schreiner, who lives at the Laufertor, and he named my son Hieronymus after my father-in-law.[14]

6   Item, in the year of Christ's birth 1474, on St Domitian's Day in the second hour, my wife Barbara bore me my sixth child. Ulrich Marck, goldsmith, became its godfather and named my son Anton.[15]

7   Item, in the year of Christ's birth 1476, in the first hour on St Sebastian's Day, my wife brought me forth my seventh child, whose godmother was the maiden Agnes Bayer, and she named my daughter Agnes.[16]

8   Item, more than an hour thereafter my wife bore me in great pain another daughter, and the child was given baptism in haste and named Margarete.[17]

9   Item, in the year of Christ's birth 1477, on the next Wednesday after St Eligius's Day, my wife Barbara bore me my ninth child, and the maiden [Ursula?] became its godmother and named my daughter Ursula.[18]

10   Item, in the year of Christ's birth 1478 my wife Barbara bore me my tenth child, in the third hour of the next day after the feast of St Peter and St Paul,

and its godfather was Hans Sterger, Schombach's kinsman, and he named my son Hans.[19]

11   Item, in the year of Christ's birth 1479, three hours before daybreak, on a Sunday which was St Arnulf's Day, my wife Barbara bore me my eleventh child, and Agnes, Fritz Fischer's wife, was godmother and named my daughter Agnes, after herself.[20]

12   Item, in the year of Christ's birth 1481, in the first hour of the day of St Peter's Chains, my wife bore me my twelfth child, and Jobst Haller's servant, called Nikolaus, became godfather and named my son Peter.[21]

13   Item, in the year of Christ's birth 1482, in the fourth hour of the Thursday before St Bartholomew's Day, my wife Barbara bore me my thirteenth child, and Beinwart's daughter Katharina was its godmother and named my daughter also Katharina.[22]

14   Item, in the year of Christ's birth 1484, one hour after midnight before St Mark's Day, my wife bore me my fourteenth child, and Endres Stromeyer was godfather and named my son also Endres.[23]

15   Item, in the year of Christ's birth 1486, at midday on the Tuesday before St George's Day, my wife Barbara bore me my fifteenth child, and Sebald von Lochheim was godfather and named my son also Sebald, that is the second Sebald.[24]

16   Item, in the year of Christ's birth 1488, at midday on the Friday before our Lord's Ascension Day, my wife Barbara bore me my sixteenth child and godmother was Bernhard Walther's wife, and she named my daughter Christina after herself.[25]

17   Item, in the year of Christ's birth 1490, on Septuagesima Sunday, two hours after midnight, my wife Barbara bore me my seventeenth child, and its godfather was the Reverend Georg, vicar at St Sebald's, and he named my son Hans. That is my third son to have the name Hans.[26]

18   Item, in the year of Christ's birth 1492, on St Ciriacus's Day, two hours before nightfall, my wife bore me the eighteenth child, and its godfather was Hans Karl from Ochsenfurt, and he named my son for me also Karl.[27]

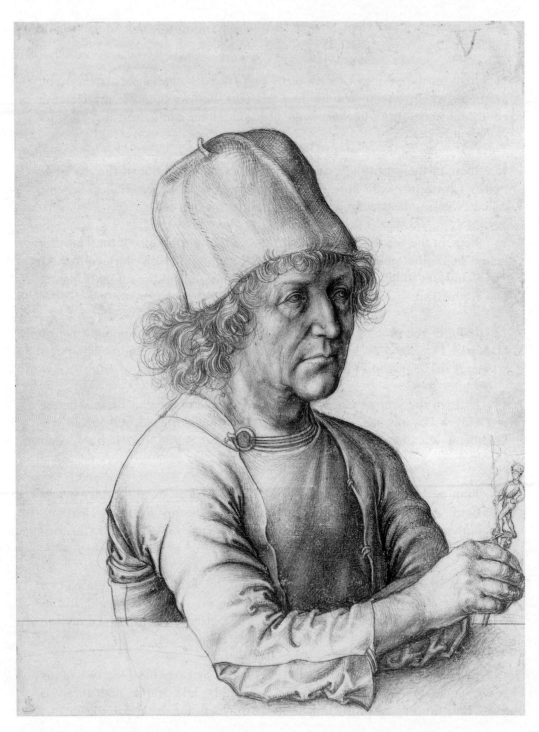

3. Albrecht Dürer the Elder, *Self-Portrait*, silverpoint drawing, 1484. Vienna: Albertina 4846

Now these are my brothers and sisters, my dear father's children, all deceased, some in their childhood, others in their youth or when they were grown up. Only we three brothers are still living, as long as God wills it, namely I, Albrecht, and my brother Endres, likewise my brother Hans, the third of that name, my father's children.

Item, the aforementioned Albrecht Dürer the Elder [fig. 3] lived a life of great toil, of hard and taxing work, and had no other means of sustenance than what he earned with his handiwork for himself, his wife and children. That means he had little indeed. He suffered also all manner of distress, disparagement and enmity. Yet by many who knew him he was highly esteemed. For he led the life of an honest Christian, was a patient, meek man, peaceable towards everyone, and he was steadfastly thankful to God. He had little use for much company and worldly pleasure; he was, too, a man of few words and one who feared God.

My dear father took great pains to bring up his children to honour God. For it was his most fervent wish to raise them in virtuous ways, so that they might be pleasing in the sight of God and before men. Hence he daily reminded us to hold God in affection and act honestly to our neighbours. And my father had a special liking for me when he saw that I was eager to apply myself in learning. That is why my father let me go to school, and once I learned to read and write, he took me out of school again and taught me the goldsmith's craft.[28] And by the time I could do competent work, I felt myself drawn more towards painting than to goldsmith's work.[29] I put this to my father, but he was not well pleased, because he rued the time I had wasted learning to be a goldsmith. However he relented and in the year of our Lord 1486, on St Andrew's Day, my father bound me as apprentice to Michael Wolgemut, to serve him for three years.[30] During this time God gave me the diligence to learn well, although I had to put up with much tormenting from those in his workshop. And when I had served my time, my father sent me off as a journeyman and I stayed away for four years until my father summoned me back.[31] And having set out after Easter in the year 1490, it was after Whitsun 1494 that I returned. And once I was home again, Hans Frey negotiated with my father and gave me his daughter, the maiden called Agnes, and with her a dowry of 200 florins, and the wedding was held on the Monday before St Margaret's Day in 1494.[32]

It then so happened that my father fell sick with dysentery, so bad that no-one could staunch it. And seeing death before his eyes he submitted to it most meekly, giving my mother into my care and bidding us live godly lives. He received the holy sacrament and – as I have described at greater length in another book[33] – passed away like a Christian after midnight in the early hours of the Eve of St

Matthew 1502, may God be gracious and merciful unto him.[34] Thereafter I took my brother Hans into my household, but Endres we sent away.[35]

Two years after my father's death, I took my mother in, as she had nothing more to live off. And when she had been living with me until 1513, she fell suddenly and mortally sick and lay ill for a whole year. Then a good twelvemonth after she first became ill, early on a Tuesday, the 17th of May 1514, having received the holy sacrament, she died a Christian death, two hours before nightfall, and I myself recited the prayers for her.[36] Almighty God be gracious unto her.

Then later, in the year 1521, on the Sunday after St Bartholomew, which was the 18th day of August in Gemini, my dear mother-in-law, Hans Frey's wife, became ill. On 29th September following, having received the holy sacrament, she passed away in the ninth hour of the night by the Nuremberg clock.[37] Almighty God be gracious unto her.

Thereafter, in 1523, on the day of Our Lady, when she was presented in the Temple, early before the sunrise bell, Hans Frey passed away, my dear father-in-law, who had been frail for six years and had suffered sheer unthinkable adversity in this world. He too died armed with the sacraments.[38] Almighty God be gracious unto him.

<div align="right">Albrecht Dürer</div>

Neither the elder Dürer's nor AD's autograph manuscript has survived. Four handwritten copies and one printed copy of the latter are extant, all from the second half of the seventeenth century. All differ in small details, but all share one telling error (see note 7), which means all must derive from a single archetype in which the error originated, not direct from Dürer's autograph. The copies are:

1 Bamberg, Staatsbibliothek, J.H. Msc. art. 50 (III. 12). Paper, Title page + fol. 1–6. Bought in Nuremberg in 1821 by Joseph Heller, author of an early biography of AD (1828). (MS β)

2 Nuremberg, Stadtbibliothek, Will-Nor. III 916. Paper, fol. 1–6. Written by the same late seventeenth-century hand as MS β. (MS B)

3 Nuremberg, Stadtbibliothek, Will-Nor. III 915 b. Paper, fol. 51r–53r. The copyist is named as Nicolaus Paulus Helffreich who died in 1684, but it is likely to be based on an older copy by Johann Hauer, painter and author of an early biography of AD. (MS A)

4 Gotha, Museum. Paper, Title page + fol. 1–5. Second half of the seventeenth century. (MS G)

5 Joachim von Sandrart, *Teutsche Akademie der edlen Bau-, Bild- und Malerkünste*, 2 vols. Nuremberg 1675 & 1679, Vol. II, Chapter 3, 226ff. Sandrart's text derives from a further, unknown manuscript. He was resident in Nuremberg as an apprentice in 1620 and again in 1649–50, and must have known Johann Hauer.

Friedrich Campe, *Reliquien von Albrecht Dürer, seinen Verehrern geweiht*, Nuremberg 1828, 182, cites a (lost) 'little book' which had belonged to a Nuremberg goldsmith, Hans Petzold (1550–1632), and appears to have been either the original or another earlier copy.

A further manuscript in the GNM, Nuremberg: Hs 4° 94045, Paper, fol. 1–4, written by or for Hans Wilhelm Kress in the early seventeenth century, is headed: *Des weitberühmten Mahlers Albrecht Dürers Herkommen und Leben...aus unterschiedlichen Schriften zusammengetragen...*It contains material collated from Christoph Scheurl's *Vita reverendi patris domini Anthonii Kressen* (101), Heinrich Pantaleon's *Prosopographia*, and a summary of the Family Chronicle with added biographical material on AD, together with extracts

from the letters of Maximilian I, Erasmus and Pirckheimer, and later sixteenth-century eulogistic verse. The more elaborate manuscript fair copy of this compilation, with the earliest known index of AD's works, is in the Department of Prints and Drawings (Kupferstichkabinett) of the State Museums in Berlin. (I owe this information to Dr Anja Grebe.) Rupprich's text generally gives preference to manuscript A.
[R I, 27–34.; Tacke 2001, 128–31]

NOTES

1   The calendar New Year began at this time on 25 December.

2   In 1427.

3   The elder Dürer's spellings of Hungarian place names, as reproduced by AD, are a German-speaker's phonetic renderings: Eytas for Ajtós, Jula for Gyula. Wardein, however, was a German settlers' name (in Hungarian it was Nagyvárad). On the origin of the surname Dürer, see the commentary below.

4   Nikolaus Dürer or Unger ('the Hungarian') became a citizen of Nuremberg in 1481 and a master goldsmith in 1482. He worked in Nuremberg at least until 1505, trading particularly with North German centres such as Lübeck, Magdeburg and Cologne. AD visited him on his two visits to Cologne in 1520 (162).

5   25 June 1455. Before the Reformation, dates were customarily expressed in relation to the nearest saint's day. The early seventh-century French saint Eligius was goldsmith to Merovingian kings and became patron saint of the craft.

6   A member of the same patrician family as AD's friend and patron Willibald Pirckheimer (BI). His bride was Anna Tintner. The great linden tree was said to have been planted by Kunigunde, wife of Emperor Henry II (died 1033).

7   All extant sources of the Family Chronicle have the name Hieronymus Haller, but it is amply documented (R I, 32, note 16) that the elder Dürer's father-in-law was Hieronymus Holper, master goldsmith from 1435, recorded in city records until 1476, silver-weigher and gold-assayer from 1460/61. The Holpers had been goldsmiths since 1387. No goldsmith called Hieronymus Haller is recorded in Nuremberg at this time.

8   6 August 1467.

9   13 July 1468. In Nuremberg, daytime and night-time hours were separately and seasonally calculated. Daytime began at sunrise, night-time at sunset. In July the sixth hour of the day would be around 11 a.m.

10   Presumably a friend or relative of Barbara's mother, Kunigunde Öllinger, from Weissenburg. For 'godparent', Albrecht the Elder uses the term *gevater/gevatter*. The noun could be masculine or feminine in gender, and corresponds to Church Latin *commater* or *compater*. It denotes joint responsibility for the religious upbringing of the child. However, it also connotes a secular relationship between friends and neighbours who stand on an equal footing within a community, and is often used as a form of familiar address. See DWb IV, I, 3, 4640–62. In a number of cases, the identity of godparents chosen by Albrecht and Barbara Dürer suggests an overlap between the two senses. The identification of godparents is taken almost entirely from R I, 32–4.

11    7 April 1470.

12    21 May 1471. The printer Anton Koberger (BI and Keunecke 1982, 2013) had recently become a neighbour in the Burgstraße. There is no contemporary evidence for the claim first advanced circa 1600 that AD was born in the back quarters of the Pirckheimer house on the west side of the Hauptmarkt.

13    14 January 1472. Sebald Höltzle or Hölzl belonged to a prominent 'honourable' family with a marriage connection to the patrician mercantile family of Hirschvogel.

14    27 March 1473. Schreiner was a sword-cutler.

15    24 May 1474.

16    20 January 1476. Agnes was perhaps the daughter or sister of the goldsmith Hans Beyer, recorded between 1471 and 1487.

17    In emergency, if the child was not expected to live, baptism could validly be administered by a lay person. The first-born of the twin girls did not live long either, since the name Agnes is used again in 1479.

18    2 July 1477.

19    30 June 1478. The second son of this name. The name was available again eight years after the birth of the first Johannes. It would be used again in 1490. (Hans) Schombach (also known as Schambach, both forms of Schönbach) was constable of Unter der Vesten until Albrecht Dürer the Elder succeeded him in 1482.

20    18 July 1479.

21    1 August 1481. Nikolaus's master was the patrician Jobst Haller I (1433–93).

22    22 August 1482. Beinwart is not recorded as a family name. Rupprich (note 37) suggests that the copyist of the archetype misread banwart, warden of a protected forest, a civic official.

23    25 April 1484. An Andres Stromer is documented in 1472. Endres – the Nuremberg version of Andreas (Andrew) – was the second of the Dürer children to survive into adulthood.

24    18 April 1486. Sebalt von Lochheim, member of an old patrician family, was the Dürers' neighbour across the road at the top of Unter der Vesten.

25    9 May 1488. Bernhard Walther (BI) was a prominent merchant, also an eminent mathematician and astronomer. In 1501 Walther bought the house at the top of the Zisselgasse which AD purchased from his executors in 1509 (53).

26    21 February 1490. The third Sunday before Lent, known as *Pfaffenfastnacht*, when priests began their Lenten observance. Georg Plödl was vicar of the Haller chantry at the church of St Sebald, parish church of the upper half of the walled city, where the Dürer family worshipped. He died in 1492. On the third Hans, the youngest of the three surviving brothers, see Mende 2004.

27    Barbara Dürer's eighteenth and last child was born on 21 August 1492, twenty-four years after her first, when she was forty years old. Hans Karl or Carl may be the nominated member of the Great Council from 1493 to his death in 1505, who crops up frequently in court records from 1485 to 1505.

28   Nothing is known of AD's formal education. His wording here implies that it was brief and minimal, although by late medieval standards Nuremberg offered above average educational opportunities. There is no evidence that he had more than a slight grasp of Latin, let alone read it 'perhaps with ease' (Price 2003, 10). It is unlikely that he attended the Latin School of St Sebald's Church, whose syllabus was grounded on close study of Latin grammar and traditional set texts. Most craftsman families sent sons to a 'writing and reckoning school' which aimed to supply the basic practical needs of boys expecting to work in trade and handiwork. See Leder 1971.

29   AD appears to have completed his training as goldsmith. In her will, dated 1538, Agnes Dürer bequeathed to her brother-in-law Endres 'a drinking vessel which was his masterpiece' – the artefact with which the apprentice demonstrated his qualification for the title 'master goldsmith'. But it is unclear whether this was AD's or Endres's masterpiece. For possible further evidence of AD's goldsmith work, see Feulner in Ex. Cat. Frankfurt 2013, 23–35.

30   Wolgemut (BI) was a near neighbour of the Dürers in Unter der Vesten. AD painted his portrait in old age (104.1).

31   There is little reliable documentation of AD's years as journeyman. Christoph Scheurl (101) claims to report AD's oral account of his abortive attempt to study with Martin Schongauer. But this is manifestly confused. The attribution to AD of woodcut illustrations in books printed in Basel in 1493–4 is disputed. Braun/Grebe 2007 have cast serious doubt on the Dürer 'signature' on the woodblock of an illustration for Nicolaus Kessler's *Epistolare* of St Jerome (Basel, 1492). See 3.8.

32   Agnes Dürer's settlement with her brother-in-law Endres over AD's estate (289) refers to a (lost) 'parchment marriage contract', befitting Agnes's relatively high social status. Hans Frey (BI) came of an old Nuremberg family, but both the Freys and the Rummels, Agnes's mother's family, had lost much of their earlier wealth, hence her dowry was relatively modest. See Stromer 1971, 18–19.

33   This is taken to refer to AD's *Gedenkbuch*, his personal record (15).

34   The Death-Knell Register of St Laurence's Church notes the tolling of the bell and the funeral as taking place on the same day that he died, 20 September.

35   Endres was now eighteen and was presumably sent away for his journeyman years. Hans was only twelve. He would later be an apprentice in AD's workshop (Mende 2004).

36   The date is wrong. Either it should read Tuesday 16 May or Wednesday 17 May 1514. She was interred beside her husband in the cemetery of St John, in the Frey family sepulchre, where Hans Frey, AD and Agnes Dürer were later also buried.

37   See note 9.

38   In 1488, Hans Frey had been arrested and sentenced to prison for receiving stolen goods, but the sentence was twice suspended and finally commuted. Whatever his earthly tribulations, Frey left his two daughters 455 fl. in cash and 600 fl. of invested capital. AD painted a gouache-on-canvas portrait of his father-in-law's

corpse. It eventually passed into the Imhoff collection of Dürer's art and manuscripts. When the collection was dispersed, its gruesome character deterred all would-be purchasers.

## COMMENTARY

AD describes the Family Chronicle as 'put together' from his father's writings. That suggests he had inherited a body of discrete material on family matters. However, close to half of the whole text – AD's characterisation of his father, the accounts of his childhood and youth, his marriage in 1494 and the deaths of his parents and parents-in-law – comprises his own continuation of the family history. The description of his parents' deaths was apparently excerpted from a personal record, of which one isolated leaf survives. This leaf contains, among other diverse material written at different times, the end of a substantially more detailed account of his father's death (15), and a much longer description of his mother's death (92.1), both strikingly emotional in tone as if reflecting the immediate impact of the events. We cannot be certain why AD made this new compilation in 1524. Possible factors are the shadow cast by his own ill-health and intimations of mortality after 1521, and an associated concern to leave behind written evidence of a personal and professional nature.

AD's forebears were ethnic Germans who had settled in Hungary. German migration into central and eastern Europe, along the Baltic littoral, and in western areas of modern Poland, the Czech Republic, Hungary and Romania, was an intermittent process spanning many centuries, until it was radically reversed by ethnic cleansing in and after 1945. The given names of family members mentioned by his father are all German, except for Laslen, a Germanised form of Ladislaus. Elisabeth, the elder Dürer's mother's name, could be either German or Magyar. When his father Anton (Anthoni) moved to Gyula, he acquired a surname, Ajthósy or similar, denoting his origin from the village of Ajtós (Germanised as 'Eytas'). Habitational designations are a very common surname-type in the late Middle Ages. The Hungarian place name is virtually identical with Hungarian *ajtó*, meaning 'door', German *Tür*. Fellow German-speakers will have translated the name identifying origin from Ajtós as *Türer* or *Dürer*. AD's cousin Nikolaus, who followed the elder Albrecht to Germany, was given a new surname in Nuremberg or Cologne of the type denoting ethnic origin: Unger, the man from Hungary. Gyula was a largely German-speaking community. Moreover the overwhelming majority of the seventy goldsmiths recorded in fifteenth-century Hungary have German names. Albrecht Dürer the Elder may well have become an economic migrant, looking to the land of his ancestors and the imperial city of Nuremberg for advancement and enrichment. Having already completed his apprenticeship in Gyula, he had a prolonged career as journeyman before he took a traditional route to the title of master, and qualification for citizenship in Nuremberg, by marrying the boss's daughter and taking over his father-in-law's business.

The Family Chronicle, in particular AD's father's record of his and Barbara Dürer's children, belongs to a tradition of family writing traceable in Nuremberg from just before 1400, which had become common among families in the upper levels of urban society by around 1500. At its simplest it consists of a list of legitimate children with their birth dates, names and godparents, but elements of biographical narrative also begin to be added. Families which produced such records include patrician dynasties like Pirckheimer, Stromer, Imhoff, Tucher, Haller, Fürer and Nützel. The practice then extends to the next lower stratum of *ehrbar*, 'honourable', families such as the Scheurls and Schreyers – and the Dürers who were to acquire honourable status through AD himself (58). A close analogy with the Dürers' Family Chronicle is that of AD's friend Lazarus Spengler, whose father Georg started a list of his children in 1469. His wife Agnes bore nineteen of them up to 1494. The Spengler list often also supplies the date and cause of children's deaths. It was continued by Lazarus. He had nine offspring. The chronicle went on to record births and marriages for a further three generations (Hamm 1995, 349–404).

Established families of the civic oligarchy used these records to demonstrate their status, sometimes appending coats of arms and legal documents such as property deeds. For honourable families, and others at the interface of craft and governing class, a written family record might represent a foundational act of social advance and integration. That may well have been in the elder Albrecht Dürer's mind, the immigrant journeyman who by circa 1470 was slowly climbing up Nuremberg's steep social ladder. It is unlikely to have been a main motive for AD, who by 1524 had achieved not only honourable status (as too had Lazarus Spengler and Christoph Scheurl), but also cultural eminence not merely in Nuremberg but right across Germany, in the Netherlands and in Italy. His marriage remained childless. Of his two surviving siblings, Endres left only stepdaughters, and Hans never married. In his framing narrative AD seems consistently to avoid opportunities to mark his father's or his own professional and social achievements. From very modest beginnings Albrecht the Elder had made a respectable marriage, built a prosperous business with prestigious clients, not least Emperor Frederick III, made investments in gold and silver mines, and held civic office as constable in Unter der Vesten and as assayer of coins and silverware (2.1–5). Yet his son depicts father and mother as humble toilers who maintain their religious faith and moral character intact through the austerities of life and in the agony of death. AD's persona is not the celebrated Renaissance artist he depicted in self-portraits, but the dutiful son concerned for the salvation of his loved ones. This is the other face of late medieval and Reformation family chronicle: the memorialising of the dead – in both the Dürer and Spengler families, lists of births are overwhelmingly also roll calls of death – and the portrayal of the family as a Christian moral institution.

[Grote 1964; Hirschmann 1971, 36–43; Hofmann 1971; Weckerle 1971/1972; Straßner 1976, 55–65; Pilz 1985; Hamm 1995, Beilage 349–404; Sahm 1998 & 2002, 2–25; Staub 1999b; Schmid 2003, 37–40; Grebe 2006, 12–19; Smith 2012, 21–5; Ex. Cat. Nuremberg 2012, 263 and Matrix, 536–41]

## 1444–1468

## 2 Early Records of Albrecht Dürer the Elder

### 2.1 Albrecht Dürer the Elder Serves in the Nuremberg Militia

*[8 March 1444]*
The hereafter listed musketeers and crossbowmen have been summoned on Reminiscere Sunday in Lent...

   List of Musketeers and Crossbowmen...who were summoned for service in Nuremberg's feud with the knights Hans and Fritz von Waldenfels at the Castle of Lichtenburg.

Nuremberg State Archive. From: Gümbel, *Repertorium für Kunstgeschichte* 37 (1915), 210–13; Ex. Cat. Nuremberg 1971, 32
   Not in R I or III

4.  House of Albrecht Dürer the Elder, Unter der Vesten/Burgstraße. Photograph, circa 1935. Nuremberg, Stadtarchiv A38-F-31-2b

## 1467

### 2.2 Albrecht Dürer the Elder is Appointed to be Silver and Gold Assayer

Item: Holper's son-in-law called Albr. shall with the same his father-in-law faithfully attend to the office of silver hallmarking and gold assaying and shall become a citizen.

Ratsbuch quarta pascha A° ect. LXVII. Gumbel 1915, 312. Ex. Cat. Nuremberg 1971, 32f.
   Not in R I or III

## 1468

### 2.3 Albrecht Dürer the Elder Becomes Master Goldsmith

*[7 July 1468]*
Goldsmiths…Albrecht Dürer is appointed Master sixth day after the Visitation of the Virgin Mary and paid 10fl. in the city's currency.

Book of New Citizens and Masters. State Archive: Amts- und Standbücher 305, fol. 55ʳ. Ex. Cat. Nuremberg 1971, 33
   Not in R I or III

## 1475

### 2.4 Albrecht Dürer the Elder Buys the House 493 on the Corner of Unter der Vesten and the Schmiedgasse

*[Nuremberg, 12 May 1475]*
I, Sigmund von Egloffstein, Knight, Justiciary, and we the Magistrates of the city of Nuremberg[1] declare publicly with this document that there appeared before us in court Albrecht Dürer, goldsmith and citizen of Nuremberg, who brought with him our register of deeds which Contz Lindner,[2] likewise citizen of Nuremberg, set before the court, and showed proof, with a valid deed therein issued with a judgement under the attached seal of this court in Nuremberg, that he [Dürer] had taken into his own sole hands the legitimate possession of the corner-house in Unter der Vesten[3] between the houses of the Beheim family and of Martin Sauerzapf deceased, and which formerly belonged to Peter Kraft the goldsmith deceased,[4] having accepted it from the same Peter Kraft in legally recorded settlement of the latter's confessed and acknowledged debt, and that he had acquired the property in accordance with the procedures of this court and the civic law and by this same jurisdiction.[5] Accordingly, before this

court, he, Peter Kraft, had declared and affirmed for himself and his heirs that he had lawfully and honestly offered for purchase and sold such heritable possession of the said corner-house, all that it encompassed, with all its parts, privileges and pertinents, to the selfsame Albrecht Dürer for him and his heirs to have and hold henceforward for ever. And he swore to invest him with it as inheritor, according to the laws of inheritance and those of this city, so that by virtue of his single sole possession of it he might do and not do as and whatever he would, once namely he had paid for it and disbursed to the vendor's satisfaction two hundred gulden in cash. For which he and his heirs declared him and his heirs free and quit of all obligation. And all this had been done with the will and agreement of Sebald Pfinzing the Younger, who had consented to such in the stead and on behalf of his spouse Anna, to whom the superiority belongs, with the condition that the same Albrecht Dürer and his heirs should in future pay annually to the aforementioned Anna Pfinzing and her heirs, as legally entitled ground-rent, four gulden in the designated currency of Nuremberg, half on St Walpurgis's Day and half at Michaelmas,[6] in accordance with feudal due and the law of this city, from henceforward for ever.[7] In testimony whereof this charter is granted with the judgement of the court and sealed with the attached seal of the court at Nuremberg. Witnesses thereto are the honourable gentlemen Hieronymus Kress and Nikolaus Groland.[8] Given on Friday, St Pancras's Day, in the Year of Our Lord fourteen hundred and seventy-five.

The original parchment deed with attached seal is in the GNM in Nuremberg.
  R I, 225f.

## NOTES

1   *schulthais vnd…schopffen der stat zu Nuremberg*: The *schultheiss* (Middle Latin *scultetus*) was originally an imperial justiciary. By the fifteenth century, as the municipality freed itself from imperial jurisdiction, he was a civic appointee who administered civil law with the help of the *schöffen*, the lay magistrates.
2   Konrad Lindner was a wealthy manufacturer married to Christina Koberger, thus the uncle of Anton.
3   The house [fig. 4] stood on the corner of the Burgstraße, earlier Unter der Vesten ('Beneath the Castle'), and the Obere Schmiedgasse, until it was destroyed by bombing in the Second World War. Its number 493 was determined by a system of registration of properties in the parish of St Sebald.
4   Peter Kraft is recorded as goldsmith from 1429 and appears in legal record in 1453.
5   The sale of the house to Dürer had evidently been agreed with Kraft before his death in part settlement of a debt.

6   St Walpurgis was an Anglo-Saxon nun who went as a missionary to Franconia (died circa 788). Her feast day was 1 May, like Michaelmas a term for payment of debts and dues (and the day of the springtime witches' sabbath, the *Walpurgisnacht*).

7   Nuremberg originated as a settlement around the royal castle. Land and building plots were allotted as feudal holdings held in vassalage to the ruler. If the vassal sub-feued the land or house on it, he retained rights in the estate, a *dominium directum*, while his vassal in turn enjoyed its use, *dominium utile*. Over the period 1219 to 1422, a succession of royal grants and privileges ceded royal/imperial rights over jurisdiction and property to the city council. Implications of this process were firstly, that feudal obligations to a monarchical superior lapsed and were replaced by citizenship rights and obligations; secondly, that in the urban context vassalage to holders of the superiority (*dominium directum*, German *eigenschaft*) became restricted to an annual feu-duty; thirdly that householders came to be the hereditary owners of the *dominium utile*, subject only to the feu-duty or ground-rent, which they had the right to redeem at an agreed price. A comparable system of land tenure and house ownership obtained in Scots law until the 1970s. In 1507 AD redeemed the feu-duty on his late father's house, in effect turning its feudal status into freehold (37).

[DRwb 2, Eigengeld, Eigenschaft; Conrad 1962, 427–9; Hwb Rechtsgeschichte 1, 882–6, 1851–6; QGKN 1, 623f., 2, 263; 3, 313 & 321]

8   Kress (died 1477) was an alderman, and Groland (died 1499) a senator of the city. Their appearance here as witnesses testifies to the elder Dürer's standing in the community.

## COMMENTARY

Unter der Vesten was a prestigious address and a number of the family's neighbours played key roles in AD's early development and later life – his godfather Anton Koberger, Michael Wolgemut to whom he was apprenticed, the city's jurisconsult Christoph Scheurl – or contributed to the social, intellectual and cultural ambience in which he grew up – Hartmann Schedel, Sebald Schreyer, Michel Behaim, the Harsdörffer, Stromer, Haller, Tucher and Kress families. The purchase price of Dürer senior's house, 200 gulden, is modest in comparison with the 800 gulden the sculptor Veit Stoß paid for his in 1496.

[Zahn in Wilson 1976, 15–18; Boockmann 1995, 315; Gulden, Ex. Cat. Nuremberg 2012]

Nuremberg, like other late medieval and early modern German cities, was a prodigious generator and preserver of legal, administrative and commercial documents (see Möncke 1982). A mass of official and private records and archives survive to shed light on aspects of the city's politics, society and culture. Starting in the fourteenth century it became the norm for urban and royal/imperial charters, letters and legal documents to be written in German instead of Latin. The styles of vernacular records, their levels of formality and the relative proximity of their linguistic forms to local dialect vary

greatly. But generally speaking, by the end of the fourteenth century the bureaucracies of large towns, and the scribes of imperial and major ducal chanceries, were evolving more consistent templates, styles and lexes, and had begun to acknowledge the need for more than merely local, supra-regional norms of writing German. In this way they contributed, along with the German of the printers, to the gradual emergence of standard forms of written language. However, it was and long remained the case that administrative and legal documents were written in a 'chancery German' couched in Latinate syntax and a hermetic, obfuscatory idiom, designed to restrict comprehension to the initiated. This charter is by no means the worst of its kind in that respect. See my introductory discussion of translation.

## 1481–1483

### 2.5 Albrecht Dürer the Elder Acquires a Stake in the Goldkronach Mine

Entry in the Goldkronach register of shareholders for the years 1481–3

Bamberg State Archive: C2, no. 1359, fol. 157ʳ. See W. G. Neukam, *MVGN* 44 (1953), 25–57; Ex. Cat. Nuremberg 1971, 33
  Not in R I or III

## 1482

### 2.6 Albrecht Dürer the Elder Becomes *Hauptmann* of *Unter der Vesten*

Hampe, Ratsverlässe 1482, v, 4ᵃ

NOTE

The *hauptmann* was the constable responsible for order in his neighbourhood. Dürer replaced Hans Schampach.

[Hutchinson 1990, 11]

## 1486

### 2.7 Hans Tucher VI Commissions Albrecht Dürer the Elder to Gild Medallions of Roman Emperors

*[1486]*
Item: I have given Albrecht Dürer 2½ Hungarian gulden, making 3 Rhenish gulden 6 shillings 8 heller, for gilding 32 copper heads of emperors; and for 9 silver heads of emperors weighing 2 loth and half a quentel[1] I paid Barthel

Egen 1 gulden and a ½ gulden of that for gilding; further, for one silver pfennig, a cast of a denar[2] for which the Lord Jesus Christ was sold, costing 68 al. This is what I have spent in sum for the 41 emperor heads and for gilding, along with the silver denar, amounting all in total to Rhenish fl. 5—2s.—ohl.

*[1487]*
Item: on the 12th day of February I paid Niclas Finck for writing the book about the emperor heads: Rhenish fl. 2—os.—ohl.[3]

Paul Joachimsohn, ed., 'Hans Tuchers Buch von den Kaisergesichten', *MVGN* 11 (1895), 1–2.
  Not in R I or III

NOTES

1   The *lot* was approximately 17 grammes or half the (locally varying) ounce, the *quentel* (diminutive of *quant*) was one quarter of a *lot*.

2   Latin *denarius*: the ancient Roman silver coin. Its value – if I am correct in reading 68 *al.* as *albus*, 'white', that is silver pence – was high.

3   Finck was the scribe who wrote out Tucher's account of the project to create the emperor medallions.

The collection of forty-two coins was mounted on a board and hung in the councillors' library of the town hall.

# 3 Works of Art

### 3.1   *Self-Portrait at the Age of Thirteen*. **Silverpoint drawing. W 1, S D 1484/1** [fig. 5]

Inscription top right in AD's hand added at a later date (1520s?):

I did this likeness of myself from a mirror in the year 1481 when I was still a boy. Albrecht Dürer

So early, let alone so assured a self-portrait of a child is unprecedented. The technique of silverpoint is extremely demanding, since lines cannot be erased, and AD's command of it at the age of thirteen is an early portent of his later genius as engraver. The silverpoint portrait of his father (see fig. 3), clearly related, could also be AD's work, though it is more generally attributed to Albrecht Dürer the Elder himself. The portrayal is strikingly close to AD's 1490 portrait of him. It may have been done as a model for AD to emulate. AD's first self-portrait was evidently kept by his parents or

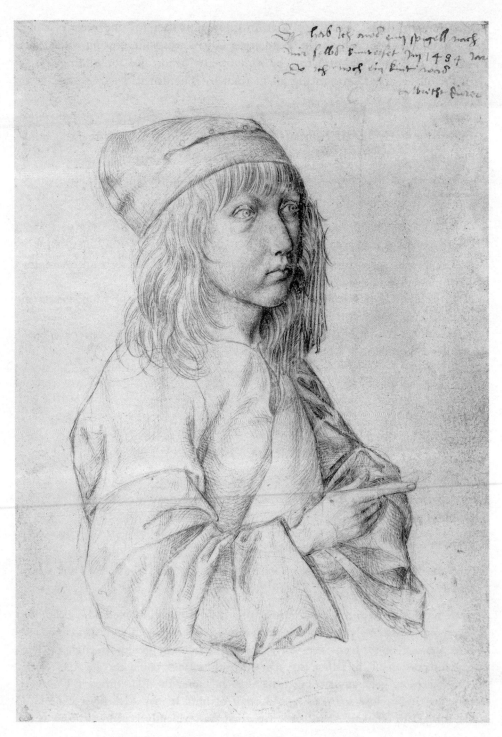

5. Albrecht Dürer, *Self-Portrait*, silverpoint drawing, 1484. Vienna: Albertina 4839

himself. Smith (2011, 38) suggests it was the first item in his 'self-collection'. What might be a copy of a possible painted self-portrait by the thirteen-year-old Dürer vanished in the Second World War from a collection in Stettin (now Szczecin, Poland). A long-haired youth in the background of a panel depicting a miracle of St Vitus, belonging to the St Augustine altar produced in 1487 in the workshop of Michael Wolgemuth, has been claimed as a portrait of the sixteen-year-old AD, then in the first year of his apprenticeship (Nuremberg, GNM).

[Winkler I, 7–9; Anzelewsky 1991, 1K, 117; Koerner 1993, 42–5; Ames-Lewis 2000, 224f.; Ex. Cat. London 2002, 79; Ex. Cat. Vienna 2003, 116–19; Wolf 2010, 27–34; Buck 2012, 94f.; Ex. Cat. Nuremberg 2012, 261, 265f.]

### 3.2   *Portrait of Albrecht Dürer the Elder.* Oil and tempera on wood panel. 1490. A 2; *Portrait of Barbara Dürer.* Oil on fir panel. 1490. A 4

The provenance of AD's painting of his mother has only recently been clarified, but it is now acknowledged as a companion work to the well authenticated portrait of his father (A 1971/1991). In 1580 Willibald Imhoff's inventory records the acquisition of a portrait of AD's mother from Ursula, widow of Endres Dürer. An entry in 1588 treats the two portraits as a diptych. Emperor Rudolf II purchased the portrait of Albrecht senior but not that of Barbara, probably because he doubted its authenticity, a doubt reflected in an early seventeenth-century note by Hans Hieronymus Imhoff. It was sent to Maximilian of Bavaria in 1628. Both portraits are likely to have been done on the eve of AD's departure on his journeyman travels. Neither is inscribed, but on the reverse of the portrait of his father AD has painted a coat of arms which combines that of the Holper family with an invented heraldic device for his paternal line (A 3, and plate 3). This is seen as supporting evidence for the two panels, which are virtually the same size and similarly posed, belonging together as a marital double portrait. AD did not return to the depiction of the family coat of arms until 1523, when he did a sketch and a woodcut (178.1). Hirschfelder argues that the father's portrait preceded the mother's. They demonstrate their piety by the rosaries they are both telling. The memorialising function of the portraiture links with AD's entries in his personal record on his parents' deaths (1, 15, 92). The portraits are not finished to the degree of AD's self-portraits.

[Anzelewsky 1971/1991; Zander-Seidel 1990, 107; Ex. Cat. Vienna 2003, 120f.; Ex. Cat. Bruges 2010/11, 419; Hirschfelder 2012, 102–7; Hess/Mack 2012, 174–6; Ex. Cat. Nuremberg 2012, 271–5]

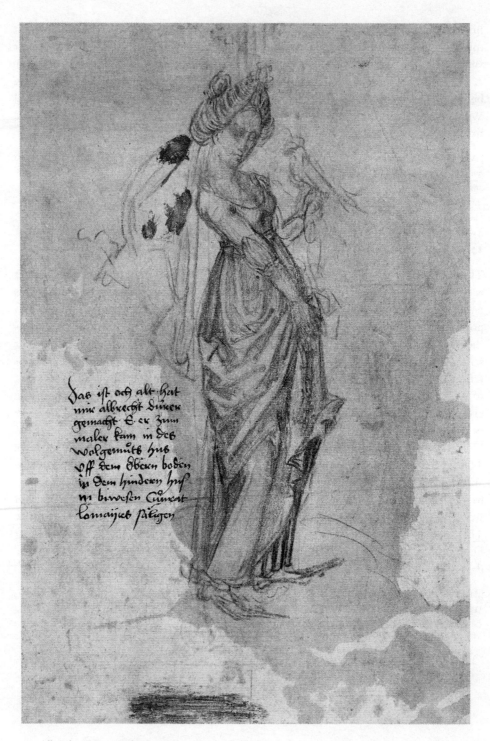

6. Albrecht Dürer, *Lady Carrying a Hawk*, chalk drawing circa 1484–6. BM Sloane 5218–90

### 3.3 *Galloping Rider*. **Pen drawing, highlighted in white. W 9, S D App.1:1**

Inscription below in AD's hand at a later date (after 1507?):

Wolfgang Peurer did this in the year 1484

There is no other record of Wolfgang Peurer. The drawing served as the model for AD's first engraving, the *Great Courier* (1495). Winkler's analysis of the condition of the drawing concluded that it has been much altered and modified and in its present state may be essentially AD's own work

[Winkler I, 13f.; Ex. Cat. Nuremberg 2012, 313]

### 3.4 *Lady Carrying a Hawk*. **Black chalk on red ground. W 2, S D 1484/2** [fig. 6]

Inscription by an unknown hand (1486?):

This is also old. Albrecht Dürer did it for me, before he entered Wolgemut's house to become a painter, up in the top attic of the back quarters of the house, in the presence of the late Konrad Lomayer

AD started his apprenticeship with Wolgemut on 1 December 1486. Lomayer became master goldsmith in 1490 and died (of the plague?) in 1494. Around 1486 he was possibly journeyman in Albrecht Dürer the Elder's workshop.

[Buck 2012, 92; Rowlands 1988, 58–60; Ex. Cat. Nuremberg 2012, 288, 292, 538]

### 3.5 *Benediction of the Saviour*. **Black ink drawing. W 13, S D XW.13**
Inscription above in light brown ink, in AD's later hand:

Handsome Martin [*hubsch martin*] did this. In the year 1469

[Rowlands 1988, 48, Ex. Cat. Bruges 2010/11, 308; Ex. Cat. Nuremberg 2012, 315]

### 3.6 Martin Schongauer, *Christ and the Virgin Mary in a Gothic Chapel*. Lost drawing

The inscription was recorded in 1786 by its then owner, Karl Heinrich von Heinicken:

> This was engraved by Handsome Martin in the year 1470, when he was a young journeyman. I, Albrecht Dürer, found that out and have noted it here in his honour in the year 1517

Dürer had intended to visit and study with Martin Schongauer (BI) when he left Nuremberg as a journeyman in 1490. However, by the time he arrived in Colmar in 1492, Schongauer had died. The drawings 3.5–6 are AD's studies of earlier work by Schongauer, possibly provided by his brothers in 1492, although scholarly opinion now tends to the view that Schongauer had worked with Hans Pleydenwurff in Nuremberg around 1469–70 and that a stock of drawings by him remained in the Pleydenwurff workshop when Michael Wolgemut took it over. Schongauer was customarily known as *Schön* or *Hübsch Martin*, 'Handsome Martin', punning on his surname and the quality of his work.

[Bernhard 1980, 18f.; Buck 2012, 95–100; Kemperdick 2004; Messling 2010, 100–103; Ex. Cat. Bruges 2010/11, 387f.; Smith 2011, 8–11; Ex. Cat. Nuremberg 2012, 312–15]

### 3.7 *Presentation of Christ in the Temple*. Unfinished elaborated pen study based on a drawing by Schongauer. W 21, S D 1491/1

Inscription in a later, unidentified hand (1492?):

> Albrecht Dürer did this piece in his bachelor years as journeyman

An adaptation of a composition by Schongauer or his studio which was used in a number of drawings, all related to Schongauer's altarpiece for the Dominican Church in Colmar (circa 1475). It continued to be used into the sixteenth century, for example in glass paintings for the Carmelite Church in Nuremberg, based on drawings by AD and his assistants. The status of the drawing and its attribution to AD are much disputed.

[S D I, 42; Rowlands 1988, 61–4]

**3.8** *St Jerome in his Study*. **Woodcut block. SMS 261.1, S W 10**

Inscribed on the back:

Albrecht Dürer of Nuremberg

The woodcut appears on the title page of the first part of the edition of the letters of St Jerome, *Epistolare beati Hieronymi* (Basel: Nicolaus Kessler, 1492). The woodcut block has long been regarded as key evidence of AD's work in Basel in 1492–4. But only the elaborate 'signature' *Albrecht Dürer von nörmergk* justifies the attribution of the woodcut to him. Braun and Grebe 2007 reject the assumption that AD himself cut and 'signed' the block. Although *nörmergk* is one of the large variety of spellings used in Nuremberg itself in the sixteenth century, AD uses it otherwise only on the captions to his Nuremberg costume studies of circa 1500 (14.1), and Braun and Grebe appear to attribute these captions to Willibald Imhoff. The chancery-style calligraphy on the woodcut block points rather to a later sixteenth-century owner who believed the block to be AD's work or wished to establish it as such. The attribution to AD of large numbers of woodcut book illustrations, done during his apprenticeship with Wolgemut and his journeyman years, is now increasingly rejected as 'a wobbly construct of mere hypotheses' (Wolf 2010, 50; see also Schoch, SMS I, 27f.). Schmitt 2010 has reopened the debate and argues the possibility that Sebastian Brant (BI) 'talent-spotted' AD from work done by him on Hartmann Schedel's Nuremberg Chronicle and gave him a major role (as the 'master' woodcut artist) in the *Ship of Fools* (circa 1492). Schmitt claims (Ex. Cat. Nuremberg 2012, 146–52 & 424–33) that it was in Nuremberg not Basel that AD found the preconditions for his mastery and exploitation of the woodcut medium.

[See also: Price 2003, 199–202; Roth 2012, 40f.; Smith 2012, 43–5]

## 1489–1492

# 4  Albrecht Dürer the Elder Serves Emperor Frederick III as Goldsmith

## 4.1  Resolution of the Nuremberg City Council

*[24 March 1489]*
Item: Krug and Albr. Dürer to apply themselves to speedily finishing the drinking vessels commissioned by Imperial Majesty.

Ratsverlass 235, fol. 11ᵛ
  R I, 252, note 3

## 4.2  Albrecht Dürer the Elder, Letter to Barbara Dürer [fig. 7]

*[24 August 1492]*

This letter is meant for the respected Frau Barbara Dürer, goldsmith's wife in Nuremberg, my dear wife.

Before all else, my affectionate greeting, my dear Barbara. This is to tell you that I reached Linz very late on the Sunday before St Bartholomew[1] after a hard and wearisome journey, and on the Monday after I had eaten my Gracious Lord[2] sent for me to come right away and I had to unpack and display my drawings. His Grace took great delight in them and straight off had much to say to me. And when I was ready to leave His Grace, he walked up [to me] and thrust [four] fl. into my hand, saying to me 'My goldsmith, go to your lodging and give yourself a treat.'[3] Since then I have not waited on His Grace again, but Stefan and the counsellor[4] have been very encouraging. So I have had to keep waiting, but I hope I shall soon be back with you. May God in his love bring me safe home. No more for now, but best regards to all the household, and instruct the apprentices to get on with things, as I think I deserve of them,[5] and [take good care of] my children and tell them to behave themselves.[6] Dated Linz on St Bartholomew's Day 1492.

Albrecht Dürer

Autograph original in the GNM, said to have been discovered in 1882 behind panelling in the house in Unter der Vesten. Mice have nibbled two holes in the paper; square brackets indicate reconstruction of missing or damaged characters.

R I, 252

NOTES

1  19 August 1492.

2  Emperor Frederick III had been in Nuremberg for the imperial diet in 1487 and in 1489 commissioned drinking vessels from Dürer (4.1).

3  Dürer interprets the fact that the emperor walks over to him, rather than summoning him to approach, as a mark of favour. The sum of four gulden, given that it is not payment for goods, is a handsome gratuity.

4  Unidentified members of the emperor's retinue.

5  It was customary for a craftsman's wife to oversee the workshop in his absence.

6  Dürer does not record the dates of their children's deaths in his Family Chronicle so it is impossible to know which of them were alive and at home in August 1492. AD had left on his journeyman travels. Endres was born in April 1484, so was eight years old; Hans, born in February 1490, was an infant; Karl, if he had survived, was a baby of less than two weeks old when his father left for Linz. Barbara, with all eighteen births now behind her, was forty years old.

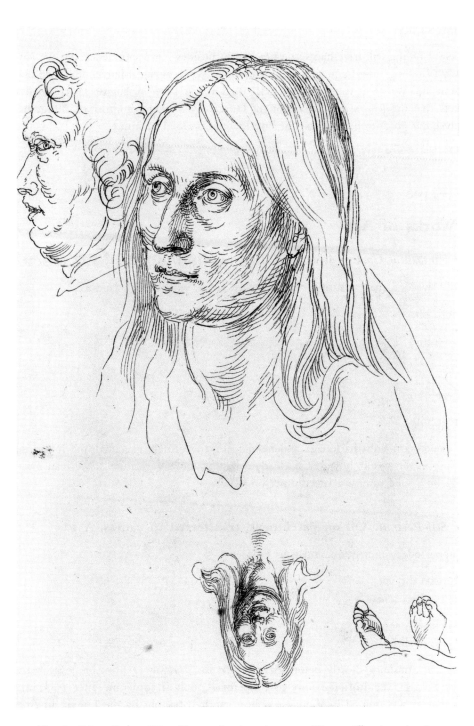

7. Albrecht Dürer, *Barbara Durer* (?), pen drawing, circa 1493. Vienna: Albertina 26327$^\text{v}$

COMMENTARY

The elder Dürer will have had some practice in business correspondence, but we have no way of telling how frequently he had cause to write personal letters. His style here is fluent and warm in tone. Frederick III died a year later, in August 1493, and it is unlikely that the journey to Linz brought Dürer any further commissions. Altogether, no surviving goldsmith work can be confidently ascribed to him.

[Ex. Cat. Nuremberg 2012, 276f.]

## 1493–1496

## 5 Works of Art

### 5.1 *Fantastical Coat of Arms*. Pen drawing. (1493/95?) W 41, S D 1493/22

On the shield, a man is sitting behind a tiled stove, with the inscription:

Fricze oho

(Fritz—oho!)

or

Hicze oho

(Hot—oho!)

The escutcheon with its foliage and heraldic bird are finely executed, the humorous drawing on the shield, however, is clearly a hastily drawn caricature. If we read *Fricze*, it may be a joke against a specific person.

### 5.2 *Self-Portrait*. Oil on parchment, transferred to canvas. A 10

On upper edge, inscription, and date 1493:

My sach die gat
Als es oben schtat

(My course is set
In the stars above)

Painted in Strasburg shortly before AD's return to Nuremberg from his journeyman travels. Sold by the Imhoff family to Emperor Rudolf II sometime after 1588, from circa 1840 it was owned by Viennese collectors, then bought by the Louvre in 1922.

Goethe described the copy now in Leipzig (*Tag- und Jahreshefte*, 1805). The idea that it was a love pledge to Agnes Frey in the context of their arranged marriage, hence painted on parchment so that it could easily be rolled up and sent home from Strasburg, is a nineteenth-century fantasy. AD holds a sprig of a plant long identified as *eryngium* (sea-holly), interpreted in herbals as a pledge of male fidelity (in German *Mannestreu*) or as an aphrodisiac, though it was also read as symbolising unhappiness and exile from home, and as a typological image of the Passion of Christ. However, Brisman (Ex. Cat. Nuremberg 2012) points to the confusion in the herbals of *eryngium* with the star-shaped *aster atticus* (in German *Sternkraut*, 'starwort') which in old superstition was believed to shine in the dark like a celestial star. In this reading the plant AD holds would be symbolic of the portrait's motto, implying stoical or proud acceptance of divinely decreed destiny. In early drafts of the contents and preface to his planned handbook for young painters, AD points to the constellation under which an aspiring painter was born as astrological evidence of professional potential (51.3.1/2). The motto may derive from a proverbial saying. Its linguistic form seems more Swabian Alemannic than Bavarian or Franconian dialect. Rublack 2010, 34, echoes Goethe by interpreting AD's distinctive clothing and striking headgear as elements in a self-conscious image of the artist's 'daring youthful originality'.

[See also Anzelewsky 1991, 124f.; R I, 211, note 6; Stumpel/Kregten 2002; Wolf 2010, 230f.]

## 5.3   *Agnes Dürer*. Pen drawing. W 151, S D 1494/7. 1494 or after [fig. 8]

Inscription:

My Agnes

AD depicts his new wife dozing at a table in a swift and fluent sketch from life. 'The heavy eyelids and the protruding eyes are characteristic facial elements of Agnes Dürer, as is her untidy hair-do' (S D I, 208).

[Ex. Cat. Vienna 2003, 140]

## 5.4   *Orpheus Slain by Bacchantes*. Pen drawing. 1494. W 58, S D 1494/11

Inscription on banderole:

Orfeus, der Erst puseran

(Orpheus, the first pederast)

Copy of an engraving by Mantegna or his school from the early 1470s, itself based on an antique model. AD could have seen Mantegna's work in Nuremberg, even before

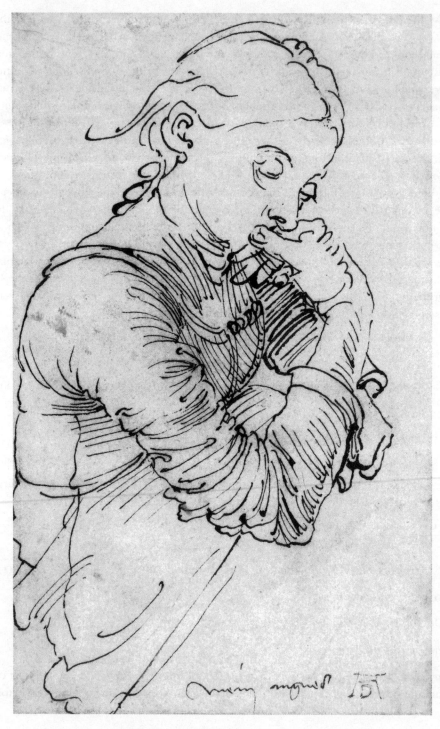

8.   Albrecht Dürer, *Agnes Dürer*, pen drawing, 1495. Vienna: Albertina 3063

he went to Italy, or encountered it in Venice. One version of the death of Orpheus is that he was dismembered by women followers of Bacchus for preferring boys as lovers. On the German word *puseran*, see Götze, *Glossar*, 44 (*buseron*), derived from Florentine *buggerare*, and DWb II, 569, with examples from Luther and Hans Sachs, proposing a derivation from Italian *bugiardo/bugiardone*. The drawing belonged to the Ayrer family of Nuremberg in the sixteenth century and to Joachim Sandrart in the seventeenth. Wolf 2010, 156f., links the inscription with the drawing of a youth and executioner (W29, S D 1493/5) and with the Greek inscription on AD's silverpoint of Willibald Pirckheimer (21.1).

### 5.5  *Watercolours of Nuremberg and of Places on AD's Route to Venice,* 1494–6.

While a local tradition of watercolour *vedute*, views of landscapes and townscapes, is discernible in Franconia from circa 1470 onwards, AD's watercolours have been regarded as among the first authentic landscapes by an artist north of the Alps. The earliest examples are dated or dateable to 1494, between his return to Nuremberg from his journeyman years and his departure for Venice. A major group of watercolours records places and landscapes on the route to or from Venice and are adduced as confirmation that AD visited Italy circa 1495. Robert 2012, 72, links them with Konrad Celtis's *Amores* and *Germania illustrata* (10, commentary). Recent studies present the watercolours not as spontaneous responses to immediately observed nature and architecture but as studio products worked up from *plein-air* sketches, often rearranging elements and combining different viewpoints, and providing a pattern-book of motifs which AD and his associates could exploit in paintings and prints.

[Winkler I, commentary; Grote 1998, 8–21; Andrews 1999, Herrmann-Fiore 2003; Moser 2003; Ex. Cat. Vienna 2003, 150–60, 170, 182f., 208; Grebe 2006, 38–45; Großmann 2007, 229–40 and Ex. Cat. Nuremberg 2012, 222–6 & chapter 2; Hess in Ex. Cat. Nuremberg 2012, 123f.; Böckem 2012; Röver-Kann Ex. Cat. Bremen 2012, 42–53]

### 5.5.1  *The Wire-Drawing Mill.* Ink and watercolours. Undated. W 61, S D 1494/3

Inscribed in AD's hand:

trotzich müll

A water-driven mill for producing iron rod or wire, using a mechanism invented in Nuremberg, was added to the flourmill on the north bank of the Pegnitz on the Hallerwiese outside the city in 1439. It catered for the manufactories of domestic and precision metalware. The drawing accurately shows the south-west corner of the walled city and the suburb of Gostenhof. Though undated, it and the companion

piece showing the church of St John (W 62, S D 1494/4) belong on stylistic grounds to the earliest phase of AD's work in this medium following his return home from his journeyman travels.

### 5.5.2 *View of Innsbruck from the North*. Watercolour. Undated. W 66, S D 1495/44

Inscribed in AD's hand:

Isprug

The first townscape *veduta* and the only one of AD's apart from that of *Nuremberg from the West* (5.5.11) in which architectural accuracy is a prime consideration. It shows snow on the Zillertal Alps behind the town, and on lower ground to the left. The river Inn has a high water level; there is foliage on trees. The time of year could be either autumn or spring, although AD did not paint his finished watercolours *in situ* but worked them up from sketches, and such indications of season or weather may not be reliable dating indicators. Accuracy of depiction may be very germane to this picture. Großmann (2007) points out that AD shows the Wappenturm (left centre) with its tall spire under scaffolding. This was a new structure, replacing an earlier tower destroyed by fire in 1494. AD evidently saw and drew it just before its completion which cannot, on documentary evidence, have been before the autumn of 1496. The tower is not shown on the watercolour of Innsbruck castle courtyard (W 67, Strauss 1494/9) which on stylistic grounds is earlier, sketched when the new tower may not have reached a height sufficient to make it visible from the artist's vantage point. If his two watercolours of the castle courtyard were done in 1495 and the view of the town in late 1496, a new basis would emerge for confirming AD's first visit to Venice but locating it at a somewhat later date than hitherto assumed (September 1494–spring 1495). But see Hess, Ex. Cat. Nuremberg 2012, 402f.

### 5.5.3 *Arco*. Watercolour. Undated. W 94, S D 95/31

Inscribed in AD's hand:

fenedier klawsen

(Venetian defile)

German *klause*, 'enclosure', refers to the narrow gorge which the castle of Arco commands and which could be blocked to close the frontier of the Venetian city state above Lake Garda (which AD made a detour to visit). The most celebrated of AD's Dolomite landscapes, with its consummate rendering of rocks and the luminous grey-green of olive-tree foliage.

5.5.4   *The Castle of Trento*. Watercolour. Undated. W 95, S D 1495/32

Inscribed in AD's hand:

> trint

5.5.5   *Dosso di Trento*. Watercolour. Undated. W 97, Strauss 1495/34

Inscribed in AD's hand:

> trintberg

(Rock of Trento)

5.5.6   *Landscape Near Segonzano*. Watercolour. Undated. W 99, S D 1495/37

Inscribed in AD's hand:

> wehlsch pirg

(Italian mountain)

The landscape is in the area of Segonzano in the Val di Cembra or Zimmertal. The word *welsch* (compare English 'Welsh') originally denoted 'Celtic' and was a loan-word from the name of one of the neighbouring ethnic groups to the Germanic tribes in the northern and central areas of modern Germany. It was taken into later Latin as *Volcae*. In early medieval German it was also applied to peoples conquered (like the Celts) by Rome and which developed Romance languages. By circa 1500 it applies especially to the Italians, often pejoratively.

5.5.7   *Castle of Segonzano*. Pen and Watercolour. Undated. W 101, S D 1495/36

Inscribed in AD's hand:

> ein wehlsch schlos

(Italian castle)

5.5.8    *Quarry*. Watercolour. Undated. W 107, S D 1495/50

Inscribed in AD's hand:

steinpruch

W 108 and W 109, S D 1495/51 and 52, have the same inscription. Three other water-
colours of quarries have no inscription. They are likely to have been done in 1496 or
later, after AD returned to Nuremberg. They show a remarkable eye for precise rep-
resentation of geological features in line and colour and of transitions from rock to
vegetation. They were probably primarily intended as workshop models.

5.5.9    *Watermill on the Meadows*. Watercolour. Undated. W 115, S D 1496/7

Inscribed in AD's hand:

weyden mull

The scene is the same as 5.5.1, showing the mills on both sides of the Pegnitz and
the bridge across the river. The comparison reveals the aesthetic and stylistic advance
in AD's watercolour technique. Winkler calls it 'the most splendid of all Dürer's land-
scapes'. German *weyde* here means 'meadow', not 'willow' as Strauss presumes. The mill
complex has been partly reconstructed and has found new uses after destruction in
the Second World War.

5.5.10    *House on the Pond*. Watercolour. Undated. W 115, S D 1496/6

Inscribed in AD's hand:

weier haws

This was the house of the fisherman Linhardt Angerer.

5.5.11    *Nuremberg from the West*. Watercolour. Undated. W 116, S D 1496/1

Inscribed in AD's hand:

nörnperg

A wide-angle panorama combining landscape and architecturally precise cityscape,
extending from the church of St John in the west to the city wall, flanked by the
Neutorturm, the Halltörlein and the Spittlertor. The castle looms on the northern
horizon.

### 5.6 *Pupila Augusta*. **Pen with black and brown ink. W 153, S D 1496/17**

Mirror-reversed monogram. The date 1516 is not in AD's hand. Inscription, also mirror-reversed, on an antique container in which putti are bathing:

PVPILA AVGVSTA

(Exalted ward)

This was the title accorded to Aphrodite (Venus), who in classical myth sprang motherless from the sea-foam (*aphros*). She is the naked beauty in the middle centre riding a fish or dolphin towards the welcoming group of three older women who are perhaps *horae*, daughters of Jupiter, named after the seasons of spring, summer and winter, and symbolising order, justice and peace. The putto chasing a rabbit also comes from the myth of Aphrodite. However, the *hora* gazing into a plate suggests, rather, the nymph Oenone, betrothed to Paris and gifted with prophecy, who foretold the judgement of Paris to Hera and Athena. The winged, ammonite-like helmet also belongs to Oenone.

AD amalgamates a bewildering collection of motifs. The background combines elements from AD's watercolour drawings of Trento and Innsbruck, which he reuses again as late as 1519 in the engraving of St Anthony (S E 89, SMS 871). Aphrodite and her companions are taken from a print by the Bolognese artist Peregrino da Cesena. The foreground figures may derive from a scene described by Philostratus the Elder. The reclining woman in the winged helmet and the basket with ox-head decoration is copied from a Ferrarese engraving. The reversed monogram and inscription indicate that this drawing too was meant for an engraving, though the foreground figures would, unconventionally, have been left-handed if engraved and printed. The eclectic mythological references must have been supplied by Konrad Celtis or Willibald Pirckheimer (BI).

[Strauss S D 1, 46; W 1, 103f.; Heard/Whitaker 2011, 92; Großmann 2012, 227f.; Ex. Cat. Nuremberg 2012, 466, 473]

### 5.7 *Fortuna*. **Copperplate engraving. S E 7, SMS 5. 1495/6**

AD monogram but undated. Known as the 'Small Fortuna' in comparison with 'Nemesis' or the 'Large Fortuna' (S E 37, SMS 33)

Fortune is precariously balanced on a globe and her instability is emphasised by the thin cane she holds. This is surmounted by the plant starwort (see AD's self-portrait 5.2), interpretable as the symbol of a higher fate overriding inconstant fortune. The voluptuous figure is probably developed from the drawing Nude Woman with Staff, seen from behind (W 85, S D 1495/10) whose stance derives from the Medici Venus. Like Pupila Augusta (5.6), the drawing and the engraving reflect AD's encounter with classical models during and after his visit to Venice.

While it has no inscription, Fortuna has an evident stimulus text, the Tabula Cebetis, a pseudo-Socratic dialogue, attributed to the Stoic philosopher Cebes of Thebes but already well known at the time of Lucian. Willibald Pirckheimer's interest in Lucian (BI) led him to translate it into German and it may have served as a stimulus to AD's engraving. It contains a passage in which a group of students discuss Fortuna:

A. Who is the woman who appears blind and foolish and is standing on a round stone? B. She is called Fortune and is not only blind but also deaf and mad. A. What kind of function does she perform? B. She wanders to and fro and from some she takes away. To some she gives and takes back from them what she gave and bestows it on others – in a thoughtless and inconstant fashion. This picture truly depicts the manner and nature of Fortune...F. It shows that the gifts of Fortune are not constant and dependable. Whoever puts his trust in Fortune suffers great and mighty harm.

[Bonnet 2000, 368; Brisman 2012]

## 1496

# 6  Household Accounts of Duke Frederick the Wise of Saxony

Extract from the accounts drawn up by the paymaster Hans Leimbach for the period from the Tuesday after All Saints to the Tuesday after St Luke's Day 1496.

35 shillings in addition to 100 gulden[1] to a painter in Nuremberg for a new panel which My Gracious Lord Duke Frederick commissioned.[2]
63 groschen carriage of the same panel from Nuremberg to Leipzig.
60 gr. carriage of the same panel from Leipzig to Weimar.

R I, 244f., from older printed transcripts

NOTES

1  *XXXV ß an ř gulden*: The contracted fee for the painting was 100 gulden. The further 35 shillings, that is 1 gulden 15 shillings, are likely to be expenses for the panel, colours etc. Rupprich I, 145, note 1, mistakenly reads ß as *schock*, but its use in following entries makes it clear that *schillinge* is meant. A *schock* was a measure of 60 units, in currency 60 pfennigs or groschen. It was not a coin as such. 35 schock is 8 gulden 180 groschen, which is too high a sum for expenses (see Money, Coinage and Currency).

2  In 1496 AD painted the portrait of Duke Frederick (A 19. See BI). It was done in tempera on canvas, but *tafel* can be used for canvases as well as panels. The central

panel of the so-called Dresden Altar (painted for Frederick's Castle Church in Wittenberg), *Mary adoring the Christ Child*, has been excluded from the Dürer canon by Anzelewsky and attributed to the Netherlandish painter Master Jan, in Frederick's service up to 1495. However, its Italianate features would fit with AD's recent return from Venice. See also 18, 86.

[Ludolphy 1984]

## 1497

## 7 Contract of Employment issued by Albrecht Dürer to Konrad Schweitzer

*[Nuremberg, 8 July 1497]*
Contz Schweitzer has sworn and avowed diligently and faithfully to serve Albrecht Dürer the painter in the coming year, as specified in the following. Namely: he will to the best of his ability convey prints of copperplate engravings and woodcuts from one country to another and from one town to another, offering them for purchase and selling them at the value and for the price, according as Albrecht Dürer has noted down for him on a piece of paper. However, where he may sell the prints more profitably, he shall spare no effort to do so, and he shall not allow himself to be distracted from selling such prints by any amusement or frivolity. He shall not lie idle in any location where he cannot make money, but shall speedily move on from one place to another as he deems fit and set out his wares, and the money he makes he shall send at such times to Dürer, or forward to such places, as he shall instruct, and he shall make do with the payment agreed with him, namely each week half a Rhenish gulden as wage and three pounds in the local coinage for his board and lodging.[1] And whenever Dürer may summon him here, let him return promptly to him and work and serve faithfully as he orders, and he shall be satisfied and content, without protest, with the aforesaid payment of half a gulden and his meals in Dürer's house. Deceit and dishonesty in these matters will not be tolerated. And to confirm that the contract as stated above has been agreed, both parties have requested Sebald Tucher and Ludwig Schnöd to be witnesses.[2] Done on the Sabbath of St Kilian 1497.

Nuremberg City Archive, Lib. Cons. Bd. K, fol. 132[b], discovered and published by Goldmann 1962, 4, reprinted by Rupprich III, 448.

NOTES

1   At half a gulden or 120 pfennigs per week, the wage-rate is approximately the same as would be paid to a semi-skilled craftsman – stonemason or carpenter – in a workshop in Nuremberg. The rate for local, on-the-job expenses is specified as a weight measure, not in fixed coinage, to take account of fluctuating currency values. One destination of the salesman is very likely to have been Italy. By this time AD apparently had premises in Nuremberg where he could accommodate his agent when he was back at base and that suggests also that he had a workshop with resident assistants and/or apprentices.

2   The witnesses, one for each party to the contract, were both, as legally required, members of the Great Council of Nuremberg.

# 8   Contract of Employment issued by Albrecht Dürer to Georg Coler

*[Nuremberg, 26 July 1497]*
Georg Coler, legitimate son of Stephan Coler and his wife, has affirmed and avowed: Having pledged himself to the painter Albrecht Dürer and promised to serve him for the year now following, he shall for the said year and in every single week of it when he is away from this city, for a wage of one half Rhenish gulden and three pounds in Nuremberg coin, faithfully serve him, promote his interests and profit, and as best he can avert any loss to him; he shall eagerly and energetically offer for sale the prints of copperplate engravings and woodcuts, which he shall place into his keeping and entrust or send to him in future, in those cities and towns where he deems it useful and favourable, and sell them for the highest price he can obtain, and travel with his wares from one town and locality to another, setting them up for sale, and letting nothing whatsoever hinder him from selling them, neither gambling nor any other frivolity; he shall conscientiously send to the aforesaid Dürer the money he takes in for his wares, or forward it to the address he shall specify to him; further he shall content himself with the wage and expenses specified above, and whenever during the period of his engagement Dürer may order him to Nuremberg, he shall pay him no more than 1 quarter[1] as his weekly wage, and he shall have his meals at the said Dürer's premises, and whatever work he may instruct him to carry out here, he will do that faithfully without contradiction, and deceit and dishonesty in these things shall not be tolerated. Witnesses summoned: Andreas Geuder and Sebald Stromer.

Fourth after St James's Day 97.

Nuremberg, City Archive, Stadtgericht, Schuldgerichtsbuch K. p. 140, discovered and printed by Schultheiß 1969, 78–80.

Not in Rupprich I or III

## NOTE

1   That is, 60 pfennigs.

## COMMENTARY

The decision to recruit two itinerant salesmen of prints in July 1497 proves that, following his return from Italy in 1495 or 1496, AD evolved a successful business plan, to concentrate a good part of his time on producing high-quality woodcuts and copperplate engravings, and to cultivate a market for this mass-reproducible, easily transportable, relatively cheap graphic medium. Apart from sales at local markets and the major trade fairs, he may have looked – in characteristic Nuremberg fashion – to build up a national and international commerce. His experience in Venice will have persuaded him that apart from German trade fairs, Italy was also ripe for this sales drive. Commercial expansion promised a degree of self-reliance and independence from patrons commissioning paintings. Schmidt 2012 points to the *Apocalypse*, in production in 1497, as the main product AD will have looked to the salesmen to promote. The recruitment of Schweitzer and Coler demonstrates AD's spirit of enterprise and business ambition at a time when there is no direct evidence that he yet had a workshop of assistants. The venture was not unproblematic. When AD took on another agent, Jakob Arnolt, in 1500, his brother Hans Arnolt was required to guarantee and stand surety for any loss of goods entrusted to him for selling (13). In 1505/7, according to his personal record (38), employees failed to keep proper accounts, while prints were lost when one of his salesmen died in Rome. During his absence in Venice in 1505–6 Agnes Dürer sold his prints at the Frankfurt trade fair while his mother manned the market stall in Nuremberg. The availability of his graphic art in Italy had the disadvantage that it could readily be copied and imitated, and even plagiarised through the unauthorised use of his monogram (29.2 and note 4; 29.5 and note 6).

[Goldmann 1962; Schultheiß 1969; Landau/Parshall 1994, 347f.; Bersebach/Hemme 1997, 40f.; Schmid 2003, 267; Witcombe 2004, 81; Grebe 2007, 124–6; Talbot 2012, 43f.; Schmidt 2012, 152–9; Hess/Mack 2012, 188]

1497–1500

# 9  Works of Art

### 9.1  *Portrait of Albrecht Dürer the Elder*. Oil on limewood panel. 1497. A 48

In November 1636, Thomas Howard, Earl of Arundel, was presented with AD's self-portrait of 1498 (9.5) and a portrait of his father as a gift for King Charles I from the Nuremberg city council. While Anzelewsky restated the case for regarding this as AD's authentic work, its flaws attributable to damage and reworking, Foister 2004 has reinforced the long-standing doubts of Campbell Dodgson, Panofsky, Levey and others about its authenticity. In the catalogue of Charles I's collection it is described as 'Alberdure his father in an old Hungarian fashion black cap in a dark yellow gown wherein his hands are hidden in the wide sleeves painted upon a reddish ground all crackt'. On the back of the panel, beneath an eighteenth-century label, is an indecipherable one in a perhaps seventeenth-century hand comparable with the label on the back of the 1498 self-portrait. Levey's and Foister's analyses conclude, on grounds of its substance and techniques, that the picture now in the National Gallery, London is 'likely to be a copy made after a lost original by Dürer, perhaps in the second half of the sixteenth century'. The inscription: 1497 ALBRECHT THVRER DER ELTER VND 70 JOR ('Albrecht Dürer the Elder and 70 years old'), is in its formulation and style, with the use of capitals in ultramarine colour, quite uncharacteristic. A version of the portrait now in Munich has an inscription: Das malt ich nach meines vatters gestalt / Da Er war sibenzich jar alt / Albrecht Dürer Der elter ('This I painted in my father's likeness / When he was seventy years old / Albrecht Dürer the Elder'), which is closely comparable with that of the 1498 self-portrait and possibly modelled on it. Charles I ordered copies of both pictures to be made and despatched to Nuremberg, but the keeper of his collection, Abraham van der Doort, noted that they had not been sent. In 1644 Wenceslaus Hollar made an etching of the portrait which, the print claims, was then in the Arundel collection. It has the same inscription as the National Gallery painting, except for a copying error, the meaningless...VI ID · ALT 70 JOR. The same error occurs on another painted copy, in the Northumberland collection at Syon House. This version may be the copy done by Richard Greenbury for King Charles, or a second one done for Arundel.

There is little doubt that the National Gallery portrait is the one sent to Charles from Nuremberg in 1636. There is no evidence that the city authorities knew it to be a copy, though as Hanns Hieronymus Imhoff (who sold much of the Pirckheimer collection to Arundel) observed, 'It may well be doubted of many [works attributed to him] whether they were actually painted by Dürer.' It is possible that the two portraits sent to London, which are virtually the same size, were regarded towards the middle of the seventeenth century as a pair or pendants. That is the impression given

by van der Doort's catalogue and it is suggested also by the inscription of the Munich copy of the portrait of AD's father.

[Levey 1959, 26–32; Springell 1963, 129–31; Anzelewsky 1971, 150–52; Pennington 1982, catalogue 1389; Goldberg/Heimberg/Schawe 1998; Foister 2004; Brotton 2006, 177–81, 258, 272; Kemperdick 2013, 96f.]

## 9.2 Two Portraits of Young Women

Arundel must also have bought in Nuremberg in 1636 a pair of virtually identically sized portraits by AD of young women, though the transaction is not documented. One (A 45) shows a woman against a plain dark background, severely dressed, with long hair flowing down over her shoulders. Her eyes are closed, her hands folded in prayer. The other (A 46) shows possibly the same or a related woman, seated by a window with a view of a landscape, in bright secular dress, with hair braided and bound up, holding the sprig of a plant in her hands. Of each picture, two versions are extant which could be taken to be AD's originals. One pair is painted in tempera on fine linen canvas, the other in oil on wood panel. Anzelewsky argued that the Frankfurt (Städel) canvas, which was the model from the Arundel collection for Wenceslaus Hollar's etching of 1644, is most probably AD's original of A 45, rather than the panel painting now in Augsburg. Anzelewsky regarded the Leipzig panel as the authentic version of A 46, not the canvas formerly in Paris, now in Berlin. Hollar also etched A 46 in 1644, but his model was clearly the Paris/Berlin canvas whose ownership he attributed to Alethea, Countess of Arundel. In 1944 Grossmann had argued that the two tempera paintings on canvas, recorded together in the 1654 Arundel catalogue as *2 ritratti de donna in aquazzo*, were clearly acquired as a pair, on the dispersal of the collection were sold as a pair, and remained together in the Imstenraedt and Olmütz collections until 1830. This view was endorsed in the 2012 Nuremberg exhibition where the two pictures were reunited.

However, the identity of the subjects depicted and the interpretation of the portraits as a pair or diptych remain problematical. It is not now accepted that they are contrasting images of the same person, as Arundel may have believed. They might be related young women of the same family, one destined for the religious life, one for marriage. Both the tempera portraits have tiny, perhaps added, coats of arms of the Nuremberg Fürleger family, in forms applicable to religious and secular members respectively. Yet records of the Fürleger family in the mid- to late 1490s show no suitable candidates for identification. One suggestion is that the secular figure might be Katharine Frey (1478/9–1547), the sister of AD's wife Agnes, but that does not resolve the question of the paired portraits. A recent hypothesis advanced by Brinkmann and Kemperdick argues that, given that AD painted family portraits in his early years, among them the 1490 diptych of his parents, it is conceivable that the two young women were his own sisters Agnes (born 1479) and Katharina (born 1482). The dates

of their deaths are unknown, let alone the particulars of their personality or fate in life. If not commissioned likenesses, the portraits may use the women rather as 'sitters', whom AD depicts as a contrasting pair of human images. Panofsky suggested that the diptych was an allegorical contrast of Chastity and Sensuality.

The Fürleger family had an art collection in the early seventeenth century, and the coats of arms may have been added as owner's mark or in the belief that they portrayed ancestors. Arundel could have purchased the pair from the Fürlegers. In the Arundel catalogue, item 719 (not attributed to AD) reads 'Fürleger of Nuremberg'.

### Portrait of a Young Woman with Loose Hair. Tempera on fine canvas. 1497. A 45

There is no inscription, but Hollar's etching (1644) has Latin verses below which express a contemporary interpretation of the portrait:

> This is what the Virgin, adorned with hair let loose, prays for
> And ponders, as she seeks to follow Christ alone:
> She desires to serve the one God and render herself
> Blessed, for the joys of the Cross alone confer blessing.

### Portrait of a Young Woman with Braided Hair. Tempera on fine linen canvas. 1497. A 46

The inscription on a cartellino pinned to the wall to the right of the head is now illegible. On the etching by Hollar and the panel now in Leipzig it reads:

> This is how I look
> At eighteen years old

The name Katharina Fürlegerin, supplied by Georg Wilhelm Panzer in 1790, is nowhere documented. Like AD on his 1473 self-portrait, she holds a sprig of a plant, generally taken to be *eryngium* (see 5.2 and 5.7), but more likely starwort, symbolic of the acceptance of fate decreed by the stars (Brisman 2012). On the Berlin canvas the statuette of a prophet, which in Hollar's etching and in the Leipzig version (perhaps based on Hollar) appears on the window frame to the left of her head, has been clumsily painted out.

[Hervey 1921, catalogue 104; Grossmann 1944; Panofsky 1948, 41f.; Pennington 1982, catalogue 1535f., Anzelewsky 1991, 147–9; Brinkmann/Kemperdick 2005, 273–86; Ex. Cat. Nuremberg 2012, 356f., 361f.; Haskell/Penny/Serres 2013, 114–18]

### 9.3 *Four Naked Women*. Copperplate engraving. AD monogram and date 1497. S E 19, SMS 17

One wears a wreath and appears to be being addressed (or initiated?) by the other three, who are often interpreted as witches (the devil lurks in the background and a skull and bone lie on the floor). Above the group hangs a pomegranate, a symbol of fertility, inscribed with the date 1497 and the inscription O·G·H. This has been variously decoded, for example as *Odium Generis Humani* – 'hatred of the human race'.

[Bonnet 2000, 368; Ex. Cat. Vienna 2003, 240; Ex. Cat. Nuremberg 2012, 466 & 474]

### 9.4 *The Dream of the Doctor or Temptation of the Idler*. Copperplate engraving. AD monogram, undated. 1498? S E 22, SMS 18

Head propped on a pillow, a man (in doctor's robe?) sits sleeping by the stove. A nude woman, perhaps a projection from his dream, beckons him temptingly. A devil blows into his ear with a bellows. A stimulus text may have been chapter 97, lines 9–12, of Sebastian Brant's *Narrenschiff* ('Ship of Fools', Basel 1494), woodcuts for which AD may possibly have produced during his journeyman time in Basel (though not for this chapter: SMS 266):

> A lazy man is good for nothing more
> Than to be a winter grape,
> To be left to sleep his fill,
> Sitting by the stove is all he's fit for.

For Brant's word *wynterbutz*, see DWb XIV, II, 432: 'grape which develops too late to be harvested'. The devil might reflect a popular expression for sleeping by the stove, quoted by Georg Wickram in his *Rollwagenbüchlin* (1555, 22) as lying *hinder dem ofen in der hell* – 'in hell', jokingly for the hottest place.

[Bonnet 2000, 368; Ex. Cat. Vienna 2003, 242; Ex. Cat. Nuremberg 2012, 467 & 476]

### 9.5 Self-Portrait. Oil on panel. 1498. A 49

Inscription beneath the window at the right:

> 1498
> Das malt ich nach meiner gestalt
> Ich was sex vnd zwanzig jor alt

(This image I painted of myself
I was twenty-six years old)

The indication of year and age allow the portrait, or at least the inscription, to be quite precisely dated. In this period in Nuremberg, the New Year began on 25 December,

and AD's twenty-seventh birthday fell on 21 May 1498. Though the overall colouring is relatively muted and the facial expression somewhat austere, the luxurious clothing and the colourful Alpine landscape, seen through the window, place the portrait in the Veneto. It seems to reflect or anticipate AD's sense of the heightened status of the artist in Venice, expressed in his letters to Willibald Pirckheimer in 1506 (29.7 and 29.10). The 'almost transparently thin leather gloves and the applied gold band at the neck of his unusually low-cut linen shirt', his 'extravagant black and white silk or very soft leather cap…assert his inventiveness in manipulating his body and clothes and images of them to create a distinctive impression' (Rublack 2010, 1–3), one which is not that of a Nuremberg craftsman but has patrician pretensions, perhaps those of an international humanist artist who no longer merely depicts himself in the act of painting. His refined self-image will be confirmed by 1500 when Konrad Celtis hails him as the modern Apelles. Eser argues, however, that the ultra-high finish of the painting and AD's self-presentation reflect a function of the portrait as a 'test-piece' or a demonstration of artistry to impress would-be clients. Hirschfelder compares AD's clothing with that of Berthold Tucher on an anonymous Nuremberg portrait of 1484. But AD was not a Tucher, entitled to patrician luxury. In 1636 the Nuremberg authorities gave the portrait to the Earl of Arundel for presentation to King Charles I (9.1). His keeper of pictures described it as: 'Item the Picture of Alberdure himself when hee was young in his long yellow haire in an old antick fashioned black and white leathorne-Capp and habbitt with gloves on his hands whereby through a windowe a Lanskipp to be seene painted upon board in an ould wooden frame presented to ye kinge by the Citty of Neronborch in high Germany sent by the Lord Marshall, Lord Embassador to the late Emperor ffardinando.' Wenceslaus Holler made an etching from it (or a copy by Richard Greenbury) in 1645. Latin verses below the image assert that the like of AD's manly virtues flourishes nowhere in the world; art will never portray genius and morals more gloriously than his own self-portrait. Sold during the Commonwealth, after the king's execution, it is now in the Prado, Madrid.

[Millar 1958; Springell 1963, 129–31; Pennington 1982; Woods-Marsden 1988, introduction & chapter 1; Anzelewsky 1991, 154–6; Warnke 1998; Manuth 2001; Ex. Cat. Vienna 2003, 226–8; Zitzlsperger 2008, 14–21; Winner 2009, 202; Eser 2011; Hirschfelder 2012, 114f.; Haskell et al. 2013, 146, 158–60; Grebe 2013, 77–80]

### 9.6  *Mounted Warrior in Armour.* Pen with watercolour. 1498. W 176, S D 1495/48

Inscription above:

   This is what the armour was like at this time in Germany

The date 1498 below, though with AD's authentic monogram, may not be in his hand. AD clearly valued and kept the watercolour drawing so that it passed into the Imhoff

collection. He treated it as a preparatory drawing for his engraving *Knight, Death and Devil* (1513). An associated watercolour drawing (W 177, S D 1495/49) shows three tournament helmets. Strauss I, 356, argues for a date of 1495.

### 9.7 *Sketch of a Coat of Arms for the Twin Portraits of Hans and Felicitas Tucher, née Rieter*. **A 60–62. Oils on wooden panel. 1499**

On the back of the panel of Hans Tucher.

A black topknot. Silver ring in ear

The back of the panel with Hans Tucher's portrait has the combined arms of the Tucher and Rieter families (A 1991, vol. 2, plate 59), the earliest of AD's many painted and woodcut coats of arms (see Neubecker 1971). These colour indications may be instructions for an assistant deputed to paint the arms. The Tucher shield has the image of a 'Moor'. The word *czopf*, modern German *Zopf*, means 'pigtail, plait, bunched hair', whereas the black man has tight curls. AD may use the word humorously for a hair type extremely unusual in Nuremberg circa 1500. See the late sketch of two beer mugs with a rather comic sketch of the Moor from the Tucher coat of arms, which is still the emblem of the Tucher brewery in Nuremberg (S D 1526/23). AD's fine portrait drawing of an African, dated 1508 (W 431, S D 1508/24) is one of the earliest images of a black man in European art. Rupprich's dating of the coat of arms as likewise 1507/8 (I, 206) is corrected in III, 443. However, his reference to Tucher's wife as 'Frau Elsbeth' confuses these twin portraits with those of Hans's brother Nikolaus and his wife Elsbeth Pusch. The portraits of Hans and Felicitas were looted by American troops from the bunker at Schloss Schwarzburg in 1945 and bought by a New York collector for $500, but they have since been returned to Weimar.

[Anzelewsky 1991, 164–6; Ex. Cat. Vienna 2003, 386; Wolf 2010, 278; Hirschfelder 2012, 108–11 & 115. On the Tucher family see Grote 1961 and BI]

### 9.8 *Mass of the Angels*. **Pen drawing with some watercolour. Circa 1500? W 181, S D 1500/11**

Inscription in AD's hand in a panel at the foot of the drawing:

Here write down what you wish

A piece of anti-clerical satire. As angels celebrate mass, the inner thoughts of their congregation of clerics spill out into visible representation as demons, devils and caricature visions of hell. Other angels seem to be encouraging the viewer to add their own sketches on the large blank screen at the bottom of the sheet.

[Winkler I, 124f.; Koerner 2004, 142–3; Ex. Cat. Nuremberg 2012, 476 & 480]

**9.9** *St Benedict Teaching*. **Pen drawing. Before 1500. W 202, S D XW.202**

On the reverse side of the leaf, the inscription in AD's hand:

Like a Priest instructing
Ursula, Veronica, Helena, Barbara, Catharine

The names of female saints appear in a vertical list, all crossed through. The dating is uncertain. The drawing shows Benedict standing at a desk, lecturing from a book to an audience of which two nuns are visible, one writing, together with a monk or priest holding a book but not recording anything in it. The inscription does not obviously relate to or authenticate the drawing. This is one of twelve related drawings of the life of St Benedict by AD and his workshop, intended as designs for the circa thirty to forty stained-glass windows of the cloister in the Benedictine monastery of St Aegidius in Nuremberg. They were commissioned by Abbot Johann Radenecker circa 1499 and paid for by members of the patrician Tetzel family. The windows were destroyed in a fire in 1697. They incorporated Latin distiches by Jakob Locher, a friend of Celtis and author of the Latin edition of Sebastian Brant's *Narrenschiff*, some of the woodcuts of which may possibly be AD's work.

[Winkler I, 136–40; Strauss VI, 2952; Rowlands 1988, 70–72; Scholz 2009 & 2012, 137–41; Ex. Cat. Nuremberg 2012, 490–95]

# Part 2

## 1500–1505

With the year 1500, an epochal date in the conventional chronology of Western European history, we reach also the midpoint of AD's life, a coincidence of the climactic and the climacteric which, of course, was merely accidental and could only become apparent in retrospect. Yet it was probably not by chance that AD chose to paint the greatest of his self-portraits in this semi-millennial year, and it was certainly not by chance that Konrad Celtis made 1500 the first of many future 'Dürer Years' by hailing him as the reincarnation of the ancient Greek artist Apelles.

While the years up to 1500 yielded a sporadic documentary record, and major phases in his early life are more or less devoid of written evidence, in the years from 1500 to 1505 a new wealth and variety of sources open up. Nothing that AD writes about himself quite matches the unveiled self-revelation of his nude self-portrait drawing (W 267, fig. 9), but now we start to find contemporaries paying tribute to his significance within the grand vista of intellectual and cultural history which was opening up as the Middle Ages receded and the sense of living in an age of renewal emerged (16). Konrad Celtis makes AD a pivotal figure in his celebration of the semi-millennium (10). AD himself places his self-portrait of 1500 in the same metahistorical perspective (11.1). He starts to inscribe his art into the forms and formulas of antiquity (11.2, 26.3). He begins to look for a scientific basis of perspective and proportion and to preserve written records of his experimentation (12, 20). This theoretical dimension of his activity is at times explicit in what he writes on works of art (14.2). Professional and commercial documents continue to give insights into the economic realities of the artist's life (13, 18). Glimpses also open up into AD's public status in the city republic of Nuremberg (22, 25). In chronicling personal experience he reveals his inner emotions and his religious sensibility (15, 19).

The linguistic range of the documentary record also expands, as AD confronts the challenge of writing in German about technical aspects of art, and as he engages the

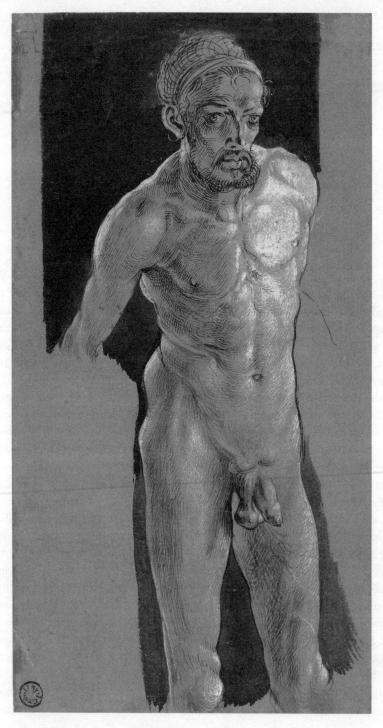

9. Albrecht Dürer, *Nude Self-Portrait*, pen and brush drawing, circa 1505.
Weimar: Schlossmuseum KK106

attention of humanist intellectuals whose written medium is Latin. As well as writing about him (in texts he most probably could not read for himself), they also help him to access key sources, like Vitruvius's work on proportion in architecture (20), and to use Latin for inscriptions on artworks of humanist pretension.

# 1500

## 10   Konrad Celtis, *Four Epigrams on Albrecht Dürer*

### 10.1   To the Painter Albrecht Dürer of Nuremberg

Albrecht, most renowned painter in German lands,
    where the city of Nuremberg lifts its head high to the stars,
As another Phidias, a second Apelles you come to us,
    and as those whom learnèd Greece admires for their educated hand.[1]
Neither Italy has seen your like, nor fickle France,[2]
    and neither will anyone ever in the lands of Spain.
You outdo the Pannonians and those whom Germany's borders
    contain, those too whom the Sarmatian shores harbour.[3]
I pray you may attend to drawing our Philosophy;[4]
    she will confer on you all knowledge in the world.

### 10.2   On the Same Albrecht Dürer

Who will now wonder at a looking glass, who at clear water,
    and at whatever, having been polished, can reflect limbs,
When Albrecht paints such human bodies with his art
    that I should think them alive, if they were to address words to me.[5]

### 10.3   On His Dog

So skilled with his pencil is he,[6] he so shades his drawn lines,
    Albrecht is gifted with such marvellous talent,
That no sooner had he painted his own portrait,
    fashioning an image of his face and body,
His dog runs in — and thinking his master was there alive
    lovingly welcomed him with his body and mouth.[7]

## 10.4   On the Same Albrecht

> Albertus was so mighty in Philosophy,
>> that for his great intellect he is nicknamed 'Magnus'.
> Likewise in the noble city of Nuremberg
>> Albrecht so holds sway in the art of Perspective and Painting,
> That he has well attained the transferable name of Albrecht the Great.[8]
>> God created equal the genius of each of them.

Dieter Wuttke identified the parchment manuscript of a collection of 500 Latin epigrams by Konrad Celtis, prepared by his amanuensis Johannes Rosenberger in 1500 for an intended printed edition which never materialised. The collection, *Conradi Celtis Protucii Germani Poete Laureati Libri Quinque Epigrammatum*, is in the Landesbibliothek Kassel, MS. poet. fol. 7. It contains (fol 69ᵛ–70ʳ) four epigrams on AD, reprinted from Wuttke 1967 in R III, 460–61.

NOTES

1   This is the earliest extant occurrence of what became a stock feature of AD's contemporary and posthumous reception: his identification as a modern re-embodiment of Apelles or Phidias, thus heir to the quasi-mythical artists of ancient Greece. The main source of knowledge of Greek artists and pseudo-biographical anecdotes about them was Book 35 of the *Natural History* by Pliny the Elder. The Apelles theme is picked up again by Jakob Wimpheling and Christoph Scheurl (16, 50, 57). See Kennedy 1964; Mende 1971b; McHam 2013. The motif of AD's 'learned hand' (*docta manus*) was taken up in particular by Helius Eobanus Hessus (226.1, 273.2, 299.4). The phrase had been used as early as 1250 by the sculptor Giunta Pisano in his inscription on a crucifix in San Domingo, Bologna.

2   The notion of France as *lubrica Gallia* – 'slimy, slippery', hence 'fickle, unreliable, deceitful' – may reflect German resentment at French foreign policy and military ambitions in Italy. Celtis's humanism was strongly indebted to Italy, but it also voices the German patriotism shared by others such as Agricola, Wimpheling, Pirckheimer and Hutten. It permeated the new learning and culture of the Hapsburg imperial court, where Celtis was poet laureate and became head of Maximilian I's 'college of poets and mathematicians'. (See Worstbrock 1974; Whaley 2012, 55f.)

3   Celtis superimposes Roman geography on Renaissance Europe. Pannonia covered parts of Hungary, Bohemia and the Balkans; Sarmatia included parts of Eastern Central Europe like Poland and Romania and more distant Slavic lands. 'Germany' was an ill-defined term in 1500. Celtis is aware of the ideological programme of Emperor Maximilian I which aspired to revive the high medieval power of the empire, based on the Carolingian *renovatio imperii*, the Christian renewal of Roman universal authority. The Holy Roman Empire was not a nation state, and contemporaries tended to refer to 'German lands' as a cultural and linguistic rather than a political entity. To the east their borders were overlapped by German colonial settlements in Poland, Bohemia and

Moravia, while along the Baltic coast the crusader state of the Teutonic Order was not part of the empire but a fiefdom licensed by the Roman Church. (See Lau 2010)

4   Celtis reveals one motive for his extravagant promotion of AD's artistic status. He urges him to complete his design for the woodcut title page of the *Quatuor libri amorum* (SMS 269.2, printed in 1502) – the poet's 'four loves' stand allegorically for his patriotic love of Germany. In 1500 the manuscript text was ready to be set up for printing. AD's title woodcut shows Philosophia [fig. 10], crowned, holding books of natural, moral and rational philosophy, seated on a throne inscribed on its wings with the Greek mottos, 'Above all honour God' and 'Render justice to all'. Her stole in the shape of an Egyptian obelisk bears the ascending scale of the seven liberal arts, in abbreviated Greek: Grammar, Logic, Rhetoric, Arithmetic, Geometry, Astronomy and Music. A giant wreath of lily-of-the-valley, maple, vine and oak represents the four seasons. In the corners the four winds embody the four elements and the four temperaments. The wreath bears four medallions celebrating the Chaldean priesthood, Plato, Cicero and Virgil, and Albertus Magnus, as historical teachers of wisdom. Below, a Latin distichon describes the realm of humanist philosophy: 'What moves heaven and earth, air and water, / What works in human nature and being, / And what the fiery God creates in the universe, / I, Philosophy, carry all this in my breast'.

5   *si mihi verba darent*: 'Give words' is ambiguous in Latin in much the same way as 'tell stories', and can be read both as 'address' and as 'deceive' [ASG].

6   *penicula*: 'fine brush'. See Wuttke 1967, 323, note 11. Celtis avoids the more usual *penicillus*: 'painter's brush, pencil' for metrical reasons.

7   Like the previous epigram, this one admires AD's ability to create images of *trompe l'oeil* naturalism, in the antique tradition of Apelles, Zeuxis and Parrhasios. Christoph Scheurl repeats the anecdote (50, 57). Wuttke 1967, 325, regrets that it is not possible to determine whether it was the self-portrait of 1498 or that of 1500 which seduced the dog into its display of affection. He claims that Panofsky deduced from AD's drawings of circa 1496–1504 that his 'pet dog' (*pace* Rupprich, I, 296 and III, 460) was a griffon terrier (*Affenpinscher*). Such speculation is otiose. The anecdote goes back to classical tradition. See the epigram by Nossis (early third century BC) in the Greek Anthology, IX, 604: 'This is Thaumareta's picture, and how well it captures / her elegance, her mild-eyed beauty! / If your little watch-dog saw you here, / she'd wag her tail, believing you were her mistress' (transl. Sally Purcell). Pirckheimer's library contained an edition of the Anthology (Florence 1491) in which AD drew illustrations. Leonardo da Vinci claimed to have witnessed the same canine devotion to a self-portrait of its artist master (Kemp/Walker 1989, 34).

8   See note 4. Albertus Magnus, 'the Great', theologian, philosopher and natural scientist (1193/1200–1280), appears on the title page of the *Quatuor libri amorum* as the icon of *Germanorum Sapientes*. In turning AD into a modern Albertus Magnus, Celtis is acknowledging him already in 1500 for his theoretical skill in geometry and perspective (*symmetria*) as well as for the aesthetic gift (*pictura*) which makes him a reborn Apelles.

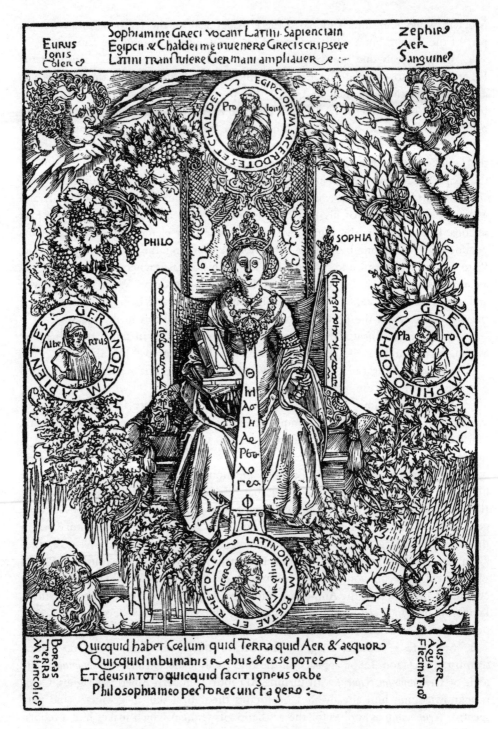

10. Albrecht Dürer, *Philosophia*, woodcut frontispiece of Konrad Celtis, *Quatuor libri amorum*, 1502

COMMENTARY

Celtis (BI) came to know AD through their mutual friend Willibald Pirckheimer. The four epigrams are extraordinary testimony to Celtis's admiration and esteem. They pay tribute both to AD's skill as a painter and to his intellect and wider cultural status. After the meagre documentation of his assimilation of the art and learning of antiquity and contemporary humanism before 1500, the epigrams and their fulsome language seem to come out of the blue. However, they are accompanied in the semi-millennial year of 1500 by similar confirmation that AD was by now an acknowledged force in the burgeoning German Renaissance. We may conclude that Celtis's friendship with and influence on him go back to the 1490s when Pirckheimer had already begun to exercise the role of AD's patron, admiring friend and guide to classical sources, amply evident in texts from now onwards.

Phoebus, Celtis claims, has appeared to him in a dream and commanded him to embody the four corners of Germany in his *Libri amorum*. The geographical points of reference are symbolised by Celtis's four loves, Hasilina of Cracow, Elsula of Nuremberg, Ursula of Mainz and Barbara of Lübeck. The erotic theme is interwoven with other schemes based on patterns of four, including the ages of man, the humours, and the points of the compass. AD's title engraving (SMS 269.2, S W 68) incorporates some of these. The first and fourth of the epigrams integrate the praise of AD into the symbolism of the *Libri amorum* and into Celtis's wider conception of himself and his fellow humanists as a new kind of post-medieval 'public intellectual' in a new age whose scholarship and culture is avowedly secular and whose roots are not in the Middle Ages but in Antiquity. The hub of their knowledge system is not theology but a Christian philosophy which encompasses science, poetry and art derived from pagan antiquity. AD is celebrated as heir and reincarnation of Apelles, whose art served not religion but the Emperor Alexander the Great, as Celtis serves Frederick III and Maximilian I (who will become AD's major patron too). AD as 'Albrecht the Great' is at the same time a reborn Albertus Magnus who had combined medieval philosophy with natural science, just as AD has begun to explore it in his study of perspective and proportion in art and in his naturalistic portraiture. So AD is enlisted by Celtis as part of an intellectual cultural progression out of a superseded Middle Age into a new dispensation, a Christian 'rebirth' of classical antiquity. Celtis's sense of the year 1500 as a symbolic transition in a metahistorical process replaces the traditional eschatological connotations of millennial dates with a sense of the dawn of a new age. He would doubtless have relished, if he could have known it, the startling fact that this year of transition, which AD entered at the age of twenty-eight, was to prove the pivotal point of his life, which ended in 1528 when he was fifty-six.

[Forster 1948; Wuttke 1967; 1980; 1985a; Rupprich 1970, especially 522–31; Worstbrock 1974; Lutz 1984; J.-D. Müller 1991, 121f.; Bätschmann/Griener 1997; Bartrum 2002, 11f., 13–22; Schauerte 2004; Price 2003, 9–19, 75–81; Ashcroft 2009; Grebe 2012; Robert 2012; Whaley 2012, 110–12; Grebe 2013, 117–20]

## II Works of Art

### II.1  *Self-Portrait*. Oil on limewood panel. A 66

Inscription to the right of the head, date and monogram to the left:

> AD 1500. Albertus Durerus Noricus ipsum me proprijs sic effingebam coloribus aetatis anno XXVIII

(I, Albrecht Dürer of Nuremberg,[1] was portraying myself[2] thus in my own enduring colours[3] at the age of twenty-eight years)

NOTES

1  The inscription differs in its calligraphy from that of the earlier self-portraits. It imitates the humanist *antiqua* script which AD may have come to know in Italy, which the scribe of Celtis's manuscript anthology of epigrams employs, and on which the *capitalis* font of Celtis's printed works is based. This is also the first of AD's paintings to have a Latin inscription. Its elegant form and formulation are doubtless owed to Celtis and Pirckheimer. He gives his name the tripartite pattern which was customary in ancient Rome, like Publius Ovidius Naso or Gaius Julius Caesar, imitated in the Latinised names of Renaissance humanists like Conradus Celtis Protucius.

2  *ipsum me ... effingebam*: the verb form is striking for four reasons. While AD often uses first-person statements in German inscriptions – for instance, *Das malt ich nach meiner gestalt* (9.5, 1498) – his Latin inscriptions are otherwise in the third person (such as *Albertus Dvrer Noricus faciebat*). Secondly, the verb *effingere* is found only in this picture and the closely related inscription 11.2, and in AD's 1519 drawing for Hans Schwarz's medallion of him (143.4 – though it was not used on the medallion itself). Thirdly, the basic verb *fingere* occurs in the third of Celtis's epigrams in the phrase *ficto ore*, the 'fashioned image' of AD's face in the self-portrait which deceives his dog into thinking it real. Pliny (*NH*. 35. 151, 153) used *fingere* in the context of sculptural 'modelling' of moulds and casts of faces (*effigies*). The fifteenth-century humanist Lorenzo de Valla (1407–57) glosses *fingere* as the skilful making of unusual, novel things, and *effingere* as the creation of figures in the imaginative or idealised likeness of someone. There it connotes an element of the creative artistic act, beyond the artisanal crafting implied in *facere*, 'make', or *pingere*, 'paint'. Pliny the Younger urges a friend (Letter I, 3.4): *Effinge aliquid et excude, quod sit perpetuo tuum!* ('Create and shape something that it may for ever be yours!' (see Baxandall 1971, 10). Fourthly, whereas in Roman, contemporary Italian, and most German artists' inscriptions in Latin, verbs appear in the third-person perfect tense (*fecit* or *pinxit*) the verb here appears in the first-person imperfect tense form: *effingebam*. This derives from a passage in Pliny's dedicatory epistle to the Emperor Titus (*NH* 1. 26f.). The greatest Greek painters and sculptors, Pliny asserts,

'used to inscribe their finished works, even the masterpieces we can never be tired of admiring, with a provisional signature such as *Apelles faciebat*, "Apelles has been at work on this", as if art were something always in flux and incomplete' (*Praefatio* 26). The imperfect verb can also be read as a modesty formula: if criticised, the work may yet be corrected. The artist sees each of his works as potentially his last, since any of them might be interrupted and left a 'work in progress' by death. AD's inscription advances his claim to be the modern Apelles and implies that his self-portrait is in a state of progression towards (an unattainable) perfection. In Greek the aorist *epóēse*, 'made', and the imperfect *epóei*, 'was (in the process of) making' were possible in this context, however the perfect *pepóēke*, 'is in the position of having made', was not. Thus both Pliny's claim about Apelles and Pirckheimer's advice to AD were strictly speaking wrong as applied to ancient Greek artists (ASG). Confirmation that Pliny's contention was accepted in the Renaissance is offered by an anecdote in the *Liber Miscellaneorum* of Angelo Politianus who tells how in 1488 he and Piero de'Medici saw a statue in the Casa Mellini in Rome with a Greek inscription, which he renders in Latin as *Seleucus rex, Lysippus faciebat*. In 1499 Michelangelo signed the figure of the Virgin in his Pietà in St Peter's with *faciebat*, the only sculpture he is known to have signed. (McHam 2013; Juřen 1974; 26.1 and 56).

3　*proprijs…coloribus*: the Latin adjective *proprius* can be read as '[my] own, special or exclusive', or as 'lasting, permanent'. Here too Apelles lies behind the phrase. Looking at the bewildering range of colours available in his own time, Pliny writes, 'one cannot but admire antiquity. The most illustrious painters, Apelles, Aëtion, Melanthios and Nikomachos, created their immortal works with just four colours' – white, yellow, red and black – 'and yet each of their creations cost the treasuries of whole cities'. AD's reduced palette marks out his picture as the self-portrait of a reborn Apelles, who can achieve with apparently modest means effects which will survive the ravages of time.

[Hess 1990; Preimesberger 1998; McHam 2013, 234–6 and Plinian Anecdote 31]

COMMENTARY

The text inscription of the self-portrait, evidently formulated for AD by Celtis, places it centrally in the celebration of the semi-millennial year 1500, which Celtis wished to mark as the secular golden year of Renaissance. It was also proclaimed a Holy Year by the Church, marking one and a half millennia since the birth of Christ, and AD's self-portrait also has an essential Christian component which is not expressed in the text of the inscription. His self-depiction, with its frontal pose, its right hand raised as if in blessing, and its Christ-like head and facial features, appears constructed and modelled according to late antique and medieval icons and images of Jesus. These were principally the *Mandylion* of Edessa (the image on a cloth which Christ pressed to his face), the *vera icon* ('true image') of the *sudarium* or sweat-cloth of the cross-bearing Christ, and the *acheiropoietos*, the image of Christ 'not made by human hands'. Willibald

Pirckheimer had in his library a text of a letter purportedly written by Publius Lentulus, Pontius Pilate's predecessor as governor of Judea, with a detailed description of the appearance of Jesus (see also 73.1). Here and in numerous other depictions AD draws on his own resemblance to received images of Christ in medieval art. His idealised self-image does not assert identity with Christ, but refers back to the Creation narrative in the Book of Genesis, where God makes man in his own 'similitude and likeness'. In the year of grace and rebirth 1500 it embodies the aspiration to restore man as the image of God and renew his spiritual conformity with Christ. On this level of the portrait's meaning, it is likely that Celtis and Pirckheimer again made essential contributions. They were mediators both of late medieval theology (in particular the writings of Nicholas Cusanus), of key Renaissance texts (Pliny the Elder's *Natural History* and Leon Battista Alberti's *De Pictura*), and of Italian ideas – expressed above all by Leonardo da Vinci – of the artist as creator, able to envision a restored, reborn humanity. AD's self-portrait looks to synthesise the Christian and the antique, to depict in the same canon of measurement and proportion Apollo, Christ, the still uncorrupted Adam, and regenerate man (73.1).

Around 1499 Leonardo da Vinci planned an oil painting of the *Saviour of the World*. Two detailed drawings of drapery survive (Zöllner/Nathan 2, cat. 40–41), together with a number of copies, including paintings and an engraving by Wenceslas Hollar (ibid. I, 250). The frontal pose, the depiction of Christ's hair, beard and dress, and his gesture of blessing raise points of comparison with AD's self-portrait in terms of their shared indebtedness to the 'image not made by human hands', especially the *Mandylion* of Edessa. In 2011–12 the National Gallery, London, included in its exhibition of paintings by Leonardo a recently cleaned version of the *Salvator Mundi*. Luke Syson in the exhibition catalogue makes a powerful case for it being the original (Ex. Cat. London 2011, 300–303). At the same time, though with no conceivable connection, it may be that AD and Leonardo were creating strikingly comparable works. AD knew Martin Schongauer's drawing of the *Benediction of the Saviour* (3.5) and himself painted an unfinished *Saviour of the World* (A 83, circa 1504/5).

[Bainton 1963/4; Wuttke 1967/1980; Baxandall 1971, 10 & 173; Anzelewsky 1983, 90–100; 1991, 166–71; Hess 1990; Koerner 1993; Bätschmann/Griener 1997, 24–7; Goldberg/Heimberg/Schawe 1998, 55–88 & 314–47; Ames-Lewis 2000, 240–42; Kopp-Schmidt 2004; Price 2003, 90–95; Nash 2008, 152–4; Zitzlsperger 2008, 63–84; Wolf 2010, 124–7 & 241–4; Schmidt 2010; Eser 2011; Smith 2012, 144–7; McHam 2013, 27, chapter 12]

## 11.2 Draft Inscription for a Self-Portrait

IMAGO · ALBERTI · DVRER · ALEMANI · QVAM · IPSE · SVIS~~MET~~ ·
EFFINXIT · MANIBUS

(Image of Albrecht Dürer the German which he created himself with his own hands)

The draft inscription is on an undated autograph page, BL Sloane 5229, fol. 51r. It is written in a calligraphy and layout characteristic of Roman monumental stone inscriptions. *Holy Family* (A 116, see 56) and *The Adoration of the Trinity* (A 118, see 64.3–5) are similarly inscribed. The antique style, the Latinised name and the use of the verb *effingere*, though here in the perfect tense, support the assumption that the inscription is a rejected draft for the 1500 self-portrait. It recurs in almost identical form in AD's draft inscription for a portrait medal dated 1519 (143.4).

# 12 Construction of a Female Figure [figs 11a, 11b]

Item: the height of the head together with the neck as far as the horizontal line of the body is one fifth part.

Item: the body without the arms comprises a rectangle two fifteenths across and one fifth long from the top of the shoulders to the flanks.

Item: take the length of the face as far as the ear and mark the same height up from the flank with a line. In the middle of this line, the length of one face from each other, will be the nipples of the breasts.

Next place the compass in each nipple and open it out to the top of the rectangle and draw a line to the middle mark.

Then change to the other nipple and draw from the other corner again to the middle mark. Thus you will have the height of the distance upwards to the neck.

Next take the breadth of the rectangle with the compass and set it at the end of the top horizontal line at the point of the long line and draw a round stroke[1] and thus it will give you how far the breast shall hang down.

Then set the compass on one thirty-second of the length and describe a curve which will give you the size of the breast.

Item: it is one sixteenth from the upper horizontal line of the body as far as the pit at the base of the breastbone.

Item: the split of the arm at the breasts shows how far from the shoulder it should be slit.

Item: the cavity at the base of the neck is on the topmost horizontal line of the body.

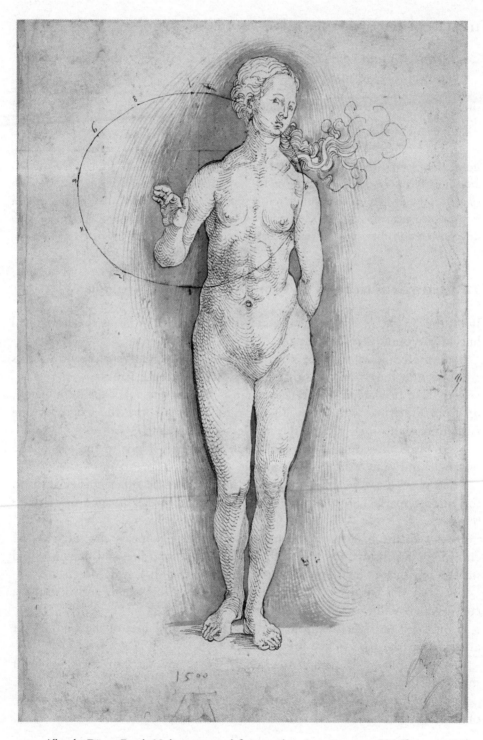

11a.  Albrecht Dürer, *Female Nude*, constructed figure and tracing, circa 1500. BM Sloane 5218[r–v]

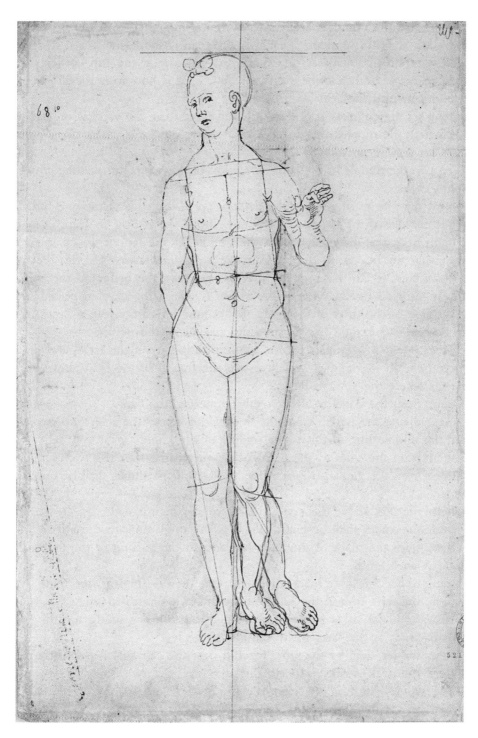

11b.  Albrecht Dürer, *Female Nude*, constructed figure and tracing circa, 1500. BM Sloane 5218<sup>r-v</sup>

Item: take the compass, set it on one tenth and place it in the neck cavity and mark at both shoulders. That is how broad it should be.

Next set the compass at one tenth and place it at the top corner of the body rectangle and describe a curve below. That is how long the flesh of the shoulder is until the arm begins.

Item: set the compass at one twelfth and place it on the vertical, on the cross line where the nipples[2] are, and describe curves outwards where the shoulders are. That is how broad they are.

Item: in the middle of the long dimension of this woman make one cross line a fifth wide.

Next draw from the line in the flank as far as the ends of the one-fifth line in the middle of the length. That is how broad she is over the hips.

Item: from the diagonal line in the middle of the length which spans the hips as far the middle of the flanks, make a diagonal stroke. On this the navel is positioned. It also takes in the division between the belly and the parts of the thighs. And just as wide as the crease is where the navel is placed, as far as the line of the sides of the body, that is how broad the roll of flesh should go beyond the straight line of the sides and all related points.

Then open the compass to one tenth, position it on the navel and draw a curve beneath it, and that will give you the length of the belly down to the breech where the genitals begin.[3]

Item: from the navel to the genitals is one eighth.

Next divide the length from the line of the hip to the soles into two parts and the middle line of this is the middle of the knee.

Item: from the soles to the end of the line on the foot is a twentieth.

Item: from the genitals to each side, the top of the thighs shall be one tenth wide.

Item: the legs above the knee shall be one sixteenth wide.

Item: the knees shall be half as thick as the thigh next to the knee.

Item: from the mark of the knee upwards to the parting of the flesh at the thigh is one eighth.

Item: under the knee mark, the outer edge of the thigh is one tenth.

Item: the foot around the knob of the ankle is one thirtieth.

Item: from the ankle to the beginning of the calf is a tenth; and the calf is a tenth as far as the knee on the inside of the leg.

Item: the leg shall be the same breadth over the calf as it is round the knee.

Item: the neck is one sixteenth thick.

The whole length is one eighth at the head.

The face to the ear is one tenth.

Divide this tenth into three parts. In the first the brow; in the second the nose; in the third the mouth and chin.⁴

Item: the head shall amount to seven and a half lengths, and the face up to the ear is nine and a half lengths.⁵

BM Sloane 5218–184, fol. 199ʳ⁻ᵛ. Dated 1500. On one side the folio leaf has a drawing of a nude woman with proportional construction lines and marks, while on the other side the figure has been traced and finished (W 411–12). The text giving instructions for constructing the figure is on another leaf of the same size, pasted together with it.

R II, 42–4

NOTES

1   AD's use of terms denoting constructional signs drawn with the ruler or the compass or freehand are not consistently differentiated. Here they are translated variously as 'line', 'stroke', 'mark' and 'curve', not systematically matched with *liny, schtrich, ryß*.

2   *dÿ dütle oder wertzl*: the diminutives are related to English 'tit(ty)' and 'wart'. The technique for producing proportioned figures was an innovation in Germany, here in its earliest stage. It required a lexis of technical and anatomical words. As also for geometrical terminology and the tools of draughtsmanship, AD had to choose words for private parts of the human body. In all spheres he overwhelmingly prefers to use a basic, demotic lexis rather than a Latin-based 'scientific' one (Müller 1993).

3   *dy pruch, do sich dy scham an hebt*: see English 'breech(es)/breek(s)'. The Germanic word denoted 'genitals and rectum' and then by metathesis the garment which covered them. AD's early female nudes do not have pubic hair and often have faintly delineated slips around the hips.

4   Here AD is citing Vitruvius's *Ten Books of Architecture* (III, 1.2).

5   However, he now corrects one tenth and one eighth to nine-and-a-half and seven-and-a-half to comply with his own drawing.

COMMENTARY

In 1523 AD described in draft dedications of his treatise on Human Proportion (182) how as a young man he had looked for informants who would teach him how to measure the human body and establish a canon of proportion and harmony. The Italian painter Jacopo de'Barbari refused to disclose his method for the 'man and woman he had constructed by means of measurement'. Unable to find other sources, ancient or modern, AD describes how he 'set to work on my own and read Vitruvius' – the *Ten Books on Architecture* (written circa 25 BC). It is possible that AD knew Jacopo already in Venice in 1494/5, but they certainly met in Nuremberg in 1500, and by then AD could also have had access via Willibald Pirckheimer to Vitruvius's work. The earliest

extant drawings and writings which document AD's long experimentation with the techniques of constructing human figures by proportional measurement bear the date 1500, though such dates on these and other drawings are often disputed and are sometimes forgeries. However, this constructed female nude and its more finished tracing on the reverse side of the same sheet, dated 1500 and with a text attached detailing their measurement, belong beyond argument among the earliest evidence of AD's quest for a theory and method of proportion. By now he was seeking to realise his belief at this stage of his work that beauty consists in the harmony of all parts of the body in relation to the whole.

What AD learned from Vitruvius, along with his study of reproductions of antique models – the Apollo Belvedere and the Medici Venus – is dramatically revealed in the engraving *Adam and Eve* of 1504 (26.1). This was the outcome of a series of drawings posed after classical models in which AD experimented with geometric and mathematical construction, based (at this stage) on the procedure established by Vitruvius. He was aiming to establish the proportions of the 'well-made body' (*homo bene figuratus*), by measurement of its component parts and devising a system of relations expressible in aliquot fractions of its total length (thus for instance the head to the base of the neck as one-fifth). For AD in the years after 1500, as for Vitruvius, this method is not a technical device, drawing by numbers, but a 'canon', an aesthetic principle and a criterion of beauty, based on the artistic realisation of the organic human form at its most perfect. It represents a crucial step in AD's artistic evolution in its commitment to naturalism and classicism. By the time he returns from Italy in 1507 and embarks on a new major phase of thinking and writing about art, he is coming to accept that an aesthetic image of a human figure cannot be delineated with compass and ruler, and that there cannot be one absolute canon of beauty (see 51).

[Panofsky 1948, 261–6; Rupprich II, 27–39; Rowland/Howe 1999; Bonnet 2001, 285–94; Ex. Cat. London 2002, 137f.; Ex. Cat. Nuremberg 2012, 501 & 502f.]

## 13  Hans Arnolt Stands Surety to Albrecht Dürer for his Brother Jakob Arnolt

*[Nuremberg, 21 August 1500]*
Hans Arnolt, painter, gave assurance that, since Albrecht Dürer has taken his brother Jakob Arnolt into his employment, to send him out with prints to be sold on his behalf, he will now and at all times guarantee and stand surety to the said Dürer for the value of the goods with which he shall at any time send him out. Thus, should Jakob Arnolt in the course of this business by his own doing cause him any loss by delay or neglect, he shall make it good and compensate the said Albrecht Dürer for such loss without let or impediment,

all by due process of existing law. Witnesses called: Heinrich Zinner and Anton Koberger. On the sixth day after St Sebaldus, 21 August 1500.

Nuremberg Stadtarchiv, Gerichtsbuch Conservarium, Bd 6, fol. 53b
  R I, 244

NOTE

The witness Heinrich Zinner was probably a relative of AD's brother-in-law Martin Zinner, whilst Anton Koberger, the book-printer and publisher, was AD's godfather.

COMMENTARY

See the contracts made in 1497 with Konrad Schweitzer and Georg Coler (7–8). It is not known whether Arnolt was an additional or a replacement salesman. In the light of experience (see 38) AD had evidently decided that a standard form of two-party contract did not adequately cover him for eventualities such as the default or death of a salesman, and he now requires a would-be employee to provide a guarantor. As in the 1497 cases, Arnolt's remit will have been to sell AD's prints at trade fairs and perhaps in Italy.

[Schultheiß 1969; Grebe 2007, 124–6]

## 1500–1501

# 14  Works of Art

### 14.1  *Drawings of Nuremberg Women Wearing Costumes Appropriate to Functions and Occasions*

They may be partly intended as model studies for workshop use.

[Winkler II, commentary; Rowlands 1988, 72; Zander-Seidel 1990, 16–18; Ex. Cat. Vienna 2003, 192–6; Rublack 2010, 126f.; Ex. Cat. Nuremberg 2012, 367 & 372]

### 14.1.1  *Woman Dressed for Church*. Pen drawing and watercolour. W 224, S D 1500/5

Inscription:

> Remember me when thou comest into thy kingdom 1500. This is how one goes to church in Nuremberg

Though this group of studies has often been treated as depictions of a kind of urban folk costume, they – especially this one – show sophisticated and luxurious dresses which

were reserved for women in the patrician and honourable classes. This woman is wearing a blue moiré silk dress with fur trim. It is probably meant to be concealed when going to church, but the woman's arm gesture reveals it, a trifle coquettishly perhaps, beneath her light-red pleated mantle which is lined with green silk. This is of conservative cut, indeed the total effect oddly combines modesty with conspicuous consumption. Her elaborate two-part head-dress was known as the *sturtz*. It consisted of a voluminous turban with a chin-strap, surmounted by a starched linen cloth, ironed into elaborate stiff folds and secured around the neck. After 1510 the city council decreed that women might be dispensed from wearing the upper head-dress. *Sturtzfrauen* is found as a term of prestige for women who possessed the privilege of wearing it.

The first line of the inscription quotes the words of the penitent evil-doer crucified together with Jesus (Luke 23:42f.). Are we meant to hear it from the lips of the woman, as evidence of her pious intention – or penitence for her sin of *luxuria*?

### 14.1.2  *Lady Dressed for a Ball*. Pen and watercolour. W 225, S D 1500/6

Inscription:

This is how Nuremberg ladies go to the ball 1500

The woman shown is a married lady dressed for the *Geschlechtertanz*, the ball in the town hall restricted to members of the closed caste of patrician families permitted to attend festive civic occasions. Her attire is a 'wing-dress', made of finest wool, with a long train and the characteristic wings or fur-lined pendant sleeves. Typical accessories are her necklace chain and the elaborate bodice clasp. The high turban head-dress with chin-strap, very like the inner half of the *sturtz*, was compulsory – prescribed by the city council. Above her brow it rises in thirteen pleats (called *vach*, like the pleats of a fan), held in place by a line of decorative studs. Earlier, in the fifteenth century, the council had permitted a stricter maximum of six *vach*. Only a lady entitled to 'wings' might be led to the dance by a gentleman; other women had to process in pairs.

### 14.1.3  *Woman Dressed for the House*. Pen and watercolour. W 226, S D 1500/3. Not dated.

Inscription:

This is how you walk around in the house

The housewife wears a long-sleeved, green dress, fur-edged at top and bottom, trimmed with velvet at the wrists, a tightly pleated apron, and a red bib covering shoulders and décolleté and with bold black-striped edging. Her hair is covered with a high, stiff net headdress. At her waist she has a draw-string bag with purse compartments and she holds

a cloth. It is not gear for domestic toil, but the understatedly expensive clothing of a *hausfrau* in the early modern sense of the word: 'lady of the house'.

### 14.1.4 *Young Lady Dressed for the Ball*. Pen and lightly applied watercolour. W. 227, S D 1500/7

Inscription:

This is how young ladies go to the ball in Nuremberg 151 [*sic!*]

The difference in the inscriptions of W 225 and 227 between *frawenn* and *Junckfrawen* is important. The unmarried patrician girl is not permitted to wear 'wings', and her hair is more informally contained in a net. However, she has a neck-chain and a bodice-clasp, as well as a dramatically cut and pleated gown with a train.

### 14.1.5 *Nuremberg Lady Dressed for Church*. Brush drawing, lightly watercoloured. W 232, S D 1500/4 [fig. 12]

Inscription:

1500 A Nuremberg lady as she goes to church

Another version of W 224, somewhat less carefully finished, so that Winkler took it to be a preliminary drawing. The same applies to W 228, another study of the lady in her house-dress, which does not have an inscription. This version of the lady dressed for church was reused, reversed, as the model for the woman at the left margin of the woodcut of the Betrothal of the Virgin in the *Life of Mary* (SMS 172).

### 14.2 *Reclining Female Nude*. Pen and brush with grey watercolour on a green ground. W 260, S D 1501/6

Inscription above with monogram and date, 1501

Dz hab ich gfisyrt

(I constructed this by measurement)

The verb *visieren* meant 'measure precisely', also 'take aim', especially using a gun-sight, 'view', using a telescope; then in artistic and architectural contexts by 1500, 'draw a design in correct proportion' (DWb XII, II, 376–8).

[Bonnet 2000, 369f., 2001, 116–20; Ex. Cat. Nuremberg 2012, 375 & 377]

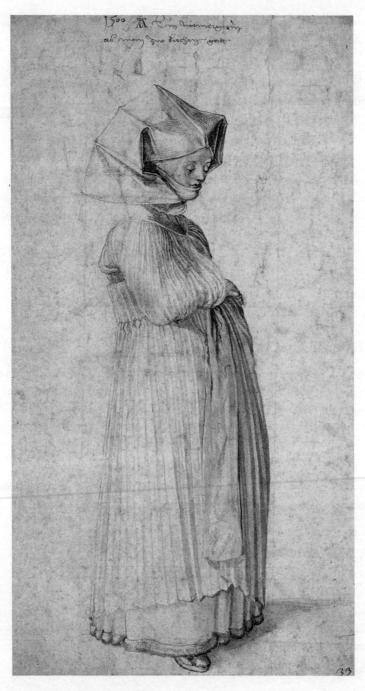

12. Albrecht Dürer. *Nuremberg Lady Dressed for Church*, brush and watercolour, 1500. BM 1895–9–15–973

**14.3** *Nemesis* or *The Large Fortuna*. **Copperplate engraving. S E 37, SMS 33. AD monogram but no date. 1501/1502**

The matriarchally corpulent winged Nemesis, standing on a sphere, is raised high above a landscape representing the village of Chiusa (Klausen) in the Valle d'Isarco (Eisack) in the South Tyrol, which AD saw on his route to or from Venice. She carries a golden chalice in her right hand; a garment, and reins and bridle, in her left. The sphere signifies uncertainty, the reins restraint on temptation. Nemesis also symbolised the transfer of Greek learning to Rome, a theme represented in Nuremberg by Willibald Pirckheimer. He is likely to have given AD access to the text which provided a stimulus for the engraving, the poem *Manto* (1482) by Angelo Poliziano:

> The goddess, raised on high and floating through the free air / her hips girdled by clouds, / wrapped in a white garment, / her head crowned by rays of light, rushes / ahead with beating wings. / She restrains unbridled hopes, / intimidates the proud; / to her it is given to set at naught / men's high-flying schemes, and to frustrate / their overweening designs…Stars shine on her brow, in her hands / she bears reins and cup.

Detailed variations apart, AD captures the spirit of the poem. His Nemesis flies on a trajectory that will take her northwards over the Alps, carrying the learning of antiquity from Italy to Germany. Unlike the normal Renaissance process of ekphrasis (Ames-Lewis 2000, chapter 9), in which a poet recreates a picture in words, AD here 'translates' a poem into visual realisation.

[Bonnet 2000, 371f., 2001, 145–54; Ex. Cat. Vienna 2003, 250f.; Ex. Cat. Nuremberg 2012, 466 & 475]

# 1502

# 15 Dürer's Personal Record: The Death of his Father

[fig. 13]

In the Family Chronicle (1) AD, writing in 1524, briefly described his father's death, drawing on this fuller account, presumably set down more immediately after the event. However, it has lost its beginning and here the context is provided again from the Chronicle:

> *[It then so happened that my father fell sick with dysentery, so bad that no-one could staunch it. And seeing death before his eyes he submitted to it most meekly, giving my mother into my care and bidding us live godly lives. He received the holy sacrament and – as I have described at greater length in another book[1] – passed away like a*

*Christian after midnight in the early hours of the Eve of St Matthew 1502, may God be gracious and merciful unto him.]*

...pleaded for. So the old wife[2] helped him up, and his nightcap had suddenly become soaked through with large beads of sweat. That is why he asked for a drink. They gave him then a little sweet Rainfel wine,[3] of which he swallowed just a sip, and asked to be laid back into bed, and thanked them. And as soon as he was in bed again, from that moment on, he entered his death throes. At once the old wife lit the death candle and recited St Bernard's verses to him, and before she had spoken the third of them, he had passed away.[4] God be merciful unto him. The young maid, once she saw the sudden change in him, ran fast to my bedroom and woke me, but before I got downstairs, he had passed on. I looked at his dead body in great distress, because I had not been deemed worthy to be present at his end.[5] It was in the night immediately before the eve of St Matthew that my father died, in the above-mentioned year. May merciful God help me too to come to a blessed end. And he left my mother a sorrowing widow, having always praised her to me as a trusty wife. That made me resolve never to abandon her. O all of you, my friends and family, when you read of my honest father's passing, I pray you for God's sake remember his soul with an Our Father and Ave Maria, also for your own souls' sake, so that, by serving God, we may inherit a life in bliss through a blessed end. For it is not possible that someone who lives well shall depart badly from this world, for God is full of mercy.[6] Through His pity may God give us after this miserable life the joy of eternal bliss through the Father, the Son and the Holy Ghost, without beginning and without end, reigning over us for ever and ever. Amen

A single leaf (31 x 21.6 cm) preserved in the Kupferstichkabinett of the State Museums, Berlin (Cim. 32). It is in a paper envelope inscribed by a sixteenth-century hand below a large AD monogram: 'The late Albrecht Dürer's own hand-written account of how his father and mother died. Also, how he drew in true clear measure and form the greatest miracle he had seen in his whole life, namely a Crucifix which fell from heaven onto a neckerchief.' Its provenance is traceable only as far back as circa 1790, when it belonged to Johann Friedrich Roth, deacon of St James's Church (*Jakobikirche*) in Nuremberg, who published it in his biography of AD. It has been in the Print Room in Berlin since 1833.

R I, 35–8

NOTES

1  Taken to refer to this 'personal record'.

2  *dy alt fraw* is ambiguous. It could refer to AD's mother, though it seems an unnatural way for him to refer to her in this situation. Compare later *mein muter*. It is quite possible however that a 'soul woman' had been engaged to sit with the sick

13.  Albrecht Dürer, autograph page from his 'Personal Record', 1502. Berlin: Kunstkabinett Cim. 32ʳ

man at night. The translation 'old wife' is meant to convey this ambiguity. *Seelfrauen* were trained also to perform deathbed rites and lay out the corpse (Hering 2001, 73–7). Here she is assisted by the household maid. It would be surprising on the other hand if Barbara Dürer were not present or at least summoned with her son.

3  Sweet Italian wine from Rivoglio in Istria, not infrequently mentioned in Nuremberg sources.

4  The 'Eight Verses of St Bernard', prayers for a blessed end to life, were a set of passages from the Psalms, a compilation attributed to the twelfth-century Cistercian St Bernard of Clairvaux. In the late Middle Ages the text was widely disseminated in Latin and German versions. In his *Praise of Folly*, Erasmus satirised the superstition which held that the verses, if recited three times, would guarantee salvation. The third of the verses reads (in Miles Coverdale's English Psalter of 1539): 'Into thy hands I commend my spirit: for thou hast redeemed me, O Lord, thou God of truth.' The family will have possessed a German prayer book, and probably the German bible printed by Anton Koberger, AD's godfather, in 1483.

5  AD shares the late medieval horror of sudden death without the requisite spiritual provisions. His sense of guilt at what he conceives as neglect of his father's salvation colours his attitude and behaviour when his mother dies (92.1).

6  The narrative of the elder Dürer's deathbed enacts the medieval Catholic theology of grace, in which the deceased's merits and good works are reinforced in their claim on salvation by the prayers of kinsfolk and the intercession of the Virgin Mary.

COMMENTARY

In the top right-hand corner the leaf is marked with what Rupprich takes to be a folio number, which can be read either as 19 or 59. Centred above the text is the letter g. The folio number is in an early sixteenth-century hand, possibly AD's. The letter g is more confidently identifiable as his script. Rupprich suggests it marks a section of a longer notebook devoted to family matters (g for *Geschlecht*). This is presumably the 'other book', to which AD refers in the Family Chronicle (1, 1524), in which he had written at greater length about his father's death. If, as Rupprich assumes, it had at least fifty-nine leaves, or even just nineteen, the loss of all but one page has deprived us of a very substantial autobiographical source.

On the surviving leaf there is a series of entries written at different times in the sequence: (recto) 'death of AD's father 1502'; (verso) 'miracle of the crosses'; 'comet' (19); 'financial losses, debt repayment, inventory of possessions 1506/1507' (38). In or after 1514, AD entered an account of his mother's death (92.1) in the free bottom margin of the recto, beneath a horizontal line, up to the word *geabsolfÿrt* ('absolved'). The account then continues in the top and right-hand margins of the verso. Dürer's hand differs in all three sections. This last addition is written in a smaller script, closer to the 1506/7 entry than to that of 1502.

Rupprich's supposition, that this is a page from a substantial 'book' of personal memoranda (the name *Gedenkbuch* is modern), is by no means unproblematic. The surviving leaf shows no signs of having been attached to or bound in with other pages. The material has evidently been compiled in chronological sequence, it is written with spacious margins and formally set out, yet the account of Barbara Dürer's death in 1513 has been crammed inelegantly into the available free space, instead of being added on a later, chronologically appropriate leaf. This suggests that by 1514 any pages subsequent to this one no longer existed, or that continuation had by now been abandoned. While the fact that the account of his father's death lacks its beginning proves that at least one previous leaf once existed, it does not follow that it was part of a much larger record of significant events in AD's life. The years between 1502 and 1507 were highly important in AD's personal and professional development, yet he notes merely rather mundane financial aspects of the visit to Venice. Evidently, the 'little notebook' (*mein schreib püchle*), which he refers to in his letter of 25 April 1506 from Venice (29.6), was not this large-format one. But if its coverage of major years was no more generous or informative than here, it is hard to see how Dürer filled the capacious space Rupprich allotted to the putative *Gedenkbuch*. The way in which accounts of some salient personal experiences co-exist in this narrative with silence on others, and with dry summary of financial and material matters, has some similarity with AD's journal of his visit to the Netherlands in 1520–21 (162). There, meticulous registration of everyday transactions is combined in great detail and at considerable length with the description of encounters with artists and other eminent people, comments on works of art, the witnessing of political events, and AD's impassioned lament on the supposed death of Martin Luther. But in that document the intention was much more clearly to construct a comprehensive chronological record. A set of much earlier Italian notebooks, the *libri di spese* of Francesco di Marco Datini, the fourteenth-century merchant of Prato, may shed light on AD's *püchle* and personal record. The *libri di spese* were essentially day-to-day records of cash expenditure, such as were also kept later, and in much higher society, by Isabella d'Este, marchioness of Mantua. But one of Datini's petty-cash books abruptly interpolates an emotional account of his joining the Bianchi, a white-robed company of 30,000 penitential pilgrims, in a juxtaposition of the financial and the emotional at least comparable with AD's record books.

[Origo 1957, 322–2 and Welch 2005, 224 & 261]

Rupprich's notion, that the *Gedenkbuch* was a sustained personal narrative, reflects a once widely held assumption that the expression of strong individuality and emotionally informed subjectivity in his drawing and painting had some direct equivalence in the writings which document his life. However, the 'Family Chronicle' has shown how strong the constraints of historically older models and stereotypes were on the written expression of emotion around 1500, and the 'journal' of 1520–21 is as much a petty cash ledger as the self-portrait of an artist. While it is unusual to find intimate descriptions of the death of loved ones in a text of such heterogeneous content, these passages

are closely modelled on a specific genre of fifteenth-century devotional literature, the *ars moriendi*, or 'art of dying'. This derived originally from manuals designed for the training of young priests, but in German translation these became also practical guides for lay-people on how to care for the dying and ease their passage into death. AD's behaviour at his father's and mother's deathbeds reflects the theology and prescriptions of these guides. Late medieval piety had a horror of sudden and lonely death, unforti-fied by the sacraments. AD follows anxiously his mother's battle to overcome pain and fear of death. He is distressed to have failed to perform the prescribed rites for his father – St Bernard's verses, St John's loving-cup – which he carries out all the more faithfully for his mother. Both death scenes are permeated with a distinctly pre-Reformation theology of redemption, based on justification through faith and works and on the merits of a godly life.

[Anzelewsky/Mielke 1984; Strieder 2000; Sahm 2002, 26–45, & 2006; Ex. Cat. Vienna 2003, 250; Kruse 2006; Schäfer 2006; Pirsig 2006; Parshall 2006; Ex. Cat. Nuremberg 2012, 262f. & 268f.]

## 16   Jakob Wimpheling, *Brief History of Germany up to the Present Day*. Chapter 68, 'On painting and clay-modelling'

Even Experience herself, who is the mistress of all things, proclaims to us that our German painters and engravers are the most outstanding of all. The engraved images by Israhel the German[1] are sought after throughout Europe and are held in highest esteem by artists. What can I say about Martin Schongauer[2] of Colmar, who was so exceptional in this craft, that his prints have been exported to Italy, Spain, Britain and other countries of the world? In the church of St Martin and St Francis in Colmar there are to be found pictures painted by his hand to which artists themselves eagerly flock to copy and imitate them, and if good artists and craftsmen are to be believed, nothing more elegant and more delightful will ever be fashioned by anyone. His pupil Albrecht Dürer, himself a German, is the most outstanding at the present time and creates in Nuremberg the most perfect engraved prints which are conveyed by merchants to Italy,[3] where they are no less esteemed by highly celebrated artists than the paintings of Parrhasius and Apelles.[4] Hans Hirtz of Strasburg[5] should also not be omitted, for during his lifetime he was held in great veneration by all painters, and his expertise is attested by the most famous and resplendent pictures he created in his native city and elsewhere. In clay modelling (by which is meant the potter's craft, which makes likenesses of the same kind

out of clay), the Germans are eminent, as is evident in their earthenware vases and numerous varieties of moulded vessels which serve the practical needs of human life. Among these are such as even Koroibos of Athens, inventor of the potter's art,[6] might have admired and commended.

Jakob Wimpheling, *Epithoma rerum Germanicorum usque ad nostra tempora* (Strasburg 1505), fol. 39[v]. Manuscript dated 1502. Latin text

R I, 290

NOTES

1    Israel von Meckenem (1440/45–1503), engraver, born in Bamberg, trained by his father (of the same name) and by the unidentified Master E. S. His works, running to some 600 engravings, are mostly copies of other artists' designs. He is best known for his double portrait engraving of himself and his wife. Wimpheling has the problem that Latin circa 1500 has no vocabulary which distinguishes between painting and engraving, and *pictor*, *pictura*, *pingere*, *tabula*, *imago* do duty for both. The translator has to make ad hoc contextual decisions as to which is meant.

2    Martin Schongauer (1435/50–1491) was famous both as painter and engraver (BI). The works which were exported across Europe were his prints. His *Madonna in the Rose Garden* in St Martin's in Colmar is the finest of his few extant paintings. AD intended to study with Schongauer during his journeyman years but arrived there only after his early death (3.5–7, 101).

3    Possibly also by AD's own salesmen (7, 8, 13).

4    The recognition of AD as the new Apelles may derive from Celtis or from Wimpheling's own knowledge of Pliny.

5    Hirtz appears in the civic records of Strasburg between 1421 and 1456.

6    Pliny *NH* 35, 146.

COMMENTARY

On Wimpheling, see BI. His *Epitome* includes surveys of the local history of Alsace and of contemporary German literature and culture. Like Celtis, Wimpheling brings a strong sense of German patriotism to his humanist scholarship, and he pioneered a German national historiography. Chapters 67–8 praise German mathematics and architecture, with particular reference to the great Gothic cathedral in Strasburg. He shows an early appreciation of the development of graphic art in later fifteenth-century Germany and of the degree to which copperplate engraving in particular was acquiring a wider European reputation. It is not impossible that he met AD in Basel around 1491–2.

[Grebe 2012, 85f., 2013, 121f.; Ex. Cat. Nuremberg 2012, 281, 288]

## 1502/1503

## 17 Works of Art

### 17.1 Konrad Celtis Presents his Four Books on Love to Emperor Maximilian I. Woodcut. 1502. S W 67, SMS 269.1

Beneath, the inscription:

QVI MALEDICIT PRINCIPI SVO MORTE MORIATUR. Ex.xxi

(He that curses his ruler shall be put to death)

The Latin text conflates Exodus 21:17, *Qui maledixerit patri suo vel matri, morte moriatur* and 22:28 *principi populi tui non maledices*.
  See 10, note 4 and commentary.

### 17.2 Designs for Stained Glass from Dürer's Workshop and two Stained-Glass Panels from the House of Sixtus Tucher. Pen and black ink on paper / stained glass. W 213–214, S D XW 213–14. Designs dated 1502

Left-hand panel: The mounted skeletal figure of Death aims his arrow at Sixtus Tucher. Latin inscription around the trefoil frame:

CAVE MISER NE MEO TE CONFIXUM TELO IN HOC TETR[ic]O COLLOCEM FERETRI LECTO

(Beware, unfortunate man, lest I pierce you with my arrow and lay you prostrate on this ugly bier)

Right-hand panel: Sixtus Tucher stands at the edge of an opened tomb, pointing into it. Behind him a cityscape of Nuremberg with the church of St Laurence. Latin inscription:

QVID MI[naris qv]OD HOC MONENTE SEPVLCHRO ECIAM SI VELIS CAVERE NEQVEO

(Why threaten me with this waiting grave, against which, even if you would allow it, I cannot defend myself)

AD's design for the left-hand panel is now in the Kestner Museum, Hanover, that for the right-hand panel in the Städelsches Institut, Frankfurt am Main. The window itself is in the GNM, Nuremberg.
  The drawings have been taken to be the work of AD's assistants, based on his designs, although Winkler argues that he played a full role in their creation and associates them

with his cycle of designs for stained-glass panels on the life of St Benedict, also from around 1500 (9.9). The text of the right-hand design has been cut off, but it is preserved, except for one phrase which can readily be reconstructed, on the glass panel itself.

Sixtus Tucher (BI) was provost of St Laurence. In 1504 he resigned his office and devoted himself to a life of seclusion and spiritual contemplation. This is echoed in the Christian stoicism with which he replies to Death in the epigrams he wrote himself for the memorial windows, which echo Horace and the twelfth-century Archipoeta. The window remained with the Tucher family until 1833. It is assumed to have been made in the workshop of Veit Hirschvogel, who was the official city glazier. AD made designs for windows from circa 1496, some of them carried out by Hirschvogel. He had spent his journeyman years in Strasburg, where he may well have seen glass designs by Peter Hemmel and his associates, leading exponents of the art in South Germany in the late fifteenth century.

[Knappe 1973, 77f.; Löffelholz 1986; Schoch and Kahsnitz, Ex. Cat. New York/Nuremberg 1986, 286–90; Schleif 1987 & 1990, 182–8; Dietz 2009; Scholz 2012, 135f., 141f.; Ex. Cat. Nuremberg 2012, 482–7; Ex. Cat. Frankfurt 2013, 282]

### 17.3   *Designs for Six Lidded Goblets.* Page of pen drawings in the Dresden Sketchbook. S D 1499/6. Circa 1502/3

Inscription in lower right-hand corner:

Tomorrow I shall do more of them

The goblets are very varied in design, combining late Gothic style with individual Italian motifs. Fine metal artefacts, especially tableware, appear occasionally among AD's sketches. See also the *Design for a Gothic cup* in the Sloane papers, BM 5218, 78. Such luxury objects were a speciality of the Nuremberg craft industry, and AD had close links with local goldsmiths, of whom his father had been one; his brother Endres was learning the craft at this time. The German Apelles was not averse to boosting his cash-flow with bread-and-butter commissions.

[Wölfflin, Drawings, 52; Rowlands 1988, 74f.]

### 17.4   *Great Table Fountain.* Pen in brown ink with red and blue watercolour marbling and traces of red chalk. W 233, S D 1499/1

An inscription with measurements and instructions on the reverse of the leaf is now pasted over but was transcribed in the BM's copy of Lippmann's catalogue. It is reproduced and translated by Rowlands 1988, 74 (here retranslated):

The plunger, which is silver and rises from the basin has the same height as the length or height of the design. [Below this, a ruled red-chalk line, circa 13.6 cm]

This is the height of the little silver men [*der silbren poslein* – see DWb II, 267f.], some higher and longer, some shorter. [Below, a similar line, circa 23.8 cm] This is the height of the water from the little figures of children. [Below, a line, circa 36.5 cm] This is the height of the water from the nude men. [Below, a line circa 47 cm] This is the height of the water from the outer men, coming out where the red stroke indicates.

The Gothic extravaganza and its complex operation appear, in the light of the inscription, to be intended for practical realisation and use. The base has armed men fighting. Water jets issue from the figures in and above the main basin, and two armed men are attached to the rim of the basin, also spouting water. It seems likely that AD did the design (*visirung*) for his father-in-law Hans Frey who was known for his fascination with mechanical table centrepieces. A further design for a less elaborate table fountain (W 946 and III, 109f., S D 1499/3) once belonged to the English neoclassical architect James Gibbs (1682–1754) and is now in the Ashmolean Museum. It has possible links with designs which AD could have found in the *Hypnerotomachia Poliphili* (1499) of which AD owned a copy perhaps bought in Venice (29.7, commentary, 331, and Eser/ Grebe, Ex. Cat. Nuremberg 2008, 37).

[Rowlands 1988, 72f., 80; Schmid 2003, 130–32; Ex. Cat. Nuremberg 2012, 477f., 481]

## 1502–1504

# 18 Household Accounts of Duke Frederick the Wise of Saxony

### 18.1 Accounts for the Period from Christmas 1501 to Reminiscere[1] 1502

2 fl. sent to Friedrich the painter's boy in Nuremberg, care of Ketzel, for his needs; on the instruction of Pfeffingen,[2] Easter Saturday.

### 18.2 Accounts for the Period from Easter to St Boniface's Day 1502

5 fl. 16 shillings. spent by Unbehau[3] on clothes for the young painter; by written instruction sent to me at the Reliquary Church[4] by my gracious Lord.

## 18.3   Accounts for the Period from the Annunciation to St Boniface's Day 1502

26 gulden paid to Unbehau which he gave to Albrecht Dürer on written instruction of my gracious Lord concerning the boy whom he is teaching at His Grace's command.[5]

5 gulden 16 s. spent by Unbehau at the written instruction of my gr. Lord, sent to me at the Reliquary Church, on clothes for the apprentice painter.

## 18.4   Accounts for the Period from St Boniface to St Luke 1502

7 fl. paid to Veit Unbehau, which he has spent, on Pfeffingen's instruction, for the apprentice painter.

3 fl. 8 s. 6 heller to Unbehau, which he has paid to Lampert, at Pfeffingen's instruction, for clothes for the apprentice painter.

3 fl. 10 gl.[6] 6 pf. paid to Hans Unbehau, who's paid it to the apprentice painter for one Sebastian, one Triumph and an Italian map.[7]

## 18.5   Accounts for the Period from St Luke's Day 1502 to Judica[8] 1503

26 fl. 20 gl. 9 pf. paid to Unbehau, which he gave, on my gr. Lord's instruction written from Würzburg, to the apprentice painter's master and to him, then dispatched him to Würzburg.

## 18.6   Accounts for the Period Judica to Trinity 1503

20 gulden to the painter's apprentice, on instruction.

## 18.7   Accounts for the Period Martinmas 1503 to Trinity 1504

101 fl. paid to Hans Unbehau, paid for a panel[9] sent here on Tuesday after Laetare,[10] being 100 fl. for the master and 1 fl. 5 gl. for the travelling case.

## 18.8   Sunday After St Laurence

Beef, pigs' trotters, roast pork, birds (1 s.), white cabbage, turnips, eggs, bread rolls. This week he has entertained four students and the painter Master Albrecht with his wife.[11]

18.1–7   R I, 244–5, on the basis of earlier printed editions.
18.8   Brück 1903, 287

NOTES

1    The second Sunday in Lent, named after the first word of the introit of the mass on that day, Psalm 25:6.

2    Degenhard von Pfeffingen, at this time chancellor to Duke Frederick, Prince Elector of Saxony. Ketzel is not identified. Nor is Frederick, the young painter, though he was seemingly of sufficient importance to merit the interest of the duke and his senior official. There is other evidence that Duke Frederick had an illegitimate son 'Fritz'.

3    Hans Unbehau was the factor who looked after Duke Frederick's affairs in Nuremberg. The money provided for the boy's clothing is generous and suggests that he was of some social standing.

4    *Heiligtumb*: the Castle Church built in Wittenberg to house Frederick's great collection of holy relics, for which the altar paintings commissioned from AD were intended.

5    AD's fee is also generous.

6    The abbreviation *gl* appears twice as the middle denomination where previously *ß* = *schilling* is used. So it does not seem to replace either *gr* = *groschen*, *pf* = *pfennige*, or *heller*. It may stand for the *guldengroschen*, a heavier silver coin in Saxony (see notes on Money, Coinage and Currency).

7    *ein Sebastian, ein tryumpff vnd ein welsche karten*: from the indefinite articles, the first two are evidently copies of woodcuts or engravings. The engraving *Sebastian at the Tree* of circa 1501 (S E 33) is possibly a workshop production, while a woodcut *Sebastian* (S W 72qq) is more probably so, produced for a large series of cuts for Nuremberg prayer books printed in 1503. It is not inconceivable that the young pupil was responsible for the latter. The other two items cannot be identified.

8    The opening word of the introit of the mass for the fifth Sunday in Lent (Psalm 43:1).

9    Assumed to be the altar panel *The Adoration of the Kings* (A 82), although there is no extant documentation that it was commissioned by Duke Frederick or belonged to him. In 1603 it was given by Prince Elector Christian II of Saxony to Emperor Rudolf II. From the imperial collection in Vienna it was sent in 1792 to Florence in exchange for Fra Bartolommeo's *Presentation in the Temple* and is now in the Uffizi.

10    The fourth Sunday in Lent, called after the first word ('Rejoice') of the psalm introit of the mass on that day.

11    Generally reckoned not to be AD and Agnes.

[Grebe 2007, 127; Ex. Cat. Nuremberg 2012, 248, 548]

**1503**

## 19   Dürer's Personal Record: Description of a Miracle

The greatest miracle I have seen in all my days happened in 1503, when crosses fell on many people, but quite particularly more on children than on other folk. Amongst all these crosses I saw one in the form I have drawn below, and this one fell on Ayrer's maid, who was sitting in the servants' quarters of Pirckheimer's house when it landed on the linen cloth of her neckerchief. She was so distressed that she wept and lamented, fearing that it meant she would die.

Also I saw a comet in the heavens.

The Berlin manuscript leaf (see 15)
   R I, 36f.

NOTE

Hans Ayrer witnessed the legal agreement over AD's estate between Agnes Dürer and her brothers-in-law in 1530 (289). The Nuremberg chronicler Heinrich Deichsler records the same incident as happening on St Walpurgis's Day, 1 May 1503, and another of the kind on 26 May. An identical 'miracle' is recorded in 1500 by Johannes Trithemius, Abbot of Sponheim, in a manuscript entitled 'On the crosses which appeared at this time on the seams of people's clothes'.

COMMENTARY

As well as AD's accounts of his father's and his mother's deaths in the personal record, other written expressions of his religious sensibility are preserved. The miracle of the crosses belongs in the context of late medieval Catholic religiosity, while texts from the 1520s arise from AD's intense concern with the early Lutheran Reformation.
   To illustrate the miracle of the crosses, he sketched in his record book a Crucifixion with the Virgin Mary and St John. The maid on whom a cross fell evidently saw it as a portent of her own death, though contemporary popular piety might have interpreted it less punitively as a moral-theological call to bear the cross in imitation of the Passion of Christ. The brief reference to seeing a comet is undated, but it can be compared with AD's woodcuts SMS 116 and 118 in the *Apocalypse* series (1496/7) and with other related works in the decade leading up to 1500. On the reverse of his panel painting of the *Penance of St Jerome* (A 14, circa 1495/7) is an apocalyptic image of a comet or falling star (A 15). It may relate to the legend that

St Jerome in the wilderness heard the trumpets of the Last Judgement, and to the medieval tradition that Jerome revealed the 'fifteen signs' of the Apocalypse, the twelfth of which was stars and planets falling from heaven. On the reverse of the *Haller Madonna* (A 43, circa 1496/8) is a depiction of Lot and his daughters fleeing the burning Sodom, and this is related in turn to the burning city on the woodcut of the Babylonian Woman (SMS 226) in the *Apocalypse*. The reverse of the *Man of Sorrows* (A 9, circa 1493/4) shows what has been interpreted either as a fiery explosion in the sky over a landscape or as a section through an agate – which AD may have regarded, following the medieval symbolic view of precious or exotic stones, as a symbol of worldly vanity.

[Anzelewsky 1971, 116–18, 122f., 140–42; Sahm 2002, 41–3; Ex. Cat. Vienna 2003, 128f., 178–81, 212–17; Wolf 2010, 232; Ex. Cat. Nuremberg 2012, 262, 269, 549f.]

## 1503/4

## 20  Vitruvius's *Ten Books on Architecture* [fig. 14]

**20.1**

The ancients made five kinds of building.[1]
  The first they called Pycnostyle.
  These buildings were as is shown below,[2] with the columns always set one and a half column widths from each other.
  The height of the column is 10 times its width.
  Pycnostyle.
  The columns stand one and a half column widths from each other.
  The second are called Systyle.
  These are buildings of the kind where the columns stand two column widths from one another, as seen below.
  The columns are nine and a half times their width.
  Systyle.
  The columns stand two column widths from each other.
  The above 2 types were seldom built, because you could not easily move around in them.
  The third, Diastyle, are the buildings shown below, in which the columns stands 3 column widths from each other.
  The columns are to be 8 and a half times their width.
  Diastyle.
  The columns stand 3 column widths from one another.

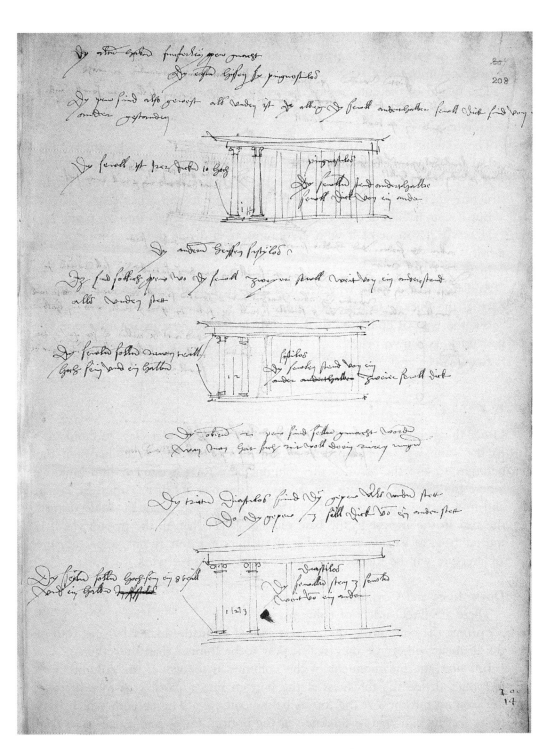

14.   Albrecht Dürer, autograph notes on Vitruvius, circa 1502–3. BL Sloane 5228–208ʳ

The fourth are called Eustyle. They were usually made as shown below. They have spaces between each pair of columns which are the width of 2 and a quarter columns.

The height of the columns of the building shall be 9 and a half times their thickness.

Eustyle.

The columns stand 2 and a quarter column widths from each other.

But the front and rear colonnades[3] are three column widths apart.

And if you design it so that there are 4 columns across the front of the structure, then divide the width of the front into 10 and a half.

But if you arrange for 6 columns, then divide the width into 19 parts.

However if you make it with 8 columns, then divide the space into 25 and a half.

In front. Behind.

And from these parts, whether it is 4, 6, or 8 parts, take one of the same parts as the thickness of the column.

But the type of building called Araeostyle should have its columns one 8th part thick, as shown below.

Araeostyle.

### 20.2

Other things must also be differentiated according to their class of building. In the same way, in proportion to the increase in the spaces between the columns, so also the bases of the columns have to increase. For in a building where the bases or columns are far away from one another…[4] must be larger, and in a narrow structure smaller, because the scale of what is visible distorts the size. In the araeostyle, the base must be larger than in the pycnostyle. It is indeed true, as Vitruvius says, that if such proportion is not respected, the architecture will be ungraceful even in newly designed work.

### Doric, Ionic and Corinthian

There are three orders of columns.

Further, the columns at the corners should be made thicker by one 50th of the diameter, otherwise they will appear to be thinner than the others.[5]

But note the measurement of the columns as follows: If the column is 15 feet high, divide the thickness at the bottom into 6 parts. 5 of these parts is the column thickness at the top, as below column a. The column which is 15 to 20 feet high, divide its thickness at the bottom into 6 and a half parts. And

5 and a half of these parts should be the column thickness at the top, as below column b.

But the column that is 20 to 30 feet high should be divided into 7 parts. 6 of these parts shall be the column thickness at the top, as below column c.

But the columns that are 30 to 40 feet high shall be divided at the bottom into 7 and 1 parts, and 6 and 1 of these should be the column thickness at the top, as below column d.

But the columns from 40 to 50 feet high should be divided at the bottom into 8 parts, and 7 of these columns [*sic!*] shall be the column thickness at the top, as below column e.

Thus whether the column is high or low, it shall be reduced by proper measurement.

The reductions of the columns are devised for the sake of attractiveness of appearance, so that the eye is not deceived and so that the work looks more graceful.

And if the column were the same thickness throughout, they would appear clumsy and awkward as you will see in some of the following columns.

*Sketches of five columns, labelled a to e, with following dimensions given:*
*a: top 5, base 6.* This column is 15 feet.
*b: top 5 1/1, base 6 1/1.* This column is 20 feet high.
*c: top 6, base 7.* This column is 30 feet.
*d:* This column is 40 feet high.
There follows the Doric column.

20.1: autograph manuscript BL Sloane 5228, fol. 208. Leaf written on both sides
20.2: autograph manuscript BL Sloane 5229, fol. 156ʳ
R II, 60–63

NOTES

1    *gpew:* Latin *aedes* could have the same generic sense as German *Gebäu(de)* but Vitruvius had in mind quite specifically the temples of Greece and Rome.

2    Sketches of temples are interspersed in the text.

3    *sewlberg:* modern German *Säulenwerk,* here referring to the double row of columns across the front of the temple.

4    The subject of the verb 'must be' is missing. Presumably 'the bases of the columns'.

5    AD does not give Vitruvius's reason for this, namely that the columns at the corners 'are sharply outlined by the unobstructed air round them, and seem to the beholder more slender than they are', just as elsewhere he clearly does not understand or does not accept Vitruvius's explanations of 'ocular deception' or perspectival distortions.

COMMENTARY

In these two texts AD provides himself with a gist translation of some basic passages from Book III of the *Ten Books on Architecture* by Marcus Vitruvius Pollio (circa 25 BC), the only surviving Roman work on architectural theory. In drafts of the dedicatory preface to his own treatise on Human Proportion, AD explains how his failure to persuade Jacopo de'Barbari to share his knowledge of the theory of proportion with him in 1500–1503, or even already in Venice in 1494–5, forced him to search for ancient and modern sources. By 1500 at the latest it is evident from architectural elements in his paintings and prints that he grasps the structural and stylistic rudiments of antique and Renaissance architecture. Three printed editions of Vitruvius's *De Architectura* were available by that date, as well as an unknown but large number of manuscripts, following its rediscovery in 1414. No copy of it is recorded in Willibald Pirckheimer's library, but it is most likely that he or some other member of Nuremberg's humanist group with scientific interests, such as Johannes Werner or Bernhard Walther, could have supplied AD with the text and given help with its reading and interpretation. One of the earliest drafts for the handbook on painting which he began to plan after his return from Venice in 1507 goes back to *De Architectura* and Vitruvius's teaching on human proportion as the basis of classical architectural form (51.1).

AD's interest in architecture as such was both practical (32, 119) and historical, as when he visits Charlemagne's palace chapel in Aachen in 1520 and recognises the Vitruvian credentials of its Carolingian-Renaissance architecture (162). The importance of *De Architectura* for AD around 1500 is quite specific. Vitruvius himself held that the symmetrical harmony of antique architecture derived from nature's design of the well-shaped human body, both of them ruled by the law of the balance of parts and whole based on the 'perfect number'. What steers AD to Vitruvius for his first textbook is not just the desire to set figures and their religious, mythological or everyday story in a classical frame and perspective, but also the ambition to draw the truly proportioned human figure out of nature into art. However, a group of fragments from the period 1503–5, then also further notes from circa 1508 and circa 1512–13, contain detailed analyses and measurements, based on Vitruvius, of classical columns, their bases and entablatures (R II, 58–73 and 354–64). In the first of AD's late printed treatises, the *Instruction on Measurement* (1523), he returned again to the construction of columns and related architectural issues, and the opening paragraph of the third book of the treatise pays a final tribute to Vitruvius as the 'best of all architects' (*Unterweisung der Messung*, G iii^v).

[Panofsky 1948, Chapter 8; Rupprich II, 27–39; Rowland/Howe 1999]

## 21 Works of Art [fig. 15]

### 21.1 *Portrait of Willibald Pirckheimer*. Head in profile, silverpoint. W 268, S D 1503/3. No date

Top right AD's initials and in line with them, crudely scrawled, the Greek inscription:

Arsenox Tē Psōlē Ez Ton Prōkton

(With erect penis into the man's anus)

The silverpoint drawing is a preparatory sketch for the charcoal portrait drawing W 270, S D 1503/4 which has the authentic date 1503, as does the similarly conceived portrait now generally accepted as Pirckheimer's wife Crescentia (W 269, S D 1503/5). Earlier commentators mostly skated over the embarrassing Greek inscription. Winkler grasps the nettle gingerly, though he offers no translation of this 'juicy piece of humanist wit'. He quotes Emil Reicke's finding that it is not a quotation from Aristophanes or some other classical Greek writer, and his assurance that its (unrevealed) content has no connection with any other evidence we have about Pirckheimer. However, Winkler does not demur at others' view that the inscription (and AD's initials) were written by Pirckheimer, even with the same silverpoint used for the drawing itself (see also SMS III, 22, note 81). Niklas Holzberg and Bodo Brinkmann connect it with 'unmistakeable hints of the homoerotic character of the relationship between Dürer and Pirckheimer', as found in AD's letters from Venice (especially 29.10) and the correspondence of Lorenz Beheim with Pirckheimer (particularly 36.6). Holzberg is in no doubt that Pirckheimer's 'practice of friendship' was indebted to 'antique models'. Wolf more specifically links this drawing with *Naked Youth and Executioner* (W 29, S D 1493/5, circa 1493) and with AD's variations on the classical model of the 'callipygous Venus'. Brinkmann suggests that Pirckheimer will have known the Lucianic dialogue *Erotes*, in which a heterosexual and a homosexual Greek discuss the 'Knidian Aphrodite' of Praxiteles, displayed in such a way that one could view it from the front or from the rear. The heterosexual Charicles points out that 'a woman may be used like a boy so that one can open up two routes to pleasure', whereas the boy offers only one. Although we need no longer be scandalised by the possibility that AD's sexual activity was not limited to the missionary position with Agnes, it remains the case that we have scant evidence of his 'practice of friendship', none of it unequivocal.

[Winkler II, 6; Rupprich 1971; Eckert/Imhoff 1971, 80–84; Holzberg 1981, 67f.; Brinkmann, Ex. Cat. Frankfurt 2007, 97–108; Schleif 2010; Wolf 2010, 156–61; Ex. Cat. Nuremberg 2012, 287 & 295]

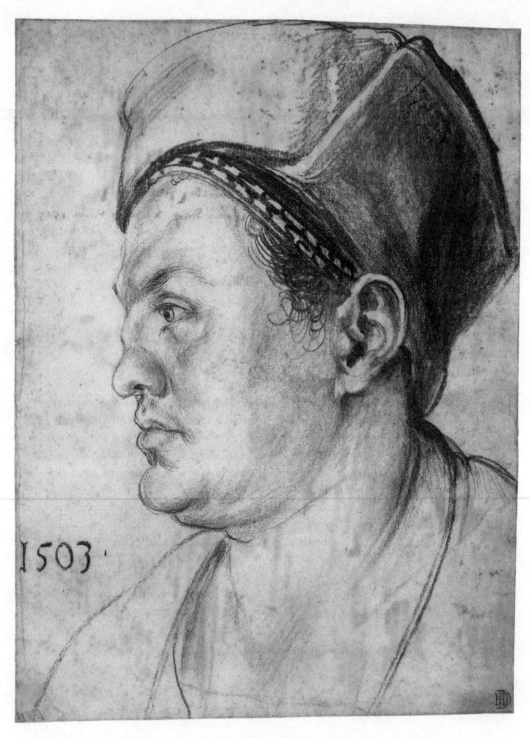

1503.

15.  Albrecht Dürer, *Willibald Pirckheimer*, chalk drawing, 1503. Berlin: Kunstkabinett KdZ 4230

### 21.2 *Bookplate for Willibald Pirckheimer.* Woodcut. S W 71, SMS 130. Circa 1503 [fig. 16]

Inscription above, in Hebrew, Greek and Latin:

The Fear of the Lord is the Beginning of Wisdom [Psalm 11:10]

Above the combined arms of the Pirckheimer and Rieter families:

SIBI ET AMICIS P[ositus]

(Dedicated to himself and his friends)

Elaborate armorial design. At the bottom, two putti fight a duel. The combination of Pirckheimer's coat of arms with that of Crescentia Rieter establishes a date before her death in 1504. Similarity of design (using antique formal idiom and showing evidence of Mantegna's influence) with AD's work for Konrad Celtis (10, commentary) and with his decoration of early printed books for Pirckheimer, speaks for a dating in or soon after 1500. Both the humanistically trilingual Psalm verse and Latin motto were beyond doubt chosen and supervised by Pirckheimer, whose portrait medal of 1517 also incorporates the main motto which Hamm (2004, 93f.) locates in the context of the 'pious humanism' of Celtis and his circle.

[On AD's heraldic designs, Glanz 2001]

### 21.3 *Head of a Suffering Man.* Charcoal on brown tinted paper. W 271, S D 1503/17. Sloane bequest, BM 5218–30

### *Head of the Dead Christ.* Charcoal on brown tinted paper. W 272, S D 1503/16. Sloane bequest, BM 5218–29

The two powerful drawings are identical in size and conception. They clearly belong together and the faded chalk inscription in AD's hand, only partially decipherable, seems to apply to both:

Die 2 [or Disz?] angsicht hab ich uch erl.../ gemacht in meiner Kranckeit

(The two faces [or: This face] I have [done?] for you during my sickness)

To relate human agony and the death agony of Christ is not an entirely unexpected conjunction. King Charles I may have owned the latter drawing, or a copy emanating from the Earl of Arundel. In one of the catalogues of the king's collections, the item is recorded as: 'upon blew paper drawen in black and white a head of Christ Crowned with thornes – thought to bee a Coppy after Alberdure very Curiously done set in a black frame...Given to yor Ma[jes]ty by yor Mats Jeweller Mr Heriott' – the goldsmith George Heriot of Edinburgh (1563–1623/4), jeweller to James I & VI and Charles I.

[Rowlands 1988, 75–8; Ex. Cat. Nuremberg 2012, 529, 532f.]

16. Albrecht Dürer, *Bookplate for Willibald Pirckheimer*, woodcut, 1503

**21.4 *Portrait of an Unidentified Youth*. Charcoal or black chalk, white highlights. W 273, S D 1503/7**

Signed and inscribed by AD and dated 1503:

This is how I look at eighteen years old

**21.5 *Portrait of Georg Fugger* (circa 1503?)**

Joachim von Sandrart (1606–88) claimed to have owned a number of AD's drawings of members of the Fugger family of merchants and bankers in Augsburg. Rupprich I, 211, note 14, citing Joseph Heller, *Das Leben und die Werke Albrecht Dürer's*, 3, p. 90, reports: 'In Joachim Sandrart's collection there was in 1679 a portrait [of Georg Fugger, who died in 1506] "drawn in life-size with black chalk", beneath which was the following distichon:

Lazarus ut Christi Galilaeus voce revixit / Alberti vivit Lazarus iste manus

(Lazarus the Galilean was recalled to life by the voice of Christ,
This Lazarus lives on by the hand of Albrecht)

In John's Gospel 11:1–45, Jesus raised Lazarus from the dead in an act which anticipates the Easter miracle. Jesus promised Lazarus's sister Martha, 'I am the resurrection and the life. He that believeth in me, yea though he were dead, yet shall he live.' The Raising of Lazarus was represented in art from the early Christian catacombs to the Renaissance and beyond.

AD produced work for the Fugger dynasty at later times: designs for sculpted panels with funerary epitaphs for the family chapel in the church of St Anna in Augsburg (61), portrait drawings of Raimund, Jakob and Anton Fugger (W 571, 915–16; S D 1525/14–16), and a portrait painting of Jakob Fugger (A 143, probably a workshop product).

**21.6 *Portrait of Hans Dürer* [?]. Silverpoint on a milky, reddish ground, white highlights. W 280, S D 1503/38 [fig. 17]**

Authentic monogram and date 1503:

This is how I look, I was [ellich] years old.
Hans Dürer.

The drawing is badly worn and much altered. The inscription is virtually illegible at the point where we expect the subject's age. If it is AD's youngest surviving brother Hans Dürer, born in 1490, he would have been thirteen in 1503, but the word that looks like *ellich* cannot be *dreizehn*. To read *etlich* ('some') makes poor sense. The face is in its basic

features quite childish, but in its present altered state is that of a young man. The beard and age-lines around the eyes are clearly additions. The puzzles seem irresolvable.

### 21.7 *Annunciation to the Virgin Mary*. **Pen with watercolours. W 291, S D 1503/20**

Dated 1503 in AD's hand:

For one pound

or

About one pound

One of seven studies for the woodcut series *The Life of Mary*. The inscription – *um* can either designate an exact price or indicate an approximate one – suggests that a connoisseur wished to buy the exquisite preparatory drawing as an artefact in its own right.

### 21.8 *The Virgin Mary Suckling the Infant Christ*. **Oils on limewood panel. A 71**

Dated 1503 in AD's hand. The painting has no inscription by AD. On the reverse of the panel is written, in German:

ISAIAH 7. Behold, a virgin shall conceive, and bear a son, and shall call his name Immanuel

The text follows exactly Martin Luther's translation, which he made in 1530 and which was first published in Wittenberg in March 1532. It is followed here by the Latin inscription:

SOLA VIRGO LACTABAT VBERE DE CELO PLENO

(The Virgin alone gave milk from a breast filled by heaven)

While the texts have been written subsequently, they register precisely the genre to which the painting belongs, that of the *Theotokos Galaktotrophousa*, the God-bearing, milk-giving Virgin, the oldest of all images of the Madonna and Child, which appears twice in the Roman Catacomb of Priscilla (early third century). AD derived his version from the later medieval tradition of the *Madonna lactans*. It shows an emotively charged, delicately conceived image of the youthful mother and a Christ Child depicted with unusual realism as a suckling baby. The intimacy of mother and child is very comparable with the engraving *Madonna on a Grassy Bank* (S E 39, SMS 36. See also the drawing *Madonna and Child*, W 290. Both are dated 1503). The picture was in the collection of

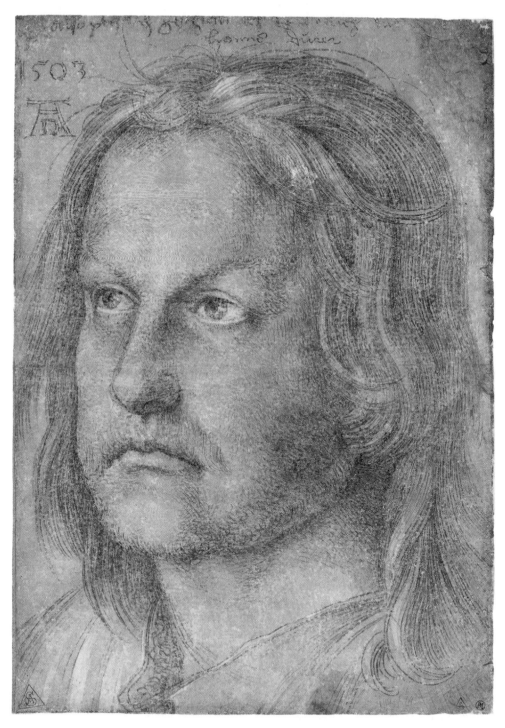

17. Albrecht Dürer, *Hans Dürer*, silverpoint drawing, 1503. Washington: National Gallery of Art, W 280

Nicolas Perrenot, Cardinal Granvella, was purchased from his descendant Francesco Perrenot, Count Cantecroy, by Emperor Rudolf II in 1600, and is now in Vienna. See also the similar provenance of *The Martyrdom of the Ten Thousand Christians* (44.1), and of *Madonna and Child with a Pear* (1512, A 120).

[Anzelewsky 1991, 177f.; Murray 1996, 288–90; Ex. Cat. Vienna 2003, 282; Wolf 2010, 245/248; Ex. Cat. Nuremberg 2012, 332; Ex. Cat. Frankfurt 2013, 248]

## 1504

## 22    Hans Harsdörfer Presents a Panel by Albrecht Dürer to King Vladislav of Hungary

Jesus 1505 Mary

Item: The gentlemen of the Finance Office[1] gave me 150 Rhenish fl. for subsistence when I was riding away.[2]

Item: They gave me at that same time 50 Hungarian fl.

Item: I received 2 Rh. fl. from the courier Paternosterer[3] in Vienna which he had left over from his subsistence.

Item: I took from young Schmidmayr[4] in Vienna for subsistence, transport costs to Hungary, and what I paid into the chancery at Budapest, [money] making altogether 267 Rh. fl.

Owing to me.

*Item for 17 days when he went to Venice, 75 Rh. fl.*[5]

Item: I was away for 104 days, less 17 days when I went off to Venice, and I spent one day living at my own expense, thus I was in my lordships' service, with my horse, for 87 days.

Item: A pretty illuminated panel, which Albrecht Dürer and his apprentice made for me, I presented to the King,[6] and His Grace received it with great delight; cost me 45 Rh. fl. Up to my lords whether they pay me something for it, given that I gave it without any instruction from them; I am not claiming for it.

Hans Harsdörfer

*Gratuities 104 new lb. for this number of days*
*For his horse 10 new lb. 8 shillings*[7]
*Note 45 fl. for tablet*

*[342 fl.]*
[On the reverse of the sheet]

*H. Harsdörfer's subsistence for Hungary.*

| fl. | new lb. | s. |
|---|---|---|
| 150 | 104 | — |
| 68 | 10 | 8 |
| 2 | — | — |
| 267 | — | — |
| 75 | — | — |
| 45 | — | — |
| 607 | 114 | 8 |

Nuremberg Staatsarchiv, Stadtrechnungsbelege, Lage 7, Bund 3 (1504)
R I, 245f.

NOTES

1   *mein herenn die loßunnger:* the Losunger were the lords of the treasury, the most powerful members of the governing council.

2   Hans Harsdörfer (died 1511), Master of the Mint in the kingdom of Bohemia. Member of the Nuremberg city council from 1501, officer in the city militia, diplomatic envoy. His mission was to persuade the king to grant the city certain villages and castles as feudal holdings.

3   Paternosterer was presumably carrying the city's mails. (His surname derives from the trade of rosary maker.)

4   Not identified, but the surname is recorded in Nuremberg.

5   Here and in the statement of account below, italics indicate passages written by a clerk.

6   King Vladislav of Bohemia and Hungary (reigned 1490–1516). What the illuminated panel was is not known

7   On the 'new pound' see notes on Money, Coinage and Currency.

COMMENTARY

The growing prestige of AD among Nuremberg's patrician class and the city authorities can be measured by Harsdörfer's decision to present a work of his as a gift to seal a diplomatic mission and by the council's endorsement of it. It is not known whether at this time there was general awareness in either Hungary or Nuremberg of AD's Hungarian roots.

## 23  Letter of Willibald Pirckheimer to Konrad Celtis

*[Nuremberg, 14 March 1504]*
Dürer sends his greeting.

PBr 1, Letter 63, pp. 206f. Latin text
  R I, 252

NOTE

Rupprich (1934, 554–6) claims that this is the only written testimony to AD's friend-
ship with Celtis, but he was writing before Wuttke rediscovered Celtis's epigrams (10).

## 24  Letter of Sebastianus Hircanus to Willibald Pirckheimer

*[Augsburg, 31 January 1504?]*
And finally, greet on my behalf all your daughters, the master creator in the
art of painting and his esteemed mother, and all your household.

PBr 2, Letter 206, pp. 331–4. Latin text
  R I, 252

NOTE

The date on the letter is ambiguous: either 1504 or 1514 (certainly before the death
of Barbara Dürer in the latter year). Sebastian Hircanus has not been identified.

COMMENTARY

From 1500 onwards, the Latin correspondence between members of the fraternity
of humanist scholars, men of letters and public affairs, becomes an ever more impor-
tant source of information about the contemporary reception of AD and his works.
Pirckheimer was a particularly prolific letter writer and his wide circle of corre-
spondents relies on him as a source of information about AD and to pass messages
to him. AD himself was undoubtedly a more active letter writer than the limited
corpus of his surviving letters suggests, though he wrote in the culturally and socially
less prestigious medium of German. For a fuller discussion of letter-writing in
Renaissance Germany, see 29, the introduction to AD's letters to Pirckheimer from
Venice in 1506.

1504–1505

## 25 Albrecht Dürer Adjudicates in a Dispute between Kaspar Geyger and Gilg Weyler

*Nuremberg, 10 July 1505*

Kaspar Geyger of Elsenutz makes this statement on his own behalf and in the name of all his heirs and relations, whose complete authorisation in this matter he claims to possess: Since Gilg Weyler, citizen of Nuremberg, took the life of the said Geyger's son, the deceased Caspar Geyger, woodturner, for which reason he, Weyler, of necessity went in fear of him [Geyger's father], his heirs and relations, and was afraid of their harsh revenge, to avoid further conflict, quarrel, and legal dispute, through the persuasion of Hans Rot, Albrecht Dürer, Sebalt Flocken, Hans Purckel, tailor, Andreas Morl, Hans Merkel and Hans Pfeilsticker, as requested conciliatory adjudicators, [the two parties] have peaceably and amicably, finally and irrevocably, reconciled their difference, also wish and intend to abide by it.

Nuremberg Stadtarchiv. Lib. Cons Bd. F, fol. 43ᵇ–44ᵃ. Goldmann 1962, 4f.
R III, 450f.

NOTE

Contrary to Rupprich, AD was in 1505 not yet a nominated member of the Great Council of Nuremberg and was thus not acting here in any public capacity but presumably as a private citizen requested by and acceptable to the conflicting parties. His fellow mediators are not members of the upper echelon of Nuremberg.

## 26 Works of Art

**26.1** *Adam and Eve*. **Copperplate engraving. S E 42, SMS 39** [figs 18a, 18b]

Latin inscription on a tablet hanging from a rowan tree top left:

ALBERTUS DVRER NORICVS FACIEBAT 1504

(Albrecht Dürer of Nuremberg was making this in 1504)

Here AD, as in the draft inscription 11.2 above, uses a monumental Latin script and, as in the 1500 self-portrait (11.1), follows the practice described in Pliny's preface to his *Natural History*, whereby the greatest Greek painters and sculptors inscribed their

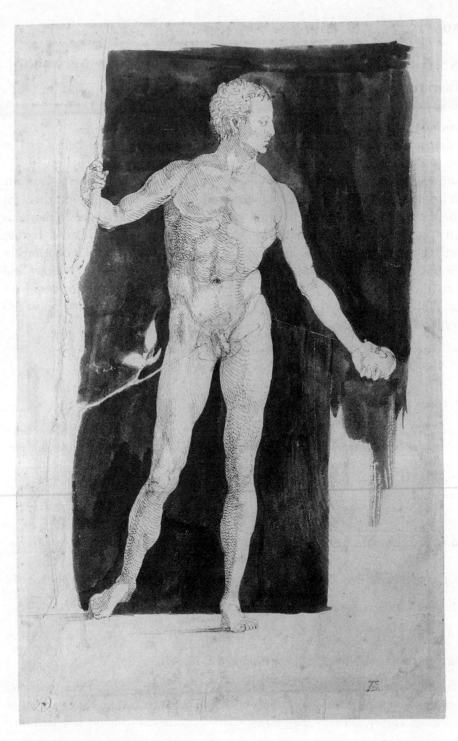

18a.  Albrecht Dürer, *Adam*, constructed drawing and tracing, 1504/5. Vienna: Albertina 3080

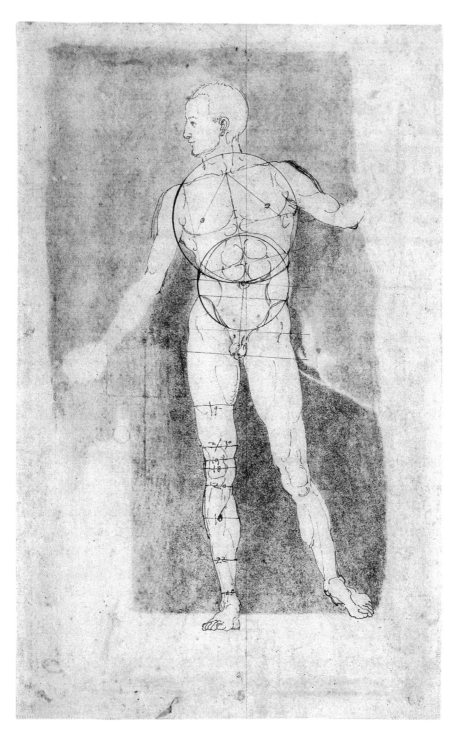

18b.  Albrecht Dürer, *Adam*, constructed drawing and tracing, 1504/5. Vienna: Albertina 3080

completed works with a 'provisional' inscription in the imperfect tense (see McHam 2013, appendix 3, 347). The process by which the engraving came about was indeed long and thorough, and the engraving turned out to be only the penultimate stage before the twin painted panels of *Adam and Eve* from 1507 (40). Adam is rehearsed in a series of drawings: W 261–4, 419–20, 421–2 (see figure 18), S D 1501/7–8, XW 263–4; 1500/36–7, 1504/11–12), part based on and successively developed from the antique Belvedere Apollo, while for Eve there is a further series, though none with a clearly identifiable classical iconographical provenance: W 265, 411–12 (see figure 11), 413–18, 423–8, S D 1500/33, 26–32, 1506/51–5). Much as AD's 1500 self-portrait combines the traditional iconography of Christ with the imitation of Apelles, so here the classical perfection of the male and female nude forms is transplanted into the Christian Garden of Eden. At the moment of their fall into sin they are unashamed of their nakedness. Adam's hand, as it reaches for the apple Eve coquettishly half hides from him, points directly to her sex, and she cannot give him the apple without uncovering her pubis, hidden not by a fig-leaf but by the leaves of the apple branch. AD here masters the art of constructing figures of perfect and frankly erotic beauty (making the centre point of Adam's body the genitals, not the navel), but what he realises in the classical ideal is the biblical pair created by God in his image. The years from 1500 to 1505 start and end with artefacts which look to synthesise the classical and the Christian traditions.

[Koerner 1993, 192–7; Bonnet 2000, 373f., 2001, 156–70; Hinz, Ex. Cat. Vienna 2003, 57–68, 254–61; SMS I, 110–13; Wolf 2010, 161; Ex. Cat. Nuremberg 2012, 373–5, 381; Smith 2012, 125–44; McHam 2013, 192f.]

### 26.2 *Death of Crescentia Pirckheimer*. **Watercolour on parchment. A 81K**

The original is lost but four copies survive, each dated 1504, and there is evidence of a fifth. The copies have Latin inscriptions in classical capitals.

Above the picture:

MVLIERI INCOMPARABILI CONIVGIQVE CARISSIMAE CRESCENTIAE MOEST[ISSIMVS] BILLIBALDVS PIRCKHEYMER, MARITVS, QUEM NVNQVAM NISI MORTE SVA TVRBAVIT, MON[VMENT]VM POSVIT

(To the incomparable woman and wife, the dearly beloved Crescentia, the deeply grieving Willibald Pirckheimer, her husband, whom she never troubled except by her death, set up this memorial)

In the middle of the picture:

MIGRAVIT EX AERVMNIS IN DOMINO XVI. K[A]L[ENDAS] JUNII. ANNO SALVTIS NOSTRAE M.D IIII [AD's monogram]

(She passed from her labours to the Lord on seventeenth May in the year of our salvation 1504)

The catalogue of AD's works compiled in 1628 for the prospective purchaser Duke Maximilian of Bavaria by Pirckheimer's descendant Hans Imhoff the Younger lists in first place 'a little tablet framed in silver and ebony by Albrecht Dürer's own hand', valued at the substantial price of 400 florins. Maximilian found that excessive, though it expressed the family's high estimation of a precious relic, and it went eventually in 1635 to an Amsterdam buyer for 150 florins. Earlier references to the work are by Goldast in 1610 and Hans Wilhelm Kress von Kressenstein in 1625. There can be little doubt as to its authenticity, which is reinforced by the existence of high-quality copies, and it is surprising that it has mostly been omitted from the Dürer canon. The depiction of Crescentia's deathbed has her surrounded by the grieving Willibald, a pair of priests and five female attendants, one a midwife. After five daughters she had borne a son, but died in labour, while the child lived only a few days. AD constructs the scene in close adherence to the traditional iconography of the scene of the Virgin's death in the apocryphal tradition of the life of Mary. AD's woodcut of the *Birth of the Virgin* in his own sequence of the *Life of Mary* may also date from 1504 and has some features in common with this work. Pirckheimer doubtless composed the Latin inscriptions himself, and they form an integral part of the composition and function of the painting.

[Eckert/Imhoff 1971, 47–9, 65, 82; Anzelewsky 1991, 185–8]

### 26.3   *Female Centaur Suckling her Young*. **Pen drawing. W 344, S D 1505/16**

Inscription top left, upside down:

Stephan Volckamer
Jörg Haller
Nikolaus Groland
Pirckheimer

All those named were prominent members of the ruling patriciate of Nuremberg. The reason for the list is unknown. The drawing, together with *Centaur Family* (W 345, S D 1505/17), is a study for the engraving *Satyr Family* (S E 43, SMS 44), dated 1505. All three derive from Lucian's ekphrasis, in his dialogue *Zeuxis*, of the latter's painting of a centaur family, to which Pirckheimer will have drawn AD's attention. The subject was popular in Italy in the 1490s, and Botticelli includes it, as a classical marble relief on the plinth of the throne of Justice, in his painting based on another ekphrasis by Lucian, *The Calumny of Apelles*, a version of which AD designed as a mural for the town hall chamber in Nuremberg in 1521–2 (168.5). The recreation of artworks of antiquity and their promotion by humanists are twin classicising themes in AD's life and art around 1500, in the years leading up to his second journey to Venice.

[Ames-Lewis 2000, 196; SMS I, 122–4]

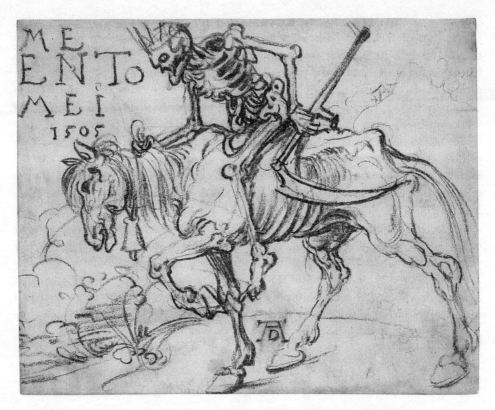

19.  Albrecht Dürer, *King Death Riding an Emaciated Horse*, charcoal drawing, 1505.
BM 1895–9–15–971

**26.4  *King Death Riding an Emaciated Horse*. Charcoal drawing. W 377,
S D 1505/24** [fig. 19]

Inscription upper left with the date 1505 in AD's hand:

  MEMENTO MEI

(Remember me)

The drawing has often been linked with the outbreak of plague in Nuremberg in
1505. The image derives from Revelation 6:8, where at the opening of the fourth seal
there appears 'a pale horse; and his name that sat on him was Death'. See also the
stained glass designs for Sixtus Tucher 17.2.

[Rowlands 1988, 81]

# Part 3

## 1505–1507

These years are dominated by AD's second visit to Italy and by the first substantial body of coherently connected texts so far encountered in the documentation of his life: the letters from Venice to Willibald Pirckheimer (29). It is unfortunate that this is only one half of a correspondence, not least because so much else of Pirckheimer's letter-writing has survived and conveys a vivid picture of his personality. At the opposite extreme from the journal of his travels in the Netherlands in 1520–21 (162), AD's account of his year in Venice may seem disappointingly lacking in the detailed documentation of an artist's day-to-day life – what pictures he saw, what he thought of them, what artists he met, what they said to each other – and too much geared to Pirckheimer – his shopping lists, his self-aggrandisement, his sexual intrigues. Yet overall it does give us a highly individual self-depiction in words, the closest equivalent in his writing to the visual images of his portraits. The frankness and licence with which he discloses himself finds expression in always graphic, sometimes virtuoso language, which will come as a revelation to those who have known the letters only in William Conway's bowdlerised Victorian version. The ten letters form such a closely geared and dynamically evolving whole that the principle of a chronological sequence of the documentary narrative is slightly relaxed here (as in other comparable instances), and minor texts are not allowed to interrupt the coherent flow of the correspondence.

Other elements in the sequence of texts from these years extend the pattern which emerged between 1500 and 1505: AD's documentation of his search for antique sources on the theoretical and technical dimensions of artistic design (33, 34), his use of text inscription to reinforce the classical credentials of paintings and engravings (31, 40), his steadily growing and widening status amongst the humanist intelligentsia (30, 36, 41–2), and his commercial acumen and financial success (37–8) [fig. 20].

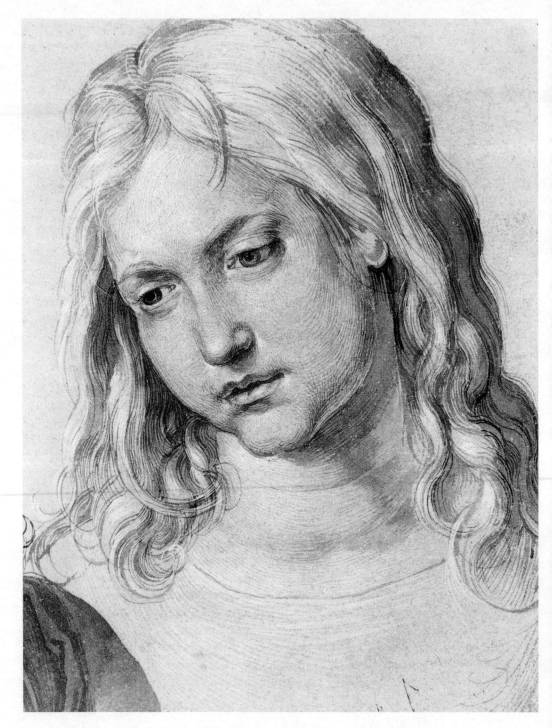

20.  Albrecht Dürer, *Head of the Twelve-Year-Old Christ*, brush drawing, 1506. Vienna: Albertina 3106

# 1505

## 27 Anecdote about Dürer's Journey to Italy

'Albrecht Dürer, having fallen ill at Stein near Laibach on his journey to Italy, was kindly taken in by a painter there, and as a grateful reminder of his stay he painted a picture on the wall of the house.'

Archive of the Counts of Attems, loose page dating from the sixteenth century. Rupprich I, 246 does not give a transcript of the text, and does not specify in what language it is written, but paraphrases it from one or both of two secondary sources: *Anzeiger für Kunde der deutschen Vorzeit*, 1864/2, Vermischte Nachrichten 25; August van Eye, *Leben und Wirken Albrecht Dürer's*, Nördlingen 1869.

### COMMENTARY

The text is clearly of dubious status and reliability and is only tentatively dated to 1505. However, in conjunction with the following drawing and its inscription (28) it acquires a measure of plausibility.

Laibach is the modern Ljubljana. In the early sixteenth century, Slovenia was the Hapsburg duchy of Krain which bordered on territories of the Venetian Republic. In 1494 AD had reached Venice via Innsbruck, the Brenner Pass and the South Tyrol, as attested by his watercolour landscapes (5.5). There is no evidence of the route he took in 1505. He probably stayed first with Konrad Fuchs in Augsburg (see 35) and may have had discussions there with the Fuggers about their chapel in the church of St Anna, and possibly about the altarpiece AD was to paint in Venice. From there it would be quite feasible for him to have travelled via Salzburg, Villach and Laibach. It is possible that en route he took in the Roman statue of a naked youth discovered in Carinthia in 1502, at that time the most significant monumental classical artefact yet found north of the Alps.

[Bushart 1994; Wolf 2010, 137f.]

## 28 Work of Art

*A Slovene Peasant Woman*. **Pen and brown ink, brown wash. W 375, S D 1505/27** [fig. 21]

AD monogram and date 1505. Inscription in AD's hand:

Vna Vilana Windisch

(A Slovene Peasant Woman)

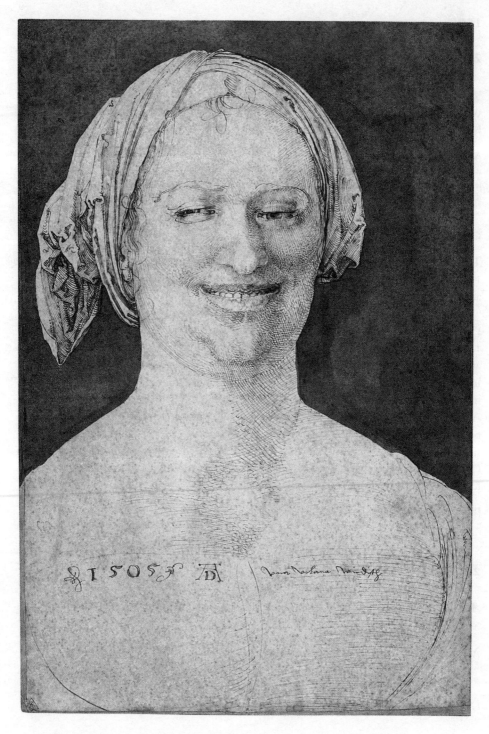

21. Albrecht Dürer, *A Slovene Peasant Woman*. Pen and wash, 1506. BM 1930–3–21–1

The finer of two such drawings; the other (W 371, S D 1505/28) lacks an inscription. AD chose to write the inscription in a mixed Italian/German, and it is possible that he met Slovenes in Venetian territory, but if he came through the duchy of Krain, he would in Laibach/Ljubljana have been only 50 km from the Windische Mark, the southern borderland between Krain and Croatia. The German terms *Winde* and *Wende* are variants of an ancient name designating Slav tribes which inhabited areas of Germanic settlement at the southernmost and northernmost ends, respectively, of the eastern borderlands between these peoples (see DWb XIV, I, 1, 1810–13 for *wendisch*; XIV, II, 309, for *windisch*). Rowlands 1988, 84, dismisses as an inferior copy a version of AD's drawing on vellum, with the same inscription, which was published by H. T. Musper in 1971.

Though utterly different in style and cultural niveau, Titian's portrait known as *La Schiavona* ('Slav woman', London, National Gallery) of circa 1510–12 offers a certain parallel. Titian was born in Cadore, a Venetian territory in the Dolomites. The title has been attached to the painting at least since it was first described in the seventeenth century.

[Winkler II, Commentary; DWb I, 1, 1746f. & DWb I, 2, 277 & 309]

## 1506

## 29  Albrecht Dürer, Ten Letters from Venice to Willibald Pirckheimer

### Introduction

What survives of AD's personal correspondence is certainly only a fraction of the letters he must have written and received. Even so, this limited corpus makes AD at least comparable with Leonardo da Vinci and Michelangelo. For major contemporaries north of the Alps like Holbein or Grünewald we have no letters at all.

The ten letters from Venice to Willibald Pirckheimer and the nine letters to Jakob Heller about the altar commissioned for the Dominican Church in Frankfurt am Main (47) were manifestly preserved by their recipients. The rest have a random provenance. Since AD kept an archive of his writings on art, it may be suspected that he also preserved at least the more significant of the letters sent to him. However, whilst the writings on art passed after his death to Pirckheimer, the collection of letters, if it existed, apparently did not. The notion that Agnes Dürer destroyed it is not proven and owes something to the demonisation of her in the earliest phase of the biographical mythologisation of AD (Schleif 1999, 2010). At all events, only five personal letters addressed to AD survive.

The provenance of three of these is untraceable. A fourth, from Johann Tschertte, answers a geometrical query and hence was filed in AD's technical archive. The fifth was written on the other side of his response to an unknown author's model draft for the dedication of the *Instruction on Measurement*, so that AD also saved this in his archive.

Two main impulses in early modern culture shape and often interact in AD's correspondence. The growth of regional and international trade networks, and the development of proto-modern forms of urban and state government and judicature all contributed to a vast expansion of written record-keeping from the middle of the fourteenth century onwards. During the fifteenth century, the German vernacular became the primary linguistic medium of this unprecedented paperwork. Texts already seen in the documentary biography have shown how family chronicle and forms of personal self-expression also emerged as by-products of these larger processes. Correspondence between merchants and their agents and partners, between the imperial, princely and civic chanceries, and on a personal level between friends or members of families, became a necessary functional mode of communication in this age of cultural change and increased travel. The earliest preserved Dürer letter, written by AD's father in 1492 (4.2), shows how business and personal concerns could overlap. In contrast, none of AD's letters to his family, from Venice or elsewhere, have been preserved. Altogether, the survival rate of letters in German written by one individual to another, whether as business or family correspondence, is extremely low at this time. Only very exceptionally do whole collections of letters survive. By the early sixteenth century, the German vernacular letter-writing tradition, particularly as a vehicle of interpersonal expression of friendship, was beginning to flourish, but it is not possible to gauge the extent or nature of AD's knowledge and practice of it before the first extant examples of his letter-writing from 1506. His evident grasp of how to address correspondents appropriately, of stock phrases for beginning and ending a letter, and of the registers and styles of formal and informal letters, could have been acquired at the writing and reckoning school or in his father's office.

The other epistolary tradition with which AD's letters connect is a very different one. Its main language is Latin, its exponents are men (occasionally also women) of culture and learning, its texts were collected in their time by recipients and still survive in impressive number. Francesco Petrarca, often seen as the founding figure of Renaissance humanism, discovered in 1345 a manuscript of Cicero's letters to his friend Atticus, which prompted Petrarch to collect and publish his own correspondence with friends as an anthology, the *Rerum familiarium libri*. The letters of Cicero (106–43 BC), and his treatise on friendship (*De Amicitia*) had already inspired imitation of classical letter-writing during earlier phases of proto-Renaissance: in the late eighth- to ninth-century Carolingian Empire and in twelfth-century medieval monastic and academic culture. In fifteenth- and sixteenth-century Germany too, Latin correspondence on the most diverse themes, personal, academic, political, literary and philosophical, became the basic genre and everyday medium of communication between 'men of letters',

whose classical learning and cultivation of the language, literature and cultural values of the ancient world, set them apart as a humanist elite. Some of the most important of them, most notably Desiderius Erasmus and Willibald Pirckheimer, figure among AD's correspondents or refer to him in their letters to each other. Over 1,300 items of Pirckheimer's and more than 3,000 of Erasmus's correspondence survive. Erasmus prepared a printed collection of his letters during his own lifetime. AD's lack of or inadequate Latin meant that he corresponded with Pirckheimer and other humanist contemporaries in German. They conceded to him, by virtue of his quality as artist and his assimilation of Renaissance style, a kind of honorary status in their exclusive sphere. His letters blend stylistic and thematic features of the demotic German and the humanist Latin letter. Thus he combines devices of the business letter – like the structuring device *item* ('next point') – with rhetorical resources like irony and inter-textual reference characteristic of the higher learning. In terms of content, he juxta-poses the trivial pursuit of bartering with Venetian hucksters for Pirckheimer's luxury shopping list and expressing his insights into the art of Giovanni Bellini.

AD's letters provide evidence of his marginal position between the honourable social estate of higher merchants and craftsmen and the closed patrician caste. He may be beginning to be acknowledged as the greatest painter and graphic artist of his age outside Italy, yet he lacks defining educational and cultural qualifications of the social and intellectual elite. This dichotomy emerges at its most acute when AD attempts to provide his two published treatises on art with dedicatory epistles in the humanist manner, whilst rejecting the Latinate rhetoric of the genre (182, 213, 257). In some measure at least his letters complement his self-portraiture in conveying his individual-ity, and in this sense they cross the line between mundane transactional and intellectual humanist discourses. AD himself, in the mottos on his late series of portrait engravings of eminent humanists (190.1 & 3; 226.1–2), seems to agree with Giovanni Pico della Mirandola's dictum 'that the difference between a portrait and a letter is that the former represents the body and the latter the mind'.

[Reicke/Scheible 1940–2009; Rupprich 1970, 542–52, 555–67; Eckert/Imhoff 1971; Möncke 1982, 231f, 305–12; 400f.; Gerlo 1983; Worstbrock 1983; Hutchison 1990; Satzinger 1991, 107–10; Smolak 1995, see Erasmus, ed. Welzig, vol. 8; Kraye 1996, 13f.; Kemp 1997, 43f.; Ex. Cat. Venice 1999; Sahm 2002, 47–60; Ashcroft 2005; Fara 2007]

Ten autograph letters are preserved, written between 6 January and mid-October 1506. Willibald Pirckheimer left them at his death to his son-in-law Hans Imhoff II. Seven of the ten (nos. 1, 3–5, 7–8, 10) are now in the Stadtbibliothek in Nuremberg (Pirckh. 394). Letter 6 was formerly in the collection of the Royal Society, London, and with letter 9 is now in the British Library. Letter 2 was in a private collection in Paris in 1969 (R III, 435).

The letters still in Nuremberg, together with letter 2, were found by Christoph Joachim, Freiherr von Haller in 1748, when alterations were being made to the Imhoff

mansion on the Egidienberg in Nuremberg, which Haller had acquired by his marriage to Anna Sibylla Sabine Imhoff. They were concealed behind a partition wall in the family chapel along with other personal manuscripts of Willibald Pirckheimer. Letter 2 was sold to a Cologne book dealer in 1861, at the same time as the remainder were sold to the city authorities. According to a note on the reverse side of letter 6, it had been given in 1624 to one Heinrich Milich. In his biography of AD (1831), Joseph Heller claims that this letter was among the large part of the library and papers purchased from Hans Hieronymus Imhoff by Thomas Howard, Earl of Arundel, in May 1636. Preserved from destruction in the English Civil War in 1642 and from the dispersal of much of the library when Arundel went into exile in the Netherlands, the letter passed to Henry Howard, Duke of Norfolk, and at the urging of John Evelyn was presented to the Royal Society in 1667, and passed to the British Museum in 1830. Letter 9 was among the archive of AD's manuscripts purchased from the Imhoffs by Amsterdam merchants around 1635. It reached the British Museum when five leather-bound volumes of these manuscripts were presented to it as part of Sir Hans Sloane's foundation bequest in 1753.

[Rupprich I, 39–40; Rowlands 1994; Sloan 2012, 169–71, 189]

## 29.1

*[Venice, 6 January 1506]*
To the honourable and learned Willibald Pirckheimer, citizen of Nuremberg, my gracious lord.

Note: I wish you and all of yours a very happy New Year.

My obedient service, my dear sir. Be assured I am well and pray God to give you much better health.

Item: as you wrote requesting me to buy a number of pearls and stones, I must tell you that I can get hold of nothing decent or worth the money, it's all been snapped up by the Germans. Those who hawk them on the Riv[1] are looking to make a regular 400 per cent profit, they're the biggest cheats alive. No one can rely on getting an honest deal from them. So several other good fellows have said I should be wary of them, they'll shit on you and everyone, there's better stuff to be bought more cheaply at Frankfurt than in Venice. And as for the books I was to order for you, the Imhoffs[2] have taken care of that.

But if you need anything else, just let me know, I shall do my utmost to fix it. And if, God willing, I could render you some great service, I would do it gladly. For I acknowledge that you do much for me. And I beg you, be patient over what I owe you, I think about it more often than you do.[3] As soon as God gets me home, I'll pay you like an honest man with all my thanks. For

I have an altar panel to paint for the Germans,[4] for which they'll give me a hundred and ten Rhenish gulden,[5] and it will cost me not even 5 fl. in outlays. In a week I shall have the white ground and rubbing down all finished.[6] Then from that moment on I shall start to paint it. Because, please God, it has to be set up on the altar a month after Easter.

I'm hoping, God willing, to put all the money by, and out of it I will pay you back, for I don't think I need to send any money for the time being either to my mother or my wife. I left my mother 10 fl. when I set out. In the meantime she will have made 9 or 10 fl. from selling prints,[7] Dratzieher[8] will have paid her 12 fl., I've sent her 9 fl. care of Sebastian Imhoff,[9] out of which she's to pay Pfinzing and Gartner[10] their 7 fl. interest. To my wife I gave 12 fl. and she took in 13 at Frankfurt, that makes 25 fl. I reckon she'll not be in any need either.[11] And even if she is short, her brother-in-law[12] will have to help her out – as soon as I come home, I'll do the decent thing and pay him back.

Herewith permit me to commend myself to you. Given[13] at Venice on Epiphany Sunday in the year 1506.

Greetings to Stephan Paumgartner[14] and other good fellows who ask after me.

<div align="right">Albrecht Dürer</div>

Autograph original in the Stadtbibliothek in Nuremberg (Pirckh. 394, 1). Single leaf, brown wax seal with the faintly discernible Dürer device of an open door within a frame, and the initials A.T.

## NOTES

1   *Riv.* The Riva degli Schiavoni, named originally after Slav traders from Dalmatia (*Schiavonia*), is the waterfront which runs eastwards from the Palazzo Ducale. Around 1500, as now, it was a busy landing place, swarming with traders keen to separate foreigners from their money.

2   AD was well acquainted with the major commercial dynasty of the Imhoffs and relied heavily on their banking and logistical services while in Venice. See Imhoff 1975.

3   Pirckheimer had advanced AD a loan to finance his stay in Venice.

4   The altarpiece known as the *Feast of the Rose Garlands* was commissioned for the church of San Bartolomeo, near the Rialto Bridge, probably by the confraternity known as the *Scuola dei Tedeschi* (or *del Rosario*), founded in 1480 by the Dominican friar Johannes of Erfurt, and devoted to the cult of the Virgin and the prayer discipline of the rosary. The confraternity had its altar in a side chapel of St Bartholomew's Church. Its membership was open to all classes of Germans in Venice, from merchants to small craftsmen and shopkeepers. The church was very close to the trading house of the German merchants, the Fondaco dei Tedeschi (in Venetian, Fontego dei Todeschi)

by the Rialto Bridge, built and administered by the Venetian authorities in order to control the activities of the foreign merchants. In 1505 it had burnt down and was being rebuilt during AD's stay in the city. The poplar-wood panel depicts the Virgin and Child distributing rose garlands (symbolising rosaries) to a crowd which ranges from Pope Julius II and Emperor Maximilian I to the German merchants and AD himself. The rosary as a devotional aid to prayer was highly popular in pre-Reformation Germany and AD's purchase of rosaries is documented in letters and in the account of his travels in the Netherlands (162). The altar panel was bought by Emperor Rudolph II in 1606 and taken to Prague (now in the Sternberg Palace section of the National Gallery).

[Humfrey 1988a–b & 1993; Schweikhart 1993; Winston-Allen 1997; Romanelli 1999; Oakes 2005; Wirtz 2005; Welch 2005, 132–3; Goy 2006; Bartilla 2006]

5  When denoting monetary values in gulden, AD fluctuates between *gulden (rein-isch)* and the abbreviation *fl.* = florin. See Money, Coinage and Currency.

6  The panel would be planed smooth, any blemishes made good with a chalk and plaster paste, and given a coat of size. The ground was gesso, a fine paste of chalk, size and hardening agents, which was then sanded and polished before painting. On AD's techniques see Luber 2005, 78–80. In Nuremberg in 1508 AD had a 'preparer' carry out this basic work, but away from home he does it himself (47.1, note 4).

7  *kunst*: Used here as AD's customary general term for his prints, which his mother and his wife were often deputed to sell at the Frankfurt trade fairs (Landau/Parshall 1994, 349) and on their market stall in Nuremberg.

8  *Trottziher*: Presumably one of the brothers Konrad and Franz Schmid, known as Drahtzieher, named after the trade of wire-drawing for producing metal wire and rod, out of which screws and bolts or small precision parts were manufactured. See AD's watercolour of the Imhoffs' wire-drawing mill (5.5.1).

9  *Bastian Im Hoff*: See note 2. Sebastian Imhoff was the family firm's representative in Venice.

10  Sebald Pfinzing III, a Nuremberg senator, and one of the three brothers Hans, Sebald or Heinrich Gartner. The debt refers to the ground rent on AD's father's house (2.4). AD redeemed the duty for 116 fl. on his return from Italy (37). Schmid 2003, 308f. claims the payment is rent on the house in the Zisselgasse (53) which, he argues, AD and Agnes had already leased since the death of Bernhard Walther.

11  This and most other references to the family's finances relate to domestic rather than commercial matters. AD left the running of his workshop in the hands of his wife (as his father did in 1492, 4.2). Oettinger 1963 suggests that his associates were able in his absence to operate with unaccustomed freedom, especially Hans Baldung Grien. But for a more sceptical view of what constituted AD's 'workshop', at least in its earlier stages, see Liebmann 1971, Grebe 2007; Ex. Cat. Nuremberg 2012, 550f.

12  Martin Zinner, husband of Agnes Dürer's sister, Katharina Frey.

13  *Tatum* for Latin *datum*, 'given', compare Modern German *Datum*, English 'date'.

14   *Steffen Pawmgartner:* patron of AD and close mutual friend of AD and Pirckheimer, mentioned in seven of these letters. He and his brother Lukas may be the figures in the foreground of the woodcut *Men's Bath House* circa 1496 (S W 31, SMS 107).

**29.2**

*[Venice, 7 February 1506]*
To the honourable and learned Willibald Pirckheimer in Nuremberg, my gracious lord.

My obedient service, dear sir. If all is well with you, I wish you so with all my heart, as much as I wish it for myself. I wrote to you recently and trust the letter will have reached you. In the meantime my mother wrote and scolded me for not writing to you and gave me to understand that you are displeased with me for not doing so. I am to make my excuses to you, and she is very upset, as she tends to be. As it is, I know of no other excuse except that I am a lazy correspondent and you have not been at home.[1] But as soon as I realised you were home again or were on your way back, I wrote to you straight away and then expressly instructed Kastulus[2] to assure you of my service. Therefore I humbly beg you to forgive me, for I have no other friend on earth save you. Nor do I believe for a moment that you can be angry with me, for I regard you as nothing other than a father to me.

I wish you were here in Venice, there are so many congenial fellows among the Italians,[3] who become more and more friendly towards me as time goes by so that it does the heart good – intelligent, well-educated, good lute-players or pipers, knowledgeable in painting and of noble spirit, true paragons, and they do me much honour and friendship. On the other hand you also find the most treacherous, lying, thieving scoundrels such as I never believed existed on earth. And if you did not know it, you would think they were the most charming people in all the world. I have to laugh at them myself, when they talk to me. They know that you know all about their villainy, but they give no hint of it. I have a lot of good friends among the Italians who warn me not to eat and drink with their painters. And many of them are hostile to me and copy my stuff[4] in churches or wherever they can get hold of it. Even so they criticise it and say it's not *all'antico*[5] and therefore no good. But Sambelling[6] has praised me highly in the presence of many *czentillomen*.[7] He would like to have something of mine, and came to me himself and asked me to do something for him, he would pay well for it.[8] And all the people say how he's such an honest man, that I feel immediately well-disposed towards him. He is very old yet still the best at painting. And the stuff that pleased me so well eleven

years ago[9] doesn't please me at all now. And if I didn't see it for myself, I wouldn't have believed it if others had told me. And I can tell you that there are much better painters here than Master Jacopo[10] is cracked up to be where you are. But Anton Kolb[11] swears an oath that there's no better painter alive on earth than Jacopo. The others laugh at him and say if he were any good, he'd have stayed here et cetera. And just today I have started to sketch my altarpiece.[12] For my hands have been so chapped and scabby that I wasn't able to work. But I've managed to get rid of that. So be kind to me and don't get cross. Be meek and gentle like me. But you don't want to take lessons from me, I haven't a clue what it's all about.

Dear friend, I'd love to know whether any of your lady-friends has died,[13] for instance one right next to the water, or perhaps this rosy one or this bristly one, or this doggy lassie[14] – so that you need another one in her place.[15]

Given at Venice at nine o'clock at night, on Sunday after Candlemas 1506. Tell Stephan Paumgartner, Hans Harsdörffer[16] and Volckamer[17] I am their servant

Albrecht Dürer

Location of the original not known to Rupprich. It was photographed when sold in 1861, and copies of the photograph are in the Stadtbibliothek in Nuremberg (Pirckh. 394, 2). A facsimile was published by Lempertz (1862).

NOTES

1   Pirckheimer had fled Nuremberg with other members of the ruling council to take refuge from the plague in Nördlingen.

2   *Kastell*: Kastulus Fugger (died 1539): member of the Nuremberg branch of the great Augsburg banking dynasty who were leading figures in the Fondaco dei Tedeschi.

3   *Walhen*: see 5.5.6. The word originally denoted Celtic speakers. In early modern German it became a derogatory term for Italians. On negative attitudes of Italians towards Germans and on Pirckheimer's animus against Italians, see Amelung 1964, 24, 65; Eser 2000.

4   *mein ding*: 'my things' is AD's informal, perhaps ironically disparaging way of referring to his artworks, especially his prints. The sale of these in Italy had led to copying and imitation of them, sometimes on altar panels. Vasari (*Vite*, 1550/67) claims that AD went to Venice expressly to take legal action against Marcantonio Raimondi for forging his work and his monogram. On the Italian reception and imitation of AD's art, see Schultheiß 1971; Schweikhart 1978; Mészáros 1983; Quednan 1983; Schoch 2002; Pon 2004; Witcombe 2004, 81–6; Vogt 2008, 45f., 92, and letter 5, note 6.

5   *antigisch art*: one of the very earliest occurrences in German of *antikisch*, 'antique' or 'classical'. In his letter of 19 March 1507 to Pirckheimer, Lorenz Beheim refers to

a drawing he has requested from AD which is to have *quandam antiquitatem*, 'something of the antique' about it (36.6). The oldest German citation according to DWb I, 500 is from Johann Fischart's translation of François Rabelais' *Gargantua* (1575). FnhdWb lists AD as its earliest occurrence. My translation assumes that AD's phrase is a loan translation from Italian *all'antico*. See Gombrich 1966. On AD's assimilation of the antique and his *maniera tedesca*, see Schweikhart 1978; Schoch 2002. On the German concept of antique as 'Italian-style', Eser 2000.

6   *Sambelling*: Giovanni Bellini (circa 1428–1516), in Venetian: *Z(u)anbelin*, later Italianised to *Giambellino* (Ferguson 2007). The anecdote about Bellini and AD's magical brush for drawing hair, in Joachim Camerarius's biographical preface to the Latin edition of AD's *Treatise on Human Proportion* (299.1), is allegedly based on conversation with AD. On reciprocal influence of the two painters and their relationship, see Robertson 1968; Mulazzani 1986; Fletcher 2004, 20, 38f.; Wilson 2004; Lucco 2004. In 1474/8 the council of Venice appointed Gentile and Giovanni Bellini to sinecures as 'brokers' in the Fondaco dei Tedeschi, in fact to be responsible for the upkeep and decoration of the building (Kemp 1997, 44). Giovanni may have had a part in the offer of a salary of 200 ducats which AD claimed to have received in return for remaining in Venice (198.1). The nineteenth-century painter Giacomo De Andrea painted circa 1865 a picture of Bellini and AD sharing a gondola (Venice, Biblioteca Corner).

7   *czentillomen*: in Venetian: *zentilomo*, pl. *zentilomini*; modern Italian: *gentiluomini*, 'gentlemen, noblemen'. AD's written versions of Venetian are aurally, thus phonetically derived. He had a command of the spoken language, but will have had little or no practice in reading or writing it.

8   It has been suggested that AD painted *Christ Among the Doctors* (1506, 31.4) for Bellini. The direct influence of Bellini on AD is evident in *Madonna with the Siskin* (1506, 31.2), which compares closely with some of Bellini's many versions of the Madonna and Child. On Venetian elements in the composition of the *Feast of the Rose Garlands*, see Wolf 2010, 146.

9   That is, in 1495. As a conjectural date for AD's first visit to Venice, it falls between the traditional date of 1494/5 and Großmann's revised date of 1496. See the commentary at the end of the letters.

10   *Meister Jacob*: Jacopo de'Barbari (circa 1440/50–1516, see BI): Venetian painter who worked for many years in Germany and the Netherlands (*dawssen*: 'outside', 'abroad'). A Venetian family identity has not been established for Jacopo, and it is not impossible that he was called *dei barbari* in Venice because he chose to work among 'the [transalpine] barbarians' (Hutchison 1990, 72; Rublack 2010, 128). AD and probably Pirckheimer knew him in Nuremberg in 1500–1503.

11   *Anthoni Kolb* (BI) was a leading Nuremberg merchant in the Fondaco and had published Jacopo de'Barbari's woodcut bird's-eye-view map of Venice in 1500 (Levenson 1978, 104f. & 165; Martin 1994).

12   *mein thafel…zw entwerffen*: the 'panel' is the *Feast of the Rose Garlands*. His hands may have suffered from the manual labour of preparing the panel or from the winter

cold. The 'sketching' he is now able to begin may refer to either or both the underdrawing on the panel itself or the extensive series of preparatory drawings in black and/or grey ink with white highlights on blue Venetian paper (W 380–401, see fig. 20).

13   In the outbreak of plague (see note 1).

14   *madle*: dialect diminutive form of *meit*, from *maget*: 'maid(en)', 'girl'.

15   The rough drawings of a rose, a brush and a dog interpolated in the text of the letter are clearly rebuses, pictures which give clues to names. The rose is taken to mean Agnes Rosenthal, documented circa 1506; the brush indicates Anna Porst (as in *Borste/Bürste*: 'bristle' and 'brush'), a sister of Lorenz Beheim (30, note 2). Pirckheimer's wife Crescentia had died in 1504. AD – presumably licensed by what Pirckheimer wrote to him – connives in stylising him as rake or merry widower.

16   Hans Harsdörfer (died 1511) was a Nuremberg patrician (see 22 and BI).

17   Stephan Volckamer (died 1517): member of a patrician family, city councillor from 1493 to 1517 (BI).

## 29.3

*[Venice, 28 February 1506]*
To the honourable and learned Willibald Pirckheimer in Nuremberg, my gracious lord.

My obedient service, my dear sir. If all is well with you, that's a great joy to me. Be assured that by God's grace all is well with me too, and I'm working at a great pace. But I don't believe I can finish before Whitsun.

Also I've sold all my little panels except one.[1] Two I let go for 24 ducats,[2] and the other three I exchanged for the three rings, these were valued for the swap at 24 ducats. But I let good colleagues see them, and they say they're worth 22 ducats. And when you commissioned me to buy some jewels, I thought I'd send you the rings via Franz Imhoff.[3] Let people at home who know about these things have a look at them. If they are happy with them, have them valued and see what they're worth. Keep them on the basis of that price. But if it's the case that you don't need them any more, just send them back by the next courier. Because someone here in Venice,[4] who helped me when I exchanged them, is willing to give me twelve ducats for the emerald and ten ducats for the ruby and diamond, which means I needn't lose more than two ducats on the deal.

I wish it were convenient for you to be here. I know you would have an entertaining time, because there are many congenial people around, men of true art and learning,[5] and there's such a throng of Italians around me that there are times when I have to hide from them, and the *czentillamen*[6] wish me well but very few of the painters.

Dear sir, Andreas Kunhofer[7] sends his respects to you. He will write to you by the very next courier. Allow me herewith likewise to commend myself to you and I commend my mother to you also. I am amazed she has not written to me for so long, the same with my wife. I begin to think I have lost them.[8] It's also a surprise that you don't write to me. But still, I have read the letter you've written about me to Sebastian Imhoff. I request you further to give the two enclosed letters to my mother, and beg you to have patience until God helps me get home, then I will faithfully repay you et cetera. Greetings to Stephan Paumgartner and other good comrades, and let me know if any of your dear ones has died et cetera. Read this letter for its sense, not its style, I wrote in haste. Given at Venice on the Saturday before White Sunday[9] 1506.

Tomorrow is a good day to go to confession.

<div style="text-align: right">Albrecht Dürer</div>

Autograph original in the Stadtbibliothek in Nuremberg (Pirckh. 394, 5). Single leaf, brown wax seal

## NOTES

1   AD took six small panel paintings with him to Venice to help defray his costs.

2   A Venetian ducat was worth approximately one-third more than the Rhenish gulden. See Money, Coinage and Currency.

3   *Francz Im Hoff* (BI): resident in Venice at this time along with his cousins Sebastian and Andreas. Welch 2005, 262–70, shows that 'mail-order' shopping in Venice for prestigious clients was common and often involved sending valuable items long distances on approval for buyers to see.

4   Presumably Bernhard Holzbock, as letter 5 suggests.

5   *recht künstner*: see my introductory notes on Translation. Not necessarily painters (*moler*) as such, but men versed in the liberal arts, the traditional branches of knowledge and accomplishment. On the significance of AD's stay in Venice for his evolving conception of art and the artist, see Roeck 1999 (*Kunstpatronage*).

6   Presumably the Italian gentlemen came to watch AD painting.

7   *Endres Kunhoffer* (BI): mathematician and astronomer who was studying in Padua. He later became secretary in the papal chancery.

8   AD fears they may have been victims of the plague.

9   Also known as Low Sunday, the first Sunday in Lent. AD's calendar is consistently based on the Church's saints' days, feasts and observances.

## 29.4

*Venice, 8 March 1506*
To the honourable and learned Willibald Pirckheimer in Nuremberg, my gracious lord.

My obedient service, my dear sir. I am sending you here a ring with a sapphire which you wrote and asked me for urgently. I was not able to track it down sooner, though I spent two entire days with a trusty assistant, whom I paid for his services, going round all the goldsmiths in the whole of Venice, German and Italian, doing a *parungan*[1] without finding one equal to what you want and at such a price. It was only by special pleading that I bought this ring for eighteen ducats and four marcelli,[2] from someone who was wearing it on his own finger and gave it to me as a favour, after I had led him to understand that I wanted it for myself. And as soon as I had bought it, a German goldsmith offered me three ducats profit when he saw me with it. And that leads me to hope that it will please you. Because every one says the stone is a real find, worth fifty fl. in Germany. However you will find out whether they are lying or telling the truth. I know nothing about it. Earlier on I bought an amethyst, from a good friend as I thought, for twelve ducats, but he'd swindled me, because it was not worth seven. But some good fellows intervened, with the result that I gave him the stone back and stood him a meal at a fish restaurant. That was me happy, and I soon got my money back. And when good friends valued the ring, the stone came out at not much higher than nineteen Rhenish fl., because the gold setting weighs roughly five fl., so that after all I haven't overstepped your mark, since you write: 'from fifteen fl. up to twenty fl.' However I haven't been able to buy any of the other stones, because you rarely find them all together at one time. But I shall keep searching hard. They say that in Germany you find such shoddy trinkets much cheaper, especially now at the Frankfurt Fair, than you do in Italy. They take all that sort of stuff abroad with them. And especially with the little jacinth cross, they laughed in my face when I mentioned two ducats. So write to me soon, how I am to go about it. I've found a place where there's a good diamond cluster, I don't know yet for how much. That I'll buy for you until I have further instructions. For emeralds are as dear as anything I've ever seen in all my life. You can very easily get hold of a little amethyst, so long as you consider it's worth twenty or twenty-five ducats et cetera.

I'm quite persuaded you've taken a wife. Watch out that you don't land yourself with a master.[3] But you're sensible enough when you need to be.

My dear Pirckheimer, Andreas Kunhofer sends you his respects. He'll write to you before long and asks you if you would vouch for him to the Council,

should it be necessary, if he does not want to stay in Padua.[4] He says the teaching there is just not at all for him et cetera.

And I beg you, don't be angry that I haven't sent you all the stones this time, because I just haven't been able to manage it.

Those in the trade[5] tell me that you should have the stone remounted on fresh foil, then it will look twice as bright, for the ring is old and the foil damaged. And I beg you, have a word with my mother, to write to me and to look after herself.

Herewith let me commend myself to you. Given at Venice on the second Sunday in Lent 1506.

My greetings to your housemates.[6]

Albrecht Dürer

Original in the Stadtbibliothek in Nuremberg (Pirckh. 394, 3). Single sheet, brown wax seal

NOTES

1   Italian *paragone*, Venetian *paragon*, 'comparison'. AD may not have had a ready German equivalent for the concept of critical comparison. *Vergleich* is not attested until the seventeenth century, and *Vergleichung* in this sense is rare in early modern German (DWb XII, 1, 448f., 458–60). In a draft from 1512 of the introduction to his planned textbook on painting, AD uses *Vergleichung* in the sense of Latin *harmonia* or *concinnitas* (R II, 121 and note p.126). The purpose of the instrument called the *Vergleicher* in the Four Books of Human Proportion is similarly that of bringing the parts of the body into a proportional relationship. AD and Pirckheimer would have been familiar with the term *paragone* in the contexts of the comparison of antique and modern painting in Renaissance theory and painting practice, and of the comparison of painting and sculpture in Leon Battista Alberti's *De Pictura* and in Leonardo da Vinci's writings (Richter 1949; Ames-Lewis 2000 chapter 6). See also Welch 2005, 123–5: 'When Venetian customers wanted to compare the best silks [offered by international traders] before making a major purchase, the relevant guild would organise a viewing known as a *paragon*...Experts from the guild would inspect and guarantee the cloth.' AD may have picked up the term in this commercial sense from the merchants of the Fondaco.

2   *marczell*: Venetian silver coin worth half a *lira* or 10, later 12 *soldi*.

3   On Crescentia Rieter's death in 1504, see 26.2. The sentence: *Schawt nun, daz jr nit ein meister über kumt*, can be read in two alternative ways. Either: *jr* is the second person plural respectful address form 'you', which AD always uses to Pirckheimer, and *ein meister* is accusative object, with grammatically deficient case ending typical of AD's colloquial German, giving the translation adopted in the text (DWb, XI, II, 345, *überkommen*, A 3) – in modern idiom, a wife who wears the trousers. Or: *jr* is the

dative form of the feminine singular personal pronoun referring back to *weib*, 'wife' (but using natural gender – *weib* is a neuter noun), and *ein meister* is the nominative subject. This gives the sense: 'Watch out that a master [craftsman?] does not get his hands on her' (DWb, XI, II, 349, *überkommen*, B 2). In his letters AD teasingly attributes to Pirckheimer the role of merry widower and may be implying that taking a new wife might clip his wings. However, in letters 9–10 AD develops the theme of mock sexual rivalry with Pirckheimer, apparently in response to the latter's threat to give his, AD's, wife 'a good flushing out'. *Ein meister* could denote AD as 'master' of his craft, and AD's mildly lewd joke here could be the trigger for Pirckheimer's more drastic mock threat in the later letters.

4  *Badaw*: see letter 3, note 7. Kunhofer had a scholarship from the Nuremberg authorities for his university study in Padua. His ancestor Konrad Kunhofer had set up three such bursaries in 1445.

5  *dÿ gesellen*: senses of the term *Geselle* in early modern German are: 'friend', 'fellow', 'comrade', 'colleague' and, more technically, 'journeyman', 'trained member of a craftsman's workshop'.

6  *ewer gesind*: the sense is ambiguous. In an urban domestic context, which seems appropriate in the case of Pirckheimer, *gesinde* as collective noun most readily denotes 'servants' (of both sexes) or 'household' in general (DWb IV, I, 2, 4111–13). Compare the letters from Lorenz Beheim to Pirckheimer (155, 157): *Saluta tuos domesticos*, where the Latin word has a broader sense than modern English 'domestics' (servants), and *Saluta et filias tuas…atque generos tuos*, where Beheim is sending his regards to the family members of Pirckheimer's household. AD may however be using this conventional greeting formula to refer back to his speculation about Pirckheimer taking a wife (note 3). The joke is taken up again in letter 8: *Grüst mir…vnser hüpsch gesind*, where the adjective 'pretty' strengthens the case for interpreting *gesind* as 'ménage', 'house-mates', or (making the implication more blatant) 'harem'.

## 29.5

*[Venice, 2 April 1506]*

To the honourable and learned Willibald Pirckheimer in Nuremberg, my dear gracious lord.

My obedient service, dear sir. On Thursday before Palm Sunday I received a letter from you and the emerald ring, and straight away I went to the man who sold it to me. He's prepared to give me my money back, though not very willingly. But he'd given his promise and so must keep to it. And I can tell you for a fact that the *soylir* [1] buy emeralds abroad and import them to make a profit. But those in the trade [2] have told me that the other two rings [3] are worth a good six ducats each. For they say they are pretty and unflawed, with

no impurities, and they say you should pay no heed to the valuers, but just ask to see what rings they'd like to sell you. Then put them side by side to see whether they are like one another. And as soon as I had swapped the ring for my money back, and lost two ducats on the deal with the three rings, Bernhard Holzbock,[4] who'd been present at the exchange, wished he had bought them off me. Since then I have sent you a sapphire ring via Hans Imhoff.[5] I imagine it will have reached you. I reckon I made a good buy with this one, because I was immediately offered a profit on it. But I'll hear from you whether that's so, because you know I have no clue about such things but just have to believe the advice I'm given.

I can tell you, the painters here are really hostile towards me. Three times they hauled me before the *Signoria*[6] and I have to pay four fl. to their *schull.*[7]

I can tell you too that I might have earned a mint of money if I hadn't agreed to paint the panel for the Germans. But it takes a lot of work and I am not likely to finish it before Whitsun. And that for a fee of no more than eighty-five ducats,[8] so I can tell you, that will all go on my board and lodging. I've also bought various things, and sent sums of money home, so that I haven't much left for myself. But I'll tell you what I'm intending: I have it in mind not to leave here until God allows me to pay you back and still have a hundred gulden to spare. I would easily have earned that much if I hadn't to do the Germans' panel. Because except for the painters, all the world wishes me well.

Speak to my mother on my brother's behalf, and tell her to ask Wolgemut if he can find a use for him and give him work until I get back, or with somebody else, so that he fends for himself. I'd gladly have brought him with me to Venice. That would have been useful for me and for him, also for him to learn the language. But she was afraid the sky would fall down on him. Now I beg you look after it yourself, it's a waste of time asking the women. Talk to the lad, as you know how to do so well, so that he keeps learning and behaves himself until I come, and doesn't sponge off his mother. For I really can't do everything, though I do my best. Just looking after myself would be no problem, but feeding a whole crew is too hard for me, for money doesn't grow on trees.[9]

Herewith let me commend myself to you, and tell my mother that she should set up her stall at the Regalia Fair.[10] But I'm confident my wife will be coming home, and I've written all about it to her.

I shall not after all buy the diamond cluster[11] until I've had your next letter. I don't reckon either that I can get away before the autumn. The fee for the altar panel, which will be ready at Whitsun, will all go towards living costs, purchases and payments. But after that, what I earn, I hope to keep. But if this seems advisable to you, then don't tell anyone. I shall put it off from day to

day and keep writing regularly as though I were coming back. However I can't make up my mind. I don't know myself what to do. Write back to me very soon et cetera. Dated on Thursday before Palm Sunday 1506.

Albrecht Dürer

your servant.

Original in the Stadtbibliothek in Nuremberg (Pirckh. 394, 4). Single leaf, brown wax seal

NOTES

1  Venetian *zoieler, zoielier*, 'jeweller', from *zoia*, 'jewel', modern Italian *gioia* and *gioielliere*. German *Juwel* and *Juwelier* ('jewel, jeweller') are first attested in Cologne German around 1500, and were borrowed from French, via Middle Dutch. It seems they were unfamiliar words in AD's Nuremberg vernacular, where there was clearly not yet a retail trade in gems.

2  *dy gesellen*: see letter 4, note 5.

3  That is, the ruby and diamond rings referred to in letter 3.

4  See letter 3, note 4.

5  Cousin of Sebastian and Franz Imhoff.

6  *dy herenn*: a literal rendering of Italian *signoria*, from *signori*, 'gentlemen', using a term with which AD also on occasion refers to the Nuremberg governing council. In his *Lives of the Artists*, Vasari relates how AD himself appealed to the Signoria to prevent Marcantonio Raimondi copying his woodcuts of the *Life of Mary*, though he succeeded only in obtaining a prohibition on the use of his monogram on subsequent copies, such as that of the *Small Woodcut Passion*. (See letter 2, note 4; Quednan 1983; Pon 2004; on the issue of copyright in this period, Würtenberger 1970; Vogt 2008, 77–94)

7  *Scuola*: 'guild'. As a foreigner AD is obliged to pay dues to the monopolistic craft union.

8  The fee is equivalent to 110 Rhenish gulden.

9  Hans Dürer, the younger of AD's two surviving brothers, was sixteen years old in 1506 and in the throes of adolescence. He was the third of his parents' sons to bear this Christian name, and the seventeenth and youngest surviving of Barbara's eighteen children. Her soft spot for him is understandable. Wolgemut was the Nuremberg painter to whom AD himself had been apprenticed. Hans later trained as a painter under AD's own supervision. AD's reference to Hans's missed opportunity to 'learn the language' confirms implicitly that AD's two periods in Venice had made him competent at least in the spoken Venetian vernacular. See Mende 2004. On language teaching and learning in fifteenth- and sixteenth-century Venice, see Rossebastiano Bart 1984; Roeck 1999; Ferguson 2007, 200–203, Häberlein/Kuhn 2010.

10  *awff daz Heilthumb*: the fair held during the annual public exhibition of the imperial regalia and holy relics, which had been kept in civic custody in Nuremberg

since 1442 (Schnelbögel 1962; Machilek 1986; Schier/Schleif 2004). Barbara Dürer was to sell AD's prints at the fair, should Agnes Dürer not return in time from Frankfurt. On working women in sixteenth-century Nuremberg: Hering 2001, especially 35–51.

11 The *gutz demunt püntle* referred to in letter 4.

## 29.6

*[Venice, 25 April 1506]*

To the honourable and learned Willibald Pirckheimer in Nuremberg, my gracious lord.

My obedient service, dear sir. I am surprised that you do not write to say how you like the sapphire ring, which Hans Imhoff sent to you by the Augsburg courier Schön.[1] I don't know whether it has reached you or not. I called on Hans Imhoff and enquired; he can only assume it will have got to you. There is a letter with it which I wrote to you. Also the stone is packed in a small sealed box, exactly the size as I've sketched it here.[2] I kept a drawing of it in my notebook.[3] And it took me much pleading to get hold of it, for it is flawless and decorative, and the fellows in the trade say it's very good for the money that I gave for it. By weight it's around five Rhenish gulden. And I paid eighteen ducats and four marcelli. And if it's gone missing I would be half out of my mind. For it has been valued at getting on for twice as much as I gave for it. When I'd bought it, someone would have given me a profit on it straight off. Therefore, dear Herr Pirckheimer, ask Hans Imhoff[4] to track down the courier and discover where he's got to with the letter and the box. Note: the courier was dispatched by young Hans Imhoff on 11th March.

Herewith I commend you to God and commend my mother to you. Tell her to pack my brother off to Wolgemut so that he stops lazing around and does some work.

Ever your servant. Read this for its sense, not its style – I've got a good seven letters to write in haste, some already written. Sorry to hear about Canon Lorenz.[5] Greet him and Stephan Paumgartner from me. Dated Venice on St Mark's Day 1506.

Write back to me soon, for I shall have no peace until I hear.

Andreas Kunhofer is mortally ill, the news has just reached me.[6]

Albrecht Dürer

Original in the British Library. Single leaf, 22.7 × 21 cm. On the reverse side a letter dated 3 July 1624, written by Hans Imhoff (a descendant both of the two Hans Imhoffs referred to in the letter and of Willibald Pirckheimer)

NOTES

1   See letter 4, written on 8 March. There were frequent and efficient courier services between the major South German mercantile cities and Venice. The express courier rode from Venice to Nuremberg in as little as four days; slower, cheaper services took five or six days (Zahn 1971; Lutter 1998, 104–15. On Maximilian I's promotion of postal services: Whaley 2012, 121). As AD states a little later, Hans Imhoff despatched the package on 11 March, thus it should have reached Pirckheimer by around 17 March at the latest. [fig. 22]

2   The sketch, drawn over the top of the previous two lines of the written text, shows a round lidded box.

3   *mein schreib püchle.* AD apparently kept a running account of his stay in Venice. This is unlikely to be the same as his personal record (15) and we cannot know whether it was at all comparable with the journal of his travels in the Netherlands (162).

4   The prominent Nuremberg merchant Hans Imhoff the Elder, father of 'young Hans Imhoff' who represented the family firm in Venice.

5   Lorenz Beheim (BI) had contracted in Italy the *morbus gallicus*, or 'French disease', the contagious syphilis which ravaged Southern Europe in the 1490s, and was spread through Italy and South Germany by the imperial armies after the siege of Naples in 1495 (see Arrizabalaga et al. 1997). In late 1506, Pirckheimer sent an ointment for his sores, for which Beheim thanked him in a letter of 9 November.

6   See letters 3, 4 and 7. Kunhofer eventually recovered.

## 29.7

*[Venice, 18 August 1506]*

Grandisimo primo homo[1] de mundo. Woster serfitor,[2] ell schciavo[3] Alberto Dürer disi[4] salus suum mangnifico miser[5] Willibaldo Pircamer. My fede el aldy[6] wolentire cum grando pisir[7] woster sanita e grondo hanor.[8] El my maraweio,[9] como[10] ell possibile star vno homo cusy wu[11] contra thanto sapientissimo Tiraybuly milytes;[12] non altro modo nysy[13] vna gracia de dio.[14] Quando my leser[15] woster litera de questi strania[16] fysa de cacza[17] my habe[18] thanto pawra[19] el para my vno grando kosa.[20] But I reckon that the Scots[21] were just as afraid of you, because you can look wild and weird too at the Regalia Fair when you dance the hippity-hoppity.[22] But it doesn't make sense for these pikemen[23] to daub themselves with *tzibeta*.[24] You would turn yourself into a proper silky-tailed beau[25] and imagine you only have to give the whores a thrill and that's it all fixed. If you became as charming a guy as me, it wouldn't make me cross at all. You have so many girl-friends, and if you were to have your wicked way[26] with every one of them just once, you wouldn't get through them all in a month or longer. Note: I am grateful to you for discussing my business with my wife to such good effect, and I

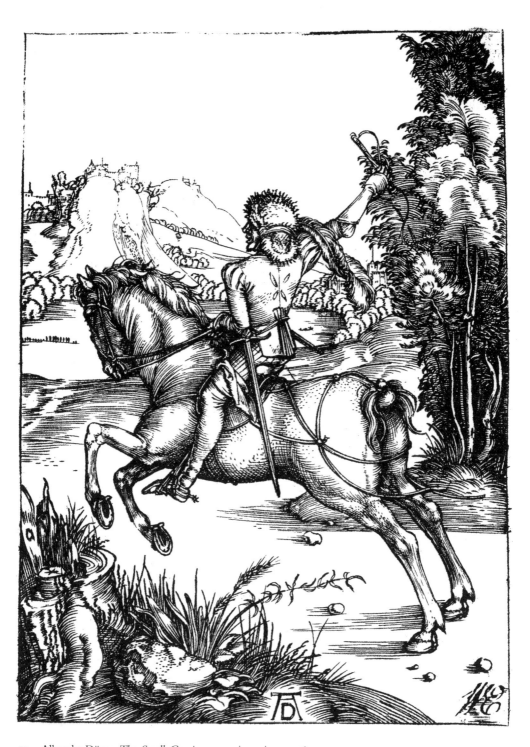

22.   Albrecht Dürer, *The Small Courier*, engraving, circa 1496

acknowledge how sensible you are deep down. If you were only as meek and mild as I am, you'd have all the virtues. And I have to thank you for the good things you do for me, if only you'll leave off buggering me about[27] with the rings. If you don't like them, just snap their heads off and chuck them in the shithouse, as Peter Weisweber says.[28] What do you imagine I care about such devil's muck?

I've become a *zentilam*[29] in Venice. I've also heard that you can write decent verse. You'd go well with our fiddlers here, they play so ravishingly that they burst into tears at their own music. Would to God that our Countingmistress[30] might hear it, she'd sob along to it. At your command I shall swallow my anger and behave more bravely than is my habit.

There's no possibility of my leaving here in two months, because I still don't have what I need to get myself away, as I wrote to you before.[31] So if my mother comes asking for a loan, I beg you lend her ten fl. until God helps me out of here. Then I'll express my thanks to you by settling up our account in an honest fashion.

Item: I am sending you the *vitrum ustum*[32] by courier. As for the two carpets, Anton Kolb will help me purchase the most attractive, broadest and best value there is. Once I have them, I'll give them to young Imhoff[33] for him to parcel up. And I'll look out for the crane's feathers, as yet I've found none. Swan's feathers on the other hand, for writing with, there are plenty of those. How would it be if you stuck some of them in your hat for the time being?[34]

Further, I've asked a printer who says he knows of nothing in Greek that's come out recently, but anything he hears of he'll let me know about, so that I can write and tell you.[35] Item: let me know what paper you mean me to buy because I know of none that's finer than we've bought at home.[36]

Item: as for histories[37] I can't see anything special that the Italians are producing that would look particularly entertaining in your study.[38] They're all much of a muchness. You could paint one yourself better than they do. Note: I've recently written to you via the courier Kannengießer.[39] Note: I'd really like to know how you are going to get back on terms with Kunz Imhoff.[40] Herewith let me commend myself to you. Tell our prior[41] I'm his obedient servant and to pray God for me that He protect me and especially from the French pox.[42] For I know of nothing I fear more at present, everyone has it, some folk it eats completely away till they die. And greet Stephan Paumgartner, Canon Lorenz, all our ladyfriends and those who ask kindly after me. Dated Venice, 18th August 1506.

Albertus Durer

Norikorius cibus[43]

Note: Endres[44] is here, sends his respects, still isn't back to full strength, and is short of money, because his long illness and debts have eaten up his reserves. I've lent him eight ducats myself. But don't tell anyone in case he gets to hear, otherwise he'd think I was betraying a confidence. I assure you, he's behaving honestly and sensibly so that everyone wishes him well.

Item: I have in mind, if the king means to come to Italy, to go with him to Rome et cetera.[45]

Original in the Stadtbibliothek, Nuremberg (Pirck. 394, 6). Single leaf, no seal or address

TRANSLATION OF THE FIRST SENTENCES

'To the greatest and foremost man in the world. Your servant, the slave Albrecht Dürer, says "Hail!" to his magnificent lord Willibald Pirckheimer. Believe me, gladly, with great pleasure, I heard of your good health and great honour. It is a wonder to me how it was possible that you held your own, one man alone, against so many warriors of the highly resourceful Thrasybulus; by no other means surely than through the grace of God. When I read your letter about these weird prick-faces, great fear seized me and it seemed to me a mighty feat.'

COMMENTARY

In the summer of 1506 Pirckheimer had been dispatched on a diplomatic mission to Würzburg, to resolve a conflict between the Nuremberg Council and Konrad Schott of Rothenberg. Schott (who in 1500 had hacked off the right hand of a Nuremberg official) had fought in 1505–6 with the Nuremberg contingent for Bavaria against the Palatinate. In a letter of June 1506 (Reicke 1940, 378), the Council thanked Bishop Lorenz of Würzburg for his good offices in resolving a dispute with Schott over prisoners captured in the war. Nuremberg was to pay Schott 400 fl. in compensation for withdrawing his claim to ransom money, and drop its own claims for damages relating to Schott's offences against Nuremberg citizens. In the letter to which AD is replying Pirckheimer apparently described his successful errand in mock-heroic terms. AD responds with this high-flown panegyric, which also provides him with the opportunity to show off his virtuoso command of Venetian idiom. It is unclear whether this often garbled language, with its barbarous orthography and grammar, its contaminations with Latin vocabulary, and German spellings, reflects a crude, essentially oral/aural command of Venetian, or whether its ineptness is part of a deliberately comical persiflage. A few of AD's word forms occur also in the *Hypnerotomachia Poliphili* of Francesco Colonna, printed in Venice in 1499. 'The Strife of Love in a Dream' is an allegorical narrative with fine woodcut illustrations, intended both as a literary and an iconographical source book for motifs of antique art and classical style.

The *paroli di Poliphilo* are in a teasingly mystifying hybrid idiom: 'although it speaks our tongue [that is, Tuscan Italian], in order to understand it one needs Greek and Latin no less than Tuscan and the vernacular' (see Godwin 1979, ix–x). The allegorical, 'hieroglyphic' iconography of the *Hypnerotomachia* became a source for AD, especially in the commissions he undertook for Emperor Maximilian I, the *Triumphal Arch* and the *Triumphal Procession* (1515–18, see 97, 169). The connection with the *Hypnerotomachia*, of which AD possessed a copy, presumably bought in Venice (now in the Bayerische Staatsbibliothek, see 331 and Eser 2008, 37), suggests that AD and Pirckheimer are sharing a multi-layered humanist joke. See Fara 2007, 69.

[For his indispensable help with the translation of this passage and with the following notes, I am indebted to my colleague Ronnie Ferguson.]

NOTES

1   *homo*: Venetian (*h*)*omo*, modern Italian *uomo*.

2   *serfitor*: Venetian *servitor*.

3   *schciavo*: Venetian *el schiavo*.

4   *disi*: Venetian *dise* (compare modern Italian *dice*).

5   *miser*: Venetian *mis*(*s*)*er*, later Italian *messer*.

6   *My fede al aldy*: *io udii*.

7   *pisir*: Venetian *piaser*.

8   *grondo hanor*: Venetian *grando honor* (modern Italian *onore*).

9   *my maraweio*: Venetian *me maraveio*.

10  *como*: Venetian, modern Italian *come*.

11  *cusy wu*: Venetian *cusoì*, modern Italian *come voi*.

12  *Tiraybuly mylites*: As Rupprich (R I, 53 & R III, 435) explains, this is a witty reference to Pirckheimer's adversary Konrad Schott, allegorising him, in the burlesquely high-flown style of the passage, as the tyrant of Syracuse Thrasybulus (circa 446 BC). The elements of both names, Greek Thrasy-bulos and older German Kuon-rât, are identical in their meaning: 'brave counsel'. The punning allusion requires a linguistic and classical knowledge not likely to have been available to AD and which must derive from Pirckheimer's mock-heroic self-stylisation in the letter to which AD is responding. Rupprich III, 435 points out that in Eobanus Hessus's *Bucolicon* (Erfurt 1509) the same etymological pun is made when Konrad Mutianus is alluded to as Thrasybulus. In a letter of 29 June 1506, Lorenz Beheim also credits Pirckheimer with resolving the dispute with Schott and congratulates him, though rather perfunctorily (Reicke 1940, letter 115).

13  Latin *nisi*.

14  *vna gracia*: Venetian *una graçia*.

15  *leser*: Venetian infinitive form.

16  *strania*: Venetian *stragno*.

17 *fysa de cacza*: Venetian *viso de cazzo*. AD writes f for Italian v, influenced by the fact that in German this initial consonant can be written either v or f (e.g. *Vater*, but *Farbe*). He interchanges a and o, as also in *grondo* for *grande*, and *hanor* for (h)onor. (In German AD sometimes writes *fan*, sometimes *van* for the preposition *von*). In vulgar colloquial Italian, *cazzo* – like *carajo* in Spanish, 'prick' in English and *Schwanz* in German – could by transference be a pejorative term of contempt for a man (see Rupprich, letter 7, note 9).

18 *habe*: German or Venetian (*ave*), '(I) have'.

19 *thanto pawra*: Venetian *tanta paura*.

20 *el para my vno grando kosa*: Venetian *el par a mi una granda cozsa*.

21 *dy Schottischen*: Scots, that is, punningly, the soldiers of Schott. It can also mean in early modern German usage 'tinkers', 'hawkers' (originally, vagrants from Scotland or Ireland).

22 *heiltum*, see letter 5, note 10. The *schritt hypferle* appears to have been a hopping dance (see German *hüpfen*) performed at the festival. Compare Lorenz Beheim's envious reference to Pirckheimer's and his friends' bacchanalian cavorting at the Lenten Carnival (36.2).

23 *lantzknecht*: there is no convenient English equivalent for *Landsknecht* in its strict historical sense, save for the curious convention of using the French loan form 'lansquenet' which would strike an absurdly false note in this context. Older tradition held that the *Landsknechte* were formed in 1482 by Emperor Maximilian I on the model of the Swiss elite troops who fought with pikes or swords and daggers in the armies of the French kings. They were recruited originally from, or to fight for, the imperial 'lands' of Swabia, the Allgäu and Tyrol. They were professional paid soldiers who formed a new standing army for the empire, which constitutionally had otherwise been dependent on levies supplied by the territorial rulers and cities. However, it is clear that as early as 1476 mercenaries of this kind were fighting in France, for instance the *aventuriers lansquenetz* who served Lorraine against Charles the Bold of Burgundy, and were already known by this Frenchified form of the name *Landsknecht*. From an early date, the name was also misconstrued as referring to the weapon *Lanze*, 'lance', though in fact they fought as infantry with the long pike, not with the cavalryman's lance. AD's *lantzknecht* or *lanczknecht* (letter 8) may be understood in either sense. By the early sixteenth century, the mercenary infantry was recruited for service in France and Italy, by kings, city republics and the papacy, and the name was borrowed again in Italian *lanzichinecco*. It is apparent here and in letter 8 that AD did not reserve the term *lantzknecht* for German imperial troops. See Boeheim 1890; Baumann 1994; DWb XII, 137–9. On the other hand, by somewhat later in the sixteenth century, *lanzi* became in Italy a pejorative nickname for 'Germans' as such, reflecting traditional hostility to the age-old German assertion of claims to Italian territories by the Holy Roman Empire.

[Blau 1882; Amelung 1964, 24, 99f.; Baumann 1994; Hale 1999, esp. 97–105; Morrall 2002; Silver 2002, 78–84; Whaley 2012, 74f.] [fig. 23]

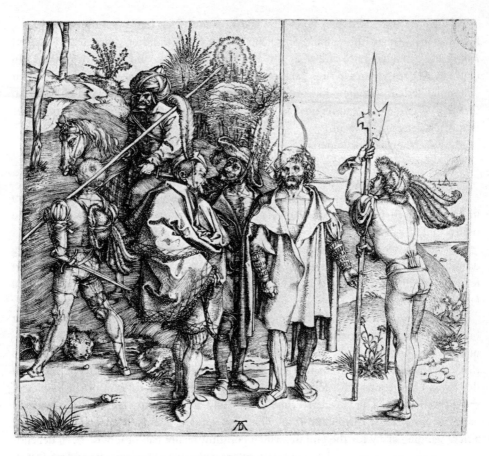

23. Albrecht Dürer, *Landsknechte and Turkish Rider*, engraving, circa 1495

24 *tzibeta*, Venetian *zibetto*: a pungent musky perfume obtained from the anal glands of the North African civet-cat.

25 *seiden schwantz*: 'silk-tail', an exotic Southern European bird, here a nickname for a dandy. Compare modern German *Paradiesvogel*. Three watercolours of the silk-tail with AD's monogram (circa 1512) are generally regarded as not authentic. See Winkler II, Anhang, plates XII/XIIII. Müller 1988, 214, shows that in fifteenth-century Shrovetide farce *Seidinswanz* occurs as a fictitious surname with a sexual meaning based on *Schwanz*, 'tail', as euphemism for 'penis'.

26 *prawten*: related to *Braut*, 'bride'. Originally 'woo, marry, take to the marriage bed', then a euphemism for seduction, sexual intercourse, rape (DWb II, 333). Here AD plays with its ambiguities.

27 *wen jr mich allein vngeheit list*: for *geheien*, see Müller 1988, 166f.; DWb IV, I, 2, 2340–50 (Rupprich's note 17, R I, 54, is mistaken). Related to *Heirat*, 'marriage', older

*(ge)hîen* meant 'set up house together' but was used euphemistically for sexual intercourse. By the fifteenth century it is a word of crude abuse. Compare *gehei dich*, 'fuck off'.

28　Captain of the Nuremberg levies in the Swiss War of 1499, in which Pirckheimer also took part, and in the War of the Bavarian Succession in 1504.

29　*zentilam*: Venetian *zentilomo*. See letter 2, note 7, and letter 10, note 17.

30　*Rechenmeisterin*: see also letters 8 and 10. She is presumably one of the bevy of lady-friends which AD alleges that Pirckheimer maintains. Rechenmeisterin can be the feminine form of the occupational-type surname Rechenmeister, quite frequently attested in Nuremberg, or the wife of someone who was a 'counting master' by profession – a teacher of book-keeping, or a practising accountant. Schleif/Schier 2009, 293–307, have solved the puzzle of her identity. She (first name unknown) appears in the letters of Sister Katerina Lemmel, nun at the Birgittine convent of Maria Mai (Maihingen, Bavaria), as the widow of the *Rechenmeister* Michael Joppel and sister of a Herr Dietherr, perhaps Jörg Dietherr, Master of the Mint in Nuremberg and a close friend of Pirckheimer. Sister Lemmel entrusts her with financial documents, and there is evidence that in 1518 Frau Joppel was a member of Pirckheimer's domestic staff, presumably with duties including household finances. A young woman trained in accounting, for whom Frau Joppel intercedes as a supplicant at Maria Mai, appears to have been taught by her. Compare Hering 2001, 25 & 63f. (I am indebted to Corine Schleif and Volker Schier for this and other assistance.) In letters not related to AD, Beheim refers to a woman, not yet identified, whom he calls *Fechterin*, either the wife whose husband's name is Fechter or whose husband is a 'fencing-master' (Pirckheimer Briefwechsel I, 114 & 115).

31　See letter 5.

32　Literally 'burnt glass', probably glass decorated with enamelled painting.

33　See letter 5, note 5, and letter 6, note 4.

34　On tall feathers, especially ostrich and peacock feathers, as adornments of headgear, see Rublack 2010, 54f., 60, 140f. They were associated with male courage, and were popular with the *Landsknechte*. They drew attention to the head as the noblest part of the body and were used in the eloquent symbolic language of paying respect and greeting. Swan's feathers, used for quills, lacked the allure of gaudy plumage and, AD jokingly implies, would mark out Pirckheimer merely as the pen-pushing scholar.

35　Booksellers in Venice were concentrated along the Marzaria, the main street from the Piazza San Marco to the Rialto, very close to AD's lodging. On the bridge itself, book hawkers accosted passers-by. The Venetian scholar-printer Aldus Manutius was the pioneer and chief exponent of printing in Greek. His press was producing editions of the Greek classics in Venice from 1494 until his death in 1515, primarily in cheap but meticulously edited pocket-sized format. Pirckheimer was very familiar with his products and claimed to Conrad Celtis in 1504 that he possessed every Greek book so far printed in Italy. On Aldus's sales to German wholesale merchants, see Chambers/Pullan 1992, 373f. There was a period of inactivity in the Aldine press between December 1505

and December 1507, but Pirckheimer must have known this, since he was told by Johannes Cuno (letter of 21 December 1505) that Aldus was coming to Germany to explore with Maximilian I a plan (which fell through) to set up an Academy in Vienna for which he would print Greek and Hebrew books. It was Erasmus who spurred Aldus into fresh printing activity in 1507–8.

[Offenbacher 1938, 242f.; Reicke 1940, 280–82; Eisenstein 1981; Holzberg 1981, 65–70; Barker 1989, 5–21; Davies 1995; Roeck 1999; Pon 2004, 48–51]

36   The oldest paper mill in Germany was opened in Nuremberg by Ulman Stromer in 1390. However, Italian paper had a reputation as the finest available. It was the Venetian blue *carta azzurra* which AD used for the preparatory studies for the *Feast of the Rose Garlands* (see figure 20).

37   *historien*: AD is using the word in its Renaissance sense of paintings of subjects taken from ancient history or classical mythology and allegory. Since these subjects are generally drawn from literary narrative sources, *historia* became a central concept in the Renaissance debate about the relationship between poetry and painting, on which the claim of painting to be a liberal art mainly rested. On Alberti's term *istoria*, see Bätschmann/ Gianfreda 2002, 31–6; for Leonardo, Kemp/Walker 1989, 220–40. In 1495 the Nuremberg humanist Sebald Schreyer had the library in his house (in the same street as AD's father's house) painted by Michael Wolgemut with classical images – Orpheus, Apollo and the Muses, the Seven Ancient Wise Men – portraits of himself and Konrad Celtis, and epigrams by Celtis (Grote 1954/5).

38   *studiorum*: correctly Latin *studium* or Italian *studio*. These words are first attested in the sense 'private room for study' in the fifteenth century and document the secularisation and domestication of learned and intellectual activity in the age of Renaissance humanism (Thornton 1997).

39   *Kantengysserle*: the letter seems not to have been delivered.

40   Konrad, brother of Hans Imhoff the Elder and a prominent member of the governing Council in Nuremberg. Pirckheimer quarrelled with him again in 1517.

41   Eucharius Carl, prior of the Augustinian monastery in Nuremberg from 1504 to 1507.

42   *vor den franczosen*: on the contagious syphilis known as the *morbus gallicus*, see letter 6, note 5. The pandemic was rife in Italy.

43   Correctly *Noricus civis*, 'citizen of Nuremberg'. AD must have been familiar with the Latin equivalent of *bürger zu Nürmberg*, and it may be assumed that he deliberately mangles the phrase in line with the parodistic treatment of language at the start of the letter.

44   *Endres*: Andreas Kunhofer, see letters 3, note 7; 4, note 4; 6, note 6.

45   Maximilian I's planned journey to Rome for an imperial coronation was abandoned. In February 1508 he formally adopted the title Emperor-Elect without papal sanction.

[Wiesflecker 1977, 109–27, 144–63, 339–44; Wiesflecker-Friedhuber 1996, 163–70; Whaley 2012, 36f., 69f.]

## 29.8

*[Venice, 8 September 1506]*

Most learned sir, proven in wisdom, versed in many languages, swift to detect all pretence at lying and to recognise the real truth, honourable and highly esteemed Willibald Pirckheimer. Your humble servant Albrecht Dürer wishes you health and great and worthy honour. *Cu diawulo tanto pella czansa chi ten e pare.*[1]

*Io vole denegiare cor woster*[2] by making you think I'm also an orator with a hundred *partire*[3] to argue. A room would need more than four corners if one were to set up statues to the gods of memory in it.[4] I *voli* not *impazare* my *caw* with it, I'll *rekomandare* it to you, for I believe there aren't as *multo* little chambers in the brain to store just a tiny bit in each.[5] The Margrave[6] wouldn't hold audience for so long: a hundred headings and a hundred words for each heading would need precisely nine days, seven hours and fifty-two minutes, not counting the *suspiry*[7] – I haven't added those up yet. So you won't spout it all at one go, it would be as long drawn out as a grandpa's bletherings.

Item: I have tried my hardest with the carpets, but can't get hold of a wide one. They're all long and narrow. But I'm still looking out every day, Anton Kolb likewise.

I passed on your greetings to Bernhard Hirschvogel,[8] and he sent you his regards in return; he is overcome by grief because his son has died, the best mannered little chap I have seen in all my days.

Note: I cannot lay hands on a single crane's feather.[9] O if you were only here, what bonny Italian pikemen[10] you would find! How often I think of you! Would to God that you and Kunz Camerer[11] might see them. They have *runcas* with 278 points,[12] and wherever they touch a German mercenary[13] with them, he'll die because they're all tipped with poison. Hey, I can do myself a favour, I'll become an Italian pikeman. The Venetians are busy recruiting, likewise the Pope, also the King of France. What will become of it, I've no idea. People make great fun of our King.[14]

Item: wish Stephan Paumgartner lots of luck from me. It's no surprise to me that he's taken a wife. Greetings to Porst,[15] Canon Lorenz and our pretty lady-friends,[16] also your Countingmistress,[17] and say thanks from me to your gentle-men's club[18] for its greetings. Tell them they're shits.[19] I have arranged to have olivewood transported from Venice to Augsburg for them. I'll have it dropped there, it's a good ten hundredweights. Tell them they couldn't be bothered to wait for it, *pertzo el sputzo.*[20]

Item: my altar painting says to tell you it would give a ducat for you to see it, it's good and the colours are beautiful. I have won a lot of praise for it but not much profit. In the time it took me I could have earned a good 200 ducats

and I've turned down a lot of work so that I can get home, and I've shut the mouths of the painters who said I was good at engraving but had no idea how to use colours in painting. Now every one's saying they've never seen finer colours.

Item: my French cloak sends greetings and my Italian tunic too.[21]

Item: it seems to me you stink of whores so badly that I can smell you here, and people tell me, when you go after women, you pretend you're no more than twenty-five. Ho hum, multiply that, then I'll believe it.[22]

My dear fellow, there are so god-awful many Italians here who look exactly like you, I can't imagine how that comes about.[23]

Item: the Doge and the Patriarch have also been to see my altar panel.[24] With that I take my humbly obliged leave from you. I really must sleep, for it's just striking seven in the night.[25] You see, before this I also wrote to the Prior of the Augustinians,[26] my father-in-law,[27] Dietrich's wife,[28] and my own wife, and empty pages quickly fill up. That's why I wrote in haste. Read it for the meaning, not the style. You'll get a good lesson from it in how to speak better to princes.

I wish you good night and good morning too. Given at Venice on Our Lady's Day in September.

Note: no need for you to lend my wife and mother anything, they've enough money now.

Albrecht Dürer

Original in the Stadtbibliothek, Nuremberg (Pirckh. 394,7). Single leaf, green wax seal. No address

NOTES

1   In modern Italian: *con diavolo tanto per la ciancia* [Venetian *zanza*], *che te ne pare* – 'In the devil's name, enough of this verbiage, don't you reckon?' AD deflates the comically fulsome address.

2   'I'm trying to wind you up…' Italian *dannegiare*, Venetian *cor* for *cuore*. More literally, 'hurt your feelings'.

3   'Points', 'headings' in a speech constructed according to the rules of rhetoric.

4   AD envisages a polygonal chamber with a statue in each corner, as a metaphor of the brain's capacity for structured memory. He was clearly familiar with the ancient *ars memoriae*, a technique enabling an orator to remember items in a speech by visualising them as *loci*, images placed in an imaginary building or 'memory palace'. My colleague Anne Simon points out that the Augsburg printer Johannes Bämler published a German-language 'art of memorising' in 1480.

[Yates 1966, 17–38 & 132; J.-D. Müller 1982, 49–50; Carruthers 1990, 89–93]

5 'I'll not trouble [*impazzare*] my head [Latin *caput*, Italian *capo*] with it, I'll leave [*raccomandare*] it to you...'; *molto*: 'many'.

6 Frederick IV of Brandenburg, Margrave of Ansbach-Bayreuth (died 1536). In the letter to which AD is replying, Pirckheimer appears to have boasted of his rhetoric and prodigious memory when representing Nuremberg at the Margrave's court. In his *History of the Swiss War of 1499*, written in 1505, he describes himself as an orator of supreme eloquence, with a 'stupendous memory' allowing him to respond instantaneously to sixty objections by his opponents (Holzberg 1981, 159, see also Eckert/Imhoff 1971, 138–72). Georg Sibutus (see 42) described him as *Ciceronis filius*, Georg Spalatin (BI) as *alter Demosthenes*.

7 *sospiri* – 'pauses for breath', or 'sighs' for rhetorical effect.

8 Nuremberg patrician merchant who had a pre-eminent position in the German community in Venice.

9 See letter 7.

10 *welscher lantzknecht*: see letter 7, note 23. On the sexual allure of the *Landsknechte*: Rublack 2010, 140–42.

11 Captain of a section of the Nuremberg foot soldiers in the War of the Bavarian Succession in 1504. He owned a brass forge close to the city.

12 The *runca* differed from the usual pike in having, just above the bottom of the main blade, a crescent-shaped protrusion with twin upward-pointing sharp tips. It was used, mainly by Italian and Spanish troops, from the later fifteenth century until the second half of the sixteenth century. Although the weapon sometimes took elaborate forms, the idea of 278 poison-tipped blades is a grotesque hyperbole (Boeheim 1890, 348–52).

13 *ein lanczknecht*: I take this to mean a German pikeman who does not have the Italian *runca*.

14 In the summer of 1506, Maximilian I was hoping to mount an expedition to Rome to secure his coronation as Holy Roman Emperor. Venice, King Louis XII of France, and Pope Julius II formed an alliance to block the passage of the German army through Northern Italy, fearing that Maximilian would take the opportunity to reassert ancient claims to Imperial overlordship there. During the summer the Venetian Arsenal worked day and night, including Sundays, to produce armaments. See letter 7, note 45. [Wiesflecker 1977, III, 339–44; Lutter 1998; Whaley 2012]

15 Nikolaus Porst was the husband of Anna (see letter 2, note 15).

16 *her Lorenczen vnd vnser hübsch gesind*: see letter 4, note 6.

17 *ewer Rechen meisterin*: see letter 7, note 30.

18 *ewrer schtuben*: the 'Herrenstube', the gentlemen's drinking club of which Pirckheimer was a member, appears to have sent an obscene message to AD via Pirckheimer. Such facilities were quite commonly provided for the patrician and honourable classes in or near the town halls of cities. The Nuremberg club is documented from 1495. The rules formulated in 1561 are more detailed and draconian than earlier

ones, proscribing blasphemy and oaths, toasts, late-night noise and drunkenness (Schultheiß 1953). For the constitution of the Augsburg Herrentrinkstube, where women were admitted for dances, Möncke 1982, 378–80.

19　*Sprecht, sy seÿ ein vnflott* (modern German *Unflat*).

20　Venetian *perçò el spuzzo*: 'hence the stink'. Olivewood was burned to dispel unpleasant smells. The club would not wait, AD jokes, until he had sent enough olive-wood to purge the stink of its lavatorial humour. Here he inserts in the middle of the page a caricature sketch of a smiling face (usually presumed to be his own, though it lacks his trademark beard, and the unruly hair suggests it may be intended to be Pirckheimer). The next two sentences are written around it.

21　In Venice AD indulged in fine clothes which sumptuary laws forbade him in Nuremberg, where the council regulated dress (and hair-length) according to criteria of social status. In the self-portraits of 1493 and 1498 (5.2, 9.5) he wears luxurious dress, as such beyond his entitlement. See Rublack 2010, 78: 'There can be few more telling examples of the rhetorical and social use of clothes as 'incarnated' signs of esteem in this period as Dürer triumphantly writing from Venice to his friend Pirckheimer 'my French mantle and brown coat send you best wishes'. Clothes could thus be imagined to literally speak their own language; they made the most immediate and powerful statement about social status to contemporaries. AD followed Italian painters like Raphael and Parmigianino in regarding fine clothes as a metaphorical expression of artistic status (Ames-Lewis 2000, 70–74).

22　Pirckheimer was born on 5 December 1470 and was almost thirty-six in September 1506, middle-aged by the reckoning of the sixteenth century.

23　Pirckheimer had spent the years 1488 to 1495 studying at the universities of Padua, in the Veneto and Pavia. No visit to Venice itself is known.

24　The doge from 1501 to 1521 was Leonardo Loredan. His portrait by Giovanni Bellini is in the National Gallery, London. The patriarch-archbishop of Venice from 1504 to 1508 was Antonius Surianus, who was also patron of the church of San Bartolomeo, for which *The Feast of the Rose Garlands* was commissioned.

25　AD uses the Nuremberg clock, which counted the hours of the night starting from sunset. Seven in the night in early September in Venice would be around 1 a.m.

26　Eucharius Carl: see letter 7, note 41.

27　Hans Frey (1 and BI).

28　Perhaps the wife of Johann Dietrich, clerk to the Nuremberg Council.

**29.9** [fig. 24]

*[Venice, 23 September 1506]*

To the honourable and wise Willibald Pirckheimer of Nuremberg, my gracious lord.

Your letter brought me great *legresa*,[1] in showing me what abundant praise you enjoy from princes and lords.[2] You must be quite transformed if you have become such a peacemaker. I shall miss the old you when I see you again.

I can tell you that my altar panel is finished, also another *quar*, the like of which I've never done before.[3] And just as you are pleased with yourself, so I too can proclaim for my part that there's no better portrait of the Virgin in the land, for all artists praise it, as the lords do you. They say they have never seen a more sublime[4] and lifelike painting.

Item: the oil you were asking about I'm sending you via the courier Kannengießer. The enamelled glass too, that I sent you with the courier Ferber, I'm sure that's also reached you. Item: as concerns the carpet, I've not bought one yet, because I can't track down a square one, they're all long and narrow. If you want any of those, I'll gladly buy them, so let me know. And be assured that I'll be finished here in another four weeks at the outside, for I have promised to do portraits of several people.[5] For the reason that I'm coming home soon, I've turned down over 2,000 ducats' worth of work since my altar panel was finished. All the people I live with can confirm that.

With that let me take my respectful leave. I could write much more, but the courier is ready to set off. I hope, God willing, to be with you soon in person and learn new wisdom from you. Bernhard Holzbock has told me very flattering things about you. Though I reckon he does it because you've now become one of his in-laws.[6] But nothing annoys me more than when they say you are growing handsome whereas I'm getting ugly. It's enough to drive me mad. I've just spotted a grey hair. What's made it grow is sheer poverty and the way I *stenter* myself.[7] I believe it was in my stars that I get a raw deal in life.

My French cloak, the husseck[8] and the brown tunic send you warm greetings. But I'd love to find out what your gentlemen's club knows, to make it so high and mighty.

Dated in the year 1506 on the Wednesday after Matthew the Evangelist.

Albrecht Dürer

BL Harley 4935, folio 41

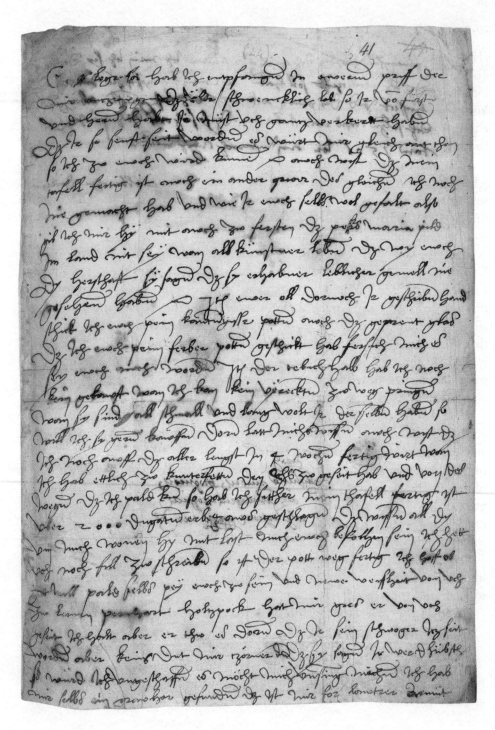

24. Albrecht Dürer, autograph letter to Willibald Pirckheimer, 1506. BL Harley 4935–41

NOTES

1    Italian *allegrezza*: 'pleasure'.

2    Pirckheimer was representing the Nuremberg Council at the meeting of the Swabian League in Donauwörth (see letter 8, note 6).

3    *ein ander quar*. Venetian *quaro*, Italian *quadro*, 'rectangular', by metonymic transference 'picture'. It is generally assumed that AD is referring to *Christ Among the Doctors*, which along with extant preparatory drawings is dated 1506. AD's inscription (31.4) describes it as *opus quinque dierum*: 'the work of five days', in contrast to his inscription on *The Feast of the Rose Garlands* (31.1): *exegit quinque mestri spatio*: 'completed in the space of five months' (Ex. Cat. Vienna 2003, 338–48). A long-held view that AD painted the picture during an otherwise undocumented brief stay in Rome is refuted by Strieder (2000) as chronologically impossible. However, *quadro* can also denote the rectangular frame of a painting. In other cases, like the Heller Altar (48), it is known that AD designed frames for his pictures. The one he designed for the Landauer Altar (64.4–5) is still in Nuremberg (Strieder 1992). If we read *ein ander quar* as 'another frame', and one in a Venetian style unlike any he has designed in Nuremberg, the passage acquires a logical progression, from the completion of the painting, to its framing, then to its reception by the Venetian public (Humfrey 1993, 265; Lübbeke 2001, 99f.).

4    *erhabner*. *Erhaben* is the older past participle of the verb *erheben*, 'raise, lift up' (in modern German, *erhoben*). In the sixteenth century its adjectival use is recorded only in literal senses: 'raised, elevated'. Not until the seventeenth century does it take on metaphorical meanings such as 'noble, distinguished, refined'. In the later eighteenth century, having lost its grammatical function as a verb form, *erhaben* comes to express a key moral-aesthetic concept in neo-classical philosophy and literature, that of 'the sublime and the beautiful' (Edmund Burke, Kant, Schiller; DWb III, 832f.; Paul 2002). But AD cannot be using the word in a literal sense. He is conveying verbal judgements of his Madonna by Italian artists or men of learning in the liberal arts (see letter 3, note 5), and so *erhaben* is likely to be his German paraphrase or translation of an Italian word. This word, we may assume, was *sublime*. By the fourteenth century it had acquired, in literary, then in broader aesthetic contexts, the extended sense 'stylistically superior, elevated, ornate'. Renaissance orators and theorists of rhetoric derived the concept from Cicero and the *Institutio Oratoria* ('The Orator's Education') of Quintilian. They gave the two broad categories of rhetorical style (the *genera dicendi*) the terms *genus humile* (the unornamented style, characterised by plainness, purity and clear expression) and *genus sublime* (elevated and embellished, characterised by rhetorical figures and grander subjects). Latin *sublimis* came from the verb *sublimare* which meant 'raise, lift up', and AD's *erhaben* is therefore a precise German equivalent on the literal level to Italian *sublime*. Through this equation it takes on a metaphorical sense which was not to become established in German lexis until eighteenth-century classicism. Quintilian himself had drawn an extended parallel between the rhetorical *genera dicendi*

and the stylistic categories of painting and sculpture (Inst. Orat. II. xiii; XII.x). This link between oratory and the visual arts is taken up by early humanist writers on rhetoric in the Italian Trecento and Quattrocento, such as Leo Battista Alberti (Bätschmann/Schäublin 2000, Introduction). Classical rhetoric was studied in later fifteenth-century Germany, and Rudolf Agricola's *De inventione dialectica* made Cicero's and Quintilian's work widely accessible. The latter appeared in eight printed editions from 1479 to 1570 (Rupprich 1970, 470f., 492f., 657f.). AD can be assumed to have gained at least basic knowledge of the *genera dicendi* through Konrad Celtis and Willibald Pirckheimer. He expects Pirckheimer to make the connection between *sublime* and *erhaben*. Indeed he could even have already acquired that German loan translation from these humanist mentors. The praise he has now earned from Venetian artists and connoisseurs implies the recognition that he can create painting at the highest level, the *genus sublime*. Hitherto, he had suffered the criticisms that his work was not *all'antico* (letter 2), and that, while he was good at engraving, he did not know how to use colours in painting (letter 8) – amounting to the charge that he could handle the 'low' or 'mediocre' style in his prints, but not the 'high', *sublime* style in his painting. Contemporaries later apply the rhetorical categories to AD's art. Philipp Melanchthon (293) places his work in the 'grand manner', whereas Cranach and Grünewald belong to the *genus mediocre*, the middling level. Erasmus argues that AD's 'art of black lines' – his woodcuts and engravings – surpasses the colours of Apelles (253). The translation of *erhaben* to English 'sublime', though inescapable in this context, is not ideal, given that in English the word does not have the literal as well as meta-phorical sense of Renaissance Italian *sublime* and early modern German *erhaben*. See also 85.1, note 1; Luber 2005, 88f.; Smith 2012, 174.

5 These may include the oil portraits of Burkhardt of Speyer and another unnamed German merchant, and the portraits of two young Venetian women (A 94 and 99, A 92 and 95; see also A 96, and 31.3).

6 In November 1506 Holzbock (see letters 3, note 4, and 5, note 4) had married Anna von Schlammersdorf, daughter of Pirckheimer's cousin Ursula.

7 *stenter*. The Venetian form of Italian *stentare*: 'exert, stress oneself'.

8 The *husecke* was a long, heavy, bell-shaped overcoat, often fur-lined. The word probably derives from French *housse*. It eventually became restricted to women's wear (DWb IV, II, 1975, Zander-Seidel 1990, 87–90). The inventory of the possessions of the painter Mathis Gothart-Neithart (Grünewald), who died in the same year as AD, includes a brown *heseck* (Müller-Wirthmann, 2002, 73). In Nuremberg, almost all occurrences of the word are in inventories of the upper classes.

**29.10**

*[Venice, circa 13 October 1506]*
There is no need for me to write to you for reassurance that you know how willingly I serve you, but I do have the most pressing need to tell you of the true joy I feel at the great honour and renown which you have achieved by your manly wisdom and practised skills, the more to be wondered at since the like of this is seldom or never at all to be found in a person so young. But it comes to you by an especial grace of God, just as it does to me. How well we feel, when we deem ourselves successful, I with my altar-piece, and you *cum woster*[1] wisdom. When people glorify us, we carry our heads higher and believe every word of it. Yet sometimes it's a malicious scoundrel who's behind it, secretly mocking us. So don't believe it when people praise you – except you're such an out-and-out rogue that you won't believe it anyway.

With my mind's eye I can see you in the Margrave's presence,[2] doing your smooth-tongued act, just as you do when you sweet-talk Miss Rosenthal with your bowing and scraping. I can just tell, when you wrote the last letter, that you were straight out of some whore's bed. You should still be feeling ashamed, at your advanced age, for imagining you're a pretty boy. Chasing women suits you about as much as a great shaggy dog fooling around with a little kitten. If you were nice and gentle like me, I might believe it. But when I become Lord Mayor I'll clap you in the Belvedere,[3] like you do to mild-mannered blokes like Zamasser[4] and me. I'll lock *you* up for once and I'll throw in the Countingmistress, Misses Gartner, Schutz and Porst[5] along with you, and a lot more it would take too long to list. They'll chop your whatsits off.[6] But they're asking for me more than for you, as you say in your letter, whores and respectable women alike are asking after me. It's a token of my manly virtue.

Once God brings me home, I don't know how I am going to cope with you and your great wisdom. But I rejoice in your excellence and generosity. And your dogs will benefit now you've stopped beating them lame. But now you are so esteemed in Nuremberg, you'll never venture to speak on the street with a poor painter, it would be a great scandal *cum pultron de pentor* et cetera.[7]

Oh my dear Pirckheimer, at this very moment when I'm writing to you in my joking mood, they're sounding the fire alarm, and six houses are ablaze next to Peter Bender's place,[8] and woollen cloth I bought just yesterday for eight ducats has gone up in flames. So I've suffered loss as well. There's constant *romer* about fire here.[9]

Item: since you write that I should come home soon, I'll do so as promptly as ever I can. It's just that I had to earn money to meet expenses. I've spent around 100 ducats for colours and other things.

I've also reserved two carpets and will pay for them tomorrow. But I couldn't get them cheaply. I shall pack them with my own things.

And since you write that I'm to come soon, else you'll give my wife a thorough flushing out, that's not allowed, unless you shaft her to death.[10]

Item: let me tell you that I'd meant to learn to dance and went twice to the classes. Then I had to give the teacher one ducat and after that nobody was going to get me on my feet again. I would have spent everything I'd earned, and in the end still not managed a step.

Item: Ferber the courier will bring you enamelled glass. Item: I can nowhere discover any new books printed in Greek. Also, I shall pack two reams of your paper. I'd have thought Kepler[11] had more of it. But the feathers you wanted I've not been able to get hold of. Instead I've bought white ones, and if I find the green ones I shall buy them too and bring them with me.

Item: Stephan Paumgartner wrote and asked me to buy him fifty beads for a rosary, cornelians. I've already reserved them, but they're expensive. I couldn't find any that were larger – I'll send him them by the next courier.

At your request I'm letting you know when I intend to come, so that My Lords[12] are duly informed. In another ten days I shall be finished here. After that I will ride to Bologna[13] where someone is going to teach me the secrets of the art of perspective.[14] Then in roughly eight or ten days I'll set off to ride back to Venice. Following that I shall come with the next courier.[15] Oh how I'm going to shiver and long for the sun.[16] Here I'm a gentleman, back home 'that scrounger' et cetera.[17]

Item: tell me what it was like poking the old crow, and say that you'll let me have a go at her too.[18]

There's lots more I have to tell you, but I'll be with you again very soon. Given at Venice, I don't know what day of the month, but about a fortnight after Michaelmas 1506.

<div align="right">Albrecht Dürer</div>

Item: when are you going to tell me whether any of your children have died?[19] Also, you wrote once that Joseph Rummel had married somebody's daughter but never did say whose. How am I to know who you mean?[20]

If only I had my woollen cloth back! I fear my cloak got burned too. Then I'd really be mad. I'm cursed with bad luck. In the last three weeks someone who owed me eight ducats has scarpered.[21]

Stadtbibliothek, Nuremberg (Pirckh. 394, 8). Single leaf. No seal or address

NOTES

1   *cum woster*: Modern Italian *con vostro*, 'with your'.

2   A further reference to Pirckheimer's diplomatic achievements when representing Nuremberg at the court of Frederick IV of Brandenburg, Margrave of Ansbach-Bayreuth (see letters 8, note 6, and 9, note 2).

3   *Luginslant*: the ironically named Nuremberg gaol, whose inmates presumably were not guaranteed a room with a view. It is the tall tower next to the former imperial stables at the east end of the ridge on which the Nuremberg castle stands. Detention 'in the tower' was the penalty for higher-class men who had pre-marital or extra-marital sexual intercourse (Jegel 1958, 254 & 267f.).

4   Hans Zamasser was a notorious Nuremberg drunkard and the most disreputable member of Pirckheimer's gentlemen's club. As a member of the ruling Council, Pirckheimer was accustomed to dispensing justice rather than to being at its receiving end.

5   *Gartnerin, Schutz*: these putative members of Pirckheimer's female entourage, mentioned only here, have not been identified.

6   *Dy müsen ewch ferschneÿden*: AD's mock sentence on Pirckheimer the reprobate.

7   Venetian *cum poltroon de pentor*; in modern Italian: *con poltrone di pittore*: 'with a layabout of a painter'.

8   *Peter Pender*: Peter Bender or Bander was a well-known, long-term German resident of Venice who had a lodging house near the church of San Bartolomeo, used by the German merchants and visitors not housed in the Fondaco dei Tedeschi, which (see note 9) was currently being rebuilt. Normally, German merchants were obliged by the Venetian authorities to lodge in the Fondaco, where they were said to have lived in a quasi-collegiate community (Schweikhart 1993, 41; Oakes 2005, 6–7). Lodging-houses in the district around the Rialto were licensed to accommodate shorter-term and occasional foreign visitors (Wirtz 2005, 9). In revised rules drawn up for the rebuilt Fondaco in 1508, rooms were to be reserved for the accommodation of visiting Germans, to prevent them lodging at inns not controlled by the authorities (Chambers/Pullan 1992, 329f.).

9   Venetian *romor/rumor*, Italian *rumore* – 'noise, hullabaloo'. The Fondaco dei Tedeschi had been razed to the ground by fire in January 1505. The Consiglio dei Dieci, responsible for the maintenance of public buildings, decreed its urgent lavish reconstruction: *refarlo presto e bellissimo*, within a week of the fire, in view of the major importance of German and transalpine trade to the Venetian Republic. By June 1506, 600 ducats per month were being spent on the new building, which was finished in July 1508. It survives today as the main Post Office. Other major buildings destroyed by fire in the decades around 1500 included the Palazzo Ducale, the Procuratie Vecchie and the Scuola Grande di San Marco, and many shops in the Corderia and the Rialto area were burned down in 1514 (Welch 2005, 146; Goy 2006).

10  *oder jr wolt mirs weib kristiren, jst ewch vnerlawbt, jr prawt sy den zw thott.* For *kristiren*, read *klystieren*, 'flush out, administer a douche or enema'. 'The clyster was a prevalent medical remedy that was prescribed from the fifteenth to the eighteenth century for women without husbands, or in the absence of their husbands, as an antidote for unfulfilled desire.' For this and the following, see Schleif 2010, 249f. Here it is a euphemism for vaginal or anal intercourse. For *prawten*, see letter 7, note 26 and compare letter 4, note 3. AD gives Pirckheimer permission to have sex, whether forced or consensual, with his wife Agnes. The construction with *den(n)* imposes a condition: 'unless...'. However, it has been read (in order to avoid the most drastic reading of the text) as *dan(n)*: '...because then you will kill her' (Schleif 2010, 264f.). Conway 1889, 58, turns it into a mocking reference to Pirckheimer's physical bulk: 'And as to your threat that, unless I come home soon, you will make love to my wife, don't attempt it – a ponderous fellow like you would be the death of her.' Although these passages must be understood as ultimately risqué humour, it is not anachronistic for the modern reader to find them decidedly discomfiting and hard to reconcile with received images of AD. Certainly they contributed significantly to the distortion of Agnes Dürer into a virago in biographies of AD from the seventeenth to the twentieth century (Schleif 1999). See also Pirckheimer's letter to Johann Tschertte (290) which indicates a deep enmity between him and Agnes Dürer. If only we had Pirckheimer's letter to which AD is responding, the sense (and perhaps the enormity of their humour) would be patent.

11  The Nuremberg bookbinder Sebald Kepler, the great-grandfather of the astronomer Johannes Kepler.

12  *mein heren*: the Nuremberg Council.

13  Christoph Scheuerl was studying in Bologna at this time and confirms AD's visit there (50).

14  AD's informant has never been identified. One candidate is the mathematician Luca Pacioli (circa 1447–1517), who published *De divina proportione* in 1509, though in 1506 Pacioli was in Florence, not Bologna. But Pacioli was a pupil of Piero della Francesca (1415–92), author of *De prospectiva pingendi*, a text AD quotes in his own later writings on perspective and which was only available in manuscript form (Kemp 1990, 54–62; Reiss 1999, 140–48). Jacopo de'Barbari was acquainted with Pacioli, having painted a portrait of him in 1495 (Naples, Museo di Capodimonte), albeit the attribution is disputed.

15  But the ex libris inscription in AD's copy of Euclid's *Elements of Geometry* (HAB), shows that he was still (or again) in Venice when he bought it in early 1507 (34). Accompanying a courier was faster than travelling with a merchant's baggage train (Zahn 1971).

16  *O wy wirt mich noch der sunen friren*: See R I, 60, note 34. This was a proverbial expression in sixteenth-century Franconian German, attested in poems by the Nuremberg writer Hans Sachs and in Luther's anthology of regional German proverbs. Willibald Pirckheimer alludes to the saying, in a quite different connection, in his

letter of 1529 to Johann Tschertte (290). In AD's usage it has both the literal sense of missing the Italian sunshine and the proverbial sense of looking back nostalgically to happier times.

17   *Hy pin jch ein her, doheim ein schmarotzer*: in fact, long before 1506, AD enjoyed the esteem of Nuremberg's cultural elite. After his return from Venice he rapidly became an affluent and highly regarded figure in Nuremberg and, following his nomination to the Great Council in 1509 (58), he came to play a valued role in civic affairs. (Strieder 1983; Ames-Lewis 2000, chapter 12).

18   AD harks back to the earlier passage (see note 10), Pirckheimer's crudely joking threat to 'flush out' Agnes Dürer. AD's readiness to indulge this lewd humour and his characterisation of his wife as *daz alt kormerle* belong in the context of a sustained sequence in the letters of more or less obscene references to Pirckheimer's sexual appetite and AD's own comic, Shrovetide-Carnival-farce role as complaisant cuckold. All this is evidence of the ingrained misogyny of the age (Schleif 1999 & 2010). *Kornmerle* is the popular name of the blue roller (*Blauracke*, also *Mandelkrähe*, *Nebelkrähe*, ornithologically the *coracias garrula*), a bird formerly common throughout Continental Europe, with turquoise-blue wings and a raucous croaking call like that of a crow. AD painted two meticulously detailed watercolour studies of the bird, perhaps in 1502 (W 614–15, S D 1502/10–11).

19   *ob ewch awch kint gschtorben sind*: see letter 3, note 8 – a reference to the plague epidemic in Nuremberg.

20   A relative of Agnes Dürer, he was about to marry (in November 1506) Ursula Wieland, whose sister Cordula married Stephan Paumgartner (in December 1506), to whom AD frequently refers in the letters from Venice.

21   Perhaps a commission agent engaged to sell AD's prints. See the account of AD's financial losses in the *Personal Record* (38) and the contracts of employment of his travelling salesmen (7, 8, 13).

COMMENTARY

Though it is nowhere unambiguously documented, and scholarly opinion about it remains divided, it seems likely that AD first visited Venice during the 1490s. When he tells Pirckheimer early in 1506 that 'the stuff that pleased me so well eleven years ago doesn't please me at all now', AD implies a date circa 1495 for this first Italian journey. On his motives, see for example Strieder, Ex. Cat. Nuremberg 1971, 62–9. Watercolour drawings of Alpine and North Italian landscapes suggest a departure late in 1494 and allow his possible itinerary to be traced, although Großmann (2007) has argued that the watercolour of Innsbruck cannot have been done before the summer of 1496. Luber's doubt (2005) that the first visit to Venice took place at all has found little support. It is assumed that AD left behind the young wife he had married in July 1494, abandoning her to her fate in a plague epidemic that killed 800 inhabitants

of Nuremberg before the end of the year. We can only speculate about his contacts with Venetian artists and the paintings he may have seen, and art historians focus their attention rather on the evidence of Italian influence as it may be discerned in his works from circa 1495 through to the first years of the sixteenth century. Letter 2 can be read as suggesting that he knew Giovanni Bellini already before 1506. Rupprich (1930) argued that it may have been Willibald Pirckheimer, who studied in Padua, Venice's local university, then in Pavia, from 1488 until 1495, who persuaded AD to go to Italy and would have had the opportunity to take him also to Rome, Florence and Milan, where his friend Lorenz Beheim had contacts with Leonardo. But Rupprich here stretches conjecture beyond reasonable limits.

AD certainly did travel from Nuremberg to Venice in the late summer or autumn of 1505. He left before the Frankfurt Fair began (15 August), probably before the plague outbreak at the end of July. He will have travelled on horseback, probably with a merchant's convoy. Texts 27–8 suggest he took the route via Salzburg, Villach and Ljubljana. By 6 January 1506 he was starting to prepare the altar panel for 'the Germans', but there is no evidence that it had been commissioned before he arrived in Italy. Giorgio Vasari (*Lives of the Artists*, 1550/68) believed that AD went to Venice to obtain legal redress against Italian painters and engravers who were imitating his work and using his monogram on counterfeit prints. AD had employed agents to sell his engravings and woodcuts since at least 1497, but there is no documentary evidence that he ever set out to bring such a lawsuit. The letters he wrote to Willibald Pirckheimer offer hints of likely motivations for travelling to Italy for a lengthy period. Having borrowed money from Pirckheimer to finance the journey, AD needed to earn enough to repay the loan, and his concern to make money from his art is evident in these and other letters. In the end he seems to have brought home a handsome profit (36.1). He had contacts with Nuremberg and Augsburg merchants in Venice and could expect work from them. He was looking to extend his knowledge of Italian art, and by February 1506 he is boasting of his contact with Bellini. At a later stage he looked for expert help with the science of perspective.

There is ample evidence that the appeal of Venice to Germans, particularly in Nuremberg, was in any case strong, be it in 1494–5 or in 1505–7. Since the early fourteenth century, German merchants are documented in Venice, including young men for whom learning Italian formed part of their commercial training. The Fondaco dei Tedeschi and the German Confraternity of the Rosary provided institutional support for residents, who included artisans and small traders as well as merchants, and for visitors. AD had easy entry to this community through his contacts with leading merchants from Nuremberg and Augsburg. His godfather, Anton Koberger, held the German agency for books printed by Aldus Manutius. German artists are known to have worked in Italy from 1395 onwards. It was in Northern Italy that young Nuremberg patricians were sent to university, usually to study law or medicine. Knowledge of Venetian art and culture, and respect for Venice as the greatest of

mercantile city republics, much larger and more powerful still than Nuremberg (which modelled aspects of its legal and administrative systems on Venice), were further factors which may have reinforced AD's decision to return to Italy.

AD refers in letter 6 to 'my little notebook' (*mein schreib püchle*, 29.6, note 3). This suggests that a more detailed record of his stay in Venice once existed. The purpose of his letters to Willibald Pirckheimer was different, though modern readers may be disappointed by their paucity of information about the painters AD met, the artworks he saw, the paintings he himself created (Mulazzani 1986 speculates that he could have met Raphael in 1505). As a biographical source, the letters are unique for their time. Pirckheimer was AD's closest mentor and friend for at least the last three decades of his life. As politician, soldier and diplomat for the imperial city, and as humanist scholar and linguist on the European intellectual stage, he was a major figure of his time. He was instrumental in helping AD gain access to classical mythology and literature, Renaissance culture and science. He introduced him to other humanists and to major patrons, and he encouraged and assisted the writing of the two treatises on art in the 1520s. Without Pirckheimer's financial support AD could probably not have made the journey to Venice in 1505. The letters seem excessively concerned with catering for Pirckheimer's luxurious tastes in precious stones, Greek books, oriental carpets and decorative feathers. His exploitation of AD as an agent for procuring high-class merchandise has parallels in Renaissance Italy. Compare Welch 2005, 262–70, on Isabella d'Este's 'mail order' networks in Venice between circa 1490 and 1506. AD feels obliged to flatter Pirckheimer for his military and diplomatic exploits and to pander to his rapacious libido. But even in these demeaning roles one may sense AD to be gaining in personal, social and cultural confidence as he explores the scope available to a new Italian-style artist, finally emancipated in the liberal climate of Venice from the craft ethos of Nuremberg.

AD's language is more varied and differentiated in the Venetian letters than in any other texts. The set titles and phrases in opening and closing formulae may derive from school instruction or one of the formularies and guides to rhetoric in German, like that of Friedrich of Nuremberg (circa 1450–60: Glück 2010, 138). But the range of styles within the letters is prompted by their shifting themes and subject matter, from the plain prose used to discuss business matters, through the racy, even obscene joshing of Pirckheimer the libidinous widower, to the macaronic satire of Pirckheimer the orator and diplomat in letters 7 and 8. Nowhere, sadly, does AD ever describe or convey his reaction to the wealth of paintings and artefacts he must have seen in the churches and public buildings of Venice. But neither Latin nor the vernaculars provided vocabulary or discourse adequate to that aesthetic and linguistic challenge (Baxandall 1971, 7, 45ff.).

Numerous passages – passed over in embarrassed silence by English-language translators and biographers from Conway (1889) to Hutchison (1990) – show that AD evidently had at least an oral command of the spoken Middle Venetian language of the city republic and its mainland territories (Ferguson 2007). In letter 5 AD suggests that his youngest brother should join him in Venice to learn the language, perhaps at a

Venetian-German language school, similar to the one run by Georg of Nuremberg in the Campo San Bartolomeo around 1425 (Rossebastiano Bart 1984; Ferguson 2007, 200–203). AD's written versions of Venetian are not garbled 'Italian' but transliterations by ear into his own Nuremberg German orthography. *Venexan*, the Venetan koine, never acquired a standardised writing system – but in the fifteenth and sixteenth centuries German too has only local or regional written forms. Within the city state *Venexan* had a status analogous to Tuscan or the Florentine *volgare*, as a language of cultural and aesthetic discourse, not blighted, as early sixteenth-century German was, by the hegemony of humanist Latin. Had Pirckheimer's letters to AD not been lost, the comparison of their respective German styles would have been instructive and would have cast a probably not unflattering light on the linguistic resourcefulness and individual character of AD's letter-writing.

[Reicke 1930; Rupprich 1930, 1957a & 1971; Amelung 1964; Eckert/Imhoff 1971; Holzberg 1981; Quednan 1983; Böhme 1989; Hutchison 1990; Martin 1993; Matthew 1999; Roeck 1999 & 2000; Ames-Lewis 2000; Sahm 2002, 62–85; Evans 2004; Luber 2005; Wirtz 2005; Oakes 2005; Ferguson 2007; Großmann 2007]

## 30   Letter of Lorenz Beheim to Willibald Pirckheimer

*[Bamberg, 9 February 1506]*
Let me know what our friend Albrecht Dürer is up to and where he is, and greet him from me. At the moment I have nothing on the go except what all the rest of us sons of Vulcan[1] are up to – eating, drinking and saying our prayers. Say hello to our friends. And last but not least our lady Porst.[2]

PBr 1, 330f., Letter 99. Latin text
R I, 253

NOTES

1   *mulciberi*: 'members of the family of Vulcan', the god of fire. These 'flame-bearers' are Beheim's fellow canons, obliged by the daily liturgical round to busy themselves with the lighting and extinguishing of altar candles.

2   Anna, wife of Nikolaus Porst, Beheim's sister. She appears in AD's second letter to Pirckheimer in the catalogue of his girlfriends, with the brush-rebus (29.2, note 15).

In Rupprich's text, last sentence, read *Et* for *Est*.

COMMENTARY

In his gossipy Latin letters Lorenz Beheim (BI) shows an avid curiosity about AD. This letter was written two days after AD's second letter to Pirckheimer from Venice.

On Beheim and his long correspondence with Pirckheimer, see Reicke 1906, Schaper 1960.

# 31 Works of Art

## 31.1 *The Feast of the Rose Garlands.* Oils on poplar-wood panel. A 93

AD depicts himself (for the first time *in assistanza*, as 'bystander' in a painted scene) at the right-hand edge of the middle ground, holding (also for the first time) a *cartellino* bearing the inscription:

Exegit quinque mestri spatio Albertus Durer Germanus · M D · VI ·

(Albrecht Dürer the German accomplished this in the space of five months in 1506)

The use of the verb *exigo* may distantly evoke Horace, Odes III, 30: *Exegi monumentum aere perennius* (Rupprich I, 211, note 17), but it is unlikely that AD himself made the link or formulated the inscription. The designation *Germanus* may reflect the painting's context in Venice and AD's rivalry with Venetian painters (29.2, 3, 5, 9), however it appears already in the unused inscription 11.2 of circa 1500. After the self-portrait of 1500, AD's only painted self-representations are as bystanders. He reports to Pirckheimer on 6 January 1506 that he is starting work on the panel, and by 8 September it is finished (29.1 and 29.8), so that it must have taken him closer to eight months' work. For the identification of the figures depicted on the altarpiece, see Wolf 2010, 252f. AD's letters trace the genesis of the panel. On his fur-clad self-portrayal, see Zitzlsperger 2008, 23, 48. On its removal from Venice by Emperor Rudolf II, who bought it for 900 ducats, and its later history, which have left it ruinously damaged, see Ex. Cat. Prague 2006; Martin 1998, 2006.

[Anzelewsky 1991, 191–202; Humfrey 1991, 1993, 120f., 265f.; Kutschbach 1995, 105–18; Ex. Cat. Vienna 2003, 326–37; Demele 2012, 116f.]

#### 31.1.1

A leaf in the BL Sloane papers, 5229, fol. 54 (R I, 216) has a note in AD's hand about the grouping of figures in the *Feast of the Rose Garlands*:

Bartholomew
The Doge kneeling

Beneath this, upside-down, in Willibald Pirckheimer's hand:

Ratio is the fusion of two quantities, partially a compatibility with one another.

[Sketches of rectangles and triangles]

These quantities have an opposed ratio, and always look to exceed one another.

### 31.2   *Madonna with the Siskin*. Oils on poplar-wood panel. A 94

Inscription on a cartellino lying on a table beneath the feet of the Christ Child:

Albertus durer germanus faciebat post virginis partum 1506

(Albrecht Dürer the German was painting this in the year since the Virgin gave birth 1506)

The Venetian, Belliniesque style of the painting and its strong echoes of the *Feast of the Rose Garlands* place it at the same time as, or immediately after, the major picture. AD returns here to the Plinian signature *faciebat* (McHam 2013, appendix 3, 347), but with a date more explicitly located in the Christian calendar. The inclusion of the infant John the Baptist is also an Italian feature. AD seems to have taken it back to Nuremberg, although it was formerly held to have influenced Titian's later *Madonna of the Cherries*. It passed into the Imhoff collection, and was purchased by Emperor Rudolf II. In the 1860s it was in the collection of the Marquess of Lothian in Edinburgh, from whom it was bought in 1893 for the Gemäldegalerie in Berlin.

[Ex. Cat. Vienna 2003, 354–6; McHam 2013, 193]

### 31.3   *Portrait of a Young Man Against a Green Background*. Oils on wood panel. A96

Same Latin inscription as 31.2.

Albrecht Dürer the German was painting this in the year since the Virgin gave birth 1506

The picture, presumably one of the unspecified portraits AD mentions in his letter of 25 September 1506 (29.9), was acquired by the Venetian patrician Gabriele Vendramin (died 1552) and went to Genoa in 1670, where it is now in the Palazzo Rosso.

### 31.4   *Christ Among the Doctors*. Oil on poplar-wood panel. A98

Inscription on a cartellino inserted into a large tome held by the doctor in the left foreground:

1506 [AD Monogram] opus q[u]inque dierum

(The work of five days)

AD's startlingly dramatic depiction of the twelve-year-old Christ arguing in the Temple with learned doctors (Luke's Gospel 2:46–52) is painted in a style unique in his whole work. It is taken to be the *ander quar*, the 'other', or 'second painting, the like of which

I've never done before', finished soon after the completion of the *Feast of the Rose Garlands* in September 1506 (29.9 and note 3). Its inscription manifestly alludes to the inscription on the altar panel. Done ostensibly in a mere five days, it is evidently meant to be perceived as a minor pendant to the major demonstration of AD's art, though also as proof of AD's *facilità*. Though the alleged span of the work on it may understate the reality in this case too, analysis of the paint shows that in its original state it was indeed applied thinly and at speed. Wolf 2010, 142, suggests that the inscription is meant not literally but as an expression of the Renaissance notion of *sprezzatura*, the spontaneity and sense of effortless creativity in the work of the virtuoso artist. The depiction of the Jewish doctors shows indebtedness to both Italian and Northern predecessors and contemporaries. It is not necessary to suppose that AD knew Leonardo da Vinci's grotesque faces. His own dating of the *ander quar* sheds doubt on the hypothesis that *Christ Among the Doctors* was painted in Rome, during an extremely short stay there, following his visit to Bologna in late October 1506, which AD looks forward to in letter 29.10. The Rome hypothesis rests on the discovery since 1944 of copy drawings of the painting which showed traces on the *cartellino*, after AD's monogram, of the words F[ecit] RO[MA?][E]. The painting too, when it was restored in 1958/9, showed traces of similar wording. However, the drawings found in 1944 have vanished in the meantime, and no trace is now visible of the wording on the painting. The current view is that the evidence of letter 29.10 is reliable and that *Fecit Romae* is likely to have been a later addition to the *cartellino*, reproduced in copy drawings. The history of the painting is unknown until it reached Rome at the end of the sixteenth century. In 1624 it was listed in the inventory of Cardinal Francesco Sforza, and from 1634 it was in the Palazzo Barberini. Since 1934 it has been in the Thyssen collection (Madrid, Thyssen-Bornemisza Museum).

[Anzelewsky 1991, 206–10; Strieder 2000, 183–8; Ames-Lewis 2000, 248; Ex. Cat. Vienna 2003, 338–54]

## 32    Sketch Elevation and Plans of a 'Venetian House'

### Introduction

Among the BL Dürer papers are four sheets, Sloane 5229, fols 167$^r$, 172$^r$, 173$^r$, 174$^r$, in a script consistent with a dating circa 1506 (S D 1506/1–4, R I, 213 and plates 40–43). The four sheets contain drawings of elevations and internal floor and roof plans of a building invariably identified as 'a Venetian house…not improbably represent[ing] the house in which [AD] lived' (Conway 1889, 47). Rupprich (I, 213) suggests that it is the house in which AD had his Venetian 'atelier', whilst fols 172–4 represent the floor plans of Peter Pender's lodging house (29.10, note 8), where AD presumably ate and slept. Rupprich further suggests that the four leaves – which are of differing dimensions – may have come from the *schreibpüchle* AD refers to in letter 29.6 [fig. 25].

Whereas fol.167$^r$ shows front and side elevations of a building, with floor layouts and ceiling vaults which clearly relate to it, fols 172–4 illustrate the plans of levels of a building which does not have any clear relationship to the one shown on fol. 167$^r$, though Rupprich presumes that they do and that the domestic arrangements depicted are those of a lodging house or inn. Fol. 167$^v$ has further sketch designs of vaulted ceilings.

Conway's never subsequently questioned guesswork and Rupprich's assumptions have been convincingly refuted in Oakes 2002, 2005, 2007. In particular, Oakes demonstrates that the house drawn on fol. 167$^r$ combines architectural and structural features of both Venetian and Nuremberg houses. Its windows are strikingly similar to the fenestration of the Palazzo Corner-Spinelli on the Grand Canal, built by Mauro Codussi in the 1490s, and the same architect's Palazzo Vendramin-Calergi of circa 1500–1509. However, the symmetrical square façade of the Palazzo Corner-Spinelli contrasts with the tall narrow front of AD's building, which opens onto a paved street, not a canal, and has a clearly marked cellar door at its bottom-left corner – a feature impossible in marshy, flood-prone Venice. The limited size of building plots and the high ground-taxes in Nuremberg dictated high narrow buildings. Water-spouts like those on the roof of the house were prohibited in Venice, where rainwater had to be collected in a cistern and stored for drinking. The high pitch of the roof (and its resultant gable-end) is characteristic of a northern climate, where rain and snow needed to be efficiently thrown off. Finally, the plain chimney contrasts with the distinctive Venetian pattern of inverted-cone pots. Given the meticulous accuracy which normally marks AD's drawings, it is unlikely that these striking differences are the result of lax observation.

AD's vaulted ground-floor hall and the additional vault designs on the reverse of fol. 167 are inappropriate for Venice, where the ground conditions made stone vaults structurally inadvisable. The stable AD provides would be redundant in Venice where people and goods were transported by water. Oakes points also to the provision of open stoves on upper floors, and to the location of the kitchen, as un-Venetian elements. Neither the internal layouts of fol. 167$^r$ nor those of fols 172–4 show any features specific to an artist's professional requirements, and in classifying rooms AD only ever uses the two terms *stub* and *kamer*, '(living-)room' and '(bed-)chamber', corresponding to the *sala* and *camera* in a contemporary Italian house (Oakes 2002, 4).

Oakes's radical new analysis of the so-called 'Venetian House' disposes of the notion that it represents a real building in the city that AD lived in and drew *in situ*. Rather, Oakes establishes that AD, either in Venice or after his return to Germany, sketched a house in Venetian style but which might feasibly be built in Nuremberg. In fact, two years after he returned home he bought the thoroughly late medieval house in the Zisselgasse which served him professionally and domestically until his death (53). Although his finances benefited from his stay in Italy, it is doubtful whether he could have afforded a modified palazzo, found craftsmen capable of building it, or persuaded the city authorities to permit it – or indeed whether he ever envisaged it as a realistic project. The drawing is more likely to have been a flight of fancy, born of the same

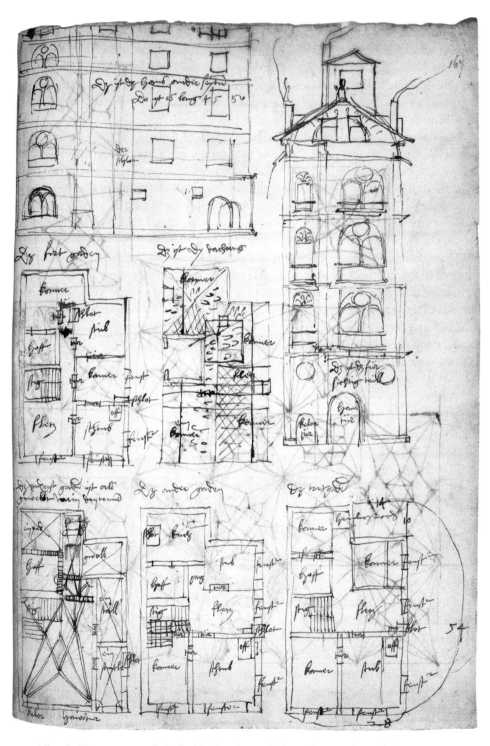

25. Albrecht Dürer, autograph leaf with elevation and plans of a Venetian-style house, 1496. BL 5229–167ʳ

desire to bring Italy to Germany and to marry Italian Renaissance with Northern Gothic, which expresses itself with rueful humour in his letters, when he contrasts the social and cultural status of the artist in Venice and Nuremberg – where, living in such a house, AD might have felt himself a gentleman, not a layabout (29.10). These architectural drawings and texts may appropriately be treated as a footnote to the letters from Venice.

A further group of sketches show other evidence of AD's interest in Venetian architecture. W 93, S D 1495/24, has on one side studies for a nude male figure and of a badger. On the other side are two buildings, one a large secular structure in Gothic style, the other part of a classical building with temple-like features. The latter has a Venetian-style chimney. Neither has been definitively identified. The very large Gothic building has some resemblance to the granary near Piazza San Marco, behind the Procuratie (Museo Correr) on the Grand Canal. It has also been suggested that it might be the Synagogue as shown on an anonymous drawing of the Canareggio, circa 1500. This sheet is held to date from AD's first visit to Venice. On the verso of the Sloane sheet 5229, fol. 167 (whose recto has the elevations of the 'Venetian House'), there are sketches of vaults and a classical pillar. There are further such studies on fols 168, 169$^r$ and 170. Fol. 171$^r$ has a section through a Gothic tower, the plan of a Gothic rotunda and the plan of a rotunda in the style of Leonardo da Vinci. These are also presumed to date from 1506.

Floor plans
Fol. 167r

*Front and side elevation:*
This is the front part. house door. cellar door.
This is the house from the side. There it is 46 56 long. The chimney

*Five plans representing 5 storeys:*

1  The bottom floor is vaulted as in the hallway. cellar. front door. courtyard. a bath. privy.$^1$ vault, door. a stable. door. a workshop.$^2$ chimney.

2  First upper floor. courtyard. stair. corridor. kitchen. chimney. door. living room. window. vestibule. window. chimney. door. living room, stove. window. window. door. chamber. window.

3  Second floor. courtyard. stair. chamber. window. privy. 14. 10. chamber. window. vestibule. window. chimney. door. living room. stove. window. 54. window. door, chamber. window. 28.

4   Third floor: courtyard. stair. door. chamber. chimney. door. living room. door, chamber. window. chimney. door. door. living room. stove. window. window. door. vestibule. window.

5   Fourth floor: This is the attic: vestibule. chamber. chamber. door. chamber. a chamber.

*Fol. 172*[r]

chamber. living room. sick room.[3] window. door. window. window. door. chamber. door. chamber. maid's chamber.[4]

*Fol. 173*[r]

stair. door. living room. stove. table. table. table. window. window. window. door. chamber. bed. bed. bed. bed. window. window. door. window. window, door, larder. window. window. door. kitchen. window. chimney. door. kitchen window. small bed. stove. door. living rooms. table. table. table. window. window. window. window. window. window. window. chamber. bed. chests. window. bed. window. latrine.[5] door. chamber. bed. window. door. midnight.

*Fol. 174*[r]

stair. living room. door. chamber. door. chamber. oven. small bed. stove. door. table. table. door. chamber. bed. bed. door. chamber. door, door, living room. chamber, kitchen. bed. stove. living room. door. chamber. chamber. living rooms. chamber. kitchen. living rooms. bed. stove. chamber. living room. chamber.

NOTES

1   *heimlich gmach*: Compare council resolution 1527 (242). Not literally a 'secret room' (Oakes 2002, 10), rather a 'private' one, that is a 'privy'.

2   *scnitle*: unclear. Rupprich: 'chopping room for fodder or wood'.

3   *sich stuble*: as English 'sick room' (DWb X, I, 852).

4   *mat*: Modern German *Magd*, 'maid-servant'. This is the only room explicitly designated as servant's quarters.

5   *scheishaus*: 'shithouse', rather than, as otherwise, the euphemism 'privy'.

## 33 Drawing of a Temple Front with Italian Architectural Terms

The double sheet has a meticulous ruled drawing of an Ionic entablature whose component elements are given Italian names in AD's handwriting and orthography.

163ᵃ

*Vnna gola tretta de cornisan*
*Vn quatretta*
*E lofelo*

162ᵇ

*E dentell*
*Vnna gola refersa*
*Vn pianetta*
*Vn vuserell*
*Vn quatretta*

(A cima recta of the cornice
A corona
An ovolo

Dentils
A cima reversa
A frieze
A fusarole
A fascia)

BL 5229, fol. 162ᵛ and 163ʳ
R II, 64f. and plate 20, 6.

NOTE

The entablature is the superstructure of stone layers which sits above the columns of a temple front, consisting, from the top, of the cornice, the frieze and the architrave.

*Cyma recta* is the wavy (Latin *cima*, 'wave') ogee moulding below the top fillet of the cornice, with the concave part of the curve uppermost.

*Corona* is the projecting squared (hence Italian *quadretta*) face below the cyma.

The *ovolo* is the moulding with a sectioned-egg shape, also known as egg-and-dart moulding or echinus (from Greek *echinos*, 'hedgehog' or 'sea-urchin') below the abacus band of the cornice.

Dentils (from Latin *dentes*, 'teeth') are small gapped rectangular blocks forming a band under the bed-moulding of the cornice.

*Cyma reversa* is a wavy ogee moulding with the convex part of the curve uppermost.

*Pianetta* is the term AD uses here for the frieze, the flat ashlar band below the cornice.

A fusarole (Italian *fusaiolo*) is the semicircular bead of the moulding usually beneath the echinus but here separating the frieze from the architrave.

AD's *quatretta* (see above 'corona') here designates the flat stone bands of the fascia of the architrave.

COMMENTARY

Rupprich was the first to reproduce this text from the manuscript. As he points out, AD has clearly written down these terms as he heard them spoken by an Italian informant. In a few cases he has perhaps misheard words, but in any case he writes them, in a way familiar from the Italian words and phrases he uses in his letters to Pirckheimer (see especially 29.7), in an orthography which derives from his Nuremberg dialectal German. That is to say, he renders – unsystematically – the Italian sounds he hears in his own non-standard written German spelling system. A further complication is that the Italian of his informant was evidently not early sixteenth-century proto-standard Tuscan, but a North Italian regional form.

Rupprich advanced the tentative hypothesis that what AD's informant spoke was Bolognese. If that were so, this small text could be claimed as unique proof that at the end of 1506 AD did indeed find an interlocutor in Bologna able and willing to assist him with aesthetic and art-theoretical matters (29.10, note 14 and commentary).

Further linguistic examination does not bear this out. The authority on Venetian language Ronnie Ferguson concludes that all the anomalous features in AD's terminology can be explained in terms of his aural reception of Venetian forms and of his transcription of them in his Nuremberg dialect graphology (see 29, commentary, and 29.7, notes 1–20). Thus *una gola tretta de cornisan* reproduces Venetian Italian *una gola dreta de cornison* (with *dreta* for Italian *dritta*, and *cornison* for *cornicione*, and with the Nuremberg vowel /a/ for /o/ in *cornisan*; compare examples in 29 such as AD's *strania* for *stragno* and both *czentillomen/czentllamen* for *zentilomini*). It is not the case that the form *dentell* for *dentelli* 'excludes Venetian' or that *cornisan* indicates Bolognese. In his commentary on the letters to Pirckheimer, Rupprich nowhere acknowledges the specifically Venetian character of AD's Italian, and he thus lacks an adequate context for the assessment of the vocabulary in this text.

[Cortelazzo 2007; Ferguson 2007, chapter 4; Cavallin 2010]

## 1507

## 34  Albrecht Dürer Purchases a Euclid Edition in Venice

This book I bought in Venice for one ducat in the year 1507. Albrecht Dürer

*Euclidis Megarensis philosophi Platonici Mathematicarum disciplinarum janitoris…Impressum Venetiis…in edibus Joannis Tacuini librarii accuratissma diligentia recognitum divinitatis MDV VIII kalendas Novembris.* R I, 221. The volume is now in the HAB, A: 22.5 Geom. 2°.

### COMMENTARY

AD's debt to Euclid's *Elements of Geometry and Optics* is documented in texts 51.2. His copy shows no evidence of use and is devoid of annotation. His letter to Nikolaus Kratzer in November 1524 (199.2) shows him still looking for a reliable German translation of it. This is the earliest evidence of AD aspiring to the status of *doctus artifex* (Białostocki 1984), the learned artist who participated in humanist book learning. See Eser 2008.

## 35  Letter of Konrad Fuchs to Willibald Pirckheimer

*[Augsburg, 12 or 16 February 1507]*
I did not keep Albrecht Dürer too long from you on this occasion.

PBr 1, 492. Letter 149. Latin text
  R I, 253

### COMMENTARY

It appears that Fuchs saw AD in Augsburg on the last stage of his journey back from Venice. The text seems to suggest that he had also entertained AD – for longer? – on his outward journey (see 27).

# 36 Seven Letters of Lorenz Beheim to Willibald Pirckheimer

## 36.1

*[Bamberg 13 February 1507]*
 Greet Albrecht Dürer in my name. I'd like to know just how much money he's made.

PBr 1, 493–5. Letter 150. Latin text
  R I, 253

NOTE

Beheim will have known from Pirckheimer that he lent AD money to finance the journey and about AD's commissions and earnings in Venice.

## 36.2

*[Bamberg 21 February 1507]*
I've heard from various sources that you debauched creatures have had a good time at Carnival[1] and brought in some travelling shows, *ballette italiane* or suchlike, plus a thousand other spectacles, right up to today. As if I blame you…Indeed if I had reckoned on you being so jolly in this bacchanalia, I wouldn't have stayed away. I too would have revelled along with you. But since it's all over, we have to think of the future. There's nothing left now but the penitential cell…
 Greet my, sorry, I mean *our*, Bearded One (as I suppose),[2] Albrecht Dürer.

PBr 1, 496f. Letter 152. Latin text
  R I, 253

NOTES

 1  *carnisprivum*: English 'carnival', also from Latin, means by etymology the deprival of or farewell to meat-eating. Shrove Tuesday was on 16 February 1507.
 2  Beheim repeatedly mocks AD's beard. See Reicke, Briefwechsel I, 501f., note 15, on the rarity of beards in Renaissance society, where they were generally regarded as odd, vain and heretical. See also Lazarus Spengler's satirical poem on AD and his riposte, texts 63.5–6.

[Grebe 2012]

**36.3**

*[Bamberg 1 March 1507]*
Remember me again and again and again to our friend Albrecht Dürer. Let me know if he's still trimming and crimping his beard.

PBr 1, 499–502. Letter 154. Latin text
R I, 253

**36.4**

*[Bamberg 8 March 1507]*
My greetings to friend Dürer. And how is it with his beard? – *fa me lo sapere.*[1]

PBr 1, 503f. Letter 155. Latin/Italian text
R I, 253

NOTE

1 'Do let me know': Like AD, Beheim sprinkles snatches of Italian into his letters. He, like Pirckheimer, had spent years in Italy.

**36.5**

*[Bamberg 7 March 1507[1]]*
My greetings to Albrecht Dürer. Pester him on my behalf to let me have a reply. I should like to get that picture finished before Easter.[2] But I am pleased that he has brought some fine mirrors.[3] Would that we could find amongst them even one in which we both looked handsome. For I couldn't stop myself laughing and laughing when I read what you wrote. So he still has his disgusting misshapen beard! That sets me off laughing still more!

PBr 1, 504–6. Letter 156. Latin text
R I, 253

NOTES

1 Reicke and Rupprich consider that 36.4 must precede 36.5 and that one of them is therefore wrongly dated.
2 The drawing or painting has not been identified. The following letter makes clear that its subject was a classical one.
3 The mirrors could well have been for use in self-portrait sketches. In Venice AD will have found flat mirrors, far more useful for the artist than the small convex mirrors

available in Germany. It was in 1507 that he drew his remarkable nude self-portrait drawing (W 267, S D 1503/18), scarcely feasible without a flat mirror. See Demele 2012.

## 36.6

*[Bamberg 19 March 1507]*

As to our Albrecht. I don't believe much badgering is needed in his case, if he is willing on his own part, and I shouldn't want it to become some great work that needs huge labours. Quite simply *un designo*,[1] with a certain flavour of the antique, just as I sketched for him in my last letter. But his beaky[2] beard gets in his way, which I'm sure he twists and curls daily, so that it looks like an imitation of protruding boar's tusks. *Ma il garzone suo* loathes *la barba sua*,[3] I know for a fact. For that reason alone he should make an effort to have a clean shave. But enough of that.

PBr1, 516–24. Letter 161. Latin/Italian text
  R I, 254

NOTES

  1   Sic. Italian *disegno* in Renaissance usage combines both 'drawing', 'draughtsman-ship' and 'composition' (Baxandall 2003, 83–5).
  2   *barba bechina*: 'Italian *bechino* is the grave-digger, presumably because – like the doctor at times of plague – he wore a mask with a long nose-piece (*becco*), filled with sweet-smelling herbs' (Reicke, Briefwechsel, note 6).
  3   *il garzone suo*: 'his boy', here 'apprentice'. 'Is the lascivious Beheim imagining an improper relationship?', Reicke wonders. Beheim could have come across stories or real cases of Italian artists' studios in which boys did more than grind colours. Leonardo's Salaì (Gian Giacomo Caprotti da Oreno) served his master as model and in bed.

## 36.7

*[Bamberg 23 May 1507]*

I have cast our Albrecht's nativity for him and am sending it to him too – he'll show it to you himself – and I believe I have set it up well, because everything seems to fit. He has Leo as ascendant house, which is why he is lean; at the end of the ascendant is Fortune's Wheel, hence he is getting rich, and because Mercury is in this house, that is evidence of his genius for painting. Since moreover Mercury stands in the house of Venus, that means he is an elegant painter. And because conversely Venus is in the house of Mercury, he is an ingenious lover. However Venus is separated from Saturn, hence they are in some

sense incompatible, yet that is of no account. Because Venus is turned towards the Moon, and the latter stands in a sign which has two bodies, he desires many women; but the Moon is turned towards the Dragon's tail, signifying rapine. And because five planets stand in the Middle Heaven, his deeds and works are manifest to all. Because Mars is in Aries, therefore he takes great delight in weapons, and because Mars is placed in the ninth house, it means that he loves to travel around. Since Jupiter is in the house of Substance, he will never be poor, however nothing of it shall remain. Because Jupiter in his descendant stands in Virgo, he shall have only one wife, according to Ptolemy, because the Moon is not turned towards any of the planets, indeed it is extraordinary that he has married even one wife. How much more can I say? If he were here with me, I might tell him other things, but let this suffice.[1] Give him my best regards.

*On the reverse side of the leaf:*
Note: according to Ptolemy's opinion, in Centiloquium 49, Dürer shall be your master. For he says that, when the ascendant house of the servant is the tenth house of the ascendant of the master, the servant shall rule his lord. The translation of Trapezuntius reads: 'when the ascendant of the inferior person is in the middle heaven of the lord, then the lord shall so trust in this servant that he will obey commands from him.'[2] I would write more but time does not permit. Farewell. Note: This is a decoction for the humectation of a beard. Take 5 parts of sage, 1 part of fresh rosemary tips, 15 parts each of marjoram, nettle root, myrtle leaves, red roses, 5 parts of camomile flowers. Make the required quantity of the decoction with river water and wet the beard with it.[3]

PB I, 538–44. Letter 170. Latin text
  R I, 254 and III, 455

NOTES

1   Rupprich advances a pleasingly circular argument: 'As Beheim himself says, the astrological calculations consistently agree with Dürer's nature and characteristics, with which Beheim was thoroughly well acquainted, so that this horoscope can be taken seriously as a source for Dürer's human qualities' – or less seriously as a self-fulfilling prophecy?

2   Reicke notes that the passage from Ptolemy's forty-ninth 'Centriloquium' is quoted verbatim from the Latin edition printed in Venice in 1493. Pirckheimer possessed a manuscript Latin translation. Georg Trapezuntius's translation of Ptolemy's *Almagest* was not printed until 1528, so that Beheim must have known this also in manuscript form.

3   *und netz den part mit*: the letter, as usual, and the recipe for a beard conditioner are in Latin but this closing phrase is in German.

COMMENTARY

Astrology was a branch of natural science in the Renaissance. Astrologers taught at universities and received pensions at princely courts. Horoscopes were forbidden by canon law because astrology denied the concept of free will. It was, however, generally respected by humanists because it had been widely practised in antiquity. Martin Luther disapproved of it, for all that he too rejected free will, but his lieutenant Philipp Melanchthon lectured on it at Wittenberg University. AD's inscription on the self-portrait of 1493: *My sach die gat / Als es oben schtat* ('My course is set / By the stars above'), seems to imply his belief in astrology.

[Rupprich 1954a, 221–3; Hale 1971, 314–16]

## 37 Albrecht Dürer Discharges the Annual Burden of four Gulden on the Family House in Unter der Vesten

I Sebolt Pfinzing the Elder,[1] citizen of Nuremberg, affirm publicly for myself and all my heirs, and make known to all men, that I have truly and honestly sold and given in purchase, and do sell and give in purchase with proper knowledge by virtue of this document, to Albrecht Dürer, also citizen of Nuremberg and legitimate son of the late Albrecht Dürer, goldsmith, and Barbara his wife, in lawful, permanent, final and irrevocable purchase, in compliance with correct and proven forms and laws of sale, as legally, effectively, and adequately as I should, can and may ever do, the superiority[2] together with the annual and perpetual ground-rent of four gulden in the city's common currency, payable always half on St Walpurgis's Day and half at Michaelmas, which I have had in, from, and over above the heritable property right of the said Albrecht Dürer the Elder and his wife in the house they bequeathed with all its rights and pertinences which lies here in Nuremberg, Unter der Vesten, on the corner, opposite Sebolt von Lochheim's house,[3] and to the south adjoining the house of Katherine Stromer, widow of Ortolf Stromer deceased,[4] for the aforesaid Albrecht Dürer [the Younger] henceforward to have and benefit from, use, collect and receive at the above named times, and as sole proprietor to do or not do as and whatever he will, unhindered by anyone henceforth for ever. I the aforenamed Sebolt Pfinzing pledge and promise also, for myself and my heirs, to transfer to the said Dürer and his heirs by this purchase the afore-defined superiority and ground-rent of this same house without any charge, payment and penalty, and to expedite and defend it against any man's objection or counter-claim, as accords with property right and rent and with the civic law of Nuremberg, since he has

honestly and faithfully paid and delivered to me a sum, namely one hundred and sixteen gulden in gold coin of the common currency of the land. For that I have declared him and his heirs in the name of my heirs and myself wholly and completely free and quit of obligation. And in validation of this sale I have delivered into his hands the documents and deeds which I possessed relating to aforesaid ownership and perpetual interest and payment. And all of that shall serve as testimony and proof. Thus I, the said Sebolt Pfinzing, have set my own seal on this deed and have further urgently requested the honourable Sebolt von Lochheim and Sebald Tucher, both citizens and appointed members of the Great Council in Nuremberg, also to set their seals along with mine on this deed in further validation of it. We the said Sebolt von Lochheim and Sebald Tucher[5] acknowledge that this has been done, though without detriment to us and our heirs. Given on the Saturday after St John at the Latin Gate,[6] the eighth day of the month of May, in the year counted one thousand five hundred and seven since the birth of Christ our dear Lord.

The original parchment charter with three attached seals is in the GNM.

R I, 226f.

## NOTES

1 In Albrecht Dürer the Elder's deed of purchase of 1475 (2.4), the holder of the superiority is named as Sebolt Pfinzing the Younger. Now, thirty-two years later, it seems unlikely that the superiority is being sold by his father, as Rupprich I, 226f. assumes. More probably, the 'younger' Sebolt has by natural process become the 'elder'.

2 *eigenschafft*: see 2.4, note 7.

3 The neighbour, member of an old Nuremberg family, had been godfather to AD's sibling Sebald in 1486 (1).

4 Stromer (died 1498) was a descendant of Ulman Stromer (1329–1407) who set up the first German paper mill in Nuremberg in 1390, and whose autobiography is a key source for the history of the late medieval city. Ortolf's wife Katherine belonged to the patrician Harsdörffer family.

5 Sebald (1462–1513), member of the powerful Tucher family, reappears in text 53, as owner of the superiority of the house AD bought in the Zisselgasse in 1509.

6 The saint's day marks the attempt to martyr St John the Evangelist by burning him in oil at the Latin Gate in Rome, related in the apocryphal Acts of John.

## COMMENTARY

AD, on his return from Venice, invested part of his earnings from commissions and sales of his prints in purchasing the superiority of his parents' house. The price is high,

116 gulden representing twenty-nine years of the annual duty of four gulden, but the possession of complete rights over the house must have greatly enhanced its value to the heritable proprietor. What induced a patrician family to sell a feudal-style superiority must have been in part at least the fact that ground rent was fixed and did not reflect changing values. Where the superiority was used as capital to supply an annuity, this inevitably became a fixed income with no protection against inflation or rising house prices. By allowing it to be redeemed, the redemption sum could be reinvested at an improved current interest rate, whether in a commercial venture or in a perpetual bond (*Ewiggeld*) with the city treasury. The current use of the house in 1507 is unclear. AD's father had died in 1502, and in 1504 he had taken his mother into his own household, though it is not clear where this was. After their marriage in 1493 it would have been normal for the young couple to have lodged with the wife's parents (the Frey family at that time had a large house on the Hauptmarkt). The wording of the Family Chronicle (1) suggests that he and Agnes may have rented the house in the Zisselgasse before they bought it in 1509.

[Smith 2012, 53f.]

# 38 Albrecht Dürer's Personal Record: Survey of his Financial Affairs

Item: what follows is a list of my possessions which I have earned through the toil of my hands, for I have never had the chance of greater gains.[1] I have also suffered substantial loss from lending money and getting no return on it. Likewise with travelling agents who did not account for their sales. Also one of them died in Rome and my goods went lost.[2] That is why, during the thirteenth year that I had been married, I paid off a large debt with the money I had earned in Venice.[3] Item: a fairly well stocked household, good clothing, pewter kitchen- and tableware, good tools, bedding, chests and containers, more than 100 Rhenish gulden worth of good artist's colours.[4]

The Personal Record (*Gedenkbuch*) is discussed in 15. This entry follows the description of the miraculous crosses (19) on the reverse of the single surviving sheet.

R I, 36

NOTES

1   To the end of his life AD complained that he was undervalued by patrons and inadequately rewarded for the quality of his work. However, he became one of the most esteemed and affluent artists in Northern Europe and at his death left an estate

comparable with that of one of Nuremberg's patrician merchants. His prints were sold in Italy, Germany and the Netherlands in large quantity by travelling salesmen and at trade fairs.

2   The fact that AD employed Jakob Arnolt (13) only on the condition that his brother provided a guarantee against loss suggests that earlier salesmen had indeed caused him problems. The incident in Rome is not further documented, although it was argued in the past that it was this that took AD to Rome in late 1506 or early 1507, where he painted *Christ Among the Doctors* – a journey which however is no longer thought to have happened (Strieder 2000, 183–8; 31.4).

3   AD married in July 1494. He returned from Venice in February 1507. Having borrowed money from Willibald Pirckheimer to finance the journey, he repeatedly assures him that he will repay it as soon as he can (29.1, 3, 5, 7). This is presumably the debt he has paid off.

4   Pigments and dyestuffs for artists' colours were expensive, as AD points out in letters to Jakob Heller (47.4, 5, 7). See his prescription for mixing ultramarine (85.2). He may have brought ultramarine back with him from Venice.

COMMENTARY

The brief account of AD's financial situation following his return from Venice in 1507 may be evidence that the notebook served in part as an informal accounting ledger. A detailed inventory of possessions was possibly attached to this record.

## 39   Dürer Makes a Tablet for the Sepulchre of St Sebald as an Appeal to Worshippers to Give Alms

In 1507 the churchwarden of St Sebald, Anton Tucher the Elder, wrote to the church's provost, Erasmus Topler, about the financing of the elaborate 'renewal' (*renouirung*) of the shrine of the church's and the city's patron saint. In 1488 a design had been prepared (much modified in practice) for encasing the silver shrine of the saint in an intricate architectural tabernacle – a kind of church within the church – with pillars, pinnacles and figures illustrating the life of Sebald, all cast in brass. It was the work of the major Nuremberg metal sculptor Peter Vischer the Younger and his foundry between 1507 and 1519. Tucher had collected 500 fl., but the entire cost would be a staggering 2000 fl., so a collection trunk (*stock*) was to be set up, with an inscription appealing to the faithful for contributions. The joint treasurers were to be the patricians Peter Imhoff and Sigmund Fürer. When he opened the chest on

30 August 1507, Fürer reported, it had yielded 10 fl. 12 shillings and 9 hellers. (Over the period 1507–19 the total raised was 1043 fl. 11 shillings 11 hellers). Fürer's account also lists the item

to the painter for painting the tablet [*teffalla*] on the trunk – 1 fl.

More explicitly Fürer records in a separate note:

† Jhs year 1507 † Item: on Monday after St Aegidius I paid Albrecht Dürer for a tablet on the collecting chest fl.1.

Schlemmer in Ex. Cat. Nuremberg 2000, 458 (citing Karl Krohn). See also Weilandt 2007, 541; Ex. Cat. New York/Nuremberg 1986, 387–91; Smith 1985b, 85

NOTE

It is surprising that AD took a fee for this small commission, given that St Sebald was his parish church where he was a devout worshipper, but the sum seems too large merely to cover expenses.

## 40  Work of Art

### Eve. Oils on wood panel. 1507. A 104 [fig. 26]

Inscription on a tablet hanging from the Tree of Knowledge:

Albertus Durer alemanus faciebat post virginis partum 1507

(Albrecht Dürer the German was making this in the year since the Virgin gave birth 1507)

The inscription is a variation on those of 31.2/3, the portraits painted in Venice. Contrary to Wolf 2010, 259f., *partum* refers not to the birth of the Virgin Mary, but to her giving birth to Jesus, or to Jesus as the 'offspring of the Virgin'. The pair of panels of Adam and Eve, done immediately after AD's return to Nuremberg, was sold to Johannes Thurzo, bishop of Breslau. He hung them in his study (*cubiculo*) and they were described in some detail by Jan Dubravius in 1516 (107). In 1569 they were in the possession of Emperor Maximilian II, then of Emperor Rudolf II in Prague, from where they were taken as booty by the Swedish army in 1648. Given by Queen Christina to King Philip IV of Spain, they are now in the Prado, Madrid. Like the engraving of *Adam and Eve* (26.1) they are an outcome of AD's studies of proportion

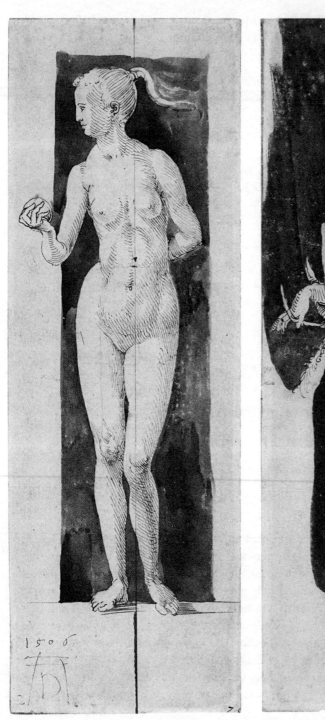

26. Albrecht Dürer, *Eve*, two pen drawings, 1506. BM 1846–9–18–10/11

since 1500, although the oil-painted panels are much less obviously 'constructed' and reflect stylistic influences of the year in Venice. A meticulous copy of the panels by Hans Baldung Grien was hanging in Nuremberg town hall by the early seventeenth century.

[Anzelewsky 1991, 212–16; Bonnet 2001, 185–96; McHam 2013, 193f.; Ex. Cat. Frankfurt 2013, 206]

## 41  Letter of Christoph Scheurl to Caritas Pirckheimer

*[Wittenberg September 1507]*
Meanwhile you have done me a very welcome service in that you have recommended me thus to your most distinguished brother, as a result of which he admitted me to his circle of friends.[1] When I was still a boy I saw him simply as a man of quite exceptional standing. Later, when his illustrious reputation reached my ears in Italy, or, to put it more correctly, when I discovered it for myself, I always wished I might be given some opportunity to inveigle myself into his inner circle.[2] Often I have earnestly discussed this very matter with our friend Albrecht, the second Apelles. Of course I shall now add the fact that you have brought off this bit of business for me to the other kindnesses which you daily bestow on me. I shall make every effort to render myself worthy of the friendship of the most eminent and learned senator, and of my adoption by a most excellent mother,[3] to both of whom I commend and entrust him also.[4]

CSB, Scheurl-Archiv, Cod. 306, fol. 360
R I, 255

NOTES

1   *in amicitiam tuam admiserit*: what is meant must be Willibald's, not Caritas's friendship. That is, either the manuscript or Rupprich's text has *tuam* instead of *suam*. The text is not as sent, but as copied by Scheurl into his record of letters. Caritas was in her way as forceful a personality as her brother and unlikely to have allowed him to choose her friends for her (see 125).

2   Scheurl (BI – born 1481) was a decade younger than Pirckheimer. Since both had been away as students in Italy, and Scheurl then also as professor in Wittenberg, they had had little opportunity to be acquainted with one another, for all that both belonged to prominent Nuremberg families. On the other hand, the Dürer and Scheurl family houses faced each other in Unter der Vesten, and AD and Christoph Scheurl had met in Bologna less than a year before the letter was written.

3   Caritas Pirckheimer (BI) was a figurative mother in the quite specific sense of being the abbess – the Mother Superior – of the Poor Clares whose nunnery was just inside the city wall of Nuremberg. Her sister Klara and two of Willibald's daughters, Katharina and Crescentia, were also nuns there.

4   Dürer, that is, who in 1511 dedicated his book of devotional woodcuts *The Life of Mary* to Caritas.

## 42   Georgius Daripinus Sibutus, 'Poem on Kilian's Fly'

One such as Praxiteles, learned in the art of painting,[1]
One like many others whom our age knows to be
Proven painters, namely the foremost glory among them,
Lukas the painter, lives here in the realm of our Prince.[2]
He deceived our eyes with the ugly hag whom he
Painted, his portraiture also depicts many girls[3]
Whom I saw at a time now long ago
And once knew well; his skill taught me as poet
To remember whose faces and figures they were.
I consider this man mastered the whole art of painting
And no one in all the world is now praised as his like.
Yet he would scarcely attempt to paint an importunate fly.
Albrecht, known as Dürer, would have trouble portraying this,
He who in this age has conquered the Venetians with his painting,
Or Ernest, the painter of Utrecht in the Netherlands,[4]
Who long ago sang songs together with me,
While I tilled the soil as an exile on foreign shores.

Georgius Daripinus Sibutus, *Carmen in tribus horis editum de musca Chilianea* (Leipzig 1507). Latin text
   R III, 461

COMMENTARY

The poem 'The Kilianic Fly' plays with the anecdote of how Sibutus's pupil Kilian Reuter sees on his teacher's bookmark the picture of a chiffchaff with a fly in its beak. He draws a fly himself (bookmark and drawing are both reproduced in a woodcut on the title page of Sibutus's book), but no one can tell what the drawing is supposed to be, and Kilian is admonished not to try drawing flies again. Even a professional artist like Lukas Cranach would be taxed by the challenge of convincingly depicting a fly.

That is true, Sibutus (BI) implies, also of Albrecht Dürer. Yet he might have known, if only from Christoph Scheurl who was also in Wittenberg by 1507, that AD had actually taken on the challenge and had painted a life-size *trompe l'oeil* horsefly over the white cloth on which Mary sits the Christ Child in the *Feast of the Rose Garlands*, the altar panel with which he 'conquered the Venetians' in 1506. And he certainly knew that it was Cranach who drew the fly on the beak of the chiffchaff on the title woodcut of his own *Carmen*. AD will have known about the fly as a test of verisimilitude for antique and Renaissance artists from humanist informants and from Italian and Netherlandish painting. Filarete (Antonio Averlino, circa 1400–circa 1469), in his *Trattato d'architettura* quotes the anecdote (which Vasari repeated) that 'Giotto as a beginner painted flies, and his master Cimabue was so taken in that he believed they were alive and started to chase them off with a rag'. This encouraged Francesco Squarcione to indulge in *trompe l'oeil* painting as a display of virtuosity, such as the earwig at the foot of the Virgin's throne in his altarpiece now in London, National Gallery (circa 1460). In his double portrait of himself and his wife, the Flemish painter known as the Master of Frankfurt (see note 4 below) includes *trompe l'oeil* flies investigating a plate of cherries and crawling on the woman's white head-dress. There are at least thirty surviving examples of *trompe l'oeil* insects on paintings before 1506. AD had painted a horsefly, a butterfly and a stag-beetle on his *Adoration of the Magi* (1504), but these have symbolic significance for the picture. He may have known the fly on Cima da Conegliano's *Annunciation* (1495) in Venice. *Trompe l'oeil* flies not uncommonly appear in conjunction with artists' signatures, as on the Venetian painter Jacopo de'Barbari's portrait of Luca Pacioli (circa 1495). The fly disappeared from AD's altar painting at some stage during its turbulent history (Martin 2006) but it is faithfully present on all three of the extant sixteenth- and seventeenth-century copies, one of which, now in an English collection, was probably that made to replace the original in San Bartolomeo in Venice when Emperor Rudolf II took AD's panel off to Prague. This fly was painted life-size on the finished surface of his picture and perhaps was meant to combine the functions of *trompe l'oeil* – demonstrating the painter's virtuosity – and religious symbol – as reminder of death and bodily corruption. For AD in Venice it may have been meant to silence critics who questioned his ability to paint *all'antico*, using a trick Renaissance artists perhaps as early as Giotto had devised to emulate Pliny's anecdotes about the *verismo* of Apelles and Zeuxis.

[Ames-Lewis 2000, 190–92; Anzelewsky 1971, 187–99 & figures 58, 65, 66; Rupprich 1970, 645f. on Sibutus & Reuter; Großmann 1975, 67; Schade 1980, 26; Konečný 2006]

NOTES

1   Praxiteles was, however, principally famed as a sculptor in bronze and marble. See Pliny *NH* 34, 69–71; 35, 122. 133; 36, 20–24. In Rupprich's text, line 1, for *Ovalis* read *Qualis*.

2 Sibutus's poem is primarily a eulogy of Lukas Cranach the Elder (1472–1553; BI) who in 1505 came to Wittenberg as court painter to Duke Frederick the Wise of Saxony and in 1506 had just completed the altar panel of St Catherine for Frederick's Castle Church. See also Christoph Scheurl's eulogy of the church (57).

3 Cranach's extant paintings up to 1507 offer no evidence for this claim.

4 According to Konečný 2006, he was perhaps the painter known as the Master of Frankfurt (active in the 1490s) or the Master of the St Bartholomew Altar in Cologne (circa 1510).

# 43 Letter of Albrecht Dürer to Johannes Amerbach

*[Nuremberg, 20 Oct 1507]*
To the honourable and wise Master Hans, printer in Klein-Basel,[1] my dear sir. Be assured of my willing service, dear Master Hans. Your good fortune is a particular joy to me, and hence I wish happiness and health to you and to all those whom you yourself wish well, and especially to your esteemed wife, to whom I send most heartfelt regards.[2] – And I beg you, be so kind as to write and tell me what good things you are producing, and forgive me for making you read my simple note. With that, a very good night. Datum Nuremberg, 20th October 1507.

Albrecht Dürer

Autograph manuscript in Basel University Library, Mscr. G. II 29, fol. 96ʳ
  Rupprich I, 61

## NOTES

1 Amerbach purchased a house in Klein-Basel in 1482.
2 He married Barbara Ortenberg, a widow, in 1483.

## COMMENTARY

Johannes Amerbach (BI) had a printing press in Basel from circa 1475. AD probably worked in Basel in 1492–4, though the attribution to him of woodcut book illustrations printed in Basel in these years is disputed. The firmest evidence has been held to be the woodcut block of *St Jerome in his Study* inscribed on the reverse 'Albrecht Dürer von Nörmergk', allegedly in AD's handwriting (3.8). It appeared in the *Epistolare beati Hieronymi* (Basel: Nicolaus Kessler, 1492), but a woodcut of St Ambrose in Amerbach's

edition of his complete works (also 1492) appears to be based on this woodcut, which suggests that AD could have been acquainted with Amerbach since his journeyman years.

The request for news of Amerbach's recent publications is evidence of AD's book culture and his interest in acquiring books.

[Braun/Grebe 2007; Kurth 1927, 10f.; Rupprich 1970, 487f.]

# Part 4

## 1508–1509

Foremost in the documentation of these years is the second major collection of AD's letters, those written to Jakob Heller (47) during the long gestation of the retable panel and wings painted for the altar commissioned by Heller and his wife for the Dominican Church in Frankfurt am Main (48). The first letter was written in late August 1507, but is included here in order to preserve the integrity of the whole set. In six of the letters AD assures Heller, or complains to him, that he is doing no other work but this, and in the last but one he vents his relief that now he can get back to more lucrative labours, to 'ordinary' paintings and engravings. And indeed, these two years were otherwise relatively unproductive. He had first completed the one other major oil painting, the altar panel of the *Martyrdom of the Ten Thousand Christians* for Duke Frederick the Wise of Saxony (March/April 1508, 44.1). Apart from that, the only further oil painting is the *Holy Family* (56) of 1509, decidedly an 'ordinary' piece. The altar for Sebald and Margareta Schreyer (45) was carried out by AD's workshop. Only a handful of engravings bear the dates 1508 or 1509 – four of the sixteen plates of the *Engraved Passion*, the production of which was clearly drastically interrupted by the Heller Altar, and two single plates: a Crucifixion and the *Virgin on the Crescent Moon* (both 1508). Just two woodcut blocks belonging to the *Small Passion* are dated 1509 (the whole cycle was published in 1511). Apart from the eighteen preliminary drawings for Heller's Altar, less than a dozen other drawings dated or securely attributed to 1508/9 are preserved. One of them, however, is the preliminary design for the *All Saints* altar ('Landauer Altar') and its Renaissance-style frame, dated 1508 (W 445), which AD then painted in 1510–11 (64.3–5).

The documentation of AD's personal life in these years covers two important events, his purchase of the house in the Zisselgasse (53–4) – probably financed from the proceeds of his stay in Venice – and his nomination to membership of the Great Council of Nuremberg (58), both of which mark his growing prosperity and prestige.

The self-portrait sketch (46), indicating an illness which might be malaria, is undated and only speculatively included here. Important expressions of the proliferating cult in humanist circles of AD as the new, German Apelles are two Latin eulogies by Christoph Scheurl (50 and 57), both associated (as is also the letter of Anton Tucher, 52) with AD's most eminent early patron, Duke Frederick of Saxony. The humanist connection is strikingly confirmed by AD himself, in his satirical drawing of Konrad Merkel (44.2).

Viewed within the entire corpus of AD's writings, however, the most significant contribution of these years is the group of texts (51.1–4) which testify to the first detailed plans and the earliest drafting of introductory passages of a comprehensive manual of painting. The conception emerges in this period immediately following AD's return from Italy out of his earlier studies of the geometry of the visual arts. Tracing the evolution of the manual and the elaboration of its technical and aesthetic concerns through the remaining two decades of AD's life, up to the publication of the treatises on perspective and human proportion in 1525/8, will be a central theme of the following sections of the documentary biography.

# 1508

## 44  Works of Art

### 44.1  *The Martyrdom of the Ten Thousand Christians.* Oils originally on wooden panel, transferred to canvas in the eighteenth century. A 105

Inscription on a paper attached to a staff held by AD as bystander in the left centre of the picture:

Iste faciebat anno Domini 1508 albertus durer alemanus

(This Albrecht Dürer the German was painting in the year of our Lord 1508)

AD's letter to Jakob Heller of 28 August 1507 (47.1) refers to the delay in his progress on the panel because of his ill-health. The following letter of 19 March 1508 indicates its imminent completion. Duke Frederick the Wise of Saxony commissioned the altar painting after AD's return from Venice. It was intended for the Castle Church at Wittenberg, where Frederick's vast collection of holy relics included bones of the 'ten thousand martyrs', the Theban Legion of St Maurice, slaughtered at the command of Emperor Maximian according to a fifth-century legend. The panel was based on AD's woodcut of the massacre (S W 35, SMS 104; circa 1495/6). At a late stage, AD added a representation of himself with Konrad Celtis in an unusually central, focal position. Celtis, AD's humanist mentor from circa 1500 onwards (10–11), who had also carried out literary commissions for Duke Frederick, had died of syphilis on 4 February 1508.

The epithet *Alemanus* may reflect Celtis's cultural nationalism (Smith 2012, 150). AD depicts himself in sombre mourning clothes, in contrast to his self-depiction on the *Feast of the Rose Garlands*. The altar panel was confiscated from Saxony by Emperor Charles V and given to Nicolas Perrenot, Cardinal Granvella, in Antwerp. It was bought from the Perrenot family by Emperor Rudolf II for 13,000 thaler in 1600 and hung first in Prague, then by 1619 in Vienna (Kunsthistorisches Museum). See also 57.

[Anzelewsky 1991, 216–21; Koerner 1993, 120f.; Kutschbach 1995, 101–4]

### 44.2 *Konrad Verkell*. Charcoal and ink drawing with brown wash. W 429, S D 1508/25 [fig. 27]

Inscribed above:

  hye Conrat Verkell altag 1508

(Here's Konrad Pig as ever was)

The startling image of a man with porcine facial structure and features, its bestial character intensified by being viewed at a steep angle from below, bushy-browed, with no eye-lashes but a beard like an animal fleece, can scarcely be classified among AD's portrait drawings. *Verkell* – German 'pig(let)' – is taken to be a punning distortion of the surname *Merkel*, and the drawing to be a satirically distorted image of the Ulm painter Konrad Merkel, a friend of AD who characterised him as having a quirky mind, and with whom he exchanged linguistic puns and humorous verse (63.7). AD alters the name Merkel to *Verkell*, and brings out animal features, or superimposes them on his face. Elements of Merkel's actual appearance may have prompted the comic distortion of his name. But there is also a learned dimension to this. Pliny, in his account of antique painters (*NH* 35, 114), says of the Greek painter Antiphilos, 'Among his comic pictures is one of a man called Gryllos ('Pig'), and this satirical genre of painting came to be called *grylloi*.' Hans Schäufelein, AD's assistant, puns on the proximity of his name to *Schäflein*, dialectally *Scheiflin* ('sheep or lamb'), and draws himself in 1512 as *Hanns Scheyffl das guott Schaif* ('the good sheep'). The inscription, the perspective similarly from below, the lidless animal eyes and the woolly beard he gives himself, echo AD's Konrad Verkel as another version of the notion that *nomen est omen*, and of classical artists' play with the habit of associating physiognomy with character and human traits with animal behaviour.

[Ex. Cat. Vienna 2003, 388]

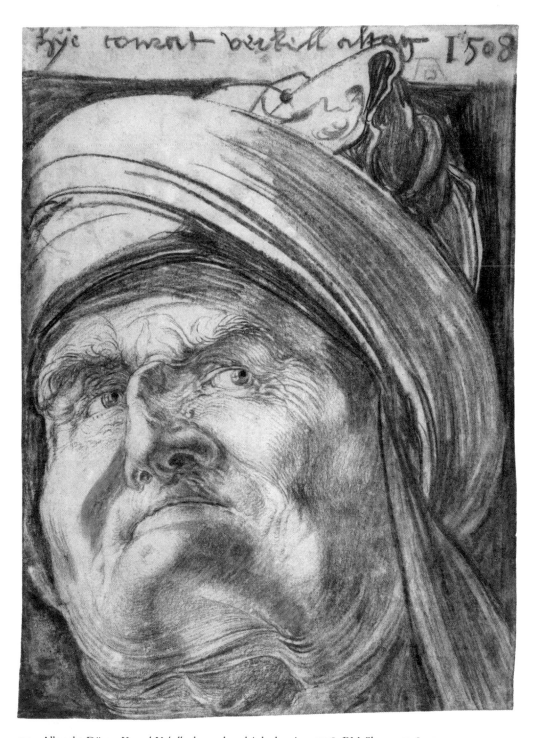

27. Albrecht Dürer, *Konrad Verkell*, charcoal and ink drawing, 1508. BM Sloane 5218–17

## 45 Dürer Receives Payment for Altar Paintings by his Workshop in the Church of Our Lady in Schwäbisch-Gmünd

*[Nuremberg, in Lent 1508]*
Item to the cabinetmaker for making the panel, wings, predella[1] and canopy[2] 10 Rhenish gulden.

To the woodcarver for carving the figures and the crucifix[3] 11 Rhenish florins.

For gilding the figures, canopy and other things 19 Rh. gld.

To the smith for mounting the metalwork[4] 3 pounds.

For colours and related materials 5 Rh. gld.

To two apprentices, each of whom spent 7 weeks painting the scenes,[5] for board and wages 14 Rh. gld.

To one more apprentice for more than one week's work underpainting and finishing 1 Rh. gld.

One more apprentice for 3 weeks' work painting the predella 2 Rh. gld.

To Albrecht Dürer for his trouble and for sparing his apprentices,[6] as honorarium[7] 7 fl. 5 lb. 12 d.

To his wife as a compliment 2 gld.

To the apprentices as tip ½ gld. and for other expenses 1 quarter.[8]

For framing the panels, to the cabinetmaker 1 gld and for fixing 1 quarter.

For transporting it to Gmünd 4 gld.

Total cost of the altar is 78 Rh. gld.

Sebald Schreyer's record of the building of the chapel of St Sebald and the donation of the altar panel in the church of Our Lady in Schwäbisch-Gmünd. Nuremberg, Staatsarchiv, Schreyer copybook, tome F, folio 138ff.

R I, 246f.

COMMENTARY

In 1505 Sebald Schreyer (BI) and his wife Margareta, née Kammermeister, took refuge in the town of Schwäbisch-Gmünd from a severe outbreak of plague in Nuremberg. On their recovery from grave illness they were persuaded by the vicar of the church of Our Lady, Hans Apenses, to found a chapel there dedicated to St Sebald, Schreyer's name saint and patron saint of the city of Nuremberg. The altar, for which AD may have sketched designs, was painted by members of his workshop. On the inside and outside of the altar's wings were painted twelve scenes, each depicting two or three episodes from the life of St Sebald, while the predella had half-length portraits of the Madonna and Child and of the Fourteen Holy Helpers, with at each edge the arms

of the Schreyer and Kammermeister families. On the inside of the doors of the predella was a painted Annunciation.

[For Schreyer, see BI; Strauss 1976; Hutchison 1990, 70; Anzelewsky 1971, 61]

NOTES

1   *sarch*: 'sarcophagus' – the 'predella', developed in the fifteenth century as a base for altar retables, it 'had the physical merit of raising the *Corpus* [the central body of the structure] above the altar table, so that it was visible and the wings could move freely'. In this instance it was clearly quite large (see the description above) though in width rather than height, so that the figures had to be depicted as half-length busts. For this and the names of other components of the retable altar, see Baxandall 1980, 62–9.

2   *gespreng*, also termed *Auszug*, *Aufzug* or *Aufsatz*. The 'crowning superstructure above the *Corpus*', with wooden vaulting, finials and foliage, often also carved figures in tabernacles.

3   The Crucifixion with the carved figures of angels, St Sebald, and the donors occupied the *Corpus* as the principal subject of the altar, hence their expensive gilding.

4   A smith was required for securing the statues in the *Corpus* and hingeing and mounting the wings.

5   *materien*: the narrative subjects from the life of St Sebald portrayed on the wings of the altar.

6   The work on the wings of the Schreyer altar must have overlapped in time with the painting of the wings of the Heller Altar (47–8). There is no consensus among art historians as to the identity of the workshop assistants involved, but they were probably not of the calibre of Erhard Schön or Hans Springinsklee (Anzelewsky 1971, 220f.). The assistants are referred to here as *knehte*. For a survey of a northern Renaissance master painter's workshop, see Nash 2008, chapter 14. Evidently the panels of the wings were painted and framed in Nuremberg.

7   *zu liebung*: the term makes it clear that the work on the altar wings and predella was not a commission but a favour on AD's part. For the customary 'compliment' paid to Agnes Dürer, see also letter 47.9 to Jakob Heller.

8   *orth*: See Money, Coinage and Currency.

## 46  Inscription on Dürer's Drawing of Himself Indicating a Symptom of Ill-Health [fig. 28]

*Self-Portrait Sketch of the Sick Dürer.* **Pen-and-ink drawing with watercolour. W 482 S D 1519/2. Date uncertain**

Inscribed above:

Where the yellow spot is and my finger is pointing to, that is where it hurts me

AD is pointing to his spleen. While Rupprich and Unverfehrt date the drawing to 1507/8, Winkler follows Flechsig's assessment of the script as circa 1510. Koerner assumes 1512–13. Mende (Ex. Cat. Vienna 2003, 232) chooses circa 1516, on the grounds of resemblance with the etching *Man in Despair* (S E 80, SMS 79). Strauss opts for 1519, when Pirckheimer reports AD being in poor health (135), and earlier art historians pointed to the severe malarial fever AD contracted in the Netherlands in 1521. An early dating is suggested by the vigorous and relatively youthful physique AD gives himself, and by resemblances to the nude self-portrait drawing of circa 1503 (see fig. 9) and to figures in the woodcut *Male Bathhouse* (circa 1496/7, S W 31, SMS 107). The inscription on the drawing of the head of the dead Christ (W 272, S D 1503/16) states that it was done when AD himself was ill (see 21.3). On 28 August 1507, AD excused himself for the delay in starting work on the altar for Jakob Heller by pleading: 'I have been afflicted with a long bout of fever, so that for several weeks I have been prevented from working on Duke Frederick of Saxony's commission' (47.1). That illness must have begun quite soon after his return from Italy. A painful spleen is one symptom of malaria, and it could be that AD originally contracted the disease in mosquito-ridden Venice or even in Nuremberg itself, and that chronic ill-health was perhaps severely aggravated by a further infection picked up in the swamps of the coastal Netherlands in 1521.

Although AD may have intended the drawing for the utilitarian purpose of helping a physician diagnose his condition, art historians have not been reluctant to probe the sore spot more deeply. Mende retitles the drawing *Self-Portrait as a Melancholic.* In ancient and Renaissance medicine, the spleen is the seat of melancholy, regarded since Aristotle as the psychic constitution of artists and great men. Koerner wishes to see the pointing finger as analogous to Christ displaying his wounds and indicating the spear-wound inflicted on the Cross (albeit on the wrong side of the body). This approach links the drawing with other Christomorphic self-representations of AD, for example Christ as Man of Sorrows (W 886, S D 1522/8).

[Rupprich I, 206; Koerner 1993, 176–9; Ex. Cat. Vienna 2003, 232; Unverfehrt 2007, 164f.; Röver-Kann Ex. Cat. Bremen 2012, 110–15]

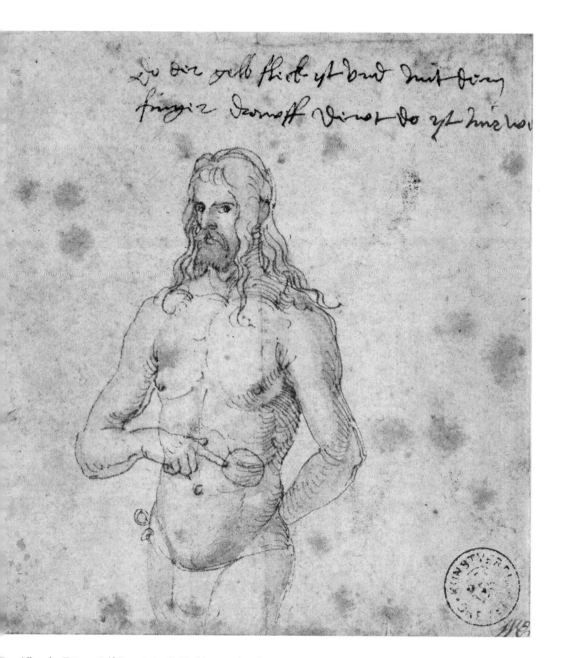

. Albrecht Dürer, *Self-Portrait in Ill Health*, pen sketch, circa 1508? Bremen: Kunsthalle KL–50

1507–1509

## 47 Albrecht Dürer, Nine Letters to Jakob Heller

## Introduction

Jakob Heller must have commissioned the altar panel of the *Assumption and Coronation of the Virgin Mary* (A 115K) from AD soon after his return from Venice in February 1507. These were busy months, in which AD completed the life-size panels of *Adam and Eve*, bought by Johannes Thurzo, bishop of Breslau (40), and started work on *The Martyrdom of the Ten Thousand Christians* (44.1). Heller's panel was intended for the chapel of St Thomas Aquinas in the Dominican Church in Frankfurt, where Heller and his wife were to be interred. Not surprisingly it had to wait its turn in the queue of major projects, and Heller's letter to which AD replied on 28 August 1507 was clearly a complaint about lack of progress. There is no evidence that patron and artist had made a formal contract (indeed no contracts survive for any of AD's works), a safeguard already becoming quite common in early sixteenth-century Nuremberg, and which would have headed off at least some of the issues which became bitterly contentious and still rankled with AD when he finally despatched the painting almost precisely two years later. However, surviving evidence for contracts between patrons and artists is meagre compared with fifteenth- and sixteenth-century Italy, where, for instance, the correspondence of a very different class of patron from Heller, Isabella d'Este, shows her having to cope with 'unaccommodating behaviour' from the likes of Perugino and Leonardo (Ames-Lewis 2000, 276–9). If we regret that the personal concerns of AD and Pirckheimer crowd out aesthetically and art-historically more significant disclosures in the letters from Venice, it may seem a pity too that disputes about the commission being behind schedule and over budget so dominate these letters to Heller – although it is likely that but for such issues there would have been no need for correspondence at all, and under provocation AD writes informatively about aspects of painting technique and the economics of workshop production.

The commission must have appeared mutually advantageous to both parties. Heller was exceedingly rich, a major patron of the Dominicans and other religious causes, and the altar was meant to be his and his wife's epitaph. AD's sense of his professional and artistic worth had been boosted by his success in Venice, he was in demand from prestigious patrons, and keen to place a substantial example of his art in Frankfurt, where it might impress other potential wealthy clients. In the end, for all the mutual irritations, the altar panel probably more or less met both his and Heller's expectations.

AD's letters from Venice already show him subsequently regretting what came to seem the inadequate fee he had agreed for *The Feast of the Rose Garlands*, and calculating what

he had forfeited in terms of other work, which would have brought a better return on his time. Later commissions from Emperor Maximilian I provoke similar complaints, and indeed throughout his career AD voices a sense of being undervalued and a financial insecurity which is belied by the evidence of his success and prosperity. Along with this sometimes peevish harping on his own misjudgement of the agreed price goes a growing exasperation at Heller's refusal to indulge his prevarications and artistic perfectionism. AD often struggles to sustain the deference due to a patron as their relationship comes close to breakdown. The letters contrast sharply in their professionally defined discourse with the more personal letters from Venice, underlining AD's grasp of differentiations of genre and linguistic register.

The lost letters of Heller would, one may guess, have shown the more straightforward impatience of a businessman used to getting prompt delivery of the goods he ordered. But there is much evidence which reveals him as a complex and characterful individual. Born circa 1460 into a prosperous mercantile family in Cologne, he married Katharina van Melem who brought with her a dowry of 7,570 fl. Heller established himself in Frankfurt as cloth merchant, landowner and banker, served several times as lord mayor, and represented the city on diplomatic missions and at imperial diets. With his wife he owned the principal hostelry in Frankfurt, the Nürnberger Hof, whose guests included the emperors Frederick III and Maximilian I, and distinguished visitors to the trade fairs. His detailed will and its codicils record an estate worth, at his death in 1522, some 20,000 fl. Out of this he left circa 3,000 fl. to charity: 1,350 fl. to the Dominicans, the rest to good causes such as the syphilitic, the poor and the homeless (for whom a shelter with under-floor hot-air heating was to be built). In his stead, a surrogate pilgrim, dressed in his old clothes, was paid to pray for his soul in Rome, Loretto, Venice, Einsiedeln and Cologne. His few surviving relatives shared the remaining 17,000 fl.

Heller was not simply a stereotypical late medieval Croesus whose treasure, though laid up on earth, might through charity still buy him salvation. From 1472 to 1475 he had studied the liberal arts at Cologne University, where an uncle was a professor. His library included two Latin bible manuscripts, theological manuscripts and printed books. He had contacts with the humanists Johannes Cochlaeus and Willibald Pirckheimer. Four letters he wrote to Pirckheimer survive. In April 1518 Heller thanks him for a medicine to alleviate pains in his head: 'I'll give it a try, although, thank God, things are not bad; it's just that I fear it might get worse now I've reached sixty...I blame it on kneeling over women and girls more often than kneeling in church. Could that be where your illnesses come from too? But we must put up with suffering here on earth, it's better than doing it in the next world.' The following month he reports on the boy he has fathered with a miller's wife. He has bribed canons from the cathedral to baptise the child and speculates that they do it because they suspect it may be the bastard of one of them. By November 1518 he claims to have parted from his mistress in Cologne and (if only temporarily) reformed his life: 'I've said farewell to the Three Wise Men [the

patron saints of Cologne], my friends, and above all Jungfer Deyltey, I shall stay here [in Frankfurt], serve God, look after the house, for I value the world no longer...that's what being sixty does to you.' Heller's written German is strongly dialectal, colloquial and crude, and makes AD's by comparison seem smooth and refined. How the cynical persona of this old devil related to the lavishly pious benefactor of the Dominicans is a not unfamiliar puzzle in the last decades of medieval Christendom.

[PBr III, 309f., 317f., 428f., Letters 533a, 539, 563a]

AD was personally and solely responsible only for the focal component of Heller's altar, the central panel of the *Assumption and Coronation of the Virgin Mary*. He himself had a particular devotion to the Mother of God (see his devotional verse, 63.8–27). He had possibly seen Raphael's *Coronation of the Virgin* in Rome in 1506/7. The Frankfurt panel was visible only on Sundays and feast days. The wings which otherwise concealed it were the work of his assistants. They showed, when opened, St James the Elder and St Catherine, the name saints of the Hellers who are kneeling below them. When closed, they showed in grisaille other sacred figures to whom the Hellers were devoted: the Three Kings, Sts Peter and Paul, St Christopher and St Thomas Aquinas. At some point, possibly only after AD's panel and the inner wings were delivered, Heller commissioned a further two outer wings from Matthias Grünewald, with depictions of Sts Laurence and Cyriacus, St Elizabeth and an unidentified female martyr. These are in superior grisaille and create a convincing semblance of stone carving.

On New Year's Eve 1513, Heller drew up a charter enumerating his donations to the Dominican priory, confirming the gift of the altar and stipulating the daily masses and other liturgical rites to be performed in the chapel. These dispositions were confirmed in his will of 1519. When Prior Johannes Dietenberger confirmed receipt of the legacies in April 1523, he had to promise that some of the gifts, such as vestments, would never be sold by the friars. Heller attached no such condition to the altar itself. According to Carel van Mander and Vinzenz Steinmeyer, it attracted a stream of prestigious visitors in the later sixteenth and early seventeenth centuries, who paid sizeable fees to have the wings opened and AD's painting displayed. Indeed, offers to buy it were not lacking, even for little bits of AD's panel, such as the feet of a kneeling apostle, AD's preparatory drawing of which is extant (W 464). The priory spurned these bids, even that of the Dürer-collector Emperor Rudolf II, but in 1614 Prior Johannes Kocher and his friars received a donation from Prince Elector Archduke Maximilian of Bavaria of an annual income of 400 fl., convertible at any time to a lump sum of 8,000 fl., made 'out of particular affection to the Dominican Order'. In no doubt pre-arranged gratitude, the Prior, out of reciprocal 'special affection' for the Wittelsbach house, gave the prince the 'far-famed Dürer panel so desired by Your Grace and until now preserved as a particular treasure of our convent'.

It is apparent that Archduke Maximilian valued AD's letters to Heller as an integral element of this acquisition of the altar panel. Already in 1607 he had commissioned a copy of it from a Frankfurt painter Friedrich Falckenburg, at a cost of 250 thaler.

Falckenburg was able to borrow from Jakob Heller's descendants a copy of the auto-graph letters still preserved by the family. A condition of the Archduke's purchase of the panel was that he would have a new copy made to replace it on the altar itself. An intermediary, David Kresser, recruited a Nuremberg painter, Jobst Harrich, to make this new copy in Frankfurt, prior to the original being packed up for transport to Munich. In the course of interviewing Falckenburg for useful hints to pass on to Harrich, Kresser stumbled on the fact that Falckenburg had access to the Heller fam-ily's copy of AD's letters: 'When I asked him how long he had taken to paint his copy of the panel, he said six months. When I expressed surprise, he said Albrecht Dürer had worked on it continuously for thirteen months. This horrified me and I asked how he knew that. He replied that he had read it in Dürer's own handwriting and could show me copies' (Kresser to Archduke Maximilian, 11 August 1613; R I, 62f.). Kresser was allowed in strict confidentiality to make a new copy of the letters for the Archduke.

AD's *Assumption and Coronation of the Virgin* no longer exists. It perished in a fire that ravaged the ducal residence in Munich on 14–15 December 1729. Harrich's faithful but necessarily inferior copy is now in the Historisches Museum in Frankfurt, together with the inner wings painted by AD's workshop, and the upper pair of Grünewald's outer wings. The lower pair are in the Staatliche Kunsthalle, Karlsruhe. Eighteen of AD's superb preparatory drawings for the main panel survive (W. 448–65, nine of them in the Albertina, Vienna).

[Weizsäcker 1923, 141–244, 348–55; Diemer 1980; Bonnet/Kopp-Schmidt 2010, 204–8; Boockmann 1989; Reicke/Scheible 1989; Schmid 1994; 2003, 352–66; 2007; Kutschbach 1995, 70–87; Decker/Damaschke 2002; Ex. Cat. Vienna 2003, 358–71; Reuter 2007; Nash 2008, 21f.; Grebe 2013, 59–62]

The autograph letters are likewise lost. After Heller's death in 1522, his marriage being childless, they passed according to the terms of his will to the children of his eldest sister Agnes von Rhein. At least until 1607 they remained in family hands, as the letter of David Kresser (see above) makes clear. Of the two early seventeenth-century copies attested by Kresser, the one lent to Friedrich Falckenburg by the Heller heirs in 1607 has disappeared with the originals. The copy Kresser made from it for Archduke Maximilian of Bavaria in 1613 was in the State Library in Munich until at least 1870, but by 1893, when Konrad Lange and Franz Fuhse published their edition of the Dürer *Nachlass*, it too had vanished. Heller's letters to AD have also not survived and, like Pirckheimer's and others', may have been destroyed after AD's death in 1528. Rupprich's text, on which this translation is based, is a collation of older printed texts:

Friedrich Campe, *Reliquien von Albrecht Dürer seinen Verehrern geweiht* (Nuremberg 1828), based on a copy supplied to him by Joseph Heller (no relation!), who presumably made it from the Munich text;

Otto Cornill, 'Jacob Heller und Albrecht Dürer', in *Neujahrs-Blatt des Vereins für Geschichte und Alterthumskunde zu Frankfurt am Main* (1871), collated with the Munich copy;

Konrad Lange & Franz Fuhse, *Dürers Schriftlicher Nachlaß* (Halle 1893), based on Cornill's printed text and collation.

R I, 61–74

**47.1**

*[Nuremberg, 28 August 1507]*

Be assured of my willing service, dear Herr Heller. I was delighted to receive your kind letter. But please be aware that until now I have been afflicted with a long bout of fever, so that for several weeks I have been prevented from working on Duke Frederick of Saxony's commission, to my great disadvantage.[1] Now, however, his work is after all getting finished, for it is more than half done. So be patient about your altarpiece. Once I have completed this work and despatched it to the aforementioned Prince, I shall straight away get on with yours, as I promised you when you were here.[2] And although I have not started it yet, I have bought the panel from the carpenter with the money you gave me.[3] He would not knock anything off, even though it seems to me it was more than he deserved. And I have taken it to a preparer who has primed and coloured it, and will gild it next week.[4] Up to now I have not wanted to accept an advance on that, until I begin painting the panel, which, please God, will be my next job after the Prince's commission. It is just that I do not like to take on too much at one time, so as not to be overwhelmed. In this way I shall not keep the Prince waiting by working on his and your panel at the same time, as I first meant to. But console yourself with the knowledge that, as God grant me and to the best of my ability, I shall create something that not many men are capable of. With that, a very good night. Given in Nuremberg on St Augustine's Day 1507.

<div align="right">Albrecht Dürer</div>

NOTES

1 AD had painted a portrait of Duke Frederick (A19) during his visit to Nuremberg in April 1496. The Duke then ordered from him the altarpiece known as the *Seven Sorrows of the Virgin*, only dispersed panels from which survive (A 20–38V). *The Martyrdom of the Ten Thousand Christians* was commissioned in 1507 (44.1). On the fever AD had been suffering from, see 46.

2 *als ich euch hie zusagte*: the formulation suggests a verbal agreement, not a written contract.

3 AD received this initial down payment for materials from Heller himself, but later payments were passed through Hans Imhoff. As AD then explains, he does not want an advance on his own fee until he has begun painting. A carpenter would cut planks of the specified wood and construct the panel to size, also carve and attach a frame (Brandl 1986, 58; see Heydenreich 2007, 39–89 on Cranach's panels; Nash 2008, 201–3).

4 *geweist, geferbet…vergulten*: Grounds commonly used were of gesso, or white colour bound with glue and chalk as a filler, though AD sometimes mixed lead white with red lead. A pigmented intermediate layer, known in Italy as the *imprimatura*, was intended to adjust the surface properties of the ground. On the role and employment of the 'preparer' (*zubereiter*), see Nash 2008, 189. Gilding at this stage was presumably applied to the interim frame and the edge of the panel (there is no evidence that any part of the panel painting involved gilding). (See Luber 2005, 78–80; Heydenreich 2007, 93–103; Letter 29.1 from Venice, note 6.)

## 47.2

*[Nuremberg, 19 March 1508]*

Dear Herr Jakob Heller,

Be assured that in a fortnight I shall be finished with the work for Duke Frederick. After that I shall start on your commission and, as is my practice, do no other painting until it is complete. In particular I shall concentrate on painting the central panel with my own hand. But that apart, the outer panels which are to be stone-coloured have also been completely set out, and I have had them underpainted as you specified.[1] I wish you might see my gracious lord's panel. I am quite sure it would please you. I have spent the best part of a year on it and made scant profit from it. For I shall get no more than 280 Rhenish gulden for it, and have used up pretty much every single one in expenses. That's why I say that, if I were not doing it as a special favour to you, no one would persuade me to take on anything at a fixed price. For that way I miss out on better jobs.[2] Enclosed I send you the measurements of the panel, length and breadth.[3] A very good night. Given at Nuremberg on the second Sunday in Lent 1508.

Albrecht Dürer

NOTES

1 *seind die fliegel auß wendig entworffen, das von stainfarb wirdt, habs auch vndermallen lassen*: as becomes clearer in letter 3, AD is talking about the back of the panels, seen when the altar is closed, not about the open faces which are painted in oil colours. The verb *entwerfen*, 'draw, sketch, set out', refers to the process of underdrawing with a pointed brush or pen and a dark pigment on the primed surface, to indicate outlines and volumes, one of the senses of Italian *disegno* (Baxandall 2003). It seems likely that AD himself would have provided the design for his assistants, and it is possible that this drafting is what Heller paid Hans Dürer 2fl. for (letter 9). The building up of

paint layers, *untermalen*, then followed and is more fully described in letter 3. Evidently Heller himself had specified that the wings should be in grey-scale, *grisaille*, simulating stone and giving the altar, when closed, the appearance of a carved-stone retable (Nash 2008, 204, 243–5). The outer wings which Grünewald supplied are much more successful in their resemblance to carved statues (Krieger 2007). Heller and AD had clearly also agreed the division of work between the panel and the wings at the outset. (On craft co-operation and division of labour in an early sixteenth-century workshop, Heydenreich 2007, 275–318)

2  AD signals already that his dissatisfaction with the fee paid him by Duke Frederick applies with at least equal force to this new commission.

3  The dimensions of the central panel determine those of the wings and the architectural frame of the altar. Heller may have asked for them in order to instruct a carpenter, but it is equally possible that he was now commissioning Grünewald to prepare the outer wings.

## 47.3

*[Nuremberg, 24 August 1508]*
Dear Herr Heller,
I have safely received your latest letter and note what you say, that I am to make a good job of your altarpiece, as indeed I have it in mind to do. Let me bring you up to date with progress on it. The outside of the wings has been painted in stone-colour, though not yet varnished, and on the inside they have been completely underpainted, so that we can begin to apply the colouring. And the main panel[1] I have set out with utmost care, taking a long time over it, and it has been undercoated with two very good layers of colour, so that I am now starting to underpaint it. For I intend, once I have your approval, to underpaint some four, or five, or six times, for maximum clarity and durability,[2] and also to paint with the finest ultramarine I can muster.[3] Moreover no one else except me shall paint a single brush-stroke of it, and so I shall spend a great deal of time on it. For that reason I am confident you will have no cause for concern, and this is why I have decided to explain to you my considered opinion – that I cannot carry out your commission for the fee of 130 Rhenish gulden because of the loss I'd incur. For I shall lose a lot of money and time. However, what I agreed with you, I shall faithfully keep to. Should you not want it to exceed the price we contracted, then I shall do the panel in such a way that it will still be very much better than befits the fee. But if you are prepared to pay me 200 gulden, then I shall carry it out as I originally proposed.[4] And even if somebody offers me 400 gulden, I won't paint another such one, for I don't know how I'd make a penny profit on it, given the long

time it would take me. So let me know your view, and once I know, I shall take 50 fl. from Imhoff. For so far I've had no advance.[5] With that I commend myself to you.

Let me say incidentally that in all my days I have never taken up a commission which gives me more pleasure than your panel that I'm now painting. I shall do no other work until I've completely finished it. I'm only sorry that winter will so soon be upon me, for when the days grow short, one gets so little done.

One more thing I must ask of you. The Madonna you saw in my workshop – may I ask, if you know anybody in Frankfurt who is looking for a panel, could you offer it to them? If a proper frame were made for it, it would be a lovely panel. You know that it's a flawless piece of painting.[6] I'll let you have it at a good price. If I were to do a new one, I'd not take less than 50 fl, but seeing that it's finished, it might get damaged if it's lying around my place. So I would give you authority to let it go as a bargain at 30 fl. But rather than leaving it unsold, I'd give it away at 25 fl. I must have spent plenty on it.[7] A very good night. Given in Nuremberg on St Bartholomew's Day 1508.

<div align="right">Albrecht Dürer</div>

## NOTES

1  *capus*: both Campe and Cornill have this word-form which may therefore derive from the Heller heirs' copy or from the original letter. It must stand either for *caput*, Latin 'head', i.e. principal part of the altar, or for *corpus*, Latin 'body', also 'framework'. AD would have been familiar with this latter term, used in the fourteenth–fifteenth centuries by sculptors for the central 'body' of a retable, the shallow box at the centre of the altarpiece which houses the principal carved figures (Baxendall 1980, 66).

2  Underpainting here refers firstly to the paint layers applied over the ground of the panel, after underdrawing and before painting proper began – the priming known as *imprimatura* which ensured that the absorbent chalk ground did not soak up subsequent paint layers. Secondly, underpainting denotes the process of building up the first layers of colour, which served both the tonal organisation of the entire painting and the modelling of local and individual areas of the panel. The number of layers AD specifies might apply to different parts of the whole and will reflect the patron's expectations of the quality of the final product (see Nash 2008, 204; Heydenreich 2007, 93–113, 177–82; Hess/Mack 2012, 192).

3  AD mentions the use of top-quality ultramarine in underpainting in order to emphasise the high quality of this picture – he is not stinting by using a less expensive azurite blue pigment beneath the final surface as he did in *Lucretia* (A 137, 1518).

Ultramarine (literally 'from overseas') is an intense blue pigment made from the mineral lapis lazuli. It was traded into Venice from Badakshan in modern Afghanistan and was used in northern Europe in this period especially in Netherlandish panel painting. The Virgin Mary was traditionally depicted in a deep blue gown. AD may have brought a supply of the pigment from Venice (in letter 4 he quotes its purchase price in ducats); later he bought it in Antwerp (162). Cheaper alternatives were azurite (*lasurblau*, 330) and smalt (*blawglasur* – blue potassium glass). See Baxandall 1988, 11; Burmeister/Krekel 1988; Heydenreich 2007, 150–58; Nash 2008, 87, 200f., 207f.; Hess/Mack 2012, 187f.

4   At all events AD is signalling here a revision of his arrangement with Heller. If the fee of 130 Rhenish florins is not increased, then Heller will get an altar of lower quality than first agreed, though AD insists that it will still be much better than the fee merits. The quality originally agreed can be had only for the higher fee of 200 fl. – though even then, AD insists, he will lose heavily on the deal. A typical written contract of the time would have contained a clause allowing for renegotiation of the artist's fee, if necessary through arbitration. AD is on weak ground, however, in that he can cite no new factors to explain the steep increase in price. It is clear that his initial quotation for the work was too low. Survival of or evidence for contracts north of the Alps are rare (Nash 2008, 22). Exceptions in Nuremberg include the contracts between Adam Kraft and Sebald Schreyer for the Schreyer/Landauer family tomb in St Sebald's Church (1490; Möncke 1982, 374f.), and between Adam Kraft and Hans Imhoff for the Sacrament House in St Laurence's Church (Huth 1925, 120–22). See Brandl 1986, 55–7, on Nuremberg and Baxandall 1988, 8–11, on Italian contracts.

5   Payment was customarily in the form of an inclusive sum, often paid in instalments to cover running expenditure on materials. Hans Imhoff was Heller's bank agent in Nuremberg.

6   Rupprich (R I, 67) endorses Panofsky (1948, no. 28) in identifying the *Maria bildt* as the *Madonna with the Iris* (A 106V). But this painting has been deleted from the Dürer canon as a later sixteenth-century imitation of AD's style, with forged monogram and date (1508). See letter 4, note 9.

7   *Mir ist wol viel speis darober gangen*: early modern German *speis(e)*, 'food', 'nourishment', was a medieval loan-word from Church Latin *spesa*, 'costs, expenses'. AD's sentiment might be 'it has taken a lot of food out of my mouth', but he might have recognised the link between *speise* and Italian *spese*, which kept the Latin meaning 'expenses'.

**47.4**

*[Nuremberg, 4 November 1508]*

Dear Herr Jakob Heller,

Recently I wrote you a letter expressing my intentions honestly and in all innocence, and you complained angrily to my relative,[1] and were heard to say I was going back on my word. Since then I have also received from Hans Imhoff your reply to the same effect, at which I take justified offence, given my previous letter. For you accuse me of not keeping my promise to you. Everybody will acquit me of that, for I reckon I behave fairly towards other honest people. I know full well what I have written and said to you. You know yourself that, when we were in my relative's house,[2] I did not want to undertake to paint something 'good' for the reason that I am not capable of it. But what I did agree to do was to paint for you something that not many men can.[3] The painstaking care I specified, I have indeed devoted to your panel, which then caused me to send you the letter in question. I am sure that when the altarpiece is finished all who know about art will be delighted with it. It will be valued at 300 fl. if not more. I wouldn't take three times the money promised to paint another one like it. For I am losing time and money and earning your ingratitude. I assure you I am using the most exquisite colours I can get. That costs me 20 ducats just for ultramarine, quite apart from the other expenses. I'm confident, once the altarpiece is done, you will say yourself that you've never seen anything more beautiful. At the same time I can't see myself painting the centre panel from start to finish in less than thirteen months.[4] I shall do no other work until it is ready, even though that's to my great detriment. For what do you imagine my living costs are? To pay my upkeep you wouldn't get away with 200 fl. You often refer, when you write, to materials. Were you to have bought 1 lb of ultramarine, you would scarcely have got it for 100 fl. For I can't buy a decent ounce for under ten or twelve ducats.[5]

And so, dear Herr Jakob Heller, my letter is not as totally out of order as you believe. Nor does it mean that I have broken my word. You also keep accusing me of having promised to paint the panel for you with the utmost care that I can. That assuredly I didn't do, unless I was off my head. For with the utmost care I barely trust myself to finish it in my entire life. With great care I can scarcely paint one face in half a year. Now the panel has roughly 100 faces, not counting drapery and landscape and the other things on it.[6] It would be quite unheard of to paint things on an altar so painstakingly. Who would even see them? But what I believe I wrote to you is this: I would paint the panel with good or special care, relative to the fact that you are refusing

to allow me more time.[7] Also I give you the benefit of the doubt, that if I had promised to do for you what you yourself then acknowledged to be to my own detriment, you would not have insisted on it. But nonetheless, be that as it may, I shall keep to what I have promised you. For so far as I can, I want nobody to have cause to reproach me. Had I not made an agreement with you, I know full well what I would do. That is why I had to respond to you, so that you should not think I was ignoring your letter. However I hope, once the panel is finished and you see it, that everything will be better between us. Have patience then, for the days are short and so, as you know, things can't be rushed. It's a lot of work, and won't get any less, and I am relying on the approval you expressed to my relative in Frankfurt.[8]

Note: you needn't look out for a purchaser for my picture of the Virgin. The Bishop of Breslau has given me 72 fl. for it. That's a good deal.[9] Allow me to commend myself to you. Given at Nuremberg on the Saturday after All Saints 1508.

<div style="text-align: right">Albrecht Dürer</div>

NOTES

1    *gegen meinen schwager*: AD had no 'brother-in-law', so *schwager* has to be understood in its old wider usage (DWb IX, 2176–8) for any male relative by marriage. It is etymologically related to *schwäher* – 'father-in-law', modern German *Schwieger(vater)*. Thus it could refer to Martin Zinner, husband of Agnes Dürer's sister Katharina, or to AD's father-in-law Hans Frey, both of whom would fit with the second use in the letter (see note 2). It became also a term of familiarity for 'friend, fellow student, workmate'. No relative of AD is known to have been in Frankfurt in 1508, and another candidate is Martin Hess or Kaldenbach (BI), a friend of AD and fellow painter, who is referred to again in letters 5 and 8 (where AD calls him 'your [Heller's] painter'). However, Martin Hess cannot be meant in the second use of the term in this letter.

2    In Nuremberg, we must presume. Willibald Pirckheimer was their mutual friend, but AD nowhere else refers to him with this degree of familiarity. Lazarus Spengler could also have known Heller through his role as town clerk. In the sense 'male relative by marriage', it is possible that Martin Zinner or Hans Frey could be meant (see note 1). Here too, it appears that the agreement between AD and Heller was an oral one.

3    Heller may be forgiven if he took this to be a rhetorical trick of feigned modesty. However, it is characteristic of a tension between self-doubt and self-belief which is particularly evident in AD's dedicatory epistles and prefaces to his printed treatises (see 182, 257.1 and 3).

4   If AD's estimate of thirteen months to paint the panel is reckoned from starting the underpainting in March 1508, then he took somewhat longer than that, despatching it as he did in August 1509

5   Materials and their cost were clearly a contentious subject in the correspondence. Heller had perhaps suggested that ultramarine could be had more cheaply, or offered to buy and provide it himself (see, with examples, Baxandall 1988, 8). In letter 5, however, AD reassures Heller that he is using the finest colours available. Baxandall 1988, 11, quotes an Italian contract of 1408 which stipulates that 'the ultramarine used for Mary [that is, her dress] is to be of the quality of two florins to the ounce, while for the rest of the picture ultramarine at one florin to the ounce will do'. Oddly, since the quantity and quality of ultramarine figures again and again in the letters, and was an important element in rendering the fee inadequate, AD does not suggest outright that materials be separated from artist's time and skill as cost factors, nor does he try to persuade Heller to pay extra for them. The price of twenty ducats for a quantity of ultramarine suggests a purchase in or from Venice, and AD's complaint that fine ultramarine cannot be had under 10–12 ducats an ounce confirms his claim that he is buying only the best. In the Netherlands he took one ounce (3 grams) in return for 12 fl. worth of prints (equivalent to circa 30 grams of gold), which implies that ultramarine was literally worth its weight in gold. (Boockmann 1989, 257; Burmeister/Krekel 1998, 103; Kirby 2000, 20–24).

6   In truth (as Heller was not yet in a position to verify) there are merely some thirty faces.

7   AD deliberately overstates the case. Neither 'utmost care' nor 'great care' is a feasible option, whether for artist or patron. That AD should suggest that paintings of such perfection are even attainable reflects his assimilation of the new conceptions of art and the artist that emerge in the Italian Renaissance (see especially Ames-Lewis 2000). He then more realistically assesses what is appropriate to an altarpiece. This was a traditional genre with which craftsmen and patrons in Germany were very familiar. In the late Middle Ages it was a commodity little different from the wares of other craftsmen. Painter and patron could be expected to agree on the time it should take to produce it. The deadline did not reflect the artist's sense of his personal potential or artistic creativity but an essentially commercial judgement of the nature and function of the product (Brandl 1986). AD concedes this when he admits that it would be senseless to spend half a year painting one face out of a hundred, which in any case no worshipper could properly see. It was not until a century later that viewers began to appreciate the artistry involved in painting the soles of one apostle's feet – see Karel van Mander, *Schilder-Boek* (Haarlem, 1604), Vinzenz Steinmeyer, *Figuren…Von den Fürtrefflichen Malern* (Frankfurt, 1620). In the contract between Hans Imhoff and Adam Kraft for the Sacrament House in St Laurence's in Nuremberg, standards of finish and detail at different levels are specified. At the base and easily seen stages, carving is to be done 'with great subtlety and excellent workmanship', at a higher level 'with great craftsmanship since it will be clearly visible', while higher still less care is required on carving 'not so clearly visible to the

beholder' (Huth 1925, 120–22; Boockmann 1989, 264–7; Nash 2008, 149). As Schmid (2007, 54) points out, AD never uses the word *kunst*, 'art' in its Renaissance sense, which fuses the elements of craft, intellect and aesthetic, in any of these letters in order to argue for a higher fee in recognition of his status or creativity. Rather it is his *fleiß*, the degree of 'care' and 'diligence' he devotes to his craft, which should determine its value, and the degree of *fleiß* is in turn governed by the time limits set by the patron. But even the limited *fleiß* which Heller allows is worth more than 130 fl. Here again, AD comes up against his own error in proposing too low a fee. On the issues raised here, see Strieder 1983; Satzinger 1991; Hess/Mack 2012 187f.

8   The problem discussed in notes 1 and 2 now arises again. Either Zinner or Frey could have talked to Heller on a visit to Frankfurt. That a different *schwager* can be meant here is improbable, however alluring Panofsky's suggestion that this time AD is referring to his painter colleague Matthias Grünewald.

9   See letter 3, note 6. The bishop of Breslau (Wrocław) was Johann Thurzo V, who had already bought AD's *Adam and Eve* (40). A letter the bishop wrote in 1511 (70) makes it clear that at that date he had still paid nothing for the picture AD sent him, and he claims he still has no idea what AD wants for it. AD is now asking for payment and the bishop instructs his agent in Nuremberg to negotiate a price. It rather looks as though AD did not yet have a done deal with the bishop, and that the alleged price of 72 fl. is a fiction to persuade Heller that 130 fl. for the altar panel is too little.

## 47.5

*[Nuremberg, 21 March 1509]*
Dear Herr Jakob Heller,
I have read your letter, and can tell you that since last Easter I have been concentrating hard and full-time on painting your panel, although I do not expect to complete it before Whitsun. I have applied much effort to this one and only piece of work. There is not very much that I feel able to tell you about it, except that I am confident you will see for yourself how much trouble I have devoted to it. Don't worry with regard to the colours for I've used over 24 florins' worth of paints on it. And if these are not beautiful, I reckon you will not find colours anywhere else that are more beautiful. For I'm putting such hard work and long hours into it, even though it is unprofitable and takes up all my time. You should believe me firmly and truly that I would never paint another altarpiece like this for under 400 fl. – and that even if I got from you what I have asked for it, it's taking me so long that my living costs would still amount to more. You can work out how profitable that is for me! But I won't start reckoning up how much effort I've put in, so that for the sake of my reputation and yours we get to the end of it, for it is going

to be seen by many well versed in art, who will perhaps give you their opinion as to whether it's a master's work or worthless. So be patient a little while yet, for the lower part of the panel is quite finished, only needing varnishing, and at the top some details of the little angels[1] have to be painted in. It is my great hope that it will please you. I think perhaps as well, it may not please certain art connoisseurs who would prefer a village church altar instead.[2] That doesn't bother me. The praise I look for comes only from the experts. And if Martin Hess sings its praises to you, then you can believe it all the more. Ask around among the painting fraternity[3] who have seen it and they will tell you how it looks. And if you see it and then don't like it, I'll keep the panel for myself. For I've had people pleading with me to put it on sale and paint another one for you. But I'll have nothing to do with that, I'll be totally honest with you and keep to my promise. I take you too for an honest man, look forward to your reply, and have no doubt that you will be pleased with the great care I've put into it. Herewith, my pledge to serve you diligently in whatever way I can. Dated Nuremberg on the Wednesday after Laetare[4] 1509.

<div style="text-align: right">Albrecht Dürer</div>

NOTES

1   *etlichen dieng von kindlein*: a couple of dozen *putti* play in the clouds of the celestial zone in which God Father and Son crown the Virgin.

2   *ain baurn-tafel*: a panel fit only for peasants.

3   *vnder etlichen gesellen*: the sense here is 'comrades', 'fellow painters', not the technical sense of 'time-served journeyman'.

4   The fourth Sunday in Lent, named by the first word of the psalm introit of the mass on that day.

## 47.6

*[Nuremberg, 10 July 1509]*
Dear Herr Jakob Heller,
From your letter to Hans Imhoff I gather you are annoyed that to date I have not yet sent you the altarpiece. That I regret, since I can write to you in all truth that I have been working hard and without a break on the panel and have undertaken no other work than this. It may be that I might have long since finished it, had I been willing to hurry it. But my thoroughness was meant to please you and to win praise for myself. If it has turned out otherwise, I am sorry. And as you write furthermore that, had you not commissioned the altarpiece

from me, we would forget the whole business and I might keep the painting, I reply to you as follows: Were I to incur a loss because of this painting, I would put up with that, for the sake of your goodwill; but inasmuch as you regret the business and are going on at me to keep the panel, I shall do so, and gladly. For I can make 100 fl. more profit from it than you would have paid me. For after all this, I would not have accepted 400 gulden to paint another one equal to it. Accordingly I gave straight back the 100 gulden I took at the start from Hans Imhoff. But he wouldn't accept the money without instruction from you. Accordingly, please write and tell him, or whoever you wish, to receive the 100 fl. and I shall remit the sum forthwith. In this way you will incur no loss or regrets over the panel. I value your goodwill more than the picture. Herewith I wish you the best at all times, and remain your willing servant. Dated Nuremberg on the Tuesday before St Margaret's Day 1509.

Albrecht Dürer

NOTE

One reason for AD's curt, though not discourteous, tone in this letter is the fact that Heller chose to vent his terminal impatience by writing to Hans Imhoff, who then let AD have it at second hand. This lack of candour allowed AD to stake out some moral high ground. When Heller thereupon wrote to him direct, he must have felt obliged to curb his irascibility, and AD is able to lay out his final terms.

## 47.7

*[Nuremberg, 24 July 1509]*
Dear Herr Heller,
I have read the letter you addressed to me. When you write that it was not your intention to cancel the altarpiece, then I have to say, I can't work out what your intentions are. But since you wrote that if you had not commissioned the work, you would not have ordered it now, and that I was to keep it as long as I wanted et cetera, I could only think that you regretted the business, and that's why I replied as I did in my last letter. But at the urging of Hans Imhoff, I acknowledge that you did commission the picture from me and that I had rather it was set up in Frankfurt than anywhere else, so I consent to letting this happen for 100 gulden less than I might otherwise wish to let it go for.[1] For although you initially ordered it from me for 130 fl., you are well aware of what I subsequently wrote to you, and you to me. And I just wish I had painted it as it was first ordered from me. I would have had it finished in

half a year. But since you encouraged me, and I wanted to give you good service, I have been working at it for more than a year and have used up over 25 fl. worth of ultramarine on it. And I can tell you in all truth what price it is you are paying me for this panel, just in order for me to make a loss on it. Earn one penny, spend three, that way I'll not survive for long. Now that I know that you do not particularly seek to inflict such great loss on me, and I am capable of making at least 100 fl. more from it than by selling it you, I am prepared to send you the altarpiece without delay. And should it please you and you feel grateful to have it, you should accept that it is good value and worth more than the 200 fl. that I am asking for it. If however, once you have viewed it, this offer of mine is not acceptable or expedient, you shall deliver the picture back into my ownership in Frankfurt. As I wrote above, I shall be able to sell it for at least 100 fl. more, although I hope that, when you receive it, you will gratefully accept my offer.[2] With that in mind, I shall pack it carefully. Be so good meanwhile as to inform Hans Imhoff of your intention, and once he tells me this on your behalf, I shall forthwith hand the altarpiece over to him. And if I were not hopeful of thereby rendering you thankful service, I should know how to achieve greater benefit from it. Yet your affection is dearer to me than such petty cash. I hope however that you will not look to cause me serious loss over and above this, because that's something you need even less than I.

Therewith at your disposal and command. Given in Nuremberg on Wine-Tuesday before St James's Day.[3]

<div align="right">Albrecht Dürer</div>

NOTES

1   In the following letter, AD acknowledges that Hans Imhoff has paid him a further 100 fl. so that his final fee was raised to 230 fl., and although this is still roughly 100 fl. less than the 300 fl. he had stated as a minimum in letter 4, eight months earlier, AD is prepared to cut his perceived losses despite his continuing sense of grievance. The fee is much higher than the 110 fl. he was paid for the *Feast of the Rose Garlands* in Venice, and not much short of the 280 fl. Frederick the Wise paid him for the *Martyrdom of the Ten Thousand Christians*. But the cost of materials for Heller's altar was 24 ducats (about 28 fl.) compared with 5 fl. for the work in Venice (see Schmid 2003, 353–60). *The Assumption and Coronation of the Virgin* took him much longer to complete than either of the other two, and AD's claim that he did nothing else during that time appears to be at most a slight exaggeration. It was, assuredly, not a very good business proposition.

2   It is doubtful whether AD seriously expects, or even wants, Heller to let him have the panel back, once he has seen it, so that AD can sell it to a customer prepared to pay 100 fl. more. Rather, he wants at least to have Heller's acknowledgement of its artistic quality and its value for money.

3   *Weinerichtag vor Jacoby*: the feast of St James (25 July) was traditionally a day whose weather was a portent for the coming wine harvest. In Nuremberg, it was also a popular patronal festival marking the consecration (*Weihe*) of the Jakobikirche.

## 47.8

*[Nuremberg, 26 August 1509]*
Be assured of my humble service, dear Herr Jakob Heller,
Following your most recent letter, I am sending you the altarpiece well packed and protected. I've delivered it into Hans Imhoff's care, and he has paid me a further 100 gulden. Believe my honest word that even so it has cost me money of my own, apart from the time I have spent on it rather than on other things. Here in Nuremberg I have been offered 300 gulden for it. These 100 fl. would have been welcome if I had not wished to oblige and serve you by sending the painting. For I value retaining your friendship higher than 100 fl. I'd also rather have this picture in Frankfurt than in any other place in all Germany. And if you consider I am acting improperly by not leaving the matter of payment to your own free inclination, then that came about because you wrote to me through Hans Imhoff that I might keep the painting just as long as I pleased. Otherwise I would have left it up to you, even though I might have suffered financially still more. However my confidence in you makes me hope that if I promised to paint you something for 10 fl., and this then cost me 20 fl., you would not wish to see me lose by it. So I beg you, content yourself that I am taking 100 fl. less from you than I might have had for it. And, I can tell you, people tried to take it from me pretty much by force. For I put all my skill into it, as you will see, and it's painted with the finest colours I was able to get. It is underpainted, overpainted, and fine-finished with good quality ultramarine, five or six times over. And even after the final coat I went over it again twice more, so that it would last a long time. I'm sure you will keep it clean, so that it will stay fresh and unmarked for five hundred years. For it is not painted as people usually paint. So make sure it is kept clean, and is not fingered and doesn't have holy water splashed on it.[1] I am sure nobody will criticise it, unless to annoy me. And I firmly believe it will please you. No one shall ever be able to persuade me again to paint a picture involving so much work. Georg Thurzo personally requested me to paint a Madonna in a landscape of the same dimensions and quality as this panel.[2] He was willing to give me 400 fl. for it. I turned him down flat because it would have reduced me to beggary. For the

next year I'll produce such a pile of ordinary pictures, that nobody will believe it possible for one man to do it. That's the way to make some money. Whereas you can't hurry real pernickety stuff.[3] So I shall get back to my engraving – and if I'd done that all this time, I'd be 1000 fl. richer today. Please note also that at my own expense I have had a new frame made for the main panel,[4] which cost me over 6 fl. I broke the old frame off it because the joiner had made it too crudely. But I have not fitted hinges on it, because you didn't ask for that. It would be a good idea for you to have the battens screwed on so that the panel doesn't split.[5] When you set up the altarpiece, let the panel hang forward by two or three finger-breadths so that reflections don't interfere with seeing it well. And when I am in Frankfurt over the next one, two or three years, you must have the panel lifted down to check if it's dried out fully. Then I'll recoat it with a special varnish, which only I can make, and then it will last for a hundred years longer than otherwise. But do not let anyone else at all varnish it, because all other varnishes are yellow and will ruin the panel. If a thing I've spent more than a year painting were to be ruined, it would grieve me too.[6] And when it is set up, make sure you are there yourself to prevent it getting damaged. Handle it carefully, you'll hear your local painters and ones from elsewhere say how well it's been painted. And pass on my greetings to your painter Martin Hess. My wife would appreciate a gratuity, as is her due from you.[7] That's the limit of my demands on you, et cetera. With that I commend myself to you. Read this for its sense, not its style, it was written in haste. Dated Nuremberg on the Sunday after St Bartholomew's Day 1509.

Albrecht Dürer

## NOTES

1   This might happen when the altar was consecrated or during the customary liturgical rites. Holy water usually had salt added to it. For the general topic of artists' concern for the proper presentation and conservation of their work, see Boockmann 1989; Nash 2008, chapter 16.

2   Georg Thurzo (died 1521) was a relative of Johann, bishop of Breslau, and a partner in the Fugger-Thurzo metal-mining consortium. He was married to Anna, daughter of Ulrich Fugger, a member of the great Augsburg banking family, a number of whom were patrons and acquaintances of Dürer.

3   *das fleisig kleiblen*: the infinitive noun *kleibeln* is the diminutive of *klauben*, 'nibble' with the teeth, 'pick at' food, 'pick out' with the finger tips or fingernails. AD uses it in the sense of doing delicate, minute brushwork.

4   *ain neue leisten*: the noun *leiste* suggests that this is a protective edging strip for the central panel. But that would cost very much less than 6 fl. (in 1538 Lukas Cranach

had four frames made for 13 groschen). Rather it is the immediate frame of the panel and will require hinges to connect the inner wings of the retable. AD seems to imply that Heller had given him instructions. Compare Heydenreich 2007, 75–89.

5   Cross battens were designed to stabilise the joints between the strips of wood out of which a panel was put together and prevent them splitting or warping (Heydenreich 2007, 65–7).

6   See Heydenreich 2007, 171: distinctions were made in sixteenth-century written sources between ordinary and good varnish, listing the addition of resins such as amber, sandera, mastic and pine resin. Schmid 2003, 351, suggests that AD's claim to have a unique special varnish may be part of his aspiration to be the Apelles of his age. See Pliny the Elder, *NH* 35, 97: '[Apelles] used to give his pictures when finished a black glazing (*atramentum*) so thin that by reflecting back the light it brought out a whitish colour, whilst at the same time protecting from dust and dirt, and becoming visible only on the closest inspection. One main purpose of using it was to prevent the brilliance of the colours offending the eyes…so that when viewed from a distance colours which were vivid to excess would be imperceptibly toned down' (McHam 2013, Plinian Anecdotes 19).

7   This commonly observed courtesy may, in some cases at least, have been intended to acknowledge the economic role a wife played in managing the extended household of a painter's studio. Compare Möncke 1982, 375: for the Landauer sepulchre in St Sebald in 1490, Adam Kraft received 200 fl. and 4 fl. gratuity for his wife.

## 47.9

*[Nuremberg, 12 October 1509]*
Dear Herr Jakob Heller,
I am glad to hear that you are pleased with my altarpiece, so that the trouble I took with it was not in vain. I am relieved also that you are satisfied with the price paid. Rightly so, for I might have had 100 fl. more for it than you paid me, but I wanted nothing other than to let you have it, for with it I hope to retain your friendly support down in your part of the world.[1] My wife sends her warm thanks for your gift and will wear it as a compliment to you. My young brother thanks you too for the two gulden you gave him as a gratuity.[2] I myself thank you also for all the honour you have done me et cetera. Since you write asking how the panel might be embellished, I am enclosing a little sketch of how I might do it, if it were mine.[3] However, you may do as you see fit.
Wishing you happiness. Dated on the Friday before St Gall's Day 1509.

Albrecht Dürer

NOTES

1   *vnden an den orten*: in 'low' Germany, presumably Frankfurt and environs, perhaps also Cologne, where Heller had strong family and commercial links. See 162: when the Dürers passed through Frankfurt on their way to the Netherlands in 1520, Heller sent a gift of wine to their lodgings.

2   Agnes Dürer evidently received a gift of jewellery or cloth. Hans's gratuity is quite large and suggests that he played a significant part in painting the wings of the retable.

3   The sketch is lost and, so far as is known, was not used in the creation of the likewise lost architectural frame and canopy of the altar. Grünewald designed his own Renaissance-style canopy for the Maria-Schnee altar in Saints Peter and Alexander, Aschaffenburg (1519). Dürer's frame for the *All Saints* altar he painted for Matthäus Landauer (1511) is in the Germanisches Nationalmuseum, Nuremberg (64.4).

# 48   Inscription on the Heller Altar

*Ascension and Coronation of the Virgin Mary*. **Oils on limewood panel.**
**A 115K**

Copy of the original, made by Jobst Harrich in 1614, when AD's panel was acquired by Duke Maximilian of Bavaria and removed from Frankfurt to Munich. Harrich's copy, together with the inner wings painted in AD's workshop, is now in the Historisches Museum, Frankfurt. On the history and loss of AD's panel, see 47, introduction. Preparatory drawings of the highest quality survive (W 448–65 and Winkler 1957, 204; S D 1508/1–19).

The small-scale figure of AD stands middle right in a landscape setting, marking the division of the earthly and heavenly regions, and holds a board with the inscription:

ALBERTVS  DVRER  ALEMANUS  FACIEBAT  POST  VIRGINIS  PARTUM
1509

(Albrecht Dürer the German was making [this] in the year since the Virgin gave birth 1509)

The wording is identical with that on 40, the panel painting of *Eve*, and relates closely to others from the years 1504–11: 26.1; 31.2–3; 56; 64.5.

[Anzelewsky 1991, 221–8; Ex. Cat. Vienna 2003, 358–72; McHam 2013, 195f. & Plinian Signatures]

## 49 Two Letters of Lorenz Beheim to Willibald Pirckheimer

**49.1**

*[Bamberg, 19 May 1508]*
I send best wishes to Albrecht.

**49.2**

*[Bamberg, 29 October 1508]*
Remember me to your housekeeper,[1] to Albrecht Dürer, Hieronymus Haller and Jakob Muffel.[2]

PBr 2, 18–24, 36–9, Letters 175 & 180. Latin text
  Rupprich I, 255

NOTES

  1  *Hospitaloriae tuae*: see Niermeyer I, 654f. Probably Ursula Kramer, widow of Hans Kramer, Pirckheimer's neighbour who perhaps acted for him (a widower) in some sense as his 'housekeeper'. But see AD's letters from Venice, on Pirckheimer's 'household' (29.4, note 6 and 29.8, note 16).
  2  For Haller and Muffel, see BI.

## 50 Christoph Scheurl, *In Praise of Germany and the Dukes of Saxony*

For the rest, what am I to say about Albrecht Dürer of Nuremberg, to whom by common consent the foremost rank in our age is assigned both in painting and in engraving.[1] When recently he went back to Italy, the artists both in Venice and Bologna, where I often acted as interpreter, hailed him as the second Apelles.[2]

  Just as Zeuxis, according to Pliny in Chapter 10 of Book 35, tricked birds into pecking painted grapes, and as Parrhasius deceived Zeuxis with a painted curtain,[3] so too my friend Albrecht was able to deceive dogs. For one day, when he had painted a self-portrait with the aid of a mirror and a fine brush, and had put the still wet picture to dry in the sun, his little pet dog came running up (for it is dogs alone, as Pliny also affirms, that recognise their own names and even their masters when they appear suddenly) and, meaning to

show affection to its master, planted kisses on the painting. I myself can confirm that the smudges are still visible to this day.[4]

How often, too, the housemaids tried to get rid of the spiders' webs he deliberately painted on the walls! Many other memorials of his divine genius are to be found. The Germans resident in Venice will point out the most perfect work in the entire city, created by him, so expressive of the Emperor that he seems to lack nothing except breath.[5]

Three altarpieces by him adorn the Chapel of All Saints Church in Wittenberg, which compete with those three best works that Apelles reckoned he had achieved.[6]

In the same way that those early painters – like all truly educated men – possessed a certain innate grace of manner, so too is Albrecht easy-going, humane, punctilious and of utter integrity. For that reason he is greatly esteemed by the nobility, and quite especially Willibald Pirckheimer loves him as if he were his only brother, that man highly learned in Greek and Latin, a supreme orator, senator, and military commander.

When this year at Ferrara the poet Sbrulius's muse was admiring the tradition of painterly skill, which after being broken off for many centuries has now been recalled to life in Nuremberg,[7] he burst forth extempore with this pair of couplets:

> If the Ancients so marvelled at Apelles, the painter,
> > How much more now will Albrecht become the world's wonder?
> Since he has so painted boys and youths and mature men,
> > That few who behold his work think them inanimate.

By the same poet, a couplet declaimed *ex tempore* to Albrecht Dürer:

> Painstaking Albertus by his art vanquished Apelles,
> > He is worthy indeed to enter the dwellings on high.

And again, an Epigram by the same Sbrulius to the prince of painters Albrecht Dürer:

> As you will make me fly through the world in a portrait,
> > So will my verses assure you perennial fame.
> And as I shall live long by the work of your fingers,
> > So shall you live forever by means of my pen.
> Thanks to a pen Albertus Dürer will knock at Heaven's door;
> > Sbrulius thanks to a finger will live on through ages to come.[8]

---

*Libellus de laudibus Germaniae et ducum Saxoniae*, second edition, Leipzig 1508, fol. h 5. 43. The first edition, Bologna 1506, does not include this passage. Latin text
R I, 290–91

NOTES

1  *fictura*: literally 'forming, fashioning'. This is an attempt to find a Latin word for the process of engraving on copper plates.

2  See AD's letter 10 from Venice, 13 October 1506: 'In another ten days I shall be finished here. After that I will ride to Bologna where someone is going to teach me the secrets of the art of perspective.' See text 29.10 and note 14. AD does not mention Scheurl in any of his letters from Venice. Scheurl had called him 'second Apelles' in his letter to Caritas Pirckheimer (41).

3  McHam 2013, Plinian anecdote 155. 'There is a story that Parrhasius got involved in competition with Zeuxis. When Zeuxis had exhibited a painting of bunches of grapes with such verisimilitude that birds flew at them, Parrhasius placed on view in front of it a painting of a curtain, so realistically rendered that Zeuxis, buoyed up by the birds' verdict, demanded that the curtain be removed, and his own picture displayed. On realising his error, he gave in gracefully, since, as he said, he had merely deceived some birds, but Parrhasius had deceived Zeuxis the painter. Subsequently Zeuxis painted a boy carrying bunches of grapes, and when some birds duly swooped on them, he was annoyed with his work, and declared with the same directness, 'I've painted the grapes better than I did the boy, for if I had spent more time on painting him, the birds would have been frightened off for sure.' (Pliny, *NH* 35. 10.4.). The quest for ultra-realism in Italy around the mid-fifteenth century led painters in the circle around Francesco Squarcione to treat Pliny's text as an *ekphrasis*, as in Marco Zoppo's *Virgin and Child with Angels* (circa 1455), where the Madonna sits in an arbour of flowers and fruit, which a putto in the picture grasps at and which allegedly Zoppo's daughter in reality attempted to pluck (see Ames-Lewis 2000, 189–91).

4  Scheurl most probably knew this anecdote from Konrad Celtis's third epigram on AD (10.3 and note 7). Leonardo da Vinci relates, 'I once saw a painting which deceived a dog by means of the likeness of the painting to its master. The dog made a great fuss of it' (Kemp/Walker 1989, 34). The anecdote goes back into Antiquity. See Scheurl's *Eulogy* (57).

5  Emperor Maximilian I is depicted on *The Feast of the Rose Garlands* (31.1). This is the first recorded reference to the painting outside AD's own letters. Scheurl does not mention AD's *trompe l'oeil* on this painting, a horsefly that appeared to have settled on the picture's surface over the Christ Child's dress (see 42).

6  Anzelewsky 1991, 140. By 1508 AD and his workshop had created no less than six major religious paintings for Duke Frederick the Wise, of which four are known to have been set up in the Castle Church. Since the *Martyrdom of the Ten Thousand Christians*, not finished until April 1508, could scarcely yet have been installed there, the three works Scheurl refers to are likely to have been the altar panels of the *Seven Sorrows of the Virgin Mary* (1496, A 20–38), the Dresden Altar showing on its central

panel the *Virgin Mary Worshipping the Infant Christ* (now generally assigned to a Netherlandish master), with AD's wings of *St Anthony the Hermit* and *St Sebastian* (circa 1496–7, A 39–40), and the panel painting of the *Adoration of the Magi* (1504, A 82).

7   See also 181.2, note 2, on Scheurl's and AD's anticipations of the term 'Renaissance'.

8   For Ricardus Sbrulius or Ricardo Sbroglio, see BI and Rupprich 1970, esp. 600, 625.

COMMENTARY

Christoph Scheurl's panegyric on Germany, in particular Nuremberg and the dukes of Saxony, was his first significant literary composition. In this second version it served as his inaugural lecture as professor of jurisprudence in Wittenberg and was intended to express his debt to Frederick the Wise. Its model is undoubtedly Konrad Celtis's inaugural at the University of Ingolstadt, written in 1491/2. It acknowledges the vital role that the duke had played in promoting Renaissance poetry (in the case of Celtis), art (in the person of AD), and scholarship in his own appointment, and it belongs in the wider enterprise of Frederick's plans to transform the hitherto obscure little town of Wittenberg into a centre of the new culture and learning. The nationalistic theme of Germany's city republics and ducal courts as incipient rivals to those of Northern Italy is characteristic of this phase of German humanism around 1500. See the writings of Celtis (10), Wimpheling (16) and Cochlaeus (81).

The *Libellus de laudibus* contains the sole direct confirmation of AD's brief visit to Bologna in late 1506 or early 1507 (29.10 and notes 13–14), though Scheurl sheds no light on AD's quest for guidance on matters of perspective and proportion. His praise of AD's art is focused, typically for humanist contemporaries, on its mastery of an extreme realism, expressed through the borrowing and elaboration of Pliny's anecdotes of Zeuxis and Parrhasius and the identification of AD as a reborn Apelles. The laudation lapses into banality with Scheurl's quotation of the pretentious and self-promoting verses of Ricardus Sbrulius.

[Scheurl BI; Mende 1971b; Großmann 1975, 69f., 73; Strauss 1976; Ex. Cat. Osnabrück 2003, 48f.; Grebe 2013, 122–5]

1507–1509

## 51 Writings on the Theory of Art

## Introduction

When he returned from Venice to Nuremberg in 1507, AD brought back new know-ledge, sources and stimuli which allowed him to begin formulating plans for a didactic work on the theory and practice of painting and graphic art. At this stage, whilst he himself was still absorbing the aesthetic impact of Italian Renaissance art and searching for written material on its scientific basis, he was already set on writing and printing an instructional manual in German for fellow craftsmen in the visual arts. This ambi-tion was realised in part at least in 1525–8 with the publication of treatises on geometry and perspective and on human proportion. The printed volumes embodied more than twenty years of work, AD's experimentation not just with their theoretical and practical content, but also with the creation of a vernacular written language adequate to the expression and communication of concepts and techniques hitherto only articulated in Latin and Italian. From the start of this project, AD accumulated notes and drafts in preparation for the definitive texts. In this 'archive' he preserved material from every stage of the project and, as if he also wished to document its genesis and evolution, he kept some of his earliest, superseded versions of drafts and sketches, on some of which he then drew again at later stages.

The large corpus of writing that survives is mostly undated and awaits a definitive modern analysis. In the framework of a documentary biography it is impossible to incorporate it in its entirety. Rather, texts that are purely technical and theoretical in nature, particularly which then appear little changed in the printed books, have largely been excluded. Included are texts which express AD's conceptions and motivations and locate the project in the wider context of his life and work. The chronology of texts, and thus their placing in a biographical sequence, is often speculative and relies heavily on Hans Rupprich's datings. In determining these he often gave decisive weight to the palaeographical evidence of AD's handwriting. A definitive chronology may eventually emerge out of future research on the whole archive.

AD's letters from Venice in 1506 tell us little about the impact his stay there had on his understanding of aesthetics and the theory of art. He is struck by how much his taste and knowledge have matured since his first visit to Italy: 'the stuff that pleased me so well eleven years ago doesn't please me at all now. And if I didn't see it for myself, I wouldn't have believed it if others had told me' (29.2). He refers repeatedly to his friendship with Giovanni Bellini, and that could have given him opportunities to meet other great contemporaries – Carpaccio, Cima da Conegliano, Giorgione, Lorenzo Lotto were all linked with Bellini and his workshop. According to Joachim

Camerarius's posthumous biographical sketch (299.1), AD came close to meeting Andrea Mantegna, Bellini's brother-in-law, and was packed and ready to set off to Mantua when the news of Mantegna's death reached him. There is unreliable evidence that he met Raphael in 1505 (see 102.3). We do have firm evidence that in early 1507 AD bought in Venice the Latin edition of Euclid's *Elements of Geometry*, published in 1505, which incorporated his *Optics* (34, 51.2). The purchase followed immediately on AD's return from Bologna, where he had gone in the expectation of meeting an unnamed man who would teach him the secrets of the art of perspective (29.10). The informant may have been the mathematician Luca Pacioli, more probably someone else familiar with Pacioli's teaching and with the writings of Piero della Francesca. Christoph Scheurl (50) was present when AD was fêted by Bolognese painters, but he does not name them.

While AD looked to Italy for Renaissance artists and theorists to inspire and inform him, he did not need to import key texts to Nuremberg, which itself housed an outstanding library of mathematical manuscripts and books. Collected by Johannes Müller or Regiomontanus (1436–76, see BI), it passed to his pupil, Bernhard Walther (circa 1430–1504, see BI), whose house AD bought in 1509 (53). AD had access to the library through Konrad Celtis and Willibald Pirckheimer, later through Christoph Scheurl and Thomas Venatorius. A further key advisor on mathematical matters, especially perspective, was Johannes Werner (1468–1522, see BI). When, after Werner's death, the Regiomontanus/ Walther library was dispersed under Pirckheimer's direction, AD is recorded as having bought ten volumes 'useful to painters' in 1523 (177). Among the works most relevant to AD's studies, the library offered manuscript editions and Latin translations of Euclid along with optical textbooks from the late Middle Ages and early humanist science. Regiomontanus had known Leon Battista Alberti personally in Italy and a manuscript of his *De Pictura* was also in the library.

Through his network of humanist friends and correspondents AD could also have had access to contemporary Italian art theory and practice, most intriguingly to the work of Leonardo da Vinci (see 51.3, note 14). Willibald Pirckheimer's friend Galeazzo da San Severino (BI), a student contemporary in Pavia, became a patron of Leonardo in Milan in the 1490s. Galeazzo attended Pirckheimer's wedding in Nuremberg in 1495 and could have met AD then. Galeazzo's servant David de Marchello corresponded with AD (68). Lorenz Beheim had served as courtier of Rodrigo Borgia, from 1492 to 1503 Pope Alexander VI. In his capacity as papal artillery and siege engineer under Cesare Borgia, Beheim was succeeded by Leonardo. From Luca Pacioli's *De divina proportione* (Venice 1509) AD could from circa 1511 have derived information about Leonardo's equestrian statue of Francesco Sforza, the Milan *Last Supper*, and his projected treatise on painting.

The texts chosen to exemplify AD's theoretical and practical aesthetic writings in 1507–9 following his return from Italy provide, firstly, further evidence of his continued interest in Vitruvius, his only authoritative source of art theory from the ancient world; secondly, his initial exploration of Euclid's *Elements* and *Optics*, in the Latin text he

purchased in Venice; thirdly, outlines and drafts of his planned handbook on painting for young artists, his earliest attempt to implant the Renaissance science of art into wider German practice.

[Petz 1887; Panofsky 1948, chapter 8; Werner 1965, 80–87; Steinmann 1979; Białostocki 1984; Kemp 1990, 9–62; Reiss 1999, 140–48, 174f.; Rupprich II, 74–7]

## 51.1 Proportional Measurement of the Male Body According to the Principles of Vitruvius [fig. 29]

### 51.1.1 On the Measurements of the Human Body

Vitruvius the ancient architect, whom the Romans employed for major buildings, says: Whoever wishes to build should take as his guide the disposition of the human form,[1] for it is from this that the well hidden secrets of measurement are derived.

And therefore, before I talk about building, I wish to explain what a well shaped man is like, thereafter a woman, a child, and a horse. In this way you can learn at the same time how to measure all things.

And therefore hear first what Vitruvius says about the human form, which he learned from the great masters, painters, and makers of cast metal statues who were highly famed. They declared that the human body should be thus:[2]

That the face from the chin to the top, where the hair begins, should be one tenth part of a human being. An outstretched hand is the same length. But the head of the person is one eighth, and from the height of the breast to the lowest roots of the hair one sixth;[3] and from the hair to the chin the head is divided into three equal parts, first the top part, being the forehead, the nose being the second, the mouth and chin the third. The length of the foot is one sixth of a person, a forearm one fourth, the width of the breast also one fourth.[4]

Such measurements he incorporated into buildings and says:[5] If a man is laid on the ground with hands and feet spread out wide and a pair of compasses is set in the navel, then the circle it describes will touch hands and feet. In this way Vitruvius shows how to find a circular structure from the human form.

And in the same way a square figure can also be found if you measure from the feet as far as the top of the head. Then the span of the outstretched arms[6] will be equal to the height. From this he derives a squared building. Thus he connected the members of the human body with a proper arrangement for buildings of all kinds, and in such a reliable relationship that neither the ancients nor the moderns can dispense with it. Let whoever is willing read it and see how Vitruvius demonstrates the best rule of architecture.[7]

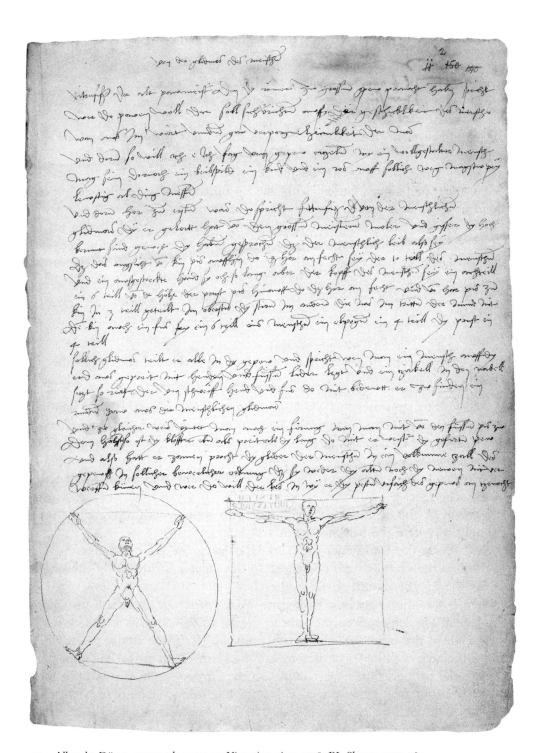

29. Albrecht Dürer, autograph notes on Vitruvius, circa 1508. BL Sloane 5230–2r

### 51.1.2  Proportioned Figure of a Man, seen from the Front

Set down a line with 8 parts. At the top put 'a'. And the first eighth part belongs to the head.

The large circle is the arms. This is a quarter of the length. Its centre is the pit of the stomach.
Let the small circle have a diameter one fourth less than the large one. Its centre is the navel on the arc of the large circle. The arc of the smaller one marks the end of the stomach on the genitals. There put an 'a'.

Take the compasses, set them with one tip on the point specified and open them up as far as the centre of the pit of the stomach.

Take the compasses, set them with one tip in the navel and draw a mark above the circumference of the larger circle and, where the circle intersects the said circle in two places, mark them 'b' and 'c'. That is where the arms begin.

Heart.

Navel.

### 51.1.3  Proportions of a Man the Height of Eight Heads, seen from the Front

If you wish to construct the whole proportion of the man, then first draw a straight line as long as you want the figure of the man to be, and draw a cross line straight through it, and make six [further] divisions below the uppermost line, equally spaced.

Next divide the [uppermost] sixth part into eighths. And this is the length of the whole head.

Next divide the eighth into a tenth part. This is the length of the face from the chin to where the hairline begins.

Next divide the face under the hairline as far as the chin into three parts. In the first the eyebrows are contained. In the second is the end of the nose. In the third is the mouth[8] as far as the chin.

Next, below the uppermost sixth part, make a rectangle, one sixth in width and height. The length from the chin to the pit of the stomach is the same as the length of the head. And the length from the pit of the throat to the line drawn between the nipples of the breast is the same length as the line from the chin to the hairline. Open the compass to the same distance as it is from the eyebrows to the chin, set the point on the long line below the pit of the stomach, and you will touch the nipples on both sides. Next open it to half of one tenth, set it below the first rectangle and draw a stroke on which will be the navel.[9]

Next take one tenth and set the compass point on the middle line in the pit of the stomach, and as far as the compass stretches is the width of the man. And this is also the same as the height from the line across the flanks up to under the arms.

Next take the compass, set it in the pit of the stomach and measure as far as the nose.

Then turn the compass downwards so that it meets the line which touches the joints at the top of the thighs.

Next take one tenth and set the compass point on the long centre line, and rotate it onto the line across the top of the thigh at both sides, and it will give you the breadth of the hips. Now take one sixth and set the compass into the pit of the throat, and draw the shoulders on both sides, as far as the point stretches. From the pit of the throat it is one fifth part as far as the little point by the navel. From the nipple as far as the point above the penis[10] is one fifth.

One eighth part.

One sixth part.

One tenth part.

Heart.

51.1.1    BL 5230, fol. 2$^r$ (single-sided leaf). With rough sketches of a male figure in a circle and in a square.

51.1.2    Dresden Sketchbook, fol. 105$^r$. With carefully sketched figure repeated on 105$^v$ without construction lines.

51.1.3    BL 5231, fol. 1$^v$ and 2$^{r-v}$. Folded double leaf with writing and figure across both inner pages. On 2$^v$ is the figure without construction lines.

R II, 163–7

NOTES

1    *der soll sich verrichten auff der geschicklikeit des menschen*: DWb IV, I, 2, 3877–8 glosses AD's *geschicklikeit* as Latin *habitudo, habitus corporum*. AD is here taking up Vitruvius's idea of the human body being 'designed by nature' (*De Architectura* 3, 1.2 ff.). The phrase shows AD drawing on an available early modern German philosophical vocabulary at this stage of his development of a vernacular language of technical discourse.

2    AD goes on to paraphrase Vitruvius 3, 1.2.

3    AD is evidently aware of an error in contemporary Latin texts of the *De Architectura*, which creates impossible dimensions of the distance from the hair roots to the crown of the head, and abridges his paraphrase accordingly (Rupprich II, 164, note 7).

4    What is meant is the distance between the shoulders.

5    Vitruvius 3, 1.3.

6   *dy kloffter*: the old German noun *klafter*, 'span of the outstretched arms', with Nuremberg vowel /o/ for /a/. This use of demotic nouns for parts of the body becomes characteristic of his technical writing.

7   See Vitruvius 3, 1.4 and the drawings of the man in a triangle and the man in a square.

8   *Maul*: see note 6 and DWb VI, 1782–4. General term for the mouth of an animal, in modern German used of the human mouth only colloquially and in a humorous or pejorative sense. However, a neutral sense – animal or human mouth – is found in older dialect usage, including Bavarian and Franconian where *Mund* did not originally occur. Nonetheless this is the only occurrence of *Maul* in AD's anatomical analyses; hereafter the modern noun *Mund* is always found. While AD has an evident preference for earthy words for the human body, he must have come to accept that *Maul* was inappropriate.

9   Rupprich (II, 27–31, 151–62) points out that this text is unusual among AD's early constructions in combining integral (aliquot) fractions of the body (for example one sixth, one eighth or one tenth of the whole body), and determining proportional relationships by analogy (here comparing as many as possible of the parts of the body with the length of the face).

10   *zagel*: a Germanic cognate (now dialectal and archaic) of English 'tail', and likewise used as a euphemism for 'penis' (compare modern German *Schwanz* – 'tail' was also the original meaning of Latin *penis*). See DWb XV, 23–5. Here too AD shows a propensity to use colloquialisms which give his technical vocabulary a down-to-earth quality, though the words were not perceived as necessarily coarse or obscene in early modern German.

COMMENTARY

After his return from Venice AD resumed his assimilation of Vitruvius's canon of classical models and their rules of proportion. It becomes apparent in the first texts of this new phase that he is moving away from the aesthetic principle of the 'well-shaped man...designed by nature' (*De Architectura* 3, 1.1), and thus away from the notion of an absolute beauty, towards the view that there are countless forms of relative beauty which reflect the endless variety of nature. The classically proportioned male body which Vitruvius inherited from the 'aesthetic anthropometry' of antiquity (Panofsky 1948, 262), in which the head is one eighth of the whole body, the face one tenth, and the breast from shoulder to shoulder one quarter, is set out once more in these texts. But here already AD's geometrical scheme, like those of Alberti or Leonardo, is derived by superimposing a given construction on a natural form, applying compass and ruler to studies from life. In 51.1.3 he varies the method of aliquot fractions with the use of analogical relationships, characteristic of Leonardo's anthropometry, which

transforms discrete metrical data into expressions of the organic relationship between parts and a harmonious whole. In the following phase AD refines and extends his methodology. The aim of his theory and practice of human proportions becomes the systematic exemplification not of a uniform canon of beauty but of the wide variety of human forms, any of which, in different contexts of theme and subject, may appear more or less beautiful, contributing as they do to the whole beauty of a work of art, which consists in its truth to nature.

[Panofsky 1948, Vitruvius, ed./trans. Rowland/Howe 1999]

## 51.2  Euclidean Geometrical Terms and Natural Perspective

### 51.2.1  Contents List of Geometrical Definitions

First: what a point[1] is.
Next: what a line is.
Next: what a plane is.
Next: what a surface is.
Next: what a circle is.
Next: what a right angle is.
Next: what a triangle is.
Next: how many different ones there are.
Next: what a quadrangle is.
Next: how many different ones there are.
Next: what a cone[2] is.
Next: what perpendicular is.
Next: what parallel is.
Next: what a cube is.
Next: what the diameter is.
Next: what proportion is.
Next: what bodies are.
Next: what quantity is.
Next: what regular bodies are.
Next: what irregular bodies are.
Next: what infinite lines are.
Next: what rays are.
Next: what quality[3] is.
Next: what a form is.
Next: what distance is.
Next: what termination is.

Next: what contact[4] is.

Next: what a cylinder is.

Lines – straight.

Lines – peripheral.[5]

### 51.2.2  Summary of Euclid's Natural Perspective

*prospectiva* is a Latin word which means 'seeing through'.[6]

Five things are involved in this 'seeing through':

The true causes of seeing are five-fold:[7]

The first is the eye that sees.

The second is the object[8] that is seen.

The third is the distance between them.

The fourth: all things are seen along straight lines, that is to say, the shortest lines.

The fifth is the separation of the things you see from one another.

From this arises firstly the following postulate:[9]

As stated in point four above, all things are seen along straight lines. But these same rays diverge from one another in the distance, so that they become separate, such that they form a cone,[10] whose tip penetrates your eye.

Then the second postulate:

Only those things can be seen to which the sight can reach.

The third postulate:

Where the sight cannot reach along straight lines, as set out above in the fourth cause, a thing cannot be seen, for the sight cannot receive crooked lines.

The fourth postulate:

All things seen by means of rays which open out wide, will appear large.

The fifth postulate:

All things caught between narrow rays, will appear small.

The sixth postulate:

All things seen in the same rays, whether large or small, wide or narrow, will appear all to be the same size.

The seventh postulate:

All things seen along high rays will appear high.

The eighth postulate:

Those seen along low rays will appear low.

The ninth postulate:

All things caught by the rays on the right side, will appear on the right.

The tenth postulate:

And what the rays catch on the left side will appear to be on your left.

The eleventh postulate:
All things which are seen from several angles will be more easily seen.

51.2.1   BL 5228, fol. 201ʳ
51.2.2   BL 5228, fol. 202ʳ and 5229, fol. 77ʳ (for 'The eleventh postulate' only)
R II, 371–4

## NOTES

1   *punctus*: the list quotes the geometrical terms throughout in Latin.

2   *kanus*: AD has transposed Latin /o/ in *conus* to the Nuremberg vowel /a/. But that means he has written the word from hearing not from a printed text. The same applies to the words in notes 3–5; see also the commentary below. In his Instruction on Measurement (1525), he uses German *Kegel* for 'cone', the first occurrence of the word in a geometrical usage (Pfeifer, 820; Paul, 527). See R II, 372, note 3.

3   *qualtas*: for Latin *qualitas*, with elision of the (unheard?) unstressed vowel.

4   *kantagtus*: for Latin *contactus*. Here too AD transposes heard Latin into written Nuremberg German. <k> conveys Latin initial /c/ when followed by the vowel /o/. Compare *tzilindrus* for *cylindrus*, where Latin <c> represents [ts]. AD regularly has dialectal /a/ for /o/; voiced /k/ and voiceless /g/ are neutralised and written as <g>.

5   *pariferia*: for Latin *peripheria*.

6   AD writes *prospectiva* for *perspectiva*, to which however his definition more strictly applies (*pro-*, 'forward'; *per-*, 'through'). The two Latin words were used interchangeably in the fifteenth century, and AD seems to have derived some of his early knowledge of perspective from Piero della Francesca's work entitled *De prospectiva pingendi* (Panofsky 1948, 247–51, and the following note).

7   See Rupprich II, 373, note 3: The following five points do not derive from Euclid; rather they closely echo the formulations of Piero della Francesca's 'five parts' in the introductory definitions of his *De prospectiva pingendi*.

8   *gegen wurff*: loan translation from *objectum* (created by the direct substitution of German for Latin word elements), found in fourteenth-century mystical theology. The word was current until the eighteenth century when it was ousted by the newer loan translation *Gegenstand* in rationalist philosophy (DWb IV, I, 2, 2302f.). Occurrences in AD's writing of words from the translation lexis of late medieval theology show the continuing influence of older Christian tradition even on people of modest education around 1500.

9   *dÿ furnemung*: This sense of the noun – clearly derived from the medieval or neo-Latin philosophical sense of *suppositio* (Niermeyer, 1316) – is not recorded in DWb IV, I, 1. Rather than 'supposition', my translation uses the modern mathematical term 'postulate'.

10   Here *conus*. See note 2.

COMMENTARY

Euclid (active in Alexandria during the reign of Ptolemy I, 323–283 BC) deduced the principles of geometry in his *Elements*, which served as the basic text of geometric instruction until the end of the nineteenth century. In the *Optics*, he developed the Platonic notion that vision comes about when discrete rays, emanating in a cone-shaped field from their apex in the pupil of the eye, encounter an object. In 1507 AD bought a Latin translation of the *Elements* and the *Optics* (34), just after his return to Venice from Bologna, suggesting a direct connection between the book purchase and what he had learned about perspective in Bologna.

Euclid's two works provided the mathematical base for AD's theory and practice of painting and the published treatises which expound it, namely the geometry of solid bodies and the optical principles of perspective. The fundamental nature of Euclid's work must have become clear to him at the very latest in Bologna, where he began to acquire knowledge of perspective from sources such as Luca Pacioli and Piero della Francesca, themselves drawing on Italian predecessors, Ghiberti, Brunelleschi and Alberti. That AD in the very first plans and drafts of his manual on painting quotes, paraphrases or echoes Euclid, Piero and Alberti, shows this constellation of influences very graphically. In the years 1507–9 he is setting out simultaneously to master and to teach two interrelated scientific disciplines, the mathematical method of organising space so as to achieve correct perspective and harmonious design, and the geometrical theory of depicting correctly proportionate human bodies.

In Nuremberg AD was now equipped to exploit two linked resources, the large library left by Regiomontanus and Bernhard Walther, and the scholarly expertise of Willibald Pirckheimer and Johannes Werner. The way in which he feels his way towards an adequate linguistic expression of his developing mental grasp of the 'science of art' often betrays the extent to which his understanding of source texts relies heavily on the mediation of others with securer Latin. Frequently, key terms appear in his transcriptions of Euclid and Vitruvius in forms evidently heard, not read, which are then conveyed not in standard Latin orthography but in a dialectally modified, ver-nacular written German. The translation and commentary of the current texts, and to a varying degree also of texts from later stages of AD's evolving technical and aesthetic writing, tries to reflect this complex cultural dimension of his authorship.

[Panofsky 1948, chapter 8; Kemp 1990, passim; Rupprich, II, introductions and notes]

## 51.3  Drafts of the Preface and Contents for the Projected Manual on Painting

### Introduction

The earliest preserved drafts of the plan, preface and introduction of the manual on painting make it plain that already around 1508 AD had a clear overall sense of its intentions and scope. Its concerns extend from the apprentice painter's mental and physical aptitude, his workshop training and his acquisition of advanced techniques, to the metaphysical justification and moral-philosophical value of art. In all of this we can recognise him in his complex persona, as the product both of the craft workshop and of the humanist culture of Nuremberg, as the avid student of antique and contemporary Renaissance art and the aspirant German Apelles, eager both to complete his own mastery of the ancient and modern science of art and to propagate it amongst his younger transalpine colleagues. The scheme he proposes reflects the evolution of a tradition of education for artists in Renaissance Italy and its crystallisation into a humanist genre during the fifteenth century (Ames-Lewis 2000, chapter 2). In the 1390s in Padua, Cennino Cennini wrote *Il Libro dell'arte o Trattato della Pittura*, designed to transmit in an empirically based manual the techniques of the school of Giotto, with as yet little attempt to set the apprentice's studies in a wider intellectual syllabus. Brunelleschi and Ghiberti having demonstrated the construction of pictorial space using geometrical perspective in the first two decades of the fifteenth century, Leon Battista Alberti's *De Pictura* (1435) describes an approximation of Brunelleschi's method, with which painters such as Donatello, Uccello and Masaccio were beginning to experiment in practice. In 1467 Francesco Squarcioni incorporated the skills of perspective, foreshortening and anatomical drawing into the curriculum of his workshop training course. His contemporary in Padua, Michele Savonarola even describes painting as a *studium*, comparable to the university subjects of the liberal arts and philosophy. The elevation of artistic training to a formal education came about in the Giardino di San Marco, the 'academy' established by Lorenzo the Magnificent de'Medici in Florence, where Michelangelo and, briefly, Leonardo studied. The latter's own 'Accademia leonardi vinci' remained an ideal on paper, with its precept 'first study science, then follow the practice born of that science' (Kemp/Walker 1989, 200), and the dubious practicability of so complete an intellectualisation of painting is expressed in the ironical dismissal of Botticelli's workshop as *un accademia di scioperati* ('layabouts' – or *schmarotzer* as AD puts it in 29.10).

Whatever AD may have known about the theory and practice of training in Italian Renaissance workshops, it seems clear that he envisaged his projected manual from the start as a printed book and that he gave it a consciously fashioned formal architecture (Rupprich II, 83–9). This is based on a numerical structure of three main parts: preface, practical execution of painting, conclusion, each divided into three sections, each of these then subdivided in turn into six chapters. The numerical symbolism of

three and six will have been familiar at least to AD's humanist collaborators from their knowledge of late medieval Neoplatonist writers such as Nicholas Cusanus, Giovanni Pico della Mirandola and Luca Pacioli. Three is the number of the Trinity, of the tripartite universe and of the three-stage history of salvation; six is the days of creation, and its multipliers provide the units of the hours of the day. In the biblical Book of Wisdom 11:21, God 'ordered all things with measure, number and weight'. AD knew from Vitruvius (3.1.6) that six is the 'perfect number', to which all integers of the duodecimal system relate, and it is the key number of his system of measuring the human body, from which in turn the architecture of temples was derived. Symbolically, at the outset of his project, AD shows his desire to reconcile Antiquity and Christianity in the very structure of his book.

A further influence on his structural conception is Leon Battista Alberti's *De Pictura*, likewise composed of three parts, though their subdivisions are less consistently devised, and Alberti may well have derived his general scheme from the classical model of Quintilian's tripartite *Institutio oratoria*. However, the thrust of Alberti's work is to free painting from the workshop and the craft tradition, and to establish its claims to be a liberal art. AD, on the other hand, shaped by his own dual apprenticeship as goldsmith and painter, is concerned to combine the practical and the theoretical. His structure leads the young painter from prenatal dispositions of birth-star and humoral temperament, through moral and humanistic education, into awareness of the social and ethical value of painting, only then into a rigorous programme of technical and intellectual study of proportion, perspective, light, shade and colour, then finally to issues which bear in on the artist who reaches the heights of his profession – where best to live, what fees to charge, and how to thank God for his genius.

The earliest draft introduction to the manual (51.4) immediately broaches topics which will remain central to further draft texts on aesthetics and the theory of art in the intensive period of thinking and writing starting from around 1512/13, in the progressive stages of the so-called 'aesthetic excursus' from circa 1515 to 1528, and in the dedicatory prefaces and the introductory material written for the planned publication of the textbook on human proportion in 1523 (82–5, 103, 151, 181–2). AD's continuing belief in the theory of the temperaments, held from ancient times until the sixteenth century to govern human character and physique, continues to be voiced in his writings and influences his last great painting, the panels of the *Four Apostles* in 1526 (233). The urgency of rediscovering lost theoretical writings on art from antiquity, of encouraging Italian contemporaries to disclose their knowledge, and of articulating his own knowledge of scientific and artistic principles for German artists to learn from, informs his written work from beginning to end. The centrality of instruction in the geometry of art, in perspective and above all in human proportion, is evident in virtually all he wrote. The question of the nature of beauty and the limits of its realisation in the visual arts is again a dominant one in the texts of 1512/13 and, to the end, in the 'Discourse on Aesthetics' (257.4) of the *Four Books of Human Proportion*, published

posthumously in 1528. Finally, the creation of a scientific and artistic vocabulary and of a German style appropriate to conveying ideas and techniques to young craftsmen of limited education, remains a problem which, as the reception of his published works shows, he never solved.

[Rupprich 1960/61 & introductory material in R II and III; Panofsky 1948, chapter 8; Brandl 1986; Kemp 1987, 11–14; Summers 1987, 235–64; Bacher 2000a-b; Bonnet 2001, 212–18; Ames-Lewis 2000, chapter 2; Hinz 2011]

### 51.3.1   Draft of the Preface and Summary of the Whole Manual

Jesus Mary
By God's grace and help, in the service of all young people desirous of learning, I shall in what follows reveal to them all that I have found out through practice that is of use in painting. And if with my help they prove capable of it, it may benefit him who seeks, should he have the inclination for it, and help him to advance further in the higher understanding of this art. For my intellect is inadequate to fathom the depths of this great, far-reaching art of true painting.[1]

Note: I shall teach and inform you so that from it you may thoroughly and properly learn to understand what is, or may be termed, a richly skilled painter.[2] For the world is often deprived of, and lacks for two or three hundred years, such a gifted artist, frequently through obstacles which prevent those who might have the potential being made fit for it. Take note now of three following main important points which are essential to such a true painter and artist. These are three main sections of this whole book.

1   The first chapter of the book is the Prologue, and it contains three parts. The first tells us how the boy should be chosen, and how attention should be paid to the suitability of his temperament.[3] This is done in six sections.
The second part of the Prologue explains how the boy is to be brought up in the fear and nurture of the Lord, whereby he may attain the grace to become strengthened in the knowledge of art. This is done in six sections.
The third part of the Prologue tells us of the great usefulness, pleasure and joy which spring from painting. This is done in six sections.
2   The second chapter of the book is the practice of painting. This also is in three parts.
The first tells of the free nature of painting,[4] in six sections.
The second part speaks about the measurement of the human being and buildings, and what is necessary to painting, in six sections.
The third part discusses all that man may see, a part of which is treated separately, in order to demonstrate it. In six sections.

3   The third chapter of the book is the Conclusion, which also is in three parts.

The first part shows where a painter should live in order to practise his art. In six sections.

The second part explains how such an excellent artist should set high prices on his art, and that no sum is too much for it, given that it is a divine and true art.[5] In six ways.

The third part tells of the praise and thanksgiving the artist owes to God, who bestows his grace on him, and which others should render on his behalf. In six sections.

### 51.3.2   The Subsidiary Material Referred to in the Draft Preface

1   The first part of the Prologue teaches:

Firstly, that the young man's birth should be examined, under which sign he was born, with sundry details.[6] Pray God it was an auspicious hour.

Secondly, that his bodily form and limbs be measured, with full details.[7]

Thirdly, how he should be taught at the start of his apprenticeship, with full details.[8]

Fourthly, it should be noted whether the boy is best to be taught with kind praise or with rebuke. With details.

Fifthly, that the boy should be kept eager to learn and not made truculent.

Sixth, if the boy has worked too hard, and fallen prey to melancholy, that he should be distracted from it by the pastime of learning to play a stringed instrument, for the stimulation of his blood.[9]

2   The second part of the Prologue teaches:

Firstly, that the boy be brought up in the fear of God, to desire of him the grace of discernment[10] and to honour him.

Secondly, that he be kept moderate in his eating and drinking, likewise his sleeping.

Thirdly, that he has pleasant living quarters, so that he is not put off by any kind of hindrance.

Fourthly, that he be kept away from the female sex, not allowed to live in the same house with them, not see or touch any naked woman, and that he be protected from all uncleanness. Nothing debases the mind more than impurity.[11]

Fifthly, that he learn to read and write well and is educated in Latin, so as to understand all manner of writings.[12]

Sixthly, that such a one be provided with the means to acquire these skills, and that he be looked after with medical aid when he needs it.

3   The third part of the Prologue[13] teaches:
Firstly, it is a useful art, for it comes from God and is practised for good and holy instruction.
Secondly, it is useful, and much evil is avoided, if a man is employed in arts which are otherwise left for idle leisure time.
Thirdly, art is useful, for no one believes, unless he is engaged in it, that art is so rich in pleasures. Great joy is to be had from it.
Fourthly, art is useful, for you may win great and everlasting fame from it if you practise it appropriately.
Fifthly, it is useful, because God is honoured by it when people see how God bestows such intellect on one of His creatures, who has such art in him, and all who are wise will be gracious towards you for the sake of your art
The sixth usefulness is that if you be poor, through such art you may attain to great wealth and possessions.

### 51.3.3   Contents List for the Second Part of the Second Chapter of the Handbook on Painting

On the measurement of human bodies.
On the measurement of horses.[14]
On the measurement of buildings.[15]
On perspective.
On light and shade.[16]
On colours and how one makes them like nature.[17]

### 51.3.4   An Expanded Contents List

This [second part of the] book comprises ten topics:
Firstly the measurement of a young child.
Secondly a measurement of an adult man.
Thirdly a measurement of a woman.
Fourthly a measurement of a horse.
Fifthly a little about buildings.
Sixthly on the projection[18] of what is seen, that all things can be projected onto a surface.[19]
Seventhly on light and shade.
Eighthly on colours to be painted as they are in nature.
Ninthly on the composition of pictures.[20]

Tenthly on free painting, which is done without aids, solely out of reasoned thought.

51.3.1   BL 5230, fol. 4ʳ
51.3.2   BL 5230, fol. 5ʳ⁻ᵛ
51.3.3   BL 5229, fol. 164ʳ, in the upper left corner of a leaf covered with geometrical and architectural sketches
51.3.4   BL 5230, fol. 3ʳ, on a leaf with text and the proportional drawing of a foot
R II, 91–6

NOTES

1   Rupprich's note 1, II, p. 92, is misleading. The primary sense of early modern German *kunst* is still 'knowledge' (of theory and practice, whether of an aesthetic or technical discipline or profession). The idea of 'art' and *kunst* as inspired creativity is as yet still emergent in the Italian Renaissance and in the writings of AD. (DWb V, 2666–84; Strieder 1983; Brandl 1986; Wellmann 1993; Ashcroft 1999; Ames-Lewis 2000).

2   *ein künstreicher moler*: the primacy of the meaning 'knowledge-based skill' in the English, Latin, Italian and German words 'art', *ars*, *arte* and *kunst*, in AD's and in sixteenth-century usage generally, raises acute problems for the translator. While I often render AD's *kunst* and *künstler* or *künstner* as 'art' and 'artist', I rely on the reader's awareness (if only from my commentaries) of the different connotations the words carry in their historical context. Often, however, that context requires me to expand or paraphrase the translated text, especially where the dimension of knowledge or acquired skill is paramount, and to use 'art' or 'artist' alone risks distorting AD's meaning. In this paragraph he refers to *künstreicher moler*, *künstreicher meister* and *kunst reich*[er] *recht*[er] *maler*, and in each instance I have found myself resorting to a different translation, in order to convey the relative weight of implication, as between knowledge and training, talent, craftsmanship and artistry.
[Wellmann 1993; Ashcroft 1999; notes on Translation in the Introduction, above]

3   *geschicklikeit seiner cumpex*: Latin *complexio* refers to the notion that the qualities of a person's character derive from the dominance in his nature of one of the four elements – earth, air, fire, water – out of which all substances are composed, according to the philosophy first stated by Empedocles (fifth century BC). The Latin word acquires this sense in medieval and early modern usage and it occurs in German loan forms *complexie*, *complexe*, *complex* in the fifteenth century, when the concepts of complexion and temperament become current in natural philosophy and medicine. AD's garbled form suggests here again that he had heard, rather than read the word (DWb V, 1685f.).

4   *von der freÿikeitt molens*: this appears to be the sole known occurrence of the word-form *freÿikeitt*. There is no immediately apparent reason why AD did not use the noun *freiheit*/*freyheit*, and we may deduce that this is not merely an odd variant spelling. Rupprich (III, 92, note 8) takes it to be a borrowing from the often over-elaborate

early modern *Kanzleisprache* (the idiom of legal and administrative writing), yet he can offer no occurrence in any such source. He understands it as meaning 'generosity'. In classical Latin, alongside the more common noun *libertas* ('freedom'), *liberalitas* (whence English 'liberality') denoted the open generous disposition of a free, or freed, man. The adjective *liberalis* (an extension of *liber*, from *libertas*) denoted the behaviour appropriate to the status of the freedman. In sixteenth-century German, the adjective *liberal* was borrowed from Latin in a similar sense. Conjoined with *ars* and *artes*, *liberalis* had the meaning of 'free or liberal arts' (*artes liberales, freie Künste*), originally those intellectual and aesthetic accomplishments a freedman ought to be versed in. The 'seven liberal arts' were formalised in the Middle Ages as the trivium (grammar, logic, rhetoric) and quadrivium (arithmetic, geometry, music and astronomy) of the university curriculum. In later Latin, *liberalitas* was a collective concept for higher education, comparable with Renaissance *humanitas*, education founded on classical Latin learning. Traditionally, painting, sculpture and associated visual arts were 'mechanical' not 'liberal' arts, because they required physical skills and manual labour. In quattrocento Italy, the idea of the revival of antiquity in modern art led to the demand that painting should be recognised as a liberal art. Thus Baldassare Castiglione in his *Book of the Courtier* (*Il cortigiano*, circa 1516–18) prescribes knowledge of painting for the accomplished courtier, 'even though it may appear mechanical', because painting is 'a worthy and beneficial art and was greatly valued in the times when men were greater than now'. My translation, the 'free nature of painting', assumes that AD means the claim of painting to be a *freie Kunst*. His newly minted noun *freÿikeitt* may be regarded as a semantic loan from *liberalitas*, a concept he probably brought from Venice. His humanist friends in Nuremberg may have helped him find a distinctive vernacular term for this. Panofsky (1948, 270), however, understands *freÿikeitt* as 'manual skill…chiefly to be acquired by copying from good masters'.

[Pfeifer, 1012; Niermeyer, I, 791; Brandl 1986, 51–4; Warnke 1993; Bacher 2000a; 33f.; Ames-Lewis 2000, 1, 9 & passim]

5   The idea of a divine sanction and inspiration of the artist, based on the example of God as creator in the Old Testament book of Genesis, is developed in later texts. AD's teaching of geometry, perspective and proportion has its biblical validation in Wisdom of Solomon 11:21 (see 51.3, introduction).

6   Astrology was regarded as a legitimate science in the Renaissance. The zodiac sign under which a child was born, the constellation of its 'nativity', was held to influence its character and physique. In the inscription on his self-portrait of 1493 (5.2), AD sees his own destiny as written in the stars.

7   Physical size and shape afforded indications of the child's temperament or complexion (see above note 3).

8   In this and all other cases, such 'details' are not specified in any extant draft. Compared to other sources, for instance the writings of Cennino Cennini or Leonardo da Vinci, AD's prescriptions for the training of apprentices lay unusual weight on general

moral education and character formation. Mende 2004, 40 suggests it is no coincidence that AD began his handbook at the point where he became responsible for his young brother Hans's upbringing. For Leonardo's advice on training the young painter, see McMahon 1956, 45–7.

9  Rupprich III, p. 93, note 7. By 1508, AD could have had access, via Celtis or Pirckheimer, or in the translation by Johann Adelphus Muling (Strasburg 1505), to the *De Vita libri tres* of the Florentine Neoplatonist Marsilio Ficino, and its precepts on health and on the nature and treatment of melancholia. See also Arnold Schlick's *Tabulaturen Etlicher Lobgesang* (Mainz 1512) which asserts the power of music 'to distract the afflicted spirit from the sadness of troubled thoughts'. Moffitt 1988 offers the mundane proposition that artists' 'melancholy' was a symptom of lead poisoning from the use of white lead in pigments. On the evidence that AD himself was a melancholic, see 93.4, 320, 328; Wittkower 1963; Klibanski/Panofsky/Saxl 1964; Schuster 1991. His own interest in lute and organ music is documented in 229.

10  *subtilitet*: Ciceronian Latin *subtilitas* denoted accuracy and subtlety of language, discernment, delicacy. Late medieval German *subtiligkeit* retains these meanings in a wide and extended range of contexts: fine-spun threads and fabrics, precise craftsmanship, intellectual and spiritual purity and refinement. The form *subtilitet* is typical of a late medieval type of scholarly and theological loan-word, forming abstract nouns by systematically substituting German suffixes for Latin ones, including *–tät* for Latin *–tas*. The earliest known occurrence dates from 1472/3 and, like older *subtiligkeit* it originates in mystical religious texts. The context of AD's use of *subtilitet* is not precise enough to determine its exact meaning. It could encompass accuracy and delicacy of workmanship, refined perception of divine creation in nature, and artistic discrimination.

[DWb X, IV, 823–32; Paul, 984]

11  The rules on diet, living environment and personal morality are also found in Marsilio Ficino's work (see note 9 above).

12  On the place of Latin in the curriculum of Renaissance artists, see Ames-Lewis 2000, chapter 2. It is likely that AD had limited knowledge of Latin from school or later reading. Although his father was a notary, Leonardo da Vinci, as an illegitimate son, was not given a grammar-school education. Both were typical in this respect of the norm of artists in their time, who had merely basic literacy and useful number skills.

13  The contentions in the final sections of the Prologue coincide in some respects with books two and three of Leon Battista Alberti's *De Pictura* (1435), in particular the sections II, 25–9 and III, 51–3. Both present a prescription for the artist as 'a man both good and well educated in the fine arts' (III, 52). Both see geometry as the most important branch of knowledge for the young painter, and both promote painting as a liberal art. They point to the divine inspiration and approval of art, its social usefulness and moral qualities, its power to generate pleasure and to bring fame and wealth to the successful painter. However, a direct influence on AD's first scheme for his own manual on painting is unlikely. It is quite possible that AD already had some knowledge

of Alberti's *De Pictura*, though it is generally assumed that he did not have access to it until he was able to consult the Regiomontanus/Walther library (see the introduction to 51.3). It is unlikely that AD found it easy to read and assimilate. Indeed, it is doubtful whether any practising artist would have found it usable. It lacks the down-to-earth didacticism, analytical scheme and rational sequence of topics that AD knew would befit a German apprentice.

[Rupprich 1960/61; Hope & McGrath 1996, 165–7; Bätschmann & Schäublin 2000; Sinisgalli 2011, 4–6]

14    It is possible that, through Pirckheimer's friend Galleazzo da San Severino, AD may have had some knowledge of Leonardo da Vinci's treatise on the anatomy of the horse, which according to Vasari was destroyed in the French sack of Milan in 1499, or of Leonardo's designs for an equestrian statue of Francesco Sforza. Hans Sebald Beham attempted to publish a treatise on the proportions of the horse in 1528, but was forbidden by the Nuremberg council. This is likely to have been, or to have been based on, AD's work (278–9). A sequence of drawings and engravings done between 1500 and 1505 allows the assumption that he had worked systematically on the constructional depiction of horses (Rupprich, II, pp. 55–7).

15    AD's own architectural interests, which arose from his study of Vitruvius and were fed by his visits to Venice, must have been primarily geared to the perspectival and stylistic correctness of buildings in his own paintings, woodcuts and engravings.

16    Alberti's *De Pictura* has information on light and shade (Book 2, 11), and it is a major recurrent theme in Leonardo's treatise on painting (Kemp & Walker 1989, esp. 88–115).

17    Alberti, Book 1, 9–10; Leonardo, esp. 70–88. See 85.1, though this is one major aspect of painting that AD failed to write on extensively before he abandoned the project of a comprehensive manual of painting.

18    *abstelung*: not in DWb I nor the revised DWb, nor in the FnhdWb. AD evidently meant by it the depiction of what the eye sees by drawing it on a surface, its 'projection'. Like the related word *abmachung*, 'copy', it is part of an existing early modern German technical vocabulary of painters. See Rupprich II, p. 95, note 4.

19    *durch tzeichen*: the verbs *durchzeichnen*, *erzeichnen*, are used with *abstehlen* in the final section of the *Instruction on Measurement* (1525) with the meanings, 'trace, project', when AD is describing the use of apparatuses to facilitate accurate perspective.

20    *ordnung der gemell*: the organisation of the parts of a painting into a coherent, balanced composition. See also Alberti, Book 2, 33–9. In paintings belonging to this period, such as *The Martyrdom of the Ten Thousand*, the altar for Jakob Heller, and the *All Saints* altar, as also in many of his woodcuts and engravings, AD was himself creating compositions which involved large numbers of figures. He never wrote the planned chapter on this topic.

## 51.4  Draft of the Introduction to the Manual on Painting

*On Painting*

He who wishes to become a painter must have a natural talent for it.

Love and pleasure in the art of painting are better teachers than compulsion.

If someone is to become a great, highly skilled painter, he must be brought up to it from his earliest youth.

He must first copy a great deal of the art of good craftsmen before he acquires a free hand.[1]

Now what is meant by painting.

To paint is when someone makes an image on a flat surface of one out of all visible things that he chooses, whatever they may be.[2]

It is appropriate to teach someone first how to divide up a human figure and to measure its proportions, before he learns anything else.

For that reason I shall set myself the task of explaining, as simply as I can and without concealing anything, how to divide and measure a human body. And I beg all those too who are thoroughly versed in this art and know how to demonstrate it with their hand, to bring that into the light of day, clearly and avoiding lengthy and difficult digressions. I reckon here to be kindling a little flame. If you all feed it with your artistic learning, in time a fire will be fanned which shall light up the whole world.[3]

Let anyone who hears me, then, try in his own work to improve on my views here, and thus much more knowledge of art will be disclosed and described to the betterment of painting.

The more exactly you imitate Nature, the better your painting will be seen to be.

Many centuries ago there were great masters of whom Pliny writes, such as Apelles, Protogenes, Phidias, Praxiteles, Polyclitus, Parrhasios and others. A number of them wrote learned books on painting, but alas, alas they are all lost.[4] So we are deprived of them and we lack their great insights.

I have heard of nothing, either, that our present-day masters are creating, describing and disseminating. I cannot imagine why there should be this dearth. However, I shall publish what little I have learned, as much as I am capable of, in the hope that a better man than I am learns of it and refutes my error with proof from his up-to-date work. I shall be glad of that, and not least because I shall have been the cause of such truth being brought into the light of day.

*On Beauty*

A painter in whose power it is placed to create a picture is expected to make it as beautiful as he can. Although what beauty is, I do not know.[5] However

for my present purpose I propose to define beauty as follows: what through the ages the majority has deemed beautiful, that is what we try to create.

Deficiency in anything is a flaw. Thus too much and too little damage everything. Harmonious things, one conforming with the other, are beautiful,[6] and what is not useful is to be avoided. But utility[7] is a large part of beauty. There is a great comparability to be found in dissimilar things. But so that you may know what is not useful, then limping and suchlike are not useful, and therefore limping and suchlike are not beautiful.

In studying beautiful things, good advice is helpful. But take that advice from those who are good craftsmen. For to the untrained beauty is like a foreign language, but anyone who has made a work with his hands, sets it before the common man and lets him judge it, speaks with knowledge. The common folk usually spot what is clumsy about it, although they cannot recognise what is good in it. When you hear a truth spoken, then you can correct your work accordingly.[8] Beauty has many differences and sources. Someone who can show these in his work is all the more to be believed. For the work that has no flaw is beautiful.

It might come about that you hear it said: Who will ever take on the effort and labour as you will find described in the following, with all the time it devours until one has made one single work? How would anyone do it, faced with painting two hundred figures on one panel and not one of them the same as the other?[9] In this book it is not my intention that everyone is going to do measurement for the rest of his life. But what I am going to write is of value, once you have learned it and know it off by heart, in making you fully aware how a thing should be. If your hand, in the free flow of your work, were to run away with you by the sheer speed of your drawing, then your mind will check by reliable eye and adroit skill that you have scarcely gone wrong, and make you vigorous in your work and free you from gross error, and your painting will always look true to nature. But if you have no true grounding, then it is not possible for you to do anything good, however free with your hand you may be.

Through a true knowledge of art you will become much more confident and proficient in your work than otherwise.

Once you have been taught the means to measure a human figure, it will serve you for any type of person you wish. For there are four human complexions as the *physici* will inform you.[10] All of these you can measure by the means that will be set out below.

You will need to copy many people, select and measure the most beautiful of them, and bring that into your painting.[11] We have to take great care that the disfigured do not keep stealing into our work without our being aware.

It is not possible for you to copy a beautiful form from one person alone. There is no single beautiful being on earth which could ever not be still more beautiful. There is no living person on earth who can say or show how the most beautiful human form might look. No one but God knows how to judge beauty. Opinions must differ on that. As it suits, one must incorporate beauty into everything. For in all things we see some feature that is beautiful, whilst in another thing it would not be beautiful. With disparate things, both of which are beautiful, it is not easy to define which is more beautiful.

Put together[12] from many small details, from many beautiful people, something good can be created.[13]

Do not imagine that I make a great boast of my following descriptions and measurements, even though I do not decry them either. I do not consider either that the most negative opinion of them should apply. It does not have to be thus and not otherwise. You may make something different out of them as you please. For that reason I shall also at the end indicate ways how you may alter everything as it pleases you and in that fashion invent better works. However, let everyone take my method as a model until you are truly taught a better one.

Through measurement you may find out how to depict all human forms, choleric or kindly, fearful or joyful, and suchlike, just as need and occasion demand.

BL 5230, fol. 14$^{r-v}$–15$^r$
  R II, 99–103

NOTES

1   In the Italian Renaissance a standard workshop practice was copy-drawing – from nature, from works in churches, and from sheets and model-books compiled and kept for this purpose. AD himself copied engravings by Pollaiuolo and Mantegna, and his own engravings became much imitated and plagiarised in Italy. See Ames-Lewis 2000, 35–46. Alberti (II, 58–9) has reservations about the value of imitation, and Leonardo denies the value of learning by copying altogether: 'I say to painters that no one should ever imitate the style of another because he will be called a nephew and not a child of nature with regard to art' (Kemp/Walker 1989, 193f.). AD consistently stresses that copying is only a step towards the acquisition of a 'free' or 'practised' hand. See Barolsky 1995, 5–14, on the semantics of Italian *mano* (and *maniera*) and the relationship between the artist's hand and the hand of God the creator.

2   The 'flat surface' is to be understood as one interposed between the eye and the image in the way that a perspectival projection is achieved. By 1508 it is already a standard definition. See Alberti III, 52: 'The task of the painter consists in drawing and

painting any given body with lines and colours on a surface, so that from a certain distance...everything one sees painted appears three-dimensional and closely similar to the depicted body itself.'

3   Luke 12:49: 'I am come to send fire on earth: and what is my desire but that it were already kindled' in William Tyndale's New Testament (1534). The biblical quotation is taken up again in 83 (1513).

4   Apelles' treatises on painting, Pliny *NH* 35, 79 & 111. Pliny does not mention writings by Protogenes, but these are known of from other sources, some of which AD could have heard about from Pirckheimer. Only two sentences survive of Polyclitus' canon on the measurement of the human body. According to Pliny, 35, 67, Parrhasios was supposedly the first to write about symmetry or proportion.

5   Rupprich, (II, 102, note 16), seems to attribute to Alberti the identical statement 'no se che'. I cannot find this in Alberti's *Della Pittura*, nor its Latin equivalent in *De Pictura*. Against his normal practice, Rupprich supplies no text reference. AD's understanding and definition of beauty are indeed quite different and essentially opposed to Alberti's (see the following note and commentary).

6   *Dy vergleichlichen ding, eins gegen dem anderen sind schon*: the concept *Vergleichung* became a key one in AD's thinking on art. It derives from Plato's dialogue *Timaeus*, in Cicero's translation, with the opposed terms *comparatio* and *separatio*, in AD's usage *vergleichliche ding* and *abgeschiedene ding*. The medieval German term *verglîchunge* was coined by the mystical theologian Master Eckhart (circa 1260–1327) and denoted the 'precedent image' which God created as material reality, such that divine idea and created thing remained 'comparable'. AD uses it in a quite different way, however, in the context of his understanding of beauty as being not an absolute, which he believes can be known only to God, but a relative category. The criteria of relative beauty include *nutz* or 'utility', *wolgefallen* or 'pleasure' as an aesthetic response, and *recht mittel*, the 'happy medium'. This last, deriving from the classical concept of the 'golden mean', became for Renaissance theorists a primary law of nature and art. Alberti calls it *concinnitas*, 'harmony', the comparability and consensus of parts (*De Pictura* II, 35), in Italian *convenienza*, *conformità* (Białostocki 1988, 64–8, and especially Panofsky 1948, 276–8).

7   *der nutz*: see the preceding note. *Nutz* can also convey aspects of English 'function'.

8   Since absolute beauty is unattainable, and no one, not even the painter himself, can pronounce authoritatively on it, one possibility is to rely on general opinion, the consensus of reasonably informed people at a given time. In this view, beauty – and what the artist should strive for – is what the world considers to be beautiful. AD is likely to have known classical versions of the idea. In Lucian's dialogue *In Defence of Pictures*, Phidias allows the common folk to tell him how his statue of Jupiter might be improved, by hiding behind a door as they view the artefact. Each person finds fault with a different part of the body, and Phidias then amends the statue accordingly, arguing that many are bound to see more than one man does, even a Phidias.

Pliny (*NH* 35, 84) tells the same story of Apelles, and Alberti repeats this (*De Pictura* III, 62). However, the individual common man is given more limited credence in Pliny's anecdote of the cobbler who criticises the sandal painted by Apelles (*NH* 35, 85; see 63.1.5).

9 There are strong echoes here of AD's letters to Jakob Heller, especially 47.4.

10 *dy fisycÿ*: Rupprich (II, 102f., note 30) suggests that the work of the Arabic 'physician' Razi (865–925), which appeared in a Latin print around 1500, may have been known to AD, through a Nuremberg informant such as Pirckheimer. Another possible intermediary is Hartmann Schedel, municipal officer of health, author of the Nuremberg Chronicle, and a neighbour of the Dürer family in Unter der Vesten, who had a large library.

11 AD had in mind the story told by Pliny, of how Zeuxis was commissioned to produce a picture of Juno. Rather than trust in his own ability to create an image of perfect beauty, he selected five maidens, chose from each her most beautiful attribute, and combined them in his portrait of the goddess. See *NH* 35, 64, and Alberti *De Pictura*, III, 56; McHam 2013, 228–30 & *Plinian Anecdotes*, 161. It is 'an immortal anecdote quoted *ad nauseam* in Renaissance writing' to encapsulate the idea of relative beauty based on *concinnitas* or *Vergeichlichkeit* (Panofsky 1948, 278).

12 *geklawbt*: past participle of *kläubeln* (DWb V, 1018f.). The literal sense is 'to pick' – to pick at food, nibble; to pick up little objects with one's fingers. Here, to select very carefully

13 The closing sentences are meant to summarise the main contentions of AD's conception of beauty at this stage of his writing.

## 1509

## 52   Correspondence between Anton Tucher[1] and Duke Frederick the Wise of Saxony

*[Nuremberg, 6 April 1509]*
And then as concerns the image of Our Lady[2] which, as my last letter said, should have reached Your Princely Grace from Albrecht Dürer, I have spoken to Dürer, and discover from him that he did send Your Grace this picture securely packed in the little casket sketched here, but how this has gone missing is a mystery to him. Accordingly he has made another cast of the same image, enclosed here for Your Grace. I also received the two penny pieces and handed one of them to Albrecht Dürer, explaining Your Princely Grace's enquiry as to how the coins might be cast, such that they be durable. But I could not get out of him any productive or useful information, how to carry out Your Princely

Grace's command, but received the answer that, since he has no experience of dealing with such things, as Your Princely Grace knows, he is thus in no position to give Your Grace an adequate report.[3]

Nuremberg, State Archive, Nuremberg letter collections 63, fol. 197ff.
 Rupprich I, 255

NOTES

1   Anton Tucher II: see BI.

2   This may be the small silver relief medallion in Tietze, *Kritisches Verzeichnis, Ausgeschieden* 444, for which AD apparently provided a drawing.

3   The medallion of AD's drawing of the Virgin is incidental to a more central theme of a protracted correspondence between Anton Tucher, Degenhart von Pfeffingen, court chamberlain to Frederick the Wise, and the Duke himself. A letter to Pfeffingen dated 6 July 1508 describes how Tucher has removed a portrait of Duke Frederick from the cloister of the Dominican priory in Nuremberg so that the Master of the Mint, Hans Krug can sketch it in preparation for the arrival in Nuremberg of Lukas Cranach, who will then oversee the casting of the Duke's image for a new Saxon silver and gold coinage. When Cranach's appearance is repeatedly delayed, Tucher suggests that Krug may as well do the entire job himself. There is no record of a portrait of Duke Frederick in Nuremberg in 1508. AD had drawn and then painted him in 1496 (A 19), but it is most likely that Frederick took that picture to Saxony. A further five letters written by Tucher in 1508, another in September 1510, and a final one in September 1513, document the importance of Nuremberg as a centre of metal casting in bronze and stone matrices, Tucher's promotion of the local craftsman Krug, the versatility of Lukas Cranach the Elder, and his authoritative position as painter to the electoral princely court.

[The texts of the letters are printed by Heydenreich 2007, 408–13; see also 277]

## 53   Albrecht Dürer Buys his House on the Corner of the Zisselgasse from the Executors of Bernhard Walther

*Nuremberg, 14 June 1509*

I Hans von Obernitz, Knight, Judiciary,[1] and we the Magistrates of the city of Nuremberg, declare publicly with this document that Markus Pfister and Georg Kötzler, citizens of Nuremberg, as curators and executors of the last will and testament of Bernhard Walther, deceased, late citizen of Nuremberg,[2] affirmed and declared on Tuesday 5 June just past, before the honourable Georg Haller senior[3] and Hans Schönbach,[4] being specially summoned witnesses, that, in an

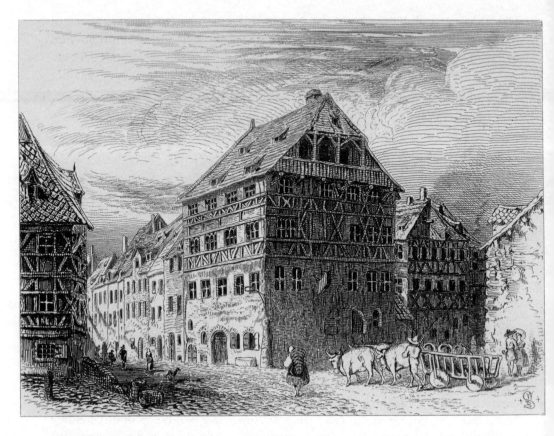

30. William Bell Scott, *Dürer's House in the Zisselgasse*, etching, 1869. Edinburgh: National Library of Scotland Cn 7

honest and permanent transaction, in compliance with the best proven laws and forms of sale, such as they should, could and might do legally, permanently, effectively and adequately, secure against any man's opposition and denial, they duly sold, gave in purchase and delivered out of their hands and authority to Albrecht Dürer, likewise citizen of Nuremberg, into his lawful possession and power to purchase, the heritable property which the said Bernhard Walther owned at the corner site and courtyard in Nuremberg by the Menagerie Gate, looking at the front towards the east, facing at one end to the south the prebendary formerly occupied by Canon Eberhard Cadmer, and at the back facing with its other end to the west and abutting the houses belonging to Hans Kifhaber the carter, just as it is, with all and each its possessed and traditional rights, with all its parts and pertinences, for the selfsame Albrecht

Dürer to possess, use, lease, sell and, as heritable rights allow, to do with it what suits him, and this in perpetuity without hindrance or claim by the vendors and all curators who might succeed them.[5] And the vendors swear for themselves and their successors to grant the said Albrecht Dürer this purchase of the heritable rights of the aforenamed residence, as specified above, without any charge, payment and penalty, and to expedite and defend it against any manner of objection or counter-claim, whether from church or secular authority, as accords with property right and with the civic law of Nuremberg, and namely such that he may henceforward as sole proprietor do or not do as and whatever he will, unhindered by anyone, since he has honestly and faithfully paid and delivered to them a sum, namely two hundred and seventy five Rhenish gulden in gold coin.[6] For that, in their capacity as executors, they have declared him and his heirs wholly and completely free and quit of obligation or claim. And all that has been done with the approval, will and knowledge of Sebald Tucher, citizen of Nuremberg, as superior who holds the superiority of the said residence, but with the specific condition that aforesaid Albrecht Dürer and his heirs shall give and pay to Tucher or his heirs annually, in rightful and perpetual ground-rent, eight gulden in the common currency of Nuremberg, half on St Walpurgis's Day and half at Michaelmas,[7] and in addition, annually to the Tracht anniversary chantry, twenty two old pounds henceforward in perpetuity.[8] In testimony whereof this charter is given with the judgement of the court and sealed with the attached seal of the court at Nuremberg. Witnesses thereto are the honourable gentlemen Andreas Tucher and Hans Stromer.[9] Given on Thursday after St Barnabas's Day, the fourteenth day of July, in the year since Christ our Lord's birth fifteen hundred and nine [fig. 30].

The original parchment deed, with the civic seal, is preserved in the city records of property and building control, with a copy in the city archive, Libri litterarum 11 (25), fol. 29.

Rupprich I, 227–9

## NOTES

1  Hans von Obernitz was *Schultheiß* (DWb IX, 1982–5) from 1505 to 1534.

2  Bernhard Walther: see 1, note 25; 51, commentaries, and BI.

3  The patrician Georg Haller may well have been summoned as witness because of his responsibility for the Haller family's prebend in the church of St Sebald to which the Tracht anniversary foundation was attached. See note 8, and text 54.

4  Hans Schambach (also known as Schombach or Schönbach) had preceded Albrecht Dürer senior as constable of Unter der Vesten and appears to have been a family friend (see 1) as well as a respected wealthy citizen.

5 The house was built circa 1418. Walther bought it in 1501 and carried out repairs and modifications, including the insertion of an astronomical observatory in the attic. The building warrant specified that this should be removed when Walther no longer used it. After Walther's death in 1504 it is possible that AD rented the house before his growing wealth allowed him to buy it (Giersch 2007, 64f.; Hess/Eser 2007, 147f.).

6 The price is almost twice the 150 gulden Walther had paid to Hieronymus, Hans and Margarethe Gartner in 1501. AD purchases it as sole proprietor (*mit sein einßhannd*), not jointly with his wife Agnes.

7 For the relationship between heritable possession, quasi-feudal superiority and ground-burden, see 2.4, note 7.

8 The Gartner siblings had inherited the house from their deceased mother Agnes. It had passed to her in 1492 from the estate of the tax official Hans Tracht (died 1479), who had imposed as a burden on the house an annual payment to the endowed altar of St Ehrhart in the church of St Sebald, to finance the perpetual celebration of a mass on the anniversary of the death of Nikolaus Tracht.

9 Andreas Tucher (BI) was a former burgomaster of Nuremberg. The patrician Stromer family were neighbours of the Dürers in Unter der Vesten.

## COMMENTARY

The house in the Zisselgasse featured prominently in the iconography of the nineteenth-century Dürer cult (even in Scotland, where William Bell Scott's oil painting *Albrecht Dürer in Nuremberg* of 1854 is in the National Gallery of Scotland, and an albumen print from a Glasgow family album, circa 1860s, is in the Scottish National Portrait Gallery, see Ex. Cat. Edinburgh 2011, figs. 27–8). Unlike the elder Dürer's house, its adjoining properties and most other houses in the street, it survived the Second World War and is an obligatory station on the tourist itinerary. Its purchase by AD reflects his growing prestige and affluence in the years following his return from Venice. Bernhard Walther died in 1504, and AD's domicile after his father's death in 1502 is unclear. He refers to 'taking in' his brother Hans in 1502 and his mother in 1504, as if by then he had his own household, and Hess/Eser 2007 suggest he may have initially leased the house until it became available for purchase. It afforded ample space for a childless couple and other dependants, and for AD's professional activity. Whether or not it was ever used as a workshop for apprentices and trained artists, in a late medieval manner or like a Renaissance studio, remains controversial. Though the neighbourhood was less stimulating than Unter der Vesten, with its remarkably mixed community of patricians, craftsmen, businessmen and intellectuals, the house enjoyed an elevated, airy location immediately below the castle, across from the Menagerie Gate, and with access to open country beyond the city wall. A few doors away was the large house of Lazarus Spengler (BI), clerk to the ruling council, who became a close friend of AD. While he took immediate steps to free the property from the burden of an annual fee to the Tracht

foundation, it was not until 1526 that AD was able to redeem the ground-burden (54, 59, 222). AD died intestate and the house passed to Agnes Dürer. In 1530 (289) she came to an agreement with Endres and Hans Dürer that on her death they should receive due shares of AD's estate from the proceeds of the sale of the house.

[Großmann/Sonnenberger 2007; Giersch 2007; Hess/Eser 2007]

## 54  Albrecht Dürer Initiates the Process of Redeeming a Burden on his House Payable to the Tracht Anniversary Foundation

*Recipimus*[1] 78 gulden in the currency of the land, 1 new pound, 4 shillings from Albrecht Dürer, with which he has purchased from us an unredeemable annuity of 22 old pounds, at the rate of one to 30, free of tax or levy, payable to the chaplain of the Haller prebendary, attaching to the altar of St Ehrhart in the Parish Church of St Sebald in this city, due half on St Walpurgis's Day coming and thereafter the whole sum always on that same day.[2] Transacted on the Saturday after St Bartholomew's Day in the year 1509.

Note: These 22 old pounds were a burden on the house in the Zisselgasse by the Menagerie Gate, between the late Canon Eberhard Cadmer's prebendary house to the east and Hans Kifhaber's, the carter's, house situated to the west, which the said Dürer has recently bought and has herewith freed of burdens, the which Stefan Jauchensteiner, now vicar of the Haller benefices,[3] accepted in the name of himself and his successors in the presence of the officials of the finance office. Transacted as above. These 22 pounds belong to the anniversary chantry of Nikolaus Tracht deceased, as the said Reverend Stefan confirms.

Nuremberg State Archive. Entry in the Annuity Book 288
  R I, 229

NOTES

  1  'We [i.e. the city treasurers] acknowledge receipt of…'.
  2  AD's payment amounts to 19,800 pfennigs. 22 old pounds was worth 660 pfennigs. Thus he purchases an annuity covering the annual sum due in perpetuity for the equivalent of thirty years' payments of 22 old pounds. In 1507 he had redeemed the ground-rent on his father's house at a closely comparable rate of twenty-nine times the annual sum due. The interest on the annuity is to be paid henceforward by the city treasury to the Haller prebendary. It may be noted that by 1524 the Reformation would have led in any case to the extinction of such endowed masses for the soul of the dead.

3    Stefan Jauchensteiner is documented as vicar of the Haller prebendary from 1492 to circa 1521. Between 1495 and 1521 he is cited repeatedly as feudal superior, guardian and advocate in property deeds enacted by the municipal court.

## 55   Letter of Lorenz Beheim to Willibald Pirckheimer

*[Bamberg, 8 December 1509]*
Remember me to our Albrecht, to Hieronymus Haller and other friends.

PBr 2, 48–51. Letter 185. Latin text
  R I, 256

## 56   Work of Art

### *Holy Family*. Oils on wood panel. A 116

Monogram and inscription in left-hand bottom corner:

ALBERTUS · DURER · NORENBERGENSIS · FACIEBAT · POST · VIRGINIS · PARTUM · 1509

(Albrecht Dürer of Nuremberg was painting this in the year since the Virgin gave birth 1509)

Wolf 2010, 279, endorses a widespread view that the Holy Family is not an authentic work. However Anzelewsky 1971 and 1991, 228f., like Strieder 1981, 304, accepts its attribution to AD. The inscription follows the pattern common in the period following AD's stay in Venice, and it is identical even in its line divisions with that of W 486–7, his designs for the sculptors of tombs in the Fugger chapel in Augsburg (61, 1510). The head of the Christ Child is based on one of the preparatory studies for the *Feast of the Rose Garlands*, also used for the Heller Altar, while the Virgin's head derives from two drawings dated 1503 (W 275 and 276, S D 1503/12–13).

   The Dutch art historian Hannema, in a 1949 catalogue of the van Beuningen Collection, relates the story that AD sold the painting along with St Jerome (A 162) to Rodrigo Fernandez d'Almada his Portuguese friend in Antwerp, in 1521. The picture is said to have remained in the Almada family's possession until 1878, after which it passed through various hands, ending with van Beuningen from whom it passed to the Boymans Museum in Rotterdam. However, there is good reason to suppose that this impressive but unsupported history is a fiction, designed to construct an alluring provenance for a picture whose condition and not wholly convincing style and composition continue to fuel doubts about its authenticity.

## 57 Christoph Scheurl, *Oration on the Importance of Literature, along with a Eulogy of the Collegiate Church of Wittenberg* (Leipzig 1509)

To the ingenious, expeditious and masterly Lukas Cranach, painter to the Duke of Saxony, the letter of Dr Scheurl.[1]

By Hercules! With the sole exception of Albrecht Dürer, my fellow son of Nuremberg, who is beyond any hazard of his talent as regards the art of painting – invented in Corinth, as certain Greeks claim, neglected for a long time, and now recalled to life[2] – on you alone Lukas Cranach, in my judgement, our modern age confers the crown, to you all other Germans yield, to you the Italians (otherwise greedy for praise) surrender, the French defer to you as their master. Proof of that are the paintings of yours in the sacred shrine of Wittenberg which are admired with exceptional awe.[3] In these works, just as in all those of Timanthes,[4] and in the three by Albrecht to be seen there, which vie in the judgement of artists with those three which Apelles considered he had done best,[5] there is always more intellect than painting can convey; nothing is more lovely or more choice. Painters flock to them, striving in contest to emulate or copy them, except that, as Zeuxis's inscription on his Athlete puts it, 'many imitate – but none can match'.[6]

Yet someone will say, 'Zeuxis even managed to trick birds and dogs.[7] Has not our German Apelles done that too?' For that is what I am accustomed to call my friend Dürer, who following the example of Marcia, daughter of Marcus Varro, painted his own image seen in a mirror.[8] His pet puppy came along, and meaning to show affection to its master, planted a kiss on the fresh painting, placed in the sun to dry, and the trace of this kiss is still visible.[9]…In the same way that those painters of antiquity had a certain innate civility, and as I have also put on record concerning my friend Albrecht, you are courteous through and through, affable, generous, cultivated and punctilious.[10]…

Just as Apelles signed his works (with three exceptions), 'Apelles was making this', Pirckheimer, that man of exceeding erudition in both Latin and in Greek, recommended Dürer, as I now urge you, to adopt this likewise.[11]…

*[From the Oration]*
There are twenty-one altars in the Basilica, and what a delight it is when one of these is adorned, and its relic alike. When one altar is dressed for the celebration of its feast day, all are dressed too, except that each single altar is adorned with different and diverse retable paintings, whereby however the beauty and quality of each panel remains consistent. Albrecht Dürer, Lukas Cranach, along with

Netherlandish, Italian and French painters, have created these with utmost success. And although all are admired with exceeding awe, one altar however, at which our Provost is accustomed to celebrate the divine office, stands out particularly above the rest, the one on which Dürer so brilliantly depicts the martyrdom of the ten thousand soldiers, a work of immense labour and anxious care, such that he may be considered to have surpassed even himself.[12] Truly he is the most noble of artists, yielding nothing to Amphion in his arrangement of figures, nor to Asclepiodorus in his command of perspective (that is in giving the accurate distances between objects).[13] It is this that gives all his works the gracefulness which the Greeks call *charis*,[14] of which I shall say more elsewhere.

But all together, I have never seen either in Venice, or in Rome, or in Naples such a complex, noble, consummate and surpassing painting, and although I am unable to pass judgement, since truly, on the authority of Pliny, only an artist knows how to judge the sculptor, the painter, the engraver,[15] just as one has to be a philosopher to scrutinise another philosopher, nevertheless, as far as painting is concerned, artists throughout Europe acknowledge that this basilica carries off the prize.

Hung around the top of this altarpiece are four tapestries, woven of gold and silk thread, so skilfully depicting Our Lord's Passion, that Albrecht or Lukas might be thought to have painted them, and said to have been bought by Duke Frederick for just as many[16] thousands of gold pieces.

Christoph Scheurl, *Oratio attingens litterarum praestantiam nec non laudem ecclesiae collegiatae Vittenburgensis* (Leipzig 1509). Printed by J. F. Köhler in *Beyträge zur Ergänzung der deutschen Litteratur und Kunstgeschichte* 2 (Leipzig 1794). Latin text

Rupprich I, 292f.

## NOTES

1 The dedicatory letter to Cranach the Elder of the printed version of the laudation, 'Oration on the importance of literature, along with a eulogy of the Collegiate Church of Wittenberg', given by Scheurl in the church of All Saints on 16 November 1508, at the graduation ceremony when the cantor and the administrator of the collegiate church had the degree of doctor of laws conferred upon them in the presence of Duke Frederick the Wise of Saxony. Scheurl (BI) had been professor of jurisprudence at the University of Wittenberg since 1507.

2 *longo tempore intermissam, nunc revocatam*: as in 50 (see there note 7), Scheurl's formulation suggests his awareness of Italian notions of the modern revival of the art of Antiquity and anticipates AD's similar expressions (in particular 181, 2–3).

3 Which of Cranach's extant pictures might be candidates for identification is not possible to say. The only altarpiece which might have been in the parish church is the

*Altar of the Holy Kinship* (after 1507), which has a panel of the Madonna and Child flanked by St Barbara and St Catherine, and wings with disguised portraits of the donors, Prince Elector Duke Frederick the Wise and Duke John of Saxony. See note 11 (Friedländer/Rosenberg 1979, no. 19; Bonnet/Kopp-Schmidt 2010, 146–8). Elsewhere in the text Scheurl refers to the portrait of himself which Cranach did in 1509 (Friedländer/Rosenberg, no. 22). Scheurl's sentence here echoes a phrase of Pliny's, *NH* 35, 10: *cum Protogenis opus inmensi laboris ac curae supra modum anxiae miraretur*, but evidently reads *anxiae* as an adverb, 'in awe', when it is the genitive of the adjective going with *curae*, 'anxious care' (Apelles 'expressed his admiration for the immense labour and infinitely anxious care of Protogenes's work').

4    Greek painter of the turn of the fifth to fourth centuries, a rival of Zeuxis. Pliny, *NH* 35, 64 & 71: 'He is the only artist whose works always suggest more than is in the picture' – *intellegitur plus semper quam pingitur*.

5    On AD's three works in Wittenberg, see 50, note 6. Pliny does not specify Apelles' three best paintings.

6    Compare Pliny, *NH* 35, 63: Zeuxis 'painted…an athlete with whom he was so well pleased that he wrote beneath it the line thenceforward famous: "It is easier for another to carp than to copy"' – *invisurum aliquem facilius quam imitaturum* (McHam 2013, Plinian Anecdotes 158). The saying is found in a variety of forms in earlier and later times. AD uses it in drafts of the introduction and dedicatory epistle of the *Four Books of Human Proportion* (182).

7    Pliny, *NH* 35, 65–6: his painted grapes were so lifelike that birds tried to eat them. See 50, note 3.

8    Marcia, daughter of Marcus Terentius Varro, is one of Giovanni Boccaccio's 'Famous Women' – *De claris mulieribus*, chapter 66. Her self-portrait from a mirror was so faithful 'that none of her contemporaries who saw it had trouble identifying the subject of the painting', a Renaissance exemplar of hyper-realism in art. In fact Boccaccio derived Marcia from an invented story by Petrarch in a corrupt manuscript of the *Natural History* where Pliny wrote about Iaia, the leading female painter of Greek antiquity. The inscription on Cranach's portrait of Scheurl (see note 3) also picks up the theme of hyper-realism: *si Scheurlus tibi notus est, viator, quis Scheurlus magis est, an hic, an ille?* – 'Wanderer, if you know Scheurl, whom do you know better, this one or that one?'

[Brown 2003, 135–7; Cumming 2009, 139–40; McHam 2013, 80f.; Friedländer/Rosenberg 1979, 72f.]

9    See 10.3, note 7, and 50, note 4.

10    See the almost identical epithets used of AD in 50.

11    See 11.1, note 2, and 26.1. Cranach's *Altar of the Holy Kinship* is signed with the Plinian formula *Lucas Chronus faciebat anno 1509* (Friedländer/Rosenberg 1979, 70f).

12    On the *Martyrdom of the Ten Thousand*, see 44.1.

13    Amphion: Greek maker of bronze statues, son of Akestor. Asclepiodorus: Athenian painter of the later fourth century BC (Pliny, *NH* 35, 80 & 107).

14 *Charitam*: Scheurl draws here again on Pliny 35, 80, which describes the way Apelles excelled all painters before and after him: 'He would admire the works of the greatest painters of his time, praising every beauty and yet observing that they failed in the grace, called χάρις in Greek, which was distinctively his own' (McHam 2013, Plinian Anecdote 14).

15 [*de*] *fictore*: As applied to AD *fictor* probably means 'engraver', given that Latin had no term for this artistic medium.

16 That is, 4,000.

## COMMENTARY

On Scheurl and his role in Wittenberg since 1507, see the commentary to text 50. As a gifted humanist and an ambitious young professional, whose eye was probably already set on high office in Nuremberg, his determined promotion of the unique gifts and status of AD was not unconnected to his own self-advancement. Even Lukas Cranach, to whose praise the dedicatory letter is ostensibly devoted, is firmly relegated to second place among the major artists of the time and the protégés of Duke Frederick of Saxony. It is remarkable that it is only in these texts Scheurl wrote in Wittenberg that AD and Cranach are directly compared in any surviving writing produced in AD's lifetime. See, however, Philipp Melanchthon 293 (1531).

[Rupprich II, 224; Schade 1980, 26f.; Silver, in Silver & Smith 2010, 130–34]

# 58 Albrecht Dürer's Membership of the Great Council

In a number of sources, AD is listed in registers of the 'nominated' members, the *Genannte*, of the Great Council or College of Nominees. Around 200 members were selected by the much smaller ruling council of the city. They were chosen from the closed caste of patricians, the 'honourable' (*ehrbar*) families of well-regarded profession-als, men of commerce and more highly qualified craftsmen, and to a lesser extent from the common citizenry. The Great Council had no governing functions, and it met only occasionally and in extraordinary circumstances, essentially to ratify decisions of the ruling council, but membership was deemed a substantial honour.

'Albrecht Dürrer' is recorded as having been elected in 1509 and is listed until his death in 1528. In marginal notes later added to his first naming, he is described as 'the artistic painter, whose like there has never been since in all of Germany' and associated with 'Emperor Maximilian primus [and] Willibald Pirckheimer'. AD's election reflects his growth in prosperity and prestige, and his social acceptance by distinguished cultural and political figures, since his return from Italy in 1507.

[Strauss 1976, chapter 2]

Other artists who became civic dignitaries were Tilman Riemenschneider in Würzburg, Lukas Cranach in Wittenberg, Albrecht Altdorfer in Regensburg, all three serving as burgomasters.

State Archive Nuremberg, records of offices and status no. 28: register of Genannten (manuscript dated 1700 but copied from older sources), p. 61 with Nominees in the year 1509. State Archive Nuremberg, two lists for the year 1520 (mid-seventeenth century manuscript Rep. 52a, nos. 188 fol. 425, and 193 fol. 65).

Johann Ferdinand Roth, Register of all Nominated Members of the Great Council, from the earliest to the most recent times (Nuremberg 1802), p. 55.

Rupprich III, 451

# Part 5

## 1510–1511

The sequence of major altar panels continues with the Landauer Altar (64.3–5). First conceived and sketched in 1508, when AD's energies were still focused on the altar for Jakob Heller, it is one of the few great religious works AD created for display in Nuremberg, in the chapel of the Hospital of the Twelve Brethren, for which he also designed the stained-glass windows. A second important Nuremberg commission came from the ruling council, for the two panels of the emperors Charlemagne and Sigismund, to adorn the silver shrine containing the city's most prestigious treasures, the imperial insignia and holy relics (64.7–11). These panels are among the few major oil paintings by AD still housed in Nuremberg.

While the slow process of completing the Heller Altar had made AD impatient to resume the more immediately lucrative production of woodcuts and engravings, his first priority in 1510–11 was to capitalise on the evident market for his established genre, and available stock, of religious woodcut series (Arnulf 2004). In 1511 he republished the *Apocalypse*, now with the Latin bible text. He supplied the title page and two final woodcuts for the *Life of Mary*, which he had first worked on from circa 1500 to 1505 and now published in book form with Latin verse texts by Benedict Chelidonius. To complete the *Great Passion* he created five new cuts, including a Last Supper and Resurrection. This third large woodcut book has Chelidonius's Latin verse narrative. The *Small Passion*, with title-page and thirty-six cuts, two of them dated 1509, two others from 1510, the rest done in 1511, also with Chelidonius's Latin verses, was AD's largest print production in these years. All other single woodcuts of 1510–11 also have religious subjects.

That is predominantly the case too with the anthology of German verse which AD wrote and compiled in a manuscript collection in 1509–10 (63). Some of the verses were evidently composed for printing as single-leaf broadsheets, which with their cruder woodcuts and vernacular doggerel bear only a distant comparison with the

woodcut books. Both cater for secular lay readerships seeking literary and artistic aids to personal devotional practice, albeit at sharply distinct cultural and perhaps social levels. The first group of texts in the verse anthology belongs in a quite different and unique generic category. Here AD, looking to polish his artistic credentials by trying his hand at poetry as a would-be Renaissance *uomo universale*, runs into the humanist mockery of Willibald Pirckheimer and Lazarus Spengler who – the one as student of classical poetics, the other as proven vernacular poet – put the uneducated painter firmly back in his cultural place, reluctant though AD is to accept his demotion.

In other respects AD can be seen in these years consolidating the enhanced status he had begun to aspire to in Italy in 1506–7. He frees his new house from irksome legal and financial constraint (59). He is appointed by the city council as one of its professional consultants on the repair of the *Schöner Brunnen*, the great Gothic fountain on the main square (67). The contract to paint the emperor panels for the regalia shrine is his most prestigious local commission thus far in his career. Emperor Maximilian's privilege for his woodcut books is the first mark of the imperial favour he will enjoy in coming years.

While only one draft text for the handbook on painting (73) can be attributed to circa 1511 (and that only tentatively) the next two-year stage of his life and work will be dominated by writings on the theory and practice of art.

# 1510

## 59 Albrecht Dürer Redeems the Burden Payable on his House in the Zisselgasse for the Benefit of the Altar of St Ehrhard in the Church of St Sebald

*[Nuremberg, 15 January 1510]*

[Certifying] that there appeared in court before us the honourable Reverend Stephan Jauchensteiner, the present administrator and holder of the prebend and benefice attaching to the altar of St Ehrhard in the Parish Church of Saint Sebald in Nuremberg and, accompanying the same Stephan, the cousins[1] Georg and Konrad Haller[2] as superiors of the aforesaid prebend, these on the one hand, and Albrecht Dürer, citizen of Nuremberg, on the other hand, and they declared that, many long years ago, for the benefit of the aforesaid prebend, two-and-twenty old pounds was ordained and set as annual and perpetual interest, reckoned at thirty pence in the pound, in common currency of the City of Nuremberg, and hitherto this duty has been levied and paid on, from, and over and above the heritable property right of the said Albrecht

Dürer's dwelling-house here in the parish of St Sebald, at the top of the Zisselgasse, on the corner by the Menagerie Gate, next to the prebendary house vacated by the late Canon Eberhard Cadmer and to the houses of Hans Kifhaber, and the superiority of which, with eight Rhenish gulden of perpetual duty, belongs to Sebolt Tucher. Since however the aforementioned two-and-twenty pounds is not ground-rent, and its status in the Church's appurtenances is uncertain, and it is not recorded in the City's common taxes and levies, all of this being injurious to the common good of Nuremberg, they have kindly agreed and arranged for the sake of the greater utility and convenience of the said benefice, that the above-mentioned Albrecht Dürer shall discharge the prescribed obligation of twenty-two old pounds in annual duty owed to the said benefice, being the burden on his heritable possession of the aforesaid dwelling house, and deposit it in a different and more certain place, whereby the currently prescribed twenty-two pounds should pass from his dwelling into the City's finance and tax office. Accordingly the above-named Albrecht Dürer requests the Honourable Council of this City of Nuremberg to accept a corresponding sum of money from him, paid into the Honourable Council's finance office, which shall henceforward annually take the interest upon it and at the appointed time pay out the said interest of twenty-two pounds to the Reverend Stephan Jauchensteiner and to his successors, and to superiors and possessors of the afore-named prebend.[3] They, the Honourable Council, have accordingly, for the reasons stated as being for the utility of the benefice, of their gracious will accepted from the above-mentioned Dürer seventy Rhenish gulden, and have therefore pledged to the said Stephan to pay him and his successors twenty-two pounds annually from the finance office.[4] All according to the clearly agreed settlement of this annual interest, the Reverend Stephan for himself and his successors, from and out of the Honourable Council's common fund and finances as a sure and certain agency. Whereby the afore-cited superiors consent to receive [the specified sum] and declare the said Albrecht Dürer, his heirs and successors, likewise the dwelling, to be free, quit, loosed and absolved of all claim, along with all past and elapsed dues and such rights as any may have had to it, with perpetual absolution of the same two-and-twenty pounds annually, and with the explicit promise to the said Dürer, his heirs and successors, to make, harbour or acquire no claim or demand upon the same house by any manner or means, canon or civil, however such might be conceived or undertaken. Witnesses to this missive: Jakob Muffel and Nikolaus Groß.[5] Dated Tuesday after St Paul the Hermit in the year 1510.

1   A parchment copy of the charter belonged until 1861 to the archive of the Haller family in Nuremberg. Bought in 1864 by the Hanover senator Culemann, it passed to the Kestner Museum there, but was destroyed in an air-raid in 1943.

2   The entry in the Nuremberg civic records, Libri litterarum, 11 (25), fol. 119.

Rupprich's text is based on the Nuremberg entry. In his footnotes he repairs its deficiencies on the basis of older summaries of the lost Hanover copy by J. J. Merlo and G von Kress.

R I, 229–31

## NOTES

1   *geuaternn*: on *gevatter*, see 1, note 10. What is meant here, however, is the noun *gevetter*, now obsolete, derived from *Vetter*, 'cousin'. The *ge-* prefix indicates collective identity and status, as in modern *Gebrüder*, 'brothers in professional or commercial partnership'.

[DWb IV, I, 3, 4680]

2   Georg Haller was one of the witnesses of the charter recording the purchase of AD's house (53, note 3). Konrad is probably Konrad Haller IV (1464–1545), a patrician who served the city in a number of legal capacities.

3   *vmb bessers nutz vnnd frummerns willen*: the expression *nutz und fromme* is a common formula in legal and commercial documents (DWb IV, 1, 1, 245f).

4   The entry in the city records is evidently incorrect, and Rupprich quotes (from Merlo) the sum given in the Haller copy of the charter, which is the same as the sum indicated in the earlier agreement with Jauchensteiner as having already been paid in to the city treasury, namely 78 gulden, one new pound and four shillings (54, note 2).

5   On Muffel, see 49.2. Nikolaus Groß (died 1520) was a member of the ruling council from 1508 to 519.

## COMMENTARY

On 25 August 1509, AD had paid into the city treasury a sum equal to thirty times the annual payment due to the Haller prebend in St Sebald's Church, this being a burden imposed on his property by a previous owner (54). This was meant to ensure that the city treasury took over the responsibility for the annual duty and so freed AD and future owners of the Zisselgasse house from the burden. The city authorities evidently discovered that the documentation of the burden and of the Haller prebend's entitlement to the annual payment was deficient. The obligation was transmitted in successive property deeds but apparently was not registered under civil or canon law. Hence the court enacts a formalising charter which satisfies the need for orderly record-keeping. For AD it has the same benefit as the redemption of a feudal burden, as in the case of his father's house (37), freeing him of a perpetual outgoing and enhancing the sale value of the house. He was not able to redeem the ground-rent on his own house until 1526 (222).

# 60 Resolutions of the City Council Concerning a Brawl Involving Hans Dürer

*Second day after St Vitus [17 June] 1510:*
To make peace between Albrecht Dürer and Andreas Wolfauer's servant,[1] also Christoph Kress,[2] and that they attend a hearing together about what has been happening.[3]
[1510, III, 12b]

*Third Day after St Vitus [18 June] 1510:*
Albrecht Dürer and his brothers[4] shall be made to swear a truce with Christoph Kress and let the business drop involving the same Kress's servant.
[13a]

The resolutions of the Nuremberg council are reprinted by Rupprich from the edition by Th. Hampe, *Nürnberger Ratsverlässe über Kunst und Künstler* (Vienna 1904).

Rupprich I, 240

NOTES

1   Wolfauer is not identified. From the second entry it appears that the servant was actually attached to Kress.

2   On Christoph Kress, see BI and 97.2.

3   A resolution of three days earlier makes it clear that AD's young brother Hans had been stabbed in a nocturnal brawl by Martin Rucker, the servant referred to.

4   Endres Dürer was evidently also involved in the affair.

## 61  Works of Art

## Designs for sculpted funerary epitaphs in the Fugger family chapel of the Church of St Anna in Augsburg

**61.1**  *Samson's Battle with the Philistines*. **Pen and brush on paper with a green ground, grey-black washes and white highlights. W 483, S D 1510/20**

(Later?) Inscription on frame:

memento mei

(Remember me)

### Second version of the same. W 486, S D 1510/21

Inscription on a tablet flanked by putti, satyrs and grotesques:

Albertus Durer Norenbergensis · faciebat · post · virginis · partum · 1510

(Albrecht Dürer of Nuremberg was making this in the year after the Virgin gave birth 1510)

In 1510 building began on the chapel of the Fugger family – the fabulously wealthy banking dynasty (BI) – attached to the church of St Anna in Augsburg. AD had had contacts with the Fuggers in Augsburg where, according to Joachim von Sandrart (*Teutsche Academie der Bau-, Bild- und Mahlerey-Künste*, Nuremberg 1675–80), he did almost life-size drawings of three Fugger brothers, and in Venice in 1505–6, and had supplied an architectural drawing for the chapel. Now he was called upon to provide designs for the sculptor of the funerary epitaph panels of members of the Fugger family which stand behind and around the altar of the chapel. One theme of the panels was to be episodes from the Old Testament story of Samson, and AD prepared designs for panels of Samson fighting the Philistines, Samson lifting up the gates of Gaza, and the Resurrection of Christ, of which the breaking open of the gates of Gaza was traditionally interpreted as a prefiguration.

AD's designs go far beyond mere working sketches for the sculptor Adolf Daucher. They are ambitious exercises in Renaissance *chiaroscuro* – scenes with dramatic contrast of darkness and highlighting. They portray their subjects in great detail, which the sculptor had to simplify drastically. Winkler suggests that AD went beyond his brief in order to demonstrate the superior pictorial resources available to the painter. Two successive versions are preserved of the panel *Samson's Battle with the Philistines*, used for the grave of Georg Fugger (died 1506). A preliminary sketch also survives (W 488). The

earlier version has an inscription generally assumed to be a later addition. The final version supplies an inscription on a prominent tablet at the base of the epitaph panel, in classicising formulation and script, identical to that of the *Holy Family* (56) and closely related to those of *Eve* (40), the Heller Altar (48) and the Landauer Altar (64.5).

[Bushart 1994, 99–111, 115–33; Häberlein 2012, 154f.; Smith 2010; McHam 2013, Plinian Signatures]

### 61.2 *Samson with the Gates of Gaza*. Pen drawing, W 484, S D 1506/40

Inscription on the base plinth:

Emphasise the battle

The epitaph panel, for which this preliminary drawing was made, was intended for the grave of Georg Fugger, but the design was not used. The inscription may be AD's reminder to himself for the next stage of the work.

### 61.3 *Resurrection of Christ*. Pen and brush on paper treated with a blue ground. W 487, S D 1510/22

Inscription on a tablet at the base:

Albertus · Durer · Norenbergensis faciebat · post virginis · partum 1510

Albrecht Dürer of Nuremberg was making this in the year after the Virgin gave birth 1510

The inscription is identical to that on the second design for *Samson's Battle with the Philistines*. This version of the panel, which the sculptor Adolf Daucher largely followed, is substantially modified compared with the preliminary drawing (W 485, S D 1506/41), on which the tablet at the base has an undecipherable scrawl.

[Bushart 1994, 99–111, 115–37, Ex. Cat. Vienna 2003, 432–4]

# 62 Lazarus Spengler, Dedication to Albrecht Dürer of his *Admonition and Instruction how to Live a Virtuous Life*

### Introduction

This is a work whose date of composition is highly problematical. Its inclusion at this point in AD's documentary biography can only be tentative. It was printed in 1520, but all the few surviving copies lack the title page, which would have supplied evidence of place and date of publication, the printer responsible and, indeed, the author's intended title of his book. The title given above was bestowed on it by Georg Wolfgang

Panzer in an essay of 1802. Panzer reveals that the copy of the book then in his pos-
session had AD's own inscription: *Von lasseruß Spengler Radschreyber außgangen und mir
geschankt Im 1520 Jar* ('Published by Lazarus Spengler, Clerk to the Council, and pre-
sented to me in the year 1520'). This was the copy given by the author to the book's
dedicatee – there is no reason to question the authenticity of the inscription, which
has characteristic features of AD's orthography (see R I, 221 and III, 447). However,
the assumption that AD's entry provided clear evidence of the publication date was
challenged by Hans von Schubert (1934, 114–23) and by Josef Benzing (1971, cat. no.
389). Schubert's argument was based on the apparent influence of Spengler's prose and
verse on AD's manuscript of his own poetry, dated 1509–10 (63). Benzing, more com-
pellingly, analysed the printed book's typefaces and dated these to the years 1510–12.
More recently, Helmut Claus identified the typography as belonging to the Nuremberg
printer Friedrich Peypus, who used it from 1512 onwards. However, he also found that
the small Schwabacher typeface Peypus used for verse texts in the book does not figure
in his repertoire of types until around 1520. Thus there now seems no reason to doubt
that AD received his copy of Spengler's book on the occasion of its publication in that
year. Schubert and Berndt Hamm, in particular, argue on the other hand that Spengler's
moral-philosophical and theological contentions in the text belong to a phase of his
Catholic humanism in the early years of the sixteenth century. By 1520 they had
become difficult to reconcile with his strong commitment to Reformation theology
and morality. Hence the general consensus is currently that Spengler wrote his *Admonition*
around 1509–10 and circulated it among his friends, including its dedicatee AD, in
manuscript form, but that it was not published as a printed book until 1520.

The *Admonition* consists of twenty-six short chapters of moral precepts, each with a
classical or biblical Latin motto, a prose exposition and a rhymed verse epigram in
German. Its expository sections are strongly indebted to stoic philosophy, particularly
Seneca, and to the Christian humanism of Celtis and his circle, while the verse epigrams
are more popular in style, frequently quoting (without attribution) Sebastian Brant's *Ship
of Fools*, either verbatim or in abridged form. The target readership is evidently the liter-
ate strata of professionals and superior craftsmen in Nuremberg society, the 'honourable'
class with their ethos of Christian citizenship, commitment to honest government,
morally responsible business practice and internalised, individual Catholic faith.

[Moeller 1965; Maurer 1971; Ozment 1975, 74–9; Grimm 1978, 28; Hamm 1986, 125f; 1995, 2–10; 2004,
91–101; Price 2003, 112; Grebe 2013, 132f.]

To the Honourable and Respected Albrecht Dürer of Nuremberg, my particular
trusted friend and brother, I, Lazarus Spengler, Clerk to the Council of that
city, proffer most diligently my obedient service.

Albeit that Reason rules and regulates all human life and bids even Sensuality
to bow in obedience to her, such that all those who are gifted with Reason
may fittingly be deemed rulers and regulators of other men, and whoever

submits to the command and judgement of true Reason, which God has ordained as our guide, will be taught an orderly means to achieve such a degree of moderation in all aspects of his life that inner appetites and outer sensualities do not usurp power over him; even so we are aware through our daily experience, and see beyond contradiction, that these same sensual acts and appetites of ours are like to untamed horses, extravagant, unmanageable, and so unable to help themselves that they need Reason to tame them, break and rein them in, and steer them on the right road. As, then, it is Reason alone that at all times gives us advice and incentive to practise virtue and what is best and most expedient, thus it is needful for us to arrive at ordered and well-founded means which will lead us to good and deflect us from evil: that is, good and reasonable teaching and instruction, amongst which self-knowledge is first and foremost.

Now although the books of the Ancient Philosophers, and in particular those who wrote of ethical qualities, are replete with such instruction and teaching, so that I might incur the reproach of audaciously taking upon myself what others before me have already done, and at that the wisest and best skilled, with greater diligence, power and eloquence than I, yet in good intention and for the reasons that follow, I have compiled this catalogue of sundry useful instructions, so that I might not spend my leisure time (which, as you know, is limited) vainly and uselessly, and that I might for my own sake have a spur to follow a more seemly and cautious path through my daily round of activity.

For what is more useful, what more fruitful for an upright, steadfast man[1] (and by that I expressly do not mean myself) and especially one who in his daily acts is charged with the common good, than in his profession and his dealings to seek to make Reason his object, to sustain himself in a Christian, God-fearing, orderly and sensible way of life, as in my understanding may most fittingly occur through regular contemplation of this and similar instruction, in so far as these are set up with God as their true architect and place their trust in him, given that all human teaching, practice, works and thoughts without his grace and co-operation are utterly useless and fruitless.

And as I acknowledge you, to write without any flattery, to be a man of understanding, inclined towards honesty and virtue, who has on many occasions been for me, in the daily neighbourly intimacy we have enjoyed together, no mean model and encouragement for a more considered conduct, as I have more than once confessed to you, I wished to present to you this collection of short admonitions and instructions (not because I consider you to need such instruction, but rather to dedicate to you the modest labour I have expended

on it), with the plea that you accept this, just as it is, in token of my friendly good will, that you correct it according to your own understanding, and consider me, as hitherto, your friend and brother. In return I promise, as best I can, to remain steadfastly your friend and loyal comrade.[2]

*Ermanung vnd Vndterweysung zu einem tugenhaften Wandel* (Nuremberg: Friedrich Peypus, 1520), given this reconstructed title by Georg Wolfram Panzer (1802) and reprinted from the original edition in 1830.
   Rupprich I, 74f.

NOTES

1   *einen tapfern mann*: the adjective has drastically narrowed in meaning in modern German ('brave') and has become archaic. In the sixteenth century it had a wider range of highly positive ethical senses.

2   As Spengler (BI) states in the dedication, he was a near neighbour of AD in the Zisselgasse, where the large mansion of the Spengler family stood until its total destruction in the air-raid of January 1945. AD's writings frequently document his friendship with Spengler.

# 63   Anthology of Poetry by Albrecht Dürer

## Introduction

The contrast and comparison of painting and poetry, and the potential of the artist as 'universal man' to practise as a painter and as a poet, were issues that engaged Renaissance theorists. In both late medieval Catholic and in early Protestant art, the interrelationship of image and word was always implicit and often visibly self-evident. In AD's poetry both secular and religious cultural historical strands are reflected.

Renaissance interest in the argument that painting could aspire to be, like poetry, a liberal art, not merely a mechanical, manual skill, was founded on the contention of Horace (65–8 BC) that painter and poet were equal in their powers of invention and imagination, expressed in the classical dictum *ut pictura poesis* – 'as a painting is, so is a poem'. The one and the other can by different means imitate nature (*mimesis*) or recreate myth and history (*fantasia*). AD will have encountered this argument in Leon Battista Alberti's *De Pictura* (1435/6), to which his humanist friend Willibald Pirckheimer introduced him. Alberti cites Horace's *Ars poetica* on the portrayal of emotion in art (II, 41–3). When he discusses the late classical writer Lucian's description (*ekphrasis*) of the lost masterpiece of Greek painting, the *Calumny of Apelles* (II, 53), Alberti suggests that the painting must have been inherently superior to the written account of it. This was the picture that AD recreated as a mural in the town hall of Nuremberg around

1522 (168.5). By the end of the fifteenth century, Leonardo da Vinci asserts that painting is superior to poetry, because sight is the 'noblest sense', a claim which AD endorses (82.1–2). Around 1500 we find painters who also compose poetry, like Raphael of Urbino and his father Giovanni Santi, or the architect Bramante. At precisely the same time as AD wrote (or wrote down) his verse, at the end of the first decade of the sixteenth century, Michelangelo was beginning to compose the sonnets which remained the only Renaissance artist's poetry to achieve supreme literary quality. The rest has to be regarded as a mostly misplaced exercise in stretching a theory some way beyond its limit. AD's poetry is particularly modest and consciously unpretentious, not least because it is principally concerned to insert itself into a vernacular, not a humanist Latin culture.

Medieval religious art related image to word in a quite different way. Painting or sculpture gave visual expression to texts of incomparably higher status and significance, pre-eminently to the biblical Word or its theological and liturgical articulations. The iconographical narratives of altar retables, panels and murals, statuary and stained glass in medieval churches provided bible stories for the illiterate. Invariably artistic expression served and was subservient to its religious subject. Thus the artistic representation of the Virgin and Child or the crucified Christ was merely an outward and visible sign of a transcendent truth. Where the physical image did not lead the mind beyond it to a spiritual reality, if it became itself the object of veneration or worship, with some imputed talismanic power of its own, it transgressed the second commandment and usurped God in 'graven images'. AD became fully aware in the 1520s of the damage that had been done to the art of antiquity, and which threatened contemporary religious art once more in his own time, by iconoclasts who invoked the second commandment to destroy altar panels and crucifixes as well as putatively miracle-working images of saints. In the anthology of his poetry a substantial number of short verses are geared to the invocation of saints, and above all the Virgin Mary, as intercessors between the individual Christian and the deity. These brief verses seem to presuppose the Christian kneeling before a statue in church or invoking a visual image of the saint in his mind's eye. Such stock modes of prayer and devotion were highly characteristic of late medieval popular piety. This became a prime target of humanist critics of the danger of superstitious religiosity, such as Erasmus, and was frontally assaulted by Martin Luther in his reinterpretation of the theology of grace from 1517 onwards. Within a decade of writing his devotional verses AD himself began to reject their presuppositions, as he came to share Luther's condemnation of the veneration of saints as a way to grace and salvation.

Whilst all religious art, especially in Germany where Renaissance still co-existed with late Gothic, always presupposed and implied the dominant Word, some forms of religious art incorporated explicit biblical, exegetical or theological text. Much of AD's most innovative art linked image and word in this way. At a time of emergent printed bibles and wider literacy, his innovative books of woodcuts and engravings allowed the

moderately affluent to acquire high-quality pictorial narratives of biblical stories for private devotional use. In the 1490s AD printed his *Apocalypse* in separate editions with the German and the Latin text of the Book of Revelation. In 1511 his later Passion series and his *Life of Mary* were provided with an interpretative commentary in Latin verse, while the 1511 reissue of the *Apocalypse* has the Latin bible text only. The reader-ship for which AD created these high-quality devotional picture-books had grown out of a confluence of social and cultural forces in Nuremberg: enhanced education and expanding literacy, provision for lay piety in churches under civic direction, the avail-ability of printed German-language bibles and devotional literature. AD's godfather Anton Koberger had printed a German bible in Nuremberg in 1483 (the eleventh of eighteen editions of this translation to appear between 1466 and 1522), which contained over a hundred woodcut illustrations by AD's master Michael Wolgemut and his work-shop. Koberger's print of Stephan Fridolin's *Shrine or Treasure Chest of the True Riches of Salvation and Eternal Bliss* (1493) had ninety-three whole-page woodcuts, while Ulrich Pinder's print of the *Enclosed Garden of Mary's Rosary* (1505) had over one thousand smaller illustrations.

Two other printed genres, in which the combination of image and text is a con-stitutive feature, also have strong connections with AD's graphic art and his poetry. During his journeyman years he spent time in Basel and may have contributed illus-trations to Sebastian Brant's *Ship of Fools* (1494), a moral-satirical review of embodi-ments of human folly and vice, which in each of 112 chapters pairs woodcut with verse motto and commentary. Debatable though art historians' attributions of early woodcuts to AD are, there can be little doubt that he at least knew the *Ship of Fools*, which through a Latin edition and translations into other European vernaculars became one of the major international bestsellers of the early book trade. It spawned imitations, notably the identically structured folly satires of Thomas Murner (*Conjuring Fools* and *The Guild of Rogues*, both Strasburg, 1512). As seen in 62, AD's friend Lazarus Spengler dedicated to him his moral didactic *Admonition and Instruction how to Live a Virtuous Life*, which has no illustrations but borrows (and plagiarises) heavily from Brant, and whose German verse epigrams perhaps directly prompted AD to try his own hand at poetry. The two surviving early manuscripts of AD's verse contain copies of his own contributions to the genre of the broadsheet (*Flugschrift*), single-sheet prints with woodcut and text, intended for cheap production and mass sale. Broadsheets around 1500 treated a wide range of topics of public interest: political events, monstrous births, social satire, moral didacticism and religious propaganda. Two broadsheets incor-porated in the manuscripts of AD's verse, *The Schoolmaster* and *Death and the Pikeman*, conform to the main themes of lay piety and morality characteristic of his poetry as a whole. In the 1520s the broadsheet became a major vehicle of Reformation teaching and controversy. AD's radical associates, Georg Pencz, Erhard Schön, and the brothers Barthel and Hans Sebald Beham, produced fine broadsheet illustrations of verses expounding Lutheran doctrine written by the Nuremberg poet Hans Sachs. Popular

religious propaganda in this genre continued to be regarded as a potential incitement to unrest in Nuremberg even after the city adopted Lutheran faith and practice in 1525, and AD himself did not contribute to it. On a higher level, the twin panels of the *Four Apostles*, which he presented to the city council as his 'memorial' (233) also combine image and text. Beneath the figures of the Apostles are their New Testament injunctions to those in power to govern by the divine Word.

Anthologised in 1509–10, AD's verse cannot be directly linked with the major vernacular poet of Renaissance and Reformation Nuremberg, Hans Sachs. He was an apprentice shoemaker in 1509 and travelled as a journeyman from 1511 to 1516. Only after his return to Nuremberg did he become a highly active and prolific poet in the genre of the Meistersang and in popular narrative and drama. However, his early religious verse from 1517 onwards, though written in the elaborate strophes and metres prescribed by the guilds of mastersingers, shows a striking similarity in theme and sentiment to AD's devotional and didactic verse. Cross-influence is not possible, since neither AD nor Sachs had access to each other's unpublished work. Rather, both testify independently to a common lay mentality and an available vernacular idiom of late medieval Catholic religiosity at the social levels of 'honourable' and craftsman families.

Hans Sachs in his later verse narrative and drama became an exponent of popularised classical and Renaissance culture, derived from humanist translations into German, including an ekphrasis of the *Calumny of Apelles* (168.5.2). AD's initial impulse to write verse was rudely rebuffed by his humanist friends Willibald Pirckheimer and Lazarus Spengler. And there is no evidence that he knew or sought to imitate available secular poetical models. The neo-Latin lyric of contemporaries like Conrad Celtis and Ulrich von Hutten was linguistically and culturally inaccessible to him, for all that both poets were warm admirers of AD the painter. In the years 1452–60, a group of patrician dilettantes, composers and musicians in Nuremberg compiled the *Lochamer Liederbuch*, a large anthology of songs and instrumental music, one of a score of such collections from all parts of Germany dateable to circa 1400–circa 1550. These document the reception and cultivation of material from medieval courtly tradition, contemporary urban lyric and folksong. But that too arose within and remained confined to socially defined groups. The only evidence that AD gained any access to this level of contemporary secular culture comes in the fragments of musical notation for the lute which he wrote down probably about a decade later than his poetry (229).

[Rupprich 1970, 193–7; Ellis 1974, 71–6; Brunner 1976; Scribner 1994; Holzberg 1995; Morrall 1998, 83–6; Schmidt 1998, 333–70; Ames-Lewis 2000, chapter 7; Sahm 2002, 87–115; Hamm 2004, 91–102; Drescher 2005; Price 2003, 97–102, 110–32]

Only one autograph text of AD's poetry survives:

BL 5529 fol. 55ʳ, the couplet 63.27, on the pen sketch of an arcaded hall. The drawing could derive from AD's stay in Venice in 1506, and the script would allow a dating in the period 1506–8 [see fig. 33].

Contemporary prints are preserved of the three broadsheets accepted as AD's authentic work (*The Seven Hours of Christ's Passion, Death and the Pikeman*, and *The Schoolmaster*, all dated 1510); the putative

autograph of a fragment of the second of these was recorded by Thausing in 1884, but its whereabouts were unknown to Rupprich.

Two other early sources remain:

The most comprehensive is a seventeenth-century manuscript anthology of eleven folio leaves which passed to the GNM in Nuremberg from the literary scholar Georg Karl Frommann (1814–87), who was assistant director of the Museum (GNM 4° Hs 81634), headed *Albrechten Dürers deß Weitberümbten Kunstreichen Malers, zü Nürmberg gemachte Reimen von seinem aignen Concept/abgeschriben*. A note on the manuscript by C. G. von Murr, writing in 1779, suggests that similar anthologies were at that time still to be found in other private libraries in Nuremberg, such as those of the Praun, Ebner and Silberrad families. The anthology is written on ten 4° leaves, two-sided with the texts varyingly in single, double or triple columns.

The oldest extant source is a manuscript in the HAB, Wolfenbüttel. Hs. 98. 12. Th. 4°. Folios 140ᵛ–144ᵛ contain the texts of the broadsheets *The Schoolmaster* (63.22) and the (probably inauthentic) *Whoever has ears to hear* (63.29). The manuscript has the half-obliterated owner's mark of Hans Imhoff the Younger, and the date 1521. The poems are written in Imhoff's handwriting, according to Reicke, PBr I, 101.

Rupprich I, 128–45

## THE TEXTS AND THEIR TRANSLATION

Rupprich does not set out his editorial principles and procedure. His text appears to be a pragmatic, even arbitrary combination of readings from the manuscript and broadsheet texts, the printed editions by Murr (1799) and Campe (1828), and his own emendations. In certain respects these do unnecessary violence to the transmitted texts.

Manuscript readings are 'corrected' on grounds of metre. A few examples among many: in 63.4 (R I, 129), Spengler's satirical poem, line 91, Rupprich emends the manuscript text *Den manngl er dem bild benam* to *Den mangel er dem bild benam*. Yet elision of an unstressed syllable is quite normal orthography in sixteenth-century German, and when the text is spoken it is difficult for the voice not to supply the suppressed vowel anyway. In line 94 Rupprich emends the MS text *Der altreüß so es vor hett gesehen* to *Der altreüß so es vor hett gsehen*, now introducing an elision like the one he had 'corrected' in the first example. In a third case, 63.12, the verses for Matins (R I, 135), line 6, Rupprich leaves untouched the line *Deß Vatters ewige weißheit*, where – as is quite usual in sixteenth-century verse – metrical stress falls on two naturally unstressed syllables (*éwigé weißhéit*). Yet in line 15 he amends the MS text *Was besténdig inn íhrem hérczenláidt* to *Was bsténdig ínn jrm hérczenláidt*, 'correcting' the metrical flaw of twice having two unstressed syllables together (a metrically 'overfilled' line).

These interferences with manuscript text which is at least as likely to be AD's as a copier's, fall foul of two editorial principles. Whilst in transcribing from AD's autographs Rupprich scrupulously preserves his orthography, however dialectal, demotic or idiosyncratic, when handling a verse text 'copied from [AD's] own draft' he feels free to amend it on mixed orthographical and metrical grounds. In the first instance he 'corrects' an elision because it is orthographically objectionable and because it loses a metrically unstressed syllable. In the second instance he introduces an elision even

though it is orthographically uncouth, because it is metrically required. In the third case he once leaves intact a metrically awkward line, then emends another for its metrical solecism. The procedure is unacceptable. Firstly, the inconsistent spelling forms of AD's German are entirely 'normal' in contemporary written German which – even when it was written by a learned humanist, a Pirckheimer or Hutten – lacks prescribed, correct norms. The manuscript and printed texts of Hans Sachs's poetry amply demonstrate that this applies to prose and verse. Secondly, as Sachs's poetry also shows, it will be another 100 years until Martin Opitz's *Buch von der Deutschen Poetery* (1624) enunciates the rules that in German verse metrical stress should respect natural speech stress, and that the rhymed couplets AD uses should have regular alternation of stressed and unstressed syllables. Only then does the 'correct' treatment of unstressed vowels become an enforceable norm. Rupprich's editorial procedure (and these two examples stand for hundreds more) is anachronistic and arbitrary.

My translations attempt to give some general sense of the metrical ductus of AD's verse. Its basic form is that of doggrel *Knittelvers*, that is rhyming couplets with four stressed syllables per line, mostly beginning with an unstressed 'upbeat' or anacrusis, in the pattern *di-dum-di-dum-di-dum-di-dum*. However, anacrusis is optional and the line can scan *dum-di-dum-di-dum-di-dum*. Also, the frequent unstressed grammatical final syllables of German nouns and verbs (*schúster, mérken*) are metrically not counted, so that *(dí)-dum-di-dum-di-dum-di-dum-di* is possible too. My translations try to give an impression of the rhythms and metrical irregularities of AD's verse. I have mixed in lines which, as frequently happens in AD's and his contemporaries' poetry, breach the general metrical expectation in ways like those illustrated by the examples just discussed.

It is impossible both to provide a closely accurate translation and also to rhyme each couplet of lines. This means that a vital – but it has to be said cumulatively wearisome – feature of *Knittelvers*, namely the insistent, mostly banally predictable rhyme-words, is missing. Readers must content themselves with AD's equally insistent, mostly banally predictable moral and religious sentiment. There are occasional lighter moments.

# Rhymes Made by Albrecht Dürer the World–Famous Artist of Nuremberg and Copied from his Own Draft

## 63.1–6  Verse Controversy between Albrecht Dürer, Willibald Pirckheimer, and Lazarus Spengler

Jesus Mary 1509
Thus says Albrecht Dürer, painter, who in his copperplate engravings uses the monogram [AD]

**63.1**

Each and every soul that shall live eternally is made alive in Jesus Christ, who is of two substances in one person, God and man, which can only be believed through grace, and can never be understood through natural reason.

**63.2**

The first rhymed lines, which I devised in the year given above (there were just two of them), had each the same number of syllables, and I thought I had hit the target well, as now follows:

> Thou mirror of all angels and saviour of mankind,
> Let thy great Passion be the full ransom for my sin.

Willibald Pirckheimer read this and made fun of me, saying that no line of verse should have more than eight syllables. Then I set to and put together the following eighteen rhymes.

**63.3**

> With great desire, honour and praise,
> I pray God grant me his eight gifts.

Or in this manner:

> With all your might strive to attain
> That God grant you his wisdoms eight.[1]
> Rightly that man is counted wise,
> Whom wealth nor poverty can blind.
> True wisdom that man practises,
> Who treats alike sorrow and joy.
> And he is truly a wise man,
> Who bears alike honour and shame.
> Who knows himself and evil shuns,
> That man indeed walks wisdom's path.
> Who revenge spurns, forgives his foe,
> Wisdom guards from the fires of hell.
> Who sees through when the devil tempts,
> Escapes harm if God wisdom sends.
> Who in all things keeps his heart pure,
> Has set his sights on wisdom's crown.

And he who truly loves God well,
A Christian is, righteous and wise.

However, the above did not please Willibald Pirckheimer. So I asked Lazarus Spengler to set my meaning into verse. Thereupon he wrote what follows:

**63.4**

He who these favours from God receives,
Fares well and fearless, when he dies.
He is esteemed as a wise man,
Whom gold nor poverty seduce.
I cede to him too wisdom great,
Whom peace and torment leave unmoved.
Great wisdom is bestowed on him,
Who bears alike honour and shame.
Who knows himself and evil shuns,
Has clothed himself in reason's garb.
Such man as mercy shows his foe,
Has chosen good in lieu of wrong.
He ties the devil's guile in knots,
Whom God makes wisdom manifest.
Whoe'er keeps himself pure in heart,
Has wisdom as his bosom friend.
He who loves God with his whole heart,
The highest wisdom has espoused.

When he had given me the above, he sent me by the hand of Willibald Pirckheimer the following poem:

**63.5**

Although all kind of things can happen
Which contradict our expectation,
Thus provoking our amazement,
Yet even so I can't refrain
From telling you a certain tale,
That cannot fail to make you laugh.
And this is what it's all about:
You know, I have no doubt, a man
With curly hair and quite a beard.[2]

By inborn talent he has been
A painter ever and a day.
His tuppence-ha'penny worth[3] (at best)
Of skill in reading and in script,
Makes him so bold as to attempt
To venture on the writer's art –
He's set his mind on writing verse.
So far he's rather come off worse,
One fears he'll likely meet the fate
That long since befell a cobbler,[4]
When he a painter's canvas spied
Put out to dry off in the sun.
Said he: 'The picture I quite like,
Except he's botched the shoes, you know.'
The master who had painted it,
And overheard the criticism,
Now remedied the picture's flaw
And propped it back in the same place.
Next day again there comes along
The sole-and-heeler[5] large as life,
Sets hands on hips, and all puffed up
He has another private view,
Says now: 'There's still a snag, you know,
He hasn't got the draperies right.
One pleat's crooked, the other straight.'
The painter hears and tells his critic:
'Now what strange pattern's this for me?
Now you claim to be a tailor,
And yet shoemaking is your trade.
Stick to that and ply no other!'[6]
With that the cobbler slunk away.
So my message to this man is:
Having mastered the painter's art,
Let him get on with what he knows,
Lest out of him we take the piss.[7]
For if a tailor made fur coats,
I bet he'd be a laughing stock.[8]

When I received this from Lazarus Spengler, I responded with the following poem:

**63.6**

You should know that at this time
There is a clerk in Nuremberg,
Much valued by our overlords,[9]
For writing missives with such skill.[10]
He's always out to trick us folk,
Plays clever dick to us dimwits,
As recently he took the piss
Because I tried my hand at verse,
A poem about the eight wise gifts,
In which I praised them piously.
He thought not very much of that,
Made out of it a Shrovetide farce,[11]
In which he cast me in the role
Of cobbler in a wide-brimmed hat,
Who dares to judge Apelles' art
And points out where he's made a boob.
The clerk thoroughly rubbed it in,
Told me I should've stayed a painter.
But I have set myself the task –
And won't be silenced quite just yet –
Of learning something I can't do,
Which no wise man will blame me for,
For one who sticks with just one thing
And never tries out something new,
Risks ending like that notary,
Another worthy of our town,
Who'd learned one single lawyer's form
And never looked to add a second.
Now these two fellows came to him
Asking for an awfudavid.[12]
He wrote as far as 'Applicants' Names',
One was called Götz, one Rosenstamm,
Which flabbergasted our good scribe.
He took each one aside and said:
My friend, you must be quite mistaken.
These names I can't find on my form.
I've heard of Fritz and Franz alright,
They're the only clients' names I know.[13]

He packed them off with empty hands,
Couldn't supply their awfudavid.
So he stuck to his one old tune,
For which they mocked him something rotten.
To avoid suffering the same fate,
I need to persevere with learning
And stick at it as best I can,
For I have many years before me.
As wise folk say, it is the young
Nettle that packs the fiercest sting.[14]
It's not just writing I would learn,
I have my eyes on medicine too.
It will be wondrous to behold
How painter's medicine sorts you out.
So hear what this new quack prescribes
As perfect stuff to boost your health:
A tiny drop of pure leach-brine[15]
Apply twice daily to sore eyes.
And if you want the sharpest hearing,
Drip almond oil in both your ears.
Whoever has a stinking breath
Suffers from a dodgy liver.
But if you're wanting snow-white teeth,
Scrub them frequently with pumice.
And should your arse-hole often bleed,
I'd recommend a laxative.[16]
Keep yourself free of crippling gout
By drinking water, not strong wine.
If healthy legs you want to keep,
Don't split a block while standing up.[17]
To live until a ripe old age
Just swallow gallons-full of milk.
Those who live to be a hundred
Will owe it to my good advice.
I shall go on making verses,
Must keep the pen-pusher laughing,
Quoth the long-haired bearded painter
To the satirical town clerk.[18]

GNM 2ʳ–4ᵛ

NOTES

1  Each couplet defines one of the eight gifts of wisdom. These were probably modelled on the nine Beatitudes, which Jesus teaches in the Sermon on the Mount in Matthew's Gospel 5:1–12 (Maurer 1971, 24).

2  Hair and beard were carefully cultivated, trademark features of AD's appearance, highlighted particularly in his self-portraits of 1498 and 1500, and mocked in the letters of Lorenz Beheim to Willibald Pirckheimer (36.2–7).

3  *Zwo elen vnnd ein virtel*: 'two and a quarter ells'. The ell – originally the length of the arm – was in Germany in this period equivalent to 27 inches. Twopence-halfpenny in pre-decimal British currency was proverbially a trifling sum.

4  In the model dedication of the *Four Books of Human Proportion* to Willibald Pirckheimer (182.1), drafted for AD by a 'ghost-writer', Apelles' cobbler (Pliny, *NH* 35, 84–5; McHam 2013, Plinian Anecdote 7) is cited to deter the unqualified from criticising AD's theoretical writing.

5  *Der altreüß*: middle High German *alriuze*, 'cobbler who repaired worn shoes'. In Nuremberg there was an *Altreißenmarkt*, a market place for shoe-repairers.

6  Apelles' reproof, 'Cobbler, stick to your last' (*ne supra crepidam sutor iudicaret*) became proverbial already in ancient Greece (Röhrich 2009, III, 1421–2). On 27 March 1527, the Nuremberg authorities censured Hans Sachs for his role in publishing an anti-papal polemic together with Andreas Osiander and Hans Guldenmund. 'Hans Sachs, cobbler, is told: This day a booklet was issued without knowledge and permission of this honourable council. This should better not have been done. He is said to have written the verses for the illustrations. Now this is not his profession and does not befit him; hence it is this council's earnest command that he stick to his trade and his shoemaking, and refrain henceforward from publishing any such pamphlet or rhymes' (Hirschmann 1976, 44).

7  *Damit mans gspött nit auß im treib*: the English idiom is equivalent, if a little coarser.

8  Trade demarcation meant that this was furrier's, not tailor's work.

9  *herren*: the executive members of the small council.

10  *missif*: the word derives from Latin *mittere*, 'send'. As still in Scots law, a missive was a formal legal document couched originally in letter form. In AD's related drawing of 1511 (W 623), Spengler is satirised as blacksmith, baker and printer creating missives on an industrial scale (64.2).

11  *ein faßnacht spil*: farcical plays performed at the Shrovetide carnival were an old Nuremberg custom. One of the commonest themes was rude mockery of the ignorant, especially peasants.

12  *finstrament*: garbled form of the legal term *instrument*, borrowed into German from lawyer's Latin in the fifteenth century in the sense of 'witness statement to a notary'. The ignorant clients merge it with *finster*, 'obscure'. The translation here apes Mr Squeers's 'afferdavid' for 'affidavit' in Charles Dickens, *Nicholas Nickleby* (Penguin Classics, London 2003, 696).

13  The two names merely prompt the form-filler to supply the names of the actual clients.

14  Proverb, documented from the thirteenth century onwards (DWb XIII, 618).

15  *laugen*: 'lye' or 'leach', a saturated saline solution.

16  *Spiegler Damis*: AD specifies a contemporary nostrum, made up of *spigelia*, for expelling parasitic worms, and the laxative seed *semen coccognidii*.

17  This seems odd advice if chopping wood is really meant. Perhaps it is a euphemism for copulation. Compare Röhrich 2009, I, 219f., 'Einen Block am Bein haben' & II, 732, 'Holzhauen'.

18  A variant version of the last four lines appeared on the back of a panel painting by AD, now lost, depicting Minerva and the Muses dancing to Apollo's lyre (64.1).

## COMMENTARY

The preliminary statement, that faith derives from grace alone, never from natural, human reason, is an appropriate introduction to the first couplet, the two versions of the Eight Gifts, and the religious and moral verse which makes up the largest part of the anthology. However, AD's first attempt at a rhymed couplet, despite its pious theme, provokes a decidedly secular controversy with his two closest humanist friends, Willibald Pirckheimer and Lazarus Spengler.

Pirckheimer's objection to the couplet is simultaneously metrical and cultural. When he says, as AD reports, that 'no line of verse should have more than eight syllables', he means this rule to apply specifically to German verse. Latin prosody, classical or Renaissance, is quite another matter. The one and only verse-form of sixteenth-century German poetry must, he insists, be the rhymed couplet with four beats (stressed syllables) per line. This has a respectable provenance, given that it is essentially identical with the standard metre of medieval courtly narrative poetry. To Pirckheimer, however, for whom the humanist revival of classical Latin language went together with the revival of classical verse forms, it is the culturally inferior medium of popular vernacular verse, even when used by a humanist writer like Sebastian Brant. That remained so until Martin Opitz's *Book of German Poetics* (*Buch von der Deutschen Poeterey*, 1624) defined a German prosody on the same level as the classically derived formal repertoire of contemporary French and Italian. From then until Goethe exploited its potential in his Faust drama, the four-beat line was dismissed as *Knüttelvers* (*Knüttel* or *Knüppel* is 'cudgel'), from its ponderously thumping rhythm and predictable, banal rhymes.

AD's couplet has thirteen-syllable lines of basically iambic rhythm (di-dum di-dum) with six metric stresses per line. Although there are other examples of verse with longer lines in sixteenth-century German, in the Meistersang for instance, or in Renaissance-influenced urban popular song lyrics, it is most likely that AD was trying

to imitate a Latin metre. The closest model is probably the alexandrine, a six-beat iambic line, with twelve syllables when the final rhymed syllable is 'masculine' (a stressed monosyllable), and thirteen when the final rhymed word is 'feminine' (disyllabic with final unstressed ending). But what AD creates is an unhappy hybrid. Because the lines have thirteen syllables, yet the rhyming words are accented monosyllables, there is one too many syllables for a consistent iambic line. Hence one metrical bar in each line has to be read or spoken as an anapaest (di-di-dum): 'ángels and sáviour óf mankínd' and 'Pássion bé the full ránsom fór my sín'. This formal solecism, betraying a cultural incompetence, is most likely what drew Pirckheimer's scorn.

AD now composes a more ambitious poem, adhering strictly to eight syllables per line, with invariable masculine rhymes. What displeased Pirckheimer now may have been a besetting flaw of sixteenth-century German verse, namely the tendency to discrepancy between metrical and linguistic stress. Here too, it was Opitz who finally enunciated a clear rule. German has a fixed stress accent in speech: the semantically significant 'stem' syllable of nouns, adjectives and verbs is accentuated; such words as prepositions and articles, and syllables like prefixes and endings, which have grammatical functions or merely modify the meaning of words, are unstressed. Verse lines in which the metrical stress falls on syllables that in prose speech are unaccented are faulty. The discrepancy is particularly painful when, as is very common in this period, verse is meant to be read aloud, whether to others or to oneself (for instance in verses to be used in prayer). An example in translation is the couplet 'Who révenge spurns, forgives his foe, / Wisdóm guards fróm the fires of hell'. Some of AD's verses here defy scansion, more so in the manuscript texts than in Rupprich's edition, which often smoothes the metre by restoring or eliding unstressed syllables, and more indeed than in the present translation, where occasional instances are deemed sufficient to make the reader aware of the problem. As explained earlier, my translations do not attempt to reproduce the unremittingly banal effect of rhyming couplets.

Lazarus Spengler also set out to give AD a lesson in German prosody. The only line in his improved version of AD's text in which metrical and spoken stress do not tolerably coincide is the penultimate one, which has one syllable too many, and here the initial *Und* in the German may be either Spengler's little joke or a scribal error. In the following exchange of satirical poems between Spengler and AD it becomes clear that cultural competence has become the main point at issue. The first lines of Spengler's verses are directed to Pirckheimer and seem to present the poem as a private joke between the two educated humanists at the expense of the unlettered painter, whose craft is *angeborn*, a gift of 'innate' nature, not of acquired culture. Spengler constructs an insulting comeuppance. AD is likened to the presumptuous cobbler who criticises not only a painter's poorly rendered shoes, but then his ability to paint draperies, in the Renaissance one of the areas of technical challenge (involving perspective as well as ability to simulate fabric and pattern) by which artists were particularly judged. The anecdote, and its moral, that 'the cobbler should stick to his last', derive

from the story told in Pliny the Elder's chapters on Greek art in his *Natural History* (35, 84–5), where the artist – as AD recognises – is Alexander the Great's court painter, Apelles. The barb is a sharp one. Since around 1500, AD had come to be hailed as the modern, German Apelles, and that by precisely the humanist friends who now ridicule his cultural hubris and deny him the right to assert himself as 'universal man' in other areas of aesthetic achievement, even with the modest aim of composing verses for pious devotions. AD strikes back at his demotion from Apelles to cobbler by turning the weapon of malicious anecdote against his tormenter. In the early sixteenth century, as ever since, lawyers like Spengler (and, even though he never completed his law degree, Pirckheimer himself) were the butt of jokes which suggested that their professional expertise did not measure up to their fees. Carried away by his own humour, AD declares his ambition to stretch to medicine too, another age-old butt of anti-professional humour, and lays out a stall of quack nostrums.

Two related texts provide clues to the context of the first part of AD's anthology of verse and his satirical exchange with Lazarus Spengler. Spengler's *Admonition and Instruction how to Live a Virtuous Life* (62) prefaces each chapter with a usually four-line German verse maxim. His dedication of the work to AD suggests that Spengler may have shown it to him at every stage, as his close friend and near neighbour, and as an 'ideal reader' of a text closely geared to a literate but not necessarily Latinate secular audience. It could well have given a stimulus to AD to try his own hand at a modest kind of didactic verse, traditionally religious rather than humanistic, expressing the moral piety of a man who lacked the higher education and Latin learning of Spengler. Precisely this appropriation could also have provoked the mixed reaction, of amusement and indignation, on Spengler's part, which is reflected in his scurrilous portrayal of AD as the meddling 'cobbler'.

The second related piece of evidence is a satirical pen drawing and message (64.2), dated 1511, which AD sent to Spengler. It is evidently a further riposte to Spengler's cutting down to size of AD, the would-be *uomo universale*, and continues his counter-satire of Spengler as the lawyer, churning out endless legal bumph. Any quarrel was clearly largely humorous and left no hard feelings. AD did a portrait of Spengler in 1518, now lost. They found firm common ground as protagonists of the early Lutheran Reformation. A spurious anecdote by Ernst August Hagen from 1829 shows that the tradition of a joking relationship between Spengler and AD was remarkably persistent (Lüdecke 1960, 50–53).

[Hamm 1995, 6–55, 305, & 2004, 91–102; Sahm 2002, 89–98; Ashcroft 2005; Price 2003, 97–132; Grebe 2012]

### 63.7 Humorous Poem Addressed to Konrad Merkel

Konrad Merklin, painter in Ulm and my very good friend, wrote me a most cheerful letter. To amuse me, he claimed to have a daft fixation which the learned of Ulm could not work out. Now he'd heard that I was a truly wise man, so I was to rid him of this fantastical notion. And this is what it was about: Recently he had set a painting on an altar. Now everyone was coming to look at it and saying: 'O what a beautiful painting there is standing on this altar.' 'But since I "set" the painting there', he reasoned, 'how can it be "standing"?'[1] In response I put the following verses in a letter along with other writings and sent it to him.

> Since you think me wise, and pretend
> Your reason struggles to comprehend,
> How your newly placed altar panel,
> As many an ass does say, is 'standing',
> And as you want to know from me
> How I would choose to speak of it,
> Whether it's 'set down' or 'stood up',
> Now this is what occurs to me:
> What's 'set down' needs a bum to sit on,
> What 'stands' must have legs to stand on,
> So those are wrong who talk about
> Your panel being 'set' or 'standing',
> Since neither two are possible.
> Go off and drink a good cool wine,
> The kind they call Green Veltliner,[2]
> Be happy that you're not a Saxon,
> Forced to make do with sour beer,
> Which makes them fart and gives bad breath.
> Now let there be an end of that,
> Lest you should find it wearisome.
> For I would rather not take sides.
> Better ask others how they'd choose.
> Now: my turn to ask you a question.
> From far away a man approached,
> Wrapped around with a lambskin cloak.
> Two other men came up to him
> Who'd started on an argument.
> The first one said: He's clothed in skin;
> The other said: No, on my soul,

His coat is surely made of leather.[3]
Now take your quill and write to me,
When you reach an understanding,
Which of them spoke appropriately
And what that man's coat was made of.
I'll look forward to reading it.
Wishing you now a Good New Year,
Prosperity to you and yours.
Herewith be commended to God
And may He grant you all health and strength,
In heaven life eternal,
Which Mary won for us, the spotless maid.

I, Albrecht Dürer, urge on you:
Now your manifold sins bewail,
Before Laetare Sunday[4] comes,
So that the devil's mouth be stopped.
And that he may be overcome.
Lord Jesus Christ will give us strength
To persevere in all that's good.
Think how we at the last commit
Our loved ones' bodies to the earth,
That rightly shocks our minds with fear,
Makes us vow to desist from sin,
Renounce the world, flesh and the devil.

GNM 5ʳ

NOTES

1   In German, as in English, the verbs *ich sitze*, 'I sit / I am sitting / I am seated', and *ich setze*, 'I set (something down)', and, in the reflexive form, *ich setze mich*, 'I sit (myself) down', are etymologically related but grammatically specialised and semantically distinct forms. Merkel argues that what has been set down is now sitting, and cannot also be standing. In English too, one sets an object down so that it is then sitting, for example, on a table. In fact, in both languages, one can also set an object down, for example, in a corner, so that it is then standing there.

2   *Der im selcklin seÿ gewachsen*: Rupprich regards the place name as a scribal misreading of *Veltlin* in Lombardy.

3   The sequence: *lambshaut…fehl…leder*, is a set of synonyms exactly comparable with 'lamb's hide, fell and leather' in English. The linguistic tic in this case is the false

assumption that it is not possible for different words to denote the same object, or to express varied aspects of the same object.

4   The fourth Sunday in Lent. The collect prayer for the day exhorts the sinner to bewail his sins.

COMMENTARY

Konrad Merkel or Merklin's alleged mental aberration is the inability to distinguish between the literal and the metaphorical or idiomatic use of words. This subject, and AD's comic verse on it, shows an ability on AD's and Merkel's part to grasp an aspect of language use and purely linguistic humour, which is still a topic of modern linguistics. It is possible also that AD knew (via Pirckheimer, presumably) of a classical and humanist joke. When Apelles was asked why he had painted Tyche (in Latin, Fortuna) sitting (rather than standing on her globe for instance), he replied οὐχ ἕστηκε γάρ – 'Because she wasn't standing up' or 'Because she wasn't standing still'. The verb (ἵστημι) can also mean 'set upright, raise into standing'. The Apelles story derives from Johannes Stobaeus, *Florilegium* 105.60 (see Pauly/Wissowa *Real-Encyclopadie*, Zweite Reihe 14, 1688). I am grateful to Harry Jackson for elucidating this point.

A similar combination of robust wit and humanist echoes is found in the other surviving evidence of AD's friendship with Merkel, the satirical 'portrait', a charcoal drawing with black ink and brown wash, entitled in AD's hand *hye Conrat Verkell altag*, 'This is Conrad Verkel as ever was' (44.2). AD alters the name Merkel to *Verkel*, 'pig', and comically distorts his face. This may well allude to Pliny's account (*NH* 35, 114) of the Greek painter Antiphilos's comic picture of a man with the name Gryllos ('pig') from which a genre of satirical painting came to be called *grilloi*.

The religious sentiments that follow AD's New Year greeting to Merkel mark an abrupt shift of subject and tone. They are written underneath the main text, in three cramped columns, suggesting that the copyist was uncertain as to their relationship with the Merkel verses.

[Carstensen 1982, 36f., 133–4; Sahm 2002, 99–102; Bartrum 2002, 165; Mende, in Schröder/Sternath 2003, 388]

## 63.8–27   Devotional and Ethical Verse

AD appears to have compiled his anthology, or at any rate he presents it, as a chronological succession of poems ('Then/Thereafter I wrote…'). It is not arranged by genre or theme but mixes short verse-prayer with longer ethical teaching and the texts of broadsheets. These have common emphases, which they share with late medieval popular piety altogether, on the processes of penance, through good works as well as doctrinal faith, through the sacraments of the Church, and through the intercession of saints, above all the Virgin Mary. Ethical teaching operates a stark polarity of good and

evil. Pre-Reformation Nuremberg was exceptional in the extent to which it had brought the administration and the liturgical practice of the city churches out of episcopal control and under civic supervision. One result of this was an unusual quality of concern for the religious education of the laity and the promotion of popular devotions, both in the two great parish churches and in the chapels of the preaching orders. The city's major festival, the Regalia Fair, linked commerce and secular merriment with open-air public worship. By venerating the imperial treasury of relics – such as the tablecloth from the Last Supper, the cloth with which Christ washed his disciples' feet, fragments of the Crown of Thorns, the Holy Lance and the True Cross – pious citizens could procure remission of purgatory and accelerated access to salvation.

What stimulated and enabled AD's religious poetry was as much this enveloping climate of religious fervour as it was specific literary models, although some of these can be discerned, most immediately Spengler's *Admonition and Instruction* and Sebastian's Brant's verse satires. There is evidence that AD collaborated in producing religious broadsheets with other artists associated with his workshop, notably Hans Baldung, and with the Latin poet Benedictus Chelidonius, who also provided the texts for his *Life of Mary*. The structure of the anthology and the range of genres and themes in his poetry suggest that AD regarded short texts for personal devotional practice, as well as the public media of broadsheet and ethical verse, as belonging on a continuum of popular religious verse rather than as discrete forms.

The narrative framework of the manuscript anthology and its precisely specified chronology place AD's entire poetry within the restricted period of time between 1509 and 1511. The year 1511 in particular, midway between his return from Venice and his first encounter with proto-Reformation teaching through the sermons of Johann Staupitz, saw an intense engagement with the available forms of late medieval Catholic piety and its artistic expression. It brought the publication or republication of AD's three major books of biblical woodcuts, the *Apocalypse*, the *Life of Mary* and the *Great Passion*, and the production of the *Small Passion*, while between 1507 and 1512 he created the plates of the *Engraved Passion*. These 'humanist books of faith', the popular broadsheets, the moral didactic poetry, and the short poems for private prayer and contemplation, together span the whole cultural range of AD's graphic religious art in image and word. What stimulated such a concentrated occupation, apparently within such a short space of time, with these interrelated expressions of religious belief and pious practice, in different media appropriate to different readerships, remains an open question for Dürer scholarship.

[Moeller 1965; Sahm 2002, 102–15; Arnulf 2004; Drescher 2005; Price 2003, 110–40]

### 63.8 I Wrote this About Saint Barbara

> O St Barbara, thou pure maid,
> In my most need come to my aid.
> I pray thee, intercede for me,
> That I shall never come to die
> Save with the final sacrament
> And having made my last confession.

GNM 5ᵛ

COMMENTARY

St Barbara was the name saint of AD's mother. It is possible that he wrote the verses for her use in private devotions. Legend places St Barbara in third-century Egypt. Her pagan father Dioscuros beheaded her for her faith and was then struck dead by a thunderbolt. Hence she came to be invoked against sudden death, and was thought to help those in danger of dying to receive the last sacraments before death. See AD's accounts of the deaths of his parents (15, 92).

### 63.9 This I Wrote About the Evil World

> Who strives to master all the world,
> And lacks control of his own self,
> All the world's constant evil tricks
> Show that there is no health in him.
> It's how an evil[1] man behaves,
> Incapable of rendering
> Evil with good, an evil man
> In wrath evades it, where he can.
> Always he seeks the mastery
> And he little heeds his neighbour.
> He strives always with might and main
> To drag lordship into the dust.
> Evil can bear no punishment;
> We all should shun evil folk,
> For they are quick to attack and wound
> Yet will not bear it from another.
> Expect abuse from evil men,
> For they will always do you wrong.
> An evil man forever schemes
> How to insult people's honour.

An evil man plots against those
Whom virtue raises over him.
Evil lies when it speaks the truth,
Even then it's plotting to deceive.
It's the habit of the evil
To rejoice in their neighbours' grief.
They are bold in their wickedness
And swift to destroy all that's good.
They boast of puny things they beget,
Belittling others' greater deeds.
Evil is boastful in its speech,
Oft commits murder in its heart.
It may put on a kindly mask,
Whilst harbouring evil in its mind.
It says: 'Other people's false hearts
Cause me to suffer grievous pain',
Pretending to feel sympathy,
Whilst more treacherous than any heathen.
The evil man hides his evil
Under a show of righteousness.
An evil man pursues how he
May sow discord among mankind.
And should he see one doing good
He puts it down to ill intent.
Evil men pronounce false judgement,
Their hearts seldom know true joy.
When one commits a wickedness,
His evil makes him shriek and rave,
He has no greater joy in life
Than the quarrels of other folk.
The evil trumpet neighbours' sins,
Would banish God, were they able.
Their own lives lack any repose,
They're avaricious and unchaste.
Deliberately they make folk sad,
Rejoice when people do wrong things.
No evil is too great for them,
For they frustrate all that's good.
Evil men close their ears to truth
Thwart it when goodness is preached.

The evil man craves honours when
He is not worth the least of them.
Malice is in each word he speaks,
Whilst never admitting his own fault.
Evil kills, burns, robs and plunders,
It smites full many lame and blind,
Sees good things and deems them wicked,
Cannot desist from doing ill.
When wickedness takes hold of them,
They take heed of no good counsel,
No answer then they'll listen to,
But lust to destroy good intent.
And if you mention Christian faith,
Your homily falls on deaf ears.
Long since they're in the devil's thrall
That drives them from all fear of God.
Evil belittles all good things,
And plunges into wickedness;
Spurning to walk in righteousness,
It hates the one who takes that path.
Evil assumes so many forms
That all of them I cannot list,
It would be foolish if I tried,
So I must let this be enough.
Whoever dwells with evil men
May suffer it as a penance.
Better to flee all evil men,
Remove yourself from their presence.
Whoever dwells unscathed with them,
Has well survived the acid test,[2]
Can lie naked with a woman
And manage to control himself,
So that his heart feels no desire,
Can be given an unjust beating
And endure that with joyfulness.
Whoe'er loves him who does him ill:
He has a pious Christian soul.
Thus says Albrecht Dürer to you:
The wholly wicked lack all virtue.

NOTES

1   *böß*: in sixteenth-century German the word has three main connotations, all of which combine and partially overlap in AD's usage in this poem. It can have a specifically Christian moral-theological sense, 'evil, wicked', 'being in the devil's thrall'. It often has a broader, more secular sense, 'malicious, anti-social, bad-neighbourly', and it can have the weaker meaning 'nasty, ill-tempered'. The word has no cognates in the other Germanic languages, and English 'evil', though indispensable to the translator, lacks its polysemic range.

2   *Den kein schaidwasser nit noch fretzt*: nitric acid dissolves silver and base metals and was used to test for gold (*scheiden*, 'divide, distinguish'). The verb *verätzen*, 'etch', led Rupprich (I, 134) to attribute the metaphor as used here to AD's knowledge of the technique of producing etched plates. But his experimentation with that medium was limited to six plates made between 1515 and 1518, and it is far more likely that AD derived the reference from his youthful training as a goldsmith (see DWb I, 597; VIII, 2415; Paul 2002, *atzen*).

## 63.10   Thereafter I Made up the Following six Rhymes:

> If you fear God above all things,[1]
> Then you shall never go astray.
> If you're content with what you have,
> You may count yourself rich and fed in green pasture.[2]
> You will fare well throughout your life
> Healthy in soul and body and free from all care.

GNM 7ʳ⁻ᵛ

NOTES

1   Unusually AD here varies the four-beat metre with six metrical stresses in the fourth and sixth lines, though the scansion in these is poorly handled.

2   *vnd wirdt satt wo er geht*: the allusion in the translation to Psalm 23:2 is admittedly much less direct in the original.

## 63.11   Thereafter I Wrote 'On Bad and Good Friends':

> If you desert a friend in need,
> Abandon him for no strong cause,
> Fail to heed when your heart tells you
> Who is your truly faithful friend,
> If you always insist you're right
> And minimise your friend's interest,

If you're for ever picking fights,
Bashing on as if armour-plated,
If you are such a mighty man,
Who's going to stay and put up with it?
If you insist on deference,
Making all crawl on bended knee,
Folk will think it better to go
Than miserably suffer that.
For the one who is your good friend,
Uses no malice towards you,
Never takes anything from you ill
But from ill always protects you,
Never abandons you in need,
And is your shield when you're assailed.
He always gives you sympathy,
When sorrow is the lot you bear,
Never esteeming you the less
Than he would estimate himself.
Hold in firm honour such a friend
Let nothing make you turn from him.

GNM 7ᵛ

NOTE

Reicke (1940, 502) suggests that this admonition on friendship is directed to, or against, Willibald Pirckheimer, and certainly some of it could be understood as criticising Pirckheimer's aggressive, lordly and prickly character. However, perhaps it is more a case of 'if the cap fits...'. The poem expresses an ideal of humanist friendship which Pirckheimer manifestly shared, and there is ample evidence that he regarded AD as his friend beyond the constraints of social caste and education.

### 63.12  Thereafter I Wrote 'The Seven Daily Times of Prayer'

### Introduction

The *Seven Hours of Prayer* derive from a Latin hymn, 'Patris sapientia, veritas divina'. The origin and authorship of the Latin hymn is uncertain. Rupprich's attribution (I, 136) to Jacopo da Todi is wrong. It has been variously ascribed, most frequently to Egidio da Colonna (1245–1316), a disciple of St Thomas Aquinas, or to Pope John XXII (in office from 1316 to 1334), perhaps because he offered an indulgence to those who used the verses in daily devotions. Divided into its component seven strophes and a

prayer which is repeated after each of them, the elements of the hymn were incorporated as the *Short Hours of the Cross* into Books of Hours which in the fourteenth and fifteenth centuries, indeed until their use was discontinued in the Counter-Reformation, were the staple material of private prayer and devotion for Catholic laity and priesthood. The *Hours of the Cross* entered late medieval local forms of the ancient monastic liturgy which was structured around the canonical hours of prayer.

In the *Hours of the Cross*, the seven stages of prayer are not the times of day and night at which the monks worshipped, but the chronological sequence of the Passion of Christ, from his arrest at Gethsemane to his burial. The non-canonical Books of Hours for lay or secular clerical use associate them with the *Short Hours of the Holy Spirit* and, in particular, with the *Hours of the Virgin*, with which they formed a set of structured devotions. Books of Hours normally prefaced the *Hours of the Cross* with a large miniature of the Crucifixion; more elaborate prayer books had illustrations for each of the seven stages of the Passion. AD's adaptation of the material as a broadsheet with woodcut and text thus reflects in popularised form an older practice of the recital of verse prayer combined with the contemplation of a sacred image.

AD's poem is a somewhat expanded paraphrase of the Latin hymn verses, as is illustrated by the following text and translation of the first strophe (Matins) of the hymn, which should be compared with AD's translation below:

| | |
|---|---|
| Patris sapientia,   veritas divina, | Wisdom of the Father,   truth divine,. |
| Deus homo, captus est hora matutina. | God made Man,   taken captive at the morning hour, |
| A suis discipulis   cito derelictus, | Swiftly deserted   by his disciples, |
| A Judeis traditus,   venditus, afflictus. | Betrayed by the Jews, sold and reviled. |

Notable in AD's expansion is the way in which Mary acquires an intermittently explicit role in the events of the Passion. The rhymed alexandrines of the Latin hymn become in AD's translation, as in other fifteenth- and sixteenth-century German versions, the stock four-beat rhymed lines of vernacular popular poetry. The hymn entered Protestant communal worship in the form of a translation by Michael Weisse for his *Bohemian Brotherhood Hymnal* (1531).

Price (2003, 131f.) draws attention to Princeton University's copy of AD's *Engraved Passion* (1507–12) which was owned by Duke Frederick the Wise of Saxony, and which is interleaved with manuscript texts to create a prayer book with, as its basic structure, the eight strophes of the 'Patris Sapientia'. This strikingly links – within the same years around 1510 – AD's provision of devotional material for humanist and prestigious readerships with his production of broadsheets for popular audiences. A broadsheet dated 1511, with woodcuts by Wolf Traut of the Birth of Christ and of Frederick the Wise praying to the Virgin and Child (Geisberg/Strauss IV, 1405), has the Latin and German texts of the *Short Hours of the Cross* and a prayer by the Virgin Mary.

AD's version of the *Hours of the Cross* seems likely to have been the direct reflex of a particular religious observance in the Dürer family's parish church of St Sebald,

where the 'Patris Sapientia' was sung each Friday evening in a popular lay devotion. In 1514 Anton Tucher endowed the service with 300 gulden for the perpetual celebration of the mass and the singing of the Passion hymn. AD's broadsheet would then have allowed the laity to extend this act of worship into their private meditations.

[Wackernagel 1864, I, no. 267–8 & III, no. 289; Arnulf 2004; Price 2003, 123–32]

These are the Seven Times of Prayer
when Christ suffered in His Passion:

## 1510

### Matins[1]

The Father's eternal wisdom suffers
Christ to be the incarnate Godhead.
Sold He was by treacherous Jews,
Who heaped gross lies upon His head.[2]
Taken captive at matins hour,
Mankind was plunged in fear for Him.
All His disciples and kinsfolk
Foreswore their faith and turned from Him.
Only Mary the spotless maid
Stayed true to Him in heartfelt grief.

### Prime

Our Lord was brought before Pilate
And accused with much false witness.
And was all unjustly beaten,
Which Christ bore with steadfast patience.
Our noble Lord was spat upon
As the Prophet Isaiah wrote.
His countenance was covered up,
And 'Jesus, tell us', they mocked Him,
'Which amongst us has smitten you,
Come, prophesy that to us now.'

### Terce

Mark everyone at the third hour
How all the Jews cry out: 'Make haste,
Crucify him, crucify him!'

Pilate leads him forth, bound with rope,
Mock arrayed in purple raiment,
And points at him with outstretched hand:
'Behold the Man with crown of thorns,
Cruelly have I whipped and scourged him.'
Naught it avails, He bears His cross,
Suffering derision and abuse.

### Sext

To the cross He was fixed with nails,
That caused his noble body hurt
So grievous, that in pain he cried
'I thirst!' Not wine they gave to drink
But vinegar with bitter gall.
The Jews kept up their loud abuse.
He was abased with common thieves.
To left, the rogue mocked him and laughed,
To right, the criminal begged His grace
Which swiftly Jesus granted him.

### Nones

In the ninth hour our dear Lord died.
His death won us eternal life.
'Into thy hands I commend my soul'.
With might he descended to hell,
To ransom the quick and the dead,
Redeem them from fiery torment.
A centurion pierced his side,
The sun's rays were plunged into night.
A violent earthquake rocked the land,
Throwing corpses out of their graves.

### Vespers

At vespers our Lord was taken from
The Cross and laid before His mother.
His strength and might now lay hidden
In God's bosom on that same day.
O man, take care to mark this death,
Your remedy in utmost need.

O Mary, immaculate maid,[3]
Look now upon Simeon's sword.
Here falls the great high crown of honour,[4]
Which abolishes all our sins.

## Compline

Joseph of Arimathaea
Came, and with him Nicodemus.
It was they who buried the Lord
From whom we have eternal life,
With myrrh and sweet-smelling spices
As is the custom of the Jews.
These things were done like this so that
The prophets' words should be fulfilled.
O ponder this death in your hearts
With utmost sorrow all your days.

## A Prayer

O our almighty Lord and God,
The great torment that has suffered
Jesus, your only begotten Son,
So that He might atone for us,
We contemplate it devoutly.
O Lord, give me true penitence
For all my sins, and better me,
This I pray you with all my heart.
Lord, you have overcome the foe,
So let us share your victor's crown.

O Lord, Albrecht Dürer beseeches
That he may be vouchsafed your grace.[5]

GNM 7ᵛ–8ᵛ. Broadsheet: Geisberg 734–4. Woodcut: S W 143, SMS 148. It shows Christ on the Cross and the grieving Virgin and St John. It has AD's monogram and the date 1510. It was printed by Hieronymus Hölzel who was also Konrad Celtis's publisher and had a role in AD's 'great books' of prints in 1511.

NOTES

1    The seven canonical hours of prayer and worship in the monastic rule of life, derived from Psalm 119:64: 'Seven times a day do I praise Thee', were matins (combined with lauds, praise of the Virgin Mary), prime, terce, sext, nones, vespers and compline.

2    This reference to the Jews appears in less virulent words in the Latin text. Price's claim, that AD turns the Patris Sapientia into 'an anti-Semitic poem', is part of an argument which overstates the extent to which AD is at all exceptional in his time in his condemnation of the Jews (Price 2003, 169–92). Nuremberg had expelled its Jewish population in 1499, when it was Willibald Pirckheimer who commanded the civic militia which escorted them out of the city. See A. Müller 1968, especially chapters 4–5.

3    As already in the first strophe, AD inserts here a double reference to the Virgin Mary. First (line 2) the body of Christ is laid before her for her lamentation though not, as Price suggests, in the pietà or mercy pose of Mary holding the corpse of Jesus in her arms. Then she is called upon to recognise 'the sword of Simeon'. This refers to the words of the aged prophet who recognised the infant Jesus when he was presented in the Temple (Luke 2:22–32) as 'a light to lighten the Gentiles', and whose death will be 'a sword [that] shall pierce through thine [Mary's] own soul also'.

4    The broadsheet has *kron der erden*, 'earthly crown', but the manuscript's *kron der ehrn*, 'crown of honour', repairs the rhyme with *verzehrn* and makes better sense.

5    AD uses his longer vernacular strophe to lay more emphasis on the Christian's personal imitation of the suffering Christ. The final couplet is an addition. As at the end of the verse epistle to Konrad Merkel, and of the other two broadsheet texts, *Death and the Pikeman* and *The Schoolmaster*, AD adapts a broadsheet and Meistersang practice (used in Nuremberg earlier by Hans Folz and later by Hans Sachs) of the poet naming himself, reinforcing and personally endorsing the sentiments of his poem, and here also praying for his own salvation.

## 63.13    Broadsheet Death and the Pikeman [fig. 31]

### Introduction

There is little if any direct reference in the text of AD's poem to the *Landsknecht*, the mercenary pikeman, whom Death accosts in the woodcut of this broadsheet. However, its insistent theme, the arbitrary unpredictability of death and the need for the Christian to be prepared to die at any moment, applies with particular urgency to the soldier, whose profession and way of life expose him to physical and spiritual danger and limit his scope for reflection and contemplation of his end. In his letters from Venice to Willibald Pirckheimer in 1506 (29.7–8), AD had invested the mercenaries who fought in imperial, papal, French or Venetian service with martial glamour and even an erotic

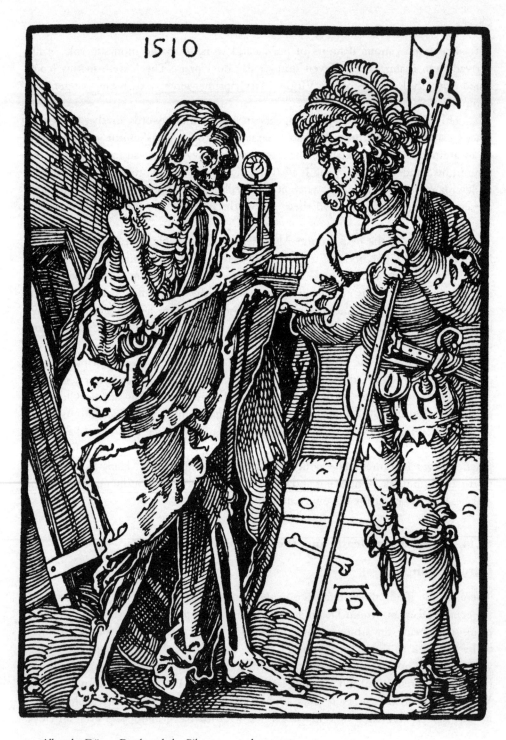

31.  Albrecht Dürer, *Death and the Pikeman*, woodcut, 1510

allure. This derives from their effectiveness in contemporary warfare, their extravagant costume, and their disregard for conventional, civil morality, which are variously depicted or hinted at also in AD's drawings, woodcuts and engravings of *Landsknechte* (for instance W 251, 253f., compare S D 1502/15, 17–18, XW.254. See fig. 23). Love songs and drinking songs, as well as historical ballads of the *Landsknechte*, were widespread by the 1520s. In his *Colloquia familiaria*, satirical dialogues published in 1526, Erasmus included the conversation on *Militaria* which exposes the *Landsknecht* Thrasymachus as a boastful and boneheaded thug with scant concern for his religious health.

AD's horror of sudden unprepared death is expressed in his accounts of his parents' deaths (15, 92) and in the verse prayer to St Barbara (63.8). In the case of the *Landsknecht*, this acute vulnerability is compounded by the inherently sinful nature of the life of the mercenary soldier, who of all men is least able to devote himself to penance or good works. *Landsknechte* played some part in carrying the pandemic of contagious syphilis from Italy to Germany in 1495. The Renaissance figures of the *Landsknecht* and the *condottiere* are the antithesis of medieval and – around 1500 still current – ideal images of spiritual and physical combat against evil, defined and sanctioned by Scripture and by the law and custom of the Church. The rule of monastic life which St Benedict formulated in the sixth century envisaged the monk as 'soldier of Christ', fighting the spiritual warfare described by St Paul in Ephesians 6:10–18, wearing the 'breastplate of righteousness' and wielding 'the shield of faith', 'the helmet of salvation' and 'the sword of the spirit'. By the eleventh century the Church had established a concept of 'just', even 'holy', war to defend the faith and serve Christendom. The medieval crusader vowed to be a soldier of Christ in the double sense of fighting simultaneously the physical battle against heathen or heretical enemies and the spiritual conflict with sin and evil for the reward of salvation. Around 1500 the Church was still seeking to mobilise Christian rulers and knights to crusade against the Turkish invaders of Eastern Europe. But in 1500 Erasmus wrote his *Manual for the Christian Warrior* (*Enchiridion militis christiani*). It turned its back both on the chivalric crusading conception of Christian warfare and also on the restriction of the idea of spiritual warfare to the monastic life. Like St Paul, Erasmus envisages every lay Christian as a warrior of Christ, not in specialised forms of monastic or chivalric life but in their everyday practice of faith. First printed in 1503, the *Enchiridion* was not widely read, let alone translated into German, until after the second edition appeared in 1518. It is unlikely that AD would have known it in 1510, unless through a humanist informant like Pirckheimer. By 1520, having met Erasmus in the Netherlands, he probably did, for he appeals to Erasmus as 'warrior of Christ' in his journal (162). There is in any case a crucial difference between the *Enchiridion* and the broadsheet, where AD rejects the life of the pikeman as fundamentally anti-Christian. The *Landsknecht* serves whomever will pay the soldier's wage, regardless in what land and in what cause he fights. He flouts the Ten Commandments in his vanity as a professional killer and through his dissolute life. He looks to neither faith nor good works as routes to salvation. AD's alternative to the hired killer is not formulated as a diametrically

opposed ethical and spiritual *militia Christi*, but as a lay piety on conventional late medieval Catholic lines.

[Baumann 1994; Welzig, Erasmus 1990, I, xiii–xxv, 56–375; Arrizabalaga et al. 1997, 20f., 88, 126; Hale 1999, 29f.; Ribhegge 2010, 46–50]

Thereafter I made these Christian verses:

Nothing wards off death when it comes,
Therefore serve God early and late.
For it is obvious to us
That death gives a man short shrift.
One day a man stands before us,
The morrow sees him dead and buried.
And so, o human stubbornness,
Why can you not bewail your sin?[1]
For you must know and have been told
That God all evil puts to shame
For ever through his stern justice,
Then none escape the awesome judge.
Only by fearing God on earth
Can you escape eternal death.
Pledge yourself now to live by Christ,
He can give you eternal life.
So turn your eyes from mortal things,
Set a course for the world to come,
And seek always only for grace,
As any moment you might die.
Don't save betterment for tomorrow,
For what's to come is still unsure.
Better it is to fly from sin
Than try to flee from timely death.
The man who has a conscience clean
Needs not fear death early or late,
Nor keep on asking how much time
God may still give us here on earth.
Longevity rarely indeed
Persuades people to mend their ways—
Rather they multiply their sins.
God grant my life be brief but good!

Although dying is terrible,
Living long does not guarantee
Winning God's grace and deep affection,[2]
But often stokes the fires of hell.
Who ponders always in his heart
That moment when his death is fixed,
Treats each day as it were his last,
God's grace has surely looked on him,
He will enter into true peace
Which God gives but the world cannot.
Whoever then lives life aright,
He is vouchsafed true bravery,
And he can treat death as a friend,
Who summons him to blessedness.[3]
He fears not God the awesome judge,
For he has paid the dues of sin
With earthly penance and has earned
God's grace on this earth, before death.
Whoever can renounce the world,
And humbles himself in this life,
Is given from on high strong hope
That he is pledged to none but God.
The man who postpones doing good works
Till he's due to depart from hence,
Relies on masses sung for him,
And hopes that they will save his soul,
His reward will be the tolling bells
Whose fading note is his oblivion.[4]
Like them he is soon forgotten,
However long he is imprisoned
In purgatory or in hell
And suffers monstrous torment there.
If you do not strive for wisdom,
Cannot to your own self be true,
You need put the blame on no one,
If in your life and in your death
God and man alike forsake you,
For you have led yourself astray.
And so let all who would die well,

With eager gladness do good works
And set their trust in God alone,
Then they can never suffer shame.
Never will God's strength desert them,
But bring them to his heavenly host.

Albrecht Dürer gives this advice.
Would God that I might live by it!

Gladly let us all pray for that,
Hoping God grants us his mercy.

GNM 8ᵛ–10ʳ. Broadsheet: Geisberg 710. Woodcut S W 145, SMS 149

NOTES

1   AD does not allow the pikeman to utter a word in his defence. But nor is the poem a harangue by Death. The hortatory voice is that of the moralising poet. This contrasts with the humanist and Reformation preference for dialogue as the vehicle of ethical and religious didactic.

2   *dye göttlich gnad vnnd jnnigkeit*: AD here uses a noun, modern German *Innigkeit*, literally 'inwardness', by extension, 'intimacy, sincerity, intensity', which is part of the late medieval vernacular lexis of mystical piety. That it should be part of his active vocabulary is further evidence of his deeply reflected faith.

3   AD's woodcut depicts Death as the skeleton cloaked in a shroud and with hour-glass in hand, an iconography which more readily goes with the notion of Death as a figure inspiring terror. The paradox of Death acting as a friend is thus made the more effective.

4   This calling into question of the idea that external acts of piety, such as masses for the soul or indulgences, could substitute for faith, and for good works done in life as expressions of faith, chimes with similar notes in Erasmus's *Praise of Folly* (also written circa 1510).

### 63.14   Thereafter I Wrote These Two Verses, Because a Man Troubled me Much, to Whom I was Loyal and Looked for Much Favour:

Without dishonour you may shun
A friend who always makes you suffer.

GNM 10ʳ

NOTE

Supposition such as Rupprich's, that the friend who has so disappointed AD is presumably Pirckheimer, lacks any evidential value and focuses interpretation too narrowly on this one, albeit central, figure of his personal life.

### 63.15  Then I Made These Six Verses About One Born a Fool:

A mother who gives birth to a fool
Is touched by blessing in disguise.
For all the time he lives on earth,
He is a source of joy and mirth,
Yet when he dies and passes on,
He bequeaths no cause for sorrow.

### 63.16  Thereafter I Wrote About St Catharine:

O Catharine, noble offspring,
Give to me true godly virtue.
Beg Jesus that he clothe me round
With wisdom and humility.
Obtain for me from Christ also
His mercy when I come to die.

GNM 10ʳ. Broadsheet: Geisberg 73

NOTE

This is St Catharine of Alexandria (fourth century), not the fourteenth-century St Catharine of Siena. As a Christian convert, she disputed with fifty pagan philosophers appointed by Emperor Maxentius to persuade her to apostatise. When the emperor condemned her to be broken on a spiked wheel, the wheel flew apart, and she was then beheaded. However, the poem is addressed to her not in her function as patron saint of Christian scholarship, but for her closeness to Christ, from whom in a vision she received a ring in 'mystic marriage', and in her capacity as one of the Fourteen Holy Helpers.

This verse prayer appears in slightly different wording on a broadsheet, accompanying a woodcut of St Catharine by Hans Baldung, and in parallel columns with unrelated Latin verses (not in prayer form) on the saint. The Latin poem is likely to be by Benedictus Chelidonius who provided the verses for AD's *Life of Mary*. Strauss's

dating of the broadsheet to 1505 is thus unlikely to be correct. There are close links also with the last strophe of Hans Sachs's song 'O sancta Katharina gut' (1518), which probably also derives from the broadsheet.

[Price 2003, 117]

### 63.17   Next I Wrote About Our Lady:[1]

> O thou who bore God in thy womb,
> Queen enthroned in highest heaven,
> Supreme hope of every sinner,
> I pray thee, through thy little child,
> Jesus, who was thy creator,
> Make me to see his Trinity.[2]

NOTES

1   The verse prayer appears, with one significant text variant, on a broadsheet with a woodcut of the Virgin Mary crowned, possibly by Baldung. It is also in parallel columns with an unrelated Latin poem, perhaps by Chelidonius.

2   In the final line, the manuscript text ends with the unusual noun *thrawthat*, 'deed of love' (read as *treutat* in DWb XI, I, 2, 392), for which no other occurrence is recorded. The broadsheet has *trinitat*, 'Trinity', which is much more plausible semantically and metrically.

### 63.18   Then I Made These Six:

> Some think they know everyone,
> When they know nothing of themselves.
> Who is not master of his tongue,
> Speaks every moment vain nonsense.
> Who reckons he's all powerful,
> Shoots at the bull's eye of folly.

### 63.19   Thereafter These Two:

> Never let any friend perceive
> That you have tired of his affection.

### 63.20 Thereafter I Wrote These Six:

> O hail to you, cross of Jesus,
> Only belief in you brings peace.
> I pray you, stand by me always
> Against the world, flesh and devil.
> And aid me in my final need,
> When bitter death bears me away.

NOTE

A further example of a verse prayer by AD which was used for a devotional broadsheet by Hans Baldung, with a woodcut of Christ crucified and parallel Latin verses unrelated to AD's text (Geisberg, 63). The dating by Geisberg/Strauss of 1505 is in this case too not consistent with the Frommann manuscript.

### 63.21 Then I wrote:

> O Mother of God, pure maiden,
> I pray you, through the bitter pain
> You bore with great lamentation
> When your dead son lay before you,
> Come to my help in my distress,
> Through Jesus your son's bitter death.

GNM 10ᵛ

### 63.22 Broadsheet: The Schoolmaster [fig. 32]

### Introduction

The woodcut image of the schoolmaster, with a pupil ducking as he waves his cane, has a whiff of caricature about it, more so than AD's drawing of a standing figure with the same headgear and cane (W 634, S D 1515/65). Price (2003, 119) suggests that AD may be ironising the poetic mode of didacticism, perhaps specifically Spengler and his *Admonition*. However, the text shows no trace of any ironical detachment. Its conventional platitudes remain within the framework of an ethic geared to urban citizenship. They advocate a measured social responsibility which respects the limitations of didacticism and moral assertion. Tolerance between neighbours and a stoical realism in personal behaviour are preferable to moral perfectionism. The contrast between the religious absolutes in AD's verse prayers, and in *Death and the Pikeman*, and the ethical

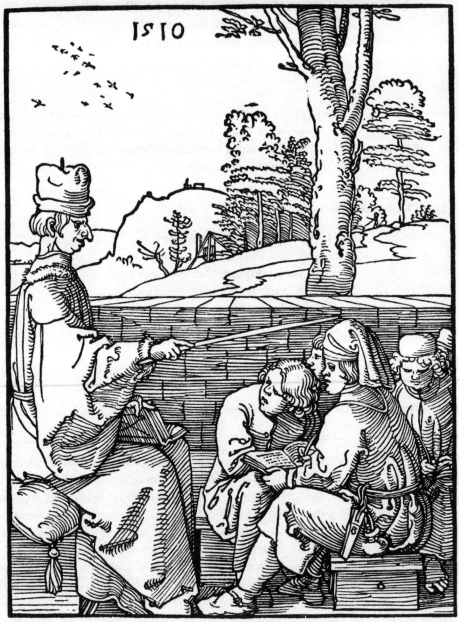

Wer recht bescheyden wol werden
Der pit got trum hye auff erden

1510

32.  Albrecht Dürer, *The Schoolmaster*, woodcut, 1510

relativism of the more purely didactic poems is striking. It suggests a complex relation-ship between the religious and the secular components of personal and collective social conduct in pre-Reformation Nuremberg.

Thereafter I wrote this

The Schoolmaster

Who would become truly wise,
Pray God to grant it here on earth.

### 1510

Whoever cleaves to this teaching
Will possess a light heart and mind,
Will always find himself at peace
With himself and with his neighbour.
Reveal your secrets to no man,
Thus spare yourself regret and pain.
For it was ever written thus:
Few folk can be relied upon,
The human heart's a fickle thing.
If you crave peace, take my advice,
Gossip and slander strictly shun,
And you shall reap the praise for it.
Your example will deter those
Who spread malice about neighbours.
Thus your heart suppresses anger
And drives hate and envy from you.
Those who hear you will come to learn
That all you do is meant for good.
Speak in seemly, measured fashion,
Don't fly at people angrily,
And think before you speak at all.
Don't talk thoughtlessly or rashly,
Then you'll not offend or insult,
And make your gestures moderate,
Bearing out your sincerity.
Stick to the truth, abjuring lies,
And do not cunningly pretend
To be other than your heart prompts,
Else you deceive yourself and God

And end up others' laughing-stock.
Don't rush to judge people too quick,
Rubbish their work, assail them with
Your vengeful thoughts and angry words,
But think: 'I might do tomorrow
More dreadful works than they have done.'
That way you'll thwart the devil's tricks.
Never let your anger fly till
You've paused and calmly thought it through,
Whether anger is justified.
That will serve you better than gold.
Don't rush to answer for all things,
If you value a quiet life,
Be patient, wait a little while,
Till someone else answers for you
Or events themselves prove you right.
That way you earn respect and honour
More than by taking on too much
Or by fighting needless battles.
So when you hear an argument,
Resist the impulse to take sides,
And if you cannot mediate,
Just be content to stay away.
Don't succumb to that temptation
Lest you get drowned in the bath tub.[1]
Always show you're sympathetic
When other folk bemoan a grievance.
Always be a friend of justice,
When justice fails, be regretful.
Do not get too involved in things
Likely to make trouble for you.
Never forget your commonsense,[2]
Then no crisis can defeat you.
Where honesty is your defence,
Nothing can wound you to the heart.

In good faith Albrecht Dürer says:
Protect yourself from all quarrels.

GNM 11ʳ. HAB 140ᵛ–142ʳ. Broadsheet: Geisberg 734–3. Woodcut: S W 144, SMS 150

NOTES

1   A proverbial idiom, one may suppose. It does not match any of the numerous proverbs involving baths and bathing in Röhrich (2009, I, 129–33), but suggests the danger of the warring parties turning on the peacemaker, or the latter finding himself in too deep and out of his depth. See DWb I, 1069f., definition 3.

2   *beschaidenheit*: a key concept in early modern German didactic literature, connoting practical wisdom and tact. It undergoes a semantic change to modern German 'modesty'.

## 63.23   After that I Made Up These Six About St Martin:

> O holy Martin, friend in need,
> How greatly Christ the Lord loves you!
> Pattern of mercy as you are,
> Be, I pray you, our protector
> And intercede for us with God,
> Help us too in our final hour.

NOTE

St Martin of Tours (316–397), a Roman soldier who, when asked for alms by a beggar in Amiens, cut his fur-lined cloak in two and gave him half of it. He founded a monastic community and was chosen by the common people as bishop of Tours. While AD acknowledges his exemplary pity, his function in the verse prayer is as helper in the hour of death.

## 63.24   After that I Wrote Six More:

> O you incarnate Son of God,
> Lord Jesus Christ, with what effort,
> What patience, what humility,
> You bore your cross and shed your blood!
> Through that I pray you: give me patience
> To bear the evil my sins have earned me.

### 63.25 Then I Wrote These Six:

> If you have a bondsman purchased,
> Once he's baptised, it is not right
> That he should longer be a slave.
> Then you should loose him to go free.
> Let good repute be your reward
> And no one's service go unpaid.

63.23–5   GNM 11ᵛ.

NOTE

The theme of the freed slave derives from the brief Epistle of Paul to Philemon, and is evidence at the very least of AD's thorough knowledge of the New Testament even before the Reformation. It seems inconceivable that AD ever had a bonded servant, in house or workshop, who was not already baptised, but by the early 1500s he could have known mercantile families who did, brought into Europe from North Africa via Venice, for example.

### 63.26

> Let each sweep his own doorstep clean,
> We'll all find muck aplenty there.

NOTE

Not in the Frommann manuscript but added by Murr to his selection. It is a proverb well attested in the sixteenth century. The sense is: 'Make sure your own house is in order before you interfere in other folks' affairs.' See Röhrich 2009, III, 1651.

### 63.27 [fig. 33]

> The man who has an envious heart
> Heaps mounds of rubbish on himself.

NOTE

Similarly proverbial in character. Not in the Frommann manuscript, but written on the lower right of the sketch of an arcade looking out on an Italianate street (W III, Appendix, plate 20) in the BL Sloane collection, Add. 5229, fol. 55ʳ. The architectural

33. Albrecht Dürer, *Venetian Street*, pen sketch, 1495? with added verses 1510? BL Sloane 5229–55ʳ

subject, and the script, would equally well allow a dating of 1505–6, during AD's stay in Venice. Or did AD write the lines circa 1510 on an earlier leaf with a Venetian drawing?

## 63.28–33 Poems of Uncertain Attribution

### 63.28 All Birds Envy and Hate the Owl

> O hate and envy everywhere,
> O treachery and avarice,
> Conflict always accompanies you.
> Even when no one plots your shame,
> Deceit is writ large on your face,
> Never have you lacked trickery.
>
> I tell you, when there's enmity,
> When one spits insult at another,
> The devil takes hold of the third.
> If the flames are not promptly dowsed,

Rape, violence, murder, strife ensue,
Of all misfortune the begetters.

You can see here from this conflict,
How the innocent gets the blame,
How the others gang up on him.
Those aware of their own shame
Keep their claws out of others' flesh
And do not flock to harry them.

O what further damage is done,
By secret malice, envy, spite,
When vile treachery knows no bounds.
O Lord, deign to take pity now,
Your goodness never failed the meek,
Whatever their calling was in life.

Undated broadsheet: Geisberg 748. Woodcut of an owl fighting with four birds, circa 1515 (S W 178, SMS 245). The printer is named as Hans [Wolff] Glaser of Nuremberg. Neither woodcut nor text has AD's monogram. Only one surviving copy has both woodcut and text. An oil-painted portrait, *Young Man with a Rosary* by Hans Baldung Grien, bearing the inscription: Anna [sic] DÑI 1509 around the head of the subject, has the separating device of an owl on a branch being attacked by a raptor (crow? eagle?) quite similar to the woodcut (Heard/Whitaker 2011, 117–19).

[Rupprich I, 142]

## 63.29   Moral Instruction

Whoever has ears to hear, now mark
Diligently what's taught here:
Hear, o man, I will teach you here
How you should lead your life on earth,
So that it may be pleasing to God
And at the same time profit you.
First of all, you should always strive
To fear God and to love Him too.
Hear mass devoutly every day
And you will never suffer lack.
Follow God's word diligently,
Be not too eager for riches.
For he who seeks to win great wealth
Can scarce escape the devil's noose.

God's Ten Commandments do not break,
And with them ponder his Passion,
The suffering he bore for us,
Be thankful to him day and night.
Of all the sins, ingratitude
Displeases God beyond all else.
Repent straightway your sinfulness,
For time and tide await us not.
Today you live, tomorrow you die,
May be, you'll be in dire straits.
Therefore seek after God's favour,
As though you'll die at any time.
O man, be mindful and repent.
Now further note a timely lesson.
You should judiciously seek wealth,
As if you expect to live for ever.
Whate'er you do, think of the end.
Seize wealth wisely, don't grab at it,
Be sensible and modest too,
Not over-eager, take time to think,
Shun idleness, keep yourself busy,
Then you may prosper and yet be saved.
That man is blessed whose hands bear fruit,
More blessed if he use wealth wisely.
Be not too trusting, guard your speech,
Advice from too many does no good.
Never was better defence from shame,
Than mastery of your own tongue.
Count one penny as precious as four.
Not fond of wine? – drink water or beer.
Eat and drink and don't despise them,
For lack in this life is not pleasant.
You can save a penny as quickly
As earning one, believe you me.
And put your money to good purpose,
Don't overindulge in gambling and parties.
Shun loans and all extravagance
And you'll come off the better for it.
Don't pick quarrels with your neighbours,
Be truthful, guard yourself from lying,

Keep out of debt and overspending,
Don't be miserly, don't gamble either,
For dice, parties and bad women
Can easily cost a man his life.
Lend sparingly, and do not borrow,
Everyone should meet his own needs.
That done, take no thought for the morrow,
For all that happens is God's will.
Many a man pursues riches,
And yet stays stuck in poverty.
But whoever gets his way on earth,
And seems to have a lucky star,
Ought properly to feel concerned
For it betokens eternal pain.
But those who are predestined for heaven
Fight on earth through thistles and thorns,
Through misery and tribulation.
And so, man, be always ready,
Endure patiently in this world,
For here you may expect no more
Than meat and drink, and clothes to wear,
And what you may have laid up on earth.
And nothing more lies in your power
Than what you consume and give through God.
And all our effort is spent upon
Accumulating goods and honour,
And when we have achieved just that,
We lay ourselves down and die.
No better counsel I can give,
Than that a man set all his hopes
Guilelessly on pleasing God.
When some harm or hard case befalls
That one cannot recover from,
Just put it out of mind and heart.
God ordains all things for the best,
What may sorely disappoint us
We ought to really thank God for.
That's what many teachers tell us.
Now you've heard all these good precepts,
You should faithfully follow them

And keep the teaching in your mind,
Then you'll acquire honour and wealth
And still come to eternal life.
May God grant us all that. Amen.

HAB 142ᵛ–144ᵛ. Also printed in Willibald Pirckheimer, *The Theatre of Virtue and Honour*, Nuremberg 1606, pp. 63ff., an anthology of selected works of and connected with Pirckheimer. As a piece of moral didacticism it has strong echoes of AD's *Death and the Pikeman* and *The Schoolmaster*, but these may be merely generic or imitation of AD's in any case conventional idiom. The metre of the verse is cruder than is the norm in his authenticated texts.

Rupprich I, 142

## 63.30 Prayer to St John the Evangelist and St John the Baptist

O Saint John Evangelist,
God's own beloved disciple,
Chosen to be a pure virgin,
Honoured above all other men
And elected by Christ's pleasure
To rest upon his holy breast,[1]
From which you drew secret knowledge
As I deduce from your own book
Of heavenly vision, Revelation.
There you write of God's own kingdom,
In which you are without equal,
How heretics will come to plague it,
Yet at the last be trampled down,
So that Christendom in the end
Preserved will be by God's own hand.[2]
What more is there for me to say?
Next to the cross God's son placed you
To care for Mary in distress,
A duty you did faithfully.[3]
Now we all pray you with one voice
That you be our intercessor
At the end, when our hearts fail us
And the hellish fiend assaults us.

O elect baptiser of Christ,
More holy man was never born,
You prepared the way of the Lord.[4]

For your mercy we now appeal,
That you will not let us perish.

The prayer verses have been printed on certain copies of a blank title page for a book, which has a woodcut frame into which a title is meant to be set. There are two extant books, printed in 1517 and 1518, for which the blank has been used. Components of the frame are two woodcuts showing St John the Evangelist on the island of Patmos (Revelation 1:9) and St John the Baptist baptising Jesus. These may be the work of AD's associate Hans Springinsklee. The copies with the prayer verses have been converted for sale as a devotional broadsheet. The texts are not strongly reminiscent of AD's verse prayers.
  Rupprich I, 144

## NOTES

1   See John 13:23. At the Last Supper, 'there was one of his disciples which leaned on Jesus' bosom, whom Jesus loved'.
2   This garbled account of the Book of Revelation cannot be by AD, in view of his masterly woodcut series of the *Apocalypse*.
3   See John 19:26–7.
4   The line quotes Matthew 3:3.

### 63.31   Prayer to St Sebastian

To Saint Sebastian

O holy Saint Sebastian,
How great is your divine reward.
Win for me help against sudden death
And guard me from the pestilence.
Come to my aid in that dread hour,
When my soul departs with my last breath.

The verse prayer with an unrelated Latin poem in parallel columns accompanies the woodcut of St Sebastian (Geisberg 70) on a broadsheet which is probably by Hans Baldung. Datings of 1494/5 and 1508 have been proposed, but the combination on a devotional broadsheet of the image of a saint and verses in German and Latin, catering for more and less educated users, is the same as a number of examples above with verses also copied in the Frommann manuscript. While the text is cruder in style than in AD's authenticated verse prayers, it seems likely to be at least a direct imitation. The broadsheet may well date from circa 1510.
  [Price 2003, 115]

## NOTE

According to legend, Sebastian joined the Praetorian Guard of the Emperor Maximian (late third century) and used his position to help persecuted Christians. He was sentenced

to be executed by a firing squad of archers. Though riddled with arrows he survived. He presented himself at the Temple of Hercules and proclaimed his faith, whereupon he was flogged to death. In the late Middle Ages he was prized as a protector against the plague, because being struck by the plague was equated with being struck by the arrows of death.

## 63.32  Prayer to Saint Paul

To Saint Paul

O Paul, God has elected you,
To be one of the apostles,
For you were chosen specially.
Help me, that I shall not perish,
Win me especial grace with God
So that the foe does not mock me.

This verse prayer is also accompanied by a Latin poem on a broadsheet with a woodcut of St Paul attributed to Hans Baldung, and seems likely to be an imitation of the format of 63.31. Again the German verses are relatively simple in style.

NOTE

The 'special choice' of St Paul as an apostle refers to the fact that he was originally a Pharisee and persecutor of Christians, until struck down by God's thunderbolt on the road to Damascus. At first rejected by the disciples, Paul insisted that his missionary vocation, chronicled in the Acts of the Apostles and the Epistles, was given him directly by Christ and not bestowed by the other apostles.

## 63.33  Prayer to St Laurence

To Saint Laurence
Hear a great wonder that God can work:
When St Laurence lay roasting on his
Griddle, heavenly dew refreshed him.
The Virgin's Son thus helped him.
Then let us all now invoke him,
So that his help be proved in us.

Likewise accompanied by a Latin poem on a broadsheet with a woodcut of the Martyrdom of St Laurence.

NOTE

Laurence (died 258) was a deacon of Pope Sixtus II, who entrusted him with the treasures of the Church. He gave these to the poor, whom he saw as the Church's true treasures. He was martyred together with the pope. The legend that he was killed by being roasted on a gridiron may derive from an early scribe's error: *assus est* ('he was roasted'), for *passus est* ('he suffered death'). He was the patron saint of the second of Nuremberg's great parish churches.

## 64  Works of Art

### 64.1  *Minerva and the Muses*

See Rupprich, 207. 'In the collection of Captain Hans Albrecht von Derschau there was in 1822 a painting on a wood panel, which [Joseph] Heller [1831] describes as follows: 'Minerva and the Muses; these are in the middle of the picture and are dancing to the lyre of a strangely garbed Apollo. In the right-hand middle ground we see King Tmolus, Midas, and three warriors. The first is talking with a satyr blowing a shawm, who bears the Pirckheimer coat-of-arms on his back. Among a number of figures and beasts can be seen in the left-hand foreground a naked boy embracing a dog.' On the reverse side of the painting were written the lines:

> I shall keep on making verses,
> Must keep you pen-pusher laughing,
> And the long-haired bearded painter
> With this picture will pay you back.

The lost painting appears to have been a gift to Lazarus Spengler, to whom the lines (mis)quoted here were addressed at the end of AD's riposte (63.6) to his satirical characterisation of the painter. Although the whole verse controversy is unlikely ever to have been meant very seriously, the picture was perhaps intended as a peace-offering. See 64.2.

### 64.2  *Satirical Drawing Addressed to Lazarus Spengler.* **Pen sketch. W 623, S D 1511/20**

Above the drawing:

Nothing but missives. They are being forged, printed and baked. In the year 1511. AD.

Beneath the drawing:

Dear Lazarus Spengler, Here I'm sending you the flatbread. Have been much too busy and couldn't bake it sooner. So do really enjoy it now.

Under the title 'Nothing but Missives', the drawing shows a three-stage production process in which missives – legal documents – are being forged in a smith's furnace, or printed on a press, or taken out of a bread oven on a baker's shovel. Smithy, printing shop and bakery are all littered with sheets of paper. The 'flatbread' seems to be both (in the actual drawing) the missives which have been hammered, pressed and baked flat, then it seems also to be the drawing as such which AD is sending to Spengler. It is in a spontaneous, not highly finished style, thus metaphorically not a well-formed loaf but a shapeless flatbread. This half-baked concoction has puzzled generations of scholars, including Rupprich, although he did at least establish a convincing reading of AD's near indecipherable script. Behind it lies a shared joke which we can scarcely expect to resolve definitively. A key, however, is the word *missÿff*, which also occurs in 63.6 as *missif*. AD characterises Spengler as 'a clerk in Nuremberg, / Much valued by our overlords, / For writing missives with such skill' (63.1.6), and lumps him by implication together with a notary who cannot put together a simple affidavit. An explanation of the drawing might be that with it AD ironically apologises to Spengler, for his disparagement of the lawyer and his profession, by depicting the mock heroic industry which manufactures missives in limitless quantity. Spengler is shown to be nothing less than versatile, skilled not just in one profession but in three – albeit lower-grade – trades. Any cooling of their friendship was certainly temporary.

See also the relief by Hans Daucher (1522) formerly held to depict AD and Spengler as knights fighting a duel (174). The figure of Spengler there has been seen as resembling both the baker on AD's pasquinade and the kneeling figure on the drawing *The Three Fates with a Supplicant* (102.1). See Strauss 3, 1290, and text 126.2 on AD's lost portrait of Spengler.

[Price 2003, 112]

## 64.3 *Matthäus Landauer*. Portrait drawing in charcoal. Dated in AD's hand 1511. W 511, S D 1511/17

Inscription beneath:

Landauer donor

Winkler declares it 'one of the most splendid of Dürer's freehand portrait sketches from nature'. Matthäus Landauer (BI) is shown in profile, white-haired and white-bearded, gazing heavenwards with a rapt expression. If AD did it as a preliminary study for the altar which Landauer commissioned from him, then it is the only such drawing that survives except for the study of the whole work, including its frame (64.4), though the fine woodcut of the Trinity or The Throne of Grace (dated 1511: S W 164, SMS 231) is certainly related to the altar panel.

**64.4** *Design for the Landauer Altar*. **Pen with watercolour washes. Dated 1508. W 445, S D 1508/23**

Inscription on the predella of the frame:

Anno dom[ini] 1508

Below, AD monogram, but not in AD's hand.

AD's earliest complete design for a major work. The altar painting and frame were not carried out until 1510/11, and in 1508 AD was still at work on the Heller Altar, so it may be presumed that this was done in response to a request by Matthäus Landauer for an advance design before the commission was confirmed. AD may have done a similar design for Jakob Heller, though his sketch of a frame for that altar was sent after its completion and not used. The final versions of the Landauer painting and its frame were somewhat elaborated, but the essential intentions of this design were adhered to.

**64.5** *Adoration of the Trinity* **(Landauer Altar). Oils on poplar-wood panel. A 118**

Signed and dated inscription on a tablet held by the figure of AD:

ALBERTUS · DVRER · NORICVS · FACIEBAT · ANNO · A · VIRGINIS · PARTV · 1511

(Albrecht Dürer was creating this in the year since the Virgin gave birth 1511)

The frame which AD designed has the inscription on its predella:

Mathes · Landauer · hat · entlich · vollbracht · das · gotteshaus · der · szwelf · bruder · samt · Stiftung · und · dieser · thafell · nach · christi · geburd · m · ccccc · x · i · jor

(Matthäus Landauer finally completed the Hospital of the Twelve Brethren together with its foundation and this tablet in the year since Christ's birth 1511)

On the form of the inscription on the painting, see 61.1 and McHam 2013, Plinian Signatures. The altar was commissioned for the chapel of All Saints in the Twelve Brethren House, a hospice for a brotherhood of twelve aged men (the number is derived from Christ's twelve disciples), built and endowed as an act of piety and penance by Matthäus Landauer. He himself was to be one of the twelve. The chapel was an exquisite late Gothic hall with a star vault, bombed in the Second World War, but since rebuilt. AD also designed stained glass windows for the chapel, carried out by the workshop of Veit Hirschvogel. These were destroyed by wartime bombing in Berlin. The altar painting remained in situ after the Reformation. In 1584–5 Emperor

Rudolf II asked to buy it but permission was withheld until all surviving descendants of the Nuremberg citizens whose faces provided models for the painting had given their consent. Rudolf finally bought it for 700 gulden, but without the frame which has remained in the city (now in the GNM). A replica frame was made for the altar panel which went to Prague, to join the *Feast of the Rose Garlands*, then to Vienna (now in the Kunsthistorisches Museum). The frame, which is more strictly classical in its first depiction on the 1508 drawing, may have been influenced by ones seen by AD in Venice and Northern Italy.

In the tympanum of the frame is Christ of the Last Judgement, on its architrave the division of the saved and the damned. The altar painting is dominated by the representation of the Trinity: the dove of the Holy Spirit hovers over the Father who holds the cross of the crucified Son. Around the crucifix, in the middle range of heavenly space, is Mary with female saints, and John the Baptist leading patriarchs, prophets and sibyls. In the lower level of the heavenly sphere are popes and clergy, while Emperor Charlemagne leads a knight in golden armour and other laity, who include contemporary Nuremberg citizens and brethren of the hospice. Landauer as donor kneels between a friar and a cardinal. In an idyllic miniature landscape at the foot of the panel is the tiny likeness of AD, as bystander and eyewitness of the great vision.

[Anzelewsky 1991, 230–33; Strieder 1992; Kutschbach 1995, 119–25; Grebe 2006, 86–9; Wolf 2010, 261–3; Bonnet/Kopp-Schmidt 2010, 112]

### 64.6  *Jörg von Eblingen*. Pen sketch. W 588, S D 1511/14

Inscription above the portrait:

Sir Jörg von Eblingen

The profile portrait sketch has been added to the original content of the leaf, Christ on the Cross, which is a preliminary drawing for the Crucifixion engraving on the *Engraved Passion*, to which the AD monogram and date 1511 refer. Jörg von Eblingen has not been identified.

### 64.7  *Design for the Emperor Portraits of the Regalia Chamber*. Ink drawing touched with watercolour, W 503, S D 1510/5. London: Courtauld Gallery

Portraits of the emperors Charlemagne and Sigismund on two framed wood panels hinged together as a diptych, intended for the Regalia Chamber in Nuremberg where the imperial coronation artefacts and holy relics were kept during the annual festival in their honour. They are sketch designs for the separate twin panels AD painted in 1511–12 (64.11), but much less heavily formal and ornate than these. Above the head

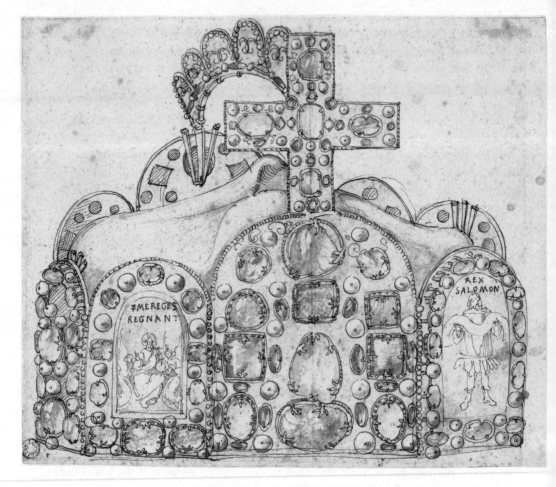

34. Albrecht Dürer, *Imperial Crown*, pen and watercolour, 1511. Nuremberg: GNM Hz 2574

of Charlemagne hang shields with the double-headed eagle of the German Empire and the fleur-de-lis of France. Above Sigismund's head the imperial shield in the centre has to either side two empty shields with, in AD's hand, the instructions 'Hungary' and 'Bohemia'. Below, to each side of his head, two further shields. One has Dürer's instruction *daltz*, scored out, with 'Dalmatia' substituted; the other has Dürer's *crabatz*, this too scored through, in favour of 'Croatia'. See DWb V, 1908f.: in the sixteenth century *krabat/krabaten* are normal, written German forms, from the Slav name *hrvat*. Although it is not to be found in DWb II, AD's *daltz* may have a similar explanation. Such forms gradually give way in German, as here already, to the more elevated usage of Latin-based *Dalmatien* and *Croatien*.

**64.8** *State Robes of Charlemagne.* **Pen drawing with lightly applied watercolour. W 504, S D 1510/6**

Inscription:

These are the robes of the Holy Emperor Charles the Great

Date 1510 and AD's monogram.

Portrait of the emperor (portrayed as very plump and without the white beard – as if someone is modelling the regalia), arrayed in meticulously coloured coronation garb – dalmatic, stole and mantle – bearing the imperial sword and orb, and wearing the accurately depicted imperial crown. AD's use of the Latin word *habitus* for 'robes' suggests the help of a learned guide to the regalia. Together with drawings of the sword (64.9), orb, crown (64.10) and gauntlet (now lost), the study belongs to the detailed preparatory stage of work on the final panels (64.11).

[Ex. Cat. Vienna 2003, 435f.; Grebe 2013, 54f.]

**64.9** *Imperial Sword.* **Pen with yellow watercolour. W 505, S D 1510/8**

Inscription:

This is Emperor Charles's sword, this too very large, and the blade is just the same length as the cord with which this paper is tied together on the outside

The whole length of the blade is not shown, hence the attached cord. The jewelled and chased hilt, and the pommel with incised imperial arms, are shown in intricate detail.

**64.10** *Imperial Crown.* **Pen drawing with lightly applied watercolours. W 507, S D 1510/7** [fig. 34]

The tenth-century crown, made for the coronation of Otto I in Rome in 961, with its roughly cut or uncut gems and fine inlaid enamel plaques, is also depicted in close-up detail. The two plaques shown, Christ in Majesty and Solomon, have their correct inscriptions:

Per me reges regnant

(Through me kings reign)

and

Rex Salomon

(King Solomon)

### 64.11  *The Emperors Charlemagne and Sigismund.* Tempera and oils on limewood panel. A 123/4

Inscription on the front side of the panel of Charlemagne:

> This is the figure of Emperor Charles ·
> His crown and manifold vestments ·
> Are publicly displayed in Nuremberg ·
> With other regalia, as is proper ·
> King Pepin's son of France ·
> And Roman Emperor likewise ·

Inscription on the reverse (portrait side) of the panel:

[flanking the portrait]

> Karolus magnus imp[er]avit Annis 14

(Charlemagne reigned as emperor for 14 years)

[around the frame]

> This is the form and likeness
> Of Emperor Charles, who made the Roman Empire
> Subservient to the Germans.
> His crown and highly esteemed vestments
> Are exhibited in Nuremberg every year
> Publicly with other holy relics.

Inscription on the front side of the panel of Sigismund:

> This portrait is Emperor Sigmund ·
> Who vouchsafed Nuremberg ·
> At all times special favour ·
> Many regalia and relics, shown each year ·
> He brought from Prague in Bohemia ·
> Most graciously as we all know ·

Inscription on the reverse (portrait side) of the panel:

> Sigismund imp[era]vit Annis 28

(Sigismund reigned as emperor for 28 years)

[around the frame]

> This picture shows Emperor Sigmund's figure,
> Who vouchsafed this city

Great favours manifold.
Many regalia and relics, displayed each year,
He brought here for public view
In the year MCCCC and 24.

Charlemagne is partnered on the panels by the Emperor Sigismund (reigned 1410–37), a figure of much less historical consequence except that it was he who transferred the *Heiltum*, the imperial regalia and holy relics, from Prague to Nuremberg in 1424 'for all time, irrevocably and indisputably', to protect them from the heretical Hussite rebels. The relics included most famously the Holy Lance, whose tip was said to have been forged from the nails used to crucify Christ. The imperial insignia and regalia themselves acquired the status of holy relics by their association with Charlemagne who was canonised by the German Church in 1169. An annual feast day for the exhibition and veneration of the *Heiltum* had been sanctioned by Pope Innocent VI in 1354. In Nuremberg the treasure was housed in the chapel of the Holy Spirit, but on the eve of the festival, which took place on the second Friday after Easter, it was moved to a special shrine, the *Heiltumskammer* in the Schopperhaus on the principal square. AD was commissioned to paint a diptych of panels portraying Charlemagne and Sigismund for the renovation of this shrine (see 87 and 233.2.4–5) and perhaps to head off a threat by Emperor Maximilian I to remove the *Heiltum* to a Hapsburg palace. The panels formed a partition on either side of the shrine. When they were closed, the viewer saw the inscriptions and coats of arms; when open, the emperor's portraits on either side of the displayed regalia and relics. Thus the panels were separated by roughly twice the width of each one of them.

AD may have had a contemporary image of Sigismund on which to model his portrait. For Charlemagne there were literary pen-portraits, like that in Einhard's *Vita Karoli Magni* (circa 817–30), and the iconographical tradition of the depiction of God the Father and the Son as heavenly kings, and thus models for Charlemagne as royal saint and the supreme example of earthly embodiment of divine majesty.

Attendance at the regalia feast day was rewarded with an indulgence by the Church. It became also a secular festival and a trade fair. Following the formal adoption of the Lutheran Reform in Nuremberg in 1525, the regalia display was abolished. The regalia went to Vienna. The portraits were moved to the town hall, where they remained in the early seventeenth century when many of AD's works left Nuremberg – Emperor Rudolf II thought them inferior work (see 233.2, note 1). From 1811 they were displayed in the castle, from 1840 in the chapel of the Twelve Brethren House. Since 1876 they have hung in the GNM.

[J. Schnelbögel 1962; Christensen 1965, 112–16; Smith 1983, 29f.; Ex. Cat. New York/Nuremberg 1986, 304–7; Machilek 1986; Anzelewsky 1991, 235–40; Schier/Schleif 2004, 401–21; Price 2003, 102–7; Grebe 2006, 100–103, 2013, 39f.; Wolf 2010, 167 & 263; Smith 2012, 263–5]

## 65 Notes for the Composition of an Altar Panel of Christ in the Winepress

In AD's hand:

> Christ shall stand in the winepress.
> Mary shall stand on the right-hand side.
> The angel on the left.
> The canon kneels before Mary.
> Peter below.

Beneath, in a different handwriting:

> The Lord hath trodden the virgin, the daughter of Judah, as in a winepress.
> [Lamentations of Jeremiah 1:15]
> Thou hast redeemed me, Lord, in thy blood, have mercy upon me.
> [see Revelation 5:9]

Beneath, sketch for the coat of arms of Dean Matthias von Gulpen, died 1475:

> A star over two axes on a red field

BL 5229, fol. 52$^r$
  R I, 216

COMMENTARY

The text plots the layout of an altar painting for which AD drew the sketch W 184, S D 1508/28, of Christ in the Winepress. It depicts Christ, naked except for a loincloth, as for crucifixion, his arms on the beam of a winepress, as if on the arm of the Cross. The grieving Mary stands on his right, with the sword(s) of Simeon in her breast (see Luke 2:22–32 and AD's poem 63.12, note 3), on the left are angels and above them a figure who is presumably God the Father, lowering the beam which would crush Christ like the grapes in the press. The dove of the Holy Spirit hovers above. Below the press, a pope wearing the papal tiara – clearly the first bishop of Rome, Peter – collects Christ's blood in a eucharistic chalice. To his right, a clerical figure kneels at Mary's feet with a blank armorial shield at his feet – presumably Matthias von Gulpen.

From the fourteenth century the winepress became an iconographical symbol of Christ's sacrifice and, by the late fifteenth century, of Christ's blood shed on the Cross and transmuted into the wine of the Eucharist. This tradition draws on imagery of winemaking in the Bible, where it prefigures Christ's redemptive sacrifice.

Sketch and descriptive notes both relate to the altar painting of *Christ in the Winepress*, made for the church of St Gumbertus in Ansbach, west of Nuremberg. However, the

altar panel is neither AD's work nor that of his workshop, so that AD's role was evidently confined to providing a model for an unknown painter. Neither the sketch nor the notes bears a date, but Anzelewsky proposes a dating of the altar panel of circa 1510.

[Winkler 1936, I, 126f.; Anzelewsky 1971, 81; Murray 1996, 568]

# 1511

## 66 Letter of Christoph Scheurl to Willibald Pirckheimer

*[Wittenberg, 25 March 1511]*
I wish to greet and commend myself to our mutual friends Hieronymus Gruner, Jakob Muffel, Hieronymus Holzschuher and Albrecht Dürer, who have all been most obliging to me.

CSB (Potsdam 1867), letter 51. Latin text
   R III, 455

NOTE

On Muffel and Holzschuher, see BI.

## 67 Resolution of the City Council on the Inspection of the Schöner Brunnen

*Quarta post Cantate*[1] *[21 May] 1511:*
The following two gentlemen, together with Master Peter Vischer,[2] Dürer and others expert in the matter, are authorised to inspect the dilapidated state of the Schöner Brunnen: H. Volckamer, Nikolaus Haller.[3]

Hampe, Ratsverlässe, 1511, I, 20b
   R I, 240

NOTES

  1  Fourth Sunday after Easter, named after the first word of Psalm 98, the introit of the mass liturgy for the day.
  2  For the sculptor Peter Vischer, see 39 and BI.
  3  Volckamer and Haller were members of the ruling council.

COMMENTARY

The Schöner Brunnen in the north-western corner of the principal square of Nuremberg dates from 1352–8. The fountain earned the name 'beautiful' because of its many gilded and painted stone statues and its high traceried canopy. Its polychromy had to be renewed on countless occasions. The original stone was insufficiently durable, so that major repairs were needed in 1540–41, while in 1821 it was dismantled and rebuilt with much new stone. In 1897 an entirely new facsimile was constructed and the remaining fragments of medieval work were retired to the GNM. There is no record of what repairs were carried out as the result of the inspection in 1511. See also 69. On other evidence of AD's architectural interests, see 32, 119 and 249.

[Strauss 1976, 274; Ex. Cat. New York/Nuremberg 1986, 132–5; Campbell 2004, 266]

## 68   Letter of David de Marchello to Willibald Pirckheimer

*[Innsbruck, 26 May 1511]*
Having arrived in Milan, I remembered Maestro Albrecht's little brother and some other matters for you.

PBr 2, 76–9, Letter 190. Italian text
  R I, 256

NOTE

It is impossible to say which of AD's two younger brothers Marchello (see BI) means or what matter he has in mind, although the diminutive *fratello* suggests Hans, who was twenty-one in 1511.

## 69   Nuremberg Civic Accounts

*[Period 19–21 July 1511]*
60 fl. Albrecht Dürer for 2 pictures.

Nuremberg city accounting record for the year 1511, state archive, Nuremberg
  R I, 247

NOTE

The payment has been taken to be an advance, perhaps for materials and expenses, on AD's commission to paint the two panels of emperors for the *Heiltum* shrine in the Schopperhaus. However, Grebe 2006, 100, argues that the payment was for the cost of refurbishing two of the figures on the Schöner Brunnen (*pild* could in Dürer's usage refer to 'statue' as well as 'picture'). See 64.7–11, 67 and 87.

## 70   Letter of Bishop Johann Thurzo V to Wolfgang Hoffmann

*[Neiße, 30 July 1511]*
To the honourable and notable Wolfgang Hoffmann[1] in Nuremberg, our especial good friend.[2]
Our greeting and best wishes! Honourable, esteemed and especial good friend, A couple of years ago, Albrecht Dürer of Nuremberg painted a panel of the Virgin Mary and sent it to us, and now he is reminding us of the payment for it. And since we do not actually know how much he expects for it,[3] we ask you kindly and earnestly to settle with him on our behalf and to pay him, with our thanks, whatever it comes to, then to claim from us the sum you have given him for it on our behalf. We will settle up here with Augustin Eber and Wilhelm Artzt[4] and reimburse them, and will repay and show our gratitude to you.
Dated Neiße, on the Wednesday after St James.
Anno 1511

<div align="right">

Johannes by the grace of God
Bishop of Breslau[5]

</div>

Christian August Vulpius the Second, *Curiositäten* (1812)
R I, 256

NOTES

1   Wolfgang Hoffmann (died 1522) was factor in Nuremberg for the Fugger family to whom Thurzo was related. The bishop had already bought the panels of Adam and Eve (1507 – see 40) from AD for 120 gulden, according to Jan Dubravius (107)

2   *genner:* modern German *Gönner,* 'patron', but in its older sense of 'friend', though with the implication of one who is a useful, helpful acquaintance, rather than carrying any suggestion of affection for a social equal.

3   See AD's letters to Jakob Heller (47.3, note 6 and 47.4, note 9). AD tells Heller on 4 November 1508 that Bishop Thurzo had already given him 72 gulden for the Madonna, but this appears to be a tactical untruth to make Heller feel that the price he is paying for his altar panel is insufficient by comparison.

4   The two have not been identified.

5   *Episcopus Vratl.:* Breslau (Latin Vratislava; since 1945, Polish Wrocław) in Silesia was founded in the eleventh century as part of the German colonisation of Slav lands in Eastern Europe.

## 71   Letter of Lorenz Beheim to Willibald Pirckheimer

*[Bamberg, 16 October 1511]*
A thousand greetings to Lady Kramer and a hundred to Albrecht.

PBr 2, 113–19, Letter 198. Latin text
R I, 256

NOTE

*Domina Kramerin:* Ursula Kramer, Pirckheimer's 'housekeeper' (49.2, note 1).

## 72   Warning to Copiers and Pirate Printers

Beware, you highway robber and thief of other men's labour and invention, take heed that you do not lay rash hands on these our works! For be it known that the Most Glorious Emperor of the Romans, Maximilian, has granted us a privilege, lest anyone dare print these images from forged blocks, or sell such prints within the borders of the Empire. For if in contempt of this or out of greed for money you make yourself culpable in such way, you may reckon with confiscation of your goods and should realise that you have put yourself in the gravest peril.

The warning appears in the colophon of all four editions of AD's woodcut books printed or reprinted by him in 1511: the *Apocalypse,* the *Life of Mary,* the *Small Passion* and the *Great Passion.* Latin text
R I, 76

COMMENTARY

The year 1511 saw the peak of AD's production of books containing his religious print series. The relative ease with which woodcuts and engravings could be copied and published in pirated editions had long been a concern to him. It was the negative aspect of his eager use of printing technology from the 1490s onwards. While woodblock and copperplate images, reproduced in large number by the printing press and sold at prices affordable to a wholly new public, were an unparalleled artistic and commercial opportunity for an artist who – in a way characteristic of a son of Nuremberg – combined aesthetic ambition with entrepreneurial acuity, he was forced at the same time to protect himself against the lack in this age of any effective copyright law. After his death Agnes Dürer continued in 1528 and 1532 to look to the imperial authority and to the Nuremberg city council for further privilege and protection of AD's 'labour and invention' – his 'intellectual property' in modern terminology (278–80, 297, 301).

[Christensen 1965, 57–9; Witcombe 2004, 83f.; Vogt 2008, 85f.]

# 73  Writings on the Theory of Art

## 73.1  Antique and Christian Art

Pliny writes that painters and sculptors of Antiquity, such as Apelles, Protogenes and the rest, wrote most learnedly on how the well-proportioned limbs of human bodies should be made.

Now it is quite possible that in Early Christian times such noble books were suppressed and eradicated out of hatred of idolatry. For they said that Jupiter should have such a proportion, Apollo another, Venus should be like this, Hercules like that, and so forth with all the other deities. If by chance I had been alive and present at that time, I would have said, 'O dear holy men and fathers, do not for this false reason so miserably destroy the noble, ingenious learning which has been assembled by great effort and labour. For art is great, difficult and good, and we can and will direct it with high honour towards the praise of God.'

In the same way that they applied the ideal form of a man to the proportioning of their idol Apollo, so we will use the same measure for Christ our Lord who is the most beautiful in all the world. And just as they took Venus as the most beautiful woman, so we will portray the same fair form chastely[1] as the purest Virgin Mary, mother of God. And out of Hercules we will fashion Samson, and we shall do likewise with all the rest.

Such books, however, we have no longer, and so, just as something lost cannot be recovered, therefore we must search for a replacement. That has been my

motivation in setting forth the following conceptions, in order that people will read it and consider it further, and that through daily use they may come upon a more direct and better method and basis. My starting points will be measure, number and weight.[2] Whoever has regard to it will find it in what follows.

BL 5230, fol. 18ʳ

  R II, 103–5

## NOTES

1  *krewschlich*: Rupprich II, 104, note 6, identifies this puzzling form as a North Franconian dialect word meaning 'delicate, pretty'. However, the context seems to require us to take it as a misspelling of *keuschlich*, 'chaste', contrasting the physical and spiritual purity of the Virgin Mary with the erotic beauty of Venus.

2  *mas, tzall vnd gewicht*: AD quotes the Wisdom of Solomon 11:21: *omnia in mensura, et numero et pondere disposuisti* – 'Thou hast ordered all things in measure, number and weight.'

## COMMENTARY

On the basis of the handwriting, Rupprich dates the text as '1512/13 at the earliest'. However, Lange-Fuhse and Panofsky regard it as belonging to the initial phase of AD's theoretical writings. Certainly, it overlaps in essential respects with 51.4, probably the earliest draft of the introduction to the manual on painting, and with drawings from the first decade of the sixteenth century. At the same time it anticipates later versions of the introduction to the manual for painters and the treatise on human proportion.

It is not clear how AD was able to state firmly that the lost antique treatises on art gave different proportions for ideal images of gods, goddesses and heroes, unless he assumed that these followed from their embodiment of the different temperaments. Panofsky speculated that AD had himself measured antique sculptures in Italy and found that they did not consistently conform to the Vitruvian canon. By 1502/3, AD's drawings and graphics reveal him, even before his return to Venice, constructing explicitly classical images of deities, such as the engraving *Apollo and Diana* (S E 38, SMS 38) and the drawing *Venus riding a Dolphin* (W 330, S D 1503/1). Venus is depicted as early as 1496/7 in *Pupilla Augusta* (5.6) and *The Dream of the Doctor* (9.4).

The translation of the classical canon of ideal beauty into AD's Christian anthropology and iconography is a central strand of his drawings between 1500 and 1510. *Apollo* is the title of the male nude W 261 S D 1501/7; variants of it are the so-called *Apollo Poynter* (W 264, S D XW.264) and the *Aesculapius* (W 262, S D 1501/8). Equivalent female nude figures are W 265, S D 1500/33, the engraving *Fortuna* (S E 7, SMS 5, text 5.7), and the drawing *Nemesis* (W 266, S D 1502/25), a preparatory study for the engraving *Nemesis* (14.3). Constructional drawings which document the evolution of

AD's classical ideal figures are preserved from the years immediately after 1500 (W 411–20, S D 1500/25–37). By 1504 they emerge into explicitly Christian form with the dated study (W 333, S D 1504/17) and engraving (26.1) of *Adam and Eve*. In 1506 AD drew a sequence of further related drawings of Adam and Eve which refine their construction, incorporating advances in technique he achieved in Venice (W 421–8, S D 1504/11–12 & 1506/50–55).

The Christian theological acceptance of aesthetic beauty as an aspect of the perfected humanity of Christ claimed biblical warrant, in particular Psalm 45:3 (Vulgate 44), *Speciosus forma prae filiis hominum*: 'thou art more beautiful than the sons of men'. At the end of the Middle Ages, the so-called *Letter of Lentulus* (see 11.1, Commentary) gave a strong impetus to the idea of the beautiful Christ as an aspect of personal and public devotional imagery. The Letter was in fact a meditative aid to help the devout to visualise the Passion, but it was understood as an authentic description of the physical appearance of Christ by Publius Lentulus, said to have been Pontius Pilate's successor as governor of Judea and an eyewitness of the events leading up to the Crucifixion. Willibald Pirckheimer possessed a manuscript of the Letter, inherited from his father. Its influence is apparent in several strands of AD's assimilation of contemporary versions of the pious iconography of Christ, whether in explicit religious subjects like Adam and Eve – as portrayals of the unblemished image of God in his original creation – and the Christ of the Passion woodcuts, or in his own self-portrayals, most notably the self-portrait of 1500 (11.1), with its iconographical and textual synergy of Apelles and Christ.

The boldness of AD's argument here, synthesising the aesthetics of Antiquity and Christianity, contrasts with the fifteenth-century polarity of the inscription, possibly composed by the humanist Lorenzo Valla, on the tomb of Fra Angelico (circa 1455): 'Let it not be said in my praise that I was another Apelles / But, O Christ, that I gave my reward to all thy people' (Warnke 1993, 41; Ames-Lewis 2000, 93–5).

[Rupprich I, 104; Panofsky 1948, 84–7; Koerner 1993, 103–26; Ex. Cat. Vienna 2003, 252–61; Price 2003, 68–74]

### 73.2 Measurement of the Human Form

Therefore I have thought further about it and realise that human figures must be measured with the greatest possible precision. Then from a whole host of them a select number of attractive features can be put together into one. For by means of measurement, if this is correctly used, any one feature can be turned into art.

Such measurement I shall now incorporate into my plan and show how a human figure may be measured according to its external shape, from which painters, sculptors, and those who cast metal or make them out of wood, stone

or other hard materials, can adapt it to their use, as a further introduction and instruction.

All the lengths or heights of parts of the body or other indications of the nature of anything, these I shall show by means of horizontal lines.

BL 5229, fol. 51ʳ. On the same side of the leaf as the draft inscription for a self-portrait, 11.2. The inscription is likely to date from circa 1500, but the content of this short text points to a date between AD's return from Venice and his detailed planning of the handbook on painting, 1509–12.

R II, 105

COMMENTARY

The recognition that beauty will rarely inhere in a single form, and that the artist or craftsman should look to combine features observed in a range of carefully observed and measured figures, is a significant step in AD's assimilation of classical and Renaissance concepts of beauty. It relates closely to 51.4 ('On Beauty') of 1508–9, and it points forward to 83 of circa 1513 and to the decision to move from the writing of a general treatise on painting to the discrete project of a textbook on human proportion.

# Part 6

## 1512–1515

The irregular patterns of artistic activity and production observed in earlier phases of AD's life also mark the next four years. Not a single oil painting is preserved or documented between 1512 and 1515. On the other hand, there is evidence of keen interest and major achievement in the graphic genres. A group of AD's most celebrated copperplate engravings date from the years 1513–14: *Knight, Death and Devil* (90.5), *Melencolia* (93.4) and *St Jerome in his Study*. These have been interpreted as a linked thematic sequence, whether representing three of the four temperaments or humours, or depicting contrasting aspects of Christian ethical and intellectual praxis – the *vita activa* of the Christian knight [fig. 35], the *vita contemplativa* of the biblical humanist and the Renaissance scientist – or, more simply, demonstrating in three very different variants the aesthetic medium of engraving at its highest level of artistic and technical virtuosity. Among other fine engravings of explicitly religious subjects, AD completed in 1512 the *Engraved Passion*, begun in 1507–8. He also experimented in these years with newly available innovations in graphic technology, drypoint and etching. Drypoint involves inscribing an iron plate with a needle instead of the copperplate engraver's burin. The finer point and softer plate allow sketch-like effects and the velvety *sfumato* achieved in *St Jerome by the Pollard Willow* (1512). Etching – which he may perhaps have come across when much younger as a goldsmith's technique – involves coating an iron metal plate with a protective layer, drawing in this with a needle, then covering the plate with acid which eats into the metal where the needle has exposed it. The effect approaches the spontaneity and *chiaroscuro* of pen-drawing.

AD's artistic and entrepreneurial energies are now focused to a significant extent on the prestige projects of Emperor Maximilian I. Perhaps planned with the emperor himself in Nuremberg in February 1512, then elaborated with Johannes Stabius and Maximilian's other cultural and ideological advisors (97), the *Triumphal Arch* was a triumph also of organisation. AD did relatively few of the 195 component woodcuts

himself, but helped co-ordinate their planning and execution. The large bulk was the work of his assistants Hans Springinsklee and Wolf Traut, while Hieronymus Andreae cut the blocks. By 1515 the overall conception was fixed. AD was one of a number of distinguished contributors of marginal illuminations – in a playfully fantastic, markedly secular Renaissance style – to the presentation copy of the *Prayer Book of Emperor Maximilian* (98), printed in innovative typography on parchment. Entirely his work is the manuscript book of pen and watercolour drawings of wrestling and fencing moves and poses, done for the emperor in 1512. By 1515 AD had begun designs for a suit of chased silver armour for Maximilian. These extravagant artefacts, conceived as prestigious representations of his neo-medieval/Renaissance political ideology, were way beyond Maximilian's pocket. The city of Nuremberg, at least as AD saw it, also took his contribution to its cultural reputation too much for granted, and was loath to offer him adequately remunerated commissions. Running through the imperial projects in these years there is a thread of financial intrigue, which in September 1515 led to the award of an annual emolument to recompense AD for his services to the emperor. In a suitably contrived compromise, this was to be paid by the city out of money which otherwise would have been due to the imperial treasury (79, 97.2, 99). The writings of Johannes Cochlaeus (81) and Christoph Scheurl (101) document the high esteem in which the city's intellectuals continued to hold the painter.

Especially in the peak years of 1513–14, much of AD's time and mental energy was given to the elaboration of his plans for a comprehensive manual of painting. Its aims and principles were defined and redefined in interrelated sequences of drafts of preparatory material (82–5). Enough of the material is dated by AD to allow us to place these attempts to focus and articulate his ideas in the quite short space of a couple of years. Towards the end of this phase, and prompted in part at least by the very difficulty these multiple drafts betray in finding a definitively formulated rationale, AD resolved to abandon, or postpone, his grand synthesis, and to work more narrowly and purposefully on what became around 1523 – though printed only in 1528 – the *Four Books of Human Proportion*. His sense of the priority of proportion and the scientifically correct depiction of the human form had been apparent in the writings prompted initially by Vitruvius from soon after 1500. Now what he plans is an ultimately detailed technical treatise. At the same time as he begins to produce measured bodies in a scheme and format which anticipate very closely what will emerge into print-ready form by 1523, he also writes the first drafts of the 'Discourse on Aesthetics', intended already by 1515 for its eventual place at the end of the third of the *Four Books* (103). This was to become his most searching exposition of the theory and philosophy of art in their – to him essential – relationship with the artist's craft and practice.

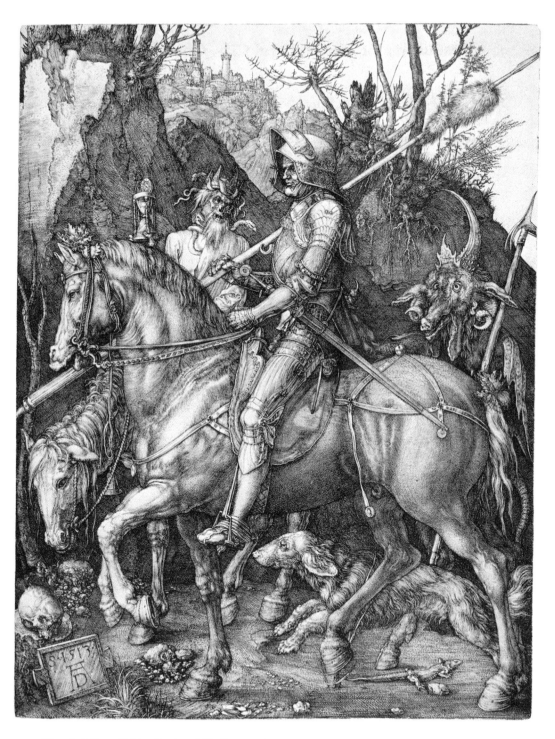

35. Albrecht Dürer, *Knight, Death and Devil*, engraving, 1513

## 1512

### 74  Resolution of Nuremberg City Council

*Sabbath after the Circumcision of Christ [3 January] 1512*
The stranger who is selling prints below the Town Hall, and among them a number that bear Albrecht Dürer's monogram, which has been fraudulently copied, shall be obliged to remove the same sign from all of them and to cease selling them here, else, should he defy this, all these sheets shall be confiscated as forgeries and handed over to the Council.

Register of Resolutions: Albrecht Dürer's prints counterfeited. 1511, X, 2b
  R I, 241

COMMENTARY

While the privilege issued to AD by Emperor Maximilian I in 1511 (72) applied to the books of prints published in that year, it may have impelled the Nuremberg authorities to regard and enforce his monogram more generally as a copyright trademark.

[Würtenberger 1970, 232f.; Vogt 2008, 87]

### 75  Letter of Lorenz Beheim to Willibald Pirckheimer

*[Bamberg, 20 March 1512]*
Greet Frau Kramer, Dürer, the Prior of St Augustine, and Frau Porst.

PBr 2, 139f., Letter 205. Latin text
  R III, 455

NOTE

For Ursula Kramer and Anna Porst, see 29.2, 49.2. The prior of the Nuremberg Augustinians in 1510–13 was Johann Rücker.

### 76  Anton Tucher, Household Book

Item: on 26 March to Hieronymus Hölzel, to binding of one Large Passion and 3 Small Passions by Dürer: 1 fl.

Ed. W. Loose (Stuttgart 1877), 91
  R I, 294

NOTE

See also 100. On Tucher, see BI and 52 note 1. Books of all kinds were mostly bought unbound in early modern times.

## 77   Letter of Lorenz Beheim to Willibald Pirckheimer

*[Bamberg, 10 April 1512]*
Give my regards to Albrecht, whenever he crosses your path.

PBr 2, 142–8, Letter 206. Latin text
   R I, 256

## 78   Jakob Baner Sells Albrecht Dürer his Garden at the Menagerie Gate by the Seven Crosses

*[Nuremberg 29 May/3 June 1512]*
I Hans von Obernitz, Knight, Provost, and we the Magistrates of the City of Nuremberg affirm publicly with this document that on Saturday after Exaudi Sunday,[1] the twenty-ninth day of the month of May just past, in the presence of the honourable Conrad and Peter Imhoff,[2] being witnesses specially summoned and requested by him, Jakob Baner[3] has affirmed and made known that, in a proper, permanent and perpetual, definitive and irrevocable bargain, he has sold and given in sale, and hereby sold and gave in sale to Albrecht Dürer, citizen of Nuremberg, the heritable proprietorship which he has in the garden outside the Menageric Gate, on the Bamberg road by the Seven Crosses,[4] now situated between Lienhart Gerung's and Walther's gardens, with all it encompasses, all its rights and all that belongs to it as part or appendage, for the said Dürer henceforward to have, use, enjoy and cultivate in perpetuity. And further namely with the right to use the well which serves both gardens, Walther's and Dürer's, such that both together make use of it and maintain the structure whenever necessary at joint cost and expense along with the access rights through Konrad Rot's courtyard,[5] according to the letter and spirit of previous documents on this matter. And further that the said Albrecht Dürer by virtue of his single sole possession may do or not do as and whatever he will with his heritable possession of this same garden, unhindered by Baner, his heirs, and in whatever way, henceforward and perpetually. Baner promised further to grant him the possession of said garden with its rights as stated without further charge, payment or penalty, and to expedite and defend it against any man's objection or counter-claim, as accords with property right and rent and with the civic law of Nuremberg, since

he has paid and delivered to his satisfaction a sum, namely ninety Rhenish gulden, for which he and his heirs declared him and his heirs free and quit of all obligation. And this sale and purchase happened with the knowledge, will and approval of Michael Paumgartner who holds the superiority over the oft-mentioned garden, as his cousin Kaspar Paumgartner has confirmed, however with the condition that Albrecht Dürer and his heirs shall pay to the said Michael Paumgartner and his heirs[6] an annual duty of three old pounds, reckoned at thirty pence in the pound, and three pence as perpetual duty and as tithe, half on St Walpurgis Day and half at Michaelmas, and two carnival hens,[7] according to the law regarding ground-burdens and following the legal practice of Nuremberg, perpetually. In testimony whereof this charter is given with the judgement of the court and sealed with the attached seal of the court at Nuremberg. Witnesses to it are the honourable Michael Beheim and Sebald Pfinzing.[8] Given on Saturday after Exaudi, in the year 1512 since the Birth of our Dear Lord Christ.

Original charter, with attached seal in the City Building Records
Nuremberg, City Archive, Libri litterarum II (27), fol. 148. The entry in the cartulary is dated 3 June 1512. Goldmann 1962, 5
R I, 231f.

NOTES

1  The sixth Sunday after Easter, named from the first word of the mass introit (Psalm 61 or 102).

2  Brothers, of the prominent patrician family.

3  Jakob Baner, merchant, was indicted in a forgery trial with the sculptor Veit Stoss, and he and his wife left Nuremberg for Cracow in 1512.

4  A group of penitential crosses required by law to be erected as a mark of penance by convicted murderers and perpetrators of manslaughter at a public place or the scene of their crime.

5  This cannot, as Rupprich assumes, be Bernhard Walther, since he had died in 1504 and AD had bought his house on the corner of the Zisselgasse, a few yards from the garden outside the Menagerie Gate. A charter of January 1513 clarifies the matter. Margaretha, widow of Hans Zoll, now wife of Hans Walther, grants the children of her first marriage the use of the garden, which she inherited from her father (see R. III, 451). Konrad (Cunz) Rot was a goldsmith.

6  The Paumgartner cousins were members of a patrician family, Kaspar being the master of the city's stone quarries and member of the ruling council in 1519.

7  *vasnachthennen*: Shrovetide hens were common payments in kind for dues which fell before the meatless Lenten fast.

8  Beheim and Pfinzing were both members of prominent families.

COMMENTARY

The possession of a garden in a densely built-up city like Nuremberg, especially one so close to the house and on an elevated site just outside the city wall, was a valuable, hence expensive, amenity. Agnes Dürer sold the garden in 1532 (310).

## 79  Emperor Maximilian I Requests the City of Nuremberg to Exempt Dürer from all Taxes and Dues

### 79.1  Letter of Maximilian I to the City Council

Maximilian by the Grace of God Roman Emperor Elect
Honourable, dear and loyal subjects! Since our and the Empire's loyal subject Albrecht Dürer has been most diligent in drawing up sketches and plans for our projects, and to our particular pleasure has shown himself willing to engage in further such schemes, considering moreover that the said Dürer, as we have often been informed, is famed in the art of painting beyond other masters, we have been moved therefore to favour him with our special patronage, and hence we earnestly request of you, that in honour of us you will set the said Dürer free from all common civic impositions, such as duties, taxes and such, in consideration of our grace and of his renowned art, for which he is rightly due some benefit from you, and we ask that you do not in any way reject what we require of you, since it is fitting that you do us that favour and help promote this art in your city. We have no doubt that we can rely upon you in this matter, in which you will be carrying out our intention and especial well-disposed desire to look graciously on you and your city in general. Given in our imperial city of Landau on the twelfth of December 1512 in the twenty-seventh year of our imperial reign.

<div align="right">At the Lord Emperor's special command.</div>

To the honourable, our and the Empire's loyal Burgomasters and Council of the City of Nuremberg.

The Lord Maximilian, Roman Emperor, desires here that Albrecht Dürer, the learned and skilled painter, live free of dues, taxes and levies.

The original has not survived. A double copy from the eighteenth century is preserved in the State Archive in Nuremberg: S. 1, L. 79, No. 15, Fasc. 1.

R, I, 77

## 79.2 Letter of Melchior Pfinzing to the Nuremberg Council

*[Weißenburg, 31 December 1512]*
His Imperial Majesty's communication, sent to you with reference to Dürer the painter, is a letter of recommendation, and you will know full well how to deal with it. I had to let it go out, since it is a recommendation and no more, but in view of his art and skill it might well be right to treat him favourably in preference to others.

R. I, 256

COMMENTARY

Maximilian I had been in Nuremberg from 3 to 15 February 1512. It is likely that on this occasion he sought AD's co-operation for literary and artistic projects he was planning, beginning with the Triumphal Arch (97). AD evidently showed him sketches for its design. In a letter of 30 November 1513 to an unidentified addressee (no longer traceable, see Rupprich I, 257) the city clerk, Lazarus Spengler reported that AD's painting of Charlemagne for the treasury of imperial regalia and relics (64.7–11) had met with Maximilian's approval: 'I expect that with Nützel's help Dürer will get some profit from it.' Melchior Pfinzing's gloss on the emperor's letter effectively sabotaged AD's chances of a comprehensive tax exemption. (For Pfinzing, see BI). His embarrassment is patent. He knew very well that Maximilian had grandiose schemes intended to promote his personal glory and his ideological project of an imperial monarchy in post-medieval, Renaissance style. He knew too that Maximilian did not have the resources to finance his ambitions (Whaley 2012, 67), but was looking to Nuremberg to subsidise AD's contribution. Lazarus Spengler, at once AD's close friend and the council's chief administrator, was also awkwardly placed. It must have been clear to him that the city council would not sacrifice tax income in order to bail out the emperor, but he points to the trusted public servant Kaspar Nützel as the man who may bring about a solution. A later letter (125) illustrates Nützel's close association with Spengler and AD. With Christoph Kress, the city's envoy to the imperial court, he was responsible for the compromise solution to the problem, reached in 1515 (97.2, 99). Yet the imperial subvention remained a continuing problem for AD himself (138, 165.1–2), and in 1524, when he asks the city council to set up an annuity for his old age (198), he reminds it again of this 'recommendation' of the emperor in 1512.

[Schmid 2003, 430–45]

# 80   Works of Art

### 80.1   *The Conjoined Twins of Ertingen.* **Pen drawing. W 645, S D 1512/8**

The twins are shown in front and rear view. Above, AD monogram and date 1512. Below, separated by a framing arabesque, the inscription:

> Note: in the year reckoned since the birth of Christ 1512 such a creature as drawn above was born in Bavaria, in the lord of Werdenberg's lands in a village called Erdingen near Rietlingen, on the twentieth day of July, and they were baptised, the one head called Elsbet, the other Margret

A copy of a crude woodcut with a longer description of the twins is preserved. AD is assumed to have based his drawing on it.

### 80.2   **Leaf with Military Equipment and an Armoured Knight on a Battle-Horse. Pen drawing. W 683, S D 1512/11**

On the left-hand edge a hooked rod for tearing down siege defences, next to it a swimming-belt with a tube for inflating it, beneath that the sketch of a mouthpiece for the device. On the right, a knight in armour galloping on an armoured horse, swinging a studded metal ball (*morgenstern*, 'morning-star') on a chain, below him a broken lance. Above the swimming-belt, the inscription in AD's hand:

> This is a belt with which one swims over a water-course. You tie it together under the armpits

Above the knight, the inscription in AD's hand reads:

> In the year of our Lord 1372, this is how one fought in Russia

The knight's face suggests that AD intended him to be Mongolian. The context of what seems likely to be a preparatory sketch for a larger scheme is unknown. The armour and weapon are of AD's own time. It is assumed that the drawing was connected with Maximilian's cultural projects in 1512.

### 80.3

On the reverse of the same leaf, swimming device for a horse, two mounted knights doing battle. Pen drawing, W 684, S D 1512/12. Next to the swimming device a plug and mouthpiece, above, in AD's hand, the inscription:

> This is a membrane for putting on a horse. If you inflate it, you can swim across a wide stretch of water with it

Here the knights' armour appears older, from around the early fifteenth century, so AD presumably copied it from a source. The inflatable swimming aid is unique. AD calls it *ein parmen*. Rupprich translate this as 'parchment', taking the word to be one of the many medieval German corruptions of *pergamente*. It is more likely to be the long vanished *barm*, something curved or swollen, thus 'bosom', 'womb', 'belly', 'bladder' (comparable semantically, though not etymologically, with Latin *sinus*). See DWb I, 1134.

### 80.4  Coat of Arms of Johannes Stabius. Woodcut. S W X–11/S W 170, SMS A15. Undated (1512/13?)

Inscriptions: at the base, either side of the bottom of the shield, IOANN STABIVS. In a rectangular frame enclosing the arms:

> FLAMMEVS ECCE VOLAT / CLYPEO IOVIS ARMIGER AVREO / EST AQVILA IN GALEA · / SVNT CRVX DIADEMA CORONA · / CAESARIS AVGVSTI / PIETAS HAEC MAXIMILIANI / MVNERE PERPETVO / STABIIS SACRA CONTVLIT ARMA

(Behold, on the golden shield there flies the fiery arms-bearer of Jove, that is the eagle who [also] surmounts the helmet [where] there is cross and royal crown. The generosity of Maximilian, Caesar Augustus, granted these sacred arms as an eternal gift to the family of Stabius)

The Latin hexameters are presumably Stabius's composition. On Stabius's service to Maximilian and his collaboration with AD on imperial commissions, see 97–9, 117 and BI. SMS regard this version of Stabius's arms as the work of one of AD's assistants, probably Hans Springinsklee. An authentic version, S W 170, SMS 233, is of later date. This is without inscription except the name STABIVS. It has, top right, a device of crossed palm and laurel branches on a ring with compass and tongues and, top left, a laurel wreath.

# 81   Johannes Cochlaeus, *Brief Description of Germany*

*Chapter IV*

*On Nuremberg, the Centre of Germany*

1   Nuremberg, the centre of Europe, let alone Germany.[1]

In this *Description of Germany* the city of Nuremberg comes close to being a kind of middle point, since in terms of position, language, power and achievement it is roughly at the centre. Hence I say that it appears to be not merely the

centre of Germany but indeed of Europe as a whole. It lies equally distant from the Adriatic and the Baltic which define the breadth of Europe. Similarly it is just as far from the river Don and from Cadiz which are the measure of Europe's length. Truly then this city can be said to lie in the centre of Europe.

As well as that, it is lengthwise almost equally distant from Vienna and from Antwerp, and breadthwise from Laibach in Carinthia and from Lübeck in Saxony.[2]

Moreover it is a centre for its surrounding areas. Its position between Bavaria, Swabia and Franconia places it on a common boundary.

2   A most convenient trading centre.

Thus it is the most famous market place of all Germany, importing the wares of southern lands and transmitting them to the countries of the North.

3   It is also linguistically central.

Its language has a middle position, drawing on various extremes, out of which it distils a well tempered blend which marks it off from the dialects of the Swabians, Bavarians and Franks.[3]

4   Central also in its power and achievement.

Its productive power has a mediating function too, because the city is rich in a variety of strengths, political, economic, moral and intellectual. These strengths derive from its centrality. However, how distinguished this city is in its political powers can be much more clearly shown by demonstrating the facts themselves than by my words.

5   Nuremberg's merchants are everywhere in Europe.

The wealth of Nuremberg's people is familiar not just to Germans, but to the most distant Spaniards in Lisbon, to the furthest flung Scythians on the Don, to Poles and Hungarians and to all Europe. Is there any corner to which they have not brought their money and their goods? They have established themselves in Lisbon, Lyons, Venice, Budapest, Cracow, Vienna, Cologne, Antwerp, and in the other commercial cities of Europe, where they enrich the inhabitants through mutual trade and keep their own people from poverty.

6   This city stands on infertile soil.

What has that to do with its politics? A great deal, in fact. Because Nuremberg stands on barren soil, its people cannot feed themselves from their farmlands, which are covered partly by forest, partly by stony ground and infertile sand,[4] whilst the population consumes every week more than a thousand bushels of grain and a hundred fat cattle, apart from the flesh of smaller animals, game

and poultry. That is why their collective industry is known to foreigners. At home they conduct excellent government, second to no other city in Europe. If most cities in Greece, Italy, Spain and France outstrip them in their wealth and abundance of produce, that can be put down to favourable climate, advantageous location and fertile fields. But this city enjoys none of those, rather it has only the energy of its citizens, which truly is to be more highly prized than if their wealth and splendour were the gifts of nature.

7   It has mighty walls.[5]

In its fortifications and buildings, its public authorities and multitude of people, it is second to none, for it is wholly surrounded and mightily defended by a threefold wall and ditch.

On the inner wall are 200 towers, built of squared dressed stone; in the outer wall are almost as many, though lower; all however are fully equipped with cannon and balls and other machinery of war.

The moat extends for a breadth of twenty cubits, it is almost of the same depth, and it is not filled with water but covered with green grass on which deer graze; a little stream runs through it. Within the city itself, earlier ditches and remnants of old walls are visible but are continually being covered over by new buildings.

8   Well fortified by a castle.

Inside their walls is a fortress, exceptional in its position, strength and age. For it is set high on a hill and looks down on the city, as the Acrocorinth once dominated Corinth. It is so secure that it is rightly the residence of the emperor, for it is hewn out of the firm rock on which it stands, defended by four great towers, a very deep and wide moat in the sheer face of the rock, spectacular to behold in its violation of nature. The castle walls, namely, rise up vertically above the quarried rock, forty cubits high, whilst the moat yawns almost immeasurably wide. On the crest of the hill are indeed two castles, one the emperor's residence, the other formerly the seat of the margrave, although this no longer has the appearance of a fortress. In its place, a granary was erected. The hill accommodates three chapels and two wells. One of the chapels is so old that people believe it was once dedicated to Diana, for the reason that old and unidentifiable idols are to be seen there. One of the wells is so deep that whoever looks down it sees no reflection of himself. On the slope and at the foot of the hill there live many citizens.

9   Secured by many gates.

There are in addition six large and two small gates. All the large ones are defended by high towers and very strong parapets; deliberately tortuous paths

lead towards the city, so that if the outer gate is breached, the inner one can still be defended, both from the outer walls with stones and cannonballs, and from the tower itself by a sharp-toothed portcullis which can be dropped to crush the enemy advancing below through the tower.

10   Well positioned on a river.

The Nurembergers also have a river, in Latin the Pegnesus, or Pegnitz as Silvius calls it,[6] which flows straight through the city. It has twelve bridges, six of stone and six of wooden piles, which connect the parts of the city, forming twin islands. Very many mill-wheels have been constructed, grinding corn, driving machines to process metal ore or to make paper; some power the screeching circular saws which cut high tree trunks into boards, others sharpen knives and work metal. The little river is navigable only for fishing boats, but for the city its value is beyond words.

11   Kept clean by an aqueduct.

Canalised water has been inserted into certain streets and is designed to wash away dirt and to be useful to butchers, dyers and tanners. Additionally, there are 120 public wells and 23 water channels or pipes.

12   Excels in its buildings.

Utterly excellent are its buildings, both public and private, for their solidity, amenity and for the grace of their exteriors, partly thanks to nature, but partly also because of the skill of citizens. They have a quarry quite close to their city, with sandstone whose softness makes it easy to cut when masons work with it. But it hardens in buildings when exposed to the air and so to speak baked by sun and wind.[7] Hence they can raise very fine walls of masonry, the outer face of which can easily be renewed if ageing renders it ugly.

13   Exceptional for its architects.

Furthermore, they have a structural engineer who is responsible for the public buildings, and two special architects, masters of building sites, experts nowhere matched in Germany, whom neighbouring princes very often consult when they are planning difficult buildings. One is in control of stone structures, the other of timber-framed buildings. Large sums are expended on these from public and private purses. The architects have permanent staffs of more than two hundred men, who never rest from their labours, so many new buildings are there to supervise. Hence the chief fear of citizens is that timber supplies will eventually give out, even though they carefully maintain the thick forests planted all around them. For that reason they have thought up a clever way of planting trees and employ very many forest wardens; these harvest young

oaks and other varieties and store them in a compound[8] until they are ready for use in building.

14  The granaries.

These are numerous and large, all of them full, a general solace for hunger and a welcome relief for the poor.

15  The arsenals.

If you inspect the arsenals, you will be dumbfounded to behold so many and such great weapons of war, drawn up according to their function so that they are always ready to hand, so many bombards, I tell you, iron bows and crossbows, shields, armour, lances and projectiles, such as even Vulcan's smithy never contained.

16  The town hall.

Should you tour the town hall, you might believe that they did not bother about buildings and armaments, so manifold are the responsibilities of the administration. They have fourteen departments,[9] differentiated according to their remits: the lords of the council, the treasurers,[10] the legal officials, the five,[11] the censors,[12] the magistrates,[13] the clerks et cetera.

17  The merchants' market.

If you then walk down to the market place, you will see there merchants of fine stature, dignified and splendidly dressed; further, a fountain shaped like a pyramid, much gilded and adorned with many skilfully carved statues, and which dispenses plentiful water from sixteen pipes for different purposes.[14] Moreover you see a clock, as unique as the fountain, which Georg Heuss recently cast with creative ingenuity and decorated with figures cast in metal, which excite general admiration by their movements, harmony and varied forms.[15]

18  The Haller meadow.

Passing on, when you go through the small Haller gateway, you will reach the Haller meadow, which is no less attractive than the Tempe of the Thessalians,[16] five hundred paces long, shaded by a fourfold avenue of trees and watered by four fountains, from each of which cold water continually issues from four spouts. The meadow is somewhat narrow – on one side the Pegnitz flows past, on the other are vineyards and orchards from which sweet birdsong sounds. At festivals young folk and with them people of all ages flock here for recreation and diverse kinds of games and gymnastics which stimulate the body's strength and refresh them for their work.

19   The other markets.

They have wine, fish, meat and corn markets, with a variety of produce unmatched elsewhere in Germany. For indeed, from wherever else you bring something to sell here, you will straight away be offered ready money.

20   The three social classes.

The population is large and falls into three classes, that is into patricians, merchants and the common people.[17] But only the patricians direct the common weal, and truly to such general satisfaction that in eighty years no uprising has come about. Nor have they split into factions amongst themselves, in which respect our city seems to be superior to others, even those in Italy. Aristotle says, namely, in book seven of the *Politics*, that it is either difficult or altogether impossible for such a populous city to be governed without the tumult of revolts.
So much for Nuremberg's politics.

21   Economic power.

How great the city's economic strength is, the prosperity of the whole people displays: their opulent household fitments, the numerous domestic servants, the charming gardens outside the city walls, their storerooms full of wine and corn.

22   Moral strength and justice.

Moral strength is in no way despised. Justice and piety are powerfully evident. So great is justice indeed, that Astraea herself, when she fled the earth, left her purest traces here, where equality is applied to all, the mighty are allowed no more than the poor.[18]

23   The censors.

They have censors for morality, speech and dress, and also many observers who report those who transgress against regulations, so that the people are kept firmly to ethical rules and no one steps outside the proper measure by wearing extravagant clothes[19] or behaving without restraint or using unbridled language. Beyond their walls, also, they practise justice, so conscientiously indeed that at great expense they maintain many armed men to protect the forests and public highroads from criminals.

24   Piety.

Their love for the divine is as strong as their love for their neighbour. Great is the people's throng to God's word in all thirteen places where they can hear it.[20] Many donations are made to the churches, nowhere are people more ready

to give, nowhere are more candles burned at services. Nine monastic houses are to be found in the city, seven for men and two for maidens.

25   Hospitals.

Two are available, one of them with so many priests, choristers, pupils and paupers, that in all Germany none more excellent exists, indeed none its equal. There are also two houses for twelve Brethren, I mean for men exhausted by old age and poverty, one of which was recently erected by a citizen at a cost of 15,000 gold gulden and endowed with income.[21] There are also hospices for pilgrims.

26   Alms.

Alms flow in abundance; in Holy Week every single year over 700 lepers converge together from far and wide and are publicly fed in body and nourished in soul in the churchyard of St Sebald, where patricians and their ladies wait upon them at table. Afterwards they are sent away with gifts, each with a coat and a linen garment, a washing cloth, and food for the road.[22] The influx of beggars on All Souls Day is so great, however, that on occasion more than 4000 have to camp outside the walls, and inside the city all churchyards are full; then many citizens dispense forty or fifty gold gulden and more.

27   Pious foundations.

Moreover there are many pious foundations, some for the support of citizens weakened by misfortune, long imprisonment or sickness, others to help maidens marry with a respectable dowry, or for citizens' sons selected for the study of science and letters.
Let that suffice as a brief description of morals!

28   Intellectual strength.

In its intellectual vigour and inventiveness this city is second to none, and this is true of every class of urban society. For the city councillors are wise and eloquent, most more than averagely learned in imperial law.
   One of them incites my limitless admiration amongst all mortal men our age has witnessed. Yet I do not wish to name him, lest I appear a sycophant. This man has indeed been showered with all nature's gifts both of mind and of fortune; truly, he is rich, tall of stature, fluent of speech, subtle of mind, exceedingly knowledgeable in Latin as in Greek literature, but versed also – God help me, this is the honest truth – in all branches of learning, with such a wealth of books, in both languages, that a library to match his can nowhere be found in Germany.[23]

How clever the merchants are at home and abroad, that, I reckon, everyone knows.

29   The Creativity of its Artist-Craftsmen.[24] The talents of Nuremberg's artists are admired not only by Germans, but also by Italians and the French, and by the distant Spaniards, and all continually seek them out. Their works themselves bear this out, for they are exported far and wide.

30   Albrecht Dürer.

Amongst these are the depictions of the Passion of Our Lord, which Albrecht Dürer recently made, engraved in copperplate, and printed himself, drawn with such subtlety and in such true perspective, that merchants from all over Europe buy these prints to provide models for their own artists.[25]

31   Johannes Neuschel.

I know this man who travels abroad and serves many kings; in music he is most talented, not merely in blowing trumpets, but in manufacturing them too, and frequently he adds the note of his instrument as accompaniment to choral song. His trumpets are despatched to clients 700 miles away and more.[26]

32   Peter Vischer.

Who is more skilled in casting and chiselling metal? I have seen a whole miniature chapel which he cast out of bronze and carved with figures, in which many live people will be able to stand and hear mass.[27] All wonder at his grave effigies and the candelabra they have seen, so great is the subtlety and the harmonious proportions of the artefacts he casts.

33   Erhard Etzlaub.

Who should not praise the talent of Etzlaub, whose solar compasses[28] are in demand even in Rome? Beyond a doubt he is an industrious master craftsman, excellently versed in the elements of geography and astronomy. He has produced a most beautiful map of Germany, with a text in the German language, from which one can adduce the distances between cities and the courses of rivers still more accurately than from the maps of Ptolemy.[29]

34   Peter Hele.

In Nuremberg from one day to the next devices of ever greater precision are being invented. For instance, Peter Henlein, still a young man, makes instruments which even the most learned mathematicians wonder at. Out of a little amount of iron he manufactures clocks with many tiny cogs, and these, without needing

a weight, no matter how one moves around with them, run and chime for forty hours, even if you wear them on your breast or carry them in a pocket.[30]

35  The musical contest.

If you were to hear the musical contest on St Catherine's Day, you could simply be amazed to find so many singers and such tuneful voices all in one place. There three masses are performed by the conductors of three schools, in front of four learned judges who stand there in a group.[31] In this not even Antwerp, nor any other city in Germany, would be superior.

This city seems, then, to have remained secure from the prevailing cultural barbarity and at the same time to have found a happy medium with its geographical site and its industriousness. Hence it truly merits its place at the centre of this, our Description.

Johannes Cochlaeus, *Brevis Germanie Descriptio*, ed. Karl Langosch (Ausgewählte Quellen zur Deutschen Geschichte der Neuzeit, Freiherr vom Stein-Gedächtnisausgabe, I), Darmstadt 1976, 74–93. Chapter 4. Latin text
R. I, 293, 4, paragraphs 29–30 only

NOTES

1   For his chapter on Nuremberg, Cochlaeus drew on two earlier books: Konrad Celtis's *De origine, situ, moribus et institutis Norimbergæ*, and the *Historia de Europa* by the Italian humanist Aeneas Silvius Piccolomini (the later Pope Pius II), who had termed Nuremberg, the 'centre of Germany' (*in medio ferme Germaniæ sita*). Johannes Regiomontanus and Celtis inflated the claim to 'centre of Europe'. Other writers made the city 'the eye of Germany' (to Luther, 'eyes and ears') or 'the German Venice', though in Venice it was said that all German cities were blind, except for Nuremberg which was one-eyed. For Cochlaeus *Germania* seems to be essentially a geographical rather than a political entity, not necessarily coextensive or coterminous with the 'Holy Roman Empire of the German Nation'. See Whaley 2012, introduction, Neuhaus 2002.
2   Laibach is modern Ljubljana, Slovenia. Lübeck, on the Baltic coast, was founded in the twelfth century by Duke Henry the Lion of Saxony. In more modern times the territories called Saxony have come to be differently defined.
3   Cochlaeus is drawing on Aeneas Silvius, *Europa* (chapter 39): 'It is a matter of doubt whether Nuremberg belongs to Bavaria or Franconia...The Nurembergers themselves do not wish to be seen either as Bavarian or Franconian, but as having a kind of third, separate identity.' Celtis even claims that Nuremberg is 'quadrilingual': around each of the main gates of the city, where travellers enter from north, south, west and east, different dialects are spoken, Franconian, Bavarian, Swabian and 'Mountain' (from the border hills of the Bohemian Forest?). In a not dissimilar view, modern historical linguists place Nuremberg on the border of two dialect landscapes and trace in the medieval urban dialect of Nuremberg an early predominance of North Bavarian

phonology and vocabulary, later gradually overlaid by Franconian. Precisely in the period of the fifteenth to sixteenth centuries, Nuremberg played an influential role in the crystallisation of early modern German, in the emergence of a supra-regional linguistic compromise, eventually also of standard forms of the spoken and written vernacular language. In the decades immediately after 1500, the medial and mediating location and functions of the city gave it and the Central Upper German linguistic region as a whole a strong role in the give-and-take, adaptation and selection, of progressive features of language change which produce 'Common German' (*Gemeines Deutsch*). Linguistically significant characteristics of Nuremberg were instrumental in this process: its location in a national communication system of manufacture, commerce and markets, and cultural transfer; its prestige and political influence as a model of effective government, with a chancery which produced and exported a huge volume of written documents; its importance as a centre of printing and publishing; its powerful national status in imperial politics; after 1524, its adoption of the Lutheran Reformation and of Luther's German as a norm of usage for printers.

[Keller 1978, esp. 370–78; Koller 1989, 13–15; Cochlaeus/Langosch, 1976; Steger 1971, 69–72. Further, my general introduction]

4    The infertile soil around Nuremberg is referred to already in Emperor Frederick II's charter for the city in 1219, and the contrast between its disadvantageous geography and its political and economic strength had long since become a commonplace in descriptions of the city. Its surrounding area to the south and south-east was known simply as 'the sand', and its inhabitants as *Sandhasen*, 'sand-hares'. Other areas around it were in fact fertile and sustained market-gardens. The dense forest which originally enveloped the city may have given it its name – from Germanic *★nurung*, 'land cleared from forest'. On the city, its origins, Renaissance politics, society and culture, see Strauss 1976.

5    The account is heavily indebted to Celtis's *Norimberga*, chapter 4, as are also the following sections on the castle and gates.

6    *Europa*, chapter 39.

7    See Celtis, as note 5.

8    *pomerium* in Latin, in Nuremberg German *peunt*.

9    *aulæ*, in Nuremberg known as *stuben*, 'chambers'.

10    *questores*: the heads of the city treasury (Latin *quaestor*) were titled Losunger in Nuremberg.

11    *quinqueviratus*: in the Roman Republic a commission of 'five men', in Nuremberg the five senators who were commissioners of police.

12    Cochlaeus's text has *doctores*, but this has just been used for 'lawyers' and must be an error. Read: *censores*, in Nuremberg usage *Rugherren*, whose task was to admonish (*rügen*) offenders.

13    *scabini*: the thirteen *Schöffen*, members of the city council invested with judicial powers.

14    The *Schöner Brunnen*, see 67.

15 In 1349 Emperor Charles IV gave the city permission to demolish the Jewish quarter and to extend the market square. In 1355–8 he built the church of Our Lady where the synagogue had stood. (On the Jews in Nuremberg, see A. Müller 1968). In 1509 its west gable was rebuilt to accommodate a mechanical clock, the *Männleinlaufen*, commemorating Charles IV's Golden Bull, which laid down a definitive procedure for electing German monarchs. Figures of the seven electoral princes, preceded by heralds and musicians, file past the effigy of the emperor.

16 The proverbially charming valley in ancient Thessaly, through which ran the river Peneus, between Olympus and Ossa.

17 Cochlaeus curiously does not mention the class of 'honourable' (*ehrbar*) families which were qualified for a subordinate role in the government of the city, through nominated membership of the great council – and to which AD belonged.

18 During the Golden Age Astraea, goddess of justice and innocence, lived on earth but she was driven away by human wickedness and metamorphosed into the constellation of Virgo.

19 On the sumptuary laws of Nuremberg, see 5.2, 9.5, 14.1.

20 By 1512 the city exercised considerable control over the city churches, and the laity benefited, to an extent not otherwise common before the Reformation, from sermons and liturgical arrangements which brought the biblical word to them in the vernacular. See Whaley 2012, 99f., 186.

21 The first hospital is the Holy Ghost Hospice, the second is the Landauer charity, for the chapel of which AD designed stained-glass windows and the altar painting of the Adoration of the Holy Trinity (64.3–5). The 'houses for Twelve Brethren' invoked Jesus's twelve disciples.

22 The protocol for this elaborate ceremony for dispensing charity to lepers was drawn up in 1394. The 'washing cloth' is in the Latin text *sudarium*, the name of the cloth given by St Veronica to Christ to wipe sweat from his face as he bears his Cross to Calvary, and on which his 'true image', the *vera icon*, was miraculously imprinted.

23 The anonymous patrician is none other than Willibald Pirckheimer, AD's closest friend, mentor and patron. A letter revealing his identity is printed at the end of the book, written by Benedict Chelidonius (BI).

24 *Artificum solertia*: the phrase raises the semantic problem inherent in the Renaissance and later vocabulary of art and craft, in Latin and the vernacular languages alike (see introductory note on Translation). Latin *artifex* could mean 'one who is master in the liberal arts', but it came also to connote a wide range of meanings, '(creative) artist', 'craftsman', 'expert', 'master in anything, in doing anything'. The category of entries for which it provides the label here comprises without exception (since AD figures only as maker and printer of woodcuts) men who practise what were still, north of the Alps at least, 'mechanical arts', compromised in status because they required manual skills and labour.

25 Cochlaeus mentions only one of the many genres of AD's work, though one which was particularly important in the years immediately after Cochlaeus returned

to Nuremberg from studying at Cologne University to become Rector of the Latin School of St Laurence's. The commercial exploitation of AD's prints is remarked upon already in Wimpheling's *Brief History of Germany* in 1502/5 (16) and is evident by 1497 in AD's recruitment of travelling salesmen (7–8). In Cochlaeus's estimation he seems to be not the new Apelles of Celtis or Pirckheimer, but merely the leading exponent of the Nuremberg talent for manufacturing precision artefacts.

26    Neuschel was the city trumpeter. Music for brass ensemble was part of civic ceremony, weddings and dance. For music teaching in the higher classes of his school, Cochlaeus wrote his textbook *Tetrachordum Musicae* in 1511.

27    For Vischer, see 39, 67 and BI. It was not true that people could stand inside the shrine Vischer created for the tomb of St Sebald. It was unfinished when Cochlaeus was writing in 1512.

28    *horologia*: see the example in Ex. Cat. NewYork/Nuremberg 1986, 434. The device incorporates a sundial, a compass and on the outside a map of Europe and Asia, oriented to the south and extending as far as Ethiopia. It was intended for merchants and pilgrims. At the edge, latitudes are indicated so that with the help of a string one could determine one's position relative to the markings and calculate the time. The intervals between the latitude markings become smaller towards the south, anticipating the Mercator projection introduced in cartography half a century later.

29    Etzlaub was an astronomer, compass-maker and cartographer. His map of Germany, printed in Nuremberg by Georg Glockendon in 1501, oriented to the south, with Rome at the top, Denmark and Scotland at the bottom, shows Nuremberg at the centre of a spider's web of roads. The map (reproduced in Langosch's edition of the *Brief Description*) also supplies instructions for using it in conjunction with a compass. On mapmaking in Nuremberg, see Meurer 2007, 1193f.

30    The locksmith Peter Henlein ('cockerel', diminutive of *Hahn*), was known in Nuremberg by the dialect form Hele or Hale. Just after 1500 he began to produce in quantity the first portable clocks, in cylindrical box shape, with a forty-hour movement and a chiming device. The city council bought them to present to notable visitors such as Philip Melanchthon and Emperor Charles V. Later sixteenth-century spherical versions were known as the 'Nuremberg egg'.

31    See note 26 on Cochlaeus's interest in music as a school subject. For a general discussion of music in Nuremberg, see Strauss 1976, 262–9. The three competing schools were presumably the Latin Schools of St Sebald and St Laurence, and the chorister-scholars of the Hospital of the Holy Ghost.

## COMMENTARY

Johannes Dobneck or Cochlaeus (BI) was a pioneer of the teaching of geography in schools. He produced an edition of the *Cosmographia* of Pomponius Mela, written circa AD 40–50, and as an appendix to it he added the *Brevis Germanie Descriptio*, an innovatory survey of the contemporary geography of Germany, with a particular emphasis

on the city of Nuremberg, to which he devoted a whole, symbolically central chapter. Its composition for use as a reader for schoolboys reflects the confident ethos and collective self-awareness of the city.

Cochlaeus's reference to AD is brief and somewhat dismissive compared, let us say, with the effusions of Konrad Celtis (10). However, it seemed justified to include the whole of this chapter in the documentary biography. It is the most revealing strictly contemporary characterisation of Renaissance Nuremberg and a striking testimony to its sense of itself. And the short shrift accorded to AD, his demotion to the ranks of those who produce 'handiwork of artistic worth', is perhaps a more realistic indication of where his graphic art, at least, ranked in the estimation of most contemporaries, as one among other ways of creating lucrative export goods of up-to-date technology and consistent quality. It is a sobering reminder of how the new Apelles might be evaluated by a reputable humanist who was likewise a protégé of Willibald Pirckheimer.

[Bagrow 1964, 125, 148; Rupprich 1970, 692f.; Langosch 1976, 7–10, 12f.]

## 1512–1513

## 82–4  Writings on the Theory of Art

## Drafts of the Introduction to the Handbook on Painting

### Introduction

AD may have conceived his plan for a comprehensive handbook for young painters during his stay in Venice in 1505–7. Certainly on his return to Nuremberg he worked to assimilate the teachings of Vitruvius and Euclid into his programme of proportionate drawings of human figures, and by 1508 he was formulating the rationale and structure of the planned handbook (51). Until 1512 he did not put dates on his drafts of the introduction to the handbook. In view of its close adherence to the overall scheme and contents lists, the oldest extant introductory sketch (51.4) may go back as early as 1508, while the chronologically next texts (73.1–2) can only be tentatively located in the years 1508–12. However, all this early draft material was preserved by AD in a kind of archive. Then throughout the genesis of his written and printed treatises he took up again material earlier superseded and rejected, and revised and extended it in subsequent versions. From 1512/13 AD began to write dates on texts which presumably, when he wrote them at least, he regarded as potentially definitive statements. The fourteen drafts which belong in this phase of intensive thinking and writing fall into three groups clearly marked thematically and by closely related linguistic formulation. Two groups have provisionally final texts with headings which greet the intended

reader and date the introduction: *Salus 1512* and *Salus 1513* (82.1 and 82.2). The third (83) has a final text in which the prefatory material is immediately followed by a detailed technical introduction to the *Teiler*, the ruler to be used in the measurement of proportional human forms.

While they contain thematic material common to texts of more than one of them, each of the three groups has distinctive lines of argument. It is not the case that any one of the drafts can be regarded as AD's clearest and putatively definitive statement of the whole intention of the treatise on painting and its wide span of concerns. Although 82.1 and 82.2 have most in common, neither of them achieves an overall synthesis. The two drafts for the introduction which AD appears to have commissioned from unidentified humanist 'ghost-writers' (84.1/2) may have been prompted by his inability to produce a satisfactory synthesis for himself. Certainly they draw on the themes of all three strands of texts. This is a pattern – related but disparate texts, none of them an evident final statement, and recourse to humanist help – which was to be repeated in 1523, when AD was preparing the *Four Books of Human Proportion* for printing (182).

Rupprich's ordering of the drafts for the introduction to the handbook on painting in the second volume of his edition requires correction. The two texts in his group 4 (R II, 106f.) prove on closer analysis to be earlier versions of the four texts in his group 9 (R II, 129–33). Characteristics are variants of the opening phrase 'To know something is good', and in the texts of group 9 the heading 'Greeting 1513'. These texts are represented here by 82.2. It may be that Rupprich presupposed a time gap between groups 4 and 9. The four texts in Rupprich's group 5 (R II, 108–14) have the characteristic opening phrase 'Saying something that does no harm/does more good than harm', and its fullest version – here, 82.1 – is headed 'Greeting 1512'. By AD's own dating, the texts of group 5 precede those of groups 4 and 9, at least in terms of their quasi-definitive versions. Nonetheless, the thematic content and structure of these texts is so closely comparable that they are best regarded as two interwoven strands, of which the later may be essentially a reworking of the earlier.

Their argument may be summarised as follows. Knowledge (1512) or knowledge and its expression in language (1513) is a natural human desire and instinct. Within individual limits of human intellect, no one is incapable of learning an art for which character and ability fit him. No knowledge or its teaching can be bad in itself. Since God knows all things, knowledge is divinely willed and inherently good. There is (1513) a particular need in Germany, and among German artists and craftsmen, for knowledge and teaching of the science of art. Sight is the noblest of the senses, and teaching of knowledge which combines the verbal with the visual will best succeed. Visual art has the goal of creating beauty, and measurement ensures the best representation of the human form. Art serves the Christian faith and its worship, but also the memorialising of human beings, and man's grasp of natural science. Good art requires both knowledge and practical skill. Its best judges and critics are other skilled artists.

The prestige of art in the ancient world (1512) makes deplorable the loss of the artefacts of Greek painters and sculptors and above all their writings on the theory and practice of art, destroyed by attrition of time and, in particular, early Christian iconoclasm. This combination in 82.1–2 of philosophical, psychological and cultural-historical arguments marks out these texts as AD's culminating attempts to encapsulate the rationale of his comprehensive manual on the intellectual preparation, technical and practical training of the artist.

Rupprich's presentation of the remaining strand of draft introductory material is once again misleading. Group 6 (R II, 115f.) contains a single text which argues, firstly, that a collective definition of beauty is likely to be more reliable than an individual one. Usefulness is an aspect of beauty, what is not functional detracts from it; the constituent elements of beautiful forms must possess compatibility and harmony. AD does not boast of his own knowledge and ability: these are limited and others may surpass them. Advice on art is best given by those with advanced knowledge, practical experience, and proven skill, though ordinary folk's common sense can make them useful critics. However, this brief passage reappears again at the end of the third, and by far the most coherently argued, of the three texts in Rupprich's group 7 (R II, 117–26). What goes before in this text (83) is heavily, often verbatim, indebted to 51.4, *Van schonheit*, the earliest of the preserved introductory drafts from circa 1508. AD, with his teaching on painting, wants to spark a flame which others are to fuel into an illuminating fire by publishing their teaching on art. Beauty is the highest demand of art, easily compromised by flaw and error. No single beautiful being exists who might provide an absolute canon of beauty. Perceptions of even relative beauty differ from person to person. But God has incorporated some element of the beautiful into all creation, and the artist must seek out and extract these elements, which he can reintegrate into images whose beauty is observed in and drawn from nature. Compatibility and underlying harmony, and measured proportion, are vital in this process of selection and synthesis. Beauty established in this way aims to achieve a consensus of collective judgement. Knowledge and understanding take us closer to the ideal; technical error and the confusion of beauty with the merely known and familiar are pitfalls to avoid. One should test one's own understanding of art both against the knowledge and experience of experts and the healthy ignorance of ordinary people.

Text 83 provides the firmest evidence that, during the course of 1512–13, AD radically changed course, abandoning or postponing the grand project of an all-inclusive handbook on the art of painting, and turning to the narrower aim of a discrete treatise on human proportion, which originally was merely to occupy chapter II.1.a of his three-part plan, with its nine sections and fifty-four subsidiary chapters (compare also 85.1, a draft for the chapter on colours). So it is that in 83 the introductory aesthetic and theoretical discussion of how to achieve beauty in the artistic representation of the human form leads straight into the initial instruction on the technical means by

which beauty may be realised through proportional measurement, which is evidently now to be the whole thrust and content of the treatise. The one earlier preceding text which elevated measurement to such emphatic importance is the brief note 73.2 dated uncertainly between 1509 and 1512. Text 83, then, marks most clearly the reorientation of AD's ambition to demonstrate the science of art, and at the same time in its content it spans the whole evolution of his scheme from 1508 to 1513.

[Panofsky 1970a, 131–6; 1948, 266–70; Białostocki 1971 & 1988, 64–8; Hinz 2011]

## 82   Drafts of the Introduction to the Handbook on Painting

### 82.1   Knowledge and Art: Greeting[1] 1512

Saying something that does more good than harm, and does not stand in the way of something better, may find a hearing. So whoever will, let him hear and see what I am doing. For human curiosity can be so sated by an excess of all worldly things that it becomes weary of them, with the sole exception of knowing a great deal, of which no one tires. It is inspired in us from nature that we long to know all things and thereby to grasp the truth of all things.[2] But our dull minds can never attain to such perfection of all knowledge, truth, and wisdom. Yet by that same token we are not entirely cut off from all wisdom. If we have the will to sharpen our minds through learning and practise its arts, we may well by proper means seek, learn to recognise, reach, and achieve some measure of truth. We know that there are many who have become experienced in all kinds of knowledge and art and have set down their expertise, which can now benefit us. So it is right that a man does not neglect, at an appropriate time, to learn something for which he finds himself best fitted. There are men who can learn all kinds of arts, but that is not given to each and all of us. Yet no reasonable man is so uncouth that he cannot sometime learn something to the mastery of which his heart and mind impel him. For these reasons no one has any excuse for not learning something. The common weal requires us to learn and to pass it on faithfully to those who come after us and to withhold nothing from them. For that reason I have set myself the task of writing something which young folk will not be undesirous of seeing. Mankind's noblest sense is sight.[3] Anything we see is more believable and lasting than what we hear. When we have both together, hearing and seeing, then we grasp that all the more powerfully. That is why I want to both write and show, so that you may better mark and learn. In this respect our sight can be compared with a mirror.[4] For all kinds of forms we are presented with pass before our vision,

such that all we see enters our mind through our eyes. Our nature is such that we see one figure or image more gladly than others, even though it is not necessarily better or worse than the rest. We like to see beautiful things, since they give us pleasure. Judgements on what is beautiful sound more persuasive when a painter expresses them rather than someone else.[5]

Accurate measurement produces a good human image, not only in painting but in all other things however they are produced. It is not improper for me to write a book of service to painters, for the art of painting is employed in the service of the Church, and by it is depicted the Passion of Christ, and it also preserves the images of men and women after their death. The measurement of the earth, seas, and stars is made comprehensible through painting and more will continue to be revealed to mankind through what art depicts. Acquiring the art of painting properly is difficult. So anyone who finds he lacks the skill for it should not attempt it. For it comes through inspiration from on high.[6]

The art of painting cannot be well judged except by those who are themselves good painters.[7] In truth it is a mystery to others just like a foreign language is to you. To learn and practise this art would be a noble thing for intelligent young men free to pursue it.

Many centuries ago this great art of painting was highly esteemed by mighty kings,[8] and they enriched excellent artists and held them in great worth, for they deemed such ingenuity a creativity in the image of God himself.[9] For a good painter is inwardly teeming with figures, and were it possible that he might live for ever, he would always, from out of these inner ideas of which Plato writes, have new things to pour forth in his works.[10]

In those past centuries there were a number of famous painters, namely Phidias, Praxiteles, Apelles, Polyclitus, Parrhasios, Lysippos, Protogenes and others, amongst whom several wrote about their art, often skilfully explained it, and clearly brought it into the light of day.[11] Yet these same estimable books have hitherto been unavailable to us and are perhaps entirely lost, whether as a result of war, the expulsion of peoples, or changes of law and religion, which any wise man will rightly deplore. Often it comes about that the ingenuity of noble minds is snuffed out by the crude suppressors of knowledge and art.[12] When they see figures drawn in a multiplicity of lines, they imagine this is no less than the conjuring of devils and so honour God by something repellent to him. To put it in human terms, God is offended by all destroyers of great mastery that has been devised with much expense of effort, labour, and time, and is gifted by God alone. It pains me often to have been robbed of the expert writings of those masters. But the enemies of art despise these things.

Nor do I hear of any in modern times, who are writing and publishing something I might read to my benefit.[13] If there are any, then they are hiding

their science away. Some write of things they know nothing about – which is a waste of breath, for their fine words are all that's good about it, as anyone who knows can see at first glance.[14] That being so, with God's help I will set down what little I have learned, even though many will despise it. That does not bother me, for I well know that it is easier to criticise than to produce something better. I shall present these things as understandably and transparently as I can, and if it is possible I shall hope to bring all I know clearly into the light of day, for the sake of talented young men who value such art higher than silver and gold. I beseech all those who have some knowledge to write about it. Do that accurately and plainly, not at burdensome length, for those who desire and seek for knowledge, to the greater honour of God and their own fame.

The text translated here is the third of a set of four closely related autograph drafts for the introduction of the manual on painting. It is the only one which bears a date and AD's monogram. Three of them are preserved in the BL Sloane collection, one is in the Stadtbibliothek in Nuremberg.

1   BL 5230, fol. 20. Leaf written on both sides.

2   Nuremberg, Stadtbibliothek Cent. V, App. 34aa, fol. 63. Leaf written on both sides.

3   BL 5230, fol. 24–5. Two leaves, each written on both sides (the version translated here).

4   BL 5229, fol. 64r&v. On one side of the leaf, a version of the first sentence of the text, on the second side, fragments of the following four sentences. Below the text of the first sentence, sketches of the palm and laurel foliage, marked with the abbreviations *polm. lorber*, which relate to the sketch for the woodcut coat of arms of Johannes Stabius on fol. 65 (see 80.4).

R II, 108–14

Texts 1 and 2 are very closely similar to text 3, although both break off in mid-sentence and were presumably continued on now lost additional leaves. The heading of text 3 is clearly related to that of 82.2, and marks it as the definitive version of this sequence. Hence it is the text chosen for translation here. Texts 1–3 have extensive emendations and revisions. On the use in text 3 of material from the much earlier draft text 51.4, see the introduction and the following notes.

NOTES

1   *Salus*: Latin expressions of greeting and farewell were commonly used in German too, and were not restricted to the educated. It may also relate to *Anno salutis*, 'In the year of grace'.

2   This and the next eight sentences – from 'It is inspired…' to '…not learning something' – are repeated more or less verbatim in 82.2.

3   From this sentence to the end of the following paragraph – 'through inspiration from on high' – the text is again reused in 82.2. The idea of sight as the highest of the senses is common in ancient philosophy (Heraclitus, Plato) and in the Italian Renaissance. It underlies the prime place given to optics by Alberti (*De Pictura*, I, 5–8). When AD calls sight the noblest of the human senses he echoes Leonardo da Vinci (Kemp/Walker 1989, 18–22). The primacy of sight is a key argument in the *paragone* between painting and poetry (Ames-Lewis 2000 166).

4   The idea is restated less coherently in 82.2. Alberti regards Narcissus, who falls in love with his own reflected image, as the 'inventor of painting' (*De Pictura* II, 26). Leonardo calls the mirror 'the master of painters', as the test of the conformity of a picture with nature: 'make your picture look like something from nature seen in a large mirror' (Kemp/Walker 1989, 202). AD used mirrors in his self-portraiture (36.5).

5   Text 2 adds: 'For a man versed in art may point out some reason why one form is more attractive than the rest.'

6   *Dan es will kumen van den öberen ein gissungen*: see also the earlier, related insistence that *es ist vns von natur ein gegossen, daz wir geren vill wessten, dordurch zw bekennen ein rechte warheit aller ding*: 'it is inspired in us from nature that we long to know much and thereby to grasp the truth of all things'. See also 83. In both formulations AD uses the verb *eingießen*, 'imbue, infuse, inspire' and the noun *Eingießung* derived from it, which may stem from the vernacular vocabulary of later medieval mystical theology (DWb III, 192). In the latter phrase especially, AD appears to be aware of, and to merge, the medieval theological concepts of *scientia infusa*, knowledge infused by God, and *scientia naturalis*, knowledge innate in man. In Martin Luther's translation of the Wisdom of Solomon 15:11, the potter who, created by God from clay, uses clay himself to fashion idols, 'does not know who made him and imbued (*eingegossen*) in him the soul which works in him and has breathed (*eingeblasen*) into him the living breath'. However, AD's insistence that the knowledge and art of painting are 'given by inspiration from on high' also suggests a conceptual linkage of artistic *ingegno* with inspiration, intellectual knowledge and manual skill comparable with that found in the Italian Renaissance (see Kemp 1989, 32–43). On the combination and collocation of *ars* and *ingenium* as bridging the polarity of knowledge and inspiration in art, see Baxandall 1971, 15ff.

7   Unlike Leonardo (Kemp/Walker 1989), and Alberti (*De Pictura* III, 62), AD does not follow Apelles' belief that passers-by (Pliny, *Nat. hist.* 35, 84) and even horses (35, 95) could make valid judgements on art.

8   Pliny emphasises the value of royal patronage particularly in the case of Apelles and Alexander the Great.

9   *dan sy achtetten solche sinreichikeit ein geleich formig geschopff noch got*: on *sinreichikeit*, DWb X, I, 1201f. and the dictionary gloss by Petrus Dasypodius (1535) – *facultas ingenii*. For *geschopff*, see DWb IV, I, 2, 3954–6 (on the neuter and feminine nouns *Geschöpf*). Human talent (*ingenium*, see Summers 1987, 99f.) is seen as a faculty created in man by God, and as an image of divine creativity. See the version in text 1: *Dan sy bedawcht, daz dy hochferstendigen ein gleichheit zw got hetten als man schriben fint* ('For it seemed to them that, as it is written, those of high intellect were like unto God'). Crossed out in the manuscript is *als Moises schreibt* – AD is here invoking the authority of Exodus 31:3, where Bezaleel is described as 'filled with the spirit of God, in wisdom, understanding, and in knowledge, and in all manner of workmanship, to devise cunning works in gold and in silver…to work in all manner of workmanship'. Compare Luther's

phrase here, *mit allerley werck*. Rupprich (II, 110f., note 10) suggests that AD knew this bible passage from his apprenticeship as a goldsmith. AD's revised translation here in text 3 substantially strengthens the idea of artistic creativity as an image of the divine creative power. Compare Barasch 1998.

10    AD's key terms here are *vigur* and *innere ideen*. The sense of *Figur* is clearly, as in medieval German, 'human form', here specifically 'figures' as the artist's mind conceives and represents them pictorially, thus both the imaginative envisioning of forms and their reproduction in art (Paul 331, DWb IV, II, 1629f.). The sense is confirmed by AD's definitive reformulation of this passage in the 'Discourse on Aesthetics' in the *Four Books of Human Proportion* (151.1, notes 8, 28, and 257.4, note 19), where *bildnuß* – 'image, portrayal, portrait' – is substituted for *vigur*. However *innere ideen* – 'inner ideas, of which Plato writes' – is a more complex matter. DWb IV, II, 2039–41, Paul, 493, and Pfeifer, 725, give no other German occurrence of the phrase before the seventeenth century, and attribute the morphologically assimilated German noun *Idee*, plural *Ideen* to borrowing by the philosophers Leibnitz and Thomasius from French *idée*. AD can only have known of Plato and his concept of idea (ιδέα) from his humanist informants, Celtis or Pirckheimer. However, the sense in which AD uses *ideen* is not Plato's concept of pre-existent, perfect and immutable ideas, not congruent with any visible realisation in the world of the senses. He may have been aware from Celtis or Pirckheimer of the etymological connection in Greek between ιδέα and the verb ιδειν (compare Latin *vidēre*), 'see'. Rupprich (II, 111) cites a statement by Seneca (Epistolae LXV, 7): *Haec exemplaria rerum omnium Deus intra se habet…plenus his figuris est, quas Plato ideas appellat*: 'God contains these exemplars of all things within himself…he is filled with those figures which Plato calls ideas.' The verbal echoes, especially the linkage of 'figures' and 'ideas' is striking. Pirckheimer certainly knew Seneca's works, and it may be that he explained the concepts of figures and ideas to AD with the help of Seneca's Christianised Neoplatonism – it is out of God's limitless treasure of perfect, immutable ideas that visible figures in the mutable world of nature and man were created. While AD may correctly have attributed the (in German still otherwise unfamiliar) notion of *ideen* to Plato, what he understands by it is concepts and images internalised by the artist from nature and reproducible in visual art. This associates too closely divine creation and artistic creativity. Thanks perhaps to Pirckheimer, AD corrects his misconception. In the 'Discourse on Aesthetics', the reference to Plato disappears and AD replaces *ideen* by *zufel* (in the sense of modern German *Einfälle*, 'ideas/notions that occur to one') and *vil newer gestalt der menschen vnd andrer creaturen* ('new forms/images of people and other creatures'). See Panofsky 1948, 279–80. Summers 1981, 69, suggests that the creation of new, inwardly generated ideas is a notion earlier associated with poets and that the 'unique psychology' of the poet is here taken over to explain the inventions of the painter.

11    This passage with the list of ancient artists picks up the earlier texts 51.4 and 73.1 of circa 1508 and 1511/12, and is found again in 84.2, a draft introduction written

by another hand. On the lost treatises written by artists in antiquity, see 51.4, note 4. However, none of the later adaptations takes up the idea in 73.1 of the adoption of the measurements and proportions of antique statues of Apollo and Venus in contemporary Christian depictions of Christ and the Virgin Mary.

12  *dÿ groben kunst vertrücker:* already in 73.1 AD had identified iconoclasts in the early Christian church as the 'suppressors' of art which they regarded as idolatry.

13  Jacopo de'Barbari was one contemporary artist who refused to share his technical knowledge with AD, who knew him in Nuremberg just after 1500, and possibly in Venice in 1495/6. AD was still trying to get hold of Jacopo's notebook in 1521 (see 162 and BI).

14  It seems unlikely that, as Rupprich suggests (II, 114), this barb was aimed at Alberti.

## 82.2  Knowledge and Art: Greeting 1513

The little book that now follows is entitled 'Nourishment for the Apprentice Painter'[1].

A man urgently needs to know how to do something, for the sake of the usefulness which accrues from that.[2] For this reason we should all be eager to learn. The more we know and can do, the more we become like to the image of God, who knows and can do all things.[3] You will find all kinds of knowledge. Aspire to one of them which may become of use to you, learn it, let no effort be too much for you, until you achieve what gives you joy. Desire makes us keen to know much and never lets us tire of it. For it is inspired in us from nature that we long to know all things and thereby to grasp the truth of all things.[4] Our dull minds can never attain to such perfection of all knowledge, truth and wisdom. Yet by that same token we are not entirely cut off from all manner of knowledge. If we have the will to sharpen our minds through learning and practise its arts, we may well by proper means and methods seek, learn to recognise, reach, and achieve some measure of truth. Therefore the man who sets out in his free time to learn something for which he finds himself best fitted, to honour God and profit himself and others, is doing well. We know that many such men have become experienced in all kinds of knowledge and have set down their expertise, which can now benefit us. Thus it is right that one person instructs others. Whoever does that gladly will have reward from God, and we [may profit] from him freely. The highest praise to him. There is no wrong in a man learning much, for all that some crudely deny it and say that knowledge and its arts make you proud.[5] If that were so, no one would be more proud than God who created all knowledge. That cannot be. For God is the highest good. Therefore whoever learns much, becomes all the better for it and grows in

love for knowledge and all exalted things. So it is right that a man does not neglect to learn something at an appropriate time.

You will find a goodly number who know nothing and will learn nothing, who despise learning, saying that knowledge and its arts are a source of much evil and some of them quite wicked. On the contrary, in my opinion, I insist that no knowledge is evil but that all knowledge is good. A sword is a sword and may be used to murder or to execute. Thus knowledge of all kinds is good in and for itself. What God has created is good, for all that many misuse it. If a man possessed of knowledge is honest and good by nature, he will shun evil and do what is good. Knowledge and its arts teach us to distinguish good and evil. There are men who can learn all kinds of arts, but that is not given to each and every one of us. Yet no reasonable man is so uncouth that he cannot sometime learn something to the mastery of which his love impels him. For these reasons no one has any excuse for not learning something.[6]

Now I acknowledge that in our German nation at this present time many painters are in need of teaching,[7] for they lack true knowledge of art and yet have great works to create, and for that they need to improve their technique, which is a great obstacle for them. One who works in ignorance must work with more difficulty than one who works with understanding. So let all learn to understand aright. With those who understand too little and yet would gladly learn, I willingly share my instruction in this book. But I want nothing to do with the arrogant, who imagine they are the best, and know everything, and spurn all else. Of the true artists who have proven themselves with their hand, I humbly and gratefully beg instruction for myself. Therefore, whoever wishes, let him hear and see what I say and do, and learn from it. For I hope it shall bring him profit and not stand in the way of better art, nor force him to neglect better things. This art of painting is set forth for eyes to see, for mankind's noblest sense is sight.[8] Hence I am sure that many will be eager for these things, which they will never before have seen or heard in our land. So let all who set eyes on these things make their choice of them, and seek for what promises them improvement, whatever they are looking for, provided always that truth is inherent in it. Anything you see is more believable than what you hear, and if we have both together, hearing and seeing, we grasp that all the more powerfully and it stays with us all the more lastingly. That is why I put words and works together, so that you may better mark and learn from them.

The multitude of things we see strike our eyesight as they would a mirror,[9] but our nature is such that we see one figure or image more gladly than others, even though it is not always better or worse than the rest. We like to see beautiful things, since they give us pleasure. Judgements on what is beautiful sound more persuasive when a painter expresses them than someone else.

Accurate measurement produces a good human image, not only in painting but in all the arts and crafts.[10]

It is proper for me to write a book of service to painters, for the art of painting is employed in the service of the Church, and by it is depicted the Passion of Christ and many other depictions of goodness, and it preserves the images of men and women after their death. The measurement of the earth, the seas and the stars, and much more besides, is made known and comprehensible through what painting depicts.

To acquire the art of painting truly professionally, scientifically, and aesthetically is difficult. It takes a long time and needs a very free, practised hand. So anyone who finds he lacks the skill for it should not attempt it. For it is given by inspiration from on high.[11] Art

The translated text is the fifth and longest in a sequence of six closely related autograph drafts of the introduction to the handbook on painting from the years 1511–13 (three of them dated 1513 in AD's hand). All are preserved in the BL Sloane collection.

1  BL 5230, fol. 28r. The reverse side of the leaf is blank.
2  BL 5230, fol. 29r. A narrow strip of a leaf, the reverse side blank.
3  BL 5230, fol. 32r. A half leaf, blank on the reverse side.
4  BL 5230, fols 30–31. A double leaf, written on all four sides.
5  BL 5230, fols 33–4. A double leaf, written on all four sides.
6  BL 5231, fol. 64v. The text occupies the bottom part of the reverse side of leaf 64, following the text R II, p. 404 (Lehrbuch der Malerei III, A, no. 2), also datable to 1513.

R II, 106–7, 129–33

All six texts show extensive emendation and revision by AD, and significant examples of this are given in the notes below. Drafts 1, 3 and 4 have been scored through, as rejected, by AD. Draft 2 and 6 are brief fragments. Draft 5 is demonstrably a synthesis of material and to some extent formulations from 1 to 4, and has not been cancelled. However, it breaks off unfinished and was clearly not seen as a quite final version. The notes aim to give a general though not exhaustive picture of the interrelationship of the successive versions.

NOTES

1  *ein speis der maler knaben*: the title was added subsequently, in AD's hand. The German noun *spîsa*, a Christian loan-word (eighth/ninth century) from Latin *expensa*, meant in early monastic usage 'ration of food given to the poor'. The sense it has here, 'nourishment for the mind', derives from the biblical use of food as a metaphor for spiritual nourishment through the divine Word, a metaphor used already in the ninth-century bible paraphrase of Otfrid. See DWb X, I, 2085 & 2097f.; *Companion to the Bible*, 95 & 506f.; Curtius 1953, 134–6.

2  In the manuscript, the sentence replaces AD's crossed-out original: 'No man should be without knowledge. For to know something is always very good', which was drawn from text 1. AD's early modern German verb *künen* (modern *können*), combines the senses 'know' (compare German *kennen*, Scots 'ken') and 'can/be able to

do something'. In this text it most frequently denotes the semantic area of knowledge, but often connotes the sense 'knowledge applied in action'. Compare the related poly-semy of *kunst* as 'knowledge' and 'artistry, artefact' (see introductory note on Translation). Hence at different points in the text, *künen/kan* and *kunst*, plural *künste* are variously translated as 'know/know how to do something', 'knowledge and its arts', 'knowledge of art', 'art, arts and crafts'.

3    *Dan dardurch werd wÿr destmer vergleicht der pildnus gottes, der alle ding kan*: the sentence occurs in virtually the same form in texts 1–4 and is fundamental to AD's conception and justification of art. It derives from the biblical idea of man being created in the image of God (Genesis 1:26f.), the corruption of the divine image through sin and its restoration through the incarnation of Christ. As creator of artistic images derived from nature, the artist possesses a measure of the creative power of God. See also 82.1, note 10.

4    Rupprich II, 107 points out that the first sentence of the second chapter of the *Imitation of Christ* (*Imitatio Christi*) of Thomas à Kempis (1380–1471) reads: 'Mankind is by nature eager for knowledge.' The *Imitation* was much used in late medieval popular piety.

5    Pride was the original sin of Adam and Eve, which led them to taste the forbid-den fruit of the tree of knowledge in Paradise. Text 2 at this point has a more complex theological disquisition which AD did not then integrate into later drafts: 'some…dare to say that knowledge of the arts makes you proud. That cannot be. For knowledge gives rise to humble good will.[a] But customarily, those who know nothing also have no wish to learn anything, they despise knowledge and art, say that much evil comes from them and some are quite wicked. But that cannot be. For God has created all knowledge, thus all of it must be rich in grace,[b] full of virtue and goodness. So I consider all knowledge and arts to be good. A sword that is sharp and keen, may that not be used for judgement or for murder? Does that make the sword better or worse?[c] Likewise in knowledge and arts. A man of good and honest nature is made better by much knowledge. For knowledge leads us to distinguish good from evil. Therefore I consider it good that a man take account of himself, to tell what he is best skilled for, so that he may set out to learn it.'

[a    gutwillikeit: the word occurs in the eighth/ninth-century German Christian vocabulary, as a loan translation of Latin benevolentia (DWb IV, I, 6, 1485–9). AD most likely knew it from fifteenth-century mystical and devotional writing. He uses it again in the dedicatory preface to the Four Books of Human Proportion (257.3).

b    genaden reich: another coining of fourteenth/fifteenth-century mystical writers DWb IV, I, 5, 582f.

c    The argumentation here closely resembles that of the dedicatory prefaces to the Instruction on Measurement (213) and the Four Books of Human Proportion (257), where AD deploys it against early Reformation iconoclasm. It anticipates Martin Luther's view of art as adiaphora, neither inherently good nor bad, and belonging to the realm of nature, not of the metaphysical (213.1).]

6   Text 1 adds: 'Therefore, should someone teach and demonstrate something which you can learn from, something which is necessary for general use, and in a way that forces no one to think it better to disregard it, then that is good, that you can listen to, see and take in.'

7   Only texts 4 and 5, which are both headed *Salus* 1513, have this paragraph, which AD took up again and developed further in drafts of the introduction to the planned 1523 printing of the treatise on human proportion (181). So it clearly belongs to a late stage of this particular sequence of drafts. The concern to raise the technical *niveau* of painting in Germany reflects AD's concern, implicit since his earliest theoretical writing around 1500 and explicit since his return from Venice in 1507, to transmit Renaissance aesthetic theory and knowledge of perspective and proportion from Italy to Germany. Text 6, headed 'On the usefulness of teaching', has a closely related formulation of the first two sentences of this section.

8   See 82.1, note 3.

9   This observation is stated rather more coherently in 82.1: 'In this respect our sight can be compared with a mirror. For all kinds of forms we are presented with pass before our vision, such that all we see enters our mind through our eyes. Our nature is such that we see one figure or image more gladly than others, even though it is not necessarily better or worse than the rest.'

10   This final section, pointing forward to the instruction on human proportion and justifying painting in terms of its religious function, appears already in 82.1.

11   See 82.1, note 6.

# 83   The Nature of Beauty and the Judgement of Painting

If I light a flame, and you all feed it with your art, in time a fire will be fanned which shall shine across the whole world.[1]

Above all else we delight in seeing a beautiful human image. Therefore I shall begin with the measurement of the human body. Thereafter, if God allows me time, I shall write and demonstrate other things. I know well that the envious will not keep their poison to themselves, but that shall in no way hinder me. For great men have often enough had to suffer similarly. We have many kinds of human forms, due to the four complexions.[2] However, when we are to paint a picture, and the responsibility is ours, we should do it as beautifully as we know how to, as is right and proper. For creating many different human forms is not a trifling art. Deformity is of its own accord constantly weaving its way into our work. It is not possible for you to make a beautiful image by copying from one person alone.[3] There is no single being

on earth which embodies all beauty and could not be still more beautiful. There is no living person on earth, who can say definitively how the most beautiful human form might look. No one but God knows that. Judging beauty is a matter for debate. One must incorporate beauty into everything as is appropriate. For in all things we see some feature that is beautiful, whilst in another thing it would not be beautiful. What is beautiful, what is more beautiful, is hard for us to distinguish. It is quite possible for two different pictures to be painted, neither resembling the other, chalk and cheese, and for us not to be able to judge which is more beautiful. What beauty is, I do not know,[4] even though it attaches to many things. If we want to bring beauty into our work, then that is a hard task, we must assemble it from near and far and, especially with the human form, right through every single part of the body. Often you can examine two or three hundred people and still scarcely find one or two elements of beauty that are usable. So, if you wish to achieve a good picture, you will need to take from these the head, from those the breast, arms, legs, hands and feet, and so on, seeking out all parts of every limb. From many beautiful things you pick something good, exactly as honey is collected together from many flowers.[5] Between too much and too little there is a proper mean; try to strike that in all your works. When it comes to calling something 'beautiful', I want to define that here in the way some will define what is 'right': that is to say, what all the world considers to be right, we too shall take as right. In the same way also, what all the world reckons is beautiful, we too will take as beautiful, and make every effort to achieve it.[6]

I do not make a great boast of the system of measurement I am describing, even though I do not regard it as the worst either. Nor do I set it up with the idea that it has to be thus and not otherwise. However, by this means you may look for and find a better way. Everyone should be thinking of further improvement in his work. But let everyone take my method as a model until he is truly taught a better one. For one man gets closer to the truth than another, according to whether his understanding reaches a higher level and he has a beautiful person before him as a model to copy.[7] Many artists simply follow their own preference. They are mistaken. So let everyone look to himself, to ensure that the bodies he sees do not blind his judgement. For every mother is pleased with her own child, and it follows that many painters paint what is like themselves.[8] There are many variations and sources of beauty. Whoever can distinguish between them deserves all the more to be believed. The more flaws that can be eliminated, the more beauty there remains in your work. Let nobody set too much faith in himself,[9] for many notice more than just one does, albeit it is possible that sometimes a single one understands better than a hundred others, although that happens rarely. Utility is a part of beauty.[10] Thus what is not useful in a human being is not beautiful. Avoid superfluity.

The harmonious relationship of one thing with another, that is beautiful. This is why limping is not beautiful. Even in dissimilar things there is a great harmonious comparability. In future, many will write about these aspects. For I am confident that many an excellent man will come forward who will write about this art and teach it better than I with my meagre understanding. Would to God, were it possible, that I might even now see the good work of those not yet born, to my own improvement.[11]

Good advice will benefit you in a work which aims to be good. So if you take advice on matters of the knowledge of art, take it from one who has advanced understanding of such things and whose handiwork bears witness to that. However, every man may do that too, and it is a good idea, when you have done work and are happy with it, to place it before common, uneducated folk and let them judge it, for they will usually spot anything really clumsy about it, even though they do not understand it properly. If you find what they say is true, you can improve your work.[12]

There is much more that could be written about these things, but for brevity's sake I shall forgo that and start upon the matter of constructing the external form of men and women.[13]

The following texts which Rupprich classifies under separate headings (II, II, B 6 & II, II, B 7.1–3) are in fact variant texts belonging to the same sequence of drafts.

1  BL 5230, fol. 35r. Single leaf; the reverse side has the description of the *Teiler* (see note 13).

2  BL 5230, fol. 21r. Single leaf, reverse side blank.

3  BL 5230, fol. 22r-v, 23r. One single leaf, written on both sides, and a half leaf, reverse side blank.

4  BL 5230, fols 26–7. Two leaves, written on all four sides. The description of the *Teiler* begins on 27v and continues on the two leaves Nuremberg, GNM, Merkel Dürer MS, fol. 5–6, concluding on the single leaf Nuremberg, Stadtbibliothek Cent. V. App. 34v/v, fol. 115r-v.

R II, 115–16, 117–26.

Text 1 is a very closely related version of the last quarter of text 4. Text 2 is brief, close to 3 and 4 in its first and last sections, but significantly divergent in its middle part. Text 3 is very closely related to text 4, but ends just after the point where text 1 begins; both these texts are heavily emended by marginal corrections. Since text 3 is the only complete version in this sequence, it is the one chosen for translation. All variant versions draw strongly on the early drafts of the introduction to the handbook on painting, notably on 51.4.

NOTES

1  The sentence is drawn from 51.4, 'On Painting', 1508/9 (see there, note 3).

2  For the complexions and temperaments, see 51.3.1, note 3, and 51.4, note 10.

3  The section beginning 'It is not possible' and ending 'hard for us to distinguish' is taken almost verbatim from 51.4, 'On Beauty'. The passage expresses AD's abandonment of the idea of the absolute expression of beauty in a classical image, the 'well-made body' (*homo bene figuratus*) which he had explored on the basis of the canon of Vitruvius in drawings of the years immediately after 1500, and of antique models like

the Apollo Belvedere and the Medici Venus, studies which culminated in the engraving of Adam and Eve in 1504.

[Bonnet 2001, 274f.; Hinz 2011, 21–5]

4 AD quotes from 51.4 his dictum *Waß aber dy schonheit seÿ, daz weis jch nit.*

5 This is the 'Zeuxisian' notion of the 'perfect composite' of beauty, based on the anecdote retailed by Pliny of how Zeuxis, commissioned to produce a Juno, selected the best parts of five maidens from the town of Croton (51.4, note 11; McHam 2013, Plinian Anecdotes 161). The story was a commonplace already in Antiquity, quoted for instance by Cicero (*De Inventione*, II, 1,1). Alberti discusses the Zeuxisian method in *De Statua* (Bätschmann/Schäublin 2000, 168), as a rationale for his tables of dimensions of the human body. Rupprich (II, 125) points out that the honey metaphor was applied by humanists to the *florilegium*, the selection of choice quotations from the poets of antiquity.

6 The idea that a criterion of beauty can be arrived at by the consensus of reasonable people is also of classical origin and endorsed by Renaissance writers. For Lucian's anecdote of Phidias, see 51.4, note 8.

7 *schön perschan for jm hat, darnach er kunterfett*: This early form of modern German *Person* is surprisingly frequent in AD's vocabulary. It enters the late medieval vernacular from Latin *persona* and – in the form *persan/perschan* as here – from French *personne* in its original sense of 'actor's mask, theatrical player' (for instance, in manuscripts and prints of Nuremberg Shrovetide farce). Here AD uses it in the sense of 'model', chosen for his/her individual appearance. See DWb VII, 1561f. See also 103.2, note 4, and 103.7 note 5. On AD's other terms for artist's model, see especially 151.1, note 24. The debate about whether AD used live nude models is unresolved (see Bonnet 2001, 297–301; Demele 2012, 71–107).

8 *vill moler machen daz jnen geleich ist*: compare the similar statements by Leonardo da Vinci. 'It is a common vice of painters to take delight in making things similar to themselves…when [our judgement] has to reproduce with the hands a human body, it willingly reproduces that body of which it was the original inventor.' 'I have known some [painters] who in all their figures seem to have portrayed themselves from the life…thus each peculiarity in a painting has its prototype in the painter's own peculiarity' (Kemp/Walker 1989, 120 & 204). In Tuscan Italian, the idea that *ogni pittore dipinge sé* is proverbial and underlies Leonardo's interest in the theme. The painter's 'judgement' he defines as 'that part of the soul that rules the formation and movement of our body' and 'is so powerful that it moves the painter's own arm and makes him copy himself, since it seems to the soul that this is the true way to construct a man, and whoever does not do so, commits an error'. Gaspari Visconto wrote a sonnet (1497/9) in which he attacks Leonardo's *automimesis* which, he claims, drives the painter in his Last Supper to make all Christ's disciples images of himself. See Kemp 1976, Kemp/Walker (above) and Zöllner 1992, 137–48. The idea that 'every painter paints himself' is of course especially piquant for AD, the compulsive self-portraitist.

9 Now AD takes up text 1 (BL 5230, fol. 35) and follows it closely to the end.

10   This and the following five sentences derive from 51.4. On the idea of *Vergleichlichkeit*: the comparability and consensus of parts, and the resultant harmony of the whole, see 51.4, note 6.

11   Here AD omits a striking passage in text 2: 'Ah, how often I see great arts and fine works in my sleep, the like of which do not occur to me in waking hours. But when I wake up, they have fled my memory.' Among the oldest epigrams in the Greek Anthology (Diehl 3) are the lines said to have been written by Parrhasios (mid-fifth century BC) on his painting of Herakles: 'Now you can see him, exactly as he came / To me Parrhasios often in my dream' (transl. Peter Jay). See further 170, Willibald Pirckheimer's letter of 1522 to Ulrich Varnbühler, on AD's interest in dreams, and 209, AD's description of an apocalyptic dream vision (1525). [Massing 2004b]

12   This discussion of the need for expert criticism by fellow artists (see 82.1–2), and the value of comment from ignorant but commonsensical laymen, are picked up from 51.4 and are possibly influenced by Leonardo (Kemp/Walker 1989, 203), and Alberti (De Pictura III, 62), who themselves draw on Pliny (*NH* 35, 84).

13   The text which follows, starting on leaf 27b, broaches the main content of the handbook on painting by describing the *Teiler*, the 'divider', a ruler and measuring rod, AD's basic technical instrument used for quick and accurate proportional division of male and female bodies.

# 84   Two Drafts of the Introduction to the Handbook on Painting not Written by Dürer Himself

## Introduction

AD was given to protestations of his own inadequacy, not as painter certainly but as theorist and as writer on art. These are different in tone and sincerity from the *captatio benevolentiae*, the ancient and in the Renaissance still conventional rhetorical trope of the 'modesty formula', pitched to solicit the indulgence of the reader. The draft introductions of 1512–13 and the draft dedicatory epistles of 1523 provide many examples. 'For myself I rate my knowledge of art quite low'; 'Let no one set too much faith in himself'; 'I am confident that many an excellent man will come forward who will write about this art and teach it better than I with my meagre understanding'; most poignantly perhaps: 'Ah, how often I see great arts and fine works in my sleep, the like of which do not occur to me in waking hours. But when I wake up, they have fled my memory.' This sense of cultural and personal inadequacy must have had various roots, in AD's deficient education, in his lack of Latinity, in the overbearing erudition of Pirckheimer. It appears to have been above all a lack of confidence in his ability to formulate what he knew, at least as much as diffidence with regard to his professional knowledge, for none of the alien, ghost-written versions of his statements on

art add anything at all to the content of his writings. Only Joachim Camerarius, in his Latin translations of the treatises on measurement and human proportion, showed anything like an equal grasp of their detailed meaning. And AD's uncertainty about the linguistic form of his writings can to some extent at least be blamed on the shortcomings of the written German vernacular of the early sixteenth century, as yet largely untried as a medium of sophisticated discourse on art theory and aesthetics.

The two 'alien drafts' by unidentified 'ghost-writers' of the introduction to the handbook on painting are quite different in style and compass. The second (84.2) – though it should be noted that neither is precisely dateable – is more easily explicable. AD himself, or possibly a humanist acquaintance reading his drafts, seems to have wanted to give his introduction more polish, a style more appropriate to humanist expectations of the preface to a work of serious science. The result – just as in the later case of the dedication to Pirckheimer of the *Four Books of Human Proportion* – AD must have recognised as a disaster, an otiose exercise in creating a German equivalent of neo-Latin rhetoric, which chokes all coherent sense in convoluted verbiage and tangled syntax. The first (84.1) is focused more narrowly on Euclidean optics and on advancing the claim that ancient and modern science are crucial to the status and truth-to-nature of contemporary painting. It is linguistically and stylistically unacceptable because of its ineptness as much as its rhetorical inappropriateness. It is characteristic of German texts produced by humanists whose written language is otherwise almost exclusively Latin. In both cases, the translation sets out to convey a measure of the strangeness of the texts, whilst tempering this in the interest of giving the reader some grasp of what the ghost-writer may have wanted to convey.

## 84.1

I have heard it said that one of the Seven Wise Men of Greece taught that measure in all things, ethical and natural, is the best,[1] for which also the Most High is highly praised for having made all creation in number, weight and measure.[2] It is beyond doubt that arts and handiworks[3] are esteemed the more noble and worthy, the more they necessitate measurement, and these are deemed supreme, second only to the divine arts like theology, metaphysics and natural philosophy. There is no art which needs measurement more and in such manifold ways and forms as the art of painting, which not alone requires geometry and arithmetic, the origins of all measure, but still more those other arts dependent on measurement, namely perspective, the art of deceiving the eye,[4] catoptrics, geodesy and chorography.[5]

*Nobiliores forme sunt mathematice in forma sphere.*
*Maxima pars creaturarum.*[6]

Given that man is of all creatures the most noble, and since producing good images of the human being is the chief aim, and in all paintings the most

practised, as also no animal on earth sees anything more dearly than its own like, so man shares the same nature, just as any being feels for himself.[7]

It being the case that the measurement of the human being is at times difficult to comprehend, not only because the human figure is composed neither of straight lines nor circles, but consists of crooked, unruled lines, it is sometimes difficult to write about and explain it, as students of geometry are well aware. For the books of Euclid, the prince of geometry,[8] describe only straight lines and circles, and the bodies these configure, such as the five regular bodies of Plato,[9] cones and cylinders, and do not teach any others besides. Further, that same measure is not how one is to draw or paint it but what it contains or may circumscribe.

The horse is man's most useful animal, which he most desires for his pleasure and needs for his labours.[10]

*Catoptrics, specularia,*[11] *optics, perspective.*

Our art is not of use only to painters and image-makers, but to all who are desirous of comprehending the common dimensions of human stature by measurement.

Thereby can be measured the height of mountains, the area of fields, forests, water and landscapes, also houses, roof vaults, columns, points, circles, the depth of wells, valleys and pits, likewise the dimensions of shadows of darkness, the illumination of bright light. And that not only by simple straight lines, but by the straight lines from the eye to objects, by reflected lines of sight, for instance from water, mirrors or other polished surfaces, when the thing seen is positioned on one side and appears on the other, through broken lines of sight, as when a thing is seen through media of unequal kind, like air and water, or air and glass, or other transparent materials of unequal kind, when it is then seen refracted because the same material is stirred. Also the greatest of all is that the painter does not use this art by means of simple common measurement, but draws all things that are seen towards the eye in a cone, whose point is in the eye and whose base is the object seen, the which measurement, as those highly versed in geometry know, is not achieved without particular difficulty.[12]

BL 5230, fols 16–17. Two leaves, written on the upper one third of the first side of folio 16, and on both sides of folio 17. The script is neither that of AD nor that of Pirckheimer.

R II, 127–8

NOTES

1    Cleobolus of Lindos, one of the so-called Seven Sages (sixth century BC), taught the 'golden mean', or 'avoid extremes'. AD may have known Celtis's edition (1500) of poems by Ausonius (circa 310–393/4) on the Seven Sages.

2    Wisdom of Solomon 11:21, quoted by AD in 73.1.

3   *kunst vnd würkhung*: DWb XIV, II, 593, B 1.a, gives a late medieval and early modern German meaning of *wirkung* as 'craft, handiwork'. AD uses this formula to encapsulate the – for him ideal – combination of theoretical knowledge and practical skills. See also 103.7, note 6.

4   In ancient Greece the expression denoted the pragmatic reproduction of reality in painting, as opposed to mathematically based perspective. The phrase – Italian *l'inganno degli occhi* – is used again for this 'practical' perspective.

5   Catoptrics: the study of the optics of mirrors and reflection; geodesy: measurement of the earth; chorography: geographical description of lands and regions.

6   'In mathematics the more noble forms are spherical. The chief of creatures.' Notes to prompt the writer?

7   The syntax is muddled and the sense unclear, but compare 83, note 8.

8   Perhaps originally because his Greek name Eukleidēs meant 'good glory'. For AD's reception of Euclid, see 51.2.1/2.

9   The Platonic bodies are the five regular geometric solids described by Plato in the Republic VII, 10 and Timaeus 20f, on the basis of older Greek geometry: tetrahedron, hexahedron, octahedron, dodecahedron and icosahedron, all of which are bounded by like, equal and regular planes.

10   This reference to a planned section in the handbook on painting on the proportions of the horse indicates that the text predates AD's decision in 1513 to concentrate on the treatise on human proportion (R II, 55–7 and 351–3). Hans Sebald Beham attempted to publish a work based on AD's notes but was thwarted by Agnes Dürer in 1528 (278–9).

11   *specularia*: synonym of *catoptrica*, 'the science of mirrors'.

12   According to Euclid, the eye sees objects that are within its 'visual cone', which consists of straight lines, that is visual rays, projecting outwards from the eye. See 51.2.2.

## 84.2

All the eager and energetic powers of the mind are capable in the end of growing weary of anything at all, however practical, however pleasurable it unfailingly appears, yet which by daily resort, by much and excessive use, sates and suffices us.[1] Only the desire to know much (which is implanted by nature in each and every one of us) makes us immune to such satiation and is not in the slightest prone to any such weariness.[2] It being so that the human heart can achieve no kind of satisfaction of knowledge or arts, save in some small part, even so it is granted us to translate these in a limited way into accessible knowledge and realisation, whereby the great extent of still concealed ignorance may in some measure be countered, and those who come after us given cause to love us and to pursue our quest. Now the learned inform us, and daily experience confirms, that the things which merely enter our ears like a gentle

breeze affect and incite us less and more lethargically than those which faithfully submit themselves credibly and visibly to our eyes. It follows from this, that the art and practice of painting, or the carving of choice materials, are not ignoble and are not to be numbered among the lowliest of the estimable arts. For not only do they exhibit curious and penetrating acuity to the inner eyes of the mind, but also delightful and pleasurable enjoyment and instruction to the physical senses, their ultimate end is for the very most part founded on the emulation of the essential in things. Thus, the nearer they approach conformity to nature and life, the more they possess of perfection, the more they are to be regarded as in some degree like to the divine. This may come about more by virtue of proportion than any others of their countless attributes. All of which the Ancients of bygone centuries observed not unfruitfully, especially amongst the Greeks, and the Romans also more than other nations. They praised, loved and rewarded the craftsmen of those peoples, among them Phidias, Praxiteles, Apelles, Polyclitus, Parrhasios, Lysippos and other excellent men, who assiduously researched and explored the fundamentals of this art, and finally with their outstanding works displayed it gracefully, wondrously and ever artfully, and revealed it to the light of day, whereby they not only attained to renown, wealth, and popular affection, but moreover secured for themselves powerful liberality, their immortal memorialisation by noble, estimable historians and poets, while some were elevated to the summit of lofty honour, by the erection of commemorative statues.

While I contemplate all this in my mind, aware of the extent of the inadequacy of our own times, which so ignorantly despise all that glory, splendour and productivity, I am no little distressed that, those rewards apart, art is now loved and sought after, let alone understood, by so few, just as if an exquisite brightly shining light were as good as dimmed, snuffed out and extinguished. Whether the long drawn-out attrition of many elapsed years or the despicable lethargy of negligent men is to blame, I leave to the judgement of each individual to assess. Thereby I am now not merely motivated but plainly impelled, with all possible vigour, to ignite again this still faintly glimmering spark, nearly drowning in a sea of ignorance, so that the lost might find the right path, the feebly blinking true vision, those thirsting for knowledge of art a gushing spring. And to support and strengthen the tottering, near derelict practice of art I have undertaken with divine help this description of systematic, aesthetically pleasing proportion, not inconsistent with the Ancients, so that in some measure I shall have fulfilled the obligation of brotherly love which the laws make incumbent upon us. To that end, lest it remain merely innate in me, lest this fruitful seed sown in thorny infertile earth remain disregarded by many, I now communicate this my diligently acquired experience, long heartfelt effort and labour, to all present and future, in the hope of binding them to me (unknown to them as I am), in eternal bonds

of favour, love and friendship. However, since the all-pervasive deadly venom of slanderous forked tongues is ever ready to spit forth, so that all works, however good and useful they be, are thoroughly besmirched and swollen with infection,[3] yet I am nonetheless hopeful that this book of mine may escape such fatal injury, thanks to the antidotal properties of the unscathed unicorn of more numerous and more just assessors.[4]

BL 5230, fol. 40–41. Leaf 40 is written on both sides, the reverse of leaf 41 is blank. The translated text occupies the whole of 40ʳ, while 40ᵛ and 41ʳ contain the introduction to the use of the *Teiler*. All is written in a hand which is not that of AD nor that of Pirckheimer. As Rupprich insists, the style of the draft introduction also does not point to Pirckheimer's authorship.

R II, 134–7

NOTES

1   The author's contorted syntax, contrived rhetoric and orotund vocabulary frequently obscure the intended sense of the text. It does not seem helpful to document in these notes all the many problems that present themselves to the translator, merely to admit that my version involves a degree of guesswork.

2   Based on the beginning of text 82.1. Throughout the author draws on AD's earlier drafts and elaborates them in overblown Latinate rhetoric. It would be otiose to index all the source passages.

3   It appears to be an obligatory feature of the humanist preface or dedicatory epistle for the author to guard himself against the envy of rivals and the spite of hostile critics. The same theme recurs in the model draft of the dedication to Pirckheimer of the treatise on Human Proportion (182.1), also written by an unidentified humanist friend of AD in 1523. In curt ripostes (182.2 & 4) AD insists that the dedication should make no mention of envy.

4   In medieval allegory and iconography, the unicorn was the symbol of chastity and also of the purity and spiritual strength of Christ. Its horn was prescribed (when available) as a specific against poison. In *The Life of Mary*, AD depicts, in the frieze of the temple arch in the woodcut of the marriage of Mary and Joseph, the battle between lion, the mount of the devil, and unicorn, ridden by chastity (SMS 170.6).

# 85 Writings on the Theory of Art. Draft for the Planned Chapter on Colours in the Handbook on Painting

## Introduction

The text is the only extant part of AD's planned chapter on colours in the handbook on painting (contents lists, 51.3.3–4). An idea of what the whole chapter might have comprised may be constructed from Alberti's *De pictura* (I, 9–11) and from Leonardo da Vinci's writings on painting (Kemp/Walker 1989, 70–84). The particular subject here, the darkening of colours in shade, is treated by both. Alberti also refers to the 'saturation' of colours in shadow (I, 11: the Latin verb is *imbuere*), and Leonardo treats the subject at length (73–6), as he does also the principle of the 'conformity' (AD's *Vergleichlichkeit*) of colours. Incomplete as AD's draft clearly is, it is not evident whether he wrote more on the topic before he abandoned the larger plan of a comprehensive book on painting.

The recipe for ultramarine (85.2) has no known connection with the handbook. It is undatable and added here simply because this seems an apposite and available context for it. For a thorough discussion of AD's colours, see Goldberg/Heimberg/Schawe 1998, 55–88.

## 85.1 On Colours

If you wish to paint in the sublime manner,[1] such that it is to deceive the eye, you must be very well instructed about colours, and when painting, keep them firmly apart, that is to say, when you are painting two coats or mantles, one white, the other red, and you are shading[2] them where there is a break, since in everything that creases and bends away from the eye there is light and dark. If that were not so, everything would look smooth and even, and in such a case one would not be able to recognise anything except merely how the colours are differentiated from one another. Thus if you are shading the white mantle, it must not be done with a black paint, as you would with the red one. It would be impossible to give a white fabric such a dark shadow as a red one, for they would not harmonise with each other.[3] Except that where no light can reach, all things are black, as when in darkness you cannot recognise colours. Therefore, if you're dealing with a white material, where you correctly use pure black for shading, that is not to be criticised. But it is a rare occurrence. You should take care, when painting something in a colour, whether red, blue, brown, or mixed – whatever – that when it is in the light, you don't make it too light, such that it loses its real character.[4] Example: an ignorant

person looks at your painting, where there's a red garment, and says, 'See there, my good friend, how that garment is such a lovely red in one place, and in the other – there! – it has white or pale patches.' That is a flaw and you haven't done the thing justice. In such a case you must paint the thing red, so that it is red all over, the same with all the colours – and yet it must still look sublime. Proceed also the same way with shading, so that people do not say a fine red has been dirtied with black.[5] Therefore be careful to shade every colour with another that is harmoniously comparable with it. As when I lay a yellow colour: if it is to stay true to itself, you must shade it with a yellow colour which is darker than the main colour. If you set it off[6] with green or blue, then it loses its character and can't be called yellow any longer, rather it turns into a shimmering colour,[7] like you find in shot silk fabric, which is woven from two colours, brown and blue, brown and green, sometimes dark yellow and green, also chestnut brown and dark yellow, then blue and brick red, also brick red and violet, and many such colours, which you can see before your eyes as you are painting them. Wherever the material breaks, where it folds or turns away, the colours divide so that you see them for themselves. You must paint them accordingly. However, where they lie flat, you only see one colour. But nonetheless, if you are painting one of those silks and are touching[8] with another colour, such as brown with blue, then you must set off the blue with a more saturated blue, where it needs that. It often happens also that when this silk is seen in darkness, it loses its brown colour, as when a person stands in front of the one wearing such a dress. Then you must set off this brown with a more saturated brown, and not with the blue. At all events, no colour must forfeit its essential character through touching.

BL 5230, fol. 7ʳ. Single leaf, the reverse side blank

  R II, 393f.

## NOTES

1   *Item so du erhabn willt mollen*: on *erhaben*, AD's German loan translation for Italian *sublime*, see 29.9, note 4. His advice on the use of colours in painting presupposes that the artist is working at the highest, most refined aesthetic and technical level. It was his panel painting of the *Feast of the Rose Garlands* that earned from his Venetian colleagues the Italian epithet *sublime*, precisely in respect of its use of colours.

2   *wen dw sie schettigst*: DWb VIII, 2273, gives as earliest occurrence of the verb a poem by the later fourteenth-century poet Suchenwirt, describing a tent cover made of shot satin, *bla in bla*, 'blue with blue', like the shot silks AD goes on to discuss. The verb is modern German *schattieren*.

3   *vnd wurt sich pey ein ander nit vergleichen*: the concept of *Vergleichlichkeit*: the comparability and harmony of parts, and the harmonious composition of the whole of an

artwork arises first in 51.4 (note 6), see also 83. Leonardo writes on 'combining colours [in proximity] with each other in such a way that one gives grace to the other' (Kemp/Walker 1989, 72f.).

4  *also daz sie aws jrer art schlach*: a figurative use of the expression *aus der Art schlagen*, which circa 1500 already had the modern sense, 'not to take after anyone in the family', see DWb I, 569.

5  *mit schwartz beschissen*: AD's expression is more graphic but not yet as vulgar as it would be in modern German (*beschissen* from *Scheiße*).

6  *absetzen*: according to Rupprich a painter's technical word. Its sense is close, if perhaps not quite identical, to English 'set off' in the sense of 'use or serve as an adornment or foil'.

7  *ein schilrette farb*: the verb *schillern*, derived from *schielen*, 'squint', had by the end of the fifteenth century acquired the meaning 'have a shimmering, iridescent colour', from silk textiles woven with separate colours for warp and weft, which give the impression of having an indeterminate colour.

8  *duschirst*: the verb *tuschieren*, from French *toucher*, meant 'apply a colour with a light touch of the brush'. In modern German it survives only with prefix, *retuschieren*, 'touch up'. In DWb XI, I, 2, 1927f., AD's text is cited as its earliest occurrence. For English 'touch' used in the same sense, see SOD II, 3348.

### 85.2  Instructions for Grinding Ultramarine

The above-mentioned Albrecht Dürer the Younger gives in his manuscript a recipe of his devising for grinding ultramarine blue, namely with nut oil, refined to utmost purity, in a wooden pyx[1] with a base the thickness of a hand, and it should be ground as finely as possible; you should oil the ground on which you intend to paint, and then apply an underpainting of pure, smooth[2] ultramarine.

Rupprich derives the text from Campe 1828, 182, and Lange/Fuhse, 390. It paraphrases, allegedly, an entry in a vanished copy of the Family Chronicle (or more likely a lost page of the Personal Record?).
   R I, 216

NOTES

1  *ein hulzens püchsen*: what is meant is a small cylindrical wooden box. Etymologically, German *Büchse* (and English 'box') derive from Latin *pyxis* (see also *Buchsbaum* and 'boxwood'). On the technique of grinding pigments, see Nash 2008, 181.

2  *mit schlechten ultermarin*: in its older usage, *schlecht* covers both 'simple' and 'smooth'.

COMMENTARY

On the quality of ultramarine and its high cost, and on AD's use of ultramarine blue in underpainting, see his letters to Jakob Heller, 47.3, note 6; 47.4, note 5; and 47.7. In Venice he could have bought it from the *vendecolori*, specialist shops dealing in pigments (Welch 2005, 12, 151). Ultramarine was the one colour AD uses that was not obtainable in Nuremberg pharmacies (Burmeister/Krekel 1998, 101). A recently rediscovered late fifteenth-century manuscript which appears to have belonged to AD contains, together with instructions for making invisible ink, painting on glass and alchemical procedures, other recipes for painter's colours. See Sauer 2009.

# 86   Accounts of Duke Frederick the Wise of Saxony: Account of the Ducal Chancellor Degenhard Pfeffinger for 1513

5 gr. gratuity to Albrecht Dürer's boy, by whom he sent me a number of copperplate engravings, for bringing to My Gracious Lord and presenting on his behalf.

R I, 244–5, on the basis of earlier printed editions.

NOTE

The most striking engraving dated 1513 is *Knight, Death and Devil* (S E 71, SMS 69). Other engravings of possible particular interest to Duke Frederick are *Sudarium Displayed by Two Angels* (S E 69, SMS 68), also 1513, and the drypoints of 1512, *Holy Family* (S E 55, SMS 66), and *St Jerome by the Pollard Willow* (S E 56, SMS 65).

# 87   Nuremberg City Accounts

*[16 February]*
Requisition 13, Burgomasters Anton Tetzel senior and Michael Beheim, fourth day after Invocabit Anno 1513.
Item LXXXV gulden, I new pound, X shillings to Albrecht Dürer for two large panels, the portrait of Emperor Charles and the figure of Emperor Sigismund to be painted for the Reliquary Chamber.

State Archive Nuremberg, year register for 1513
  R I, 247

COMMENTARY

The fee of a little over 85 gulden is not particularly handsome for two high-quality panels in a commission of considerable prestige. This adds force to the argument that it is the second instalment of a total payment of 145 gulden, following upon the 60 gulden paid in 1511 (69). The entry says that the portraits are *zu malen in die heilthums kammer*, that is: 'are to be painted', however there is no reason to believe that they were not finished by this date. Invocabit is the first Sunday in Lent, named after the introit to the mass (Psalm 89).

## 88   Georg Beheim, Inscriptions in Books of Dürer's Prints

In a bound copy of *The Life of Mary*:

> *[Nuremberg 1513]*
> This book belongs to Georg Beheim, Licentiate in Theology. The gift of Albrecht Dürer.

In a compendium volume of *The Apocalypse*, *The Life of Mary* and the *Large Passion*, in the versions of 1511:

> This book belongs to Georg Beheim, Licentiate in Theology, given by Albrecht Dürer.

The volumes are now in the Albertina, Vienna (88.1) and the GNM, Nuremberg (88.2).
  R I, 462; III, 293

NOTE

For Georg Beheim, brother of Lorenz Beheim, see BI and Schaper 1960.

## 89   Letter of Lorenz Beheim to Willibald Pirckheimer

*[Bamberg, 10 May 1513]*
Greet Frau Kramer, Lazarus and Albrecht.

PBr 2, 228–30, letter 242. Latin text
  R I, 257

# 90 Works of Art

## 90.1 Bookplate or Design for a Window. Pen drawing with watercolour. W 702, S D 1513/25

With date 1513 in AD's hand. Inscription on a scroll above the head of a crane, standing with wings outstretched:

GI GI GIG

The size (441 × 339 mm) and style are like those of AD's cartoons for windows. It might be a heraldic device. The inscription is meant to convey the crane's call. Colour reproduction in Rowlands 1988, plate 11.

## 90.2 Bookplate or Design for a Window. Charcoal drawing, rubbed out and redrawn in pen, with watercolour. W 703, S D 1513/26

Date 1513 in AD's hand. Inscription on a scroll above a lion, with claws extended, crouching on a crown placed on the headless rump of a bird:

FORTES · FORTUNA · IVVAT

(Fortune favours the Brave)

Although smaller (270 × 215 mm), it is in the same style as 90.1 and these are possibly together the designs for a pair of windows. Variants of the motto occur in Terence (*Phormio* I, 4), Virgil (*Aeneid* X, 284) and other classical authors. Rowlands suggests that the two drawings may have been intended as emblems for use by jousters in a tournament.

[Anzelewsky/Mielke 1984, 76–8; Rowlands 1988, 90f.; Winkler III, 102f.]

## 90.3 Bookplate for Melchior Pfinzing. Pen drawing with watercolour. W 704, S D 1513/27

Wheel of Fortune, who is enthroned at its top, with four ascending and descending figures of workmen holding tools – hatchet, hammer, pliers, set-square. Set in a frame of intertwining vines. Semicircular scroll with inscription:

HILFDGTGHE + LVCK [...] K + BERAT

On the reverse side:

Albrecht Dürer painted this in Melchior Pfinzing's book

On Pfinzing, confidential secretary to Maximilian I, see 79.2 and BI. Fortune's Wheel was a favourite motif for bookplates. The inscription is difficult to make sense of, and

it may be more or less arbitrary lettering to show how a chosen inscription would fill the scroll of an eventual design. However, it does relate in some measure to the picture, and a possible reading is:

Hilf d[ir] G[ot]t Glück berät

(So help you God, Fortune provides)

[Winkler III, 103; Anzelewsky/Mielke 1984, 78–80]

### 90.4 *St Coloman as a Pilgrim*. Woodcut. S W 169, SMS 234. 1513 [fig. 36]

The Scottish saint was martyred at Stockerau in 1012 and is also depicted in the woodcut of *The Austrian Saints* (102.4). In the four corners are the Habsburg imperial arms, the arms of Austria and Scotland, and (bottom right) of Johannes Stabius. AD's drawing W 572, S D 1517/15 is almost certainly a portrait of Stabius. He is characterised by his bushy beard and stocky figure. In his letter to AD of 24 October 1524 (199.1), the mathematician and court astronomer of Henry VIII of England, Nikolaus Kratzer, asks AD for a copy of the woodcut. One version of it (see S W p. 485) has a lengthy Sapphic ode by Stabius on Coloman as 'sacred patron of Austria', which ends characteristically with a paean to Maximilian I (see 97, commentary).

### 90.5 *Knight, Death and Devil*. Copperplate engraving. S E 71, SMS 69 [See fig. 35]

Inscription on a tablet in front of a skull on the ground:

S · 1513 ·

With AD monogram below. The S may stand for *Salus* as in AD's dated manuscripts (82.1–2).

The title is modern. AD refers to it in the Netherlands Journal simply as *Reuter* ('rider, knight'). The knight and his horse are closely modelled on the pen and water-colour drawing *Mounted Warrior in Armour* 1498 (9.6), via an intermediary squared constructional sketch, over original silverpoint, then traced on its verso as a semi-finished drawing (W 617/18, also 1513). The rendering of the horse in the drawing draws on the engraving *Small Horse* (1505; S E 44, SMS 42). It is likely that AD's proportioned horses were influenced by Venetian horses: those on the façade of San Marco, Verrocchio's equestrian statue of Colleoni, and the tomb of Paolo Savelli in the Frari. He may have known Leonardo da Vinci's studies of horses in the ducal stables in Milan through his patron Galeazzo da San Severino, a friend of Pirckheimer (BI).

The setting of the warrior's journey, in a deeply hollowed lane with steep rocky sides surmounted by dead trees, the spectral figures of Death and Devil, the more than

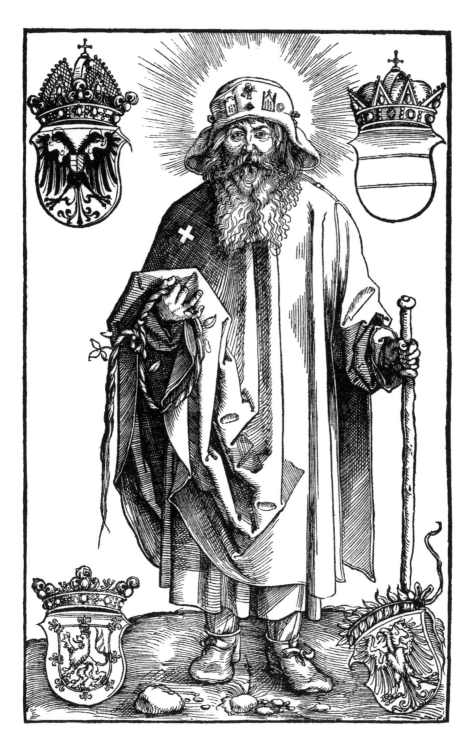

36. Albrecht Dürer, *St Coloman as Pilgrim*, woodcut, circa 1512

half-spent hourglass, the skull and lizard, all signal allegory. Erasmus's *Enchiridion militis christiani*, 'Handbook' or 'Sword of the Christian warrior' (the Greek-derived noun means both 'manual' and 'small sword, side-arm') has generally been cited as the underlying reference, the exegetical clear-text of the allegory. In his lament on the supposed death of Luther in 1521, AD appeals to Erasmus as *ritter Christi*, a direct German translation of *miles christianus* – there in the sense of putative champion of the Lutheran cause. The *Enchiridion*, written in 1501, printed in 1503, reprinted in 1509, then six more times in 1515–16, was well known yet not widely read until the Froben edition of 1518 which coincided with the first major impact of Luther's Reformation writings. It is not very likely that in 1513 AD had read or absorbed the gist of Erasmus's longish and challenging Latin book. Nor did he need to have done so in order to be familiar with the allegory of Christian chivalry and to conceive the iconography of his engraving. Its quintessential biblical formulation, Paul's Epistle to the Ephesians 6:10–18, will have been familiar to him from the vernacular bible and as a sermon text: 'Put on the armour of God, that ye may stand steadfast against the crafty assaults of the devil', 'the breastplate of righteousness', 'the helmet of salvation, and the sword of the Spirit'. The extended metaphor inspired the characterisation of the monk in the Rule of St Benedict (sixth century) and was given a literal sense in the eleventh century when the Church recruited the feudal warrior class to fight the physical 'warfare of Christ' (*militia Christi*), for the papacy against heretics and as crusaders against the heathen, deemed literal embodiments of the devil. AD's knight is meant in the original sense (to which Erasmus gave its culminating statement) as allegorical image of the Christian who fights 'not against flesh and blood but…against spiritual wickedness for heavenly things'.

[Fantazzi, ECorr 1988, introduction; Welzig, *Erasmus* 1995, vol. 1, xiii–xxv; Ex. Cat. Vienna 2003, 412–16; Grebe 2006, 117–19; Smith 2012, 233–41]

## 1514

## 91 Letter of Lorenz Beheim to Willibald Pirckheimer

*[Bamberg, 17 April 1514]*
If you have returned, remember me to Madonna Kramer, Albrecht, Kaspar Nützel, and particularly Lazarus Spengler.

PBr 2, 362–73, letter 307. Latin text
  R I, 257

## 92 The Death of Barbara Dürer: Albrecht Dürer's Personal Record, and the Inscription on Albrecht Dürer's Drawing of his Sick Mother

### 92.1

Now you should know that in the year 1513, early in the morning on the Tuesday before Rogation week, when my poor pitiable mother, whom I took in two years after my father's death and cared for because her means had quite run out,[1] had been living with me for nine years, she fell suddenly so mortally ill, that we had to break open her bedroom, since otherwise, because she was unable to unlock the door, we could not get to her. So we carried her downstairs to another room and she was given both sacraments, for every one thought she was going to die.[2] Ever since my father's death she had had nothing but ill-health, and her usual habit was to spend her time at church, and she was for ever chiding me whenever I did not behave well. And she was for ever worrying about my and my brothers' sins, and whenever I was entering or leaving the house, she was for ever quoting 'go in the nomen Christo'.[3] And constantly she would be solemnly admonishing us and ever worrying about the state of our souls. And the good works and acts of pity she did to every one I cannot adequately number nor her kind words. My honest mother coped with bearing and bringing up eighteen children, often suffered the pestilence[4] and many another serious illness, put up with great poverty, scorn and derision, spiteful words, terrors, and great adversity, yet was she never vindictive.[5] More than a year from that said day when she first fell sick, on a Tuesday in the year 1514, it was the seventeenth day of May, two hours before nightfall,[6] my worthy mother Barbara Dürer passed away as a Christian should, with all the sacraments, absolved by papal power from guilt and torment.[7] She had already given me her blessing and wished me God's peace with much good advice how to guard myself from sin. She also asked that she might drink St John's blessing,[8] as she then duly did. She feared death greatly, but said she was not afraid to come before God. Her death was hard, and I was aware of her seeing some terrible vision, for she demanded holy water even though it was a long time since she had last spoken. This was the manner of her death. I could see also how death dealt her two mighty blows to the heart, and how she closed her mouth and eyes and passed away in pain. I recited the prayers for her. That caused me such grief as I cannot put into words. God be gracious unto her. Note: her greatest joy was always to speak of God and seek God's honour. And she was in her sixty-third year when she died.

I performed the exequies for her as reputably as I could afford.[9] Lord God grant me that I too achieve a blessed end, and that God with his heavenly

host, my father, mother and kin, will all be present at my end, and that Almighty God will give us eternal life. Amen. And in her death she looked much better than when she was still living.

The surviving single leaf of the 'Personal Record' is described in detail in 15, AD's account of his father's death. Other entries are to be found in their chronological place (19 and 38). In or after 1514 AD entered the account of his mother's death in the blank bottom margin of the first side of the leaf, beneath a horizontal line, up to the word *geabsolfijrt* ('absolved'). The account then continues in the top and right-hand margins of the verso.

R I, 35

NOTES

1   Although Albrecht Dürer senior appears to have been quite prosperous, Barbara Dürer seems rapidly to have exhausted her widow's means. The domestic arrangements of the family are unclear at this point in time. It is possible that by 1504 AD had already moved from his parents' house Unter der Vesten, perhaps to rent the house of the late Bernhard Walther in the Zisselgasse, which he bought in 1509. In the Family Chronicle he refers to taking Hans Dürer into his household in 1502 as if it were separate from his mother's. Only after her death did the old family house pass into the joint ownership of AD and Endres Dürer, who then lived and worked as a gold-smith there (Hess/Eser 2007, 145–8).

2   Holy Communion (as the sacrament of penance) and Extreme Unction.

3   Properly: *in nomine Christi*. The practice of invoking the name of Christ or a saint was based on Paul's Epistle to the Colossians, 3, 17: 'Whatsoever ye do in word or deed, do all in the name of the Lord Jesus.'

4   *pestilentz* passed into German from Latin *pestilentia* in the fourteenth century, originally to denote bubonic plague. By circa 1500 *pest* from French *peste* is becoming the more usual form, and in this period most commonly refers to the contagious syphilis. It is of course unlikely that Barbara Dürer had either of those diseases, let alone frequently. Rather, 'pestilence' should be understood as a generic word that was attached historically to a wide range of less clearly distinguishable, contagious pandemic infections with a high death-rate. See Arrizabalaga/Henderson/French 1997, 126.

5   In the case of his mother as of his father, AD emphasises stoical acceptance of travail and hardship, in imitation of the suffering, self-sacrifice and mockery exempli-fied in the Passion of Christ, as the qualification for divine grace and salvation.

6   See the Family Chronicle (1, note 36). Tuesday was in fact 16 May. The error appears again on the date added in 1514 to the charcoal drawing of the mortally ill Barbara.

7   The assertion that she held a plenary indulgence 'by the power of the Pope' is unusual if not unique at this date. See Sahm 2006, p. 50: such certificates were offered for sale by papal indulgence commissions on several occasions in Nuremberg between

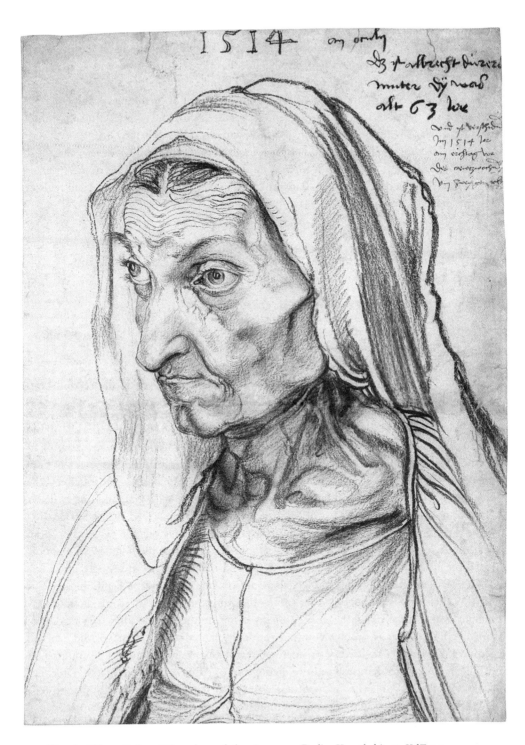

1514

dz ist albrecht dürer
mutter dy was
alt 63 ror

37.  Albrecht Dürer, *Barbara Dürer*, charcoal drawing, 1514. Berlin: Kunstkabinett KdZ 22

1489 and 1510. They promised the purchaser plenary absolution from the guilt and punishment of sin after confession, 'alike in life and in the agony of death'. Such absolution assured the penitent of immediate direct entry into heaven.

8   At Christmas, wine was consecrated in church and could be taken to private houses as the 'loving-cup of St John the Evangelist', for drinking as a pledge of remembrance at occasions of parting and departure, with the words 'drink St John's blessing in the Name of the Father, the Son, and the Holy Spirit'.

9   These comprised burial, requiem mass, and commemorative masses on the third, seventh and thirtieth days after death and on its anniversary. The tolling of the mourning bell of St Sebald's Church for Barbara Dürer is recorded in the death-knell register for the period Lent to Whitsun 1514.

### 92.2   *Barbara Dürer*. Charcoal drawing. W 559 [fig. 37]. Dated, top centre, 1514

Inscription in right-hand top corner, in charcoal:

On oculi [19 March]. This is Albrecht Dürer's mother, she was 63 years old

Inscription in right-hand top corner, added in ink:

and died in the year 1514 on Tuesday before Holy Cross Week at the second hour of the night

AD's behaviour at both his father's and mother's deathbeds reflects the norms of late medieval Catholic theology and the mentality of a laity with an increasing sense of its personal religious responsibility. A doctrine of grace which prioritised the works of faith inculcated in the pious laity a horror of sudden and lonely death, unfortified by the sacraments. AD follows anxiously his mother's battle to cope with pain and fear of death. He is distressed to have failed to perform for his father the prescribed rites – St Bernard's verses, St John's loving-cup – which he now faithfully carries out for his mother. Both death scenes are permeated with a distinctly pre-Reformation theology of redemption, based on justification through faith and works and on the merits of a godly life.

The conventional language of piety does not obscure the evident depth and fervour of AD's filial love. But he lacks the means to express emotion in words as startlingly unique as the visual image he created of his dying mother in the charcoal drawing of 19 March 1514. This is simultaneously a ruthlessly naturalistic exposure of old age and terminal illness and – by its very starkness – a searing expression of grief. The comparison of picture and word demonstrates the dichotomy of AD as artist and writer. A medical analysis of the drawing (Pirsig 2006) has claimed to detect extraordinarily precise representation of emaciation, anatomical symptoms of arteriosclerosis, malnutrition, dental and ocular deterioration, wasted musculature and systemic frailty which, Pirsig claims,

document not merely drastic general effects of ageing but specifically the likelihood of a terminal malignant abdominal tumour. However, it is methodologically problematical to proceed even from such precise representation of external symptoms to a reliable pathological diagnosis. The precision of AD's observation is extraordinary given that, unlike Leonardo or Michelangelo, he is not known to have witnessed post-mortem dissection.

[See 15; Anzelewsky/Mielke 1984; Kruse 2006; Pirsig 2006; Sahm 1998, 2002, 26–39, 2006; Schäfer 2006]

## 93 Works of Art

### 93.1 *Endres Dürer.* Silverpoint. W 558, S D 1514/30 [fig. 38]

Above, date and monogram in AD's hand. Inscription to the right:

This was how Endres Dürer looked
When he was thirty years of age

Unusually large for a silverpoint drawing. Perhaps done to mark his brother Endres's entry as master silversmith into the guild of goldsmiths in 1514. Probably at the same time, AD did a similar-sized pen drawing of Endres, wearing the same clothes, in 'lost profile', with the face averted two-thirds away from the viewer (W 557, S D 1514/31 – fig. 38). This imitates Apelles's portrait of Hercules which according to Pliny (*NH.* 35, 94) seemed 'by a triumph of art, to show the face more true to life than merely to suggest it' (Carstensen 1982, 145–9; W III, 27f.). AD's portrait served as a model for his etching *The Desperate Man* (S E 80, SMS 79).

[Ex. Cat. Vienna 2003, 426]

### 93.2 *Decorations for Two Spoons.* Brush drawing. W 722, S D 1517/25

Inscription at the right margin:

Choose which little head you want

In the bowls of the spoons, kneeling figures of a man and woman. An alternative woman's head between the sketch and the inscription. A second drawing (W 723), without inscription, has religious motifs, St Christopher, Madonna and Child with St Anne, St Agnes. Winkler suggests that AD did them circa 1515 (but later according to Strauss 3, 1686) for Endres to use in his silversmith work. Rowlands 1988, 92, quoting Fritz 1966, insists that they are designs for engraving on the feet of mon-strances (the ornate late Gothic receptacles in which the consecrated host was dis-played for veneration).

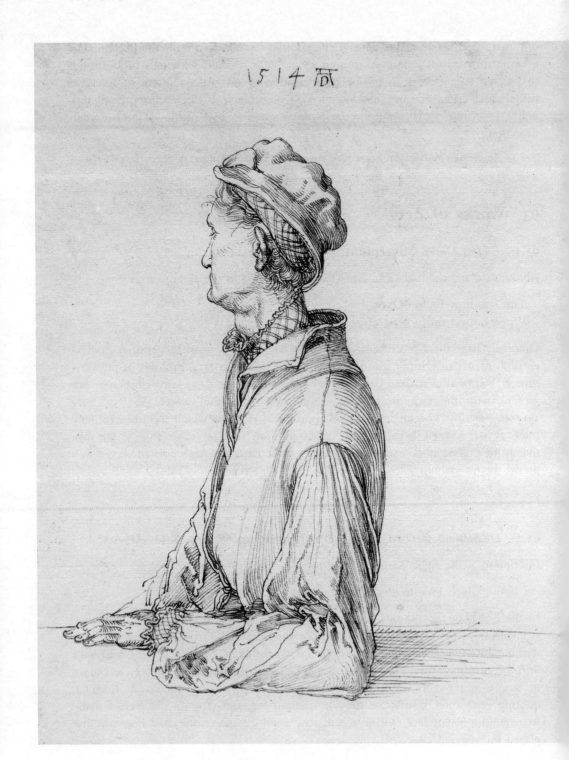

38.  Albrecht Dürer, *Endres Dürer*, pen drawing, 1514. Vienna: Albertina 3138

### 93.3 *Spiritello with Balance and Sextant*. **Pen sketch. W III, pl. 15, S E 1514/25. BL 5230, fol. 4**

Inscription to the right:

| schlüssel | gewalt |
|---|---|
| pewtell | reichtum |
| betewt | |

(Key means power, purse means wealth)

A preliminary sketch for Melencolia I. In the engraving the winged cherub sits beneath the balance with closed eyes in a dejected pose. There is no sextant; instead he holds a book, interpreted as a grammar, the study of which was traditionally an activity which induced melancholy. Other preparatory drawings are W 619–20, S D 1514/22–4 & 27–8.

[S E 79; SMS 71, Winkler III, supplement, plate 15; Klibansky/Panofsky/Saxl 1964, plates 3–5]

### 93.4 *Melencolia*. **Copperplate engraving. S E 79, SMS 71**

Above, a bat-like creature bears a scroll with the inscription:

Melencolia I

The Greek-derived word means 'black bile'. The dominant figure of the dark-faced brooding woman embodies the melancholic temperament. The engraving, according to Panofsky and many others, a spiritual self-portrait of the artist, has generated research publications on an industrial scale, too huge to permit meaningful summary here. Schuster 1991 alone devotes 840 pages to it. For useful introduction, see Klibansky/Panofsky/Saxl 1964; SMS, 179–84; Ex. Cat. Vienna 2003, 422–4; Smith 2012, 243–7. The title appears to promise further depictions of other types of melancholy, although Strieder (2001) suggests that what has been taken to be the numeral I is merely a stroke filling a miscalculated gap on the inscription scroll. See the early evidence of the reception of the engraving by Joachim Camerarius (320) and Philipp Melanchthon (328).

### 93.5 *Arion*. **Brush, overdrawn in pen, watercolour wash. W 662, S D 1514/34**

Latin inscription:

PISCE SVPER CURVO VECTVS CANTABAT ARION

(By the dolphin Arion was borne singing over the sea)

Herodotus tells how on a voyage to Sicily Arion (poet and musician from Lesbos, seventh/sixth century BC) was thrown overboard by sailors and rescued by a dolphin,

to which he clings here, clutching the harp to which he is rapturously singing. AD drew on sketches by Hartmann Schedel of drawings of antique sculpture by the humanist Cyriacus of Ancona, which he found – together with the verse – in a manuscript from Schedel's library in Nuremberg.

[Ex. Cat. Osnabrück 2003, 116f.]

### 93.6 *Nymph of the Spring*. Brush, overdrawn in pen, watercolour wash. W 663, S D 1514/36

Latin inscription:

HVIVS NINPHA LOCI SACRA CVSTODIA FONTIS / DORMIO DVM BLANDE SENCIO MVMVR AQUE / PARCE MEVM QVISQVIS TANGIS CAVA MARMORA SOMNVM / RVMPERE SIVE BIBAS SIVE LAVERE TACE

(Here I lie slumbering, the nymph of this place, keeper of the sacred fount, listening to the murmur of the soothing water. Forebear, whoever you may be who touches the hollowed-out marble, to disturb my sleep; whether you drink or wash: be silent!)

Like *Arion*, it is based on a sketch by Hartmann Schedel. The ample, minimally veiled nymph lies in front of an agricultural-looking trough. The inscription is pseudo-classical (R III, 444). Bonnet 2001, 195 argues for a dating of 1505. Lukas Cranach painted the same motif in 1518, with an unclothed, Italianate (though anatomically incorrect) nude and a more elegant fountain against a German landscape. His inscription is briefer but to the same effect (Bonnet/Kopp-Schmidt 2010, 164f.).

### 93.7 *Allegory of Eloquence*. Brush, overdrawn in pen, watercolour wash. W 664, S D 1514/35

Inscription: in upper left corner, in two columns: twenty Greek names for the very varied attributes of the god Hermes (Latin Mercury), such as *Psychopompos*, companion of souls (leading them to the underworld), the Hellenistic mystical epithet *Trismegistos*, 'three times greatest', *Mystagoge* presiding over puberty rites, *Charidotes*, thief, *Nómios*, protector of herds, *Propylaios*, guardian of homes. The flying figure of Hermes, in winged helmet, with the winged, snake-entwined staff (*caduceus* or *kerykeion*) and winged feet, has golden chains padlocked to his tongue, the ends of which are attached to the ears of male and female figures who are drawn irresistibly after him. This allegory of eloquence derives from Lucian.

The group of classical studies is completed by W 665, S D 1514/33, *Venus and Cupid the Honey-Thief*. It has no inscription but shows Cupid being attacked by a swarm of bees and running to Venus for protection. She reminds him that his arrows sting as sorely as a bee. The subject derives from the possibly inauthentic Idyll 19 attributed

to Theocritus (third century BC). Cranach's oil painting of the subject is dated 1530 and has a Latin inscription in Roman capitals with a post-classical moralising *pointe*:

> Whilst Cupid was stealing honey from the hollowed tree, the bees stung the thief's fingers. So too the brief transient sensual pleasure we lust for injures us, mixed as it is with bitter pain. (Bonnet/Kopp-Schmidt 2010, 174f.)

All four of AD's drawings were collected in the later sixteenth century by Archduke Ferdinand of the Tyrol in an album with engravings, woodcuts and drawings by AD, known as the *Ambraser Kunstbuch* (from Ambras Castle near Innsbruck), now in the Kunsthistorisches Museum, Vienna. The inscription of *Arion* appears also in Petrus Apianus, *Inscriptiones sacrosanctae vetustatis* (Ingolstadt 1534), the title-page illustration of which is based on AD's drawing of the *Allegory of Eloquence*.

[Rupprich III, 443; Winkler III, 77–80; Grebe 2013, 92–4]

## 1515

## 94   Letter of Ulrich Varnbühler to Willibald Pirckheimer

*[Mainz, 13 February 1515]*
Farewell, pride of all Nuremberg, and yet again, with my dearest friend Albrecht Dürer, farewell.

PBr 2, 520–22, Letter 351. Latin text
   R I, 257

NOTE

For Varnbühler, see 173.4, 262 and BI.

## 95   Resolutions of the City Council in the Prosecution of Jorg Vierlein

*Sabbath after the Invention of the True Cross*[1] *[5 May] 1515*
To interrogate Albrecht Dürer and Jorg Vierlein, one against the other, and according to what is found out, take the matter back to the Council and reach agreement what punishment Vierling shall face.[2]

[1515, I, 23a]

*Second Day after Cantate Sunday³ [7 May] 1515*
To put Jorg Vierlein of Kleinreuth in the dungeon and call him to account tomorrow regarding Albrecht Dürer.

[24a]

*Third after Cantate [8 May] 1515*
Jorg Vierlein is to be interrogated in the chapel, bound and shown the instruments of torture, on account of his behaviour towards Dürer.⁴
And tell his family the Council will do their relative no injustice.

[24b]

*Fourth after Cantate [9 May] 1515*
Interrogate Jorg Vierlein further, at first kindly, but if he still will not tell the truth, do him hurt, once.

[25b]

*Fifth after Cantate [10 May] 1515*
To hear officially the witnesses Dürer can present in the case of Jorg Vierlein.

[II,1b]

Further interrogate Jorg Vierlein and get a straight confession out of him, that he threatened to strike Dürer and made false accusations against him; have him bound and shown the instruments and, if he cannot be made to talk by kindness, have pain inflicted.

[2a]

*Sixth after Cantate [11 May] 1515*
To tell Jorg Vierlein's family, their relative has behaved unjustifiably and criminally, such that he deserves a public punishment. But bearing in mind Dürer's plea for him and their offer to pledge life and wealth in surety for their relative, so providing assurance for Dürer and those involved in the matter, the Council will give them a caution as answer.⁵

[3a]

*[Record of Sentences, p. 202a, 11 May 1515]*
Jorg Vierlein of Kleinreuth was arrested and put in the dungeon for having presumed to accost and strike Albrecht Dürer. Subsequently, on the plea of Albrecht Dürer and on the surety and pledge of the persons named below to

guarantee with their life and wealth that he [AD] will remain safe and unmolested by Vierlein, he has been released from arrest on sworn bail after payment of his upkeep, and in addition sentenced to spend four weeks in the dungeon.[6] Suspended until St John's Day solstice [24 June].

*Sixth Day after St Urban [1 June] 1515*
On the plea of Albrecht Dürer, Jorg Vierlein's sentence, imposed on him for his offence against Dürer, is lifted.

[1515,II,22b]
　Hampe, Ratsverlässe 1032–40.
　R I, 241

NOTES

　1　According to early Christian legend St Helena, mother of Constantine, the first Christian Roman Emperor, made a pilgrimage to Jerusalem in AD 326 and discovered the cross on which Christ was crucified. The Invention of the True Cross (Latin *inventio*, 'discovery'), along with the feast of the Exaltation of the Holy Cross, were celebrated liturgically in the Middle Ages. Putative fragments of the Cross were venerated with particular fervour.

　2　Jörg [Georg] Vierlein or Vierling is not identified. Kleinreuth is just to the north of the walled city.

　3　Cantate Sunday: in post-Reformation English usage, Rogation Sunday, the fifth after Easter, named from the beginning of the introit of the mass for that day, the psalm verse 'Sing unto the Lord'.

　4　On the use of torture in the Nuremberg judicial process, see G. Strauss 1976, 225–9. Only the council could order the use of torture, and confessions extorted by it were only legally valid if repeated freely before magistrates. A listening tube connected the torture chamber and the council chamber so that councillors might monitor what was happening.

　5　For all the ferocity of the means available to it, which were indeed frequently and sometimes drastically applied, the preliminary investigation appears to have been quite careful, giving the accused several chances to confess freely, allowing his family to plead for him and offer sureties, and heeding AD's reluctance to press charges.

　6　*loch*: 'hole' is the laconically eloquent name for the prison cells in the cellars beneath the town hall.

[Würtenberger 1971, 45–8]

## 96   Three Versions of a 'Comic Expostulation'

I

That's so, isn't it?[1]    Even so.
It's not worth it.[2]    Let it be.
Crazy[3].       Hey, a useless business![4]

2

That's so, surely? Fool's errand.[5]  Now on.[6]
Quite so!        A sin.[7]
It's not worth it.     Crazy.

3

Quite so, a fool's errand. It's not worth it. Crazy, now on.
A sin, harmful. That's so, isn't it?

BL 5229, fol. 61ʳ (1)
 Dresden Sketchbook, fol. 98ᵛ (2 & 3)
 R III, 446f.

### NOTES

The translation and notes are based entirely on Rupprich's ingenious explanations.

1 *Hendoch*: Nuremberg expression, found also in Hans Sachs (DWb IV, II, 985).

2 *Es jst sant*: 'sand' as a dry, barren substance? A connection with *sand* in its specific Nuremberg sense (81, note 4) seems unlikely.

3 *Gemlich*: medieval German *gemelich*, 'jokey, daft, funny'.

4 *Eÿ ein sandgeschichst*: 'a sandy business' – see note 2.

5 *Nart das*: DWb VII, 366f.

6 *Nundaling*: another Nuremberg dialect form, also used by Hans Sachs (DWb VII, 996).

7 *ein sunt*, in 3, *ein sont*: in standard German *Sünde*, 'sin'.

### COMMENTARY

In both cases, these expostulations are written on leaves which have on the other side sketches that relate to AD's studies of human proportion (which leads Rupprich to date the texts circa 1513–15). It is impossible to know what may have provoked them.

# 97 Albrecht Dürer's Work on Commissions from Emperor Maximilian I

## Introduction

The project of a gigantic representation of a *Triumphal Arch*, more than three metres high and composed of 195 woodcuts, was first mooted during Emperor Maximilian I's visit to Nuremberg on 3–12 February 1512. Johannes Stabius, imperial historiographer and astronomer, gave AD a thematic programme of his own devising and an architectural drawing of the structure by the Innsbruck court painter Jörg Kölderer. AD's status as overall artistic director is evident by the presence, lying on the steps of the smaller right-hand arch, of his heraldic shield, along with those of Stabius and Kölderer. However, his own direct contribution was probably a mere nineteen of the 192 blocks, which were cut by Hieronymus Andreae of Nuremberg between 1515 and 1517 (SMS 238, S W 175 and pp. 501–7). His associates Hans Springinsklee and Wolf Traut carried out many of his designs, and the Regensburg artist Albrecht Altdorfer worked on the flanking towers.

On a large tablet, forming part of the drum of the dome which surmounts the great central tower of the Triumphal Arch, and continued on five parallel columns beneath the gateways, is printed Stabius's exposition of the thematic and iconographical scheme of the whole composition (97.1). It encompasses the genealogy of the emperor, stretching back to Hector of Troy, his kinship and dynastic affiliations, his military and diplomatic achievements, his place in Roman imperial history. His image as classical *imperator* presides over the vast structure. Maximilian vetted the scheme in close detail throughout its gestation. Stabius's commentary trumpets the grandiose ideological pretension of this post-Roman triumph, its representation of the Habsburg aspiration to universal monarchy, even before Charles V added the Spanish New World to the Holy Roman Empire of the German Nation.

The Triumphal Arch turned out to be the most complete but by no means the only one of Maximilian's imperial artefacts to which AD contributed. A *Book of Wrestling and Fencing*, consisting of thirty-five leaves of coloured drawings, bound up into a volume, dates from 1512. AD's drawings have an incomplete manuscript commentary, in German, written in at least three different hands, which may be those of AD and Pirckheimer and an unidentified other. Maximilian is likely to have commissioned it. In 1513 the Augsburg printer Hans Schönsperger created a new font, based on late Gothic manuscript calligraphy, for the printing of a prayer book for the emperor. One copy of the limited edition was printed on parchment, folios of which were sent for decoration with marginal scenes and motifs in freely realistic and fantastical style, and of a decidedly secular character, to AD and other contemporary artists, Lukas Cranach, Hans Burgkmair, Jörg Breu, Hans Baldung Grien and Albrecht Altdorfer. The Augsburg humanist Konrad Peutinger oversaw the project which proved difficult to co-ordinate

and was unfinished when Maximilian died in 1519 (see 98). Between 1515 and 1517 AD did four pen and watercolour drawings of sumptuous costumes for imperial courtiers, and in 1515–16 five meticulous drawings of components for a suit of tournament armour, part of it to be made in silver and to be richly decorated with etched designs, which Maximilian commissioned from the Augsburg armourer Kolman Helmschmied. By 1514 AD had become involved in the planning of a grandiose funerary monument which Maximilian envisaged as his ultimate memorial. AD was to provide a number of the models from which sculptors and bronze-founders would create over-life-sized statues of heroic figures from Hapsburg genealogy, to stand guard for eternity over the funerary bronze of Maximilian himself. Only a reduced version of the project was carried out in the court chapel in Innsbruck.

It is not surprising that by July 1515 AD was looking to Stabius and to influential acquaintances in Nuremberg to support his case for overdue payment of his work on the *Triumphal Arch* and the other ventures. While Maximilian had acknowledged AD's claim already in 1512 (79), the perennial disjuncture between his cultural-ideological ambitions and his precarious finances did not begin to be resolved until 1515, and even then only thanks to creative accounting which relied on the connivance of the Nuremberg council and ran into difficulties once Maximilian died in 1519. Its tortuous history can be traced through the next five years of the documentary biography (see 99, 109–10, 127, 138, 153, 165).

AD's role in Maximilian's artistic programme of the representation of imperial power continued until the emperor's death and beyond it. As early as 1514 Stabius had engaged Albrecht Altdorfer to prepare a manuscript of coloured ink drawings depicting a *Triumphal Procession* in Roman imperial style (for this and the following, see 123–4). It was completed by 1516, but in the meantime, with the *Triumphal Arch*, the medium of giant composite woodcut had emerged as the suitably scaled, technologically advanced style for Maximilian's ideological art. Konrad Peutinger was now deputed to oversee the transposition of the original project into woodcut medium. He engaged Hans Burgkmair but it became apparent, as with the *Triumphal Arch*, that more than one artist would be needed, and AD was an obvious choice. However, of the 136 woodcuts prepared, the great majority were Burgkmair's work. What survives of AD's contribution are twenty-six leaves of woodcuts by his workshop, only two of them by AD himself (*Small Chariot of the Burgundian Marriage*: K 309/10–311, SMS 239), and six drawings (1518: W 690–99, S D 1518/2–11 – some in two states), of three mounted courtier-knights bearing trophies – the plundered weapons of defeated foes – a standard bearer, and Johannes Stabius carrying a blank plaque, which indicates his role in devising the thematic and allegorical programme of the procession.

The culmination of the procession was meant to be the *Triumphal Chariot* conveying the emperor and his family. AD made a brown ink drawing for it in 1516/17, essentially based on Albrecht Altdorfer's depiction in the recently completed manuscript version.

In 1518 he then made a new design, elaborately watercoloured, on multiple sheets of paper and measuring 250 cm in length, on which the chariot is drawn by six pairs of horses. It reflects a further developed, more explicitly allegorical conception on the part of Stabius. In 1519 the death of Maximilian brought the project of the *Triumphal Procession* to an end. However, AD revived the *Triumphal Chariot* in 1521 as a mural painting in the great chamber of the town hall in Nuremberg (168.6), and in 1522 he transferred his 1518 drawing into woodcut form, modified and provided with a textual commentary in German and Latin versions by Willibald Pirckheimer, and printed it with great success (169). In September 1518 AD had been allowed to make a portrait drawing of Maximilian I, from which he derived two oil paintings and a woodcut. The painted portraits with their grandiloquent inscriptions, though not commissioned by the emperor, reflect the same concern as the major woodcut projects to exploit the aesthetic and technological potential of Renaissance art in the representation of Hapsburg political ideology (126.1, 143.1).

Apart from the planning and realisation of Maximilian's projects, Johannes Stabius (see BI) collaborated with AD around 1515 on a number of private productions, such as the star charts of the Northern and Southern Hemispheres (102.6) and the *Terrestrial Globe* (102.5). A drawing of a bearded man (W 572, S D 1517/15) is probably of Stabius. It may be associated with *St Coloman as a Pilgrim* (90.4) which has verses on the saint by Stabius. On the large woodcut of *Austrian Saints* (102.4), St Coloman is again given the features of Stabius. AD also made a woodcut of his coat of arms (80.4), and probably designed a portrait medallion of him by Peter Vischer (circa 1518–20; Maué 1986, 406). Stabius left the imperial service in 1521 and died the following year. On his possible collaboration with the Augsburg sculptor Hans Daucher, see 174.

[Eckert/Imhoff 1971, 100–115; Silver 1985, 2004, 155–61, & 2008; Kaufmann 1995, 67–73; Schauerte 2001; Schmid 2003, 430–34; Ex. Cat. Vienna 2003, 438–68; M. Müller 2003; Silver 2010, 134–48; Ex. Cat Vienna 2012; Smith 2012, chapter 8; Whaley 2012, 108f.]

### 97.1 Johannes Stabius, Inscriptions on the Composite Woodcut of the Triumphal Arch [fig. 39]

To the Most Serene, Most High and Mighty Prince and Lord, the Lord Maximilian, Roman Emperor Elect and Head of Christendom, also Hereditary King of seven Christian Kingdoms, Archduke of Austria, Duke of Burgundy and of other Mighty Principalities and Lands in Europe et cetera, this Gate of Honour, adorned with his many deeds, is erected to his praise and as an eternal memorial of his honourable rule, his well-disposed magnanimity, and victorious conquests.

The Gate of Honour of the Most Serene, Most High and Mighty Emperor and King Maximilian, in the same form as in ancient times the *arcus triumphales*

39.  Albrecht Dürer, *Triumphal Arch* (detail: Gryphon with motto of Maximilian I), woodcut, 1515

for Roman emperors in the city of Rome, of which some are ruined and others may still be seen, was created and set up by me, Johann Stabius, historiographer[1] and poet of the same Roman Imperial Majesty, and divided into seven parts as depicted and clearly described here. The first part: the three great gates to be seen at the base. The second part: the great tower which stands above the great central gate with its constituent parts. The third part: the figures of the outstanding histories and fortunes of Emperor Maximilian, such as are depicted in the squared fields above the two smaller gates on their upper and lower faces. The fourth part: of all emperors and kings the most precious and favoured whose images frame the fields on the upper faces of these towers. The fifth part: kinship, family and affinity who flank the squared fields on the lower faces. The sixth part: the two towers which stand at the furthest edges

of the Gate of Honour at high and low level. The seventh part: the decoration with which the Gate of Honour is dressed in every part.

...

The three gates or portals have the title of their significance written on them. Namely the central great gate is the most noble and is called the Gate of Honour and Might; signifying that Honour is a reward for manly virtue and splendour, and as Emperor Maximilian has performed many honourable deeds of manly virtue and splendour...so this gate is set up and opened, and his imperial spirit has entered it in high honour. Likewise the power this emperor possesses with the crown of the Roman Empire, along with His Majesty's children and descendants, is demonstrated by the host of coats of arms of the kingdoms, archduchies, duchies, margravates, landgravates, palatinates, principalities, earldoms, counties, and lordships, which have accrued to the illustrious House of Austria by the said deeds of His Imperial Majesty, the which arms are displayed in order with name and armorial bearings above this Gate, namely on the upper level those which serve the heritage and ancient tradition of the Lands of Austria, and on the lower level the kingdoms of Spain and Burgundy which have been added to the House of Austria by marriage. The gate at the upper side is called the Gate of Praise, which signifies that to true honour is always attached praise and dignity...The third is called the Gate of Nobility...The central tower through which the great Gate of Honour passes has on it the ancestral trees of the bloodline and ancient origins of the illustrious House of Austria from which this emperor has received his blessed descent; and at the very bottom sit the figures of three women which signify famed and renowned nations and lands of Troy, Sicambria,[2] and France, meaning that the Merovingian dynasty of the first kings of the Franks sprang in direct line of descent from the magnanimous Hector of Troy, whereby they captured and occupied the Pannonian lands, now Hungary and Austria, also Sicambria on this side of the Rhine, and whose people were then called Sicambrians and thereafter Franks, afterwards bringing all of Gaul likewise under their sway and rule...and thus the present dynasty began with Chlodwig, the first Christian king of the aforementioned Merovingian and Frankish heroic royal house, from which this ancestry derived and proliferated from person to person, that is from father to father by manifold stages and vicissitude to the princes of Habsburg, from them to the archdukes of Austria, down to the present Emperor Maximilian. The same Emperor who is enthroned in Imperial Majesty has seated at this highest level beneath him his consort Maria, heiress of Burgundy, born to the present royal house of France on paternal and maternal side. On the other side Johanna, Queen of Spain, she too born of her father and mother from the royal house of Spain and Castile, the consort of King Philip of Spain and Castile, and below His Majesty's consort is seated Margareta of Austria and Burgundy, His Imperial Majesty's only daughter, an adornment of womanhood. Then this family tree bends with its branches and fruit downwards

from His Imperial Majesty's supreme dignity, and beneath His Imperial Majesty stands the Most Serene noble King Philip, His Majesty's only son, having on his right hand the serene noble princes Charles and Ferdinand, sons of King Philip and Queen Johanna of Spain and Castile, and on their lower side their daughters, the ladies Leonora, Isabella, Maria, and Catharina. On both sides of the tower next to the dynastic tree there stand also the coats of arms of those named here. And above His Imperial Majesty are depicted the twenty-three victories, these are the winged female figures holding in their hands laurels or wreaths of honour, signifying that the laurel tree by ancient tradition is dedicated to victory or conquest, and laurel wreaths are used to crown victors and conquerors. And because the laurel tree is evergreen and never sheds its leaves, so should well earned outright victory and conquest remain perpetually green and fresh in the memory of those who come after...In the tabernacle above the title is an enigma composed of ancient Egyptian hieroglyphs,[3] deriving from King Osiris, which interpreted word for word say: Maximilianus, most excellent, magnanimous, powerful, strong, and foresighted of all princes, a lord of imperishable, eternal, and illustrious fame, born of ancient lineage, embellished with all gifts of Nature, supremely gifted with all arts and good learning, Roman Emperor and mighty ruler of a great part of the circumference of the earth, has with warlike hand, high wisdom, and surpassing victory conquered the mightiest king here shown, hitherto deemed by all men impossible, and thereby sensibly secured and protected himself against revolt by his enemies.

...

In this Gate of Honour there are many further adornments of which much might be written, which each spectator may interpret for himself, but which for brevity's sake I leave aside.

*Triumphal Arch of Maximilian I* (large panel below the dome of the central tower of the Arch, and five parallel columns at the foot of the woodcut). Extracts in Wiesflecker-Friedhuber 1996, 234–40.

NOTES

1  Stabius was an antiquarian, propagandist and poetaster. The true historian at Maximilian's court was Johannes Cuspinian (1473–1529), a major humanist scholar who wrote a *History of the Roman Consuls* (1512) and *The Roman Caesars and Emperors*, or – in the German translation published in 1541 – *Chronicle from Julius Caesar to Charles V*. In it he prays God 'to grant Emperor Maximilian an outstanding man, who may write him the history he deserves, just as Alexander the Macedonian wished himself a similar historian and for the benefit of posterity came out with a decree that no one but Apelles should paint him, and no one should chisel or sculpt him but Pyrgoteles, and no one should cast his likeness in iron or bronze but Lysippus' (2, 252). In AD the emperor at least got his Apelles.

2 The Sicambri or Sigambri: according to Ptolemy, Strabo, and ancient historians, a Germanic tribe occupying lands between the rivers Sieg, Ruhr and Lippe.

3 In 1514 Willibald Pirckheimer had translated into Latin the *Hieroglyphs* of Horapollo (the legendary Egyptian author of a fourth-century AD Greek anthology of hermetic texts). The manuscript, discovered in Italy in 1419, purported to provide a key to the hieroglyphic writing of Ancient Egypt. AD provided illustrations for Pirckheimer's book, *Mystery of the Egyptian Hieroglyphs*. This in turn provided material for framing AD's woodcut of Maximilian which crowns the *Triumphal Arch*. Stabius here provides a German translation for the emperor's benefit.

[Rupprich 1970, 546; Eckert/Imhoff 1971, 101–6; Hope/McGrath 1996, 173–5; Smith 2012, 265–9]

## 97.2 Letter of Albrecht Dürer to Christoph Kress

*[Nuremberg, 30 July 1515 or soon after]*
Dear Herr Kress,
Firstly, may I ask you if you will find out for me from Herr Stabius whether he has negotiated anything for me in my claim against His Imperial Majesty, and how things stand, and let me know when you next write to the Council.[1]

If however Herr Stabius has not arrived at anything, and it has been too difficult to achieve what I want, then I ask you, gracious sir, to negotiate with His Imperial Majesty, as Kaspar Nützel instructed you and as I have requested you.[2]

And in particular point out to His Imperial Majesty that I have served him for three years, paying my own costs, and if it were not for my skill and efforts, the intricate work would not have been accomplished. Request His Imperial Majesty therefore, as I am sure you will know how to put it to him, to reward me with the hundred gulden.[3]

Further, be reminded that apart from the Triumph I have done a great variety of other sketches and plans for His Imperial Majesty.

With that I commend myself to you.

Further, if it is your understanding that Stabius has achieved something in this matter, there is no need for you to do more on my behalf at the present time.

Albrecht Dürer

On the reverse: Albrecht Dürer's Memorandum

The autograph was presented to the Royal Museum in Berlin in 1833 by Friedrich von Nagler, along with the page from AD's Personal Record (15).

R I, 77–79

NOTES

1  Christoph Kress (BI) represented Nuremberg at the imperial court and helped bring about the arrangement whereby AD was paid a liferent, diverted from the civic tax payable by Nuremberg to the emperor (99). Maximilian I's correspondence shows evidence that both Stabius and Konrad Peutinger had to intercede with the emperor on behalf of artists and craftsmen needing payment.

2  For Kaspar Nützel see 79, 109f., 125, 126.3, 213.5 and BI.

3  In the formal privilege dated 6 September 1515 (99), Maximilian I acknowledges AD's 'art, skill and intellect', and confers on him the annual liferent of 100 gulden, to be disbursed by the city council.

## 98  Fragment of a Draft Letter of Konrad Peutinger to Hans Baldung Grien

*[Augsburg, Late Summer/Autumn 1515]*
...good friend, I am sending you...
...three gatherings. On the first....
...to be at the bottom an interpretation...
...Trinity in skilful fashion...
...at the beginning of this prayer...
...Roman manner, which my Lord...
...my good friend Dürer well...
...29 leaves, of the other...
...to the prayer of Saint...
...of the above-named kind, and...
...a Saint George in full...
...cuirassier with the dragon...

Konrad Peutingers Briefwechsel, 265, letter 164
  R I, 257

COMMENTARY

Konrad Peutinger (BI), an eminent humanist, friend and advisor of Emperor Maximilian, was responsible for the compilation of an illuminated copy of a printed Prayer Book intended for the emperor's personal use. The book contains psalm and gospel texts, hymns, and prayers for private devotions. Printed on parchment in very limited numbers (only five copies survive) by Hans Schönsperger in Augsburg in 1513, in a

specially designed typeface, gatherings of printed leaves were sent out for marginal decoration with pen drawings. The artists commissioned were AD, Lukas Cranach, Hans Burgkmair, Jörg Breu and Hans Baldung Grien, possibly also Albrecht Altdorfer and AD's brother Hans. This de luxe copy of the prayer book was left unfinished at the death of Maximilian in January 1519. A draft of Peutinger's letter to Hans Baldung was evidently torn into strips of which the centre one is preserved. The twenty-nine leaves referred to are those which were allotted for illumination to AD (among them the drawings of the Trinity and St George slaying the dragon) and to Lukas Cranach. Peutinger is evidently sending them to Baldung (who had probably been trained by AD) as exemplars for the three gatherings (three times three double sheets) for which he was to be responsible.

[Waetzoldt 1936, 276–83; Smith 2012, 269–73]

## 99   Emperor Maximilian I's Privilege for Albrecht Dürer

We Maximilian, by the Grace of God Roman Emperor elect, Augustus, ever extending the bounds of Empire, King of Germany, Hungary, Dalmatia, Croatia et cetera, et cetera, Archduke of Austria, Duke of Burgundy and Brabant, Count Palatine et cetera, do declare publicly with this document for ourselves and our Imperial successors, and make known to all, that we have regarded and taken cognisance of the art, skill, and intellect for which our and the Empire's trusty and well-beloved Albrecht Dürer has become renowned at our court, likewise the pleasing, loyal, and useful service which he has oft and gladly rendered, still daily renders, and henceforth may and shall render, to us and the Holy Empire and also in sundry ways to our own person, and that therefore, on mature consideration, and on the timely counsel of our and the Empire's princes and estates, with full awareness, we graciously grant to and confer on the said Dürer, and enact this grant knowingly and by virtue of this document, for as long as he shall live and no longer, yearly and in each and every year, from and out of the customary city tax, which their honours, our and the Empire's trusty and well-beloved Burgomasters and Council of the City of Nuremberg, yearly and each and every year are obliged to deliver and pay into our Exchequer, in return for his quittance, one hundred Rhenish gulden, to be tendered, rendered and disbursed by the said Burgomasters and Council of the City of Nuremberg and their successors. And what the same Burgomasters and Council of the City of Nuremberg and their successors thus tender, render and disburse to the aforesaid Albrecht Dürer, in return for his quittance, as set out above, these same sums shall be recorded and reckoned to their account as having been paid and discharged as part of the customary city tax, which

as stated above they are obliged to pay annually to our Exchequer, just as if the sums had been paid into our own hands and received in return for our quittance. And therein they and their successors shall incur no damage or detriment at our or our imperial successors' hands in any way or wise. Witness this missive, sealed with our seal affixed. Given in our City of Innsbruck, on the sixth day of the month of September, in the year of Our Lord fifteen hundred and fifteen, in the thirtieth year of our Imperial reign and the twenty-sixth year of our rule in Hungary,
Maximilian

LS
At the Special Command of His Majesty the Holy Emperor.

Eighteenth-century copy of the lost original, in the State Archive, Nuremberg, S. I, L. 79, No. 15, Fasc. 2. R I, 79f.

## COMMENTARY

The Nuremberg council had declined, understandably, to pay AD what Emperor Maximilian owed him by exempting the artist from its own dues and taxes (see 79). It is now requested to divert 100 gulden annually to AD out of the city tax payable to the imperial treasury. This is the ingenious compromise which Johannes Stabius on the emperor's behalf, and Christoph Kress and Kaspar Nützel on the city's behalf, had arrived at. It cost the city nothing, since it was obliged to pay the tax in any case; it was convenient for Maximilian, since it absolved him from having to persuade the imperial treasury to pay for his cultural projects; it gave AD a reliable, if by no means munificent, return for the considerable work he carried out or undertook for Maximilian between around 1511 and 1515: his share of the 195 woodblocks of the *Triumphal Arch* (97), his contribution to the *Prayer Book* (98), designs for courtiers' livery, the *Book of Wrestling and Fencing*, the emperor's silver suit of armour, the early phase of the *Triumphal Procession*, the design for the statue of Albrecht von Hapsburg for the imperial tomb in Innsbruck. The portraits of Charlemagne and Sigismund (64.7–11), and the illustrations for the emperor's presentation copy of the Latin translation of the *Hieroglyphica* of Horapollo, though paid for by the city and by Willibald Pirckheimer respectively, were also works redounding to Maximilian's greater glory. The annual stipend turned out to be less straightforward than AD must have expected when it lapsed on Maximilian's death in 1519 (138, 153, 165). For a fuller account of the imperial commissions, see 97.

## 100  Anton Tucher, Household Book

Item: on 15 October bought from the painter Dürer three copies of Jerome and four of Melencolia printed from copperplate, sent to Rome as a mark of my respect for Engelhard Schauer and Jacob Rumpf.      Paid in cash: 1½ gulden.

See 76. Loose, p. 126f.
  R I, 295

NOTE

Engelhard Schauer was factor for the Fuggers in Rome.

## 101  Christoph Scheurl, *Life of the Reverend Father Anthonius Kress*[1]

*[fol. 4a–b]*
He took pleasure in those contemporaries who showed talent and skill, and he held in great esteem Albrecht Dürer of Nuremberg, whom I am accustomed to call the German Apelles, because of his excellence. My authorities for this, passing over others, are the painters of Bologna, who, in my hearing, publicly and to his face attributed to him the supreme mastery of painting in all the world, declaring that now having at last set eyes on the long-awaited Dürer they might die more happily.[2] Further witness to this is the book about the theory and practice of painting, which since Apelles he is the first and only in our age to have written, and which I leave to painters and posterity to judge.[3]

What pleases me no less in my most agreeable friend Dürer is his innate integrity, his readiness of speech, his friendliness, good-nature, and human kindness. With all this in mind, there is one thing I cannot pass over in silence. Jakob Wimpheling, whom I never fail to mention without special respect, writes in chapter 68 of his *Epitome of German History* that Dürer was a pupil of Martin Schongauer of Colmar.[4] But Dürer, when I showed this to him, wrote and has often confirmed orally, that his father Albrecht (who was born in a village called Cüla, near Wardein in Hungary), was willing to send him, when he was entering his thirteenth year, as an apprentice to Martin Schongauer, on account of his excellent repute, and had written to him to that effect, but in the meantime Martin had died.[5] For that reason he became a pupil for three years in the school of our mutual neighbour and fellow citizen Michael Wolgemut. Later, when he was a journeyman here and there in Germany, and came to Colmar

in 1492, the goldsmiths Caspar and Paulus, and the painter Ludwig, also the goldsmith Georg in Basel, all brothers of Martin, gave him kind hospitality and treated him generously. Yet not only was he never in any way a pupil of Martin, he indeed never ever set eyes on him, for all that he most earnestly wished to. However, elsewhere I shall have more to say about Albrecht.

*Vita reverendi patris domini Anthonii Kressen* (Nuremberg 1515). Latin text, which Scheurl himself translated into German, in a manuscript in the Kress archive of the GNM.

R I, 294f.

NOTES

1   Anton Kress (BI) had died on 8 September 1513.

2   See 50 and 57.

3   In 1515 AD's manual on painting was certainly not a completed book as Scheurl seems to suggest. Indeed he was in the process of abandoning his original plan (see 51.1–4 and 82–3) in order to write his treatise on human proportion and, later, the separate treatise on geometry and perspective.

4   The *Epithoma rerum Germanicarum* (16). Scheurl's correction is in itself only partially correct. AD writes in his expanded version of his father's *Family Chronicle* (1) that it was on 30 November 1486 that his father gave way to his pleas to allow him to be apprenticed as a painter, that is more than two years after AD turned thirteen.

5   The elder Dürer (and Michael Wolgemut) may well have known Martin Schongauer, who probably worked briefly in the workshop of Hans Pleydenwurff around 1469–70, and for that reason thought of sending his son to Colmar for his apprenticeship. The reason why this did not happen is not known. However, it was not Schongauer's death, for he did not in fact die until 2 February 1491. AD tells us that he left Nuremberg for his journeyman years, having served his time as apprentice with Michael Wolgemut, after Easter in 1490. Even then he did not make his way directly to Colmar and so arrived there after Martin's death. His indebtedness to the other Schongauer brothers need not be doubted.

COMMENTARY

Christoph Scheurl's memoir of Anthony Kress is dedicated to a mutual friend of all three, Hans Ebner. The book incurred the displeasure of members of the patriciate, who resented the praise meted out to AD and Ebner which, they alleged, disparaged those not so favoured, and the book was withdrawn from sale. Both what Scheurl writes about AD's plans for the manual on painting and his unreliable correction of Wimpheling shows him overreaching himself as a putative authority on the artist. In his assertion of privileged knowledge about AD's personal history there is an implicit element of self-promotion which seems to have been a trait in his personality.

## 102 Works of Art

**102.1** *The Three Fates with a Supplicant.* **Pen on parchment, gold and deep blue watercolour grounds, clouds and costumes in violet, green and red watercolours. W 705, S D 1515/63**

Dated 1515 in AD's hand. Inscriptions, top, on a scroll:

LANIFICAS Nulli Tres exorare Puellas / Contingit obseruant quem statuere diem

(Never did anyone by their entreaty move the three wool-spinning maidens / they keep to the appointed day)

Names of the Fates on scrolls:

Clotho, Lachesis, Atropos

Supplicant's speech scroll:

Grata trahe Lachesis fila

(Draw out, o Lachesis, the thread of life, gratefully accepted)

Below:

Certo veniunt ordine parce

(The Fates come in due order)

Clotho spins the thread, Lachesis hands it on to Atropos who cuts it; the supplicant kneels at their feet (he resembles the baker in the drawing of the 'missive bakery', 64.2, and both may represent Lazarus Spengler). With its delicate colouring this drawing is comparable in style with AD's illuminations for the Prayer Book of Maximilian I. It forms a pair with the drawing Satyr and Nymph (W III, 103–5 & plate xx) of the same year. This has a coat of arms which is also associated with Lazarus Spengler. See also AD's devotional drawings for Spengler in 1525, 211.3.

**102.2.1** *Rhinoceros.* **Pen drawing. W 625, S D 1515/57. BM**

Title above:

Rhinoceron

Next to it, the date 1515. Below, inscription:

Note: In the year 1513, on the 1st May, there was brought to our King of Portugal in Lisbon a living beast like this from India which is called Rhynocerate. It is such a marvel that I felt bound to send you this likeness of it. It is the same colour as a tortoise and very strongly protected by thick scales. In size it is similar to an elephant,

but less tall, and it is the elephant's mortal enemy. On the front of its snout it has a strong sharp horn. And when the animal approaches an elephant to attack it, it will always have sharpened its horn on a stone in preparation, and it charges the elephant with its head down between its front legs, then it gores the elephant where its hide is at its thinnest and so slits its throat. The elephant is desperately afraid of the rhinocerate which always slits its throat whenever it comes upon it. For it is well armoured and very bold and agile. This creature is called *Rhinocero* in Greek and Latin, and in Indian *gomda*.

### 102.2.2    *Rhinoceros*. Woodcut. S W 176, SMS 241 [fig. 40]

In left corner:

1515 Rhinocervs

And AD monogram. In the panel above, inscription, closely related to that on the drawing:

In the year of Our Lord 1513, on 1st May, there was brought to the great and mighty King Emanuel of Portugal in Lisbon a living beast like this from India which is called Rhinocerus. It is here portrayed in all its particulars. It is the same colour as a speckled tortoise and all over it is armoured with thick scales. In size it is comparable to the elephant but has shorter legs and is very strongly protected. On the front of its snout it has a sharp and strong horn, which it sets to and sharpens whenever it comes across stones. This creature of those parts[1] is the elephant's mortal enemy. The elephant has a terrible fear of it, for when the rhinoceros attacks it, the beast charges with its head down beneath its front legs and gores the elephant underneath in its stomach and slits its throat, and the elephant cannot defend itself. For the animal is so well armoured that the elephant is powerless against it. They say too that the rhinoceros is swift, bold and cunning.

NOTE

1   *das dosig Thier.* Scarcely *dösig*, 'tame, dozy', rather AD's dialect form of *dasig*, 'belonging there', as opposed to *hiesig*, 'belonging here' (DWb II, 809f., 1311). The phrase is also used in AD's caption to his drawing of a walrus (1521, 163.26).

COMMENTARY

The date in the inscriptions should properly also read 1515. AD never saw a rhinoceros himself, and his remarkable depiction of it was entirely based on written evidence and an accompanying sketch. These came to Nuremberg in the form of a newsletter, either by a member of the German merchant community in Lisbon, or possibly by Valentim Fernandes, a Moravian printer there. The animal, thought to be a now extinct species

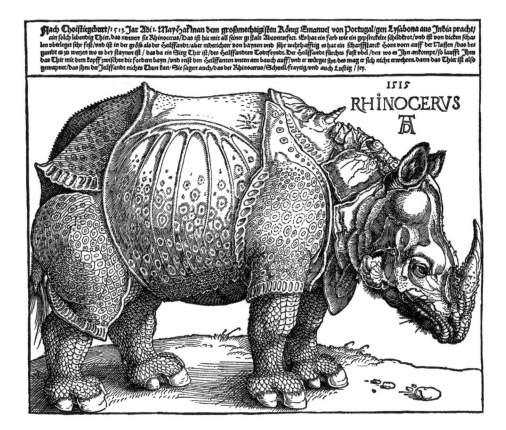

Nach Christi geburt/1513. Jar Adi 1. May/Hat man dem großmechtigisten König Emanuel von Portugal/gen Lysabona aus India pracht/ ain solch lebendig Thier.das nennen sie Rhinocerus/Das ist hie mit all seiner gstalt Abconterfect. Es hat ein farb wie ein gespreckelte schildkrot/vnd ist von dicken schalen vberleget sehr fest/vnd ist in der gröss als der Helffandt/aber nidrichter von baynen vnd sehr wehrhafftig es hat ein scharfstarck Horn vorn auff der Nassen/das begundt es zu wetzen wo es bey staynen ist / das da ein Sieg Thir ist/des Helffandten Todefeyndt.Der Helffandt fürchts fast vbel /den wo es Jhn ankompt/so laufft Jhm das Thier mit dem kopff zwischen die fordern bayn /vnd reist den Helffanten vnten am bauch auff/vnd er würget jhn/des mag er sich nicht erweren.dann das Thier ist also gewapnet/das jhm der Helffandt nichts thun kan/ Sie sagen auch/das der Rhinocerus/Schnell/fraytig/vnd auch Lustig / sey.

1515
RHINOCERVS
𝕬𝕯

40.  Albrecht Dürer, *Rhinoceros*, woodcut, 1515

of Indian rhinoceros, was presented by the ruler of Gujarat, Sultan Muzafar II, to Alfonso d'Albuquerque, governor of Portuguese India, who shipped it to Lisbon for King Manuel I. To test out Pliny the Elder's account of the natural enmity between rhinoceros and elephant, the king set up a duel with one of his elephants – which abjectly fled. To ingratiate himself with Pope Leo X, to whom he had already sent the elephant Hanno in 1514, the king despatched the rhinoceros to Rome via Marseilles, where King Francis I and his queen inspected it. It did not reach Rome alive. The ship sank and the beast drowned, although one account tells that its carcass was recovered, stuffed and delivered to the pope. Hans Burgkmair also designed a woodcut of the Lisbon rhinoceros, based on AD's, which, though in some respects more realistic, did not have remotely the same impact on contemporaries or much later. A rather crude pen drawing in the Vatican Library, also 1515, has elements in common with both woodcuts and could be either a source or imitation of them (Monson 2004). AD's woodcut was widely imitated in the seventeenth and eighteenth centuries (Bubenik 2013, 100–103). Via its use in English textile designs it was adapted in a Persian drawing of circa 1665 which was in turn used in textiles made in Iran for export to England. Winkler (III, 65), writing in 1938, claimed

that 'until very recently' AD's image had still been reproduced in German school zoology textbooks and was only then supplanted by photographs. Winkler (born 1888) may be recalling school books from circa 1900.

[Eichberger 1998, 16f.; Rowlands 1988, 92–4; Bartrum Ex. Cat. London 2002, 283–92]

### 102.3   Raphael, *Three Male Nudes*. Red chalk drawing. Albertina, Vienna

Inscribed by AD:

> 1515 / Raffahell de Vrbin der so hoch peim / pobst geacht ist gewest der hat / dyse nackette bild gemacht vnd hat / sy dem Albrecht Dürer gen Nornberg / geschickt / im sein hand zu weisen

(Raphael of Urbino, who was so highly esteemed by the pope, drew these nude pictures and sent them to Albrecht Dürer in Nuremberg, to show him his hand)

A number of earlier assumptions and controversies about the drawing and its inscription may now be regarded as resolved. There is no reason to doubt the authenticity of the inscription. The past tense *ist gewest* (in southern German dialects, the perfect was already by 1500 used as a simple past tense) suggests that AD is writing after Raphael's death on 6 April 1520. Since AD quite often added later inscriptions to drawings and paintings, it may well be that he wrote this after the event, but dated it to the year he received the gift. The view that the drawing was a study for Raphael's *Battle of Ostia*, and that it provided evidence for the dating of this fresco (currently regarded as March–June/July 1517), is no longer universally held, though it does appear to have a relationship with some details of the fresco. Thus it need not be argued that Raphael was slighting AD by sending him a mere working drawing. On the contrary, it is an autonomous life drawing, and red chalk was at the time a preferred medium for prestigious works. Nor is it now held to be a product of Raphael's studio but rather, as AD took it to be, Raphael's own demonstration of his 'hand', his individual manner and style. It may have been indeed a direct, personal response to AD's gift to him of a small self-portrait, as Giorgio Vasari reports. In Ludovico Dolce's dialogue *L'Aretino*, 1557, Aretino claims that 'Raphael himself did not think twice about hanging Albrecht's drawings, which he praised highly, in his own studio.' In Antwerp in September 1520, following Raphael's death on 6 April, the painter Tommaso di Andrea Vincidor, whom AD describes as a 'disciple' of the master, brought him an antique gold ring, presumably as a memento (162, notes 132–3). It is not impossible that AD may have had personal contact with Raphael while in Venice in 1505. Shearman 2003 includes in his documentary biography of Raphael the report of an extract from a letter of Marco Mantova Benavides to Raphael, dated 1505, which records that 'Raphael and Dürer were guests for nine days in Benavides's house in Padua' and that Raphael was to paint a St Jerome. However, the source of the report, Jacob Anton

Bulters, writing in the acts of the Academy of Science, Letters and Arts in Padua, failed to produce the letter, and Shearman classifies the claimed record as spurious.

In *Le Vite de' più eccellenti pittori, scultori, et architettori*, 2nd edition (Rome 1568), Giorgio Vasari has two versions of the story of AD's gift to Raphael.

*[From the Life of Raphael, Book 3.1]*
By these and many other works the fame of this most noble artist spread to France and Flanders. Albrecht Dürer, a marvellous German painter and engraver of the most beautiful copperplates, paid him tribute by sending him his own portrait, his head painted in gouache, on cambric that was so fine that it was equally visible on both sides, the lights shone through, not done with white-lead paint, and the ground and colouring rendered only by the use of watercolours, the white of the cloth serving as the ground for the bright areas. This seemed wonderful to Raphael, who sent him in return many drawings by his own hand which Albrecht valued very highly. This portrait head was among the possessions of Giulio Romano, Raphael's heir, in Mantua.

*[From the Life of Giulio Romano, Book 3.2]*
Among the rare things he had in his house was the portrait from life of Albrecht Dürer, painted on a piece of fine cambric linen by Albrecht's own hand, sent by him (as related elsewhere) as a gift to Raphael of Urbino. This portrait was an exquisite object, for it was painstakingly done in gouache with watercolours, and Albrecht had achieved it without using lead-white, relying instead on the white of the cloth itself, and taking advantage of the delicacy of its threads to render the hairs of his beard so convincingly that it was almost impossible to conceive, let alone carry out. Thus when held up to the light, the face showed through on both sides. This portrait Giulio so treasured that he exhibited it to me in the manner of a miracle, when during his lifetime I went to Mantua on some business of mine.

The portrait has not survived. Paintings on fine linen were a Netherlandish speciality and much prized in Italy. Like less fine canvas they could be rolled up for sending away. The medium was normally glue-size, not oil (Nash 2008, 101f.).

[Jones/Penny 1983, 153, 159; Quednan 1983, 130; Mulazzani 1986, 149–53; Kemp 1987, 11f.; Nesselrath 1993; Schoch 2002, 436f.; Shearman 2003, I, 218–20 and II, 1464; Pon 2004, 99–105]

### 102.4    *The Austrian Saints*. Woodcut. S W 174, SMS 237. 1515/1517

There is a first version with six saints, a second with eight saints. The latter appeared with a 46-line Latin poem by Johannes Stabius in praise of the saints as 'friends of the Austrian fatherland' and is dated 1517. As in the woodcut 90.4, St Coloman is depicted as Stabius in the guise of a pilgrim.

### 102.5    *Terrestrial Globe*. Woodcut. S W 173, SMS 242. 1515

The globe is surrounded by twelve flying figures of winds. In the corners, the arms of Cardinal Matthäus Lang, archbishop of Salzburg (top left), dedication to Lang by Johannes Stabius (top right), arms of Stabius (bottom left), the privilege granted to Stabius by Emperor Maximilian I (bottom right). This is in fact a traditional *mappa mundi* based on Ptolemy, with some extensions from Martin Beheim's globe of 1492, but showing none of the discoveries of Diaz, Columbus or the Portuguese explorers. However, the steno-graphic polar projection is up to date. See also the Armillary Sphere (204.3).

[Meurer 2007, 1195f.; Kleinschmidt 2008, 134, 221]

### 102.6    *The Northern Hemisphere of the Celestial Globe*. Woodcut. S W 171, SMS 243

With figures of astronomers of the ancient world in the four corners. Inscription above:

Imagines coeli Septentrionales cum duodecim imaginibus Zodiaci

(Images of the Northern hemisphere with twelve zodiac figures)

### *The Southern Hemisphere of the Celestial Globe*. Woodcut. S W 172, SMS 244

Dated 1515. Arms of Cardinal Lang, archbishop of Salzburg (top left) and dedication to him (top right). Coats of arms of Johannes Stabius, the Nuremberg astronomer Konrad Heinfogel and AD (bottom left), and the privilege granted to Stabius by Maximilian I (bottom right). See also 204.3.

In George of Trebizond's edition of books 7–8 of Ptolemy's *Almagest* – *Phaenomena stellarum MXXII fixarum*, printed in Cologne in 1537 (according to the Latin title page), 'There is appended Johannes Noviomagus's Introduction to the longitudes and lati-tudes of the non-wandering stars, to which have been added forty-eight images of the Egyptian sphere on two celestial maps by Albrecht Dürer.' However, no known extant copy contains these two maps. See R III, 464.

[Bagrow 1964, 127f.; Smith 1983, 114]

## 103  Writings on the Theory of Art

### Early Drafts of the 'Discourse on Aesthetics' in the *Four Books of Human Proportion*

#### Introduction

At the end of the third of the four sections of his treatise on human proportion, AD discusses at length, in a passage which has acquired the name 'Aesthetic Excursus', the underlying intentions and principles of his work. It will become clear why I have preferred to give it the title 'Discourse on Aesthetics'. In some sense it came to substitute for the fact that, despite his labours in 1512–13 (82–4) and again in 1523 (181–2), the book as published contains no introduction, only a dedicatory epistle to Willibald Pirckheimer which itself may possibly not be entirely of AD's own formulation. It must be pointed out, however, that the earliest sketches of material for the 'Discourse' are roughly contemporaneous with drafts of the introduction from 1512/13, and to a significant extent the 'Discourse on Aesthetics' and the introduction that never quite was grew from common roots. Its thematic concern, like that of the first of AD's draft introductions that presuppose a treatise on proportion and not a handbook on painting (83), is with the nature of beauty, and the first few fragmentary notes that follow overlap with 83 and its main source, On Beauty (51.4, of circa 1508).

Rupprich (III, 267f.) illustrates how deep the roots of the concerns of the 'Discourse' are by citing AD's drawing of the female centaur suckling her young (W 344, S D 1505/16), the associated drawing *Centaur Family* (W 345, S D 1505/17), and the engraving *Satyr Family* (S E 43, SMS 44) of 1504–5 (26.3). These works are responses to Lucian's *Zeuxis* or *Antiochus*, specifically to Lucian's ekphrasis of Zeuxis's painting of a centaur family, famous in Antiquity. It can only have been Willibald Pirckheimer, editor and translator of Lucian, who revealed and expounded the description to AD. The picture, as Lucian describes it, showed the half-woman, half-horse lying suckling her children, one held to the breast like a human child, the other lying beneath her, suckling like a foal. Lucian praises its perfect art, despite its paradoxical, incompatible extremes. 'To the extent that she is horse, she is the match of the most beautiful mare of the Thessalian kind, still untamed and unbroken; her upper half is a woman of spotless beauty, apart from her rather satyric ears. The transition from one to the other is so imperceptible, they merge so delicately into each other, that it is impossible to see where the woman ends and the horse begins.'

In AD's treatments of the ekphrasis, only the drawing of the suckling centaur shows her as half-woman, half-horse; the other two contrast her as a classically cool female nude with her wild shaggy mate, the centaur. As early as 1504, before his second journey to Venice, AD was evidently already attuned to a mythical story which encapsulates, in Lucian's interpretation, central issues which will later take shape in his evolving drafts

of the 'Discourse on Aesthetics'. These include the dialectic of the beautiful and the ugly, the possibilities of transforming the beautiful into the grotesque, implicit in the shape-shifting devices and procedures of book three of the treatise on *Human Proportion*; they embrace imagination, fantasy and the artist's inexhaustible resource of images; they evoke the antinomies of hard and soft, crooked and straight, even and uneven, sharp and blunt, tame and wild, which AD lists at the beginning of book three; they extend to the 'beautiful Negro', the propositions that 'there is nothing impossible that nature does not tolerate' or that 'all things in a beautiful form must conform with each other'.

Disparate, in some respects contradictory, and occasionally obscure as these early fragments are, an extended draft, containing already at least two-thirds of the final printed Discourse, emerged at some point between 1515 and 1520 (151.1).

### 103.1

Everyone who has not previously learned to paint or to cut woodblocks, whereby he knows through practical experience and sureness of hand how to draw the lines of a human figure with expansion and reduction, such a one's work will not be good to look at, nor judged to be good, even if he knows the measurements of bodies well enough. For practical skill and theoretical knowledge must go together.

BL 5231, fol. 103ʳ. Second page of a double leaf. The reverse of the page is blank.
  R III, 271

### COMMENTARY

The key terms in this fragment are *geprawch* (modern German *Gebrauch*), 'practical skill, derived from traditional workshop practice', and *verstand*, 'theoretical knowledge', the 'art' of drawing and painting according to mathematically based science. This fragment seems to be the earliest text in which AD links them together in what becomes a recurrent formula. Expansion and reduction refer to the techniques of transforming images which is the subject-matter of book three of the treatise on human proportion.

### 103.2

A good picture cannot be made without effort and application. Thus one should be well aware in advance, before one sets to work, that it does not happen by chance. Because the lines of its forms may not be done with compass and ruler, but must be drawn from one point to another by the hand, it is very easy to make mistakes. Therefore it will be useful with such pictures to take thorough note of human measurements and examine all kinds of them. I consider that the more exactly and closely a picture resembles the models, the better that

work will be. For such a work deserves praise to the extent that one brings together in its images the most attractive part of each one of many well-formed men and women.[1]

However, a number of people are of a different view and write of how a man or woman ought to be. I shall not dispute this with them. In such matters I take nature as my teacher and hold human opinion to be human error. Once and for all, God created mankind as they were to be, and I consider that beauty and the truly well-formed body are distributed among the whole mass of mankind. The man who can properly draw them out[2] – him I will more gladly follow than one who dreams up a new measure in which human beings have no part. For once and always, the human figure must be separated off[3] from other creatures, let them do otherwise what they will. If I am criticised for constructing especially strange measurements of images, I shall not argue with anyone. But these are not inhuman, for all that. But I deliberately place them so far away from each other, that everyone will draw his conclusion from it and make a note, should it seem to him that to his thinking I am being too tolerant or intolerant as regards natural forms, to avoid them and follow nature. For in all the various lands one finds a whole host of differences. If you travel far, you will find it so and see them for yourself. The most beautiful human figure is a matter of opinion. The Maker of the World knows how it might be created in one person,[4] but from far away we struggle to approach it a little closer, even when we are doing well. That is because we have our own different minds, and the majority, who simply follow what pleases them, are usually on the wrong track. Hence I will persuade no one to follow me either. I do as much as I can, but even for my own self it is not enough.

BL 5230, fol. 49ʳ⁻ᵛ. Single leaf, written on both sides.
    R III, 271f.

NOTES

1   *aüs filen wolgestalten menschen*: see also, *die recht wolgestalt vnd hübscheit*. AD is consciously alluding here to the much earlier drawings and writings in which he assimilates Vitruvius's teaching on human proportion, his canon of beauty, and the ideal figure of the *homo bene figuratus*. See the commentaries to 12 and 51.1.

2   *Welcher das recht heraüs zihen kann*: the phrase seems to anticipate the famous dictum in the later and final printed versions of the Discourse: *Dann warhafftig steckt die kunst inn der natur, wer sie herauß kan reyssenn, der hat sie* (see 151.1, 257.4). The use of *heraüs zihen* here for later *herauß reyssen* may be an argument against the idea of a conscious ambiguity in *reyssen*: 'extract' and 'draw, sketch'. See 151.1, note 24.

3   *ab geschiden*: Rupprich follows Panofsky in contrasting this 'differentiation' with *die vergleichlichen ding*, whose 'comparability' constitutes harmony in the human figure

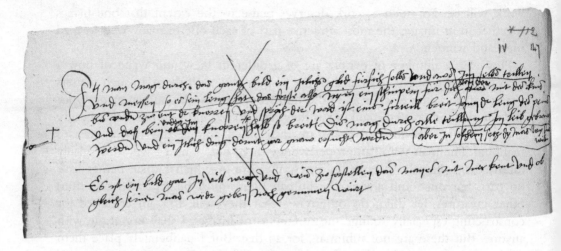

41. Albrecht Dürer, autograph draft of the 'Discourse on Aesthetics', circa 1515. BL Sloane 5231–119ᵛ

and in the composition of artworks. See 51.4, 'On Beauty', note 6. Like the noun *vergleichung* in late medieval German, *abgeschiedenheit* is a word-coining from fourteenth-century mystical writing, and belongs to a distinctive, quite numerous category of AD's vocabulary of vernacular art theory.

4 *jnn einer perschan*: on *perschan*, 'Person', see 83, note 7. A further use of the noun in medieval and early modern German is for 'person of the Trinity' (DWb VII, 1563f.). AD, we may take it, refers here to Christ, in whom the Creator embodies perfect human beauty, otherwise 'distributed among the whole mass of mankind'.

### 103.3 [fig. 41]

All things are to be very thoroughly researched, parts within parts, each one for itself, until you painstakingly tease out[1] their harmonious relationship.[2] Take trouble to find out what is good, for the whole must be made correctly, then each separate part, so that each one is fittingly in place.

BL 5231, fol. 119ᵛ. Strip of a leaf. The other side has the text R II, I C a 3, no. 3.2 (p. 140).
  R III, 273

NOTE

1 *heraüs klaübet*: the verb *klauben* means 'nibble' with the teeth, 'pick at' food, 'pick out' with the finger tips or fingernails. In a letter to Jakob Heller (47.8 and note 3),

AD uses the verbal noun-diminutive *kleibeln* in the sense of 'delicate, minute brush-work' (DWb V, 1019–23, section II. 4. b).

2    *wolstand*: as Rupprich points out, none of the sixteenth-century occurrences of the noun (modern German *Wohlstand*) listed in DWb XIV, II, 1181f. has the meaning AD gives it. Nor in fact does the verb *wolstehn* (ibid. 1184), as used by Johann von Simmern in his *Kunst des Messens* (1531, 291), a work purporting to offer a more comprehensible version of AD's Treatise on Measurement (292). AD is clearly referring here to the idea of *vergleichung*, as in 103.2, note 3.

## 103.4[1]

Someone might say: 'Who will ever spare the trouble and effort, and consume the long time it takes – as you tell him to do here – in order to make a picture all by himself, when often an artist includes a thousand faces in a story he's painting, not one identical with another?'[2] It is not my expectation here that everyone shall spend his whole life measuring. Yet what follows is good, once you've learned and mastered it, so that from then onwards you know how a thing should be. So if, as you work freely, your hand leads you astray, then your good eyes will prompt you with the measure your acquired art and skill has given you, and you'll soon recognise where you have gone wrong, and it will minimise your errors. However, if you lack the basics, you can do nothing correctly, because you don't know how to do it. And you will become more confident, once you have laid a proper base beforehand, and everything will work out more smoothly in all that you do.

BL 5231, fol. 82ʳ. Double-sided leaf, on the reverse the text on altering a male head (R II, 471).
    R III, 274

NOTES

1    A draft for the passage on fol. T4v of the *Four Books of Human Proportion*, as printed in 1528.

2    In the 1528 printed treatise, AD writes: 'when it often happens that in a short time one has to paint twenty or thirty different pictures'. The 'thousand faces' in one 'story' (*jn ein materÿ*) perhaps harks back to the *Martyrdom of Ten Thousand Christians*, the altar panel he painted for Duke Frederick of Saxony in 1507/8. He complains to Jakob Heller that for his altarpiece in 1508–9 he has to paint 'roughly 100 faces, not counting drapery and landscape and the other things on it' (47.4), when in fact there were no more than thirty faces.

**103.5**

However beautiful a human being is considered to be, there will always be a more beautiful one.

Hence we must observe with great attention and prevent what is ugly and out of place weaving its way into our work. So we must avoid what is not useful.[1] I mean deformity.

As an example, take the blind and the lame, and withered cripples, and the like. All that is ugly. The more you leave out all the ugliness of this kind and paint instead attractive, strong, bright things which all men are accustomed to like, the more people will find it beautiful.

Yet beauty exists in the mind which contemplates it,[2] and our judgement of it is so dubious, that we can find two people, both beautiful and praiseworthy, and neither will be like the other in a single part or detail, whether in measurement or in innate characteristics. Nor do we understand which is more beautiful. So blind is our insight. Thus when we give our judgement of it, it is uncertain. In certain respects one may be more beautiful than the other, although it is equally true that this one is more beautiful than the first.[3]

BL 5231, fol. 104ʳ. One side of a single leaf, the reverse blank. The text has been scored through and other material then added in margins.

R III, 274f.

NOTES

1 The formulation first occurs in 51, 'On Beauty'.

2 'Beauty is in the eye of the beholder' is a nineteenth-century English tag. My translation paraphrases David Hume (Essays: Of Tragedy).

3 What AD actually writes is tautological: *Aber jn etlichen teiln mag einer hübscher sein dan der ander, als woll do war ist, das ein mensch hübscher ist dan der ander.* I take the intended sense to be that it is perfectly possible to find either man the more beautiful, depending on the perception of the beholder.

**103.6**

I do not know how to determine by measurement which is the most beautiful human form, for the differences are countless. But someone who wants to make a portrait based on the general estimation of what people consider beautiful, may achieve their aim by the method I show. And whoever can truly set forth to me how the most beautiful form is to be portrayed, that man I shall hail as the greatest master.

Advice should be obtained from those knowledgeable in this art, who will demonstrate in their work, each in a separate picture, by what means the best

and the most beautiful may be sought out and rendered through all parts of the body and in the most minute of details.

And so, when you have done the head properly, and with that the body shall also be done correctly, first do the neck best fittingly.

BL 5231, fol. 105ʳ. One third of a leaf, written on both sides. The verso has the draft title for Book 3 of the *Four Books of Human Proportion* (R II, 403).

R III, 275

NOTE

On the two notions combined here, deriving a definition of what beauty is from the general consensus at a given time, and deferring to the judgement of those well versed in art, see 82.2 and 84.

## 103.7

Thus you have learned in the foregoing discussion of measurement how you may make a thing long or short, fat or thin, broad or narrow, by using the reverser.[1] You may also do so a lot or little and make a thing large or small. But not too much in the case of any one thing, because nature does not tolerate it. You may equally not do too little to something, for no one would notice it. Therefore, best aim to strike a true medium.

And note this in particular, that you make any nude[2] hard or soft.[3] But it is more appropriate that a strong corpulent nude figure is given a harder stamp and made much more bloated than a delicate, thin, slender nude. Delicate figures should be made soft and sweet.

However, hard and soft may be used in all nude figures. For one can make all nudes more plump or more skinny, evenly or unevenly built, and make use of youth and age, for youth is soft but age is harder, more worn and wrinkled.

It is particularly to be noted that in every image, you make a nude compatible in its features,[4] so that all its particulars show equal age or youth, and you do not portray the head of a young man with the breast of an old one, hands and feet of a middle-aged one, or again a body that is young from the rear and old from the front, or vice versa.

Similarly, softness and hardness should be used consistently so that all things add up together properly and are not wrongly combined.

If you intend to use various measures for a figure and end up with an artistically correct image, then take live models, as beautiful as you can get hold of, and plenty of them, so that you can more readily collect together good details. However, if you are going to draw so many models, be clear in your mind beforehand whether you want to produce a young nude or an old one, or middle-aged, fat or thin, hard or soft. Then choose for yourself individuals[5] of

the same age, of the same girth, soft or hard, equally plump or thin, out of which you may select and draw something comparable for what it is you aim to portray.

Note, therefore, in particular, that you preserve comparability in the innate characteristics of your nude figure, lest the torso have a large number of these, while arms and legs have few, and conversely the same in all respects, but rather that the whole image is either pervaded with many such details or, on the contrary, has very few. For the whole body should possess harmonious comparability, so that one part is not hard when the other is soft. Then you will make fewer errors. The more exactly a human image is made to conform with living nature, the better your work appears appropriate for any use to which you need to put it. But if you are so confident in your practice of art, having acquired this through much and long copying, that you know all aspects of it by heart, how each and every human type should be, and need no model for it, then that is so much the better. See to it now that your art does not fail you. For a man who has a proper long experience and a good understanding,[6] it is possible to do something good, but not for one who has not, unless it happens by pure chance. But that cannot be. Note, if you keep on practising the things I spoke about above, then that will let you draw with ease all manner of human figures, of whatever complexion they may be: melancholics, phlegmatics, cholerics or sanguinaries.[7] For it is quite possible to depict a person out of whose eyes Saturn or Venus shines, especially in a painting, with the aid of colours and other things too.

Using the falsifier[8] you can also devise the strangest things, and alter an image in manifold ways, if you go about it thoroughly.

In the dissimilarity of people there is both beauty and deformity. One group have large heads, the other small; one lot are broad across the shoulders, the other narrow; some are broad across the hips, like women, the others slim; some have a long trunk and short legs, and vice versa. Each should take note of these same things according to which he should shape something.

Accordingly you can introduce crookedness and straightness into legs and limbs, since nature offers all these. But how beautiful that makes your work, that is for you to determine.

However each one should produce a rustic and an aristocratic figure. Between the two, many figures of a middle kind are to be found, and it is a great skill to show and properly exploit true power and art in crude peasant subjects.

Next, if you say the measure I have described is wrong, and does not incorporate beauty, then take into account that it does not miss beauty by much, that beauty is achievable by this measure. For I prescribed earlier[9] certain lengths, breadths and depths of parts of the body, and if I have gone wrong, then that must have happened in those three dimensions – either in length,

breadth or depth. If I make an error in length, then that must be what went wrong: either I made the parts too short or too long. Or I erred in the depth: either too thick or too thin. Or I erred in the breadth: too broad or too narrow. Now all that lies within your free choice, in the scope of your art and knowledge. If I made something too long or too short, too thick or thin, too broad or narrow, you find and target the true medium of measurement, and that will be to God's praise and to your honour, and to your neighbours' great benefit, when you have so demonstrated true proven beauty.

Differentiation of bodily parts. In any one figure, you can make its limbs long or short. So firstly make the head long or short, thick or thin, broad or narrow, a long or short trunk, set the flanks and navel high or low. You can move the genitals and ends of the buttocks high up or low down. In the same way you can make the shinbone long or short, hands and feet likewise. You can make the arm bones behind or in front of the elbow long or short. That you can do in all parts of the body, making each and every limb long or short, thick or thin, broad or narrow, just as long as it remains human and not beyond possibility.

Nuremberg, Stadtbibliothek Cent. V. App. 34, fol. 64$^{r-v}$. Single leaf, written on both sides. The text has been subsequently scored through. There are many emendations in margins and above lines.

R III, 276–8

NOTES

1   The device allows the artist to undo or reverse the measured dimensions of a figure, turning long into short and then short back into long, at will. See further note 3.

2   *ein jtlich nackett*: AD evidently uses *nackett* not merely as an adjective (like modern German *nackt*, English 'naked'), but as an adjectival noun meaning 'naked body' (as in modern German *das Nackte* for *das nackte* [*Bild*] or [*Leib*], like, for example, *eine Schöne* [*Frau*], 'a beauty'). In this instance, too, his language usage is innovatory. English 'nude' as a noun (and as a specialist adjective in artistic and art-historical contexts) is not found before the eighteenth century. German *Akt* in the same noun function as 'nude' evolved in the later eighteenth century from the sense of 'stage, variety, circus performance', to denote first the 'pose' of an (often naked) artist's model, then in the later nineteenth century to denote the naked body itself in its artistic depiction (Pfeifer 1989, 29f., Paul 2003, 53. See Bonnet 2000 & 2001, 25–9). AD may have known the Italian *ignudo*, used by Cennini and in Alberti's Italian text *Della Pittura*. DWb VII, 244–6 gives no sixteenth-century occurrences of *das nacket* and only considers it as an adjectival noun, even in eighteenth-century texts. AD's vocabulary sees the first emergence in German of a distinct and often innovative lexis of visual art and aesthetics. See also 151.1, notes 18 and 20.

3   *hert oder lind*: it is not self-evident from the opposed terms how the flat, unshaded drawings of AD's drafts and the printed woodcuts of the *Four Books of Human Proportion* can convey what is suggested by the normal usage of 'hard' and 'soft', namely contrasts of texture, focus or illumination. When he goes on to suggest that 'a strong corpulent nude figure is given a harder stamp' and that 'delicate figures should be made soft and sweet', it seems that the opposition has little if anything to do with texture. The 'corpulent', 'bloated' figure is 'hard', whereas the 'thin' or even 'skinny' (German *mager*) figure is 'soft'. The conjunction *lind vnd süß* implies, rather, a quality that is more emotive than visual and tactile. Although AD seems to associate 'hard' with obese, 'bloated' bodies, he also links age with 'worn' (*ferwesen*) and 'wrinkled' (*gerumfen*). Compare this with Leonardo da Vinci's much more anatomically informed discussion (Kemp/Walker, 1989, 132). The phrase *ein dick starck nackett pild van herterm geprech*, 'a strong corpulent nude figure of a harder stamp', also suggests that the categories 'hard' and 'soft' are not directly or exhaustively translatable into the purely physical characteristics they immediately seem to connote. AD's word *geprech* is modern German *Gepräge*, literally 'the striking or minting of a coin or medal, stamped on hard metal'; more generally and figuratively then 'the stamp of individual or typical character on a person, revealed in face or general physical appearance, behaviour et cetera.' Leonardo stresses that the painter paints both 'man and the intention of his mind' (Kemp/Walker 1989, 144). Like the notion of 'complexion' or temperament later in the passage, which AD suggests can 'shine out of the eyes' like the stars Saturn and Venus, the notions of 'hard' and 'soft' seem to be conceived and deployed here with a mind to the effects achievable when these measured figures develop into fully drawn or painted images. In the *Four Books of Human Proportion* (fol. Oir), *hert* and *lind* are among a series of opposed pairs (young/old, fat/thin, pretty/ugly, et cetera) listed at the beginning of Book III when AD explains the operation of the *Verkehrer* ('reverser') which can turn one into or in the direction of its opposite. See DWb VI, 1027–30, for medieval and early modern examples of *hert* and *lind* used of aspects of character, mentality and emotion. See also 151.1, note 23.

4   *fergleichlich*: on the principle of *Vergleichung*, 'comparability, compatibility, harmony' (103.2, note 3, and 51.4, note 6). The following passage may be influenced by Alberti's comments on harmonious composition, *De Pictura* II, 35f., and they are very similar also to Leonardo da Vinci's remarks on the principles of proportions (Kemp/Walker 1989, 119).

5   *perschonen*: used here in its common early modern German sense of 'individual figures'. On the Zeuxian approach to achieving beautiful human forms, 51.4, note 11 and 83, note 7.

6   *ein rechten langen geprawch vnd guten verstand*: see 103.1. The complementary relationship of *gebrauch* and *verstand* (or *kunst* in its sense of understanding of the theory of art) becomes a frequent theme from this stage in his writings. It has relevance both for the training of the apprentice painter, for whom, AD insists, traditional craft training must be reinforced by a grounding in the theory of perspective and proportion, and for the mature artist, as in this passage.

7   In early modern Europe the idea was still prevalent that the 'complexion' – physical constitution – of an individual was determined by the proportions in the body of the four 'humours', phlegm, blood, choler and bile. A just balance made for 'good humour', a preponderance of any one for 'ill humour'. The black humour of melancholy is represented in AD's great engraving *Melencolia* (93.4, 1513), with which this text is closely contemporary. Certainly, the brooding figure who dominates it can very well be said to be 'a person out of whose eyes Saturn shines' (or glowers!). It has been claimed that the two other major engravings of 1513/14, *Knight, Death and Devil* and *St Jerome in his Study*, were also meant to depict humours, the sanguinary and the phlegmatic respectively (S E 71, 77, 79, SMS 69, 70, 71). AD is said to have asserted that his *Four Apostles* embodied the four humours (see 327).

8   The two *felscher* are geometrical procedures which allow the systematic 'falsification' of standard proportionate figures. AD describes them in the drafts printed in R II, 414f. and 489–99.

9   In the final printed *Four Books of Human Proportion*, the detailed measurement of different kinds of human figures precedes the Discourse on Aesthetics, of which this is an early sketch. The formulation here shows that by 1513/14 AD has a clear conception of the treatise and has abandoned his older scheme of a handbook on painting. In the final paragraphs of this text, AD is concerned to set out some of the ways in which the standard examples of measured figures can be altered, using the techniques and devices he defines at the beginning of Book Two of the printed treatise.

## 103.8

You should know that the more precisely you follow nature and life with your copying, the better and more artistic your work becomes.

*On Turning and Bending Figures*
You should also know that all the images I have already detailed, when they are bent in their limbs, do not retain their prescribed breadth and depth at the same points as indicated. For in life these things move and turn around, and what one part may lose through bending, turning or twisting, another part will gain.[1] Living beings make you realise, as you see them bending before your eyes, how it is happening and how you should draw it.[2] But you must really concentrate so that you do not get it wrong.

You may say, 'Who on earth will take the trouble and effort, with all the time it consumes, to measure and draw a figure like this, when so often it is the case that one is supposed to do two or three hundred images in a short time?' In this it is not my intention that every one shall spend his entire life measuring. But understanding and measuring, once one has learned and mastered them, have the value that one knows them inside out, and how to use

them, and how to apply them to anything. Then, when your hand, as you work freely and at speed, might be prone to lead you into error, understanding will guard you from it, and you will thus develop a good, practised eye. True art means that you will rarely make mistakes, it will give you strength in your work and protect you from error, you will be confident and nimble, and your work will always look true and accurate.[3]

However, if you have no proper grounding, it is impossible for you to do something good and accurate, even if you were to have all the practical experience in the world in respect of freedom of hand. For theory and practice must go one with the other.[4]

Through practice in measurement you can carry out properly each and every figure that is required of you, whether it is angry or mild and all such variants.

*On the Stretching of the Shape of the Body*[5]

...

Whoever wants to do this, and does not have advanced knowledge, will need to set up live models[6] for himself, observe and copy them accordingly.

...

Whoever wishes to make a well-formed image, needs to do it like this: we know that the human being is made up of many parts and yet is one creature, but each and every part of him is to be separately well formed. The human head is one such part. This comprises many other parts, like the eyes, nose, mouth, chin, forehead, cheeks and ears; furthermore a particular round shape peculiar to that head, and also the other smaller details, whatever they all are. The first necessity is that the head is put together as a well-formed whole, thereafter the individual features listed before are each separately measured correctly.

*On the Face*

Then thought is needed how a well contrived forehead is to be, in sundry ways, that is with eyebrows, eyes; how the eyelids should be. How a well contrived nose is to be, mouth and chin, ears and cheeks, and what multiple adjustments should be looked for in them. For the very smallest details of all these particular parts need quite precise scrutiny, like the little corners of the eyes, the nostrils, the lips, and all such smaller things across the whole face.

This kind of attention is needed right through the whole figure, limb by limb, what in each is the best and can be made beautiful. Thus first, how the neck is to be, in front, behind, at the sides. How the breast, the navel and belly should be, how the nipples should be set; how the hips, the whole back, the buttocks, the flanks are to look. How the arms, in front and behind the elbow; how a comely hand, how each individual finger on its own should be shown.

Indeed how a well shaped nail should be set on each finger. The same is to be done with the feet and the toes. You should look carefully too how the legs above the knee, to the front, behind and to the side of it, should be well formed, how the shinbone and the calf, outside and in, above and below, should be made beautiful with all the tendons, cords and nerves of the instep and sole,[7] as evident in a nude model where you can see it all.

*On Feet*

Note especially that in a foot it is a great skill to find out how one toe projects beyond the other and how each should be shown and the heels and all that makes up the whole foot. How all the parts are to be closely examined and carefully distinguished.

Thus you must look most thoroughly at all the details, which time prevents me from enumerating, equally the smallest and the largest, if you want to produce something good. And this whole assemblage is to be well integrated into a whole, so that all things cohere in the most beautiful way.

*Finally, How All Things Are to be Finished*

All the details in a figure should be thoroughly finished in the most perfect way. One should not, if at all possible, overlook even the very tiniest wrinkles and spots.[8] Let it not be that you skim over and dash through things and just do a quick impression of them, unless it be that you are in a great hurry, in which case it may be enough just to sketch the thing so that people get the gist of how you mean it to be.

Nuremberg, GNM, Merkel Dürer Manuscript, fol. 10–11. Two leaves, first written on both sides, the second blank on the verso

R III, 278–81

NOTES

1   There is an instructive comparison to be made with Leonardo da Vinci's 'On the measurement of the human body and the bending of limbs' (Kemp/Walker 1989, 127f.).

2   AD did not however have the knowledge of anatomy, 'the internal structure of man', that Leonardo obtained from witnessing and indeed conducting the dissection of bodies, and which makes his discussion of this point much more modern in tone (Kemp/Walker 1989, 130–32; see Nicholl 2004, 240–47, 422f., 444f.).

3   This paragraph elaborates somewhat the earlier draft, text 103.4.

4   See 103.7, note 6.

5   The translation omits passages with detailed technical instructions on readjusting measurements to achieve proportional lengthening.

6   *lebendig perschan*: here again, 'person' is a term which connotes the individual particularity of the (especially nude) figure, the model seen before one, studied and copied.

7   *mit allen span vnd plat odern*: the passage is not wholly clear. By *odern*, modern German *Adern*, 'veins and arteries', AD most likely meant rather the musculature of the shin, calf and foot. Leonardo, for all his better knowledge of anatomy, uses *chorda* and *nervo* 'in an anatomical sense that is difficult to translate, since the substances of the nerves, tendons, ligaments and muscle fibrils were taken to be continuous'. See Kemp/Walker 1989, Glossary 311, 314.

8   *dÿ aller kleinesten rüntzelen vnd ertlein*: see also 151.2. Throughout his published treatises, AD prefers to use anatomical names which are not drawn from Latin terminology but from quite earthy German vernacular usage. See earlier in this text, *dÿ tütlen*, 'nipples' (compare English 'tits, titties'), and *ars*, 'buttocks'.

# Part 7

## 1516–1520

This section takes the documentary biography to the end of the fifth decade of AD's life and the third of his major activity as an artist. It contains no large block of his own writings, save for the first draft of the Discourse on Aesthetics for the *Four Books of Human Proportion*, which reaches its definitive form only in 1527/8. The dominant text-type here is the letter, though of the forty-odd dated in these years only four (132–3, 138, 154) are written by AD and a solitary one (125) is addressed to him. Most of the rest comes out of the voluminous correspondence of humanists who are sometimes merely passing on their polite greetings, though that in itself is a measure of the respect in which he is held. This is particularly evident in Christoph Scheurl's epistle to Johann Staupitz (106), while the survey of the structure of Nuremberg's government, which that letter accompanies, provides a detailed description of the civic framework within which AD's personal and artistic activity takes place. His professional status is reflected in commissions to advise on the redecoration of the town hall and the repair of a local nunnery (105, 119).

Two themes of huge importance in his life and work run through the texts of these years, however. They see the final chapter in AD's long association with Emperor Maximilian I, who died in 1519. AD did four portraits of him: a drawing based on a sketch from life in 1518 (126.1), two formal portraits in oils, and a memorial woodcut of 1519 (143.1). Letters to and from the imperial court (117, 123–4) testify to the importance of two final commissions, the wreath of honour and the Hapsburg chariot, both part of the grandiose project of a Roman imperial triumph, and to Maximilian's delight in these fruits of AD's and Pirckheimer's collaboration in his service. The obverse face of imperial patronage also shows itself in the extended manoeuvres and machinations that eventually issue in an agreement, which squares the vicious circle of Maximilian's perennial cash crisis, Nuremberg's fiscal prudence and AD's horror of poverty in old age, by granting AD a liferent (109–10), only for it to be jeopardised by Maximilian's death (136.3, 138, 149).

Another prestigious patron in these years was Prince Elector Albrecht of Brandenburg, cardinal archbishop of Mainz, for whom AD did a further three portraits, the two drawings and the copperplate engraving, also of 1519 (143.2). Like the portraits of Maximilian, these derived from a sketch from life done at the imperial diet in Augsburg in 1518, which AD attended together with Nuremberg's diplomatic envoys Kaspar Nützel and Lazarus Spengler, another mark of his accrued prestige. It was to the Augsburg diet that Martin Luther was summoned to answer to the papal legate, Cardinal Cajetan, for his first questioning of the teaching of the Roman Church in 1517. The Nuremberg delegation probably did not wait to witness Luther's appearance. But all three of them were by then already familiar with the basic theology of the incipient Lutheran controversy and committed to its study and propagation; at this juncture it was not yet civic business. Here is the second major theme in the documents of 1516–20, one which will gather momentum and significance and come both to illuminate and overshadow AD's final years. A string of letters testifies to the rapid spread of the new doctrines among the governing and intellectual elites of Nuremberg (106, 120, 122, 129–30, 137, 139, 144–6). It is clear that AD was from the start a prominent and committed member of the reformist group which gathered around the preacher Johann Staupitz, a seminal figure in Martin Luther's theological education and thinking. AD notes down a key point from a sermon of Staupitz; he avidly collects early vernacular pamphlets by Luther; his interest in the new doctrines is repeatedly invoked in the letters of his friends; in 1520 he writes a remarkably frank and self-revealing letter to Georg Spalatin, a pivotal figure in early Reformation Wittenberg (108, 152, 154). He painted no major religious work between 1516 and 1520, and produced only a trickle of woodcuts and engravings, still devoted to traditional themes of Catholic piety. This was not yet a phase of the Reformation which required a wholesale abandonment of older beliefs or fixed a sectarian gulf. Rather they are years which show a Janus-face of old and new in terms of AD's personal Christian faith and the content and styles of his public art.

# 1516

## 104  Works of Art

### 104.1  *Michael Wolgemut*. Oil painting on limewood panel. A 132

Inscription top right-hand corner:

> Albrecht Dürer made this portrait of his teacher Michael Wolgemut in the year 1516. And he was 82 years old and lived until the year 1519. He then passed away on St Andrew's Day, early before the sun rose.

Rupprich, on the basis of analysis of the script, regards the inscription as having been written in two stages, the second and third sentences added after Wolgemut's death. However, doubt persists as to its date and even its authenticity (Wolf 2010, 266). By the early seventeenth century the portrait belonged to the art collection of the Nuremberg patrician Paulus Praun. In 1809 it was sold by a dealer for 300 ducats to Crown Prince Ludwig of Bavaria. Since 1911 it has been on permanent loan in the GNM.

For Wolgemut, see B1. It is difficult to know what AD derived from Wolgemut's tutelage, beyond his access to the collection of drawings by Martin Schongauer which the workshop inherited from the elder Pleydenwurff. However, the image and the inscriptions suggest that AD held him in affection and meant to pay him dignified homage.

A version of the portrait on parchment mounted on a wood panel (A 131, formerly in the Schäfer collection, Schweinfurt) was held by Winkler and Anzelewsky to have been made by AD as a gift to Wolgemut. It now seems more likely to be a later sixteenth-century copy.

As a strikingly naturalistic portrayal of old age, the image of Wolgemut may be compared with AD's charcoal drawing of Barbara Dürer (92.2).

[Zander-Seidel 1990, 228; Anzelewsky 1991, 247f.; Grebe 2006, 18–23, 34–6; Smith 2012, 28–35]

### 104.2  Bookplate for Hieronymus Ebner. Woodcut. S W 181, SMS 246

Dated 1516. Latin inscription above the coat of arms of Ebner:

DEUS REFUGIUM MEUM

(The Lord is my refuge)

[After the opening words of Psalm 45/46]

Below:

> Liber Hieronimi Ebner

(This book belongs to Hieronymus)

Two shields, supported by putti. From the helmet twin curved horns rise. To either side cornucopia. The left-hand shield is that of the noble Ebner-Eschenbach family, the right-hand one that of his patrician wife Helena Fütterer.

## 105   Resolution of the City Council on the Decoration of the Town Hall

*8 July 1516*

To take advice on how to clean the Council Chamber[1] and to repaint[2] it: Architect,[3] C. Nützel, A. Dürer.

Nuremberg State Archive, Council minute books
R I, 242

NOTES

1   *die ratstuben*: in older morphology this could be accusative singular or plural, thus referring either to the room in which the Council met or to different rooms in the Town Hall.

2   *in ain farb zu bringen*: more specifically it could suggest standardising the colour.

3   The city architect was Hans Beheim. This is the first intimation of the major refurbishment of the town hall to which AD devoted his attention after his return from the Netherlands in 1521. See 168 and Mende 1979.

## 106   Epistle of Christoph Scheurl to Johann Staupitz on the Constitution and Government of the Imperial City of Nuremberg

### Introduction

It is only in his concluding letter to Johann Staupitz that Christoph Scheurl refers to AD. The reference is extravagantly generous, as Scheurl is accustomed to be in his tributes to the German Apelles (see 50, 57, 101). However, his *Epistle on the Constitution and Government of Nuremberg* provides an indispensable context for AD's documentary biography, given the extent to which he was to his core a Nuremberg citizen and artist. In this respect it complements the chapter on Nuremberg in Johannes Cochlaeus's *Brief Description of Germany* (81). It has links with a large number of other texts, and for all its dryly factual character, the reader should obtain from it a useful sense of the city's complex but coherent, and for its time progressive, institutional arrangements. A

selective paraphrase of Scheurl's *Epistle* can also be found in Gerald Strauss's *Nuremberg in the Sixteenth Century*, there with a fuller commentary than is possible here.

Why Staupitz should have wanted this little constitutional textbook we cannot tell. He will have been struck by the presence at his sermons of members of the ruling elite of the city. Scheurl, the Council's jurisconsult and Lazarus Spengler, its principal clerk, were leading members of what Scheurl humorously dubbed 'the Staupitz Club' (see 120). How this impressive city functioned may simply have engaged his intellectual curiosity, prompted by his social contacts and discussions over dinner on visits there. In 1516 he cannot yet have envisaged the possibility that Nuremberg would eventually carry through a religious reform based on Luther's theology. It is interesting that Scheurl does not go into detail in his *Epistle* about the civic control of its churches' finances and staffing. Another possibility is that Staupitz may have looked to Nuremberg as a model for the governance of Wittenberg, the town which Scheurl's earlier patron Duke Frederick the Wise of Saxony wanted to develop as a university, cultural and commercial centre and seat of ducal power.

Like Cochlaeus's book (intended for schoolboys), Scheurl's essay in constitutional analysis is innovatory, not least in its expanded German version (the basis of this translation), which was evidently meant as a reference guide for the everyday use of the city's administrators. It has no parallel in contemporary Germany as an expert account of how the city's systems of law and government were set up and functioned, written by an eminent jurist who was the Council's chief legal advisor. There is, in fact, one other early sixteenth-century commentator who shared Scheurl's interest in political systems, albeit in quite different modes of thought and writing and from a less objectively descriptive, more radical theoretical and philosophical standpoint. That is Niccolò Machiavelli (1469–1527, thus an almost exact contemporary of AD). Machiavelli had visited Germany as Florentine ambassador to the imperial court, and the German *Reichsstädte* provided him with a model of the city republic against which he could critically measure the Italian city states – though Nuremberg's constitution may in part have been based on that of Venice (Roeck 1999, 148). In his *Discourses on the First Ten Books of Livy* (circa 1517, almost contemporary with Scheurl's *Epistle*), he presents a kind of prelapsarian notion, startlingly reminiscent of Tacitus's *Germania* (written in AD 97–8), of a 'political life [that] survives uncorrupted' in German cities, where 'there still prevails a measure of the goodness of ancient times', in that 'many republics there enjoy freedom and observe their laws in such a way that neither outsiders nor their own inhabitants dare to usurp them' (*Discourses* 1.55,3–5, transl. Walker 1950). This republican integrity is based, he argues, on their self-sufficiency and their freedom from aristocratic domination. Machiavelli also adduces the weakness of the imperial power, which requires of the cities only 'the payment of a small annual tribute' (*Discourses* 2.19, 4–5). Nuremberg's imperial tax was tapped in AD's case to recompense him for his artistic service of Maximilian I (see 99, 109–10). A famous passage in his *Florentine Histories* (written in 1520–25) encapsulates Machiavelli's case for the superiority of republican governance,

based on stable institutions which resist both aristocratic tyranny and populist anarchy and command a measure of general social consent: 'When it happens (and it happens rarely) that by the good fortune of a city there rises in it a wise, good, and powerful citizen by whom laws are ordered by which the humours of nobles and men of the people are quieted or restrained so that they cannot do evil, then that city can be called free and that state be judged stable and firm: for a city based on good laws and order has no necessity, as have others, for the virtue of a single man to maintain it' (Book 4.1, transl. Banfield 1988). If we substitute for the one 'wise, good, and powerful citizen' the 'wise, good, and powerful patrician families' of Nuremberg, we have a prescription for the city republic which Scheurl could have endorsed. For him, Machiavelli's pragmatic sense of civic virtue, in which 'the republic is not the embodiment of virtue, nor instituted to affirm and enhance virtue, it is a civil order which needs virtue' (Viroli 1998, 128), would have seemed a step too far towards a secularised political philosophy. Although – in an *Epistle* addressed to the Augustinian Staupitz – Scheurl makes surprisingly summary reference to the ecclesiastical functions of the Council, or to any responsibility it has for promoting Christian belief and praxis, he would have found outrageous Machiavelli's radical critique of Christian morality as being irreconcilable with the amorality of political power, and the general tendency in Italian humanism to draw a sharp distinction between political and religious thinking and values.

[Hirschmann 1968; Strauss 1976; Hankins 1996; Viroli 1998; Posset 2003, 164; Whaley 2012, 47f.]

**An Epistle or letter sent to one highly learned honourable man by another such, the former learned in Holy Scripture and Provincial of the Order of Saint Augustine, the latter Doctor of Civil and Canon Law, concerning the civic administration[1] and good governance of the estimable city of Nuremberg, divided into twenty-six chapters.**

### 1. Preface

My due obedience. Venerable Father, in your innate kindness you have often desired to know in what manner our city and commonweal is ruled. Wherefore I have always desired to be of service to you, since you are so minded that when someone does you a favour he can as confidently expect the like from you, as though he had always enjoyed it. Although in this work of mine I have had no predecessor whom I might imitate, I have tried without omission to meet your request by describing briefly the form and manner of our governance, in the hope that Your high and excellent Wisdom will require of me not a long exhaustive history but simply a short account of main points, whereupon you may assess for yourself from my scanty indications the extent and importance of the matter, as you are accustomed to do with your inborn intellect.

But to begin my undertaking: Firstly, the people of Nuremberg are accustomed to seek and desire all wisdom, counsel and rule from God alone, mindful of the common saying that all are familiar with: Man proposes, God disposes.[2] I shall not say much to you on that, Venerable Father, lest I be accused of the Greek proverb *sus Minervam*,[3] that is, the ignorant wants to teach the educated. I shall content myself with indicating only the one fact, that whenever weighty matters arise on which counsel must be taken, the practice of the Nuremberg Council is always to command their priesthood to set in place special prayers, petitions and processions in appeal to God. Also, following old tradition, on the third day of Easter every year in every church an Office of the Holy Spirit is sung, the common folk are exhorted to pray and God is with one voice beseeched through his divine grace to set in authority over them such people as are gifted along with wisdom and understanding also with fear of the Lord, so that the public offices are allocated to these same honest god-fearing men rather than the men being allocated to the offices.[4] To achieve this, as soon as the ceremony is completed and the council bell is rung, the senators of the Small Council together with certain honourable men, who are called nominees of the Great Council, go into the Town Hall with the intention of electing a new Council.

## 2. The Number of Nuremberg Councillors and Their Titles

The supreme and most powerful Council in Nuremberg consists of forty-two men, of whom thirty-four are chosen from the noble dynasties of ancient bearers of arms,[5] and eight are chosen from the commonality. The thirty-four patricians are further divided so that eight of them are called the eight Old Nominees[6] and the other twenty-six are Burgomasters. Of the twenty-six Burgomasters, thirteen are called sworn Magistrates,[7] the other thirteen simply have the name Burgomasters, but these same twenty-six Burgomasters are further divided, thirteen of them being chosen as Senior and thirteen of them as Junior Burgomasters, although the name apart any distinction between them is insignificant. Note further that out of the thirteen Senior Burgomasters seven supreme governors are selected who are called the seven Aldermen,[8] out of whom three are appointed to the office of Chief Captains[9] of the city, and of these three men, two have charge of the treasury and by virtue of their office are called Losunger.[10] Whichever of these two is the man first named to this post becomes the chief officer of the whole Council and is regarded as the first man in the city.

## 3. The Nominated Members and Their Office

The Great Council of the city is made up of honourable,[11] capable citizens, whose number is not fixed nor always the same, but is usually more than

two hundred. They are called jointly and severally the Nominated Members[12] and they are men of honourable character who earn their living in respectable trades, not lowly manual work, except for a few of good repute, whose craft skills are especially useful to the city. The seal or private signet[13] of these Nominees is so esteemed that according to the pronouncement of statutes concerning them the seals of just two of them suffice to validate a testament, whereas otherwise imperial law decrees that seven witnesses are required. From their ranks are chosen at due times the proper councillors,[14] indeed it is they whose initial vote picks out and names the first Electors by whom the whole Council is to and must be chosen. The Nominees' pronouncement, opinion and vote are consulted when a tax is to be imposed, war declared, or the subjects need warning of impending danger.[15] They are collectively informed what provision the princes are making for safe escort to the Frankfurt Fair. In brief: their office consists mainly in consenting to and ratifiying all kinds of treaty[16] and in closely perusing and conforming to the Council's legislation. Hence it is considered no small honour for a man to be chosen and made a Nominee of the Great Council.

## 4. Selecting the Electors of the Council

Now the election of our [Small] Council takes place as follows: When, as noted already, on the third day of Easter every year the Great Council assembles for the purpose of electing the Small Council, the Nominated Members choose by oath, from among the Seven Aldermen or the Seven Senior Burgomasters, one Burgomaster and one Magistrate as Electors, and thereafter the Small Council itself names three Senior Nominated Members as the Electors of its choice, so that in votes out of five Electors there will be a majority. However no two members of the same family may serve as Electors, nor a man who has been an Elector the previous year. As soon as the five Electors are inscribed, the other Councillors are quit of their offices and duties, are no longer titled councillor but rejoin the ranks of plain ordinary citizens. Thus at the time of the Election all offices and powers of the whole government of Nuremberg are free and untenured.

## 5. The Powers of the Electors and How They Elect the Council

The five Electors, having first sworn an oath on their lives to Almighty God, shut themselves into a special locked room from which all others are excluded and proceed to elect the whole Council, except for the eight Old Nominees, who will be appointed later by the new Council. However the Electors generally give preference to the incumbent Councillors, but occasionally they

promote a younger man or retire an old one who from age and incapacity or some other honest reason has asked to take his leave and ease. Otherwise they never replace anyone without weighty cause, for it is considered a great insult to be retired from the Council against one's will. Thus a new Council member is chosen only upon the death of an old one since the honour of Council membership is taken away only by death or occasionally (and rarely) for the commission of a crime. Yet the power of the Electors is nonetheless highly esteemed, for they may as they please raise to honours whomever they wish, for they can promote one of the Old Nominees to the rank of Senior Burgomaster and, further, they assign to every Senior Burgomaster one of the Junior Burgomasters to make a pair (who may however not be of the same family) to be the Governing Burgomasters of the city for the term of one month. The Electors also out of the twenty-six Burgomasters choose the thirteen Magistrates[17] and assign to each his seat on the Council benches where he then sits in Council for the whole year, but this must be done in such a way that Old Nominees, Burgomasters, and the members chosen from the Commoners sit in mixed order. Moreover, they determine the order of precedence according to which men may speak in Council, for it is deemed a great honour to be the first to be called upon to give an opinion, for the right to speak first usually indicates that a man is on his way to becoming a Losunger. So when one wishes to refer to the unsuitability of a Councillor, using a polite expression one says, 'He is still sitting on his old cushion', it being the custom to place one for each Councillor on his designated seat. Once the Electors have set everything up, on the fourth day they notify the Councillors-elect who are then sworn into office.

## 6. The First Business of the Newly Appointed Council

On the following Thursday the newly elected Council meets to name the Old Nominees, insofar as death or other deficiency has not affected their number, then proceeds to appoint to all the civic offices, powers and governances. No post is so lowly that it is not thoroughly debated by the whole Council, and each member's opinion is sought on the choice to be made. If any office-holder is found to be an adulterer or otherwise guilty of unvirtuous conduct, he is either entirely replaced or punished in some other way. Because the office of First Burgomaster is not only the most honorific but also the most arduous since it charges him with the exhibition of the Holy Regalia,[18] it is conferred on the Senior Losunger, and as his companion in office that Junior Burgomaster is commonly appointed of whom it is expected that he will most likely be chosen as Senior Burgomaster in the following year. Next, after four weeks

have elapsed, two new Burgomasters, a senior and a junior, are put into office, such that in the course of the year, the twenty-six Burgomasters each and all will have served in office and governance. And according to whether it happens that Easter in the next year falls later or earlier the last period of office as Burgomaster has to be shortened or extended.

### 7. The Office of Burgomaster

Those who serve as Burgomasters are most earnestly exhorted that they devote their term of office to the common weal. Hence they must make do with little sleep and spend the greater part of their time at the Town Hall or on the street outside, to hear complaints, settle disputes, urge debtors to pay up, conciliate opponents[19] and so forth. In particular the Senior Governing Burgomaster receives ambassadors and emissaries with due ceremonial, opens all official letters and reads them the moment they arrive, whether by day or night, whether or not the Council is meeting. When it is time for it to meet he convenes the Council even though it is the sworn duty of all members every evening to prepare to attend a session the following morning. When the Council sits he must consult members on current matters, put the question and count the votes, order decisions to be put in writing, and adjourn the session. When the Seven Aldermen convene separately on urgent matters,[20] as often happens, the Senior Governing Burgomaster must meet with them. Without his permission, no one can raise matters for discussion and put motions to the Council. The Junior Burgomaster's responsibility is to be on duty in the Town Hall while the Council is sitting and at other times, to receive letters and supplications and to speak to them in Council, to adjudicate minor instances of quarrel and dispute.

### 8. The Character and Dignity of the Nuremberg Council

The government of our city and its common good reside in the hands of the *Geschlechter*, the Ancient Families, whose ancestors from earliest times were likewise members of the government and ruled the city. Incomers who have settled here, and common people, have no say, nor should they, for all power comes from God and only those few may wield it whom the Creator of all things and of Nature has endowed with particular wisdom. Hence we admit no one to the Council (save for the eight commoners referred to before) whose parents did not likewise serve on the Council. Some exceptions to this rule are now made, it is true, with certain incomers who have recently arrived in Nuremberg and with men born here, those of respectable birth and notable family. Even so, such men may not occupy a position of higher dignity than

Junior Burgomaster, whereas members of ancient Nuremberg families may rise in dignity and title from Junior to Senior Burgomaster and from Senior Burgomaster to the seven Aldermen, ultimately to the high rank of Losunger. Here it is a great thing to be a Councillor, all the greater to be a Senior Burgomaster, but greatest of all to be an Alderman or Losunger. Although in our city there are many Geschlechter out of which Councillors are recruited, there are many who do not rise higher than the rank of Senior Burgomaster, for the dynasties from which the seven Aldermen are drawn are very few, even fewer those from which the Chief Captains are taken, the fewest of all those from which Losunger are elected. Such things are not explicitly regulated by law, rather they are generally acknowledged, so far as I can tell. I cannot omit to point out one thing: no one with a doctorate, whether born of a Geschlecht or however noble he be, can sit in the Council. Equally, two born into the same family cannot be elected to the Seven Aldermen, though they may be both admitted to the Council.

## 9. How High Offices are Appointed by the Council

When it occurs that an Alderman or a Losunger dies or is found to be at fault and others must be appointed in their place, the two governing Burgomasters instruct five of their number in the Council to propose four candidates they deem qualified for such offices. Whichever of them receives most votes when opinion has been canvassed succeeds to the empty or unfilled office, however all those Councillors who are close friends of a candidate, or related to one up to a degree specified by the relevant law, must abstain and cannot be present at such an election.

## 10. The Emoluments of Councillors

All our office-bearers receive emoluments to ensure they perform their duties diligently. The Losunger receive the highest payment because while they are in office they are disbarred from any kind of business activities.[21] The Seven Aldermen receive fifty gulden each, but they hold other offices because of their prestige for which they draw large benefit and income, such as sealing missives, wills et cetera. Those who travel on behalf of the city each receive half a gulden per day (years ago it was a whole gulden). For each Council meeting he attends, a member receives a token worth fifty pence when cashed in at the end of each month. However if he arrives late he is fined four pence on each occasion, to be paid in the collecting box for foundlings, and if absent without cause he forfeits one of his tokens. Senior Burgomasters receive annually eight gulden, Junior Burgomasters four. These men earn it, for they work hard, since Council

meetings usually last for three hours and there are almost always weighty matters which the Seven Aldermen have to deliberate further on their own, sometimes for half a day after their colleagues have gone home.[22]

### 11. The Losunger

Now I must comment on the responsibilities of the Losunger. The two incumbents of this office possess the highest power and dignity, since they are entrusted with the keys to the municipal treasury. A man chosen from the ranks of the eight Commoners on the Council is nominated as their associate, but his sole duty is to open and close the doors of the treasury chamber and escort visitors. The Losunger draw on the assistance of two experienced secretaries who keep complete records. They meet three times a week, after noon on Mondays, Wednesdays and Saturdays. During the four weeks in which the four quarter-days fall, they have to attend full-time in their office. When the common people pay their tax or Losung they are busy for a whole month together,[23] and for the whole of Lent they are receiving and auditing accounts from all other office-bearers, and at the end of their year in office they must give a full account to the Aldermen of their incomings and outgoings. All public monies disbursed or taken in by the city which concern the tax office pass through their hands, and all documents issued by the Civil Court must bear their seal. In sum, no aspect of public affairs may escape them, no secret is so great that they do not know of it.

### 12. The Three Chief Captains

The three Chief Captains have custody of the keys to the imperial regalia and to the city gates. They are also custodians of the seals of the city together with all else that is needful to the security of the common weal, its honour and welfare. Therefore one must swear and observe obedience to them and report to them at times of unrest.

### 13. The Seven Aldermen

For the rest, all powers of the whole government of Nuremberg reside in the hands of the Seven Aldermen, for they deal with all secret matters and take counsel on all emergencies before these reach the other councillors. Thus the highest power rests with them alone and the others know and can do little in comparison with them. Yet although these Seven Aldermen must account every year for all income and outgoings, they do not know how rich and wealthy the common treasury or Losung office is. Not one alone but two of them are elected as Senior Governors, so that if one of their number as Seven Aldermen

leaves office, an election is always postponed until another one dies, so that two may be elected together. Hence it has happened once or twice that at times of danger, for the common good, the number of seven aldermen has been increased by one and eight have been elected.

### 14. The Eight Old Nominees

The eight Senior Nominees are comparable with army veterans who have been released from the burdens of military service.[24] They hold no particular office and thus cannot rise to the highest dignity, except that one of them may occasionally be chosen as Junior Burgomaster. However, none may ever be made Senior Burgomaster. When in Council sessions the issue in question reaches them, they give their vote or cast their lot as they please. Generally such men are made Old Nominees who have been prevented by having friends who have been in government before them, or a brother who was elected to the Council first and became Burgomaster, which means he cannot hold office in their lifetime since two brothers cannot both have appointments of authority and prestige. Likewise if a parent has never been in government, his son cannot expect to hold a ruling position. Hence such people who for these two reasons cannot hope for any higher position are made Old Nominees, a rank formerly of greater prestige than nowadays, although still now the three Senior Electors, because they choose the whole Council, are comparable in prestige to the Senior Burgomaster and the remaining five to the Junior Burgomaster.

### 15. The Sworn Magistrates

The thirteen Magistrates chosen by the Electors have the following obligations: Some of them not numbered among the Seven Aldermen must be present to hear the answers of an accused interrogated under torture and testify to a criminal's confession, and to judge all together in capital offences, although the verdict they reach cannot differ from the decision already arrived at by the Council as a whole.[25] For every Council member has to swear an oath always to accept the majority decision, regardless of his own view and vote.

### 16. The Craftsmen

In the city there are eight crafts, each of which is entitled to a seat on the Council and is paid the same emolument. These eight elected men are free to attend the Council and vote at will, or they may stay at home if they prefer. They hold no office, are pleased to accept the decision of other Councillors and, should they involve themselves in a question, to vote along with those whose opinion seems to them the most proper.[26]

### 17. The Court of Five

There is a further a court called the Court of Five called after the number of its members, among whom are the two former Governing Burgomasters whose monthly term has just expired, the two whose term has just started, and one further member drawn from the Council, such that one member succeeds another in turn, excluding the two Losunger who are exempted. Thus the membership of five changes monthly. It meets three times weekly, on Monday, Wednesday and Friday afternoons, each time for three hours. The judges have their own clerk and each is paid twenty-five pence. They hear cases of slander and injury and punish offenders. Its proceedings are speedy and pertinent, tolerating no verbosity or judicial rigmarole, accepting no written briefs and allowing no party to engage a procurator or advocate. Witnesses are rarely called, most matters are decided on oath. Its verdicts cannot be appealed, though if the matter is very serious it is customarily referred to the Council,[27] a custom of the Court of Five I consider so useful to the whole city that I cannot find adequate words, as you can well understand.

### 18. The Military Commanders

The incidence of daily threats to the security of our city has brought the number of Military Commanders to a total of seven, though at any one time rarely more than three are burdened with duty. (You will have noticed that we generally prefer officials to be in sets of odd numbers.) The senior figure has the actual title of Military Commander. They operate from a room in the Town Hall, called the War Room. There they meet to confer in times of war or danger and exercise their functions from there. Each member and their clerk are paid one hundred gulden a year. Their remit encompasses every aspect of military significance, and hence they have to hand a detailed register of all villages, peasants, horses, carts et cetera. in the city's entire territory. They deal with many secret matters and daily receive confidential intelligence – but I forebear to disclose such things in this context, since if a war is justified and declared for honest reason, it is of no great consequence (as those versed in papal decretals will doubtless know) whether the enemy is attacked secretly or openly, according to the rules of war or treacherously. From this you can adduce what kind of office the Commanders daily exercise and its attendant daily cares, troubles and labours.

### 19. The Administrators of the Nuremberg Territories

Only about two years ago did we set up an Office of Territorial Administration. Before that, each of our towns, villages, castles and so on was under the supervision

of a single councillor, but recently it was thought wiser to appoint five Territorial Administrators to take charge of the whole Territory, in particular the towns and villages conquered in the recent war with Bavaria.[28] It is the remit of the Administrators, who each receive yearly twenty-five gulden, with a clerk paid one hundred gulden, to exercise specified and defined powers to govern these areas in the name and in lieu of the Council and to receive annual accounts from officials in the territories. They are bound by oath not to accept any gifts, no matter how trifling, even if it be merely food or drink.

### 20. Chief Guardians of Widows and Orphans

The council also chooses three of its number to be Guardians of Widows and Orphans, each of them paid forty gulden annually. This body and its assigned clerk meets on three days a week, Tuesday, Thursday and Saturday afternoons, but it has no contentious or summary jurisdiction, but rather a voluntary one, that is to say it has no final power to issue binding decrees, but merely an indicative one, advising on the right way to proceed and urging the parties to accept this. The Guardians allocate legacies, execute wills, assign guardians to orphans, and replace the deceased or the dubious with others. They ascertain that the investment of money of children below the age of consent is bearing interest and paying for their appropriate upkeep and education. Without their express consent no one may sell or interfere with any immoveable property, pension or interest of a minor. They also check guardians' accounts and declare them quit of their responsibility. They require, receive and distribute funds left by testament for the service of God. The Office of Guardians was set up twelve years ago on the model of Venice,[29] and since then it has beyond doubt prevented much testamentary suppression, formerly a daily occurrence. Another estimable service performed by the Office is that the Chief Guardians diligently and efficiently monitor and supervise the terms, revenues and properties of ecclesiastical benefices, along with funds donated or bequeathed for the carrying out of good works. It maintains a register of all anniversaries, stipulated masses and other divine services and ensures that what has once been donated to Almighty God is wholly and without deduction paid into the hands of priests.[30]

### 21. The Officer of Pledges and the Censors

There is also an official charged with settling disputes between servants and their employers. Called the Pledges Officer, he is elected from the Great Council and has further duties, to ensure that streets and alleys are cleansed, that bread, meat and other foodstuffs sold at the public market are of good quality and fairly priced. The Officer of Pledges also presides at a Court of four Councillors which

meets on Tuesdays, Thursdays and Saturdays to interrogate and punish workmen accused of breaches of trade or other regulations, cheating customers or producing shoddy work. This Court of Five also appoints a Sworn Master for each of the city's crafts, that is to say, what in other places is done by the Masters of Guilds is assigned in our city to the five Censors,[31] who are paid twenty-five pence each time they meet.

## 22. The Supervisors of Churches

Every church, monastery and hospital within and without the city has an appointed Councillor to be its Supervisor, to protect its interests, represent it in the Council and carry out its business. Thus Fürer[32] is protector of St Sebald and of the Hospital of the Holy Ghost or New Hospital, of St Augustine's and St Catherine's. To Ebner is assigned Our Lady's and the nunnery of Engeltal where the virgin Christina Ebner shines forth before all others by her miracles and is revered for her sanctity.[33]

## 23. The City Court

A tribunal of eight men chosen by the Council from among the Nominees, who all have sufficient income from investments and interest, forms the City Court which is split into two benches with a Council member assigned as assessor to each bench. The City Court meets on Mondays, Wednesdays and Fridays for three hours running and is competent to interrogate any person, whether citizen or not, to interpret the law, pass interim and final judgement, settle legal adjournments and terms, exemptions and complaints, hear arguments and counter-arguments, oral or written, and proceed in all matters on the basis of law. Minor matters amounting to no more than thirty-two gulden are treated summarily and in short order. On the other three days – Tuesday, Thursday, Saturday mornings – the judges read judicial documents, deliberate on impending judgements and frame verdicts. If a matter is substantial and weighty, both benches meet together and arrive at a unanimous judgement. In addition to the eight members, three or four doctors of law are assigned to the court as assessors to advise the judges, especially where a case involves provisions of the written law, whereupon the magistrates can cast their vote and make a judgement. Verdicts may be appealed from the Court to the Council, unless the case at issue concerns a sum of six hundred gulden or more, when the appeal goes to the Imperial Chamber Court. Whenever the magistrates convene, each is given a token which at the end of a month is redeemed for thirty-six pence, whoever is absent from court not only does not receive anything but has to surrender a previously received token, and anyone who comes late must

donate four pence to the foundling box. There is also a City Judge charged with the execution of verdicts. He must be present at executions and when a man is subjected to torture. For that he receives honourable payment. Further to these courts, we have a petty tribunal of four men called *Fronboten*,[34] in other places known as Bailiffs, who hear cases concerning sums not exceeding five gulden.

## 24. The Peasant Court

The Peasant Court is composed of honourable and honest citizens who have recently become husbands and joined the Great Council. This Court is regarded as a kind of training-ground to give sons of Councillors practice and experience, hence its number is not fixed but fluctuates as it pleases the Councillors. If they do well on the Court, learn the discourse and procedures of judicial practice, and show promise of an aptitude worthy of payment, they will later be raised to the Civil Court and ultimately perhaps to the Council itself.[35] The Peasant Court has jurisdiction over all disputes arising among the country folk of our Territories. It meets for three full hours on Saturday afternoons. For this reason there has been for years a great dispute between Margrave Albrecht and our city, on account of the fact that in times of war it behoves everyone to fight for his appointed judge who has jurisdiction over him, from which the city has derived great benefit. This court meets every Saturday afternoon and sits for three whole hours, from which each magistrate earns sixty pence. If they meet earlier or on another day together with their attendant doctors of law, read minutes of cases and arrive at verdicts, each has 40 pence payment.

## 25. Nuremberg Counsellors Who Are Versed in Written Law

No doctor of laws is admitted to membership of the Council. Should it occur, as it often does, that the assembled Councillors are divided in their proposals, or the case is complex and weighty, so that those learned in laws need to be consulted, two Councillors are deputed after breakfast to seek expert advice from the doctors and next day to relay this advice to the Council. That happens often three, four or five times a week according to how often difficult issues arise. Ordinarily five or six doctors of law are retained full-time by the Council, four additional ones are available for consultation and receive a not inconsiderable salary, though they may also appear for Nuremberg citizens, for which they are termed sworn and general advocates, whereas those who act only for the Council may not assist an ordinary citizen without the Council's permission. Moreover the Council retains salaried doctors in Augsburg and Ingolstadt whose advice they also make use of in difficult cases. Altogether the office of

the learned counsels in Nuremberg includes defending the common interest outwith the city, acting as its envoys, presenting its grievances before princes and lords, reading matters on appeal at home, advising on these, and finally drawing up just verdicts, for the Council's practice is never to pronounce judgement in any appeal case, before the matter has been studied and the opinion of two, three or four or, when there is disagreement, the findings and recommendations of still more doctors have been heard. Thus exhaustive and cautious are our distinguished Councillors in all matters. Hence also the emoluments of each doctor are close on two hundred gulden, and thus it is incumbent on them to work by day and night and rest but little. Lawyers are accordingly held in great regard here, ranking in esteem with the Seven Aldermen and the Senior Burgomasters.

### 26. The Nuremberg Chancery

The Chancery is run by two First Secretaries who are privy to all the Council's secrets. They must both attend whenever the Council convenes, though when the Seven Aldermen sit by themselves, only one secretary is always present. They set down in writing every decision made by the Council, they draft letters to be sent out and read incoming correspondence. In sum, they are the eyes of our government.[36] Each receives a salary of two hundred gulden a year. The Chancery employs six clerks who are kept busy writing all day long. Each gets about one hundred gulden a year.

### Conclusion of the Epistle

Here then, holy Father,[37] you have from me the fruit of ten hours of diligent labour, which in truth I have neither reread nor revised. Rather, whatever the word that came to my lips, the same passed unpolished straight to my quill. Such great vanity and confidence I draw from your innate kindness, which has never yet spurned my handiwork. Hence it is no surprise to me that you take pleasure in the gifts our Albrecht Dürer daily presents you[38] with which are supremely refined and beautified and of a quality rivalled only by what is attributed to Apelles of Cos and by you the Prelate of the Augustinians, to whom nothing is appropriate than what is in all ways perfect and learned.[39] But we cannot all be Dürers. In what pertains to the gifts of the spirit, I willingly cede him superiority. In my love for you, I yield neither to Dürer nor to anyone else, and as concerns this my unpolished work it is merely that those who have no incense make their atoning sacrifice with flowers and milk.[40] Hence, even though in this my work, in particular as regards the good works and charitable institutions of the city, I might have written something

more elegant and complete, shortness of time, which I am spending in the translation of your sermons, has prevented me, however in that undertaking all that I have neglected here shall be richly compensated, and for this, I hope, you will consider my lack of diligence to be sufficiently excused and accept it with gracious indulgence.[41]

Herewith, Reverend Father, be commended to Almighty God. Given at Nuremberg on the fifth day of December in the year 1516.

No manuscript copy of the original Latin text survives. It was printed in two seventeenth-century editions by Christoph Gastelius (*Tractatus de statu publico Europae*, Nuremberg 1675) and Johann Christoph Wagenseil (*De civitate Noribergensi commentatio*, Altdorf 1697). A German translation was made, though not by Scheurl himself, in or soon after 1516, and this is preserved in three very carefully written sixteenth-century codices, A and C in the Nuremberg State Archives, B in the Stadtbibliothek. They often gloss and expand the Latin text and use the normal vernacular terms for city offices and practices. This exegetical character of the German text suggests that the translation was meant for use as a reference source in the city's administration.

R III, 462f., has only the Latin and German texts of the concluding letter to Scheurl. The Epistle is translated from the German text in *Chroniken der deutschen Städte* 1862ff., volume 5, 785–804, since this offers the fullest version, that of manuscript A, current in sixteenth-century Nuremberg and used by the city administration.

## NOTES

1   *von polliceischer ordnung*: see DWb VII, 1981–5. Early modern German *policei* is a fifteenth-century borrowing from Middle Latin *politia*, itself derived from Greek *politeía*, 'citizenship, state constitution and administration'. On the meaning of *policei* and the concept of *gemainer nutz* ('common good, common weal'), see Whaley 2012, 47f.

2   *der mensch nimbt im für, got aber der füerts hinauß*: a later German version is: *Der Mensch denkt, Gott lenkt*. Scheurl has the saying not from a classical Latin source but from the *Imitatio Christi* of Thomas à Kempis (I, xix): *Nam homo proponit, sed Deus disponit*.

3   *sus Minervam [docet]*: 'a sow lectures Minerva' (the Roman goddess of wisdom).

4   The principle of idoneity: office should be conferred on those suitable to discharge it.

5   *aus den edeln geschlechten der alten wappen genossen*: the terms *edel, geschlechter, wappen genossen* ('noble, lineages, bearers of heraldic arms') are freighted with connotations of privilege and aristocracy. The Latin text has simply *patricii*, a term which denoted the urban upper class of Rome and the later Italian city republics. It entered German only in the later seventeenth–eighteenth century (DWb VII, 1503, Pfeifer 2, 1242f.) and would thus be anachronistic in this translation. In the southern German imperial cities the old established families of the urban upper class had a monopoly of service on the Small Council, as a ruling caste. The right to bear arms, to possess dynastic heraldic symbols, had become extended by the fifteenth century from the

feudal nobility to the emergent urban patriciate. See DWb IV, I, 2, 3912 and XIII, 1598f. However, in Nuremberg the *Geschlechter* were too numerous (42–3 families) to be an 'oligarchy' and not so sharply demarcated around 1500 as to be an urban 'aristocracy'. By this time the possession of a coat of arms was often claimed even by non-patricians like AD himself (178.1). Only from 1521 were the Nuremberg *Geschlechter* a closed class, when the Council ruled that it should be constituted only of 'those Families who used to dance in the Town Hall in olden times and who still dance there' (the so-called 'dance-statute'). See chapter 8 and Strauss 1976, 78–83.

6   *Alte Genannte*: The Latin term is *nominati*, the same as is used of the 'honourable' citizens appointed to the Great Council. In both cases these seem to have been men of substance and authority whose position and roles are sufficiently sensitive for them to be designated by the ruling Council rather than by election. Men from among the *Genannte* may then be chosen to serve on the Small Council, and the *Alte Genannte* can be promoted to be Junior Burgomaster. The adjective *alt* indicates not their age, but the antiquity of their families.

7   *Schöffen*: while Strauss 1976, 58f., calls them 'jurors', the better term is '(lay) magistrates'. See 2, note 1 and other legal charters in the documentary biography, where they sit with the *schultheiss*, the *scultetus* or 'Justiciary', originally a royal appointee, later nominated by the Council, to administer civil law.

8   *Ältere Herren*: the now obsolete English municipal term 'Aldermen' corresponds precisely as word-form, and quite closely in status. See chapter 8.

9   *Oberste Hauptmänner*. Their functions, defined in chapter 18, have to do with institutional security as much as specifically military functions.

10   The word *Losung* – not restricted to Nuremberg – related to modern German *Lösung* (and to English 'loose/loosening'), came to acquire the specialised sense of 'money paid to release one from an obligation, to redeem a pledge', then more generally 'payment of dues, taxes'. In Nuremberg *Losung* was the name of the main tax levied on citizens. Scheurl discusses the position of Losunger in chapter 11. See also note 23 and Machiavelli's description of how taxes were paid in German imperial cities.

11   The term *ehrbar*, attached to professional men and prosperous craftsmen, implied both the expectation that well-established families below the ruling class were respectable, and honourable in the specific sense of 'fit to receive honours' and suitable for being accorded the 'honour' of nomination to serve on the Great Council. AD acquired this status in 1509 (58).

12   *Genannte*: see note 6.

13   *sigil oder secret*: see DWb X, I, 404 and Pfeifer, 1611. 'Seal' suggests a ring or stamp with the matrix of a coat of arms or identifying symbol. The latter is what Scheurl means by *secret*, from Latin *secretum* (in the sense of a personal mark, not 'secret' in the modern sense). The words can be synonymous, but here show the transitional situation in the early sixteenth century, when men of the 'honourable' class might

already have a coat of arms for use on a seal, but might still rely for the authentication of letters and documents on the use of a 'trademark' (commonly a geometrical design with monogram and/or motto). An example is Holbein's portrait of 'Hans of Antwerp' (1532/3), shown with a seal on his desk and his mark on a letter in his hand (Ex. Cat. London 2006). AD's (and earlier artists') authenticating monogram or trademark must owe something to this more general practice (compare Nash 2008, chapter 12).

14   Scheurl's phrase *die rechten rathsherrn* betrays the inferiority of the *Genannte*.

15   The details Scheurl gives show how limited these consultative discussions were. There was no question of the Great Council overruling the Small Council on major matters. It was in front of the combined Small and Great Councils, however, that the debate took place in March 1525 which led to the city adopting the Lutheran Reformation (206, see also Strauss 1976, 175–7).

16   *allerlei contract*: the word shows its Latin origin – *contractus* – and occurs in chancery usage, as a bureaucratic and legal term from the fifteenth century. Niermeyer I, 348, Pfeifer, 906.

17   See note 7.

18   The Imperial Regalia, which included a number of holy relics, had been entrusted to the city by Emperor Sigismund in 1424, and were exhibited annually with elaborate ceremonial until the eve of the Reformation in Nuremberg in 1524. See 64.7 and Strauss 1976, 212f.

19   *hedrischen*: this and other terms from the root noun *hader* ('enmity, strife, conflict, feud'), are now archaic, but were central concepts in earlier vernacular legal vocabulary.

20   In this function, as a kind of privy council or executive group, the Aldermen are often called the *septemviri*, a term and institution which go back to the Roman Republic. See chapter 8 and Strauss 1976, 86f.

21   According to Strauss, 62, note 1, the total income of the Losunger from their Council functions amounted in 1500 to around 400 gulden for the year.

22   'Considering the wealth of incumbents, these sums constituted little more than honoraria. Only since the middle of the fifteenth century did Nuremberg remunerate her government officers and then only to meet complaints that official business consumed so much time that private affairs had to be neglected' (Strauss 1976, 62, note 2).

23   In his *Discourses*, Book 1, 55, Niccolò Machiavelli uses the collection of the *Losung* as the prime example of the probity and public integrity that, so he claims, characterises the German imperial cities: 'When these republics have need to spend any sum of money on the public account, it is customary for their magistrates or councils, in whom is vested authority to deal with such matters, to impose on all inhabitants of a town a tax of one or two per cent of the value of each one's property. The decision having been made, each person presents himself to the tax collectors in accordance with the constitutional practice of the town. He then takes an oath to pay the appropriate sum, and throws into a chest provided for the purpose the amount

which he conscientiously thinks that he ought to pay; but of this payment there is no witness save the man who pays. This is an indication of how much goodness and how much respect for religion there still is in such men, for presumably each pays the correct sum, since, if he did not do so, the tax would not bring in the amount estimated on the basis of previous collections made in the customary way, and failure to realise it would reveal any fraud, and in that case some other method of collecting the tax would have been adopted' (transl. Walker 1950). In fact, in Nuremberg the citizens bought chits, little metal tabs, from the treasurers' office and dropped these into the chest. For the whole procedure of tax collection, see Strauss 1976, 72–4.

24   The comparison is distinctly odd. There was no imperial standing army (Maximilian I developed the use of mercenary *Landsknechte*) and in any case the patrician *Genannte* would not have felt flattered by being likened to demobbed old soldiers. It may be that Scheurl has in mind the Roman practice of setting up veterans with land and civic duties in towns given the status of *colonia*, such as *Colonia Agrippina* (modern Köln/Cologne) or *Lindum Colonia* (modern Lincoln).

25   There was then no pretence of a 'separation of powers' between executive and judiciary. On the practice of torture in Nuremberg, see for instance 95, note 4, and Strauss 1976, 225–30.

26   After an artisan revolt in the mid-fourteenth century, Nuremberg had proscribed trade guilds, that is corporations of craftsmen legally privileged to control their own standards and practices. Craftsmen were members of Sworn Crafts, under an elected Sworn Master who was responsible to, and essentially an agent of the Council.

27   These procedures were at basic variance with those of Roman law which since the fifteenth century had gradually been replacing traditional Germanic statute and custom law. On this process and the *Reformation of Statutes and Laws Undertaken by the Honourable Council of the City of Nuremberg in the Interests of the Common Need and Cause* (Nuremberg 1484), and for a succinct survey of the city's courts and their jurisdiction, see Strauss 1976, 218–30. Scheurl, like Willibald Pirckheimer had studied law in Italy and was trained in the principles and methods of the Justinian code. Doctors of law were not permitted to serve on the Council, which is why Pirckheimer never graduated; Scheurl acted as its principal jurisconsult.

28   The War of the Bavarian Succession (1503–5), in which Nuremberg supported Duke Albrecht IV of Bavaria-Munich against his rival contender Prince Ruprecht of the Palatinate whom the deceased Duke George the Rich of Bavaria-Landshut had designated as his successor. The post-war settlement (at which Willibald Pirckheimer was the city's envoy) brought Nuremberg these new territories.

29   The Nuremberg merchants resident in or frequent visitors to Venice will have taken an interest in the institutions and functioning of this other great city republic.

30   On the city's management of ecclesiastical provisions and finance in the late medieval and early sixteenth century, before the Reformation of 1524–5, see Strauss 1976, 154–9.

31  *Rügsherren*: in early modern German, *rügen* had a range of meanings, from 'admonish, censure' to the stages of legal process 'accuse, judge, punish'. The function of the *Rügsherren* and their court in Nuremberg was to censure and admonish those guilty of minor transgressions, especially arising from the activities of trades and crafts. See DWb VIII, 1412–16. The Officer of Pledges, the *Pfänder*, owed his title to an older function as the legal official who took securities from accused persons to earn bail or to compensate victims. See DWb VII, 1608, Strauss 1976, 65, 98.

32  The Latin text has *Tucher*. Although all three German versions have *Füerer*, this is demonstrably an error. Anton Tucher was Chief Captain from 1500 and Losunger from 1505. Records show him as Supervisor of the New Hospital since 1500 and of St Sebald from 1505.

33  *mit wunderzaichen leuchtet und für hailig geert würt*: in his Latin text Scheurl makes the theologically important distinction between imputed 'beatitude' and 'sanctity': *suis miraculis claret et beata colitur*. Christina Ebner died at the age of seventy-nine in 1535. Scheurl pays further tribute to her in his letter to Martin Luther and Otto Beckmann of 19 May 1519 (139).

34  *Fronbote* had in medieval German a startling double sense: 'angel' – literally, 'divine messenger' – and 'seigneurial or official steward, bailiff', the sense which it has in early modern Nuremberg. The prefixal *Fron-* derives from ninth-century German *fro*, 'Lord', applied in earliest texts to God as well as to secular rulers. The noun was ousted above all by *Herr*, but the adjective *frone* survived, mainly in noun-prefix functions, such as *Frondienst*: 'unpaid labour due to a feudal overlord', and with its old religious sense in *Fronleichnam*: [the feast of] Corpus Christi (Pfeifer 480).

35  The condescension towards the peasantry in Scheurl's account of this court, in which patrician youth is allowed to play at justice, needs no gloss. Across Germany the rural unrest which fuelled the Peasants' War in 1525 arose in part from grievances concerning the legal process – judgement by jurists and superiors rather than peers, and according to Roman law rather than Germanic custom, so that medieval concepts of serfdom and feudal tenure yielded to that of servility.

36  Town clerks were important also in the development of German as a language of serious discourse and literature in the early modern period. Particularly prominent in Nuremberg were Georg Alt, who wrote the German version of Hartmann Schedel's *Book of Chronicles* in 1493–4 (Schedel was also a civic appointee as Municipal Physician), and Lazarus Spengler, whose civic role and writings are strongly represented in this documentary biography of his close friend AD.

37  Johann von Staupitz (BI and Posset 2003) was vicar-general of the Augustinian Order in Germany. He was Martin Luther's closest early mentor and advisor. He regularly visited the Augustinian congregation in Nuremberg and his sermons there in 1516 and Lent 1517 attracted the interest of leading councillors and of AD and Lazarus Spengler, and were instrumental in preparing the ground for the city's eventual espousal of the Lutheran Reformation (see 206). Scheurl as the city's jurisconsult was

the most appropriate person to provide Staupitz with a digest of Nuremberg's civic constitution. It is not clear why Staupitz requested it. As the last sentence of the covering letter makes clear, Scheurl was at the same moment preparing a printed German edition of Staupitz's sermons in the church of the Augustinian priory during Advent 1516.

38    It appears that, unsurprisingly, AD had presented prints, probably his biblical books, to Staupitz. Posset 2003, 183–4 suggests even the gift of 'one of his pictures from his studio' at 'daily sessions' of the Staupitz sodality.

39    *Aurelianum Praesulem*: that is, 'head of the Augustinians' (Augustine's first name was Aurelius). Classical Latin *praesul* 'leader of a troupe of dancers' (literally 'the one who leaps ahead of the others') came in Church Latin to mean 'ruler, bishop' (Niermeyer, 1098).

40    Would-be elegant humanist flattery. The reference is to classical practices of pagan sacrifice. Staupitz in his sermons would have insisted that 'the sacrifices of God are a broken spirit: a broken and contrite heart' (Psalm 51:17/50:19).

41    For other dimensions of the friendship of Scheurl and Staupitz, see 120, note 3.

## 107   Jan Dubravius, Commentary on Martianus Capella, *The Marriage of Philology and Mercury*

### Introduction

The 'Marriage of Philology and Mercury' by the late classical writer Martianus Felix Capella (BI) is a schoolbook presenting, in the form of a didactic allegory, the basics of the seven liberal arts, the classical educational disciplines of Grammar, Dialectic, Rhetoric, Geometry, Arithmetic, Astronomy and Musical Harmony. Instruction in the liberal arts is set within the allegorical framework of the education of Philologia (the girl who literally 'loves letters'), in preparation for her marriage with the god Mercury, here (among many other imputed functions) the embodiment of intellectual curiosity.

In the very early Middle Ages, especially during the Carolingian Renaissance of the eighth and ninth century, Martianus's work was a staple of the school curriculum. Though never wholly forgotten, its influence waned in the later Middle Ages. First printed in Vicenza in 1499, it attracted the attention of sixteenth-century humanists like Jan Dubravius, though more as a curiosity than for any pedagogical value. Modern views of it are generally not positive. C.S. Lewis commented that 'the universe, which has produced the bee-orchard and the giraffe, has produced nothing stranger than Martianus Capella'.

Johannes Dubravius (in Czech, Jan Skala z Doubravy – BI) was born in 1486 and died in 1553. Having studied in Vienna, Pavia and Padua, he returned to Bohemia and

became canon of Olmütz (Moravia, modern Olomouc) and secretary, later counsellor and chancellor of Bishop Stanislaus Thurzo, whom he succeeded as bishop in 1541. His study with Konrad Celtis in Vienna and his friendship with Stanislaus Thurzo gave him humanist interests, expressed in the edition with commentary of Martianus Capella's *De nuptiis* (Vienna 1516) which he dedicated to Bishop Stanislaus. The BL copy, 11852. f6, has the bishop's coat of arms on leaf A2r and appears to be the author's presentation copy to his patron. Each paragraph of Martianus's text is followed by Dubravius's gloss.

*[Book I, 36, page G3ᵛ-G4ᵛ]*
*The question whether Mercury and Philology may marry, and how Philology should be educated so that she can be elevated into the sphere of the gods, has been referred for their adjudication to Jupiter and Juno. Jupiter comments that Mercury 'has a wonderful magic gift for painting, and as a sculptor in bronze and marble he brings life into the features, the whole effect is excellent – he has everything that contributes to the perfection of a young man. Jupiter said that he had delayed the lovers' union for a while, though they had long been joined by the bonds of mutual love, so that Mercury should not hasten into marriage on a youthful impulse only, when he should have to go on his travels, and thereby lose something of his constancy, through the languor of those many nights of love.'*

Let Plautus's farce *Amphitryon* be an incidental demonstration that Mercury was a miracle-worker in his deceptions: in that play, by means of a deception which is by any measure astonishing, Mercury was able to impersonate Sosia as and when he pleased, in both matching form and identical costume, so that he filled not only the servant Sosia, but also his master Amphitryon, and his whole household besides, with delusion and dementia. Indeed in no other way could Jupiter himself have had his way with Alcmena, keeping it secret from her husband Amphitryon, if Mercury had not known how by deception to impersonate Amphitryon.[1]

However, Mercury was far from limited to this sort of deception, and had already turned his mind also to other more worthwhile and more praiseworthy forms of deception, like sculpture, the art of painting, and in short every aspect of delineation, his mind thus focusing on the liberal arts in the way that, as Nicomachus puts it, the liberal arts focus on mathematical philosophy.[2] And, though Pliny attributes this to the authority of the painter Pamphilus, perhaps that is why it came about first at Sicyon, and later throughout the whole of Greece, that boys of free birth were taught engraving, that is cutting an image on boxwood, before anything else, and that this art took first place among the liberal arts.[3]

Indeed there is a great deal in Pliny about the antiquity and prestige of each of the two arts and about the fame and number of their practitioners. However not even Pliny's age would have justly accused its own generation as unproductive in these respects. For today too the hands of very famous artists are flourishing, and display themselves in the most refined technique of painting in such a way that, whether one chooses to examine their light, their shadows, or their perspective, they would not be found wanting in comparison with the ancients. Indeed I recently saw a picture painted by a certain Albrecht, a German by birth, which was, as far as I can tell and as artists themselves confirm, absolutely brilliant. In that picture Adam and Eve are depicted standing naked and, wide-eyed and with mouths slightly opened, looking up with wonder at the tree set in the middle, as if it were (as yet) still charming them.[4] There is a nobility of expression in both of them, glowing with abundant full-blooded vigour. Their hair is blond and rather blown about in the breeze. Their eyes are blue and shining, and in short the beauty of the physique of each is noble. The contrasts of nature and of gender being preserved, the artist has rendered that beauty to a wonderfully appealing degree, with the chest and shoulders of Adam swelling with a certain manly fullness, while in contrast he has not emphasised Eve's parts except those below her belly and around her hips. Their other limbs match each other so perfectly that a tape-measure finds no deviation.[5] They say that the painter himself practised with such care and scrupulousness (no doubt following Zeuxis) that when about to paint that picture he would again and again visit the public baths, where it is normal for bodies to be bared, so that he might render in the picture what he saw as the most praiseworthy feature in each physique.[6] But this dedication was not without its reward; indeed Johannes Thurzo, the Bishop of Breslau, ever to be counted by me as among the leading connoisseurs, with his usual liberality, magnificence and good taste, bought the picture from the artist for 120 gold pieces and placed it in his private apartment, where it arrests the gaze not only of princes and of the most distinguished guests, but challenges the hands of sculptural artists to imitation.[7]

*Martianvs Foelix Capella, De Nvptiis Mercvrii et Philologiae cvm Adnotationibvs Iohannis Dvbravii* (Vienna 1516)

NOTES

1   The comedies of Plautus (circa 254–184 BC), as the earliest surviving intact works of Latin literature, were important to Renaissance humanists, notably Konrad Celtis, Dubravius's teacher in Vienna (Rupprich 1970, 637f.; 1973, 370–72). By impersonating

the servant Sosia, Mercury helps Jupiter seduce Alcmena in the absence of her husband Amphitryon. She bears twin boys, one Jupiter's son Hercules, the other Amphitryon's.

2   The Greek mathematician Nicomachus (circa AD 60–circa 120) followed Pythagorean teachings on the mystical properties of numbers and, in his *Manual of Harmonics*, developed the insight that in music pitch is determined by numerical ratios.

3   Dubravius here quotes Pliny, *NH* 35, 77, establishing a prestigious antique pedigree for AD's graphic art-form. The claim is an odd one, given the lack of evidence for engraving in Greek antiquity. It may be that Pliny misunderstood his Greek sources in taking this to refer to a form of visual art, since *graphice* can more plausibly be understood simply to mean the skill of literacy – teaching free-born boys to inscribe the alphabet on waxed boxwood tablets (see, for example, Propertius, *Elegies* 3. 23, 7–8). I am obliged to Adrian Gratwick for this suggestion.

4   It is assumed that what Bishop Johannes Thurzo of Breslau (the elder brother of Bishop Stanislaus of Olmütz – BI) bought from AD was the diptych of *Adam and Eve* (40, 1507). He certainly also possessed a now lost Madonna by AD (see 47.3, note 6, 47.4, note 9, and 70). It is strange, however, that Dubravius refers to the two panels by the singular noun *pictura*, and states clearly that the Tree of Knowledge is 'set in the middle', between Adam and Eve, whereas its foliage is only rather vaguely indicated above the figures and its trunk is to the right of Eve (Anzelewsky 1971, 209).

5   AD's engraving of *Adam and Eve* (26.1, 1504) and, to a lesser extent, the painted diptych derive from a series of drawings developed from antique models, some proportionally constructed (see 26.1), so that Dubravius's reference to the tape-measure (*Nil ut deliret amussis*) is probably more apposite than he realised.

6   Dubravius may well have known AD's woodcut of the *Men's Bathhouse* (S W 31, SMS 107). He is much less likely to have seen the drawing of the *Women's Bathhouse* (W 152, S D 1493/4) which Winkler (I, 102) describes as an 'academy' of naked female forms, providing potential models for other works. At all events Dubravius's perception is an acute one. It is prompted also by the 'Zeuxisian anecdote' of Pliny (*NH* 35, 64. See McHam 2013, Plinian Anecdotes 161). From circa 1509 AD accepted that a truly beautiful figure had to be a composite of different models (51.4, note 11).

7   From a different perspective, Bishop Thurzo's 'liberality, magnificence and good taste' were censured by the cathedral chapter of Breslau as arrogance and extravagance.

## COMMENTARY

Dubravius's close characterisation of *Adam and Eve*, viewed in the context of Plinian art history and informed by a broader knowledge of AD's work and its contemporary appreciation, is the earliest description of the visual experience of one of his works. It may be that Dubravius set out here to emulate the late antique genre of the *ekphrasis*.

## 1517

## 108   Reflection on Salvation [fig. 42]

Item. As through the disobedience of sin we have succumbed to eternal death, there was no other way by which we might be helped than that the Son of God became Man, so that through his guiltless suffering he superabundantly paid our debt to the Father and redeemed all our guilt, in order that God's justice would be satisfied. For he repented of the sins of the whole world, atoned for them, and obtained eternal life for us from the Father. Thus Jesus Christ is the Son of God, the highest power who can do all things, and he is the eternal life. Every one into whom Christ enters is born again and himself lives in Christ. Therefore all things are good things to Christ. In us there is nothing good unless it is made good in Christ. Thus whoever seeks to justify himself is not justified. We can will what is good, provided Christ wills it in us. No human repentance is so great that it can be sufficient to [expunge] a deadly sin, [although even this human repentance is such] that it can bear [living] fruit.

Autograph note, BL Sloane 5231, folio 23ʳ
  Rupprich I, 216; III, 447

COMMENTARY

This succinct, informed statement of Lutheran theology on grace and justification by faith implanted by Christ, reflects AD's assimilation of Luther's teaching between circa 1516 and 1522 and underlines how secure AD's grasp of the reformed faith was at this earliest stage of the Reformation. Berndt Hamm has identified the text as AD's paraphrase, presumably remembered by heart, of a passage in one of Johann Staupitz's Lenten sermons, preached in the Augustinian chapel in Nuremberg in Advent 1516 and Lent 1517. Lazarus Spengler used his clerkly skills to transcribe the 1517 sermons, and his account provides the words of Staupitz that fill the gaps where AD's memory gives out: *wiewol auch solche des menschen berewung geschickt ist, lebendig frucht zu bringen.* Staupitz's sermons confronted his Nuremberg congregation with a critique of optimistic humanist Stoicism and a Lutheran declaration of christocentric dependence on divine grace and mercy. Natural man is exposed as incapable of virtue and good. Human reason is corrupt and self-focused. Faith in divine love, beyond mere reason, alone can save. Lutz 1968 cautions against the assumption that this early endorsement of Lutheran theology made AD thereafter an unquestioning convert to the evangelical cause as it evolved during the 1520s. Price 2003, 282, describes this 'scribble on a scrap of paper' as 'the only clear expression of Dürer's allegiance to Protestant justification by faith that has survived' in his writings or his art.

[Carlson 1975, 65–9, 130–34; Wiederanders 1976; Smith 1983, 30f.; McGrath 1985, 128–36 & 1986, 2–14; Hamm 1989b, 161–75; Cameron 1991, 111–28; Reinhard 1991; Moeller/Stackmann 1996, 318–25; Schmidt 1998; Chadwick 2001, 93–4; Posset 2003, 186–90]

## 109  Letter of Kaspar Nützel to the Aldermen of the Nuremberg Council

*[Augsburg, 1 August 1517]*
If it should please Your Worships that His Imperial Majesty should remit the city tax to Your Worships, once it is available, for four or five years, such that Your Worships at each due date may retain half of what is due without obligation on your part,[1] and apply the other half to the work on His Majesty's Tomb and to the other projects in Nuremberg involving only your own citizens, I am confident of achieving that without further cost, notwithstanding Your Worships' prerogative and according as Your Worships shall supply me with transcripts relevant to this necessity. In this way, the 200 gulden which Ölhafen[2] has had will come back into Your Worships' hands, as I have heard nothing to suggest that he will retain them, but Jörg Vogel's[3] and Albrecht Dürer's money will continue to be paid.

Nuremberg, State Archive Act. S. I, L.64, No. 10
  R I, 257f.

NOTES

  1  *an ir schuld*: here *an* represents the older *âne*, modern German *ohne*, 'without'.
  2  Sixt Ölhafen (1466–1539), a principal official in the Habsburg imperial chancery under emperors Frederick III, Maximilian I and Charles V.
  3  Georg Vogel was valet and barber to Maximilian I.

## 110  Letter of the Aldermen of the Nuremberg Council to Kaspar Nützel

*[Nuremberg, 8 August 1517]*
The financial machinations[1] with Duke Frederick of Saxony[2] can be countered by His Imperial Majesty granting the said city tax, to the entire extent that it exceeds Jörg Vogel's and Albrecht Dürer's allotments, to no one else except

exclusively His Majesty's Tomb and Triumph. In that way the greater part of this money will benefit our citizens, and it is far more convenient and preferable for us to gratify His Majesty in this regard, since we have in any case an obligation to supply this money to him, than to please Duke Frederick, not just to the glory of Imperial Majesty but to the benefit of our citizens.

Nuremberg, State Archive, Letter Register LXXVII, fol. 46

R I, 258

NOTES

1   *vinanz*: the noun, from Middle Latin *finantia*, though first recorded (as *finantie*) in a document of 1341 in Cologne in the sense of 'payment', is otherwise not found before 1500 when it has a negative sense: 'usury, financial trickery, deceit'. The preacher Johann Geiler von Keysersberg uses it to characterise the dealings of Italian merchants, Luther to condemn the simony and exploitation of the simple faithful by Pope Clement VII. Modern German *Finanzen*, used only in the plural, was reborrowed from French in the seventeenth century, like English 'finances' (DWb III, 1639f.; Paul, 332; Pfeifer, 435).

2   Duke Frederick the Wise of Saxony was at this time Imperial Chancellor. The Nuremberg aldermen seem to suggest that in this matter he is not acting in the emperor's best interest.

COMMENTARY

The letters reveal that there was another dimension to the agreement between Emperor Maximilian and Nuremberg providing for AD's payment for imperial commissions (see 97.2 and 99). Two of the emperor's officials were also being, or were now to be, paid out of the annual city tax. Nützel was the city's delegate at the assembly of the Swabian League in Augsburg, where he evidently negotiated with representatives of Emperor Maximilian I, notably the imperial chancellor, Duke Frederick of Saxony. It is not at all clear why Sixt Ölhafen should be paid in this way. Jörg Vogel, as Maximilian's valet and barber, was evidently, indeed literally, close to the emperor's ear and perhaps needed back-handers for whispering words into it. The machinations required to resolve how Nuremberg should contribute to the emperor's cultural extravagances – the Triumphal Arch, the Triumphal Procession and his tomb (see 97, introduction) – seem to have taxed even Nützel's diplomatic ingenuity. He and the Nuremberg aldermen may have felt that a device of creative accountancy risked turning into an imperial slush fund (see note 1 on *vinanz*). On the continuing irritation of the city council with these payments to court officials, see 153 and 165.5–7.

## 111  Jakob Fugger, Statement of Account to Emperor Maximilian I

*[31 August 1517]*
On 8 August Fugger has had delivered to Albrecht Dürer and Kaspar Nützel in Nuremberg 36 ells of black damask at 2 fl. per ell, and 8 ells of best Genoese velvet at 4.5 fl. per ell. Fugger has debited the price to the Emperor

See R III, 451f., quoting a paraphrase of the account from historiographical sources.

NOTE

The emperor's gift appears to be an outcome of Nützel's attendance at the assembly of the Swabian League in Augsburg (see 109–10). The next item in the accounts records the payment of 160 fl. to Johannes Stabius for the purchase of paper, presumably relating to one of Maximilian's commissions.

## 112  Letters of Lorenz Beheim to Willibald Pirckheimer

### 112.1

*[Bamberg, 10 August 1517]*
If all yours are well, I give thanks. Greet them and likewise Frau Κραμεριν.[1] And our Albrecht. Farewell.

### 112.2

*[Bamberg, 11 October 1517]*
Greetings. Our friend Albrecht brought me your letter. I should have preferred to see you. He is lodging with me of course, but up to now he has eaten with me on precisely one occasion. He is permanently invited out and today he is with the most reverend Lord Bishop.[2] I don't know what he has his eye on... Dürer was with the bishop today and sketched Sella his jester and he will be doing a likeness of the bishop himself. This evening he is dining with the bishop and our most exalted prior.

You may send the enclosed things to Dürer's wife.

## 112.3

*[Bamberg, 12 October 1512]*

Our Albrecht, who is gossiping with my cook, won't allow me to write any more now.

PBr 3, 178–96, Letters 460, 476, 477. Latin texts
   R I, 258

NOTES

   1   Frau Kramer: The Greek transliteration is perhaps Beheim's way of suggesting that Pirckheimer has an erotic relationship with Frau Kramer.
   2   Beheim may have invited AD to Bamberg in order for him to secure and/or carry out a commission to paint the bishop, Georg Schenk von Limburg (consecrated 1505, died 1522).

# 113   Payments for the Portrait of Georg Schenk von Limburg, Prince-Bishop of Bamberg

## 113.1

*[Bamberg, 24 October 1517]*

Item gave 1 gulden as gratuity to Bartholomeus Dil,[1] assistant of Albrecht Dürer the painter, who made a portrait of My Gracious Lord. Paid Saturday after St Luke. Receipted: Chamberlain.

## 113.2

*[Bamberg, 16 December 1517]*

To workers. Painter: Item 2 gulden 1 quarter 6 pounds 24 pence paid to Master Hans Wolff, painter,[2] for polishing and gilding My Gracious Lord's cuirass and jousting saddle, also for colours and to gild the panel when Dürer painted My Gracious Lord's portrait, and then for making sundry sketches and models[3] for the winter livery, as per enclosed note, paid on Wednesday after St Lucia.

Accounts of the episcopal chamberlain, Hans Müller. Bamberg State Archive 1739, fol. 235ᵛ and fol. 276ʳ
   R III, 452

NOTES

1   Bartholomäus Dil is not otherwise recorded.

2   Hans Wolff (died 1542) had been the bishop's own court painter since 1516. He seems to have put his equipment and facilities at AD's disposal, perhaps because AD was visiting Beheim and had not anticipated the bishop's request for a portrait. He appears also to have provided colours and perhaps prepared the panel with a ground. The gilding could apply to the frame, though Rupprich suggests that it was Wolff who did the inscription in gold leaf (see commentary below).

3   *mendlein*: small model figures, perhaps with articulated limbs, painted with Wolff's proposed patterns for the winter livery of the bishop's court personnel.

COMMENTARY

Only copies of the portrait survive, in the state archive in Bamberg and at nearby Pommersfelden (Anzelewsky 1991, 134K, 249). Rupprich accepts the view of W.G. Neukam (1957) that the Pommersfelden portrait is the original, but Anzelewsky dismisses that. It does have an inscription, but this is not by AD and is quite unlike his normal style. Rupprich assumes it was added by Hans Wolff, but there is no supporting evidence; if it were the case, it might mean that Wolff was the copyist. The inscription reads (in the German the lines are crudely rhymed): 'Georg. Bishop. of. Bamberg. highborn lord. / of Limburg. Aged. 48. years. portrayed. by. Albrecht. Dürer. / of. Nuremberg. A[nno]. 1517.' Wolff helped to entertain AD and Agnes on 13 July 1520 on their journey to the Netherlands (162).

# 114   Letter of Michael Marstaller to Willibald Pirckheimer

*[Ingolstadt, 13 November 1517]*
Farewell, and greetings on my behalf to Lazarus, Dürer and indeed all our friends.

PBr 3, 215, Letter 485. Latin text
   R I, 258

NOTE

Marstaller (died 1533) was an advisor to the Nuremberg city council.

## 115 Resolution of Nuremberg City Council on the Appointment of New Masters of the Mint

*Third Day after St Andrew [3 December 1517].*
The elder and the younger Jorg Diether have taken their oaths for the office of Master of the Mint.

To be told that they are to have the new dies made following the advice of Albrecht Dürer.

Their oaths to be heard before the Council and copies of these to be given to them.

Hampe, Ratsverlässe, 1517, IX 4b
  R I, 242

NOTE

Presumably AD was expected either to vet or provide the design for new coinage.

## 116 Letter of Lorenz Beheim to Willibald Pirckheimer

*[Bamberg, 3 or 8 December 1517]*
I didn't find out anything about the gift the bishop sent to Albrecht. Next week Schöner will come to Nuremberg with ten or a dozen globes. If you wish, he will pack ones for you and Albrecht. Greet him from me.

PBr 3, 231–4, Letter 494. Latin text
  R I, 259

NOTE

Johann Schöner (BI), mathematician, astronomer and geographer, was at this date a priest in Bamberg. He became professor of mathematics at the new Protestant Gymnasium in Nuremberg in 1526. He was well known as a maker of terrestrial globes.

## 117 Letter of Johannes Stabius to Willibald Pirckheimer

*[En Route with Maximilian I's Court, mid-December 1517]*
On 3 December, whilst we were at Lorch, there was talk in His Majesty's presence about the most ancient forms of writing. Among other things Caesar said 'Pirkinger, the learned doctor who runs Nuremberg these days,' – I interrupted

him: 'Your Majesty means Pirckheimer' – 'Yes, that's him, he has done me a book with a lot of animals and images, which the first people supposedly used as their alphabet.' (Later many other instances were contributed, as happens in a developing discussion).[1] I wanted to tell you about this so that you might know how good an impression you have made on the Emperor with your work.[2] On 5 December at Linz, we showed Caesar the laurel wreath devised by you.[3] I can't describe how delighted His Majesty was. He valued it at a thousand gold pieces, saying 'This Laurea is worth more to me than a thousand gulden', and he told my lord Geroldseck, who was supremus praegustator or head of the food-tasters (he was at lunch, in his function as Steward of High Table):[4] 'Horstus, I've thought up many fine things for my Triumphs and other books of mine, but in this one I admit defeat, I could not have devised one like this.' And he was in great good humour, praising the laurel wreath, until he retired from the table to his room. A few days later the Cardinal of Gurk[5] came along, to whom while hunting, when I was not present, he sang the praises of the Laurea, whereupon the cardinal congratulated His Majesty, who promptly sent him to us so that we might show it to him. He also gave orders that we should display it to the envoy of the King of France, and he plainly showed how greatly it pleased him: 'I commend your supremacy and your achievements as highly as I can.' Then later, during conversation after dinner, he called you 'the most learned doctor in the whole Empire'. From this your good sense will inform you how His Highness is disposed towards you.

PBr 3, 242–4, Letter 499. Latin text
  R I, 259 (without the final sentence)[6]

NOTES

1   The book was Pirckheimer's translation of the Greek manuscript of the *Hieroglyphs* of Horapollo, discovered in Italy in 1419. It purported to provide a key to the hiero-glyphic writing of Ancient Egypt. AD had provided illustrations for the book, *Mystery of the Egyptian Hieroglyphs*, printed in 1514. See 97.1, note 3.

2   Less charitably perhaps, Stabius cannot resist recounting Maximilian's imperfect recall of Pirckheimer's name. As Schauerte 2001, 94f., points out, while his account conveys Maximilian's most fulsome recorded praise of any artist or aesthetic advisor, it is also shot through with involuntary humour and may not have wholly delighted the notoriously touchy Pirckheimer.

3   Pirckheimer devised a 'wreath of honour' for the emperor as an adornment for the Triumphal Procession.

4   *stäbelmeister*: see DWb X, II, 1, 360f. and Niermeyer I, 77: *architriclinus*. Originally, the *stäbelherr* or *Stäbelmeister* was the court official who started and concluded tourna-

ments by signalling with his staff (German *Stab*). In the Hapsburg lands of Austria and the Tyrol, the name came to signify the hereditary steward – here Horst von Geroldseck – who directed protocol and ceremonial at the royal table.

5　Matthäus Lang von Wellenburg, an early patron of Stabius, had been private secretary to Frederick III and Maximilian I, and became a cardinal and the archbishop of Salzburg. AD drew his portrait (W 911, S D 1518/25 – 126.4) and made a sketch of an extravagant archiepiscopal throne for him in 1521 (W 920, S D 1521/64 – 166.2).

6　On 5 February 1518, Maximilian himself wrote to Pirckheimer: 'We have seen and received with especial grace the Laurea you sent us in recent days, which belongs in our Triumphal Procession, and we are not the least delighted with it since our said Triumph will be greatly adorned by it. We shall be mindful of this your new invention and adornment and acknowledge you for it with all favour. Our counsellor, Provost Melchior Pfinzing, had also intimated to us that you are said to have devised a new conveyance for us, unlike the other vehicles. Accordingly we earnestly request of you to send us by the hand of our aforementioned counsellor the Provost a design of the said conveyance and not to neglect this matter, in which you will graciously perceive our special favour.' On the Triumphal Chariot, see particularly 123–4 and 169.

[Schauerte 2001, 94f.; Ex. Cat. Osnabrück 2003, 79–81]

## 118　Letter of Lorenz Beheim to Willibald Pirckheimer

*[Bamberg, 18 December 1517]*
Furthermore, since Albrecht was so munificently honoured by our people, he is to be congratulated. It pays to do portraits!

PBr 3, 244f., Letter 500. Latin text
　R I, 259

## 119　Albrecht Dürer, Report on the Roof Construction of the Church of the Nunnery at Gnadenberg

### Introduction

In 1517 AD acted as consultant to advise on the roof construction of the convent of Gnadenberg in the Upper Palatinate. Founded in 1426, the nunnery came briefly under the control of the city of Nuremberg between 1504 and 1521. The patrician Fürer family took a particular interest in it, as a suitable place to which an upper-class urban dynasty might send unmarried daughters, gave it benefactions and paid for its restoration and

completion in 1511–18 (though by 1517 the brothers Sigismund and Christoph were already members of the proto-Reformation Staupitz Society, see 120). After damage in local hostilities, the church needed the rebuilding of its vault, which raised questions about the structure of its roof. What led the Fürers to regard AD as a competent structural engineer is not easy to understand, although he evidently had a basic knowledge of the statics of a medieval church. When AD refers to a 'previous opinion' he evidently means the original architect's design.

His well-argued advice, to simplify and lower the particularly high and steeply pitched roof, was prompted by considerations of safety – the existing roof was very heavy and created avoidable stresses, the large amount of timber in its construction brought an increased fire risk – and its maintenance costs could be greatly reduced. He was seemingly not concerned with aesthetic factors, though his mention of Vitruvius might suggest that in proposing a much lower roof he had Italian models in mind.

Gnadenberg was a Birgittine house, belonging to the order founded by St Birgitta, patron saint of Sweden (in Britain the forms Bridget and Bridgettine are also commonly used). Of around seventy houses established in the late Middle Ages, the overwhelming majority were in Scandinavia – Sion Abbey, west of London, was its only English community – but Nuremberg had in its vicinity also the nunnery of Maria Mai, patronised too by patrician families. The mother-house founded by St Birgitta at Vadstena was prescribed in the rule of the order as the model for all daughter-houses, and it was laid down that the roof of the church was to be as high as possible. Gnadenberg, whose roof was said to have required 3,000 tree trunks, was noted for its fidelity to the foundress's wish. This is likely to have been the reason why AD's recommendation was rejected.

[Reicke 1926; Kamann 1928, 223–5; Schleif/Schier 2009]

## 119.1 [fig. 43]

Here you see the difference between the two roofs. Compare the previous opinion and mine.[1]

Note: Were it up to me to construct the roof, I would make it pointed in the middle like the roof of a tower, and the apex would be not more than one quarter more in height than the length of the roof.[2]

Note: If I were the master-builder, I would make the roof-height not more than one fourth part of the width and I would set no more than two trusses on top of each other. That would be beneficial in case of fire, and is what the excellent ancient authority Vitruvius recommends.[3] And if the old roof structure was too low, you may raise it between the trusses.

This is my view of how the long beams should be anchored and fastened on the pillars. It is a rough idea, but the carpenters will know how to do it properly.[4]

43. Albrecht Dürer, autograph page from report on the church of Gnadenberg, 1517.
BL Sloane 5229–165$^r$

Note: The height of the roof is one third of its own length and it is constructed of three trusses on top of each other. The lowest truss must be one quarter higher than the second truss which it supports, and the top truss must be one quarter lower than the middle one. Then the weight is properly distributed. The strongest timber should be used for the bottom truss, less strong for the middle one, and the least good for the top one. Then again the weight will be properly carried.

Note: It is the first and second trusses that carry the roofing. The top truss under the ridge of the roof is borne on the lower two.[5]

Note: The sides of the roof are angled inwards one quarter of their length measured from each side, which again greatly reduces the weight. And the whole roof must be integral, so that it does not thrust down on the walls but is self-supporting as the master-carpenter will know full well. And in this way the whole roof shall rest on the walls and pillars without any lateral thrust. That means it supports itself quite effortlessly.

Note: Such a roof is not so readily damaged by high wind as it would be if seven trusses high. That is clear and logical. Even if thick snow were lying on it, it would not be so severely stressed as the other roof would be simply under its own weight. And it is safer against fire if it were struck by lightning. It will also not cost as much to keep in good repair as regards day-to-day maintenance.

Note: Also the previous timber can be re-used, which means that the great expense of buying new wood will be unnecessary.

And the real truth is that if the great roof is not removed from the church and this is then vaulted, the roof will thrust the walls away from one another and the whole building will be damaged.

### 119.2 † Jesus 1517. Albrecht Dürer's Model, Showing the Weight Stresses of the Roof of the Church at Gnadenberg.[6]

Firstly it should be considered whether it is more practical to leave the roof as it is or to dismantle it.

Here follow reasons why the large roof is damaging:

Firstly, it is mighty heavy, and the walls have to carry a great weight.

Secondly, I am told that the present roof thrusts downwards onto the walls, and that will create long-term damage.[7]

Thirdly, high winds impact with great force on such a roof, and that is a cause of real concern.

Fourthly, such a large timber construction incurs a fire risk if it is struck by lightning, and no one could save it in that event, because of the large quantity of wood involved.

Fifthly, the day-to-day upkeep of such a vast roof costs a lot of money in maintenance.

The following reasons show why this small roof design is more practical:

Firstly, it does not need to be so large, since it is not used for grain storage.

Secondly, it does not impose stresses on the walls, since its weight is reduced by two thirds and more.

Thirdly, the wind will easily blow snow off such a roof.

Fourthly, high wind will not exert force on it, since it presents no resistance.

Fifthly, the relatively small amount of timber in this roof is less of a fire risk if it were to burn as discussed before, because it would burn out more quickly or be sooner extinguished.

Sixthly, such a roof is less dangerous to construct and also is not so costly in annual maintenance as the previous one.

Seventhly, the low roof shown below is one quarter of its length in height up to its apex, and no more than two trusses need to be set up on each other, which can be made from the timber of the previous one, and enough timber will still be left over to build a large house.

Eighthly, the roofing shall be made in such a way that it is integral and self-supporting, in order not to transmit stress to the walls, but merely to sit and rest upon them. Good carpenters are well able to do that.

Ninthly, should however a roof with a steep pitch be preferred, it should be given hipped ends, angled inwards to one quarter of the roof length, if a grain floor is wanted, but otherwise it has no purpose, and in my view the best idea is to have the roof with a point in the middle as shown before.

Two versions of the written advice have survived. The leaves BL Sloane 5229, fols 165, 166, 167$^r$ with sketches and text, probably comprise AD's first draft report which he retained in his archive of technical writings. A double folio leaf, with sketches and in part rather sparse text, and a single side with a heading by another hand, were acquired by the city archive in Nuremberg in the early 1920s (Cod. man. 159 2°), having belonged previously to the Fürer family. These may be taken to be the report which AD submitted to his clients. Six sides are reproduced R I, V, Tafeln 44–9, and all seven by Strauss as S D 6, AS:1517/1–7.

R I, 218–20 and III, 447

NOTES

1   The drawing on 165r has adjacent sections of the two alternative roofs (figure 43). There are similar drawings on the double folio sheet in the Nuremberg archive.

2   Above the text are sketches of a hipped and ridged roof and AD's preferred roof with a central apex.

3   *De Architectura*, Book 6, Chapter 3. See the lower drawing of fol. 166r.

4   Illustrated by the sketch top left of fol. 165v, and by the upper drawing of 166r.

5   See the right-hand drawing on fol. 165v and the drawing on 166v of the roof trusses set on the nave arcade. 165v has a sketch ground plan of the church (a hall church with aisles of the same height as the nave).

6   This heading is written on a separate leaf. It is not in AD's hand nor, according to Rupprich, in that of Christoph Fürer.

7   AD's point is that the thrust of the weight of this huge roof is directly transmitted to the wall and its inadequate buttressing. It is more fully explained in point eight of his case for a lower roof.

## 1518

### 120   Letter of Christoph Scheurl to Johann von Staupitz

*[Nuremberg, 15 January 1518)*

It often happens, reverend father, that bales and panniers are heaped upon a more or less useless mule: thus your Staupitz Society of Nuremberg[1] has imposed this much of a burden on me, encumbered and poorly qualified as I am, that I should greet you in the name of everyone and earnestly wish that you are well, that I should demand not a letter from you but yourself in person, and that I should beg and beseech you that you will deign to preach the Word of God in our assembly this Lent, because thus, by your supreme favour, you would bind our entire people in obligation to yourself. We know that you are also warmly cherished and welcomed in Munich[2] and Salzburg, but just as our people in Nuremberg are generally men of distinction, so also they are confident of yielding to no one in their love for you and would wish not to be the last in the register of your friends, being men who always respectfully applaud your jests,[3] sing your praises, honour you and aspire to please you. On which account each of the following commends himself to you: Anton Tucher, father of his fatherland, Hieronymus Ebner, apple of the eye, nay pearl, of the people of Nuremberg, Kaspar Nützel, most assiduous of men, Hieronymus Holzschuher, Andreas and Martin Tucher, Sigmund and Christoph Fürer, Lazarus Spengler, Albrecht Dürer, our German Apelles, Wolfgang Hoffmann and I myself, in joint first place, and then all the others whose names elude me.[4]

CSB 42f. Letter 159. Latin text
  R I, 260 and III, 455

NOTES

1   *sodalitas ista Staupiciana apud Nurnbergam*: see 106. Whether the group of Staupitz's devotees had already adopted the name, or whether Scheurl invents it here (perhaps

half humorously) it is impossible to say. The tag must have been modelled on the establishment of associations of humanists which can be traced in southern Germany in the early sixteenth century (Lutz 1984).

2  Staupitz had also preached Advent sermons in Munich in 1517.

3  See Rupprich III, 455. The Scheurl family archive contains a manuscript by Lazarus Spengler with sermons and humorous anecdotes by Staupitz, entitled *Etlich nutzlich leren und facecien, die der erwirdig und gaistlich her Johann von Staupitz, doctor vicarius Augustinerordens, etlich erbern personen, die mit ime die malzeit genomen, mundlich, also über tisch mitgeteilt hat* – 'Numerous useful teachings and anecdotes which the venerable and reverend Johann Staupitz, doctor and vicar of the Augustinian order, conveyed to a company of honourable persons who dined with him, by word of mouth, that is at table.' Staupitz was valued for his humanist conviviality as well as for his exposition of proto-Reformation doctrine. The literary tradition of the humorous moral anecdote, often told at table, is an example of the way shared cultural interests and practices cross the in some other respects contentious demarcations of humanism and Reformation. Among many examples are the *facetiae* of Sebastian Brant, the *Colloquia familiaria* of Erasmus, his *Convivium fabulosum*, the *Tischreden* – 'table talk' – of Martin Luther, and the *Loci communes* – 'commonplaces' – of Philipp Melanchthon (see Wachinger 1993.) This reference in Scheurl's letter sheds light back on his choice of the name *Sodalitas Staupiziana*. It sets the Nuremberg circle of laymen interested in new religious thought into the context of progressive Christian humanism looking for possibilities of Church reform.

4  The list of leading members places AD among an interrelated group of Nuremberg patricians. Anton, Andreas and Martin Tucher were senior figures in one of the most powerful of all the mercantile dynasties. Staupitz dedicated the Latin edition of his 1516 sermons to Ebner, who was the brother-in-law of the Fürers (for whom AD prepared his report on the church at Gnadenberg). Sigmund Fürer was related by marriage to Hieronymus Holzschuher. Kaspar Nützel was the ruling council's arch-diplomatist. The town clerk Lazarus Spengler, AD – whom Scheurl 'ennobles' as the 'German Apelles' – and Scheurl himself, the city's foremost jurist, were not patricians, rather the three most outstanding representatives of the 'honourable' class. In the end, neither Scheurl nor Staupitz broke with the Catholic Church.

[Wetzel 1986; Hamm 1989b, 161–75; Reinhard 1991; Chadwick 2001, 93–4; Whaley 2012, 185]

## 121  Letter of Lorenz Beheim to Willibald Pirckheimer

*[Bamberg, 9 February 1518]*
Greetings to your family, to Albrecht, and Frau Kramer.

PBr 3, 282–4, Letter 521. Latin text
  Not in R I

44   Albrecht Dürer, 'Hungarian Trophy' from the *Triumphal Procession*, pen drawing, 1518. Vienna: Albertina 3156

## 122  Letter of Martin Luther to Christoph Scheurl

*[Wittenberg, 5 March 1518]*

I received two letters from you, my best and most learned Christoph, one in Latin and one in German, along with the gift from the excellent Albrecht Dürer,[1] further my *Theses* in Latin and the vulgar tongue.[2] ...Meanwhile, I ask you to commend me to that best of men Albrecht Dürer and assure him of my gratitude and remembrance. Truly I beg of you and of him, that you will abandon your exaggerated opinion of me, and expect no more from me than I can perform. In truth I can do nothing and am at bottom nothing, and day by day I become even more nothing.[3]

Martin Luther Werke, Briefwechsel I (Weimarer Ausgabe 1930), 151f., Letter 62
  R I, 260f.

NOTES

  1  We may presume that AD had sent Luther prints of engravings and/or woodcuts. On his desire to meet and draw a portrait of Luther, see his letter to Georg Spalatin (154, written in early 1520).

  2  *positiones meas latinas et vulgares*: another member of the Staupitz Society in Nuremberg, Kaspar Nützel, had translated the *Ninety-five Theses* into German.

  3  This existential humility is the other face of the aggressive self-assertion evident in some of Luther's polemical writing. The last words he wrote, two days before his death in February 1546, were *Wir sein pettler. Hoc est verum* – 'We are beggars. That is the truth.' See Leppin 2006, 346.

## 123  Letter of Willibald Pirckheimer to Emperor Maximilian I [fig. 44]

*[Nuremberg, early 1518]*

Most gracious Lord,

  My conception of this Chariot was not such that it has to remain exactly thus; on the contrary, whatever Your Majesty in your wisdom finds displeasing in it may easily be adapted, changed or wholly abandoned. Yet I am humbly confident that this my *inventio*, not merely *triumphalis* but also *philosophica* and *moralis*,[1] shall not displease Your Imperial Majesty in your wisdom, and if the work has flaws, it may nonetheless be apparent from my intellectual zeal and humbly willing diligence – which shall not cease nor falter with this one device, but proceed

ever onward in constant thought, so that Your Imperial Majesty will be served with other new inventions whenever it comes to my attention – that such things are meant for Your Imperial Majesty's gracious pleasure, to which herewith I commend myself and beg with humble diligence that Your Imperial Majesty will be my ever gracious Lord.

Most gracious Lord,

The reason why the dispatch of this Chariot has been delayed is as follows: the sheer number of the attendant Virtues has taken much time to achieve their proper arrangement, and had Your Majesty's servant Albrecht Dürer not expended such great pains and taken the work entirely into his own hands, it would have been a yet more difficult matter for me and would have been yet longer delayed. I explain this to Your Majesty so that you may know the cause of the delay and the zeal and diligence of Albrecht Dürer.[2]

Your Imperial Majesty's humble servant

Willibald Pirckheimer of Nuremberg

PBr 3, 298–303. Letter 530. The text translated here is the last two paragraphs of a longer description of the allegorical conception of the Triumphal Chariot. The full version can be found in 169, together with the translation of Pirckheimer's commentary on the 1522 print of the Triumphal Chariot.

R I, 259f. & 261. The version Rupprich prints as Letter 37 is a draft for the second part of this letter (R's Letter 40). The full text of Pirckheimer's letter was reprinted in the *Theatre of Virtue and Honour* (Nuremberg 1606), see 169.

NOTES

1   'my invention, not merely befitting a triumph, but also philosophical and moral': the initial conception of the Triumphal Chariot was a further contribution to the representational programme and artistic demonstration of Maximilian's imperial status and power, in forms derived from Roman models of the celebration of triumphant emperors and generals returning to Rome with the spoils of victory. Pirckheimer's elaboration of the theme superimposed on the dynastic political level an allegorical dimension, in which the quasi-divine ruler embodies the classical moral virtues. In Renaissance Italy, Latin *inventio*, Italian *invenzione*, expresses the intellectual and poetic aspect of artistic *fantasia*, and is often seen specifically as an attribute of patrons and writers (like Lucian) who conceive and commission, or describe and interpret, artistic projects (see Ames-Lewis 2000, 180f., 185f.).

2   Pirckheimer is concerned here to protect AD from any displeasure Maximilian might feel at the delay in submitting the conception and model drawing of the Chariot, given that AD will be looking for financial, not merely rhetorical thanks. The emperor took the hint, to the extent of asking Nuremberg to pay to AD an advanced transfer of tax due to the imperial treasury in 1519 (see 127).

COMMENTARY

In 1514–16 Johann Stabius and the artist Albrecht Altdorfer began work on a project (first envisaged as early as 1512) to depict an imperial triumphal procession of Maximilian I as conquering hero in antique Roman style. What was conceived as a sequence of miniatures on parchment was then transferred into the hands of Konrad Peutinger, who commissioned first Hans Burgkmair, then AD to prepare a sequence of woodcut images. In the Albertina, Vienna, a number of AD's preparatory drawings survive, of Stabius as a mounted standard bearer, and of mounted figures intended to accompany tableaux of military campaigns in Bohemia, Italy and Hungary (see fig. 44). These figures are based on Mantegna's engravings of the triumph of Caesar (1486), and were intended as drafts for component woodcuts which were never carried out after Maximilian died in 1519.

By 1516 Stabius also envisaged a grandiose image of a triumphal chariot, conveying the whole of Maximilian's Hapsburg imperial family, as the climax of the procession. Albrecht Altdorfer, in this instance too, produced a first watercoloured pen drawing. Again the commission passed to AD who in later 1516/17 carried out a large-scale, elaborated model drawing of the chariot in brown ink. What Pirckheimer sent to Emperor Maximilian early in 1518 was an even grander brown-ink drawing, now finely embellished with delicate shades of watercolour, the chariot pulled by twelve rearing and plunging horses and attended by dancing or floating female allegorical figures, modelled here too on a Mantegna engraving, of dancing Muses. These, and the portrayal of Maximilian as embodiment of Jupiter (very similar to the drawing of him AD did in Augsburg later in 1518), articulate Pirckheimer's 'philosophical and moral invention'.

Maximilian's death in 1519 put paid to the immediate translation of this grandiose vision into a woodcut sequence, but in 1522 AD returned to the project despite the loss of imperial patronage for it, producing not only the woodcuts of the chariot but also a mural version of it for Nuremberg town hall – see 168.6 and 169.

[M. E. Müller in Ex. Cat. Vienna 2003, 430f., 454–67]

# 124 Letters of Emperor Maximilian I to Willibald Pirckheimer

### 124.1

*[Innsbruck, 29 March 1518]*
To the honourable and learned, our counsellor and the Empire's trusty well-beloved Willibald Pirckheimer, expert in law. Maximilian by the grace of God Roman Emperor elect et cetera.

Honourable and learned, trusty well-beloved!

We have received the Triumphal Chariot, together with the exposition with which you have been humbly pleased to adorn our Triumph and have sent to

us by the courier who brings this letter.[1] We have cursorily scanned it[2] and take gracious pleasure in this your zeal and devotion, and we are also minded to undertake in the near future a further project in which we will make use of your services, and we wished in this gracious intention not to conceal from you our gracious expectation that you will apply your best endeavours also to this commission.[3] All this we will reward you for with special favours.

Given in our city of Innsbruck on the twenty-ninth of March anno et cetera. 1518, in the thirty-second year of our reign.

Signed at His Imperial Majesty's own command,

S. Westner.

## 124.2

*[Innsbruck, 29 March, 1518]*

Maximilian, by the grace of God Emperor Elect of the Romans, to our honourable and the Empire's trusty subject, the well-beloved Willibald Pirckheimer, our councillor.

Honourable, loyal and well-beloved!

We have received by the bearer of this letter, and closely perused, the Triumphal Chariot, which you devised for the embellishment of our Triumph and had engraved by Albrecht Dürer, along with your exposition, and find them most pleasing, as also your ingenuity and keenness of intellect, and as you well deserve, we embrace you with the highest good will, and shall attend you with every due service.

Given in our city of Innsbruck on the twenty-ninth day of March in the year of salvation 1518, and in the thirty-second year of our reign.

At His Imperial Majesty's own command,

Westner

124.1 PBr 3, 305f., Letter 532. German text, printed in amended form in the 1522 edition of the *Triumphal Chariot* (169).

124.2 The Chancery's Latin version of the letter is not reproduced in PBr, but it is printed in the *Currus triumphalis*, the 1523 Latin edition of the *Triumphal Chariot*. It was issued simultaneously with the German version dictated by the emperor.

NOTES

1 *bey zayger dits briefs*: see DWb XV, 507. In the sense of the courier who delivers or presents a letter and conveys a reply, this is a common early modern formula of chancery and commercial communications.

2 *notdurftigklich vbersehen*: oddly, in the Latin text the emperor has 'closely perused' – *quem…diligenter inspeximus* – not merely 'cursorily scanned' it.

3   What this further commission might have been is not known. There is no mention of it in the Latin version. In his *History of the Swiss War*, completed between 1516 and 1518 but not published before Maximilian's death, Pirckheimer was at pains to portray him as ideal prince (Eckert/Imhoff 1971, 138–72; Wiegand 2006).

## 125   Letter of Caritas Pirckheimer to Kaspar Nützel, Lazarus Spengler and Albrecht Dürer in Augsburg

To the prudent wise gentlemen Kaspar Nützel, Lazarus Spengler and Albrecht Dürer, presently in Augsburg, our gracious lords and good friends.

In the name of Jesus

All that is good from the highest Good I wish you as my friendly greeting, prudent wise and gracious masters and special good friends, brethren and patrons.

Your friendly dispatch of latest news befitting my class or trade[1] I received with particular pleasure and read with such great devotion that my eyes were more than once filled with tears, though more ones of laughter than of deep emotion. Be highly thanked, that Your Wisdoms, engaged in such affairs of state and such junketings, have not forgotten me, and have so diligently instructed this poor nunlet[2] how to live her regulated life, having as you do such a clear mirror of it before your eyes.[3] Note further, that beyond all doubt it is a good angel who has impelled you to my gracious dear lord in Augsburg, in order that you should model yourselves on the free Swabian spirits, when instructing and regulating the poor cloistered little bunnies in their sandy warren.[4] For as our faithful warden, that lover of the religious life, gladly helps reform Gründlach, it is needful that he look to the Swabian League for an image of holy observance.[5] Let Herr Lazarus Spengler verse himself in the apostolic common life, so that in our annual audit he can give us and others counsel and guidance how we may feast and drink until nothing is left over.[6] Likewise, the most sketchily ingenious[7] Herr Albrecht Dürer can inspect the monastic buildings as needful, so that, when one of these days we look to remodel our choir, he can help and advise us how to build in ample slit-windows, lest our eyes entirely give up the ghost.[8] But I shall not further importune you to bring back a manuscript from which we can learn to sing in parts,[9] because since our beer is so sour now, I fear the dregs might stick so fast in the four windpipes or voices and make them sound so sweet that the dogs would flee the church.[10] I do however still humbly beg you, do not let the black-and-white magpies make your eyes pop out so that you do not recognise the little grey wolves in Nuremberg again.[11]

I have always heard tell of the clever Swabians, but now it is necessary for me to hold them in still higher esteem, since they display such prudent sense

as to work on His Imperial Majesty to ensure that the apostolic life is not destroyed, whereby it is manifest what quite different friends of the religious life they are than our own lords and masters.[12]

Pardon my written writing,[13] my dear gracious lords. It is all done in charity.[14] Summa summarum, the end of it all is that I heartily wish that you all come back home in rude health, with good fortune and a happy end to all the matters entrusted to you, for which I and my sisters heartily pray God night and day. Yet we alone cannot achieve this, and thus my advice is that you also call upon the hearts of the pure and holy, that they lift up their voices in their travail,[15] so that all may go well. With that I wish you blessing.

Dated Nuremberg, 3 September 1518.

Sister Caritas,
useless abbess of
St Clare in Nuremberg

The original of the letter is lost. The text derives from early nineteenth-century printed copies.
Rupprich I, 80–81

NOTES

1  *meiner gattung oder kaufmannschaft gemeß*: humorously, for her gender and her vocation as nun.

2  *nündlein*: playful diminutive of *nunne*, modern German *Nonne*, 'nun'.

3  *regulirisch leben*: see Latin *regula*, German *Regel*, the monastic rule of life. The expression *clar spigel* may hint at the use of 'mirror' as a title for late medieval books of instruction in proper living, and at the 'poor Clares', the title of the monastic order founded by St Francis and named after the abbess of its first house, Clare of Assisi.

4  *main gunstig lieb herr*: Emperor Maximilian; *freyen Schwebischen gaysten*: ironic allusion to the traditional stereotype of Swabians as dour and taciturn; *die armen gefangen santheßlein*: Nuremberg and its environs are situated on sandy soil, hence this satirical name for its citizens. It is possible that Caritas also has in mind the allegorical tract 'A Spiritual Interpretation of the Hare' by the Strasburg preacher Johann Geiler von Keysersberg (1445–1510), in which monks and nuns are compared in the successive phases of their lives with the hare, seen as a simple, sheltered creature (DWb, IV, II, 529).

5  Nützel had been involved in the reform of the Cistercian nunnery of Gründlach to the north of Nuremberg. Caritas mockingly proposes as a model for Christian life the Swabian League, the alliance of South-West German cities and princes, whose armed forces set out to impose order on disruptive groups, whether peasants or robber knights.

6  Spengler, it appears, had ex officio responsibility as town clerk for the annual audit of the nunnery, and Caritas implies that he took full advantage of the audit feast

(a stock occasion in contemporary colleges and monasteries at which the normal austerities of corporate life were relaxed).

7 *fast visirlich und jngeniosus* makes respectful fun of AD's pretensions to be an artist of scientific and antique cast of mind. Among the several senses of early modern *visierlich* are 'accurately designed, artistically sketched', 'elegantly', 'cleverly', 'wittily, facetiously', while *ingeniosus* relates to Latin *ingenium*, Italian *ingegno*, 'ingenuity', then 'genius', a key notion in the Renaissance revaluation of the intellectual status of the artist.

8 See AD's work for the nuns of Gnadenberg in 1517 (119). The night-time choir offices of monastic worship strained the eyesight of monks and nuns.

9 *in figuris*: Church Latin, singing parts following a score.

10 Rupprich (I, 81, note 12) dismisses an old suggestion that this alludes to nuns taking lapdogs into church to keep their feet warm!

11 Dominican nuns wore black-and-white habits, whereas Caritas's Poor Clares were robed in grey.

12 Caritas may be alluding to the financial and administrative control which the Nuremberg ruling council exerted over the churches and monastic houses in the city (the reason why Nützel and Spengler exercised their functions at St Clare's), having taken over older powers of the bishops of Bamberg. This had consequences fateful for the Poor Clares and other monastic houses in the course of Nuremberg's reformation after 1524.

13 *mein schrifftlichs schreiben*: Caritas's self-ironical tone extends to mockery of her own literacy.

14 *in caritate* puns on her own name Caritas, 'charity, love'.

15 *das sy jn erumpnis hoch ruffen*: either Caritas or the much later copyist miswrote Latin *aerumnis*. She has in mind the Old Testament verse Ecclesiastes 2:23: 'For all his days are sorrow and his travail grief', in the Vulgate: *Cuncti dies eius doloribus et aerumnis pleni sunt*. The inscription of AD's depiction of the death of Crescentia Pirckheimer (26.2) contains the phrase *ex aerumnis*.

## COMMENTARY

Caritas Pirckheimer (BI) was the elder sister of Willibald and abbess of the nunnery of the Poor Clares in Nuremberg. Through him she knew AD, whose *Life of Mary* (1511) ends with Latin verses by Benedictus Chelidonius, accompanying AD's closing woodcut of the Veneration of the Virgin and addressed to Caritas: 'Indefatigable abbess of watchful nuns, the Latin works you avidly read make you treasured in the eyes of those like us who are devotees of the Muses. To you, virginal Caritas, I dedicate these pleasing lines which hymn the Virgin Mary, model for all virgins.'

AD accompanied Nützel and Spengler, as representatives of the city council of Nuremberg, to the Imperial Diet at Augsburg in September 1518, Lazarus Spengler as town clerk, Kaspar Nützel as the city's chief diplomat. He had been Warden of the Poor Clares, their legal and administrative guardian, since 1514 and remained so until 1529 during the process of its dissolution following the Protestant reform of Nuremberg.

By the autumn of 1518, all three were committed supporters of Martin Luther and his neo-Augustinian theology. Nützel had published a translation of Luther's *Ninety-five Theses* on indulgences (1517). Spengler transcribed the Lenten sermons preached by Johann von Staupitz, Luther's mentor and confessor, in Nuremberg in 1517, which prompted the formation of the Sodalitas Staupitziana, the Christian humanist circle of which the three friends were members (see 106 and 120). The major event of the Imperial Diet at Augsburg was the interrogation of Luther by the Papal Legate, Cardinal Cajetan. This began on 12 October 1518. Luther was able to turn it into a doctrinal disputation on his theology of grace. At this early stage, however, reformed theology does not yet presuppose confessional hostility between lay Christians, and their religious fervour may indeed have enhanced rather than diminished Caritas Pirckheimer's warm regard for her evangelical friends. Her racy, ironical German style conveys the sharp impression of a distinctive, independent personality.

[Pfanner 1966; Kurras/Machilek, Ex. Cat. Nuremberg 1982, Guth 1982; U. Hess 1987; Hamm 1986 & 2004, 113f. & 140; Barker, 1995; Lippe-Weißenfeld Hamer 1999; Scherbaum, Ex. Cat. Schweinfurt/ Wolfenbüttel 2005; Scherbaum/Wiener 2006; Leppin 2006, 137–41]

## 126  Works of Art

### 126.1  *Emperor Maximilian*. Black chalk (or charcoal?) drawing with red and green elements in the flesh tones and white highlighting. W 567, S D 1518/19

In upper right-hand corner, inscription in AD's hand:

> This is emperor Maximilian, I Albrecht Dürer made a portrait of him at Augsburg, high up in the palace in his little chamber, in the year numbered 1518, on Monday after St John the Baptist

AD may have joined Nützel and Spengler, Nuremberg's envoys to the imperial diet at Augsburg (125), mainly to secure a sitting with the emperor, or even to carry out a prior arrangement. He also took the opportunity to do portrait drawings of Cardinal Archbishop Albrecht of Mainz (W 568), Cardinal Archbishop Matthäus Lang of Salzburg (W 911), and Count Philipp zu Solms (W 528). His drawing of Maximilian served then as the basis for the two painted portraits and the woodcut of the emperor (143.1.1–3).

[Winkler III, 33f.; Ex. Cat. Vienna 2003, 470–74; Smith 2012, 261f.]

### 126.2  *A Lost Portrait of Lazarus Spengler* 1518

According to Joseph Heller (1827, II, 233), a portrait on a wood panel of Lazarus Spengler was in the collection of Gottfried Thomasius circa 1740. It was enclosed in a wooden box with a sliding cover bearing Spengler's coat of arms, and the panel had

AD's monogram and the date 1518. Also from around the middle of the eighteenth century there is an engraving (initialled R.F.) with what Anzelewsky accepts as an inferior copy based on AD's painting. This has below the portrait the text:

Lazarus Spengler / vörderster Rahtschreiber zu Nürnberg, war / gebohren A 1479, d. 13. Mart; starb A 1534. d. 7. Sept

(Lazarus Spengler, principal clerk to the Council of Nuremberg, was born on 13 March 1479 and died on 7 September 1534)

Anzelewsky associates the portrait with the presence of Spengler and AD at the imperial diet in Augsburg.

[Anzelewsky 1991, 253f. (140 K/141 K)]

### 126.3   *A Lost Portrait of Kaspar Nützel*, circa 1517/18. A 135K

The subject of two portrait drawings by AD (W 565 and 566), variously identified, is regarded by Matthias Mende (1982) as being Nützel. A portrait seemingly derived from the drawings, formerly in the royal palace in Berlin, may be a copy of a lost painted portrait of Nützel by AD.

[Anzelewsky 1991, 249f. and illustration 128; Mende 1982, I. no. 113 and 130f.]

### 126.4   *Portrait Drawings of Cardinal Lang*

Either at the imperial diet in Augsburg or during 1518 in Nuremberg, AD drew Cardinal Matthäus Lang in a style closely related to his portraits of Cardinal Albrecht (143.2). The first is a black chalk drawing: W (1957), 337, S D 1518/24. It was followed by a larger version, in pen on oiled paper, clearly the preparatory copy for a projected woodcut which however seems not to have been carried out: W 911, S D 1518/25. See also 166.2, the drawing of an archiepiscopal throne for Lang (1521).

### 126.5   *Coat of Arms of Johann Tschertte*. Woodcut. G 731, S W 197, SMS 249 [fig. 45]

No date: circa 1518 (but S W 'circa 1522'). Latin motto above:

SOLI DEO GLORIA

(To God alone be the Glory)

Shield with wild man blowing hunting horn, with two greyhounds on the leash. Above the helmet, a wild man blowing the horn and flanked by two giant horns. The whole coat of arms in an arbour of vines growing out of stoneware jars. Tscherrte (BI) was an acquaintance of Willibald Pirckheimer (see 176, 189, 212, 218, 290).

45. Albrecht Dürer, *Coat of Arms of Johann Tschertte*, woodcut, 1518

## 127   Letter of Emperor Maximilian I to the Burgomasters and Council of the City of Nuremberg

*[Augsburg, 8 September 1518]*
To the honourable Burgomasters and Council of the City of Nuremberg, Our and the Empire's well-beloved subjects. Maximilian by the Grace of God Roman Emperor Elect et cetera.

Honoured well-beloved subjects! Given that at Martinmas next year you will be due to pay us a remainder, namely two hundred Rhenish gulden, of the customary city tax which you normally tender to our and the Empire's treasury, we earnestly request you, in view of the fact that you and your city in common have received freedom and privileges from us and our predecessors on the imperial throne, Roman emperors and kings, to render the said city tax revenue to no other hands than ours, and to pay this sum to our and the Empire's well-beloved subject Albrecht Dürer, our painter, in return for his faithful service, performed at our command in creating our triumphal chariot and other commissions, for which sum you have herewith our quittance. Accordingly, these two hundred gulden will be deducted at the appointed date from your customary city tax. Thereby you will be carrying out our earnest wish. Given in our and the Empire's city of Augsburg, on the eighth day of September anno domini 1518, in the thirty-third year of our Roman kingship and the twenty-eighth of our rule in Hungary.

<div align="right">

At His Imperial Majesty's
own command,
Serntein.[1]
Registered: M. Püchler[2]

</div>

On behalf of
the king himself

Text of the Quittance:

We Maximilian, by the Grace of God et cetera, declare for ourselves and our successors and make known to all that the honourable our and the Empire's well-beloved loyal burgomasters and council of the city of Nuremberg have now accounted and paid in cash two hundred Rhenish gulden, which they are due to us as the remainder of the customary city tax at Martinmas in one year's time. Hereby we for ourselves and our successors declare the said burgomasters

and council of Nuremberg and their successors wholly quit and free of the aforementioned two hundred gulden. In witness whereof this document is sealed with our attached seal. Given in our and the Empire's city of Augsburg on the eighth day of the month of September in the year of Our Lord's birth fifteen hundred and eighteen, in the thirty-third year of our Roman kingship and the twenty-eighth of our reign in Hungary.

Nuremberg, State Archive S.I, L.79, No. 15, Fasc. 3, and Vienna, Court and State Archive, Reichsregiment Vol. BB, fol. 447 and 447b

R I, 82f.

NOTES

1   Cyprian von Northeim (died 1524), known as Serntein, court chancellor from 1509.
2   Matthes Püchler, registrar of the imperial chancery.

COMMENTARY

The 200 gulden proposed in the letter represents an additional payment by the Nuremberg council to AD, over and above the annual liferent of 100 gulden agreed in 1515 (99) between the imperial and the civic authorities as a device to remunerate the artist for his work on Maximilian I's commissions. That it was a once-and-for-all fee is made clear in AD's letter to the council in 1519, when he had to remind the council that his 200 gulden were still unpaid (138), and the emperor's letter does not relate this payment to past or future instalments of the liferent at the rate of 100 gulden per annum. As it turned out, the emperor issued the instruction in the nick of time, since he died on 12 January 1519. As it was, AD was obliged to obtain renewed confirmation of the standing agreement from Emperor Charles V at his coronation in 1520 before the city council was willing to continue paying the liferent (138, 153 and 165.1–8). Surviving city account records suggest but do not conclusively show that this special allotment of 200 gulden was paid to AD in 1519 (165.5–6).

## 128   Endres Dürer Surrenders his Rights in the House Inherited from their Parents to his Brother Albrecht Dürer

*[Nuremberg, 24 November 1518]*
I Endres Dürer, citizen of Nuremberg, acknowledge publicly and make known to all men, that from this day's date Albrecht Dürer, my dear brother, has bought from me and paid me in cash to my satisfaction and gratitude, for the portion

and entitlement, bequeathed to me by my deceased father and mother as my inheritance, in the dwelling in Nuremberg, below the Castle, situated on the corner next to the house of the late Ortolf Stromer, which formerly Albrecht Dürer and Barbara his lawful wife, my dear deceased parents, left behind on their death. Accordingly I for myself and for all my heirs declare and herewith deem the selfsame Albrecht Dürer, my brother, and his heirs quit, free and released of such and all other appropriations of a fixed nature arising from my parental inheritance, inasmuch as I ever shall, can and may do; further have declared my whole and entire renunciation of all my rights and entitlement, such as I have hitherto had or held myself to have in the same dwelling, so that the said Albrecht Dürer, my dear brother, may now and henceforth do and not do with it as with the rest of his own property, unhindered by me, my heirs and any one on my behalf. In witness whereof I have earnestly requested the honourable and wise gentlemen Willibald Pirckheimer, councillor, and Lazarus Spengler, secretary to the Council of Nuremberg, in validation of this matter, publicly to affix their own seals to this document. That this has been done, we the herementioned Pirckheimer and Spengler confirm, but without prejudice to ourselves and our heirs. Given on Wednesday the eve of St Catharine the holy virgin and martyr, in the year of our dear Lord's birth, fifteen hundred and eighteen.

Original deed, with two attached seals, in the Germanisches Nationalmuseum, Nuremberg.
R I, 232f.

## NOTE

Although AD died intestate in 1528, Endres Dürer states in a deed of 15 November 1538 (see 308) that he inherited the house Unter der Vesten from his late brother. Thus he eventually found himself in full possession of it, despite having renounced his half share in 1518. In fact, it is likely that he had lived there, in their late father's property, continually from AD's purchase of his own house in the Zisselgasse until the sale of the old family house in 1538. In 1514 Endres had qualified as master goldsmith. The likeliest explanation why AD now proposes to purchase Endres's share is that in 1518 Endres needed capital, to set up or sustain his goldsmith's workshop, and that AD agreed to supply it by buying Endres out of the former family home, while letting him continue to live and work there, probably as rent-free tenant. That the transaction was validated by friends, Willibald Pirckheimer and Lazarus Spengler, tends to confirm that it was a family arrangement rather than a business deal. Whether by accident or design, AD's unhampered possession of the property allowed him to offer it as surety to the city council when the death of Emperor Maximilian in January 1519 jeopardised the agreement between empire and city to pay AD his annual liferent (138).

## 129   Letter of Christoph Scheurl to Georg Spalatin

*[Nuremberg, 17 December 1518]*
But you, Spalatin,[1] my beloved brother, fare well and live well, as is the prayer of my friends Ebner, Holzschuher, Tucher, our Prior Wolfgang Volprecht,[2] Wenzeslaus, who does not belie Luther,[3] Dürer and more besides, and when it is convenient do not neglect to commend me when you write to the most amiable Melanchthon.

CSB 2, 65f. Latin text
  R I, 262

NOTES

1   Georg Spalatin (BI) became private secretary to Duke Frederick the Wise of Saxony in 1524 and became his confidant and trusted counsellor, eventually also a key advocate of Martin Luther.

2   Volprecht (died 1528) was the last prior of the Augustinian house in Nuremberg, dissolved in the Reformation.

3   Wenzeslaus Linck (BI) was preacher in the Augustinian priory in Nuremberg from 1517 until he succeeded Staupitz as vicar-general of the order in 1520. In Advent 1518 he was preaching sermons on the Beatitudes.

## 130   Letter of Christoph Scheurl to Johann von Staupitz

*[Nuremberg, 23 December 1518]*
Here we live peaceably, and keep to the right path, now that Wenzeslaus is preaching to a grateful congregation. His listeners greet you – Hier. Ebner, K. Nützel, Hier. Holtzschuher, L. Spengler, A. Dürer, and I add myself, your devoted chancellor Scheurl, and Frau Ebner; all desirous of Martin's wellbeing. Meanwhile may R.D.T. fare well and let him inform his friends about his returning.

CSB 2, 77f. Latin text
  R I, 262

NOTE

The initials R.D.T. must refer to Staupitz himself. Perhaps *Reverentia [vostra] doctor theologiae.*

## 131  Letter of Ulrich von Hutten to Willibald Pirckheimer

*[Augsburg, 25 December 1518]*

It was you who convinced your fellow citizens that it was right to learn and be educated. It was a stroke of good fortune that you were born in the city which was the first of all in Germany to house a plenitude of bright minds and to honour them, the first to respect the fine arts, and was long alone in this. In our fathers' time, Nuremberg was the only city to value and support Johannes Müller,[1] to award him citizenship, when other places were blind to his worth – that Regiomontanus who, as all acknowledged, rivalled Archimedes for the victor's prize in knowledge of mathematics, and who, at a time when arts and sciences were scarcely yet out of the womb, of all men of this century, not just in Germany but in all the world, was the one who spoke and wrote pure and flawless Greek and Latin. And in recent years, Nuremberg honoured and subsidised Konrad Celtis,[2] then as yet unknown as a poet in Germany, and took in and generously supported several others. I believe it was this fact that suggested to the Venetians their saying, according to which 'all cities in Germany are blind, except for Nuremberg which sees through one eye'. For so it is said there, whether for the reason I suggested, or because your merchants there excel through their sharp wits and unmatched industriousness.[3] This can be seen in the artefacts which are the work of your people's hands. All are now persuaded that your city's products are outstanding and more skilfully crafted than by the standard other men aspire to. You also have the reputation that nothing you make is faked or forged. The famous Albrecht Dürer, by his artistry the acknowledged Apelles of our age, has given the Italians convincing evidence of this by his art alone. The Italians – who do not easily concede that anything German deserves their praise, whether out of envy, their peculiar besetting flaw, or because it is the now commonly accepted view that we are weak and unskilled in anything that requires a mind – admire Dürer so much, that they do not merely concede his superiority but, in order to make their own works more saleable, even display them under his name.[4]

Printed as *Ulrichi de Hutten equitis ad Bilibaldum Pirckheymer patricium Norimbergensem Epistola vitae suae rationem exponens* (Augsburg 1518). PBr III, 400–426, Letter 561. Latin text.

R I, 262. Rupprich's brief extract is expanded here to provide a fuller context for Hutten's reference to AD.

NOTES

  1  On Müller or Regiomontanus, see 51 Introduction and 51.2 Commentary.
  2  On Celtis, see 10 and 44.1.

3   The knight, poet and humanist Hutten despised the mercantile and entrepreneurial class. Here he suppresses his distaste in deference to Pirckheimer's position as Nuremberg senator.

4   Hutten is evidently familiar with the copying of AD's prints and the appropriation of his monogram in Italy (29.2 and 5, 72, 74).

## COMMENTARY

Ulrich von Hutten (BI), humanist scholar, fiercely anti-papal and politically arch-conservative. His humanism was overshadowed by his ideological commitment to the anachronistic dream of a united empire in which his knightly class would play a leading role. It led him into participation in an abortive revolt of imperial knights in 1522, which ended in his exile and death. His main link with Willibald Pirckheimer was his contemporary imitations of the satires of the late classical writer Lucian, four of which appeared in German translation in 1521, including *Die Anschawenden* ('The Spectators'), a satirical commentary on the Diet of Augsburg in 1518. Hutten's target is the corruption of the Roman Church and he does not refer to the encounter at the end of the Diet, when the papal legate Cardinal Cajetan attempted to persuade Martin Luther to recant his allegedly heretical teaching.

[Eckert/Imhoff 1971, 334–49; Bernstein 1988; Neuhaus 2002; Whaley 2012, 112–14]

# 1519

## 132   Letter of Albrecht Dürer to Wolf Stromer

*[Nuremberg, 1519 or later]*
Dear Herr Wolf Stromer,[1]
My most gracious Lord Archbishop of Salzburg has sent me a letter by the hand of his glass painter. Whatever I can do to assist him, I would gladly do, for he is to buy glass and equipment here. He is complaining to me that he was robbed at Freystadt[2] and had 20 fl. stolen from him. He's asked me to direct him to you, since his gracious lord has ordered him, should he need anything, to refer the matter to you. So I'm having my servant bring him for your wise attention. My regards.

   Your obedient

A. Dürer

The autograph draft for the letter forms part of the Dresden Codex (fol. 106ᵛ). On the other side of the leaf, there is a pen drawing of a jointed male doll (as used by artists for trying out posed figures),

and beneath it AD's note 'Nicklas on the horse market'. The reference may be to Nikolaus Dürr, recorded at this address between 1494 and 1500. The designation of Matthäus Lang as archbishop of Salzburg allows the dating 1519 or after.

Rupprich I, 83 and III, 436

## NOTES

1  Wolf Stromer (BI), a member of the prominent patrician family, was attached to Matthäus Lang when the latter was imperial chancellor.

2  A small town about 20 km south of Nuremberg.

# 133  Letter of Albrecht Dürer to Michael Beheim [fig. 46]

*[Nuremberg, 1518/20]*
Dear Herr Michael Beheim,

I am sending you back this coat of arms.[1] Please leave it as it is, no one is going to improve on it, for I've made it with all skill and art. So those who see and understand it will set you right about it. The foliage on the helmet is meant to be bunched up, so it covers the ties.[2]

Your servant

Albrecht Dürer

Autograph written on the reverse of the pear-wood block with the design of the Beheim coat of arms, in the possession of the Beheim family until the late nineteenth century, now in the Metropolitan Museum of Art, New York. The handwriting style is held to indicate a date after 1518. If that is so, the Michael Beheim in question is not the architect Michael Beheim (1459–1511) but the Michael Beheim who married Katharina Lochner in 1495, witnessed AD's purchase of garden ground in 1512 (78), and died in 1522.

Rupprich I, 84

## NOTES

1  Evidently Beheim had returned the woodblock and demanded improvements. AD added these, then scribbled his reply on the woodblock itself, leaving Beheim to have the design cut.

2  On the shield is a helmet (with the visor closed as befits a non-chivalric bearer), surmounted by the crest of an eagle of the heraldic type 'eagle rising with wings displayed'. It perches on a 'torse', consisting of a twined wreath of silken ribbons. From this there issues 'mantling' of acanthus leaves which cascade around the helmet and shield. The foliage hides the loose ends of the ribbons which would otherwise hang from the wreath.

46.  Albrecht Dürer, *Coat of Arms of Michael Beheim*, woodcut, 1518

COMMENTARY

By the beginning of the sixteenth century, the original military uses of coats of arms had become redundant, and their function purely that of prestige and socio-political representation. AD had presumably encountered the engraving of arms, particularly on seals, during his training as goldsmith. Heraldry was not yet formulated as a fully elaborated system and was not designed for urban patrician dynasties. It is unclear to what extent AD followed available patterns or freely invented coats of arms. The latter is certainly the case with his own family device (178.1). Commissions like Beheim's (SMS 250, S W 191), often intended for use as ex-libris bookplates (as here, with the blank panel below the arms), must have been a lucrative sideline for AD or a way of obliging friends and eminent fellow-citizens.

[Glanz 2001, 109; Neubecker 1971]

## 134   Letter of Lorenz Beheim to Willibald Pirckheimer

*[Bamberg, 3 January 1519]*
Greetings to Lady Κραμεριν and Albrecht et cetera.

PBr 4, 1f., Letter 574. Latin text
    R I, 263

## 135   Note by Willibald Pirckheimer on a Letter Written to him by Thomas Venatorius

Dürer is unwell.

R I, 263. The note is not recorded in PBr 4, 10–12.

## 136   Letters of Lorenz Beheim to Willibald Pirckheimer

### 136.1

*[Bamberg, 21 February 1519]*
Greetings to Lady Κραμεριν and Alberto.[1]

### 136.2

*[Bamberg, 23 March 1519]*
My regards to you and yours. Greet Lady Κραμεριν and the imperious Albrecht with his high and mighty Stabius.[2]

**136.3**

*[Bamberg, 29 March 1519]*

If Alberto intends to go to England or even miserable Spain, I believe that it is his fates that are driving him. He is not a mere lad any longer, he is not robust, and he will not be able to cope with the discomforts of such a journey. To say nothing of the foreign climate. If he is sensible, let him look after his wife and in return she him. Since he has no children, his means are quite adequate for him and he can live a quiet life serving God.[3]

PBr 4, 24–7; 37f.; 39–41, Letters 589, 596–7. Latin texts
    R I, 263

NOTES

1  *Albertonem*: Beheim Italianises, then Latinises, Albrecht. Enclosed with the letter is a horoscope of Emperor Maximilian who had died on 15 January 1519.

2  *Albertum imperatorium cum suo Stabio magnifico*: the incurably ironical Beheim mocks AD's role in Stabius's and Maximilian's imperial designs.

3  Beheim is evidently aware of AD's dilemma after Maximilian's death, of how to ensure the continuation of his imperial pension, which the Nuremberg council will not disburse without a warrant from the new emperor. The letter is evidence that AD was considering travelling to Spain, to find Charles V there, or intercepting Charles in England on the way to his coronation in Aachen. Instead he decided, sensibly, to attend the coronation along with the civic delegation from Nuremberg, via the Netherlands.

## 137  Letter of Christoph Scheurl to Nikolaus von Amsdorf

*[Nuremberg, 10 April(?) 1519]*

Greetings, most honoured sir, and excellent brother in Christ.[1]

You have done outstanding service in instructing us, by means of your little book, how to pray in accordance with Luther's teaching.[2] I beg you send me five copies of it. Martin himself is gaining great favour in the eyes of the people through his writings in German, in which you too excel and write more elegantly than many learned doctors are wont to do. By this you will have served the Christian commonwealth very well, if you will produce accurate translations of the Commandments[3] and the Sermons. In particular, my friend Albrecht Dürer asks to have the Sermon on Penitence[4] translated.

CSB 2, 86, Letter 196. Latin text
    R I, 263

NOTES

1   Amsdorf (1483–1565) was a canon and professor in Wittenberg, an early and committed follower of Luther.

2   The book *Ein christliche Fürbetrachtung, so man will beten das heilige Vater Unser* (1519. WA 2, 74–130), was compiled from Luther's sermons. See 144 and 152.

3   The sermons on the Ten Commandments (WA 1, 247–65) which Luther preached in the parish church of Wittenberg in 1516–17 and wrote down in Latin and German.

4   Beginning with the *Sermon von dem Ablaß und Gnade* (on indulgences and grace – WA 1, 243–6) in 1518, Luther published a number of his sermons in 1519–20, as a convenient way to spread his teaching among the common people. The *Sermon von dem Sacrament der Puß* (on what he still accepted as the sacrament of penance – WA 2, 709–23) appeared with three other related sermons, on baptism and on the body of Christ, in 1519, dedicated as a group to the Dowager Duchess Margarete of Braunschweig-Lüneburg.

## 138   Letter of Albrecht Dürer to the Burgomasters and Council of the City of Nuremberg

*[Nuremberg, 27 April 1519]*
Prudent, honourable and wise, dear Lords.

Your Honours are well aware that at the last Imperial Diet I obtained from His Majesty the Roman Emperor, our most gracious Lord of highly esteemed memory, not without exceptional effort and pleading, in recognition of the diligent labour and pains which I undertook for His Majesty's sake over a protracted period, His Imperial Majesty's gracious grant to me of two hundred Rhenish gulden out of the annually due city tax of the City of Nuremberg, for which was sent His Majesty's order and command, signed with his customary signature, receipted also in required manner in the signed and sealed quittance which I have to hand.[1] It remains now my humbly confident expectation of Your Honours, that you will take gracious heed of me, your loyal citizen, who has expended much time and effort in the service and employment of His Imperial Majesty, the rightful lord of us all, and yet without large recompense, and has thereby forfeited profit and advantage from other patrons, and that you will now extend to me those two hundred gulden in accordance with His Imperial Majesty's provision and quittance, whereby I, as is fitting, may have due benefit and satisfaction for my pains, labour and diligence. In return, should Your Honours face a demand for these two hundred gulden from a future king or emperor, or for other reason will not be able to dispense with the sum and will require it back from me, I offer to discharge Your Honours

and the whole City of the burden, and to pledge and mortgage as surety for it my dwelling house on the corner below the castle, which belonged to my late father,[2] so that Your Honours may not suffer damage or loss from it. This I am most willing to regard as my due service to Your Honours, being my gracious sovereign lords.

Your Worships' obedient citizen

Albrecht Dürer

Nuremberg, State Archive S. I, L. 79, No. 15, Fasc. 5. On the reverse side in a chancery hand, 'Albrecht Dürer, 200 fl. City Tax' and 'Easter IV 1519'

R I, 84f.

NOTES

1   See the emperor's letter to the Nuremberg council in September 1518 (127).

2   Whether fortuitously or foresightedly, AD had bought out his brother Endres's share in the house Unter der Vesten in 1518 (128).

COMMENTARY

AD pledges his late parents' house as guarantee in the event that the successor to the deceased Emperor Maximilian reclaims from the Council the 200 fl. allotted to him as an extra payment for his work on imperial commissions, over and above his annual liferent of 100 gulden. Although its financial records are not entirely clear on this point, it seems likely that the Council paid him the 200 gulden in 1519, and in 1520 AD was able to obtain Emperor Charles V's confirmation of his liferent (see 127, and 165.1–6).

## 139   Letter of Christoph Scheurl to Martin Luther and Otto Beckmann

*[Nuremberg, 9 May 1519]*
Farewell, and if we have any influence, we shall use it on your behalf. Kind regards to you both come from Hier. Ebner, Kaspar Nützel, Hier. Holzschuher, Albrecht Dürer, and our entire fraternity which is wholly devoted to your cause.

CSB 2, 89f. Latin text
   R I, 264

NOTE

Otto Beckmann (BI), theologian and humanist, professor of rhetoric at Wittenberg University. Initially an associate of Luther and Melanchthon, he soon detached himself from the Reformation and became a vigorous defender of the Catholic faith.

## 140 Albrecht Dürer Witnesses a Property Transaction

*[Nuremberg, 12 March 1519]*
The provost and magistrates of Nuremberg confirm that Margreth, widow of the baker Heinrich Recken, has sold her house at the Menagerie Gate to the baker Kunz Süßner and his wife Margaretha for 335 Rhenish gulden. Albrecht Dürer and Jorg Winckler are cited as specially requested witnesses.

GNM, parchment charter no. 7758
  R I, 248

## 141 Anecdote about Veit Stoß

## [1517/19]

When Anton Tucher commissioned Veit Stoß to carve the Annunciation, he appointed Albrecht Dürer to adjudicate the artistic quality of the work, which was to determine the artist's fee, and Veit Stoß readily accepted him in this capacity.

M. M. Meyer, *Albrecht Dürer* (Nuremberg 1840), p. 11. No documentation of the story is given.
  R I, 247

COMMENTARY

Veit Stoss (BI) is first mentioned in documents of 1477. In Nuremberg his most famous work is the *Annunciation in the Rosary* in St Laurence's Church. It was commissioned by Anton Tucher II, first Losunger from 1507 to 1524, who ordered a lime tree to be felled in the St Sebald forest for a *Mariapild* in March 1517. The wood must have been carved unseasoned, since the *Annunciation* was installed by 17 June 1518. Mary and Gabriel are suspended in an oval frame of roses, draped with rosary beads, which hangs from the high vault of the choir. By 1519, the Reformation had so discredited the theological assumptions underlying the sculpture – prayer to the Virgin as an act of merit earning

remission in purgatory, and the efficacy of the rosary beads as a device of sustained prayer – that the *Annunciation* was hoisted to the top of the vaulting and veiled in a leather sack (Nuremberg was averse to iconoclastic destruction of Catholic artefacts).

The insistence that Stoss welcome AD's adjudication of his work may hint at his problematical personality and at AD's skill in humouring it. When he came back to Nuremberg in 1496 he attracted adverse criticism by spending the inordinate sum of 800 gulden on a house. When he was the victim of fraud over a business investment of 1265 fl. in 1506, Stoss forged a document to help him pursue his enemies. For this he was prosecuted, imprisoned, branded on the face and fined punitive damages. Records describe him as *ein unruwiger haylloser burger* and *eyn irrig und geschreyig man* – 'a turbulent, incurable citizen', 'a wrongheaded, bawling man'. In matters of artistic judgement he was still essentially Gothic and his work made few if any concessions to an emergent Renaissance style. The *Annunciation in the Rosary* stands in the same tradition as AD's altar panel of the *Feast of the Rose Garlands* in Venice, although this is a key work in AD's transition from medieval to Italianate forms. By 1517 AD had begun to turn away from a piety based on the belief that human merit, earned in part through prayer to the Virgin, contributed to salvation. However, the Netherlands Journal shows him still buying and giving gifts of rosaries in 1520–21 (162).

[Baxandall 1980, 191–201, 271; Kahsnitz 1986, 70, 72–4, Ganz 2002]

## 142    Letter of Lorenz Beheim to Willibald Pirckheimer

*[Bamberg, 7 July 1519]*
Greetings! I return best wishes to you and your Albrecht, and I am delighted for you and congratulate you for having, as I am informed, carried out your mission so well and efficiently. But then to have been struck down by illness!

It is right that the Swiss have treated you all so liberally and well, for this agreement will be of no small benefit to them, if I am not mistaken. Greetings to Albrecht and Κραμεριν.

PBr 4, 59–61, Letter 608. Latin text
  R I, 264

NOTE

After the death of Maximilian I the Nuremberg authorities felt threatened by their neighbours Brandenburg-Ansbach and the Palatinate in respect of the city's imperial privileges and the territories it had acquired in the war of the Landshut succession. It tried to form alliances with Augsburg and Ulm. Pirckheimer represented the Nuremberg council as its envoy to Switzerland where he was to seek support against breaches of

the imperial law and permission to recruit Swiss mercenaries. AD accompanied him and en route did the drawing *Siege of Hohenasperg* (W 616). AD evidently got to know the Swiss reformer Felix Frey in Zürich, and through him Ulrich Zwingli (see his letter to Frey of 1523, 185).

# 143  Works of Art

## 143.1  Three Portraits of Emperor Maximilian I

The portrait drawing of the emperor which AD made at the imperial diet in Augsburg in 1518 (126.1) served as the basis for two painted portraits and a woodcut of Maximilian in 1519.

### 143.1.1  *Portrait of Emperor Maximilian*. Oils on canvas, with a blue (originally malachite green) ground. Nuremberg, GNM. A 145

Inscription on a strip of parchment attached to the top of the canvas (an approximate German version of the Latin inscription on the Vienna panel 143.1.2):

> The Most High and Mighty Invincible Emperor Maximilian, who exceeded every-one in his lifetime in sagacity, skill, wisdom and manliness, and who performed remarkable great feats and deeds, was born on the XIXth day of the month of March in the year MCCCCLVIIII, lived LVIIII years, IX months and XXV days, and departed this life at Wels, in His Majesty's ancestral lands, on the XIIth day of the month of January in the year MCCCCCXIX. May the Almighty graciously deign to grant his soul His divine mercy.

The portrait may have been given to Willibald Pirckheimer. Certainly, it was in the collection of Willibald Imhoff and remained there at least until 1650. As well as the Augsburg drawing, a preparatory sketch of Maximilian's hands holding a pomegranate survives (W 635, with the possibly subsequently added date 1519). The emperor is sumptuously dressed, has on his velvet cap a badge of the Virgin Mary, and holds the pomegranate in his left hand. This takes the place of the orb (in German, *Reichsapfel*) of traditional royal insignia, the symbol of universal rule under the sign of the cross. See AD's portraits of Emperors Charlemagne and Sigismund (64.11). The significance of the pomegranate is clarified by Johannes Stabius, in his commentary on the Triumphal Arch, as an emblematic expression of the principle 'Be more than you seem' (*mehr sein als scheinen*). Its rough skin and lack of scent belie its countless sweet-tasting seeds – supposedly as many of them as the emperor's good deeds for the state. The German name *Granatapfel* may allude to the conquest of Granada by Ferdinand of

Aragon, father-in-law of Maximilian's son Phillip the Fair, in 1492. Maximilian wears the collar and badge of the Order of the Golden Fleece, while to his left is the Hapsburg imperial coat of arms, the double-headed eagle, within the same collar and with the same suspended badge of the Golden Fleece. This inscription and the more formal, unhelpfully abbreviated inscription on the Vienna panel might be the work of Konrad Peutinger or Willibald Pirckheimer; they may have been written by the Nuremberg calligrapher Johann Neudörffer. It seems likely that this first version of the painted portrait was done as a *modello* for the much more carefully finished Vienna picture. There is no evidence to support the view that the earlier painting, let alone the later one, was the portrait which AD offered to the Regent Margaretha in Mecheln in 1521 (she did not like it and declined the offer, see 162).

### 143.1.2 *Portrait of Emperor Maximilian.* Oils on limewood panel, with a green ground. Vienna, Kunsthistorisches Museum. A 146

Above the emperor's head, in AD's hand, in classical majuscule, the Latin inscription:

Potentissimus · maximvs · et · invictissimvs · caesar maximilianvs / qui · cvnctos · svi · temporis · reges · et · principes · ivsticia · prvdencia / magnanimitate · liber-alitate · praecipve · vero · bellica · lavde · et / animi · fortitvdine · svperavit · natvs · est · anno · salvtis· hvmanae / m·cccc·lix · die · marcii · ix · vixit · annos · lix ·menses · ix · dies · xxv / decessit · vero · anno · m·d·xix · mensis · ianvarii · die · xii · qvem devs / opt · max · in · nvmervm · vivencivm · referre · velit ·

(The most high and mighty Invincible Emperor Maximilian, who exceeded all kings and princes in his lifetime in justice, wisdom, magnanimity, and liberality, most of all in martial renown and in fortitude of spirit, was born on the XIXth day of the month of March in the year of our salvation MCCCCLVIIII, lived LIX years, IX months and XXV days, and departed this life on the XIIth day of the month of January in the year MCCCCCXIX, whom Most Merciful God deigned to summon back into the number of the living)

The second version of the portrait is excellently preserved and painted to an exacting standard. The position of the pomegranate orb is more prominent and better balanced within the overall composition. Maximilian no longer wears the collar and badge of the Golden Fleece, now confined to the coat of arms. The latter is smaller and relates more effectively to the emperor's head and to the beautifully written inscription. In both portrayals the lowered gaze of Maximilian is perhaps meant to befit a deceased subject. The definitive version is clearly a state portrait, in which the Latin text and the sombre but luxuriously accoutred figure complement each other. AD's model is the Netherlandish-Burgundian tradition of depictions of rulers.

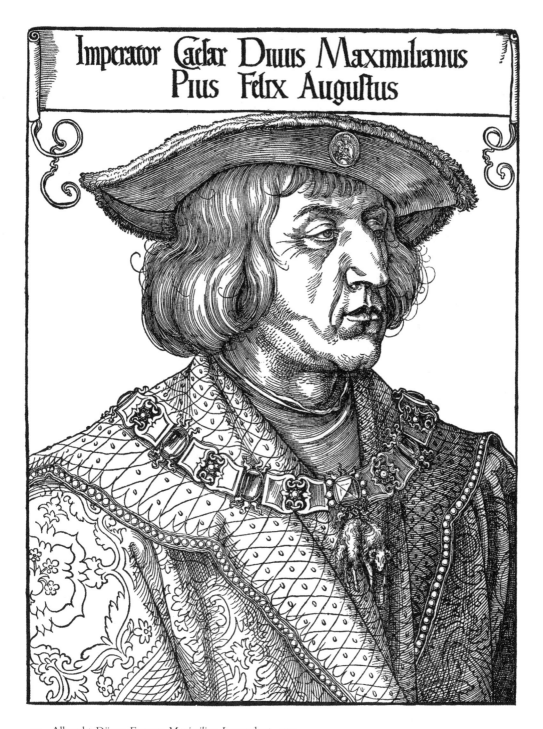

Imperator Cæfar Diuus Maximilianus
Pius Felix Auguftus

47. Albrecht Dürer, *Emperor Maximilian I*, woodcut, 1519

**143.1.3**   *Emperor Maximilian.* Woodcut S W 190, SMS 252 [fig. 47]

Latin inscription:

Imperator Caesar Diuus Maximilianus / Pius Felix Augustus

(Emperor Divine Caesar Maximilian, Pious Propitious Augustus)

The plate has neither monogram nor date. It is modelled on the Augsburg drawing, reversed when printed so that the figure looks to the right. The emperor wears a brocaded pearl-studded garment, the collar and badge of the order of the Golden Fleece, and the cap-badge of the Virgin Mary. As in the drawing, the hands are not visible. The inscription is remarkable for its unqualified citation of classical Roman imperial titles. Maximilian's eyes are wide open as if it were the depiction of a living emperor, but the inscription gives him the title *divus*, which Roman emperors were granted only after their death, so that, less obviously, this image too has a memorialising function. There are four later states, each transferred to a new block, so clearly the woodcut was a popular one.

[Kurt Löcher in Ex. Cat. New York/Nuremberg 1986, 322–4; Anzelewsky 1991, 256–9; Ex. Cat. Vienna 2003, 470–74; Wolf 2010, 268; Smith 2012, 279–83]

## 143.2   Three Portraits of Cardinal Albrecht of Brandenburg

In 1518–19 AD did two drawings and a copperplate engraving of Cardinal Albrecht of Brandenburg, archbishop of Mainz and Magdeburg.

**143.2.1**   *Cardinal Albrecht of Brandenburg.* Black chalk or charcoal drawing. Vienna, Albertina. W 568, S D 1518/23

AD's monograms in both left- and right-hand corners are probably not authentic. There is no inscription. Another, inferior pen version of the drawing, W III, plate V, S D 151/3 (disappeared in 1945 from Bremen, Kunsthalle), is seen as a preparatory sketch for the engraving (143.2.2). On the reverse AD started to draw the nose and mouth, but they were clearly too small and he began again on the other side of the leaf. Inscriptions: (at the top in German, in AD's hand):

1519 bishop of Mainz

Immediately below, above and around the head, in mirror script majuscule:

Sic ocvlos sic ille genas / sic ora ferebat / Anno etatis / sve XXVIII

(Thus were his eyes, his cheeks and his features in the 28th year of his life)

Lower down, either side of the body:

MDXVIII

(1518)

The Latin inscription rehearses that of the 1519 engraving and it is reused in AD's second engraving of the cardinal in 1523. The Vienna drawing is unusually large and highly finished, unlikely to be the probably hasty sketch AD made at the imperial diet in Augsburg, but a drawing done in the studio on the basis of that sketch. Both the drawings, and the engraving itself, have always been judged critically by art historians for the expressionless face they depict, in contrast to the more revealing silverpoint drawing made for the engraving of 1523 (W 896).

[Ex. Cat. Vienna 2003, 476]

## 143.2.2 *Cardinal Albrecht of Brandenburg*. Copperplate engraving. S E 88, SMS 89 [fig. 48]

Latin inscriptions (top right, beside the cardinal's coat of arms):

ALBERTVS · MI · DI · SA · SANC · ROMANAE · ECCLAE · TI · SAN · CHRYSOGONI · PBR · CARDINA · MAGVN · AC · MAGDE · ARCHI · EPS · ELECTOR · IMPE · PRIMAS · ADMINI · HALBER · MARCHI · BRANDENBVRGENSIS

(Albrecht by Divine Mercy Presbyter Cardinal of the Holy Roman Church, Titular of St Chrysogonus, Archbishop of Mainz and Magdeburg, Primate Elector of the Empire, Administrator of Halberstadt, Margrave of Brandenburg)

Below in a bottom panel:

SIC · OCVLOS · SIC · ILLE · GENAS · SIC · / · ORA FEREBAT / ANNO · ETATIS · SVE · XXIX · / · M D XIX

(Thus were his eyes, his cheeks, his features at the age of twenty-nine, in 1519)

The upper inscription, with its many abbreviations of the cardinal's formal titles, must have been copied from an official source; the lower inscription is that of the Bremen drawing, but with amended age and date. AD's letter of 1520 to Georg Spalatin (154) tells us the engraving was commissioned by Albrecht himself.

Albrecht, margrave of Brandenburg (BI), born in 1490, was by 1514 archbishop and prince elector of Mainz. The need to pay Rome for confirmation of his consecration led him, with papal permission, to promote the preaching of an indulgence, the certified remission of sins in return for donations. The preaching of the indulgence in Wittenberg by Albrecht's pardoner, the Dominican friar Johann Tetzel, was the catalyst which provoked Martin Luther's *Ninety-five Theses*, 'the first true basic beginning of

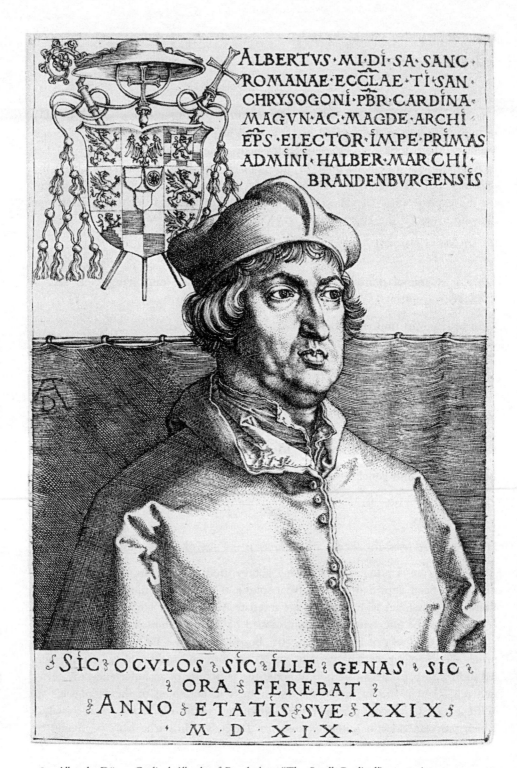

ALBERTVS·MI·DI·SA·SANC·
ROMANAE·ECCLAE·TI·SAN·
CHRYSOGONI·PBR·CARDINA·
MAGVN·AC·MAGDE·ARCHI·
EPS·ELECTOR·IMPE·PRIMAS·
ADMINI·HALBER·MARCHI·
BRANDENBVRGENSIS

SIC·OCVLOS·SIC·ILLE·GENAS·SIC·
ORA·FEREBAT·
ANNO·ETATIS·SVE·XXIX·
·M·D·XIX·

48. Albrecht Dürer, *Cardinal Albrecht of Brandenburg* ('The Small Cardinal'), engraving, 1519

the Lutheran commotion' (*der erste rechte grundliche anfang des Lutherischen Lermens*) according to Luther himself.

Before Nuremberg's civic reformation in 1524–5 began to foreshadow sectarian divides, AD had no reason to decline the cardinal's patronage. Albrecht was a patron also of Peter Vischer, Matthias Grünewald and Lukas Cranach, who produced a weak imitation of AD's engraving in 1520. The Nuremberg book-illuminator Nikolaus Glockendon painted a portrait based on AD's model for a Book of Hours produced for the cardinal by various artists circa 1520. In the same year, Albrecht used AD's engraving itself as the frontispiece of the printed catalogue of his immense collection of holy relics and artefacts, the *Halle'sches Heiltum*, to house which he had rebuilt a special church in Halle.

This engraving became known as 'the Small Cardinal', to distinguish it from the larger-format 'Great Cardinal' of 1523 (180.2).

[W.L. Strauss 1972, 204; Jürgensmeier 1990, 30–36; Reber 1990, 83–92, 202; Walter 1990; Lohse 1991, 73–83; Kaufmann 1995, 124–8; Riether 2002, 231–4; Ex. Cat. Halle 2006; McHam 2013, Plinian Signatures]

## 143.3 *Head of a Small Boy*. Chalk or charcoal drawing, white highlighting, on red paper. BM Sloane Collection. W III, plate VII, S D 1519/8

Below, the date 1519 and inscription in AD's hand:

Vergeß mr das / als du wol wist, / an allen raugken

Rupprich's palaeographical skills (R III, 444) are superior to Winkler's. The sense might be:

Let's forget it, / since you're so good, / We'll not be cross

– reading *mr* as Nuremberg dialect form of *wir*; *wist* as Nuremberg dialect for *bist*; *raugken*, following DWb VIII, 237, as 'irritation'.

Rupprich identifies the drawing as AD's own copy of W 394, a study originally for the angels of the *Feast of the Rose-Garlands*, done in Venice in 1506, but not used until the Heller Altar of 1508. Perhaps the copy was done as a placatory offering?

## 143.4 Drafts of the Inscription for a Portrait Medal of Dürer. Pen. BM Sloane 5218, 67. W 720, S D 1519/17

Two drafts, one fragmentary, of an inscription for the reverse of a portrait medal commissioned from Hans Schwarz in 1519. Latin inscriptions in Roman capitals, the last two lines on either side of a shield with AD's heraldic device of an open door:

IMAGO / ALBERTI · DVRER / ALEMANI · QUAM · SVIS / MET · IPSE · EFFINXIT M / ANIBUS · ANNO · AETATIS / SVAE · XLVIII · SALUTIS / VERO [] · M·D · / X [C] IX

(Portrait of Albrecht Dürer the German which he fashioned of himself with his very own hands at the age of 48 in the year of salvation 1519)

Below the complete inscription within a rimmed circle, a second draft improves the layout (line divisions) of the first four lines. It is virtually identical with the unused draft inscription BL 5229, 51r, written much less elegantly in a continuous line without an age or date. This has generally been linked with the inscription of AD's 1500 self-portrait (see 11.1–2) which also uses the verb *effingere*. The quality of the lettering on the medal draft is comparable with that of the neo-classical drawings 93.5–6. In Antwerp in 1520 AD received the boxwood model of his unstruck portrait medal by Hans Schwarz which does not use this inscription (see 162, note 127).

[Ex. Cat. New York/Nuremberg 1986, 417; Rowlands 1988, 107–9; Ex. Cat. Osnabrück 2003, 22f.]

## 144   Letter of Christoph Scheurl to Otto Beckmann

*[Nuremberg, 18 July 1519]*
I send best wishes to all our friends, especially Martinus and Amsdorf, whose works Dürer and I were very glad to receive. Would that Amsdorf might honour and benefit all Christians by translating the Ten Commandments.[1]

CSB 2, 93f, Letter 203. Latin text
  R I, 264

NOTE

  1   See 137, note 3.

## 145   Letter of Christoph Scheurl to Nikolaus Amsdorf

*[Nuremberg, 3(?) August 1519]*
I and my friend Albrecht Dürer, so pre-eminent among painters for his intellect and judgement, are immeasurably pleased by your translation.[1] If only you were now teaching the German people the Ten Commandments and the like, truly you would be on the way to putting the Christian commonwealth in your debt, and most gloriously so. Privately, however, you would earn our thanks if you would send us anything at all, and even the slightest bits and pieces, from Luther's press. By the same token you will certainly be doing Dürer a favour, and I ask you to address yourself to him direct. He himself, quite properly, pays

you many, many tributes, even though he has not ventured to appeal to you to write. For myself, I thank you for your enduring loyal friendship. My plea is that you will ever persist in that. As for me, you will find me a frank and honest friend, whenever you need one. Greetings to mutual friends, and farewell.

GNM, Cod. C. 246b/247. Latin text
R I, 264

NOTE

1    Luther's exposition of the Lord's Prayer. See 137, note 2.

# 146    Letter of Christoph Scheurl to Andreas Bodenstein von Karlstadt[1]

*[Nuremberg, 3(?) August 1519]*
Both my friend Dürer and I acknowledge most gratefully your *Two Carts*,[2] your commentaries, your civility and your goodwill. Dürer returns the favour, I at the same time give thanks but postpone any recompense, since I am asking whether, if anything else of this kind comes to light in Wittenberg, you would share it with us. Should there be anything here in Nuremberg, which you might deem affects your good name or is useful to you in your work, consider it as your own. Farewell, and pass on my greeting to my friend Lukas the painter.[3]

Ibid. Both these letters are copies of Scheurl's originals, written by an amanuensis. Latin text
R I, 264f.

NOTES

1    Andreas Bodenstein, known as Karlstadt after his birthplace in Franconia (see BI and 167). Appointed professor in Wittenberg in 1505. From 1517 he enthusiastically endorsed Luther's theology, but rapidly veered to the radical left wing of the early Reformation, which led to an eventual irrevocable breach with Luther.

2    An early and influential example of Reformation propaganda in the form of the single-leaf broadsheet, with a woodcut and explanatory text. The woodcut of *Two Carts* (1519), by Lukas Cranach, shows a cart with a large cross making its arduous way to heaven, whilst the other hurtles towards hell.

3    Scheurl was well acquainted with Cranach (BI) from his years in Wittenberg (see 57).

## 147    List of Guests at the Wedding of Christoph Scheurl and Katherina Fütterer

*[Nuremberg, 29 August 1519]*
Nominated members of the Great Council and other Honourable citizens:
...
Lazarus Spengler and his wife
Albrecht Dürer and his wife
Hans Ritter's wife
...

Scheurl, *Mein Doktor Christoffen Scheurls vnd Junckfrawen Katherina Fütrerin hochzeit* (1519)
  R I, 248

## 148    Letter of Bernhard Adelmann von Adelmannsfelden[1] to Willibald Pirckheimer

*[Augsburg, 1 November 1519]*
Lucian wrote a description of the Calumny, which doubtless you have read.[2] I have two translations of it, one (the authorship of which I do not know) has been printed, the other, by Rinucci,[3] is unreliable. Please write back and tell me what you know of this latter translation. I may wish to give our prince[4] this account and a picture of the Calumny. But to tell you the truth, neither satisfies me.

PBr 4, 104–7, Letter 627. Latin text
  R I, 267. Rupprich gives the date wrongly as 1520/22.

NOTES

  1  Adelmann (BI) was a canon in Augsburg and Eichstätt.
  2  In his work *Non temere credendum esse delationi*, the late classical writer Lucian wrote a description (*ekphrasis*) of the painting *Calumny* by the Greek artist Apelles. It was paraphrased by Alberti (*De pictura* III, 53), and Botticelli and Mantegna produced recreations of the picture. In 1522 AD drew on Pirckheimer's translation of Lucian to design a mural of it for the town hall in Nuremberg. See 168.5, Massing 1990 and Ames-Lewis 2000, 193–8.
  3  Rinucci da Castiglioni translated a number of Lucian's dialogues.
  4  Either Christoph von Stadion, prince bishop of Augsburg, or Gabriel von Eyb, bishop of Eichstätt.

# 149   Letter of Hans Lochinger[1] to Ursula Kramer[2]

*[Spain, Court of Emperor Charles V, 15 November 1519]*
Would you also tell Albrecht Dürer, I am sure I shall bring him a favourable
answer.[3]

R I, 265, quoting a modern printed text

NOTES

1   Lochinger (died 1551) was in the service of the Nuremberg council, as a repre-
sentative at the imperial court between 1514 and 1521, and as keeper of the town hall
from 1522 to 1539. He was an acquaintance of Pirckheimer, Spengler and AD. This
letter is sent from the court of Emperor Charles V in Spain, and Lochinger appears
at this time to be involved in the reconfirmation of AD's imperial pension.

2   Ursula Kramer, widow of Hans Kramer and neighbour of Pirckheimer was a
relative of Lochinger's mother-in-law. She is frequently referred to by Lorenz Beheim,
in 49.2 as Pirckheimer's 'housekeeper'.

3   See Beheim's letter 136.3 which reveals that AD had considered travelling to
Spain to state his claim to Charles V.

# 150   Letter of Lorenz Beheim to Willibald Pirckheimer

*[Bamberg, 27 December 1519]*
Have the enclosed letter delivered to Alberto and greet Lady Kramer, your
daughters and their husbands.

[Note in Lorenz Beheim's hand with instructions for Albrecht Dürer]

In the margin:

Albrecht Dürer

Auf ein durchsichtig glas, mit der tinten zw designiren. Ungatur prius vitrum
cum acqua gummata, et eo siccato designa desuper, quod vis.

Ad invernicandum[1] cartas de papiro. Distemperetur la bianca [carta], mit eim
leinwasser gemacht, von pergamen, subtil [tenuissime] abschabig, et subtilissime
cum pinello[2] illiniatur papirus semel aut ad maximum bis. Postea cum dente
bene imbruniretur.[3] Deinde designa tuos circulos desuper aut quod vis. Postremo
super inducatur vernizium lucidum, ut scis.

Zw trucken mit dem firnis. So dy form⁴ uberstampft ist mit dem firniß, leg darüber das pewcklein⁵ und aufs peücklein ein tuch oder filz. Darnach uberreibs mit eim löffel, et est factum.

(For drawing a design on clear glass: first moisten the glass with liquid adhesive, and when it has dried, draw your design on it.

For applying a glaze to sheets of paper: moisten the blank paper with a solution of paste, made from fine shavings of parchment and, using a brush, finely coat the paper once or at the most twice. Next roughen well with a sharp tool. Then draw your circles on it, or whatever you wish. Finally apply a coating of clear varnish in your usual way.

To print using this varnish: when the forme has been firmly impregnated with the varnish, lay the sheet of paper over it, and cover the paper with a cloth or felt. Then rub it with the back of a spoon, and it is done.)

PBr 4, 166f., Letter 654. Latin text, enclosed note in macaronic Latin/Italian/German
    R I, 266f. has, erroneously, the date 1520.

NOTES

 1  *invernicandum, vernizium*: these word forms are playful variants of German *firnis* (compare English noun/verb 'varnish') which derive from Italian *vernice*. The root is a Middle Latin form *veronice*, 'resin', from Greek *beronike*. The resin may originally have been brought from the city *Berenike* (Βερενίκε), modern Benghazi.
 2  Italian *pennello*: 'brush'.
 3  Italian *imbrunire*?
 4  The prepared plate to be printed from, English 'forme'.
 5  Presumably a diminutive related to *Bogen* in the sense of 'sheet of paper'. But the first recorded occurrence of this dates from only 1499 (Pfeifer, 195). Perhaps Beheim knew it only aurally, from printers' usage.

## 151  Writings on the Theory of Art

### Introduction

Towards 1520 AD wrote the earliest preserved lengthy draft of the 'Discourse on Aesthetics' which ends the third of the *Four Books of Human Proportion* in the published version of 1528. The dating of the draft rests partly on Rupprich's analysis of its handwriting. However, other features strongly reinforce the view that it was composed at the end of the drafting process which took AD from his decision in 1513 to abandon his initial project of a comprehensive handbook on painting, and to start

writing a discrete textbook on the construction of proportionate human figures, through to the completion in 1523 of a print-ready copy of the work (partially preserved in the Dresden Manuscript, see R III, 163–217). In mid-July 1520 he set off on his expedition to the Netherlands and returned to Nuremberg in late July 1521. There a new major project awaited him, the redecoration of principal rooms in the town hall, and AD's time in 1521–3 was thus limited. The draft of the 'Discourse on Aesthetics' is incomplete, evidently a work in progress which needed further rewriting before it was publishable. In the manuscript there is a plethora of second thoughts and emendations between the lines and in the margins. Before the treatise was printable, the many dozens of sketches of highly detailed measured proportional figures needed conversion into woodcut designs, and the blocks themselves had to be cut. It is inconceivable then that the 'Discourse on Aesthetics' had not been at least extensively drafted by 1520.

Further, the draft clearly shows that it was an integral, if not original part of AD's conception of the *Four Books of Human Proportion*, and that when it was drafted in this form at least the text which went before it was already written. It contains frequent, sometimes very specific, cross-references to the text and diagrams of the first three books. Its essential function in the overall conception, as an aesthetic complement, even corrective, to the highly technical matter of the treatise, is conveyed at the very least in implication. Although AD had spent much time and effort in 1512–13 on drafting an introduction, originally to the general handbook on painting, then to the redefined project of a treatise on human proportion (82–4), it is clear in the draft discourse on aesthetics, as indeed in the earliest drafts of it (103.1–8), that by circa 1515 at the latest topics and formulations from the draft introductions were being incorporated into the new discourse.

As is painfully evident in all these essays in extended writing on aesthetics, and again when AD attempts to write prefaces and dedicatory epistles in 1523 (181–2), he is hampered and inhibited by the inadequacies both of his formal education and of the available range of styles, linguistic registers and lexis of contemporary German. This extended draft often lacks clarity and precision, semantically and syntactically, as well as rigour and cohesion in its overall structure and argumentation. My translation relies particularly heavily on exegetical, interpretative notes, as it sets out to help the reader follow the gist of the discourse at the same time as it conveys at least something of its obscurity of thought and expression. The final version which appears in the printed *Four Books of Human Proportion* in 1528 has been revised and improved, possibly with some assistance from Willibald Pirckheimer. The contribution of this revision process to our understanding of AD's evolution as thinker and writer is the reason why both this draft and the published version (257.4) are included in full in the documentary biography.

[Białostocki 1971; Panofsky 1948, chapter 8, esp. 272–84; Rupprich III, 19–306]

## 151.1 Draft of the 'Discourse on Aesthetics' in the *Four Books of Human Proportion*

Using this altering device[1] one can turn a figure the size of seven head-lengths into one that is eight, nine, up to ten heads long, thus extending the figure between the head and the instep of the foot stepwise by once, twice or three times the length of the head. When the figure is so much extended, one must then also extend the head somewhat as the case requires, so that the head does not look too misshapen.[2] Then however the figure will no longer be the same number of heads long as before.

Note next that whoever wishes can, by using the reverser, the selector, the twin, the pointer or the falsifier,[3] distort the measurements of any figure described above a further time in a different way, in particular aspects or as a whole, by whichever of the aforesaid means one wishes. You can also combine all the figures that have been made with one another, as cleverly as may be done, until you find something that pleases you and others.

And mark quite especially: if you want to contract the shape of any figure and its lines by narrowing all its extended lines and the spaces between, then you must take very precise care that you do not produce any disfigurement on the outside of them.

Between and on the horizontal lines are indicated length, depth and breadth. Here there is no danger of error if you follow what is written. But when you are making adjustments between horizontal lines it is easy to go wrong. For sometimes one draws things too far inwards or outwards, so that things themselves become too fat, broad, thin or narrow. How to do it in every instance, to describe how it should all be drawn, would be too much for one book.[4]

If everyone were to sketch figures according to this book and was not well informed in the matter, he would at first find the business difficult to master. But he should set before himself a person who is roughly appropriate for the given measurement. Then draw the external lines as best you know how to. For that is a good rule to follow: the more exactly one can copy and render an attractive form from life and nature, the better and more true to art the same work will be.

But beyond that it is up to each individual whether and how he wants to make use of all the terms of contrast and difference set out above and listed one after another.[5] If he wishes, a man may learn how to work with the art and skill in which truth resides, or without art, whereby everything will go astray. Work that is refined, well made, earns praise, gives pleasure and is useful.

What is inherently poor deserves mockery, criticism and rejection whether in small or large works.

Hence it is necessary that everyone applies experience and understanding to work that is to be on public display. So render nature neither as less nor yet as more than it is. If you do too little to a thing, it will not be recognisable, but too much is no use either. What is best is a true mean.

For that reason one should take care to demarcate the contrasts more subtly from each other than I have done in the woodcuts of this book. That I have shown them starkly here was done so that they are better seen in their small format.[6] Whoever is dealing with these things in a large work should do it gently so that it looks artistic. The contrasts do not show a master's touch if they are wrongly used.

Nor is it a surprise if a skilled master considers all kinds of contrasts which he might make if he had time, for which reason he has to dispense with many. For there are innumerable contrasts which might be made in a human mind.[7] Hence if it were possible that a man might live a thousand years, with all his God-given strength, who was well versed in this art and has a natural disposition for it, he would have every day a host of new forms of human and other beings to pour forth, such as no one had seen before nor any other had conceived.[8] Thus in such matters God gives an artist great power. And although much is said about contrasts and differences, we know very well for all that, that all things in themselves are different from each other. So that there is no artist alive who is so sure, that he could make two things so alike to each other that they would not be recognisably distinct from one another. What we make will never be identical, that we cannot prevent. We see, when we print two copies of an engraved copperplate, or cast two forms from the same mould, that we can tell one from the other by all sorts of details. If that can happen with the most predictable artefacts, how much more so with others which are done by the free, unmediated hand.

Yet this is not the kind of difference I am speaking of here. Rather, I am talking about the difference which a man deliberately undertakes and which is subject to his will, and this I shall go on discussing. When a man takes it into his mind to do this or that, by that he intends a difference. But not the kind which we cannot eliminate from our work, but such a difference as brings about beauty and ugliness, the kind we achieve through the terms of contrast set out earlier in this book when we create them in our work. A man's sight can judge this by applying his discrimination. This is why I want to freely offer up all the things I have described and transformed above, so that just as you wish you can leave nothing unaltered in the way I have depicted it. Hereafter

I shall give you instructions how that may be done. However, all of you should guard against making anything that is impossible, that nature does not tolerate, unless it were the case that someone wanted to create a fantasy, in which one may mix all manner of things together.[9]

Getting down to work now, let us first turn to the way a figure is divided in its length by horizontal lines. More or fewer of these may be done than I have set down. But drawing more transverse lines serves a more precise measurement, thereby a fuller analysis than I have given. An eager master will find that useful.

If however you make fewer horizontal lines than I have, you need take less trouble. But equally you will achieve less.

Now the second alteration, as is shown above in the section on faces, is that you can disarrange all the horizontal lines or shift part of them away from or closer to one another. If you move them nearer together, the spaces between them are shortened. If you move the lines further from each other longer spaces are created between them. All this has to do with long and short.

Now let us turn to depth and breadth. This alteration comes about on and between the horizontal lines. Whichever and wherever you wish, make that same end thicker, thinner, broader or narrower. Wherever you add or take away, the body, at that point at least, becomes larger or smaller, whether it be in profile or frontal figures.

It is not appropriate, however, to make a thing too short, long, fat, thin, too broad or narrow. Yet there is no doubt that, using these devices I have described, you may create remarkable alterations of forms, juxtapose great discrepancies and distort the forms of nature.

Through such contrasts and differences it comes about that some figures acquire broad shoulders, become slim in the flanks, narrow in the hips and vice versa. Thus others get short bodies and long legs and vice versa. Some have straight bodies and legs, others crooked.

As a result one can create beautiful and ugly things. Therefore everyone has to know what he wants to make. That is why I have demonstrated my above method, so that a man figures out before he starts work what he wants to achieve.

It is necessary if he wants to have a reputation for art and skill that a man apply the best that is appropriate for this particular work.

It must be said in this connection that an informed and practised artist can show more of his great power and art in a commonplace thing than many another in a major work. True artists will well understand this statement and that I speak the truth.[10]

It follows that one man may draw something with his pen in one day on a half-sheet of paper that is better art than another man's great work on which he has spent a whole year's endeavour.

Hence God often sends someone whom he lets learn and create in a way that no one in his lifetime can be found who is his equal, and even in four centuries before him. We can see an example of that in the case of Rome, where can be found the old ruins and remains of the ancient artists, whose like is unknown to anyone alive, who could not achieve half their like.[11]

Now let us return to discussing how we might make a beautiful image. Can human judgement define the beautiful? Many will not concede that, and nor do I. For I believe that there in no one alive who can perceive ultimate beauty embodied in one small creature, let alone in a human being. I do admit that one person recognises and explains better what makes something more beautiful than another can, yet not to the extent that it might not be yet more beautiful. Such a conception cannot arise in a human mind. Rather, God alone knows that and if he were to reveal it, man would know it too. Truth alone possesses the secret of what the most beautiful measure and form of the human image may be.[12]

Men speculate about it and have an infinite number of different opinions and try many differentiations in their beautiful forms, leaving aside the ugly ones.

But I do not know how to prescribe a special measure which would approximate to ultimate beauty. Yet I would gladly help, so far as I know how, so that crude deformity is avoided, unless one specially seeks it.

In that connection we should bear in mind that certain human forms are more prized and praised at one particular time than at another, and many masters set to work with these in mind. But to produce one pattern of human form unerringly correctly as being the most beautiful, seems to me impossible. For we are full of error. Therefore, if one man comes forward who can demonstrate with well founded truth that he can show through measurement the most beautiful human form, I shall deem him the greatest master and gladly listen to his reasoning.[13]

I hold, however, that it is by the highly skilled in this art, those who have demonstrated in their works with their hand by what means and methods, measuring all parts, meticulously in the smallest as in the largest things, that an image can be sought and achieved [that is] the best and most beautiful, for then we may the more closely approach the goal.

When we then set out and say: a man is an image and this image shall be in its whole body in all respects well formed, and comprise many different aspects and parts, each one of these same separate parts must each be skilfully

examined with distinct care according to its true character and its natural property, and to our best ability fashioned as beautifully as can be. Wherever someone wants to fashion an image whose appearance earns praise, let him make it to the best of his ability.

When one first begins to make a head, one must consider, as I have described in books one and two, what a most strange rounding it has at every point, one that cannot be drawn with any compass.[14]

The same with the brow, to make it well shaped, the nose with its nostrils. Not to forget each eyelid, still less mouth, cheeks and chin, lest these be not first closely examined. And just as each little bit of the head should be well formed in itself, so also the whole assemblage of the head should be well formed altogether and each thing pleasingly harmonious with another. Also the neck should match well with the head, so that it is neither long, short, thick nor thin. One must take care that breast, in particular belly, back and buttock, legs and feet, arms and hands, similarly the smallest bits like fingers and toes, each separately be well formed in itself and fashioned for the best.[15]

And these things, once each for itself is well made, shall then all as separate parts be brought well together, so that they rhyme and harmonise as a whole, and so that the character of the whole body is consistently formed. Let it not happen that one part is fleshy, the other skinny. What I mean is that the arms should not be smooth and even, while the calf has lots of peculiarities, as then also with the other parts. And just as it is essential that, as was said before, the very smallest components in the image be minutely examined, so also that the whole assemblage of the image be well put together in hard or soft manner, fleshy or skinny, so that all details rhyme with each other and are not discordant. For harmony is what we deem beautiful.[16]

Hence also in every image in all parts of the limbs a consistent age should be depicted, not the head of a youth, the breast of an older person, hands and feet of a middle-aged one, and so that the image is not young at the front, old at the back, or the other way round. For a thing is reckoned good if it adds up naturally.[17]

Thus whoever makes an image, let him do it in the same way throughout, either skinny or fat, young or old or middle-aged, entirely smooth or entirely rough nude figures,[18] just as fresh youth is smooth and ripe old age is all wrinkled and the flesh wasted. The outlines serve to indicate this, when you sketch the image you intend, so that you can see how it might be before you properly set to work, whereby you will not do something which you will later regret.

Hence it is essential for every artist to learn to draw, for much depends on it. For even when a good measurement is described, if someone comes across

it who lacks understanding of drawing, and goes ahead with length, depth and breadth, he will very soon make a mess of what he is supposed to be making. But where someone does understand drawing and sets out on a well explained image, it will help him in sketching it out so it will turn out still better.

If we want to achieve a good measure through all the parts of a whole body, and so bring one element of beauty into our work, it seems to me useful if you take your measurements from many living people who possess beauty, and carefully copy their character from their whole body. For out of many people something good can be brought together. Rare is the single person all of whose limbs are good.

Yet, as I said earlier, for one image you should assemble what you require from one kind of people. For a young image choose only young people as models,[19] for an old image old folk, for a fat one, fat ones, for a thin one, thin ones, for a soft one, soft ones, for a hard one, only hard nudes,[20] strong or weak or in-between. Take pains over this, for you will find enough for the requirements of your work out of copying the creatures of nature, provided you undertake it with true understanding.

There are many kinds of people to copy,[21] black and white.[22] The difference is easy to notice, on account of the natural characteristics they share. A moor's face is seldom handsome, as you know. Likewise their legs are knotted and usually scrawny. Yet you will find many among them who in their whole body down to the buttocks are well built and comely, their arms too. However, white people have better hands, likewise legs. Even so each can be usable in its own right. For in achieving the differences of a wide variety of image, it is necessary to copy examples of the whole variety of complexions.

For that reason some seek to make an image of a hard nature and with an incisive stamp. Another sets out to make a soft image with a light stamp. But it is more appropriate to give a hard and coarse stamp to a hard image than to a slight, delicate image with which softness is better matched. However, both soft and hard can be used where one wishes.[23] So examine them closely, be guided by the complexions, as is stated above, and not by what seems best to you, nor by the idea that you will find the best by yourself. You will be led astray. For truly, art is implanted in nature, if you can draw it out, it will be yours.[24] That will ensure that you do not go wholly wrong.

As for Geometry, one can prove certain things and show they are true. But certain other things one must leave with human opinion and judgement, just as in matters of civil law what is right is decided by the adjudications of men.[25] The more precisely your work is compatible with life, the better your work shall be.[26] That is indeed the truth. Therefore never seek to want or be able

to make a better likeness of a thing than God has allowed his created nature to achieve. It follows from this that a man can never make a beautiful picture out of his own sense perceptions, unless it is the case that by much life-long copying of beautiful images, which you have grasped and drawn in from external nature, out of which you can then by acquired art and skill invent new division, whereby you reveal what secret treasure, collected by you, lies concealed in you, and now reaches the light of day.[27] This is the new creature which you create as a form in your heart.[28]

It may also happen, though rarely, that through long and diligent practice and wide experience, out of his own acquired understanding and without a model to copy,[29] an artist draws something better into his work than another who has less understanding but copies many living people.

Thus someone who reaches the stage where he does not need always to be copying is better placed. But few reach that stage, which allows them after long effort to make something proper out of their understanding alone.

Therefore it becomes possible for those who have attained good practice out of true understanding to make something without any model, so far as a man can. For the others it is impossible, for these things do not happen by chance.[30]

In this connection realise that no master will find perfect limbs in one single human being, for there is no living creature on earth, so we think, whose form is perfect.

If many a man is beautiful, nonetheless another will be found who is still more so, although yet a further one will surpass him too in certain features.

It happens that two people are found, both beautiful and praiseworthy, and that neither is like the other in stature and character. Nor do we understand which of them is more beautiful. Thus blind is our perception, and it is hard for man to make such judgements.[31]

It follows from this that a powerful artist should not devote himself to one style but should be practised in all manner of ways. That will bring him the understanding to be able to do whichever is asked of him. And on the basis of the above-mentioned insights he will know how to make a choleric or friendly or other kind of figure, which can be done well each in its own fashion.

When someone comes to you and asks for a Saturn, Mars or Venus, then you will be readily informed by the said studies what measures you are to use for them.

Through these all categories of person can be depicted in their external form, whether they are fiery, watery or earthy by nature.[32] For artistic power, as I have said before, pervades all works. Fellow craftsmen with understanding will mark these things well and know what right practice is. For knowledge is true but opinion often deceives.

So let no one set too much faith in himself so that he does not go astray in his work and fail. But let each and every man accept with more certainty that he learn from others, failing which he may find it out for himself.

Yet beware of learning from those, of whom I have seen many, who talk well about the matter but with their hands have produced only blameworthy work. For if you follow them, they will lead you into error, for their work betrays their lack of art.

Talking and doing are two different things.

## 151.2  Additional Material for the 'Discourse on Aesthetics'

The eyes or eyebrows can be made one higher or lower than the other, or crooked.

Some who arc unskilled in drawing, if they follow my instruction and make a mess of it, will lay the blame on me for having described it badly.

But if in what has gone before I go on at length and in detail about my differentiations, no one is supposed to follow me to the letter. Others need to exercise restraint and go less far. For in this book my demonstrations have been emphatic so that others in smaller things should follow my thread better. But anyone who wants to embark on a large work, let him go along with me, carefully, so that it doesn't turn out too slavish.

And in your work these things should also be finished as impeccably and carefully as possible, and the merest wrinkles and spots not left out, as far as may be. For it is not on to do a quick job and dash a thing off and do no more than give an idea of it.

151.1  BL 5231, fols 106ʳ–108ᵛ. AD's autograph. Three leaves, each written on both sides. The text has very extensive interlinear and marginal emendations. Dated 1515–20 on the basis of the handwriting.

151.2  BL 5231, fol. 75ᵛ. AD's autograph. Half leaf, written on both sides. 75ʳ has a preliminary version of part of 151.1, while 75ᵛ has supplementary material for two passages in 151.1. See notes 4, 15.

R III, 281–9

NOTES

1  *ferkerer*: see text 103.7, note 1. The verb *verkehren* means 'turn (around), reverse', but AD's sense is more generally to do with altering, magnifying and reducing figures

2  *nit zw munckett*: see Rupprich I, 288. His note 1 follows the Bavarian dialect dictionary of Schmeller/Frommann (1872), similarly Götze, Glossar: 'bad-tempered hostile'. But the sense has to do with shape, not expression. DWb VI, 2695f. gives a second, parallel sense of the adjective *munk* as 'bloated, swollen, distended' and a Nuremberg occurrence (Hans Sachs) with that meaning.

3 *ferkerer, weler, zwiling, zeyger, felscher*: see Müller 1993. There does not appear to be a standard set of English terms. Conway 1889 did not attempt to translate any of the passages which name the devices. The translation of the first two books of the 1532 Latin edition of the *Human Proportion* in the Octavo CD-ROM edition (2003) also offers no English equivalents for Camerarius's Latin terms. An agreed terminology would be a desirable by-product of further research on AD's technical and aesthetic writings.

4 The passage 'Some who are unskilled…' to '…too slavish' in 151.2 is intended to be inserted here. 'Slavish' translates AD's *tirisch*, literally 'bestial'. See DWb XI, I, 1, 381f.: blind obedience to rules as a mark of animals and humans devoid of reason.

5 At the beginning of the fourth book, page O1r, AD lists sets of contrasting, opposed 'terms of difference', to characterise the possibilities of transforming, reversing and deforming the proportioned human figures of the first two books.

6 The terms *lind[iglich]* and *hart* are among the above contrasting 'terms of difference'. In this context they appear to characterise degrees of emphasis with which contrasts are marked in drawings or woodcuts. Outlines of a woodcut figure will be 'harder' than those of a drawing. The broader problematics of the terms are discussed in note 3 to text 103.7.

7 *in des menschen gemüt*: the semantic field of 'mind, intellect' is notoriously more complexly structured in German than in English. Modern German *Geist* has a rich polysemy extending into the irrational, 'spirit, ghost'. While Modern German *Gemüt* means primarily 'feeling, emotion', it needs to be translated here as 'mind', or possibly 'imagination'. Later in the draft discourse AD talks of the same idea as the 'secret treasure' which 'lies concealed in you…which you create as a form in your heart'. In both contexts the Latin edition of the *Four Books* by Joachim Camerarius (1534) has *mens* ('mind') and in the second also *animus* ('spirit'). The inner agency of ideas in medieval German can be variously *herze*, *sele* ('soul'), *muot* ('thoughts', 'mind', 'spirit', 'soul' – cognate with English 'mood'). The form *gemüete* was in origin a collective noun derived from *muot*, with the sense 'thoughts', 'feelings', then their supposed organ in the body, which could variously be identified as 'mind', 'heart', or 'soul'. AD very rarely chooses *gemüt* and there is no reason to think that he differentiated it clearly from *herze*. His usage is thus still essentially medieval. Contrary to Rupprich's reading (III, 288, note 11) of DWB IV, I, 2, 3298, the notion of the mind or heart as the receptacle of artistic images as well as intellectual ideas is traditional rather than an innovation of late medieval mysticism or Renaissance aesthetics.

8 This is a much less ambitious version of AD's statement of artistic creativity in 1512 (82.1, and note 10 there), where he identifies the 'new forms of humans and other beings' with Platonic ideas. The explicit analogy there between divine and human artistic creativity, the artist who is 'inwardly teeming with figures…a creativity in the image of God himself', is reduced here to power conferred by God on the artist. See Barasch 1998.

9 'Fantasy' translates AD's unusual word *trawm werg*, the product of (day)dream or nightmare, or of subjective fantasising. See DWb XI, I, 1, 1525. Rupprich (III, 288, note 16) connects AD's usage with Renaissance Italian *sogni dei pittori*, which conveys the artistic notion of the grotesque, inherited from Antiquity, which AD may have encountered in Vitruvius's *De architectura*, chapter 7, 5.3, on mural painting. The arbitrary mingling of elements of different creatures is one form of the grotesque. For a definition of *fantasia* in the context of Leonardo's work, see Kemp/Walker 1989, 312: 'the faculty that has the ability to recombine images or parts of images in new compounds'. Indeed Leonardo urges on the artist the deliberate juxtaposition of strong contrasts, the combination of ugly and beautiful, old and young, as in his own drawings of grotesque faces (Zöllner/Nathan II, 366 and catalogue 215–25). See Massing 2004b, 500–505. Summers 1981, 69, compares AD's passage with the statement attributed to Michelangelo in Francisco de Holanda's third Conversation on Painting: 'I am happy to explain why it is customary to paint what is never seen in the world and how reasonable and right such liberty is', citing as his authority Horace: 'Poets and painters have always had equal licence in daring invention…this liberty we claim for ourselves and give again to others' (*Ars Poetica* 9). On the obviously related Italian terms *fantasia* and *invenzione*, see Kemp 1977 and Ames-Lewis 2000, chapter 8.

10 These and the following sentences are first formulated in the short draft BL 5231, fol. 75r, R III, 281. In the published text of the Discourse, 'this statement' becomes *dise seltzame red*, 'strange-seeming' in that it contradicts the classical principle, to which AD had subscribed until around 1508, that the 'beauty' – the aesthetic value – of a work of art is contingent on the beauty of its subject. See 257.4, note 8.

11 The formulation seems almost to suggest that AD had been in Rome himself, but there is no reliable evidence of this (see 31.4). If he went to Venice via Carinthia in 1505, he may have seen the Roman statue of a naked youth excavated there in 1502, at the time the most significant monumental classical work yet found north of the Alps. In the published text of the Discourse, 'in the case of Rome' is rephrased as 'in Roman times'.

12 The theological reasoning is that God is truth (John 14:6) and 'the master of all beauty', who has 'ordered all things with measure, number and weight' (Wisdom of Solomon 11:21, 13:3). See also 103.2.

13 This sentence appears earlier in the fragmentary draft 103.6.

14 The relevant passages are, in the first book Evir–Fiv, and in the second book Niii$^v$–Niv$^v$. The alteration (*verkerung*) of the head is discussed at length earlier in the third book, Piii$^v$–Qv$^v$.

15 The passage in 151.2, from 'And in your work…' to the end, is intended to be inserted here.

16 See the earlier draft 103.3. AD's insistence on harmonious composition as a prerequisite of beauty in pictures concurs with Alberti II, 35–9, and Leonardo da Vinci

(Kemp/Walker 1989, 220–22). On the relationship between proportionality and overall harmony, ibid., 119f.

17  See the longest of AD's earlier drafts of the Discourse, 103.7.

18  *nacket*: not, as R III, 288 (note 33) suggests, used adverbially in the sense 'merely, only', for which I know of no warrant in early modern German. It means 'nude model' from which one can 'make an image'.

19  *zum ab machen*: 'as models to copy'. See the further discussion in note 29.

20  *zw linden lind, zw herten hert nacket*: see note 23. The implication is clearly that for all the types listed here, a nude model is to be copied.

21  *Es sind mencherley menschen ab zw machen*: see notes 19 and 29.

22  The paragraph reformulates the fragmentary draft BL 5231, fol. 75r. AD seems to suggest that he has studied numerous black models, some nude as his anatomical observations imply. There are certainly a number of black subjects in his preserved works, probably unusually many for the early sixteenth century in Germany. Most remarkable are the handsome, sensitive drawing of a male head and bust W 431, with the probably forged date 1508, and the portrait drawing of Katharina, the 'Moorish' servant of João Brandão in Antwerp (W 818). The black kings in the panel painting *Adoration of the Magi* (1504, A 82), and in the woodcuts of the Magi (SMS 170,12, S W 76 in the *Life of Mary*, circa 1500/1502, and SMS 225, S W 161, dated 1511), also give the impression of having been done from life. Striking too is the fact that the head of a black boy surmounts the fanciful woodcut coat of arms AD made for himself in 1523 (SMS 258, S W 198, based on the sketch W 941, S D 1523/1).

23  On the problematical concepts of 'hard' and 'soft', and on AD's use of the term *[ge]brech* (Modern German *Gepräge*), see the earlier draft 103.7 and note 3 there. The translation 'hard and coarse stamp' corresponds to AD's *hert vnd quallet brech*, where *quallet* seems to relate to the medieval and early modern German noun *qualle*, 'large, heavy, uncouth man' (Lexer II, 314, Baumann, 185; not in DWb VII). The translation 'slight, delicate image' renders AD's *subtiln vnd schwanglen bild*. On *subtil*, see DWb X, IV, 823–9 and Paul 2002, 984. For *schwangel*, medieval German *swankel*, see Lexer II, 1336 and DWb IX, 2250. AD's use of the adjective, held to have died out in the late Middle Ages, postdates any of the occurrences listed in these sources.

24  *Dan warhaftig steckt dÿ kunst jn der natur. Wer sy raws kan reissen, der hat sÿ*: this is the first version of one of the best-known and most quoted of AD's pronouncements on art. Certainly, it is one of those moments in his writing when his sometimes workaday German dramatically arrests the reader. The essential sense is clear enough. Nature is the source of art – here primarily in the sense of *ars/kunst* as 'knowledge of natural science' – which the artist must interiorise and recreate in an artefact. Odd is the use of *stecken*, which is cognate, and both as transitive and intransitive verb comparable in usage, connotations and collocations, with English 'stick' (see DWb X, II, 1, 1298–348). In what sense is art 'stuck in nature'? The translation 'implanted' attempts to accommodate the problem that, in German as in English, what is stuck in the ground is not

organically rooted, though firmly and fixedly there, so it needs to be 'drawn, or torn out', both of which English verbs can render *reissen*. Who 'stuck' (or 'implanted') art in nature? Indisputably, God – in which case 'stuck' seems stylistically a less happy choice. In his Latin translation of the *Four Books*, Joachim Camerarius has *in natura demersa est ars*. The primary sense of *demersa* is 'sunk', but it has the marginal meaning 'planted'. Both German *reissen* and English 'draw' share an altogether happier polysemy, meaning in a given context 'extract' and 'draw [a sketch or picture]'. Whereas *[heraus]reissen* can have the stronger sense 'tear, rip [out]', English 'draw [out]' is a less violent act. So AD's statement can be read as ambiguous: 'Whoever can draw art out of nature' may be taken as either or both 'extract' or/and 'make a drawing'. There is no way we can tell whether AD intended a punning double sense. Here Camerarius has *si extrahere potueris*, which plumps for the literal 'extract', but then it is impossible to reproduce the ambiguity in Latin. More tellingly, perhaps, in the earlier draft 103.2 (see there note 2), AD in a related, though not identical passage had used the verb *heraüs zihen* which is unambiguous and directly comparable with *extrahere*/extract. Simon Schama in *Landscape and Memory* (1995, 494) quotes an amusing Romantic-era echo of AD's formulation. In 1818 M.J.G. Ebel in his *Traveller's Guide through Switzerland* warns that the mountains so crawl with watercolourists that Alpine sketching is thought of by natives 'as a kind of larceny, *das Land abreissen*, the seizure of the mountains through their representation'.

25    A quite sophisticated point for the layman AD to make. Perhaps it owes something to the lawyers Scheurl or Pirckheimer. Specifically AD refers to *dÿ weltlichen recht* ('civil – as opposed to canon – law') and to *dÿ obinian der menschen* – the lawyers' *opiniones*, a technical term never borrowed into German and which AD evidently spells from hearing, not reading. The formulation is dropped in the published Discourse.

26    In the earlier draft 103.7, the point is better made: 'The more exactly a human image is made to conform with living nature, the better your work appears appropriate for any use to which you need to put it.'

27    The translation follows the errant track of this long sentence until it loses its way in the thickets of its own syntax. On the heart as the seat of the 'secret treasure' of artistic images, see note 7. The metaphor has a biblical ring: 'I [the Lord] will give thee the treasures of darkness and the hidden riches of secret places' (Isaiah 45:3).

28    AD's formulation, *dy new creatur, dÿ dw der gstalt halben jn deinem hertzen schobfstz*, implies a close analogy between God as Creator (in German *Schöpfer*) and the artist who fashions 'new creatures' (*creatur* is a loan-word in German from theological Latin and also evokes the context of divine creation). In this climactic passage, the restraint apparent in earlier sections of the text (see note 8) is relaxed again. AD's religious validation of artistic creation reflects his desire to synthesise the Antique and the Christian and anticipates his defence of religious art against iconoclastic attack in the early Reformation. See Barasch 1998.

29    *an ein gegen gesicht das er ab mach* ('without a model he can copy'); see, two sentences later, *an allen gegen würff etwas gutz zw machen* ('to make something good without

any model'). It is puzzling that AD should use two different words for 'model' in close succession, and both are odd coinings. In 83 (see there note 7) he had used the modest descriptive phrase *schön perschan for jm darnach er kunterfett* ('beautiful person in front of him whose likeness he copies') and earlier passages in this text refer straightforwardly to drawing posed models (notes 19 and 21). Here he seems impelled to find or contrive more technical terms. The second, *gegen würff*, occurs already circa 1507–9 in his list of geometrical/optical terms from Euclid (51.2.2). There it is a loan-translation of Latin *objectum*, in the specific sense of 'external object encountered by an optical ray'. By the early sixteenth century it is a well-established term in German, originally coined in late medieval translation of philosophical and mystical theological texts and supplanted during the eighteenth century by modern German *Gegenstand* (see DWb IV, I, 2, 2302–4, and text 51.2.2, note 8). Here, seemingly, AD wishes to express the notion of 'model' more abstractly in terms of '(visual) object to copy from'. The first term, *gegen gesicht* is apparently of AD's own coining. Certainly it is nowhere attested in early modern sources or in historical dictionaries. From the earliest German texts of the ninth century through to the sixteenth century, *gesicht* denotes both 'sight, view' and 'face, visage' (DWb IV, I, 2, 4087–96). Both senses may be operative: 'external object which presents itself to the sight' and 'face positioned in front of one'. If AD knew Italian *modello* from his time in Venice, then he clearly did not associate it with human models for portraiture. German *Modell* (with stress on the second syllable) appears in dictionaries from the seventeenth century, but only during the eighteenth does it acquire the sense 'human [nude] model for painters and sculptors'. Until then it had the same sense as the older noun *model* (with stress on the first syllable), which entered German from Latin circa 800, probably in the vocabulary of architects and stonemasons from Rome and Gaul, and denoted 'plan' or '[wood/clay] model of a building or carving'. In the sixteenth century *model/ modell* were words familiar to Nuremberg goldsmiths who imported lead or plaster models from Italy for their gold and silver figurines.

[DWb VI, 2438f. and 2439f.; Bonnet 2000, 2001, 25–9; Hinz 2011; Demele 2012, 71–107]

30   On the above, see also the draft 103.4.

31   The passage uses the formulation of the draft 103.5.

32   AD expands the similar statement in 103.7, which itself picks up a strand of reference found already in the earliest plans for the general handbook on painting. The innate character and the appearance of human beings is at least co-determined by the four elements of earth, air, fire and water, out of which according to ancient and medieval philosophy all substances are composed. The predominance of one element may make for 'a choleric or friendly or other kind of figure', and so 'all categories of person can be depicted in their external form, whether they are fiery, watery or earthy by nature'. The antique deities were conceived as embodiments of the range of elemental characteristics and humours, so that living human models for neo-classical depictions of Saturn, Mars and Venus are available to the artist.

**1520**

## 152 Albrecht Dürer's Catalogue of Works by Martin Luther

1  Conclusion on the Indulgence and what that is [*Resolutiones disputationum de indulgentiarum virtute*, Wittenberg 1518 (WA 1, 522–628) – or Kaspar Nützel's lost German translation of Luther's *Ninety-five Theses* (*Disputatio pro declaratione virtutis indulgentiarum* 1517)?]

2  A Sermon on Indulgence [*Eynn Sermon von dem Ablaß und gnade*, Wittenberg 1517—WA 1, 243–6]

3  A Sermon on Excommunication [*Ein Sermon von dem Bann*, Wittenberg 1520 – WA 6, 61–75]

4  Conclusion on God's Law [*Eine kurze Erklärung der zehn Gebote*, WA 1, 247–65, reprinted as *Die zehen Gebote Gottes mit einer kurzen Auslegung ihrer Erfüllung und Übertretung*, Nuremberg 1518]

5  Conclusion on Penance [*Sermo de poenitentia*, Wittenberg 1518 WA 1, 317–24]

6  A Sermon on Penance [*Ein Sermon von dem Sakrament der Buß*, Wittenberg 1519 – WA 2, 709–23]

7  A Sermon on three kinds of Sin and Justification [*Sermo de triplici justitia*, Wittenberg 1518 (WA 2, 41–7) – see also: *Sermo de duplici justitia* (WA 2, 143–52) and *Ein sehr gute Predig von zweierlei Gerechtigkeit*, Wittenberg 1520?]

8  An Instruction on Confession [*Ein kurz Unterweisung, wie man beichten soll*, Leipzig 1519 – WA 2, 57–65]

9  How you should prepare yourself for the Sacrament [*Ein gute trostliche Predig von der wirdigen Bereitung zu dem hochwirdigen Sakrament*, Augsburg 1518 – see WA 1, 325–34]

10  How you should contemplate the Sufferings of Christ [*Ein Sermon von der Betrachtung des heiligen Leidens Christi*, Wittenberg 1519 – WA 2, 131–42]

11  On the Estate of Matrimony [*Ein Sermon von dem ehlichen Stand*, Leipzig/Wittenberg 1519 – WA 2, 162–71]

12  A Justification of Certain Articles [*Ein Sermon gepredigt zu Leipzig ufm Schloß...mit Entschuldigung etzlicher Artikel, so ihm von etzlichen seiner Abgunstigen zugemessen sein*, Leipzig 1519 – WA 2, 241–9]

13  Interpretation of the Lord's Prayer [*Auslegung deutsch des Vaterunsers für die einfältigen Laien*, Leipzig 1519 – WA 2, 74–130, or earlier 1518 edition]

14  Interpretation of the Seven Psalms [*Die sieben Bußpsalmen mit deutscher Auslegung nach dem schriftlichen Sinne*, Wittenberg 1517 – WA 1, 154–220]

15   Interpretation of the 109th Psalm [*Auslegung des hundertundneunten Psalmen*, Augsburg 1518 – WA 1, 687–710]

16   The first proposition which Martinus disputed with Eck [*Disputatio et excusatio F. Martini Luther, adversus criminationes D. Johannis Eckii*, Wittenberg 1519, or *Resolutiones Lutherianae super propositionibus suis Lipsiae disputatis*, Wittenberg 1519 – WA 2, 388–435]

BL 5231, fol. 115ʳ. 115ᵛ has a draft for Book 4 of the treatise on Human Proportion (folio X5ᵛ).
  RI, 221

COMMENTARY

The list may date from 1520, the date of the latest items in it. AD bought further works by Luther in the Netherlands. His contemporary Matthias Grünewald (Mathis Neithart Gothart) possessed 27 of Luther's printed sermons, his New Testament translation, and other unnamed Lutheran pamphlets and broadsheets (see Strieder 1983, 23; Arndt/ Moeller 2002). On AD's book collecting in general: Eser 2008; Smith 2011, 15–17. On the vastly larger book collections of Leonardo da Vinci, Schneider 2002, 112–15, 162–70.

## 153   Letter of the Aldermen of the Nuremberg Council to Johannes Stabius

*11 January 1520*
Our willing service, most learned and respected dear Sir!

Your letter, sent to our council colleague Christoph Kress, with its request concerning the 200 gulden of our city tax now due, has received our consideration, and we acknowledge that, during the lifetime of His late Roman Imperial Majesty, our most gracious lord of highly estimable memory, we agreed to deliver said 200 gulden on receipt of His Imperial Majesty's quittance. Had on this occasion the same quittance been sent, we would not have failed to remit to you the relevant 200 gulden. Since however the death of His Imperial Majesty occurred before the sending of the quittance, our agreement has changed accordingly. Therefore, as you yourself will understand, we are not inclined, nor would it be appropriate for us, in these circumstances to tender you the 200 gulden, without the consent of His Roman Imperial Majesty, our most gracious lord, and without his own particular quittance. We ask you to attribute this to no other motive than to what the circumstances require. In what other way we may show you our ready service and good will, we shall gladly do so. Given on Wednesday after St Ehrhard, 11 January 1520.

Thomas Ulrich Schauerte, *Die Ehrenpforte für Kaiser Maximilian I.* Quelle 52, p. 422
  Not in R I or III

COMMENTARY

This is the first preserved evidence that Johannes Stabius had joined the ranks of imperial officials who were being paid out of the diverted resource of Nuremberg's city tax. The Council's caution about paying the money after the death of Maximilian I in January 1519 is entirely understandable. His successor Charles V was an unknown quantity in Germany, he had had no involvement in the cultural-ideological projects of his grandfather, and his confirmation of AD's *liferent*, let alone of the complex package put together in order to divert Nuremberg's taxes to the payment of Maximilian's debts to artists and courtiers, could not be taken for granted. The city accounts for 1520 (165.5–6) show that Stabius was paid his 200 gulden.

## 154 Letter of Albrecht Dürer to Georg Spalatin

*[Nuremberg, January/February 1520]*
To the honourable and most learned gentleman, Georg Spalatinus, chaplain to my gracious lord the Prince Elector Duke Frederick.

Highly esteemed dear Sir,

My thanks I have already expressed in the brief letter written when I had read only your little note. Thereafter, when the bag in which the booklet was wrapped was turned inside out, I found the proper letter in it, and learned that my gracious lord himself had sent me Luther's pamphlets.[1] Therefore I ask Your Honour to be so good as to convey my humble thanks in highest measure to His Grace the Prince Elector, and to beg His Grace in all humility that he deign to protect the praiseworthy Dr Martinus Luther, for the sake of Christian truth,[2] which is more to us than all wealth and power of this world, that utterly perish with time, whilst truth alone endures eternally. And if with God's help I should come to Dr Martinus Luther,[3] I will use my skill to sketch his portrait and engrave it in copperplate as a lasting memorial of this Christian man, who has rescued me out of deep anguish.[4] And I ask Your Honour, when Dr Martinus publishes something new in German, please to send it to me and I shall pay you.

Note: since you write to me about the pamphlet in defence of Martinus, I should tell you that it is all sold out. It is being reprinted in Augsburg, and when it's ready I will send you a copy.[5] But I can tell you that, although it was written here, this booklet has been condemned from the pulpits as a heresy that ought to be burned, and the preachers are denouncing the author, who published it anonymously. It is said too that Dr Eck wanted to burn it publicly in Ingolstadt,[6] as happened years ago to Dr Reuchlin's books.[7]

Note: herewith I am sending my gracious lord three prints of a copperplate portrait of my most gracious lord of Mainz, which I engraved at his request.

I sent His Grace the Prince Elector Albrecht the plate itself with 200 prints, as a gift, in recognition of which His Grace presented me with 200 fl. in gold and twenty ells of damask for a tunic.[8] I received this with joyful gratitude, and particularly at that time when I was in financial difficulty. It is true that His Imperial Majesty of blessed memory, who for me died too early, had of his grace provided for me in return for my substantial and protracted labours. But the 100 gulden, to be paid to me life-long out of the city's tax income, which I then received annually as long as His Imperial Majesty was alive, the Council is no longer willing to remit to me.[9] Thus I shall have to go short in my later years and I shall forfeit the fruits of my long and arduous service of His Majesty. For when my eyesight fades and my hand loses its dexterity, I shall not be well provided for.[10] This I have felt constrained to explain to you, my trusted, gracious sir.

May I ask Your Honour whether, if my gracious lord chooses to provide for the debt with antlers, you will lay claim to these for me, so that I can get hold of some fine branches. For I want to make two candelabra of them.[11] Further, I am enclosing two impressions of a crucifixion, they are engraved in gold, and one is for Your Honour.[12]

Assure Hirschfeld and Albrecht Waldner of my ready service.[13] In conclusion, Your Honour, commend me in loyalty to my gracious lord, the Prince Elector.

<div style="text-align: right">

Your servant Albrecht Dürer

of Nuremberg

</div>

The autograph is in Basel University Library, Mscr. G. I 32, fol. 41[r-v].

Rupprich I, 85–7

---

NOTES

1   It is not clear what Duke Frederick had sent. AD says he found a 'booklet' (*das püchlein*, singular), but he then refers to *dy püchlein Luteri*, plural, sent by 'my gracious lord'. In early modern German *büchlein* in the singular refers to a small book or volume, bound or unbound, but in the plural it can also denote the 'books' which form the component parts of a whole volume, which as a composite whole may itself be referred to as *die büchlein*. Thus AD's *Four Books of Human Proportion* (1528) is in four sections comprising one volume. If the 'little book' sent by Spalatin on Duke Frederick's behalf was bound, it is also possible that it contained a number of short pamphlets (binding pamphlets together in this way became particularly common in the Reformation), and for this too, *büchlein* in the plural would be the proper designation. For the most part, it was purchasers rather than printers or publishers who had books bound at this time and it is quite possible that the Duke did this as a compliment to AD. By 1520, Martin

Luther was turning out pamphlets in German in great number, and it is not possible to say which the Duke might have chosen. In the list of books he owned in 1520/21 (152), AD cites sixteen of Luther's publications, all of which appeared between 1518 and 1520.

2  *van kristlicher worheit wegen*: the phrase recurs in the variant form *umb der christlichen wahrheit willen* in AD's lament for the supposed death of Luther in the journal of his travels in the Netherlands, written on 17 May 1521 (162).

3  *Vnd hilft mir got, das jch zw doctor Martinus Luther kum*: as Hutchison (1990, 125) points out, the text does not imply that AD had never met Luther (see Conway's mistranslation, 'if ever I meet Dr Martin Luther' – 1889, 89), but rather, perhaps, that he is contemplating a journey to Wittenberg 'with the object of making a portrait engraving' (or, at least, a sketch for a portrait). Luther had been in Nuremberg twice in October 1518, on his way to and from the Augsburg diet, and AD could have met him in either place. Luther certainly met Spengler, Linck and Pirckheimer.

4  *der mir aws grossen engsten gehollfen hat*: a major theme of Luther's teaching in the vernacular during the first phase of the Reformation was that justification before God was possible only through faith and grace conferred by Christ, and that no good works done by man could ever themselves atone for sin. The fear that man was powerless to earn his own salvation may well be the crisis AD alludes to here. A main statement of Luther's theology for the layman was the treatise *On the Freedom of the Christian*, published in the autumn of 1520 and possibly among the pamphlets by Luther that AD bought in the Netherlands (162). For an overview of the aspects of the early Reformation referred to in AD's letter, see Cameron 1991, esp. 99–135, 179–81.

5  *dy schucz pücklein Martini* is the *Apologia and Christian Response of an Honest Lover of the Divine Truth of Holy Scripture to Sundry Contradictions, with Arguments as to why Dr Martin Luther's Teaching should not be Rejected, but rather Followed as Christian*, written and anonymously published in 1519 by AD's friend Lazarus Spengler. It provoked a refutation by the Franciscan satirist and anti-Lutheran polemicist Thomas Murner, *On Doctor Luther's Teachings and Sermons* (1520).

6  Johann Maier von Eck (BI), professor of theology at the university of Ingolstadt, was a leading Catholic apologist and critic of Luther. He planned to burn Spengler's *Apologia*, along with Luther's writings, in Ingolstadt at the beginning of 1520, but was dissuaded by Johannes Reuchlin. Luther himself burned Eck's works and the papal bull *Exsurge Domine*, which condemned him as a heretic, on 10 December 1520.

7  Johannes Reuchlin, pioneer of Hebrew philology in Germany (BI), had been attacked in 1509–10, for promoting anti-Christian theological opinions, by the converted Jew Johann Pfefferkorn and the Dominicans of Cologne, and his writings publicly burnt in Cologne and Paris in 1514.

8  This is the portrait engraving known as the 'Small Cardinal' (143.2.2) which AD made in 1519 on the basis of a drawing (W 568) done during the Imperial Diet at Augsburg in 1518. AD sketched Albrecht a second time in 1522/3 (W 896) for the engraving termed the 'Great Cardinal' (180).

9  See Commentary below, and texts 138, 153 and 165.

10  *Dan so mir ab get am gesicht vnd freiheit der hant, würd mein sach nit wolsten*: the sense is not, as Hutchison 1990, 127 translates it, 'as I am losing my sight...my affairs do not look well'. The conjunction *so* means 'if/when', and the verb *würd* is future tense. AD is not yet suffering from middle-aged presbyopia but fears its eventual onset. In the Netherlands in October and December 1520 he in fact twice bought spectacles.

11  AD's interest in antlers is well documented. See the watercolour drawing of an elk's head (W 369), and the drawings of antlers as chandeliers (W 708 and 709). The first of these two, an elk horn of thirty-four points, hung from 1522 in the chamber of the town hall in Nuremberg where the governing council met. It was designed by AD and probably carved by the sculptor Veit Stoss. See 168.7–8. Compare also Willibald Pirckheimer's letter to Johann Tschertte of 1530 (290).

12  This is the smallest known engraving by AD, done on a gold disc 37 mm in diameter (S E 92, SMS 90). Because the letters INRI on the Cross are not reversed, as they would be in order to be displayed correctly on a print, and the Virgin and St John are standing on the opposite sides of the Cross to that which is customary, it may well be that the engraving was not intended to be printed but was meant as a hat badge or for the pommel of a sword. The sketches W 602, S D 1519/19, may be the basis for the plate.

13  Bernhard von Hirschfeld, high chamberlain to Duke Frederick, was a correspondent of Anton Tucher, supplying him with Reformation publications. Albrecht Waldner is not identified.

COMMENTARY

The gift of a Reformation pamphlet for which AD thanks Duke Frederick and Spalatin in this letter, written six months before he set out on his year-long visit to the Netherlands, is an early token of his enthusiasm for the evangelical cause and evidence of the value placed on his support by Duke Frederick, a patron of his art since 1496, for whom, up to 1520, AD had painted a portrait and four altarpieces or panels. The central significance in AD's art of altar paintings inviting worshippers to regard the Virgin Mary and saints as intercessors with God meant that he had a similar theological adjustment to make after 1517, as did Duke Frederick himself, who had assembled in Wittenberg a vast collection of relics of saints which were venerated for the sanctity attributed to them and for the indulgence value they carried – the remission of time spent in purgatory after death.

AD's tribute to Luther's message of 'Christian truth' – what is meant is doubtless Luther's principle of *sola scriptura*, his insistence on the exclusive validity of the New Testament word – and his avowal that Luther has 'rescued me out of deep anguish' – a testimony to Luther's early theology of grace – anticipate the passionate words which

AD inserts into his Netherlands journal when he hears of Luther's abduction after the Diet of Worms in May 1521 (162). While he sketched Duke Frederick again for his engraved print of 1523, AD was not able to do the same for Martin Luther.

The immediate reason for AD's impending journey to the Netherlands was to re-establish his right to the liferent granted him by Emperor Maximilian. It may be that by bemoaning his plight in this letter he was hoping to gain support from Frederick the Wise, whose prestige in the empire can be measured by the fact that he had declined the offer by his fellow princes to elect him as King of the Germans in 1519. It may seem odd that he should cite the generosity of Cardinal Albrecht of Mainz as an example to Luther's patron. The proceeds of the sale of indulgences in Saxony in 1517, which were a catalyst for Luther's first public attack on traditional Catholic doctrine and practice, were meant to go in large part to Cardinal Albrecht. However, at this point in the early stages of Luther's protest against Rome, the final confessional divide between Catholics and Protestants still lay in the future. Indeed, Albrecht initially showed sympathy with humanist proponents of reform and even with some of Luther's early theological positions. At the very least, AD appears to have regarded the cardinal as a paragon of princely munificence.

AD's religious zeal, his financial concerns and his intimations of infirmity are all facets of his mentality with advancing years (fifty was seen as the threshold of old age in early modern times). They are also linked in the journal of his travels in the Netherlands and in several sources from the 1520s. He was anxious to secure his material position against the day when he could no longer practise his art, and he regarded the imperial liferent as crucial to this provision. While the juxtaposition of evangelical faith and financial calculation may seem incongruous to the modern reader, it was to prove justified when, a few years later, the rise of fanatical iconoclasm brought home to AD the inherently problematical impact of the Reformation on religious art and its practitioners in Germany.

[On Frederick the Wise: Angermeier 1984, 232; Ludolphy 1984; Borggrefe 2002; Silver 2004. On Albrecht of Mainz: Walter 1990; Jürgensmeier 1991; Lohse 1991. On AD and the early Reformation: Lutz 1968, 30f.; Seebaß 1971; McGrath 1986, 2–17; Reinhard 1991, 19; Price 2003, 225–8]

## 155  Letter of Lorenz Beheim to Willibald Pirckheimer

*[Bamberg, 4 March 1520]*
Greetings to your household, likewise Lady Kramer and the bearded Dürer.

PBr 4, 205f., Letter 673. Latin text
 R I, 265

## 156    Letter of Johann Cochlaeus to Willibald Pirckheimer

*[Frankfurt am Main, 5 April 1520]*
Please give my kind regards to Albrecht Dürer.[1] Yesterday our Burgomaster[2] saw his *St Jerome* and his *Melancholia* here in my house. We had much to say to one another about them. I am astonished however that his prints are so rarely to be found here, whereas Lukas the Dutchman's engravings were there in abundance at this year's trade-fair.[3]

PBr 4. Latin text
  R I, 265

NOTES

1    Cochlaeus was in 1520 dean of the chapter of the church of Our Lady in Frankfurt. He had accompanied Pirckheimer's three nephews to Italy in 1515–19.
2    Rupprich identifies him as Philipp Fürstenberger.
3    AD's wife Agnes is known to have sold his prints at the Frankfurt book fair in earlier years (29.1; Landau/Parshall 1994, 349). The 'St Jerome' is *St Jerome in his Study* of 1514 (S E 77, SMS 70). AD was soon to meet Lukas van Leiden in the Netherlands (162).

## 157    Letter of Lorenz Beheim to Willibald Pirckheimer

*[Bamberg, 18 April 1520]*
Greet for me your daughters and your sons-in-law, and Albrecht Dürer the bearded one.

PBr 4, 223f., Letter 684. Latin text
  R I, 265

## 158    Letter of the Aldermen of the Nuremberg Council to Lazarus Spengler

*[Nuremberg, 4 June 1520]*
Dear Spengler,
    You are to know that we are planning a fine impressive medal and intend to have dies of it engraved and struck.[1] A clean and usable design for it has been drawn up by Albrecht Dürer with the advice of Willibald Pirckheimer. However we need guidance and information on the following three points. Firstly, whether

in the enclosed print, at the top, where it is numbered 'nineteen', His Roman and Hispanic Majesty's name and coat of arms are placed and formed correctly and ordered in the right sequence, or whether one or more errors are apparent here?[2] Secondly, whether there is good reason for the two pillars, with a crown between them, together with the underlined inscription reading 'still further', and whether it is His Imperial Majesty's style and usage, that in paintings and such-like honouring of His Majesty, the pillars are done in this fashion and above them these words are placed, whether, that is, this is a motto commonly used at court and in His Majesty's Hispanic kingdoms?[3] Thirdly, how the Imperial Eagle is depicted now, namely, whether centrally on the eagle's breast only the arms of Austria and Burgundy are to be placed, or rather Austria on the one side and Spain on the other in small shields?[4] To find out all this reliably and in detail we consider it most fitting to do so in Augsburg and specifically from Johann Stabius,[5] and it is therefore our wish and command herewith that you should approach Stabius in this matter and ask for reliable information concerning these three points, yet be in all respects careful not to reveal to him in what you say, what our motive and intention is, but pretend it is for your personal use, to know how such kinds of architectural device or painting are carried out at the castle or on our town hall, for which reason you are getting this guidance from him or others, should Stabius not be in Augsburg. Please write this down clearly and then send it to us promptly along with the enclosed. Thereby you shall give us good cause to show you our gratitude.

Given under the seal of Hieronymus Holzschuher, Burgomaster, on Monday after Trinity, anno et cetera 1520.

Nuremberg, State Archive, Briefbuch LXXXI, fol. 137
  R I, 265f.

NOTES

1   The context and purpose of the commissioning of the cast silver medal is discussed in the commentary below.

2   The obverse of the medal has a crowned bust of the emperor in armour, facing to the right, wearing the chain of the Order of the Golden Fleece, with his title carolus : v : ro[manorum] : imper[ator] : . Around the edge are fourteen coats of arms of Charles V's Spanish domains, and at the top his device, the Pillars of Hercules. The reverse has the imperial two-headed eagle and the date 1521. Around the edge are thirteen coats of arms of Charles's Spanish possessions, and at the bottom a wreath enclosing the initial N of Nuremberg.

3   The Pillars of Hercules in antiquity marked the limits of the habitable world. These were the rocks of Calpe and Abyla (Gibraltar and Ceuta) at the entrance to the Mediterranean. Legend had it that they were bound together until Hercules tore them

apart. In allusion to the Pillars of Hercules, the Spanish royal motto was *Ne plus ultra* – 'Thus far and no further' – but after the discovery of America, and when Charles V inherited the crown of Aragon and Castile with all Spain's American possessions, he struck out *ne*, and made his motto *Plus ultra*, with the aspiration that Spain could go further in its universal power. On his device and on the medal, the pillars are linked by a ribbon bearing the revised motto.

4 On the medal, the eagle has the single escutcheon of Hapsburg and Burgundy centrally on its breast.

5 Johann Stabius was thoroughly well known to Pirckheimer and AD, from his role in the Triumphal Arch and others of Emperor Maximilian's projects and as expert on imperial heraldry and ideology (see particularly 97).

COMMENTARY

See Maué 1986: 'The Nuremberg city council intended to present the young emperor with as many as one hundred copies of this medal as a welcoming gift on the occasion of his first visit to the city. The Golden Bull of Charles IV (1356), which regulated the manner of electing the emperor, stipulated that every emperor was to convene his first Imperial Diet in Nuremberg. The coronation of Charles V took place in Aachen in 1520, and it was expected that an Imperial Diet would take place in Nuremberg in 1521. However, after a sudden outbreak of the plague, the emperor was forced to hold the Imperial Diet in Worms instead. Preparations for the gift had proceeded to the point that probably twenty-four medals had been struck, yet it remains unclear why these were never given to the emperor.

'With the large silver medal…the city hoped to demonstrate to the emperor Nuremberg's artistic and technical achievements. Albrecht Dürer provided the design, Willibald Pirckheimer advised him in heraldic matters, and Hans Kraft executed the final work…Technically, no other sixteenth-century medal of this size is comparable.'

[Mende 1983, 50–57; Maué 1986, 105–7, 325, & 1987, 227–44]

## 159 Letter of Sabina and Eufemia Pirckheimer[1] to Willibald Pirckheimer

*[Bergen, 10 June 1520]*
The chasuble is finished and we used it for the festive time.[2] It has beautiful embroideries of saints, the like of which we have not had until now, but we would like to find a place for them at our altars,[3] they don't have thread over their faces like trapped hares in nets.[4] If our wish could come true, we would dearly like you and Dürer to see them.[5]

You wrote to us recently about a couple of pieces of rusty armour. Thanks for being so obliging and offering them to us, but since we are so unaccustomed to riding, we can think of no other use for them than as pan scourers. We don't rest our souls on such hard beds. Even our nightgowns often seem a bit rough, such tender martyrs we are. Our sister abbess of St Clara has provided us at our request with hair shirts for when we need them. So keep your armour for your own use.[6]

PBr 4, 255f., Letter 696
  R I, 266

NOTES

1   Sabina (1481–1529) and Eufemia (circa 1483–1547) were Willibald's sisters, both Benedictine nuns in the nunnery of the Holy Cross at Bergen, near Neuburg on the Danube. Sabina became abbess in 1521 and Eufemia succeeded her in 1530.

2   Either Whitsun or Corpus Christi may be meant.

3   *ein stat vergünnen in unsern eltern*: or 'amongst our older [mass vestments]' (Reicke 1928, 376).

4   *hasengarn*: the allusion to 'hare-thread' is puzzling. Perhaps it is a joking tribute to the quality of the nuns' needlework which does not obscure figures with embroidery threads (Reicke, ibid.), which can also be termed *nätz/netz*, 'netting' (DWb VII, 638f.) as in Georg Wickram, *Rollwagenbüchlin* (1555), 16.

5   It seems most likely that AD had helped by sending drawings of saints.

6   The sisters' letters are full of humour and mockery of their distinguished brother. When the chasuble (the vestment in which the priest celebrates mass) arrives, they write (letter 665 of 30/31 January 1520) that it has obviously been made to fit (the corpulent) Willibald and they look forward to the priestly ordination of this notorious reprobate. His letter with its doubtless joking offer of old bits of armour is not preserved. Abbess Caritas of St Clara was their eldest sister (see 125).

[Lochner 1866, 528f., 530–32, 536f.]

# 160  Albrecht Dürer's Copy of Lazarus Spengler's *Ermahnung und Unterweisung*

In 1520 Lazarus Spengler published his *Ermahnung und Unterweisung zu einem tugendlichen Wandel* ('Admonition and Instruction How to Live a Virtuous Life'). See 62, his dedication to AD of the manuscript of the work, and the discussion there of the complex questions surrounding the writing and publication of the work.

Georg Wolfgang Panzer, Additions to *Annalen der älteren Deutschen Litteratur* (Leipzig 1802), p. 167, No. 971d, states:

'The copy in my possession lacks its title page, but has the following inscription in Dürer's own hand: Published by Lazarus Spengler Clerk to the Council and presented to me in the year 1520.'

[Hamm 1995, 6–55; Eser/Grebe 2008, 36f.]
  Rupprich I, 221 and III, 447

## 161  Payment of Albrecht and Agnes Dürer's Overnight Expenses by the Bamberg Court Treasury

*[Bamberg, 16 July 1520]*
Item 4 pounds 16 pence to the landlord of the Wild Man for the expenses and board of Albrecht Dürer, who stayed overnight here with his wife when he had been at Vierzehnheiligen, paid for on the order of My Gracious Lord as per invoice on Monday after the Dispersal of the Apostles.

Bamberg, State Archive No. 1742, fol. 155ʳ
  R III, 452

NOTE

The second night of the journey of AD and Agnes to the Netherlands (13 July) was spent at Bamberg, where they were entertained by the bishop, whose portrait AD had painted in October 1517 (112–13). AD does not mention in his journal that between Forchheim and Bamberg he and his wife visited the pilgrimage church of Vierzehnheiligen. The Fourteen Holy Helpers included St Christopher and were appropriate saints to invoke in prayers for a safe journey.

# Part 8

## 1520–1521

## 162 Albrecht Dürer's Account of his Travels in the Netherlands

From July 1520 to July 1521 AD spent almost exactly twelve months visiting the Netherlands. This is chronicled in AD's Journal, his largest single piece of writing. This section of the documentary biography also contains inscriptions written on topographical and portrait drawings done in the Netherlands, and documents relating to the renewal of AD's imperial liferent by Emperor Charles V at his coronation in Aachen (163–5).

### Introduction

On Thursday 12 July 1520 AD, his wife Agnes and her maid Susanna left Nuremberg for the Netherlands. One year later, on 15 July 1521, they arrived in Cologne to begin their river voyage home along the Rhine and Main. The motives for their long journey – there and back around 1,700 km – and their long absence were several. Most pressingly, AD needed to re-establish the payment of the annual pension or liferent granted him by Emperor Maximilian I in 1515, which was meant to be disbursed by the Nuremberg council out of the tax due by the city to the emperor. After the death of Maximilian in 1519, the city council had refused to pay further instalments of the 200 gulden authorised by the late emperor four months before his death (see 154). AD must from the start have geared his journey to the impending coronation of Maximilian's heir, his grandson Charles V. Clearly he was not inclined to rely on the Nuremberg delegation to the ceremony to press his case with the new emperor. Charles was crowned in Aachen on 23 October 1520, and AD received the written

confirmation of his pension, after 'great trouble and effort', in Cologne on 12 November. It was vital to him, not merely as recompense for the major commissions he had carried out for Maximilian, but also as provision for his old age.

While the most pressing business of the journey was quite rapidly concluded, AD did not consider returning home at that point. Other financial considerations run as a central thread through the rest of the Journal. AD took with him large quantities of his prints, which he used as gifts to hosts and well-wishers but also sold in great number. They and the portrait sketches he did of acquaintances and strangers served not merely to defray expenses but also, he hoped, to ensure a profit on the expedition. At the end of June 1521 he registers, with some bitterness, that overall he has lost out, in particular because Archduchess Margareta, regent of the Hapsburg Netherlands, has refused him patronage. Less tangibly, his energetic distribution of prints, and his production of formal and informal artworks during his stay, must have enhanced still further his already high reputation amongst the artists and connoisseurs of the Netherlands. They treated and celebrated him as a prestigious guest, he displayed his customary sociability, and he was able to see major artworks and architectural monuments. The journey came too late in his career to influence his professional development as an artist, although it cannot be ruled out that he may have been there before, during his journeyman years in the early 1490s, just as his father in the 1450s had 'spent a long time in the Netherlands learning from the great masters of his craft' (1). AD made a greater impact on Netherlandish artists than they did on him. But his visit brought him important new contacts among artists, men of letters and men of affairs; for him and – despite the much less public life she led – his wife, it will have meant welcome fresh stimulus after long years in Nuremberg, however much their native city itself had a metropolitan atmosphere. Given the securing of the imperial liferent, and with it his long-term economic position, and the intangible rewards of stimulus and prestige he garnered, AD's audit of his finances as he prepares to return to Nuremberg can sometimes seem pessimistic and even peevish.

The variety of motivations for the journey to the Netherlands is one reason why the generic character and the narrative structure and style of the Journal can disappoint a modern reader. I retain the established genre term 'Journal' (based on German *Tagebuch*, commonly translated also as 'Diary') in the commentary to this translation of the text, but it will be immediately apparent to the reader that this is not a personal diary in any now current sense. AD rarely dates his entries precisely, and the recording of activities, encounters and impressions is closely geared to financial record-keeping. What he keeps is in the nature of a running account book, into which he inserts other, more personal notes on the people he meets and on his professional activities and transactions, and the impressions that places, buildings and artworks make on him as a knowledgeable, cultured tourist. A more apposite title, which I use as the heading to the text, is 'Account', which has the double meaning of descriptive narration and financial record. The ambiguity of the English word is not achievable in German.

'Account' combines the separate senses of German (*Reise-*)*Bericht* and *Rechnungsbuch* (on this and for the following, see Sahm 2002, 133–7). Comparable contemporary travel accounts with this combination of income-and-expenditure record and travelogue are not found in Nuremberg before 1520. Account books of Nuremberg mercantile families are concerned with domestic housekeeping rather than the economics of travel. Nuremberg travellers who kept and then published accounts of places visited, hospitality and expenditure, were the half-dozen members of the patrician class who went on and wrote about pilgrimages in the second half of the fifteenth century. This popular genre of the time had a different character and intention. It was published in book form, reworking notes made during the journey, which itself followed prescribed itineraries, and it was designed as a guide to future pilgrims and as edifying reading for those who could not aspire to reach Rome or Compostela, let alone Jerusalem. The only example of a travelogue which reproduces a text in the form compiled during the journey itself is Sebald Örtel's account of his travels to Compostela in 1521–2.

The overriding priority of assuring his pension partly explains why AD confined his travels essentially to the Hapsburg territories and the imperial centres of Cologne and Aachen. But once that was achieved, his cultural and artistic interests come more fully to the fore. His choice of Antwerp as his main base has to do with the status of the city as the premier European market place of the first half of the sixteenth century which attracted merchants not just from England, the Netherlands and the Hanseatic towns but from South Germany – Nuremberg in particular – Italy, Spain and Portugal. AD's social contacts, patrons and clients, and his avid collecting of exotic gifts and purchases (see Smith 2011, 18–31), reflect this international character of Antwerp quite precisely.

For all that the Journal, to the modern reader, may too much resemble a petty cash ledger, and often conveys a rather money-grubbing side to AD's character, it is a unique source of copiously detailed information on the economics of the artist's life and on the monetary arrangements of the time. It should be read with the assistance of the introductory notes on Money, Coinage and Currency, and with reference to the Biographical Index, for it drops names every bit as assiduously as it counts pennies. All in all, the Journal is unique as the documentation of a year in the life of a great Renaissance artist. That said, what AD has to say about the artists he meets and the artworks and buildings he sees can be disappointing in its blandness and its reliance on a narrow range of descriptive epithets, deficient in critical-analytical penetration or a sense of their personal impact on him. Finding 'words for pictures' is to quite some extent an inherent problem of art-historical discourse: 'The difficulty is that it is at any time eccentric to set down on paper a verbal response to the complex non-verbal stimulations paintings are designed to provide' (Baxandall 1988, 24f. and 2003). In the Renaissance, the shortcoming is not (for once) to be blamed on the inadequacies of the German vernacular (Baxandall 1971, 7, 45ff. and 1980, chapter 6). Contemporary humanists found in the sections on painting in the elder Pliny's *Natural History* a

comparably bland Latin vocabulary drawn from non-pictorial, usually literary contexts. Quattrocento Italian writers often limit themselves to saying that a work is 'good' or 'skilful', though some, like Cristoforo Landino, push beyond these limits (Baxandall 1988, 117–53). Did AD *talk* to fellow painters more eloquently than he could write about the paintings they stood in front of and reacted to? As it is, his repeated use of words such as *künstlich* or *wercklich* ('expert', 'workmanlike') seem to privilege the technical over the aesthetic, while *köstlich* ('costly', only in later usage 'delightful'), in the context of what is so much an account-book, seems to commodify art, although it may also be meant to impute to it intellectual, aesthetic and moral as well as commercial value (Baxandall 1980, 92f.; see also Wood 1988, 41–3).

AD is capable, however, of giving quite vivid verbal pictures of townscapes and street festivals. At a few points he gives us sharp impressions of personal experiences, like his close encounter with shipwreck in Zeeland. All such are eclipsed by his dramatic emotional outburst at hearing the news of Martin Luther's supposed abduction, even death as seemed possible, on 4 May 1521 as he returned from Worms to Saxony. So suddenly does the commonplace prose of the journal take flight that this has been impugned as a pious forgery. Yet both earlier manuscripts have it, and it is convincing as well as astounding, as the climax of a strand of accumulating interest in and commitment to the cause of religious reform, running through AD's and others' letters since at least 1517, as well as through the Journal itself.

Rebarbative in tone and concern though the Journal may on occasion seem to the reader less interested in mining its ultimately rich veins of detail, it has to be acknowledged for its unparalleled depiction of a red-letter year in the life of the artist. It should be seen also in its relationship to the artworks which came out of the year's travels, the book of silverpoint drawings and the book of pen or brush drawings which, so to speak, provide illustrations for the Journal (163). Though not all survive, and those that do are often difficult to attribute, AD also produced a host of portrait sketches and some fifteen paintings. Not a single letter written from the Netherlands has survived to complement the professional perspectives of the Journal with the human insights AD provided in his letters from Italy (29). Equally, we may regret that such records as the *schreib püchle*, the lost notebook he kept in Venice in 1506, were not written up like the Netherlands Journal. Frustrating though these gaps in our knowledge are, the documentations of AD's travels remain unique in the context of the early Renaissance.

[Baxandall 1980, 143–60 & 1988, 117–51; Howarth 1985, 154 & 202; Anzelewsky 1988b; Hutchison 1990, chapters 13–16; Landau/Parshall 1994, 351–7; Jardine 1996, 99–101; Eichberger 1998 & 2010; Sahm 2002, chapter 6; Schmid 2003, 471–84; Ex. Cat. Vienna 2003, 486f.; Harreld 2004; Massing 2007a; Unverfehrt 2007; Nash 2008; Fierks 2010]

## Chronology and Summary of the Journal

*12–25 July 1520:*
Departure from Nuremberg, visit to the pilgrimage shrine of Vierzehnheiligen. Entertained by Bishop Georg of Bamberg and given a pass requesting waiving of customs tolls. Travel by river Main to Frankfurt, Mainz and Coblenz, then by river Rhine to Cologne. Visits nephew Nikolaus Unger.

*28 July–2 August 1520:*
Travel by rivers Rhine, Maas and overland to Antwerp.

*2–25 August 1520:*
First stay in Antwerp. Takes lodgings with Jobst Planckfelt. Entertained by the guild of painters. Contacts with Quentin Massys, Erasmus, Peter Gilles, Nikolaus Kratzer, Joachim Patinir, João Brandão, Felix Hungersberg, Tommaso Bombelli, Rodrigo d'Almada, Konrad Meit. Visits the burgomaster's house, the cathedral and the abbey of St Michael. Watches the pageant on the feast of the Ascension of the Virgin.

*26 August–2 September 1520:*
Visits Mechelen. In Brussels, meets the Nuremberg delegation to the coronation of Charles V. Contacts with Jakob Banisius, Margrave Johann of Brandenburg. Sees works by Rogier van der Weyden and Hugo van der Goes. In the royal palace sees treasures of Montezuma. Meets Bernaert van Orley. Receives a letter from Archduchess Margareta of Austria.

*3 September–3 October 1520:*
Second stay in Antwerp. Contacts with Wilhelm and Wolfgang von Rogendorf, Frederick II Count Palatine, Marc de Glasere, Dirk Vellert, Jakob of Lübeck, Hennen Doghens, Jan Provost. Watches Charles V's triumphal entry into Antwerp. Thomas of Bologna brings AD news of Raphael's death. Contacts with Niklas Ziegler, Adrian Herbouts.

*4 October–21 November 1520:*
At Aachen: visits Charlemagne's chapel, the state chamber of the town hall and the cathedral treasury. Attends the coronation of Charles V. In Cologne: sees Charles V's royal ball and banquet. Buys Lutheran pamphlets. Sees altar panel of *The Annunciation* by 'Master Stephan' (Lochner?). Visits church of St Ursula. Charles V issues his confirmation of AD's imperial liferent. Returns via Düsseldorf, Nijmegen and 's-Hertogenbosch to Antwerp.

*22 November–3 December 1520:*
Third stay in Antwerp. Hears of a stranded whale in Zeeland and resolves to travel there.

*3–14 December 1520:*
At Bergen op Zoom visits the marquis's palace. Sails for Zeeland with Sebastian Imhoff. At Arnemuiden a storm drives the ship from its mooring and it almost founders. At Middelburg abbey sees Jan Gossaert's altar of *The Deposition*. At Zierik finds the whale has been carried out to sea by the storm. Returns via Bergen to Antwerp.

*14 December 1520–6 April 1521:*
Fourth stay in Antwerp. Entertained to a festive carnival dinner by the Antwerp gold-smiths. Contacts with Florent Nepotis and Jean Mone. Ascends the tower of the church of Our Lady. Begins to pack and send baggage to Nuremberg. Completes oil painting of *St Jerome* for Rodrigo d'Almada. Contact with Cornelius Graphaeus. Buys gifts for friends in Nuremberg.

*6–11 April 1521:*
Visits Bruges: lodges with Jan Provost. Mark de Glasere organises a festive dinner with goldsmiths and painters. Sees the Prinsenhof and paintings by Rogier van der Weyden and Hugo van der Goes. Sees Michelangelo's Madonna in the church of Our Lady, and works by Jan van Eyck and/or Hans Memling. Visits Ghent: greeted by the guild of painters. Sees church of St John (now cathedral of St Bavo) and altar of the *Adoration of the Lamb*. Sightseeing in the city.

*11 April–5 June 1521:*
Fifth stay in Antwerp. Illness, attributed to fever contracted in Zeeland. Continues to pack and send baggage to Nuremberg. Attends Joachim Patinir's wedding. At Ascensiontide Dirik Vellert organises banquet in AD's honour. Does oil paintings of Lorenz Sterk and Jobst Planckfelt.
Lament for Martin Luther: hears of Luther's abduction on his return journey from the imperial diet at Worms and fears he may have been killed. Tribute to Luther as religious reformer and appeal to Erasmus to take up his mission.
Contact with John Abarrow and Gerhard Horenhout. Watches the Circumcision and Corpus Christi processions in Antwerp.

*6–7 June 1521:*
In Mechelen. Lodges with Hendrik Keldermans. Entertained by Johann Poppenruyter. Audience with Archduchess Margareta, sees her treasures and artworks.

*8 June–3 July 1521:*
Sixth stay in Antwerp. Contact with the Augustinian friars. Guest of Lucas van Leiden. Meets Aert van Ort. Given Luther's *Babylonian Captivity*. Final preparations for return journey. King Christian II of Denmark arrives in Antwerp and summons AD to sketch him and paint his portrait. Leaves Antwerp.

*3–11 July 1521:*

In Brussels. Presents King Christian with collection of his prints. Sees Charles V receive the king outside the city. Present at Christian II's state banquet for Charles V. Finishes and presents Christian's portrait.

*12 July 1521:*

AD, Agnes and Susanna leave on their return journey to Nuremberg, reaching Cologne on 15 July.

# Journal, 1520–1521

These are the journeys which Albrecht Dürer made in the Netherlands, together with his wife, during which he received great honour and gracious good will from Emperor, King and Princes alike, as herein may be seen and heard.[1]

## From Nuremberg to Frankfurt, 12–20 July 1520

On the Thursday after St Kilian's Day [12.7.1520] I, Albrecht Dürer, at my own cost and expense, set out with my wife from Nuremberg towards the Netherlands. And when that same day we had passed through Erlangen, we took lodgings for the night at Baiersdorf and spent on that 3 pounds less 6 pence.[2] Then on the next day, Friday, we came to Forchheim and paid 22 pence for escort. From there I went to Bamberg and presented the Bishop with a painting of the Virgin, the *Life of Our Lady*, the *Apocalypse*, and engravings worth one gulden.[3] He invited me to dine, gave me a letter of exemption from tolls and three letters of introduction, and took over my lodging expenses amounting to around one gulden.[4] Item: I paid the ferryman 6 gulden in gold to carry me from Bamberg to Frankfurt. Item: Master Lukas Benedict and Hans, the painters, stood me wine in welcome.[5] 4 pence for bread, 13 pence more as tips. So I sailed from Bamberg to Eltmann where I showed my pass and they let me go free of tolls. From there we went past Zeil. On the way I had spent 21 pence. Next I came to Hassfurth and showed my toll letter and they let me pass here too. I paid 1 gulden to the Bishop of Bamberg's chancery. Next I came to the Monastery at Theres and presented my letter, and they let me pass. Then we reached Rein, where I slept the night and paid £1 for it. From there we set off towards Mainberg, where I showed my toll pass and they let me go free. When we came to Schweinfurt, Dr Rebart[6] invited me in and gave me wine for the voyage. There too I was let go free of tolls. 10 pence for a roast chicken. 18 pence for the kitchen and the young one. Then we

travelled to Volkach, I showed my pass and we went on our way again, reaching Schwarzach, where we spent the night and got through 22 pence.

On Monday [16.7.1520] we were up early, sailed past Dettelbach and came to Kitzingen; I showed my pass and they let me through, and I spent 37 pence. And we went on past Sulzfeld to Marktbreit, where I showed my toll-pass and they let me proceed. And past Frickenhausen we got to Ochsenfurt, where I showed my pass and they let me go on. We came to Eibelstadt, then to Heidingsfeld, and then to Würzburg. Again I showed my toll pass and we were let through. Next we reached Erlabrunn where we tied up for the night and it cost 22 pence. From there we passed Retzbach and Zellingen and reached Karlstadt, where I showed my pass and was allowed through. Reaching Gemünden, we lunched and spent 22 pence; here too I showed my pass and was let through. Next we came to Hofstetten, I showed my pass and they let me through, the same at Lohr and Neustadt. I also spent 10 pence on wine and crayfish. Thereafter we reached Rothenfels; I showed my pass and was let through free, and there we moored for the night, and spent 20 pence.

Early on Wednesday [18.7.1520] we set off past St Eucharius, came to Heidenfeld, and from there to Triefenstein. Then we reached Homburg where I showed my pass and we were let through, as also next at Wertheim. There I spent 57 pence. We sailed on to Prozelten, where I showed my pass and was let through, and past Freudenberg, where again my letter gave us free passage. Then we reached Miltenberg, where we spent the night and spent...Here too I presented my pass and was allowed to travel on, and I spent 61 pence. At Klingenberg too I showed my pass and was given free passage. We came to Wörth, from there passed Obernburg, then reached Aschaffenburg, where I showed my pass and we were let through toll-free, and I spent 52 pence. Next we sailed to Seligenstadt[7] and on to Steinheim, where I showed my pass and was allowed through. And we tied up for the night at Johansen's; he opened the town gate for us and gave us a very friendly reception, I spent 16 pence.

So we set off early on Friday [20.7.1520] and were let through the toll at Kesselstatt. Then we came to Frankfurt and there too I showed my pass and was allowed through. I spent 6 silver pence and 1½ hellers, and I gave the lads 2 silver pence, and overnight cost me 6 silver pence. Herr Jakob Heller sent wine to my lodgings.[8]

## From Frankfurt to Antwerp, 22 July–2 August 1520

I arranged to be conveyed with my baggage from Frankfurt to Mainz for 1 gulden and 2 silver pence. In addition I gave the boy 5 Frankfurt hellers, and

overnight accommodation cost us 8 silver pence. I went by the early boat on Sunday [22.7.1520] from Frankfurt to Mainz, reaching the halfway point at Höchst, where I showed my toll pass and was allowed through. There we spent 8 Frankfurt pence. From there we set out for Mainz. It cost me a further silver penny for unloading. Plus 14 Frankfurt hellers for the crewman. Plus 18 pence for girths.⁹ Plus I booked myself onto the ship to Cologne, myself and baggage, for 3 gulden. In Mainz I spent 17 silver pence on subsistence. Item: Peter, the goldsmith and warden of their guild, presented me with two bottles of wine.¹⁰ Veit Varnbühler invited me to be his guest, but his host would take no payment from him, insisting I should be his own guest.¹¹ And they did me much honour.

And so I left Mainz, where the Main flows into the Rhine, on the Monday after Mary Magdalene [23.7.1520]. For meat taken aboard I paid 10 hellers, and for eggs and pears 9 hellers. Leonhard the goldsmith¹² gave me wine aboard and poultry to be cooked en route to Cologne. And Master Jobst's brother gifted me a bottle of wine.¹³ The two painters gave me two more bottles for the voyage. Next we came to Eltville, where I showed my pass and they levied no toll. Next we came to Rüdesheim. It cost me another 2 silver pence for loading my cargo. Next we reached Ehrenfels. There I showed my toll pass but had to pay 2 gold gulden, with the proviso however that, if within two months I produced a dispensation, the customs officer would return my money.¹⁴ Thereafter we came to Bacharach, where I had to undertake to pay toll within two months or produce a dispensation. Next we reached Kaub, and there I once more showed my pass, but it would no longer serve, and I had to give the same undertaking as above. I spent 11 hellers there. Thereafter we came to St Goar and I showed my letter; the customs officer asked me how I had been treated before. So I replied that I would pay him no money. I gave the courier 2 silver pence. Then when we came to Boppard, and I presented my toll pass at the Trier customs post, I was allowed to proceed. However I had to confirm in writing, signed and sealed, that I was not conveying ordinary merchandise, and then he was happy to let me pass. When next we reached Lahnstein, and I showed my letter, the customs officer let me go free, but requested me to commend him to my gracious lord, the Archbishop of Mainz. He also gave me the gift of a can of wine, for he knew my wife well and was very pleased to see me.¹⁵ Then reaching Engers, which belongs to Trier, I produced my letter and was let through without charge. I said again that I would report it favourably to my Lord Bishop of Bamberg. Coming next to Andernach, I showed my pass and they let me through free. And I spent 7 hellers plus 4 more on subsistence.

Early on St James's Day [25.7.1520] I sailed from Andernach to Linz, and from there on to the customs station at Bonn, where again I passed freely.

From there we went on to Cologne. On the ship I spent 9 plus 1 silver pence and 4 more pence for fruit. In Cologne I paid 7 silver pence for unloading, and 14 hellers to the ship's crewmen. To my cousin Nikolaus I gifted my black fur-lined coat with velvet trimming, and to his wife I gave a gulden.[16] Item: at Cologne Hieronymus Fugger gave me wine, as also did Jan Chroserpeck and my cousin Nikolaus.[17] Moreover I was given refreshment[18] in the Franciscan Friary and one of the monks gave me a handkerchief.[19] Master Johann Großerpecker[20] gave me 12 measures of the finest wine. I paid 2 silver pence plus 8 hellers into the kitty.[21] Beyond that I spent on subsistence in Cologne 2 gulden plus 14 silver pence, and 10 silver pence to strap the baggage;[22] 3 pence for fruit. Further I paid 1 silver penny as a gratuity on departure and 1 silver penny to the couriers.

Then on St Pantaleon's Day [28.7.1520] we travelled from Cologne to a village called Büsdorf, where we stayed for the night and paid 3 silver pence for it. Early on Sunday [29.7.1520] we went on to Rödingen, where we breakfasted for 2 silver pence and 3 pence, plus 3 pence more. From there we came to Aldenhoven, where we lodged the night at a cost of 3 silver pence. Then on Monday morning [30.7.1520] we travelled towards Frelenberg, passed the little town of Gangelt and ate our morning meal at a village called Süsterseel, which cost 2 silver pence, 4 hellers, plus 1 silver penny and 2 more besides. From there we went to Sittard, a fine little town, and on to Stockem, which belongs to Liège. There we found a pleasant hostelry, stayed the night there and paid 4 silver pence.

After we had crossed the Maas, we set off early on Tuesday morning [31.7.1520] and reached Mertenslinden,[23] where we had breakfast, spending 2 stuivers and paying 1 silver penny for a chicken. From there we travelled on across heathland to reach the Stosser where we paid 2 stuivers to spend the night. On Wednesday morning [1.8.1520] we travelled to West-Meerbeck, where I bought bread and wine for 3 stuivers, went on to Verbrande Molen and lunched there for 1 stuiver. Then we travelled as far as Heist-den-Berg, where we stayed the night and paid 3 stuivers 2 pence for it. Early on Thursday [2.8.1520] we went on to Op ten Kruys and ate breakfast there for 2 stuivers.

## At Antwerp, 2–26 August 1520 [fig. 49]

From there we reached Antwerp. I took lodgings with Jobst Planckfelt,[24] and that same evening Bernhard Stecher, factor to the Fuggers,[25] invited me to an excellent meal, though my wife ate in the hostelry. I paid the carter 3 gold gulden for conveying the three of us, and for carrying the baggage I

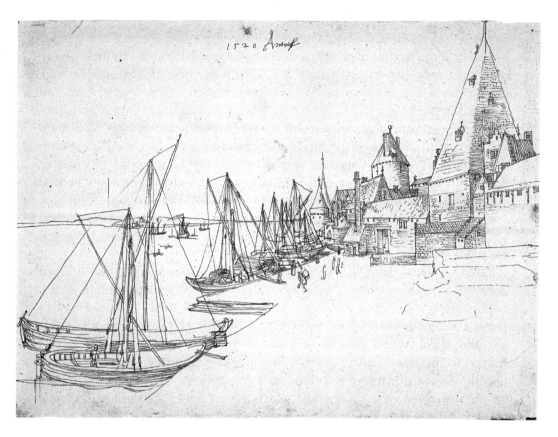

49. Albrecht Dürer, *The Harbour at Antwerp*, pen drawing, 1520. Vienna: Albertina 3165

paid Staber...[26] Note: on the Saturday after St Peter in Chains [4.8.1520] my landlord took me to see the house of the Burgomaster of Antwerp,[27] newly built, exceedingly large and very well appointed, with extraordinarily beautiful and spacious rooms, and many of them, a splendidly decorated tower, and a very extensive garden, all told a noble house, the like of which I have never seen in all the German lands. And to oblige the mayor, and also at his expense, they have constructed a completely new street, very long, and both ends of it lead you to the house. Item: I paid the courier 3 stuivers, 2 pence for bread, 2 pence for ink.

And on Sunday, it was St Oswald's Day [5.8.1520], the painters invited me to their hall[28] with my wife and the maid, and had set it all out with silver cutlery and other precious tableware, and splendid food. All their wives were there too. And as I was conducted to the table, the company rose to their feet

and lined the way, as if some great lord was entering. There were present most eminent and renowned persons who bowed deeply and showed me humble deference. They vowed they would do everything, whatever lay in their power, once they knew my pleasure. And as I was sitting there amidst such honour, there entered the Syndicus of the Antwerp Council[29] with two servants and presented to me four cans of wine with the compliments of the City Councillors, who bade me know that this gift was in my honour and a mark of their good will. I returned them humble thanks and pledged my humble service. Thereupon came Master Peter, the City Carpenter,[30] who presented me with two cans of wine, in token of his willing service. When we had spent a long and convivial evening together lasting late into the night, they did us the honour of lighting our way home with lanterns, bidding me accept the assurance of their good will and their ever-ready help in whatsoever I wished to do. For that I thanked them and went to my bed.

What is more, I have been in Master Quentin's house.[31] I have also been to their three shooting-ranges. I have eaten an excellent meal with Staiber,[32] then on another occasion with the Portuguese factor and I did a portrait of him in charcoal.[33] My landlord I have also drawn a likeness of, that is Jobst Planckfelt, he gave me a branch of white coral.[34] Paid two stuivers for butter. Paid 2 stuivers to the joiners in the painters' warehouse.[35] Note: my landlord took me into the Antwerp painters' workshop, in the warehouse where they are setting up the triumphal entrance through which King Charles is to process.[36] It is 4 hundred arches long, each one spanning 40 feet, and they will be built up on both sides of the street, elegantly ordered, two storeys high, and on top of them they will put on their plays.[37] For joiners and painters to make this will cost 4000 gulden, and on top of that it will all be fully decked out and the whole thing done with utmost expense.

Item: I dined again with the Portuguese and once with Alexander Imhoff.[38] Item: Sebald Fischer bought from me at Antwerp sixteen *Small Passions* for 4 gulden. Plus thirty-two large books for 8 gulden. Plus six *Engraved Passions* for 3 gulden. Plus three sets of twenty half-sheets of all kinds mixed together for 1 gulden per set, total 3 gulden. Plus quarter-sheets, each at forty-five per 1 gulden, 5¼ gulden worth. Whole-sheets of all kinds, at eight sheets for 1 gulden, 5¼ gulden worth. Paid for.[39] Item: I gave my landlord a Madonna painted on a small canvas[40] for him to sell for 2 Rhenish gulden. Item: I made a second portrait of Felix the lutenist.[41] 1 stuiver for pears and bread. 2 stuivers to the barber. Further I paid 14 stuivers for three small panels, plus 4 stuivers for white ground for preparing them. I also ate once with Alexander the goldsmith,[42] plus once with Felix. Master Joachim[43] ate once with me and his apprentice

once too. For the painters I did a sketch design with colour washes.[44] I took 1 gulden for expenses. I made Peter Wolfgang a present of the four new little engravings.[45] Further Master Joachim's apprentice ate with me again. I gave Master Joachim 1 gulden worth of prints for lending me his apprentice and colours and made his apprentice a gift of prints worth £3.[46] Item: to Alexander the goldsmith I sent the four new prints. I did a charcoal drawing of these Genoese, called Tomasin Florianus Romanus, a native of Lucca, and his two brothers, named Vincentio and Gherardo, all three surnamed Bombelli.[47] I have dined with Tomasin as often as this: iiiiiiiiiiii.[48] The Treasurer[49] gave me a child's head painted on canvas, plus a wooden shield from Calicut and one of those hollow wooden tubes.[50] Also Tomasin gave me a hat made of plaited alder bast.[51] Again I ate with the Portuguese. Also I gave one of Tomasin's brothers engravings to the value of 3 gulden. The honourable Erasmus presented me with a small Spanish coat and three portraits of men.[52] Further Tomasin's brother gave me a pair of gloves in return for engravings worth 3 gulden. I did a second portrait of Tomasin's brother Vincentio. Also I gave Master Agostino the Lombard the pair of *Imagines*.[53] Further I painted the Italian with the crooked nose who's called Opitius.[54] Item: my wife and maid ate for one day in Tomasin's house, which makes four meals.

Item: the Church of Our Lady at Antwerp[55] is vast, so that many masses can be sung there simultaneously without one disturbing another. And there are lavishly endowed altars where the best musicians available are employed. The church has many devout services and fine stonework, especially a handsome tower. I have also been in the rich Abbey of St Michael where they have the most splendid triforium gallery chapel[56] with traceried stone arcades, the like of which I never saw, and costly choir-stalls. At Antwerp they spare no expense in such things for they have money in abundance.

I have done a portrait of the honourable Nikolaus, an astronomer who is resident with the King of England, and has been most informative and useful to me in many ways. He is a German, born in Munich.[57] And I have done a likeness of Tomasin's daughter, who is called Miss Sute.[58] Item: In return for my charcoal portrait of him, Hans Pfaffrot[59] has given me a St Philip gulden. I ate again once with Tomasin, and once my landlord's brother-in-law invited me and my wife too. Also I exchanged 2 light gulden[60] for 24 stuivers, for living costs. Plus I gave 1 stuiver tip for letting me see a panel painting.[61]

Item: on the Sunday after the Assumption of our dear Lady [19.8.1520], I saw the great procession from the Church of Our Lady in Antwerp, when the entire city foregathered, all trades and estates, each most richly dressed according to their status.[62] Each rank and guild had its badge by which they could be

recognised. In the gaps between each contingent huge candles were borne on poles along with their old-fashioned long silver trumpets. There were also in German style many pipers and drummers. All these were blown loudly and thunderously beaten. In the street I watched those processing in two straight lines, at a wide distance from one another, but in close succession: the gold-smiths, the painters, the stonemasons, the silk-embroiderers, the sculptors, the cabinetmakers, the joiners, the carpenters, the sailors, the fishmongers, the butchers, the tanners, clothmakers, bakers, tailors, cobblers and all the kinds of craftsmen, and many workmen and dealers, who serve in the food trades. Likewise there were shopkeepers and merchants, and their assistants of every sort. Next followed marksmen with guns, bows and crossbows, likewise cavalry and infantry. Then came a great throng of officials of the city council, after them a whole company of notable people, in lordly and costly dress. But preceding them, in devout procession, all religious orders and those sworn to a rule of life, in their different categories.[63] Processing too was a large group of widows, such as earn their bread by handiwork and observe a special rule of life, all in white linen, made so that they were covered from head to foot, most affecting to see.[64] Amongst them I saw some quite notable persons. And last came the canons of the Church of Our Lady with all priests, scholars and their treasures. Twenty people carried aloft the Virgin Mary with the Lord Jesus, most sumptuously adorned in honour of our Lord God. In this procession a host of joyful sights were exhibited in the most costly show, for there were driven past many carts, plays acted on wheeled ships and other stages.[65] Among them were the company and hierarchy of the prophets, then the New Testament, that is, the Annunciation, the Three Wise Men riding on great camels and other strange creatures, most artfully staged, Our Lady on the Flight to Egypt, most devout, and many other things I omit lest they be tedious.[66] Last of all came a great dragon which St Margaret and her virgins led by a girdle. She was exceptionally attractive. St George followed her with his squire, a most handsome knight. In this company there also rode boys and maidens, most pretty and dressed exceedingly finely according to the custom of many different lands, standing for a large company of saints. From start to finish, until it had all passed in front of our house, this procession lasted for more than two hours. So many things there were in it that I could never write them all down in one book, and so I must leave it at that.

Item: I have been in the Fugger house here in Antwerp, which he has recently built in costly form[67] with a remarkable tower, broad and high, and a lovely garden, and I saw his handsome stallions. Item: Tomasin gave my wife fourteen ells of good thick Arras cloth for a mantle and three-and-a-half ells

of wool and linen arras for the lining.[68] I did a sketch design of a lady's turban for the goldsmiths. Item: the Portuguese factor sent a gift of wine, French and Portuguese, to my lodgings. Item: Signor Rodrigo of Portugal gave me a cask of preserved sweets of various kinds, including a box of sugar candy, two large trays of barley-sugar, marzipan, all kinds of other sweets, and quite a lot of sugar-canes just as they were harvested.[69] In return I gave his servant 1 gulden for a tip. For living expenses I exchanged 1 light gulden for 12 stuivers. Item: the pillars of the tribune gallery chapel of the monastery of St Michael's in Antwerp are all made of one single piece of fine black goldstone.[70] From Antwerp I have sent gifts to Sir Giles, King Charles's Gentleman Usher,[71] and to the fine stone-carver called Master Konrad, whose equal I have never seen,[72] who serves the King's daughter, Lady Margareta,[73] namely *St Jerome in his Study*, *Melencolia*, the three new engravings of the *Virgin Mary*, *St Anthony*, and *St Veronica*.[74] And to Master Gilles[75] I presented a *St Eustace* and a *Nemesis*.[76]

Item: I owe my landlord 7 gulden 20 stuivers, and 1 heller, that was on the Sunday before St Bartholomew [19.8.1520]. Item: for bed- and sitting-room and for bed-linen I owe him per month 11 gulden. I came to a new arrangement with my landlord on 20 August, which was the Monday after St Bartholomew,[77] that I shall eat with him and pay 2 stuivers for the food, with drinks charged separately, but my wife and maid can cook and eat upstairs. I gave the Portuguese factor a small woodcarving of the Christ Child.[78] Further I gave him an *Adam and Eve*, *St Jerome in his Study*, *Hercules*, *St Eustace*, *Melencolia* and *Nemesis*.[79] Later, from the half-sheets, the three new *Virgin Marys*, *St Veronica*, *St Anthony*, the *Nativity* and the *Crucifixion*; then the best of the quarter-sheets of which there are eight; then the three books: the *Life of Our Lady*, the *Apocalypse* and the *Large Passion*; then the *Small Passion* and the *Engraved Passion*. That is altogether worth 5 gulden. I gave exactly the same to Signor Rodrigo, the other Portuguese, who has given my wife a little green parakeet.

## Visit to Mechelen and Brussels, 26 August–3 September 1520

Item: on the Sunday after St Bartholomew's Day [26.8.1520] I travelled with Signor Tomasin to Mechelen, where we spent the night. I invited Master Konrad and a painter who was with him to dine with me. This Master Konrad is the good woodcarver in the service of Lady Margareta. From Mechelen we passed through a little place called Vilvorde and reached Brussels at midday on the Monday [27.8.1520]. I gave the courier 3 stuivers. I dined with my Lords[80] at Brussels and on one occasion with the honourable Banisius,[81] to whom I gave a copperplate Passion. Item: at Brussels I gave Margrave Johann[82] the letter

of introduction which my Lord Bishop of Bamberg gave me, and I presented him with an *Engraved Passion* that he might remember me. Further I dined once more with my Lords of Nuremberg.

In the Golden Chamber of the Town Hall in Brussels I saw the four works[83] which the great Master Rogier painted.[84] Behind the King's House in Brussels, I saw the fountains, the maze, and the menagerie, and have never seen anything more entertaining and pleasing, quite like a Garden of Eden.[85] Item: The little chap who drew up my supplication at Jakob Banisius's, is called Erasmus.[86] Item: the Town Hall in Brussels is a very magnificent building, large and carved with beautiful stone tracery, and has a noble openwork tower.[87] I did a night-time portrait by candlelight of Master Konrad who gave hospitality to my Lords in Brussels.[88] And at the same time I did a charcoal drawing of Dr Lamparter's son,[89] also the host's wife.

I also saw the objects which men have brought back for the king from the new Land of Gold: a sun made all of gold, a good six feet across, likewise a moon of pure silver, of the same size, also two rooms full of those natives' armour, all manner of their weapons, military gear and missilery, amazing shields, curious costumes, bed coverings and every kind of spectacular things for all possible uses, more worth seeing than the usual prodigies. These things are all so precious that they are valued at a hundred thousand gulden. I have never in my life seen anything that gave my heart such delight as these things, for I saw amongst them marvellously skilful objects and was amazed at the subtle ingeniousness of people in foreign lands. I cannot find words to describe all those things I found there.[90] In Brussels I saw many other fine objects, in particular a fish bone, so huge it might have been built up out of squared stone blocks – it was six feet long and very thick, weighing around fifteen hundred-weight, and shaped as I have sketched here:...[91] and it stood at the back of the fish's head. I was also in the Count of Nassau's townhouse,[92] lavishly built and beautifully decorated. Again I have twice dined with my Lords.

Item: Madonna Margareta has sent word to me in Brussels and promised me she will put my case to King Charles and has shown herself extremely friendly towards me. Have presented to her my *Engraved Passion*, with another copy to her Treasurer, Jan de Marnix,[93] whose charcoal portrait I have also taken. I gave 2 stuivers for a buffalo ring,[94] plus 2 stuivers to have St Luke's painting opened up.[95] Item: When I was in the Count of Nassau's house, I saw in the chapel the fine picture Master Hugo painted,[96] also the two handsome state rooms and all the treasures throughout the house, including the great bed in which 50 people can lie down.[97] Further I saw the immense stone which the storm hurled down in a field right next to the Count. This house stands high up

and out of it you have a lovely view which is to be marvelled at. And I don't believe there is the equal of it in all German lands.

Item: Master Bernhart, the painter,[98] invited me and prepared such a costly meal that I can't think it could be had for 10 gulden. Others who invited themselves to ensure me good company were: Lady Margareta's treasurer, whose picture I had taken, the King's High Steward, called de Metenye,[99] and the City Treasurer, van Busleyden.[100] I gave him an *Engraved Passion* and he gave me in return a black Spanish purse worth 3 gulden. I also gave Erasmus of Rotterdam an *Engraved Passion*.

Item: To Erasmus, Banisius's secretary, I also gave an *Engraved Passion*. The man in Antwerp who gave me the canvas of a child's head is called Lorenz Sterk. Item: Did a charcoal portrait of Master Bernhard, Lady Margareta's painter.[101] I did another sketch of Erasmus of Rotterdam.[102] I gave Lorenz Stark a present of a *Seated Jerome* and the *Melencolia*, and did a likeness of a woman who is my landlady's neighbour.[103] Item: Six people have given me nothing for doing their portraits in Brussels. I paid 3 stuivers for two buffalo horns, and 1 stuiver for two copies of *Eulenspiegel*.[104]

So then on the Sunday after St Giles's Day [2.9.1520] I set off with Signor Tomasin to Mechelen and took my leave of Hans Ebner. He would accept no payment for my keep, for seven days, all the time I lodged with him.[105] I paid out 1 stuiver on Hans Geuder's behalf.[106] One stuiver I gave for a tip to my landlord's servant. At Mechelen I stayed the night with Lady van Nykerken.[107] Set off early on Monday from Mechelen to Antwerp [3.9.1520]. Ate early with the Portuguese who gave me a gift of three porcelain bowls, and Rodrigo gave me a number of feathers from Calicut.[108] I spent 1 gulden, and gave 2 stuivers to the courier. I bought Susanna a mantle for 2¼ gulden.[109] My wife has spent 4 Rhenish gulden for a washtub, a bellows and a washing-up bowl, slippers for herself, wood for cooking, knee-stockings, also a cage for a parakeet, two jugs, and a tip. In addition my wife paid out 21 stuivers for food, drink and sundry necessaries.

## At Antwerp, 3 September–4 October 1520

Now on the Monday after St Giles's Day I moved back into Jobst Planckfelt's and have eaten the meals marked down as follows: iiiiiiiiiiiiiiii. Item: to Nikolaus, Tomasin's servant, 1 stuiver. I paid 5 stuivers for the small moulding for a picture-frame, plus 1 stuiver. My landlord has given me an Indian nut,[110] also an old Turkish whip. Starting again I have counted these meals eaten with Tomasin: iiiiiiiiiiii. Item: the two gentlemen von Rogendorf invited me.[111] I

ate with them and I sketched a large coat of arms on a woodblock, so that it can be cut.

I gave 1 stuiver as a gift. My wife has changed 1 gulden into 24 stuivers for living expenses. I gave 2 stuivers as a tip. I have eaten once in Fugger's house with young Jakob Rehlinger.[112] Ate once more with him. Item: my wife has changed a second gulden into 24 stuivers for subsistence costs. I have given Duke Frederick the Count Palatine's servant, Wilhelm Hauenhut, an engraved *Jerome* and the two new half-sheets, the *Virgin Mary* and the *St Anthony*.[113] Item: further I gave Jacob Banisius a good painted *Face of St Veronica*,[114] a *Eustace*, a *Melencolia*, and a *Seated Jerome*, *St Anthony*, the two new *Madonnas*, and the new *Peasants at Market*. Then I gave his secretary Erasmus, who wrote the supplication for me, a *Seated Jerome*, *Melencolia*, and the *Peasants*, and I have also sent him a *Little Madonna*, and all together what I have given them is worth 7 gulden. I have given Master Mark the goldsmith an *Engraved Passion* and he squared the debt with 3 gulden.[115] Plus I have got back 3 gulden 20 stuivers for prints. To Heneken the glazier I gave four little copperplates.[116] I ate with Banisius: iii times. I paid 4 stuivers for anthracite and black chalk.[117] I gave 1 gulden 8 stuivers for wood. Paid 3 stuivers more. Meals eaten with my Lords of Nuremberg: iiiiiiiiii. Item: Master Dietrich, glass-painter, sent me the red colour that you find in Antwerp in the new bricks.[118] Item: I did a charcoal portrait of Master Jakob of Lübeck,[119] who presented my wife with a St Philip gulden. Again I changed 1 Philip gulden for living expenses. To Lady Margareta's doctor[120] I gave a copperplate *St Jerome Seated*. I sold a *Woodcut Passion* for 12 stuivers, plus an *Adam and Eve* for 4 stuivers. Item: Felix, the captain and lutenist, paid me 8 gold gulden for one whole-sheet of copperplate prints and a *Woodcut Passion*, plus an *Engraved Passion*, 2 half-sheets, 2 quarter-sheets; so I threw in a full-sheet copperplate print for free. I drew a charcoal likeness of Banisius.[121] Item: Rodrigo gave me a parrot and I gave his boy a 2 stuivers tip. I gave Johann van den Winkel, trumpeter,[122] a *Small Woodcut Passion*, *St Jerome in his Study*, and a *Melencolia*. Paid 6 stuivers for a pair of gloves, 5 stuivers for a Spanish walking cane, and Georg Schlaudersbach[123] gave me one as a present which had cost 6 stuivers. I dined once with Wolf Haller, formerly factor to the Fuggers,[124] when he invited my Lords of Nuremberg. Item: for prints earned 2 St Philip gulden 6 stuivers. Again ate once with my wife. Gave 1 stuiver to Hans Dene's lad[125] for a tip. Item: sold prints for 100 stuivers. Item: Made a charcoal sketch of Master Jakob, von Rogendorf's painter, and incised Rogendorf's arms on wood for him, for which he gave me seven ells of velvet.

Have dined again with the Portuguese: i. I have done a charcoal drawing of Master Jan Provost of Bruges[126] and he gave me 1 gulden. Item 23 stuivers for

a fur from a rabbit's back. I have sent Hans Schwarz 2 gold gulden for my portrait[127] in a letter to Augsburg entrusted to the Fugger branch in Antwerp. Item: Have paid 31 stuivers for a red woollen shirt. Have eaten with von Rogendorf again once. I paid 2 stuivers for the colour they get from bricks. Item: Gave 9 stuivers for an ox-horn. Did a charcoal portrait of a Spaniard. Dined again with my wife as shown: i. I paid 2 stuivers for a dozen little pipes.[128] Paid 3 stuivers for two little fine-grained maplewood bowls. Two of this kind Felix had given my wife, and one such bowl Jakob, the painter from Lübeck, gave her. Ate with von Rogendorf: i.

Item: Gave 1 stuiver for the print of the *Triumphal Entry into Antwerp*, showing the splendid celebration with which the King was received there.[129] The gates were richly decorated, there were plays, rejoicing, and beautiful girls as living statues, the like of which I have scarcely ever seen.[130] I changed a gulden for living expenses. In Antwerp I saw the bones of the great giant. This bone from above the knee is five-and-a-half feet long, inordinately heavy and very thick; the same applies to his shoulder-blades, one of them is broader than a strong man is over his whole back, and so on with his other bones. The man was 18 feet tall, he ruled over Antwerp and did marvellous deeds, so that the Lords of the city have an old book in which much is written about him.[131]

Item: Raphael of Urbino's stuff has all been scattered since his death. But one of his pupils called Thomas of Bologna, a good painter, asked to see me.[132] So he came and presented me with a gold ring, antique,[133] with a well cut stone, worth 5 gulden though I was offered double that for it. In return I gave him some of my best prints, to the value of 6 gulden. Item: Paid 3 stuivers for a length of calico.[134] I gave the courier 1 stuiver. I spent 3 stuivers with friends. Item: Gave Lady Margareta, the Emperor's sister,[135] a complete set of all my prints, and have drawn two subjects on parchment for her, with utmost care, and estimate all this to be worth 30 gulden. For the doctor, her physician,[136] I did drawings for a house he wants to build. For doing that I would not charge under 10 gulden either. I gave the servant 1 stuiver, plus another for brick colour. Item: Gave Nikolaus Ziegler[137] a *Deposition from the Cross*, worth 3 gulden. Gave the Portuguese factor a painting of a child's head, worth 1 gulden. Paid 10 stuivers for a small buffalo horn. Paid 1 gold gulden for an elk's hoof.[138]

Item: Made a charcoal portrait of Master Adrian.[139] Paid 2 stuivers for the *Condemnations* and the *Dialogues*.[140] Gave the courier 3 stuivers. Gave Master Adrian 2 gulden worth of prints. For a piece of red chalk[141] 1 stuiver. I drew a likeness of Sir Wolf von Rogenstein. Gave away 3 stuivers. Drew a noble-woman in Tomasin's house. Gave Nicolo[142] a *Jerome in his Study* and the two new *Madonnas*. On the Monday after Michaelmas [1.10.1520] gave Thomas of

Bologna a complete set of prints which he's sent to another painter in Rome for me, and he in return will send me Raphael's engravings.[143] I ate once with my wife. Paid 3 stuivers for the pamphlets. Thomas of Bologna did my portrait and will take it to Rome with him.[144] Gave 20 stuivers for an elk's hoof. Plus I paid 2 gold gulden and 4 stuivers for Hans Ebner's little panel. Dined out. I cashed a crown to pay expenses. Dined out. Have taken out 11 gulden to pay living costs in Aachen. Received 2 gulden 4 stuivers from Ebner. Spent 9 stuivers on wood. Paid 20 stuivers to Meuting to convey my trunk.[145] Did a portrait of a lady from Bruges who paid me 1 St Philip gulden. I gave 3 stuivers as departure tips, 2 stuivers for pine nuts,[146] 1 stuiver for stone-colour. Paid the furrier 13 stuivers, 1 stuiver for leather. Gave 2 stuivers for two seashells. In Johann Gabriel's house I painted an Italian gentleman and he gave me 2 gold gulden. Paid 2 gulden 4 stuivers for a satchel.

### Visit to Aachen and Cologne, 4 October–21 November 1520

I set off from Antwerp to Aachen on the Thursday after Michaelmas [4.10.1520] and took an extra gulden and a noble with me. And after I had passed through Maastricht, we came to Gülpen and from there, on the Sunday, to Aachen [7.10.1520]. So far I have spent 3 gulden, including the fare and all else. At Aachen I saw the classically proportioned pillars, with their fine capitals, made of green and red porphyry and drain-stone, which Carolus had brought from Rome and inserted here. These were made with professional accuracy following Vitruvius's book.[147]

Item: At Aachen I paid 1 gold gulden for an oxhorn. I did a charcoal portrait of Hans Ebner and Georg Schlauderspach, and then a second one of Hans Ebner. I gave 2 stuivers for a soft whetstone. Item: 5 stuivers for bathing and drinking with my companions.[148] I cashed 1 gulden for living expenses. I gave 2 silver pence to the Town Hall attendant who showed me up to the State Chamber.[149] I went through 5 silver pence bathing and drinking with my friends. I lost 7 stuivers gambling with Hans Ebner at the Mirror.[150] I did charcoal portraits of young Christoph Groland,[151] also my landlord Peter von Enden.[152] I spent 3 stuivers with friends, and gave the courier 1 stuiver. I drew portraits of Paul Topler and Martin Pfinzing in my little sketchbook.[153] I saw the Emperor Henry's arm, Our Lady's shift and girdle, and other relics in the Cathedral Treasury.[154] I sketched the Church of Our Lady with its surroundings. I did Sturm's portrait,[155] and a charcoal sketch of Peter von Enden's brother-in-law. Gave 10 silver pence for a large oxhorn. I gave 2 silver pence for a tip, and changed another gulden for petty cash. Gambled 3 silver pence, plus

another 2. Gave the courier 2 silver pence. Presented the painted Trinity to Tommaso's daughter, it's worth 4 gulden.[156] Paid 1 stuiver for washing. Made a charcoal likeness of Köpfinger's sister-in-law in Aachen,[157] and another with metalpoint. Bathed away 3 silver pence. Gave 8 silver pence for a buffalo horn, 2 for a belt. Item: paid 1 Philip gulden for a scarlet bodice. Sixpence for paper. Changed a gulden into spending money. Paid 2 silver pence for washing.

Item: on 23 October, King Charles was crowned at Aachen. There I saw all royal panoply, more of it than anyone alive today can have witnessed, as it has all since been described in print.[158] Item: To Mathes I gave prints worth 2 gulden.[159] Also I presented three prints to Stephan, Lady Margareta's valet.[160] I paid 1 gulden 10 silver pence for a cedarwood rosary.[161] I tipped little Hans the stable-boy 1 stuiver; the same to the young house-servant. One-and-a-half stuivers lost at gambling, 2 stuivers for expenses, 2 to the barber. Again cashed 1 gulden. Left 7 silver pence for tips to the household.

And travelled from Aachen to Jülich and from there to…[162] Spent 4 stuivers for a pair of spectacles;[163] wasted 2 stuivers on a stamped silver coronation medal.[164] Gave 8 silver pence for two oxhorns.

So I left Aachen on the Friday before St Simon and St Jude [26.10.1520], and travelled to Düren and went into the church where the head of St Anna is kept.[165] From there we went on, and on Sunday, Saints Simon and Jude's Day [28.10.1520], we reached Cologne. In Brussels I lodged, ate and drank with my Lords of Nuremberg, and they would take nothing from me for it. Likewise in Aachen I ate with them for three weeks, and they took me to Cologne and here too would accept no payment.

I have bought a pamphlet of Luther's for 5 silver pence. Plus one more for the *Condemnatio Lutheri*, that godly man.[166] Plus 1 silver penny for a rosary. Plus 2 silver pence for a belt. Plus 1 for a pound of candles. I changed 1 gulden for living expenses. I had to give Leonhard Groland my large oxhorn, and to Hans Ebner I had to give my large cedarwood rosary. Six silver pence for a pair of shoes. I spent 2 silver pence on a small skull.[167] Spent 1 silver penny on beer and bread. Plus 1 silver penny for braided shoe-straps.[168] I paid two couriers 4 silver pence. I gave Niklas's daughter 2 silver pennies for Hallowe'en biscuits.[169] Item: 1 silver penny to a courier. I gave 2 gulden worth of prints to Herr Ziegler's man Linhart. I paid 2 silver pence to the barber. I paid 2 silver pence, then again 2 silver pence for having the altar-piece opened which Master Stephan painted at Cologne.[170] Gave 1 silver penny to the courier and drank 2 silver pence worth with friends. I did a likeness of Frau Gottschalk's sister.[171] Paid 1 silver penny for a little pamphlet.

At Cologne in the public ballroom[172] I saw Emperor Charles's Royal Ball and Banquet on the Sunday night after All Saints' Day [4.11.1520], and it was a lavish occasion. I drew Staiber's coat of arms on a wood block.[173] I gave a young count a *Melencolia*, and Duke Frederick the new *Madonna*.[174] I did a charcoal portrait of Nikolaus Haller.[175] Item: 2 silver pence to the doorman. I spent 3 silver pence on two pamphlets. Paid 10 silver pence for a cowhorn. I went into St Ursula's Church, saw her tomb and great relics of the Holy Virgins and the others.[176] Did a charcoal likeness of Ferenberger.[177] Changed 1 gulden for living costs. Gave Nikolaus's wife 8 silver pence when she invited me to be their guest. I spent 1 stuiver on two prints. My lords Hans Ebner and Nikolaus Groland[178] have refused to accept anything for my board for eight days in Brussels, three weeks in Aachen and a fortnight in Cologne. I did a likeness of the nun[179] and gave her 7 silver pence and three half-sheet copper engravings.

My *confirmatio* from the Emperor to my Lords of Nuremberg was issued on the Monday after St Martin's [12.11.1520], after much effort and travail.[180] I gave Nikolaus's daughter 7 silver pence as a parting gift, his wife 1 gulden, plus a quarter gulden more to his daughter, and I set off from Cologne. Before that Staiber had entertained me as his guest, likewise my cousin Nikolaus once, as also old Wolfgang,[181] and I was invited to dine one more time. I gave Nikolaus's servant a *Eustace* as a parting gift and his little daughter another quarter for all the trouble they have taken over me. I paid 1 gulden for an ivory skull. Plus 1 silver penny for a little box turned on a lathe, also 7 silver pence for a pair of shoes, and finally I gave Nikolaus's man a *Nemesis*.

Early on the Wednesday after St Martin's Day [14.11.1520] I boarded the ship as far as…I paid 6 silver pence for a pair of shoes. I gave 4 silver pence to the couriers. From Cologne I sailed on the Rhine as far as Zons, from Zons to Neuß, and from there to the Stein crossing. We rested there for the day and I spent 6 silver pence. Then on to the little town of Düsseldorf; spent 2 silver pence. From there to Kaiserswerth, on to Duisburg, another little town; passed two castles, Angerort and Ruhrort; on again to the small towns of Orsoy and Rheinberg; there I spent the night at a cost of 6 silver pence. From there I went to the small towns of Burg Wesel, Rees and Emmerich. Next we reached the toll station at Lobith and from there came to Nijmwegen where we stayed the night at a cost of 4 silver pence. From Nijmwegen I travelled to Tiel and on to 's Hertogenbosch. At Emmerich I had made a halt and spent three silver pence on an excellent meal. I also made a portrait sketch of a goldsmith's journeyman, Peter Federmacher from Antwerp, and one of a woman. And the reason for the halt was that a violent storm hit us. In addition I spent another 5 silver pence and cashed 1 gulden for expenses. I did a

portrait of the landlord too. So we did not reach Nijmwegen until the Sunday [18.11.1520]. I paid the skipper 20 silver pence. Nijmwegen is a beautiful town with a fine church and a well situated castle.[182] From there we travelled on to Tiel, where we left the Rhine[183] and sailed down the Maas to Heerenwaarden where the two towers stand; there we anchored for the night and that day I spent 7 stuivers. On Tuesday [20.11.1520] we set off again early towards Bommel on the Maas. There a great storm came over, so we hired farm horses and rode with no saddles as far as 's Hertogenbosch. For the river voyage and the horse-ride together I had to fork out 1 gulden.[184] Bosch is an attractive town with an exceptionally beautiful church[185] and very well fortified. There I spent 10 stuivers, even though Master Arnold paid for my meal.[186] And the goldsmiths did me the great honour of attending me.

Then we set out on Our Lady's Day [21.11.1520] and passed through the very large and handsome village of Oosterwijk, but we ate our morning meal at Tilburg, spending 4 silver pence. Next we came to Baarle, stayed overnight there and paid 5 stuivers. But my fellow travellers quarrelled with the landlord and we left in the night for Hoogstraten, where we halted for two hours before going on to Harscht past St Leonard's Church, where we breakfasted and spent 4 stuivers.

## At Antwerp, 22 November–3 December 1520

We went on to Antwerp and gave the carter 15 stuivers, and that was on the Thursday [22.11.1529] after the Day of Our Lady's Assumption.[187] I gave an *Engraved Passion* to Jan, Jobst's brother-in-law's servant, and I took Nikolas Sopalis's portrait.[188] And on the Thursday after Our Lady's Assumption I moved in again with Jobst Planckfelt and ate the following meals with him: iiii, my wife ii. I cashed 1 gulden for small change, plus 1 crown. And in the seven weeks I have been away, my wife and the maid spent 7 crowns, and they also bought other things worth 4 gulden. I got through 4 stuivers with friends. These meals I ate with Tommaso: iiiiii. On St Martin's Day [11.11.1520] in the Church of Our Lady in Antwerp, someone cut off my wife's purse with 2 gulden in it. The purse and all the rest that was in it were worth 1 gulden and there was a number of keys there too.

Note: On St Catherine's Eve [24.11.1520] I paid my host Jobst Planckfelt 10 gold crowns on account. Meals eaten with the Portuguese: ii. Rodrigo gave me a present of six Indian nuts and in return I gave his boy 2 stuivers as a tip. Note: Paid 19 stuivers for parchment. Note: Cashed 2 crowns for expenses. For two *Adam and Eves*, one *Sea Monster*, one *Jerome*, one *Knight*, one *Nemesis*, one

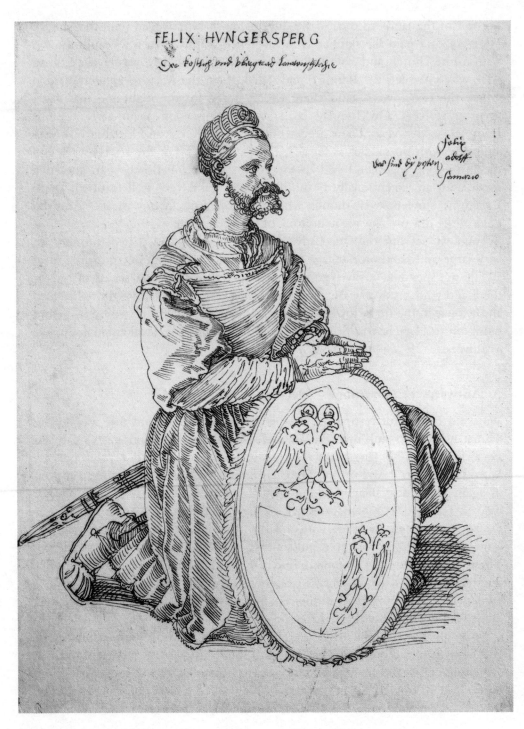

50.   Albrecht Dürer, *Felix Hungersberg*, pen drawing, 1520. Vienna: Albertina 3162

*Eustace*, one whole sheet, plus seventeen etchings, eight quarter sheets, nineteen woodcuts, seven of the inferior woodcuts, two books and ten small *Woodcut Passions*, I made in all 8 gulden.[189] Note: Gave three of the large books for an ounce of *schon lood*.[190] I changed one Philip for petty cash and my wife changed another gulden. Item: At Zieriksee in Zeeland a whale has been driven ashore by a great storm[191] and gale; it is far more than a hundred fathoms long,[192] and there's no one alive in Zeeland who has seen one as much as a third this length, and the fish can't get itself back afloat. People would like to get rid of it because they're afraid it will stink to high heaven; because it's so huge, they think it would take more than half a year to chop it up and boil down the blubber. Note: Stephan Capello has given me a cedarwood rosary, for which I promised to do his portrait, and have done it.[193] Note: Paid 4 stuivers for chestnut brown[194] and a candle snuffer. I spent 3 stuivers on paper. I did a pen drawing of Felix kneeling in his notebook.[195] He gave me a hundred oysters [fig. 50].[196]

I have given that great man Lazarus[197] an engraved *Jerome* and the 3 large books. Rodrigo gave me strong wine and oysters. Paid 7 silver pence for black chalk. I entertained for dinner Tomasin, Gherardo, Tomasin's daughter, her husband, Hennik the glass-painter,[198] Jobst and his wife and Felix, that cost me 2 gulden. Note: Tomasin has given me four ells of grey damask to make a doublet. Plus I have changed 1 Philip gulden for living expenses.

## Visit to Zeeland, 3–14 December 1520

On St Barbara's Eve [3.12.1520] I rode from Antwerp to Bergen op Zoom, paid 12 stuivers for the horse, and spent 1 gulden 6 stuivers there. Note: At Bergen bought my wife thin Dutch cloth for a headdress, cost 1 gulden 7 stuivers. Plus 6 stuivers for 3 pairs of shoes, 1 stuiver for spectacles, plus 6 stuivers for an ivory button. I gave 2 stuivers as tips. I drew likenesses in charcoal of Jan de Haas, his wife, and two daughters, and drew the maid and old woman in my sketchbook with the silverpoint.[199] I looked at my lord of Bergen's palace, it's very spacious and of fine design.[200] Bergen is an attractive place in summer and they hold two large fairs there each year.

On Our Lady's Eve [7.12.1520] I set off for Zeeland with my fellow travellers, and Sebastian Imhoff lent me 5 gulden.[201] On the first night we lay at anchor out at sea; it was very cold and we had nothing to eat or drink. On the Saturday [8.12.1520] we reached Goes, where I sketched a girl wearing her folk costume.[202] From there we went on to Arnemuiden where my outlay for board and lodging was 15 stuivers. We sailed past the drowned village where we saw the tops of roofs sticking up out of the water. Then we passed the

small island of Wolphaartsdijk and the little town of Kortgene on another nearby island. Zeeland has seven islands, and Arnemuiden, where I stayed the night, is the largest of them. From there I sailed to Middelburg; in the abbey there Jan Gossart has painted a great altar panel, not as good in terms of the modelling of the heads as in its use of colour.[203] Next I went on to the ferry port, where ships of all lands tie up: a very fine little place.[204]

But at Arnemuiden, as I was coming into port, a serious accident happened to me. As we were approaching land and casting our mooring ropes ashore, a big ship collided with us violently, just as I was disembarking, and to escape the crush I was letting everyone else get off before me, so that only I, Georg Kötzler,[205] two old women and the skipper with a little lad were left in the ship. When the other ship collided with us then, and I was still on board with these people and couldn't get out of the way, the thick cable snapped, and that very moment a strong gust of wind hurled our ship backwards. We all yelled for help but no one would risk coming to our rescue. The wind then started to carry us out to sea again. The skipper began to tear his hair and cry out, for his crew had all left the ship unmanned and empty. We were in fear and peril, for the wind was strong and there were not more than six of us aboard. Then I told the skipper to take heart, put his hope in God and think through what was to be done. He said, if he could just hoist the small sail, we might see whether he could try and reach land again. So all together we made a great effort and with failing strength[206] got it halfway up and made for land again. And when the people on shore, who had given us up for lost, saw our efforts to save ourselves, they came to the rescue and we reached the land.

Middelburg is a good enough town and has a very fine town hall with a lavish tower, on all of which much skill has been expended. In the abbey are elaborately worked choir stalls and a costly stone gallery chapel, and there is an attractive parish church. Altogether the town made a delightful subject for drawing.[207] Zeeland is fascinating to see because of the water, for its level is higher than the land. I drew my landlord at Arnemuiden. Master Hugo,[208] Alexander Imhoff and Friedrich, the Hirschvogels' servant, each gave me an Indian coconut which they had won at dice.[209] And the landlord gave me one of the sprouting bulbs.[210]

Then early on Monday [10.12.1520] we embarked again and sailed past Veere op Walcheren and Zierikzee. I wanted to see the whale, but the storm had carried it out again [fig. 51].[211] I had wasted 2 gulden on the fare and food and spent 2 gulden on a coarse woollen blanket.[212] Paid 4 stuivers for a fig-cheese, and 3 stuivers for porterage, and lost 6 stuivers gambling. And back we came to Bergen. I gave 10 stuivers for an ivory comb. Did a portrait sketch of the Highwayman.[213]

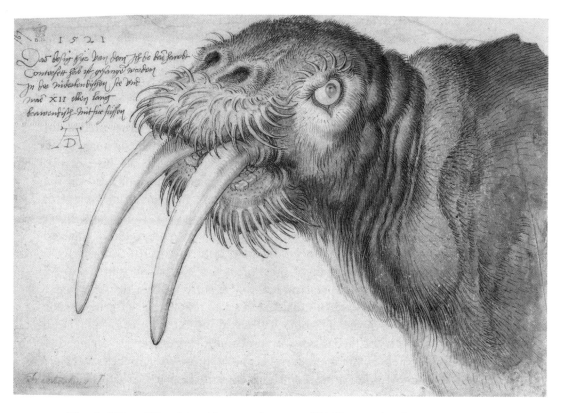

51. Albrecht Dürer, *Walrus*, ink with watercolour 1521. BM Sloane 5261–167

Also drew Claus, the landlord's son-in-law.[214] I paid 2 gulden less 5 stuivers for a piece of pewter. Plus 2 gulden for a piece of inferior pewter. Note: Did portraits of young Bernhard of Breßlen,[215] Georg Kötzler and the Frenchman from Cambrai,[216] each of whom gave me 1 gulden at Bergen. Jan de Haas's son-in-law gave me 1 Horn gulden for his likeness, as also did Kerpen from Cologne.[217] Further I paid 4 gulden less 10 stuivers for two bedspreads.[218] I drew a portrait of Nikolaus the jeweller.[219] These are the meals I have eaten at Bergen since I got back from Zeeland: iiiiiiiii. And once for 4 stuivers.

## At Antwerp, 14 December 1520–6 April 1521

I paid the carrier 3 stuivers and spent 8 stuivers on living expenses, and on the Friday after St Lucia's Day [14.12.1520] I came back to Jobst Planckfelt's in Antwerp, 1520. Have eaten the following times with him: –; paid; and my

wife: +; paid. Note: Herr Lazarus of Ravensburg has given me, in return for the three books I gave him, a large fish scale, five snail shells, four silver medallions, five copper ones, two small dried fishes, a white coral, four bamboo darts and another white coral.[220] I changed 1 gulden for paying expenses. Note: Also changed 1 crown. These meals I have eaten alone: iiiiiiiii. Note: The Portuguese factor gave me a brown velvet purse and a box of good electuary.[221] Gave his boy 3 stuivers for running the errand. I paid one Horn gulden for two small panels, but got 6 stuivers back. I gave 4 gold gulden for meerkats,[222] plus 14 stuivers for five fish. Paid Jobst 10 stuivers for three meals. Bought two pamphlets for 2 stuivers. Gave Lazarus of Ravensburg his portrait head on the small panel which cost 6 stuivers. And in addition I have given him eight of the large engravings, eight of the half sheets, an *Engraved Passion* and other copperplates and woodcuts, in total worth more than 4 gulden. Plus I changed 1 Philip gulden for petty cash, likewise a gold gulden. I paid 6 stuivers for a panel and did a charcoal portrait of the Portuguese factor's servant on it. All of that I gave him for a New Year present and 2 stuivers for a tip. Changed 1 gulden for expenses. And gave Bernhard Stecher a complete set of prints. Note: bought 31 stuivers' worth of wood. I have done a portrait of Gherardo Bombelli[223] and one of Sebastian the procurator's daughter.[224] Changed 1 gulden to pay expenses. Spent 3 stuivers, plus 3 more for lunch. Gave Herr Wolf von Rogendorf one *Engraved* and one *Woodcut Passion*. Gerhard Bombelli gave me a printed Turkish cloth and Wolf von Rogendorf gave me seven Brabant ells of velvet, so I gave his servant a Philip gulden as a tip. Spent 3 stuivers on a meal. Gave 4 stuivers for a tip. Did a charcoal likeness of the new factor.[225] Paid 6 stuivers for a small panel. Ate with the new Portuguese: iiiiiiii times, with the Treasurer: i, with Tomasin: iiiiiiiiii times. Note: Gave 4 stuivers for a tip. With Lazarus Ravensburger: i, Wolf von Rogenberg: i, Berhard Stecher: i, Utz Hanolt and Meuting: i, Kaspar Lewenter: i.[226] Note: Gave 3 stuivers to the man who sat as model for a portrait.[227] Plus 2 stuivers to the servant. Paid 4 gulden for flax. Sold prints for 4 gulden. Cashed a crown for expenses. Note: paid the furrier 4 stuivers, plus 2 more. Lost 4 stuivers at gambling and paid 6 stuivers for food and drink. Exchanged 1 noble for cash. Paid 18 stuivers for raisins and three pairs of knives. Paid 2 gulden for a number of meals at Jobst's. Lost 4 stuivers at gambling and paid the furrier 6 stuivers. Gave Master Jakob[228] a gift of two copperplate *Jeromes*. Plus 2 stuivers gambled. Cashed 1 crown. Gambled 1 stuiver. Gave Tommaso's three maids three pairs of knives, cost 5 stuivers. Earned 29 stuivers for prints.

Rodrigo gave me a musk-ball, as cut out of a musk-deer,[229] also a quarter-pound of peaches, another box of quince electuary and a large box full of

sugar. So I gave his boy a 5 stuivers tip. Note: Gambled 2 stuivers. I've done a charcoal drawing of Jobst's wife. Made 4 gulden 5 stuivers for three small canvasses. Changed 2 gulden one after the other for small change. Gambled 2 stuivers. My wife put 1 gulden into the child's swaddling clothes and 4 stuivers more into the cradle [see fig. 53].[230] Note: Changed 1 crown for cash and spent 4 stuivers, gambled 2 stuivers, gave the courier 4 stuivers. Turned 1 gulden into small change. I have given Master Dietrich the glass-painter one *Apocalypse* and the *Six Knots* [fig. 52].[231]

Paid 40 stuivers for flax. Lost 8 stuivers gambling. I gave the little Portuguese factor, Signor Francisco, my canvas of a child, worth 10 gulden.[232] I gave Dr Luppin of Antwerp[233] the four books and a copperplate *Jerome*. Likewise to Jobst Planckfelt. Drew the coats of arms of Staiber and another. Did silverpoint portraits of Tommaso's son and daughter.[234] Note: Painted the face of a duke in oils on a panel.[235] Earned 5 stuivers for prints. Rodrigo, the Portuguese Secretary,[236] gave me a present of two Calicut cloths,[237] one of silk, and also an embroidered cap, a green jug with myrobalan plums,[238] and a branch from a cedar tree, in sum worth 10 gulden. Gave the boy a 5 stuivers tip, and spent 2 stuivers on brushes. For Fugger's people I did a design for a masque, and they paid me 1 angel.[239] I changed 1 gulden for petty cash. I paid 8 stuivers for two powder horns. Lost 3 stuivers gambling. Cashed 1 angel for change. Note: drew for Tommaso two sheets full of really pretty masks. Painted a good *Veronica Face*[240] in oils, worth 12 gulden, and gave it to Francisco, the Portuguese factor. Then I did another oil painting of *Holy Veronica*, better than the previous one, and I gave this to factor Brandão. Francisco gave the maid first 1 Philip gulden as a tip, then because of the *Veronica* 1 gulden more. Factor Brandão gave her 1 gulden also. I paid Peter 8 stuivers for two cases.[241] I cashed 1 angel.

Note: Early on the Men's Carnival Day [10.2.1521],[242] the goldsmiths invited me together with my wife. For their gathering of many notable people, they had laid on a most elaborate meal and they did me exceeding honour. And for the evening the retired Prefect of the city[243] had invited me and gave a feast and showed me much honour. Many exotic mummers appeared. I have done a charcoal likeness of Florent, Lady Margareta's organist.[244] On Monday night [11.2.21] Sir Lopez[245] gave me a carnival invitation to the great banquet which lasted until two o'clock and was most extravagant. Note: Herr Lorenz Stark gave me a Spanish fur. And at the feast just described there were many splendid mummers, none more so than Tomasin Bombelli.[246] I won 2 gulden in gambling. I cashed 1 angel for expenses. I paid 14 stuivers for a basket of raisins. I did a charcoal sketch of Bernhard of Castell[247] from whom I won the money. Note: Tommaso's brother Gerhard gave me a gift of four Brabant ells

52. Albrecht Dürer, *Knot*, woodcut after an engraving by Leonardo da Vinci, circa 1506? Washington: National Gallery of Art R 20101201–0029

of best black satin, along with three large boxes of candied lemon zest, and I gave his maid 3 stuivers as a tip. Paid 13 stuivers for wood, 2 stuivers for pine-nuts. I made a neat portrait sketch with the silverpoint of the procurator's daughter.[248] Turned 1 angel into cash. Did a black chalk drawing of Master Jan, the skilled marble-sculptor, who looks very like Christoph Coler – he learned his skills in Italy and comes from Metz.[249] Changed a Horn gulden into petty cash. Paid Jan Tierik[250] 3 gulden for Italian prints, and gave him 12 ducats worth of prints for an ounce of high-grade ultramarine.[251] Earned 3 gulden from the *Small Woodcut Passion*. I sold two sketches and four books of Schäufelein's woodcuts.[252] Gave 3 gulden for two Calicut ivory saltcellars.[253] I sold prints for 2 gulden. Cashed 1 gulden. Note: Rudiger von Gelern[254] presented me with a snail-shell and some gold and silver coins, worth a quarter of a gulden. In return I gave him the three large books and an engraved *Knight*.[255] I made 11 stuivers from selling prints. I paid 2 Philip gulden for *St Peter and St Paul* which I mean to give to Coler's wife.[256]

Note: Rodrigo gave me a present of two boxes of quince electuary and a lot of assorted sugar. For that I gave 5 stuivers in tips. I paid 16 stuivers for boxes. Lazarus Ravensburger gave me a sugar-loaf, so I tipped his boy 1 stuiver. Paid 6 stuivers for wood. Note: ate one meal with the Frenchman, twice with Hirschvogels' Fritz, and once with Master Peter the secretary,[257] when Erasmus of Rotterdam ate with us.

I paid 1 stuiver for letting me climb the Antwerp tower, supposedly higher than the Strasburg one.[258] From the top I could survey the whole city in all directions, which was very entertaining. Paid 1 stuiver to bathe. Exchanged 1 angel for cash. Note: Factor Brandão of Portugal made me the present of two large, pure white sugar-loaves, a dish full of glazed sweets, two green pots of candied sugar, and four ells of black silk, so I tipped the servants 10 stuivers. Paid the courier 3 stuivers. For Gherardo I have twice more sketched the beautiful girl with my silverpoint.[259] Again cashed 1 angel. Sold prints for 4 gulden. I paid 10 stuivers for Rodrigo's case.[260] I ate with Treasurer Lorenz Sterk, who gave me an ivory whistle and a beautiful piece of porcelain,[261] and I responded with a complete set of prints, giving the same also to Adrian Herbouts, the public orator of Antwerp. Again changed 1 Philip gulden for petty cash. I have presented the largest and wealthiest guild of merchants in Antwerp with a *Seated St Nicholas*, for which they have rewarded me with 3 Philip gulden.[262] I have given Peter[263] the old frame of *St Jerome* plus 4 stuivers for the frame of the Treasurer's portrait. Note: Paid 11 stuivers for wood. Also I got small change for 1 Philip gulden. Paid 4 stuivers for an auger and 3 stuivers for 3 canes.

I have handed in a small bale to Jakob and Andreas Hessler for carriage to Nuremberg, and they are charging me 2 gulden per Nuremberg hundred-weight, and they are to deliver it to Hans Imhoff the Elder, for which I have paid 2 gulden; also I packed it in a carter's barrel.[264] Done on the Saturday before Judicae 1521 [16.3.21 – *Judica*: the last Sunday before Easter].

Note: On the same Saturday Rodrigo gave me six big coconuts, a really pretty coral and two large Portuguese gulden, one weighing 10 ducats. I tipped his boy 15 stuivers. I bought a lodestone costing 16 stuivers. Changed 1 angel for cash. Paid 6 stuivers for lashing cargo.

I have sent Master Hugo in Brussels an *Engraved Passion* and several other small pieces in return for his little porphyry stone.[265] For Tomasin I did a design, drawn in pen and tinted, for having his house painted.[266] I painted a *Jerome* in oils, taking care over it, and gave it as a gift to Rodrigo the Portuguese,[267] and he gave Susanna a ducat as gratuity. Cashed 1 Philip gulden and gave my confessor 10 stuivers.[268] Paid 4 stuivers for the little tortoise. Ate with Gilbert who gave me a Calicut targe,[269] made out of fish-skin, and two Indian fencer's gloves. Gave Peter 2 stuivers. Paid 10 stuivers for the fish's fins and gave 3 stuivers as tip. I did a really good likeness using rock-chalk of Cornelius, Secretary to the Antwerp Council.[270]

I paid 3 gulden 16 stuivers for the five silk girdles which I mean to give as presents, and 20 stuivers for a braid. The six braids I have sent as gifts to the wives of Kaspar Nützel, Hans Imhoff, Straub, the Spengler brothers, and Löffelholz, with a good pair of gloves each.[271] For Pirckheimer I've sent a large cap, an expensive buffalo-horn writing-set, a silver emperor,[272] a pound of pistachios, and three sugar-canes. To Kaspar Nützel[273] I've given a large elk's foot and ten big pine cones with pine nuts. To Jakob Muffel I've sent a scarlet breast-cloth of one whole ell. For Hans Imhoff's son a scarlet needlework cap and pine nuts, for Kramer's wife four ells of Italian silk worth 4 gulden,[274] for Lochinger's wife[275] one ell of silk worth 1 gulden, for both Spenglers' wives a purse each and three fine horns, to Hieronymus Holzschuher a particularly large horn. Ate twice with the Factor.

I ate with Master Adrian, the Antwerp secretary, who gave me the little panel which Master Joachim painted of *St Lot with his daughters*.[276] Earned another 12 gulden for prints. Sold 1 gulden worth of Hans Grien's prints.[277] Rüdiger von Gelern has given me a piece of sandalwood.[278] Gave his lad 1 stuiver. Did a portrait in oils of Bernhard von Resten.[279] He paid me 8 gulden for this and gave my wife 1 crown and Susanna 1 gulden worth 24 stuivers. I paid 3 stuivers for the *Swiss War*[280] and 2 stuivers for the ship, plus 3 stuivers for the storage case.[281] A further 4 stuivers for my confessor. Cashed 1 angel for small change.

I sold prints for 4 gulden 10 stuivers. Paid 3 stuivers for ointment. Bought wood for 12 half stuivers. Changed 1 gulden for expenses. Paid 1 gulden for fourteen pieces of *lignum sanctum*.[282] I have given Ambrosius Höchstetter a gift of the *Life of Our Lady*, he gave me his ship design.[283] Note: Rodrigo has given my wife a little ring, worth more than 5 gulden. Exchanged 1 gulden for petty cash. I did a charcoal drawing of Factor Brandão's clerk and a silverpoint likeness of his Moorish woman.[284] And took a likeness of Rodrigo on a large sheet of paper with the brush in black and white. I gave 16 gulden for a piece of camlet,[285] twenty-four ells, cost 1 stuiver to have it carried home. Paid 2 stuivers for gloves. I did a charcoal drawing of Lukas of Danzig,[286] who gave me 1 gulden and a piece of sandalwood.

## Journey to Bruges and Ghent, 6–11 April 1521

On Saturday after Easter [6.4.21], with Hans Lüber[287] and Master Jan Provost, a good painter and native of Bruges,[288] I travelled across the Scheldt from Antwerp to Bruges. We reached a large village called Beveren, then Vracene, another large village. From there we passed through several more villages and entered a fine large village where the rich farmers live, and there we breakfasted. Then we went on past the rich abbey of Boudelo,[289] through Caudenborn, a handsome village, and reached Kalwe, a large and extensive settlement, and Ertvelde, where we spent the night. On Sunday [7.4.21] we were up early and went on to the little town of Hertvelde. From there we reached Eeklo, an impressively large place with paved roads and a square; here we had our morning meal. On then to Maldegem, after that still more villages, before we arrived in Bruges which is a noble and beautiful town. On subsistence I spent 20 stuivers and on travel 1 more.

When I came to Bruges, Jan Provost took me to lodge in his own house and that night arranged a delicious meal, inviting many people for me to meet. On the next day [8.4.1521] Mark the goldsmith[290] invited me to a festive dinner and asked many others to meet me. Then they took me to see the Emperor's Palace[291] which is large and sumptuous. There I saw the chapel which Rogier painted, and pictures by a great old master.[292] Gave a stuiver to the attendant who let us in. Later I bought three ivory combs for 30 stuivers. Next they led me to St Jakob's and let me see the rich paintings by Rogier and Hugo who were both great masters.[293] Then I saw the alabaster Madonna in the Church of Our Lady, sculpted by Michelangelo of Rome.[294] After that they took me to many more churches and showed me all the fine paintings of which they have an abundance there. Once I had seen the things by Johannes and the

rest,[295] we came finally to the Painters' Chapel where there is much good work.[296] Afterwards they treated me to a banquet, and then I went with them to their guildhall, where they had gathered together many people of repute, goldsmiths, painters and merchants. I had to have supper with them, they presented gifts to me, made friends with me, and paid me generous compliments. The two brothers Jakob and Peter Mostaert, city councillors, presented me with twelve cans of wine, and the whole festive company, more than sixty people, escorted me home with a host of torches. In their archery club I saw the enormous fish barrel at which they eat; it is nineteen feet long, seven feet high and seven feet broad. Then early on Tuesday [9.4.1521] we departed. But first I did a metal-point portrait of Jan Provost and gave his wife 10 stuivers as a parting gift. So we travelled to Ursel, where we ate our morning meal, and three villages on the way there. Then through three more villages we proceeded to Ghent. For transport I paid 4 stuivers and spent 4 more on subsistence.

When I arrived in Ghent, the Dean of the Painters' Guild greeted me along with the foremost masters, paid me great respect, received me most nobly, pledged me their good will and devotion, and ate supper with me. On Wednesday morning [10.4.1521] they took me up the tower of St John's[297] where I surveyed the extensive and impressive city in which I had already excited much attention. Then I looked at the altar of St John's which is highly precious and skilfully painted, and quite especially Eve, Mary and God the Father are very good.[298] Next I saw the lions and drew one with the silverpoint.[299] Also I saw on the bridge where criminals are executed the two memorial figures set up to mark where a son chopped off his father's head.[300] Ghent is an attractive and remarkable city. Four great rivers flow through it.[301] I gave the sacristan and the lion-keeper each a 3 stuivers tip. Apart from these I saw many unusual sights in Ghent, and the painters and their Dean accompanied me everywhere, ate with me morning and night, paid for everything and showed me nothing but friendship. Even so I left a parting tip of 5 stuivers at my lodging.

On Thursday morning [11.4.1521] I departed from Ghent and passing through several villages reached the hostelry called The Swan where we took our morning meal. From there we travelled through one more pretty village and came to Antwerp. The fare cost 8 stuivers.

## At Antwerp, 11 April–5 June 1521

I have made 4 gulden from selling prints and exchanged 1 gulden for petty cash. I did a charcoal portrait of Hans Lieber from Ulm, who wanted to pay me a gulden, but I refused to take it. Gave 7 stuivers for wood and one to

have it delivered. Cashed 1 gulden. In the third week after Easter [14–20.4.1521] I was struck down by a high fever and drastic weakness, nausea and headache. Before, when I was in Zeeland, I suffered a mysterious illness that no one had ever heard of, and this sickness has never left me.[302] Paid 6 stuivers for containers. Note: The monk has bound two books in exchange for the prints I gave him.[303] Have spent 10 gulden 8 stuivers for a length of Arras to make cloaks for my mother-in-law[304] and my wife. Paid the doctor 10 stuivers and the apothecary 3 stuivers. Cashed another 1 gulden. Spent 3 stuivers with companions. Paid the doctor another 10 stuivers and a further 6 stuivers. Note: Rodrigo sent me a lot of confectionary while I was ill. Gave his boy a 4 stuivers tip. I drew Master Joachim with the silverpoint and then did a second portrait for him too.[305] Changed a further crown for expenses, and another gulden. Paid the doctor 6 gulden and the apothecary 7 stuivers. 1 gulden cashed for small items.

Note: For packing the third bale sent with the carrier called Hans Staber from Antwerp to Nuremberg, I paid 13 stuivers, and on top of that gave the carrier 1 gulden. Accepted a carriage rate of 1 gulden 1 quarter per hundredweight from Antwerp to Nuremberg, and the bale is to be delivered to Hans Imhoff the Elder. Paid the doctor, the apothecary, and the barber 14 stuivers. I also gave Jakob the doctor[306] prints worth 4 gulden. I did a charcoal likeness of Thomas of Bologna, from Rome. Item: My camlet coat took twenty-one Brabant ells, these are three finger-widths longer than Nuremberg ells. To go with it I have bought black Spanish skins costing 3 stuivers each, and there are thirty-four needed, making 10 gulden 2 stuivers. And for making them I have paid the furrier 1 gulden, plus velvet for trimming, two ells costing 5 gulden; plus for silk laces and thread 14 stuivers, plus the tailor's fee 30 stuivers. Note: The camlet material for the coat itself cost 14½ gulden. And a 5 stuiver tip for the errand-boy.[307]

Holy Cross after Easter [5.5.1521].[308] From now on we calculate from the beginning again. Again paid the doctor 6 stuivers. Note: Took in 13 stuivers for prints sold. Note: Received 53 stuivers for prints and took this for paying expenses.

Note: On the Sunday of Rogation Week [5.5.1521] Master Joachim, the skilled landscape painter,[309] invited me to his wedding and received me with all honours.[310] At it I saw two pleasing plays, particularly the first was most devout and uplifting.[311] Paid the doctor 6 stuivers more. Cashed 1 gulden.

On the Sunday after Ascension Day [12.5.1521] Master Dirik, the glass-painter here in Antwerp, invited me and many others in my honour, among them in particular Alexander the goldsmith, a man of wealth and substance,

and we enjoyed a rich meal and I was greatly esteemed. I sketched in charcoal Master Mark, the goldsmith from Bruges.[312] I paid 36 stuivers for a broad brimmed cap. I paid Paul Geiger[313] 1 gulden to take my small box to Nuremberg, and 4 stuivers for the letter. I did a charcoal likeness of Ambrosius Hochstetter and dined with him. Have eaten approximately six meals with Tomasin. Paid 3 stuivers for wooden platters and dishes.[314] Paid the apothecary 12 stuivers. I have made gifts of two copies of the *Life of Our Lady*, one to the foreign doctor,[315] the other to Mark's house-servant. Again paid the doctor 8 stuivers. Gave 4 stuivers for cleaning an old cap. Lost 4 stuivers gambling. Paid 2 more gulden for a new cap. I swapped the first cap because it was rough, and paid an extra 6 stuivers for a different one. I have painted the head of a duke in oil colours.[316] I have taken much trouble to paint a very faithful oil-colour portrait of Lorenz Sterk, the Treasurer.[317] I gave it to him as a gift, and in response he gave me 20 gulden and Susanna a 1 gulden gratuity. Note: Took pains to paint a faithful oil-colour portrait of my host, Jobst. He has now rendered me like for like.[318] His wife I have also painted again, a portrait in oils too.

### Lament for Martin Luther, 17 May 1521

On the Friday before Whitsun in the year 1521 [17.5.1521] news reached me at Antwerp that Martin Luther had been treacherously taken captive.[319] When he was granted an imperial escort led by the Emperor's herald, he naturally put his trust in them. But once the herald had brought him to an inhospitable area near Eisenach, he said Luther did not need him any longer and rode off. Within minutes ten horsemen were there who treacherously abducted that godly man, illuminated by the Holy Spirit, who was thus betrayed, but who was following in the footsteps of Christ[320] and in true Christian faith. And whether he is alive or whether they have put him to death, which I cannot know, he has suffered that for the sake of Christian truth, and because he has denounced the unchristian Papacy, which by oppressing us with man-made laws strives to prevent Christ setting us free, and because we are robbed and stripped of our sweat and blood which is then so scandalously and criminally consumed by idle folk, whilst sick and needy mankind must die of hunger.[321] And beyond all else, for me the very hardest to bear is that God may perhaps intend us to remain subject to their false blind doctrine, which those men they call Fathers of the Church concocted and imposed, ensuring that the divine Word has on many points been falsely interpreted or withheld from us altogether.[322] O God in heaven, take pity upon us. O Jesu Christ our King,

pray for thy people, redeem us while there is yet time, preserve in us true proper Christian faith, gather together thy scattered lost sheep with thy voice, that Scripture calls the divine Word, help us to know this same voice of thine, and not follow the false shepherd's piping of human error, so that we are not led astray from thee, Lord Jesu Christ. Call the sheep of thy flock together again, a part of which is still to be found in the Roman Church, along with the Indians, the Muscovites, the Russians and the Greeks, who have been split off by the oppression and greed of the popes and their false halo of holiness.[323] O God, set free thy poor folk from the yoke of edict and banishment, which it does not obey gladly, so that it must sin against its own conscience when it disobeys. O God, thou hast never before so grievously oppressed any people with man-made laws as we poor people are oppressed under the Roman Pontiff, we who should be free Christians redeemed daily by thy blood. O Highest Heavenly Father, pour into our hearts through thy Son Jesus Christ such a light as will make us see what laws we are bound to keep, so that with good conscience we can forget those other burdens and may serve thee, eternal God, Heavenly Father, with unconstrained and joyful hearts. If we lose this man, who has written more clearly than anyone who has lived in the last 140 years,[324] to whom thou hast granted such an evangelical spirit, we pray thee, Heavenly Father, give thy Holy Spirit instead to another who will bring together again thy holy Christian Church throughout the world, that we may live once more as one Christendom, and by our Christian works convert to our faith all unbelievers, like Turks, heathen and Indians, so that they accept Christian beliefs. But Lord grant, before thou comest again to judge, that as thy Son Jesus Christ had to suffer death at the hands of priests, rise again from the dead, and then ascend into heaven, it will also happen in like manner to thy follower Martin Luther, against whose life the Pope treacherously conspires with his pieces of silver, but whom thou wilt restore to life.[325] And just as thou thereafter, my Lord, didst decree that Jerusalem be destroyed, so wilt thou likewise destroy this self-assumed power of the Roman Throne. O Lord, give us thereafter the newly adorned Jerusalem that will come down out of Heaven, as it is written in the Book of Revelation,[326] the holy pure Gospel, not obscured by human doctrine. Therefore let each man see, who reads Dr Martin Luther's books, how transparently clear his teaching is when he sets forth Holy Scripture.[327] Therefore these books are to be held in great respect and not to be burned,[328] unless it were that his adversaries, who for ever contest the truth, be cast into the fire with all their *opiniones*[329] that try to make men into gods – albeit only with the aim that new Lutheran books be printed. O God, if Luther be dead, who will henceforth proclaim the Holy Gospel to us with

like clarity? Ah God, what might he have written for us in ten or twenty more years! O all pious Christian folk, help me to weep for this man imbued with God's spirit,[330] and to beseech God to send us another man who bears his light. O Erasmus Roterodamus,[331] why do you hold back? See, what the unjust tyranny of worldly might and the powers of darkness are capable of![332] Hear us, soldier of Christ! Ride forth with the Lord Christ, defend the truth, win the martyr's crown.[333] Else you are nothing but a feeble old *manneken*.[334] I have heard you say yourself that you only give yourself another couple of years before you're too old to do anything useful. Put these two years to good purpose, to benefit the Gospel and true Christian faith. If you let your voice be heard, the gates of hell, the Vatican, shall, as Christ says, not prevail against you.[335] And were you to make yourself like to Christ your master,[336] follow him and suffer shame from the mouths of the Pharisees of our time, then you will pass all the sooner from death into life and be transfigured through Christ.[337] For if you drink out of the cup he drank from,[338] you will reign with him and judge justly those who have not acted wisely. O Erasmus, bear yourself in this such that God may boast of you, as it is written of David: for you can do it, and verily you can slay Goliath.[339] God stands by the Holy Christian Church, as indeed he can be found among the Romans, according to his divine will.[340] May he help us to win eternal blessedness, God Father, Son and Holy Spirit, one and only God. Amen. O Christian men, pray God for help, for his judgement draws nigh and his justice shall be revealed. Then shall we witness the innocent blood which Pope, priests and monks have shed, judged and condemned. *Apocalypsis*.[341] These are the slain who lie at the foot of God's altar and cry out for vengeance, to whom the voice of God answers: Await the full number of the innocent slain, then will I judge.[342]

### At Antwerp (continued)

Changed another 1 gulden for cash. I paid the doctor a further 8 stuivers. Note: Ate two more meals with Rodrigo. Ate with the rich canon.[343] Cashed 1 gulden. I entertained Master Conradus, the sculptor from Mecheln,[344] during the Whitsun festival [19–20.5.1521]. I paid 18 stuivers for Italian prints. Another 6 stuivers to the doctor. I drew for Master Joachim four St Christophers on grey paper highlighted in white.[345]

On the last day of the Whitsun feast [21.5.1521][346] I was at the Antwerp horse-fair and saw a very large number of handsome stallions being ridden, and two of them in particular that were sold for 700 gulden. For prints I have taken in 1¾ gulden and took this in small change for expenses. Paid the doctor

4 stuivers. Bought two pamphlets for 3 stuivers. Have eaten three times with Tomasin. I sketched three sword-hilts for him and he gave me an alabaster vase. I drew a charcoal portrait of an English nobleman[347] who paid me 1 gulden which I changed for ready cash. Note: Master Gerhard, the book-illustrator, has a daughter Susanna, around eighteen years old, who has illuminated a small sheet with a Saviour. I gave her 1 gulden for it. Amazing that a woman should have done something like that.[348] Lost 6 stuivers gambling.

I watched the great procession in Antwerp on Trinity Sunday [26.5.1521].[349] Master Konrad has given me fine razors for shaving, so in return I gave his little old man a *Life of the Virgin*. I made a charcoal drawing of Jan, the gold-smith from Brussels,[350] and one of his wife. Sold prints for 2 gulden. Note: Master Jan the goldsmith gave me 2 Philip gulden for doing the design for his seal and the two portraits. I have given Jan the goldsmith the *Veronica* I painted in oils[351] and the *Adam and Eve* which Franz did,[352] in return for a jacinth and an agate with a *Lucretia* engraved in it.[353] Each of us estimated his part of the bargain at 14 gulden. In addition I traded a complete set of prints for a ring and six small jewels. Each valued his contribution at 7 gulden. Paid 14 stuivers for two pairs of gloves. Paid 2 stuivers for two small boxes. Cashed 2 Philip gulden. I sketched three times *Christ led away to Calvary* and twice the *Mount of Olives* using five half sheets.[354] I sketched three heads in black and white on grey paper. I drew two Dutch costume studies also in black and white on grey paper.[355] For the Englishman I did his coat of arms in colour and he paid me 1 gulden.[356] As well I have at various times done many designs and other such things to oblige people here, and for most of my work have had no payment. Andreas of Cracow gave me 1 Philip gulden for a shield and children's heads.[357] Exchanged 1 gulden for cash. Paid 2 stuivers for brooms.[358]

I saw the great procession, most lavish, which happens on Corpus Christi [30.5.1521] in Antwerp. Paid 4 stuivers in tips and 6 stuivers to the doctor. Cashed 1 gulden. Paid the doctor 6 stuivers. One stuiver for a small box. Have eaten five times with Tomasin. Spent 10 stuivers at the chemist's and paid the apothecary's wife 14 stuivers for laxative and the apothecary 15 stuiv-ers for the prescription. Exchanged two more Philip gulden for ready cash. A further 6 stuivers to the doctor. Again paid the apothecary's wife 10 stuivers for purging and 4 stuivers more at their shop. I gave 8 stuivers to the monk who heard my wife's confession. Gave 8 gulden for a whole piece of Arras. Gave 8 gulden more for fourteen ells of fine Arras. A further 32 stuivers to the apothecary for medicine. Note: Paid the courier 3 stuivers and the tailor 4 stuivers. Ate once with Hans Fehle,[359] three times with Tomasin. Paid the packers 10 stuivers.

On Wednesday after Corpus Christi 1521 [5.6.1521] I handed over my large bale at Antwerp for transportation to Nuremberg by a carrier called Kunz Metz from Schlauerdorf, and I contracted to pay him 1½ gulden per hundred-weight for carriage as far as Nuremberg, and gave him 1 gulden in advance. And he is to deliver it to Hans Imhoff. Did a charcoal sketch at Antwerp of young Jakob Rehlinger.[360] Ate three more meals with Tomasin.

## Second Visit to Mechelen, 6–7 June 1521

On the eighth day after Corpus Christi [6.6.152] I travelled with my wife to visit Lady Margareta in Mechelen. Note: Took 5 gulden for our expenses. My wife changed 1 gulden for expenses. I lodged in Mechelen at the Golden Head with Master Heinrich the painter.[361] There at my lodgings the painters and sculptors invited me to dinner and treated me nobly in their assembly. I was also at Poppenreuther's, the gunsmith's house[362] and found remarkable things to see there. I also visited Lady Margareta and showed her my *Emperor* and wanted to present it to her, but she disliked it so much that I took it away with me again.[363] On Friday [7.6.1521] Lady Margareta showed me all her beautiful pieces. Among them I found forty small oil-painted panels whose equals for quality and precision I have never seen before. There I saw also other good things, works by Jan and by Jacopo the Italian.[364] I asked my lady for Master Jacopo's little book, but she said she had promised it to her own painter.[365] Many other precious things I saw too, and a very valuable library. Master Hans Poppenreuther invited me as his guest. I had Master Konrad[366] twice and his wife on one occasion as my own guests. Note: Invited Stephan the Chamberlain[367] and his wife as my guests. Spent 27 stuivers and 2 stuivers on fares. Also did charcoal drawings of Stephan the Chamberlain and Master Konrad the woodcarver, and on Saturday I returned from Mechelen to Antwerp.

## At Antwerp, 8 June–3 July 1521

Note: My trunk did not leave until the Saturday after the eighth day of Corpus Christi [8.6.1521]. Again cashed 1 gulden. Note: gave the courier 3 stuivers. I have eaten twice with the Augustinians.[368] Note: ate with Alexander Imhoff. Paid 8 stuivers at the apothecary's. Ate once more with the Augustinians. Note: Did a charcoal drawing of Master Jakob,[369] had a framed panel made of it for 6 stuivers and presented it to him. Made portraits of Bernhard Stecher and his wife and gave him a complete set of prints; drew his wife a second time, spent

6 stuivers on framing it, and gave the whole thing to them, whereupon he gave me 10 gulden in response.

Master Lukas invited me to be his guest, he is the engraver, a little chap born in Leiden in Holland, who was here in Antwerp.[370] Ate with Master Bernhard Stecher. Paid 1½ stuivers to the courier. Got 4 gulden 1 quarter from selling prints. Sketched Master Lukas of Leiden with the silverpoint. Lost 1 gulden. Note: paid the doctor 6 stuivers. Again 6 stuivers. Presented the Steward of the Augustinian Priory here with a *Life of Our Lady*, and his servant 4 stuivers. I have given Master Jakob an *Engraved* and a *Woodcut Passion* and five other prints, and his servant 4 stuivers. Exchanged 4 gulden for ready cash. I have paid 2 Philip gulden for another fourteen fish-skins. I drew portraits in black chalk of Aert Bruyn[371] and his wife. I gave the goldsmith who valued the three rings for me prints worth 1 gulden. Of these three rings which I got by swapping prints, the two smaller ones are assessed at 15 crowns, but the sapphire is valued at 25 crowns, that makes 54 gulden 8 stuivers. And apart from the other things that the Frenchman[372] took, there were thirty-six large books, makes 9 gulden. I paid 2 stuivers for a screwcutter. Note: The fellow with rings gave me half as much again in value – I can't understand it. I gave my godson 18 stuivers for a red cap.[373] Note: lost 12 stuivers gaming. Spent 2 stuivers on drink. Note: I have sold the three pretty little rubies for 11 gold gulden and 12 stuivers. Cashed 1 gulden. Ate again with the Augustinians. Ate a further two meals with Tomasin. Paid 6 stuivers for thirteen wild guinea-pig bristles, plus 3 stuivers for another six bristles.

Item: Did a further, carefully studied portrait of big Anthony Haunolt[374] in black chalk on a royal-folio sheet. Likewise in the same format Aert Bruyn and his wife, and I did a further sketch of him with the metalpoint; he gave 1 angel. Item: Exchanged one more gulden for ready money. Paid 1 gulden for a pair of boots. Paid 6 stuivers for a calamary.[375] Paid 12 stuivers for a trunk to be packed. Item: Gave 21 stuivers for a dozen ladies' gloves. Paid 6 stuivers for a bag, and 3 stuivers for three brushes made of bristles. Cashed 1 gulden. Paid 1 stuiver for fine red leather.

Item: Anthony Hanolt, whose portrait I made, has given me 3 Philip gulden, and Bernhard Stecher has given me a tortoise-shell.[376] I did a likeness of his wife's sister's daughter. I ate once with her husband and he gave me 2 Philip gulden. Item: gave a tip of 1 stuiver. I presented Anthony Hanolt with two books. Sold prints for 13 stuivers. Gave Master Joachim Hans Grien's prints.[377] Item: Exchanged 3 Philip gulden for cash. Item: Have dined twice with Bernhard Stecher, and twice more with Tomasin. I made Jobst's wife a present

of four woodcuts and gave Friedrich, Jobst's man, two books, the large ones. Gave two books to Henekin, the glass-painter's son.[378]

Item: Rodrigo gave me a gift of one of the parrots they bring from Malacca, and I tipped his servant 5 stuivers. Ate twice more with Tomasin. Note: Paid 2 stuivers for a bird-cage, 3 stuivers for a pair of leather feet sewn into my hose, and 4 stuivers for eight small boards. I made Peter a present of two whole-sheet engravings and one sheet of woodcuts. Note: Ate twice with Tommaso. Changed 1 gulden into petty cash. Gave Master Aert the glass-painter[379] a *Life of Our Lady*, and Master Jan the French sculptor[380] a complete set of prints – he has made my wife a present of six little glasses with rosewater, most delicately made. Note: Paid 7 stuivers for a packing container. Cashed 1 gulden. Also paid 7 stuivers for a fringed bag.

Cornelius the Secretary[381] has given me Luther's *Babylonian Captivity*,[382] and in return I presented him with my three large books. Note: Gave the monk from Peter Pot's almshouse[383] prints worth 1 gulden. Note: Gave Henes the glass-painter two large books. Paid 4 stuivers for a piece of painted calico.[384] Note: Changed 1 Philip gulden for expenses. Note: For the complete prints of Lukas I traded 8 gulden worth of my own prints. Cashed a further 1 Philip gulden. Note Paid 9 stuivers for a bag. Note: Bought half-a-dozen Dutch cards for 7 stuivers, also a little yellow *perßschüch*[385] for 3 stuivers. Note: Paid 24 stuivers for meat, 12 stuivers for coarse cloth plus 5 stuivers for more. I have eaten twice more with Tommaso. Gave Peter 1 stuiver. Paid 7 stuivers to the packers and 3 stuivers for sailcloth. Note: Rodrigo made me a gift of six ells of heavy black cloth for a travelling cape,[386] cost 1 crown an ell. Exchanged 2 gulden for cash. Tipped the tailor's lad 2 stuivers.

I reckoned up with Jobst and owe him 31 gulden. I paid the bill, in which the two portrait heads I did in oils were marked as deducted, and for them he gave me five pounds of borax by Netherlandish weight.[387] In all I have done, in my living expenses, sales and other dealings in the Netherlands, in all my relationships whether with higher or lower classes of people, I have lost out, and quite especially with Lady Margareta who in return for what I presented to her and made for her has given me nothing.[388] And this settling of accounts with Jobst happened on Sts Peter's and Paul's Day [29.6.1521].

I have given Rodrigo's servant a tip of 7 stuivers. I gave an *Engraved Passion* to Master Henri[389] who had given me the scented candles. I had to pay the tailor 45 stuivers for making the cape. I have contracted with a carrier to transport me from Antwerp to Cologne and will have to pay him 13 light gulden, that's to say ones at 24 stuivers each, and have also to foot the subsistence costs of one man and his lad. Note: Jakob Rehlinger gave me 1 ducat for his charcoal

portrait head. Gherardo gave me a gift of two small casks of capers[390] and olives, and I gave him a gratuity of 4 stuivers, and Rodrigo's servant 1 stuiver. I gave my portrait of the Emperor[391] in return for a white English cloth that Jakob, Tomasin's son-in-law, gave me. Item: Alexander Imhoff has loaned me interest-free 100 gold gulden on the eve of Our Lady's Visitation 1521 [1.7.1521]. Therefore I have given him my sealed bond which he is to serve on me in Nuremberg, whereupon I shall pay him back with gratitude. I paid 6 stuivers for shoes, 11 stuivers to the apothecary, and 3 stuivers for cordage. In Tomasin's kitchen I left 1 Philip gulden as parting gift, and gave Miss Sute, his daughter, 1 gold gulden in farewell. Have eaten three times with him. To Jobst's wife I gave as parting gift 1 gulden and left another gulden for the kitchen staff. Note: Paid the loaders 2 stuivers. Tomasin has given me the present of a jar full of the best-quality theriac.[392] Item: Cashed 3 gulden for small expenses and gave the house servant a parting gift of 10 stuivers. Gave Peter 1 stuiver. Paid out 2 stuivers in tips and 3 stuivers more to Master Jacob's man. Paid 4 stuivers for tarpaulin. Gave Peter 1 stuiver. Note: Paid the courier 3 stuivers.

On Our Lady's Visitation [2.7.1521], when I was about to leave Antwerp, the King of Denmark[393] summoned me to come in haste and do his portrait. So I sketched him in charcoal, and also his servant Anthony.[394] I was obliged to dine with the King who treated me most graciously. I have entrusted my small bale to Leonhard Tucher and handed over my white cloth to him. Note: the carrier I previously contracted with did not in fact convey me – I had a disagreement with him. Gherardo has given me a quantity of Italian seeds. On Our Lady's Visitation I gave the Vicarius,[395] for him to take home for me, the large turtle-shell and the fish-skin shield, the long bamboo cane, the lance, the fish fins, and the two casks with lemons and capers.

## At Brussels, 3–12 July 1521

The next day [3.7.1521] we set off for Brussels at the request of the King of Denmark, and I engaged a carrier to whom I paid 2 gulden. Note: I presented to the King the best items out of all my prints, worth 5 gulden.[396] Again cashed 2 gulden for expenses. Paid 1 stuiver for dishes and baskets. Note: It struck me how people in Antwerp greatly admired the King of Denmark, when they saw what a virile and handsome man he was, and how he had ridden through his enemies' lands with a mere couple of companions.[397] I watched too when the Emperor rode out from Brussels to greet him respectfully and with great pomp. Then I witnessed the noble and lavish banquet the Emperor and Lady Margareta laid on for him on the following day. Paid 2 stuivers for a pair of gloves. Item:

53.  Albrecht Dürer, *Agnes Dürer as St Anne*, brush study, 1519. Vienna, Albertina 3160

Sir Anthony gave me 12 Horn gulden, out of which I paid 2 Horn gulden to the painter for the panel to be used for the portrait and for getting the colours ground for me.[398] The remaining 8 Horn gulden I kept as cash for expenses.

Note: on the Sunday before St Margaret [7.7.1521] the King of Denmark held a great banquet for the Emperor, Lady Margareta and the Queen of Spain,[399] and I was invited and dined there. I paid 12 stuivers for the protective case for the royal portrait which I painted in oil colours, and for which he gave me 30 gulden.[400] I gave two stuivers to the boy called Bartholomäus who ground the paints for me. I paid 2 stuivers for a little glass jar which had belonged to the King. Paid 2 stuivers as a tip. Note: Paid 2 stuivers for the engraved goblets. Note: Gave Master Jan's lad four half-sheets of prints.[401] Also gave the master-painter's boy an *Apocalypse* and four half-sheets. The Bolognese[402] has given me one or two Italian prints, and I paid 1 stuiver for another. Master Jobst the cutter[403] invited me and I ate supper with him. For rent of my room in Brussels for a week I paid 32 stuivers. Gave Jan the goldsmith's wife an *Engraved Passion*, having eaten with him three times. I gave Bartholomäus the painter's boy another *Life of Our Lady*. I dined with the honourable Nikolaus Ziegler and gave 1 stuiver to Master Jan's servant. I stayed idly in Brussels for two extra days because I could find no means of transport to take me further. Paid 1 stuiver for a pair of short socks.

On Friday morning before daybreak [12.7.1521] I set off from Brussels and had to pay the carrier 10 gulden. For the single extra night I paid my landlady 5 stuivers more. We passed through two villages and reached Louvain, ate breakfast there and paid 13 stuivers for it. Next we went through three more villages and came to a small town called Thienen, where we spent the night, which cost me 8½ stuivers.

Early on St Margaret's Day [13.7.21] we travelled on through two villages and came to the town called St Truyen. There they are building a new, well designed and large church tower. From there we went by a number of poor dwellings and reached the small town of Tongern, where we had our morning meal costing 6 stuivers. Then passing through a village and past more poor houses we came to Maastricht, where I stayed the night and paid 12 stuivers for board and lodging. Plus 2 silver pieces for a watchman.

Next we travelled on Sunday morning [14.7.1521] to Aachen, eating there for 14 stuivers all told. Then on to Altenburg, taking six hours over it because the carrier did not know the way and took the wrong route. But we spent the whole night there and spent 6 stuivers. Early on Monday [15.7.21] we passed through Jülich and came to Bergheim. There we ate and drank for 3 stuivers. Then we went through three villages and reached Cologne.

## Instructions on the Making of a Netherlandish Lady's Mantel

AD's autograph version (see Sources):

7 feet long. 8 feet 3 inches long. This part you put on the head. This is also a Netherlandish lady's mantle.

This is a Netherlandish lady's mantle which stretches to the ground. This part goes on the head.

Manuscript A (see Sources) has the two instructions in reverse order. It does not use the word 'Netherlandish', but refers in the first occurrence to 'the beguines' mantle'.

The autograph original manuscript of the Journal is lost. The last record of it was in 1620. Along with much else of AD's writings, it will have passed on his death in 1528 to Willibald Pirckheimer and from him to his relatives in the Straub and Imhoff families. After Willibald Imhoff died in 1580, and especially during the crisis of the Thirty Years War, the family began to dispose of the Pirckheimer inheritance. In 1633–4 Dutch buyers acquired material from the Pirckheimer/Imhoff library. In 1636 Thomas Howard, Earl of Arundel, Charles I's ambassador to Emperor Ferdinand II, bought what remained of the library, and purchased or was given paintings by AD in Nuremberg for his own and King Charles's collections. Arundel probably attempted to buy AD's papers in Amsterdam, but there is no evidence that he succeeded. However, five bound volumes, acquired from a Dutch collector, came to the British Museum by the bequest of Sir Hans Sloane in 1753. It is highly likely that the autograph manuscript of the Journal was among the material in Dutch hands. Evidence for this assumption is the leaf BL Add. 5229 fol. 50, which on one side has the drawings of a woman's cloak, labelled in AD's script as 'Netherlandish lady's mantle'. A version of the drawing is found also in the Bamberg manuscript copy of the Journal. The London leaf may thus be presumed to have become detached from the autograph manuscript of the Journal or from a lost notebook kept during AD's travels, from which he compiled the autograph.

Two relatively early copies of the Journal have survived. They were probably copied from different older transcriptions of the autograph original. Manuscript A is now in the Stadtbibliothek in Bamberg, codex 246. J.H. Msc. art. i (III. 18). It reached the library from the estate of the pioneer Dürer scholar Joseph Heller (died 1849), who had acquired it from the effects of a Prussian officer, Hans Albrecht von Derschau, in 1825. Derschau bought it before 1812 from the Ebner family archive in Nuremberg, where it had been discovered by Christoph Gottlieb von Murr in 1778. On the front cover Derschau claimed that Ms A had been copied from the original, when still in the possession of the Imhoff family, by the painter Johann Hauer in 1620 (see Tacke 2001, 124–7). Lange and Fuhse (1893, 99ff.) adduced evidence that the copy was neither the work of Hauer, nor a direct copy from AD's original, and they concluded that it was the work of a professional scribe of the seventeenth century, though later opinions have varied between datings in the early and late seventeenth and early eighteenth centuries. It is scrupulously written, and has also been extensively amended and corrected, apparently on the basis of collation with the source version, by a very competent, scholarly versed editor.

The Nuremberg copy, in the Staatsarchiv, S. I, L. 79, No. 15, Fascicule 18, known as Manuscript B, is less reliable and useable than A, because its text is less carefully copied and the scribe takes more liberties with AD's written German. Moreover, it has a lacuna of some 20–30 per cent of the journal. Lange and Fuhse dated Ms B to the late seventeenth or early eighteenth century, whereas Veth and Muller (1918, 7–12) put it in the mid-sixteenth century and Rupprich concurs with this dating. Its writer was evidently a chancery scribe who superimposes orthographical habits characteristic of later sixteenth-century bureaucratic German on the original language.

Rupprich I, 146–202. His text is based on Ms A with its marginal corrections and improvements. For a more recent assessment of the sources, see Sahm 2002, 172f.

NOTES

I acknowledge extensive use of the information provided by Rupprich (R I, 179–202), especially on place names and the identity of people AD meets in the Netherlands.

1   This title appears only in B and there at the end of the text. It was most probably not in AD's autograph.

2   For a key to monetary references throughout the Journal, see the introductory notes on Money, Coinage and Currency.

3   AD had visited the bishop of Bamberg, Georg Schenk von Limburg, in 1517, had painted his portrait and been generously entertained (112–13). The painting of the Madonna is recorded as hanging in the chapel of the bishop's palace in Bamberg in the early nineteenth century. The copies of AD's *Life of Mary* and *The Apocalypse* (both 1511) are the first of many which AD gave as gifts or sold during his Netherlands journeys. He frequently refers to sets of prints by monetary value rather than by title. The number of engravings he gave to the bishop for a notional gulden would depend on their size and subject. The three great prints of 1513–14, *Knight, Death and Devil, St Jerome in his Study* and *Melencolia*, would be good value for this money.

4   Until the nineteenth century the river voyage along the Main and Rhine was plagued by numerous toll bars as the traveller crossed boundaries between larger and smaller independent territories. AD's wearying repetition of the formula which lets him pass free of charge shows the extent of this privilege. He evidently had a large amount of baggage, including substantial stocks of pictures and prints, so that he fell awkwardly between the categories of private traveller and merchant. In fact, by this date mercantile traffic largely took overland routes, in part to minimise tolls and avoid the difficulties of navigating the Rhine delta (Harreld 2004, 102–10). One of AD's letters of introduction was to Margrave Johann of Brandenburg (note 82). It becomes clear a little later that AD paid the episcopal chancery 1 gulden for the pass. The bishop's accounts for 1520 record the payment of AD's party's expenses on 16 July to the landlord of the Wild Man 'when [they] had been to Vierzehnheiligen and stayed here overnight' (161). This visit to the pilgrimage shrine of the Fourteen Holy Helpers in Need, at Staffelstein near Bamberg, presumably intended as spiritual insurance against the perils of their journey, happened on the way to Bamberg, given the date of the entry in the chancery's accounts, not earlier in 1520, as Rupprich insists (III, 461), though it is odd that the Journal does not mention it.

5   Lukas Benedict is not identified. Hans Wolff (d. 1541) was painter to the prince bishop (see 113).

6   Not identified.

7   At some point on the river journey, AD drew 'Meister Arnolt van der Selgenstat' (W 752, S D 1520/7). This is Arnold Rucker (163.1).

8   The Frankfurt merchant, for whom AD had painted the altar panel of the *Assumption of the Virgin Mary* in 1508–9 (47–8).

9   *die gürtel*: for lashing the baggage with ropes as deck-cargo (DWb IV, I, 6, 1183, 2 Gürtel).

10   Not identified. As *wardein*, 'warden' of the guild, Peter would be in charge of the assaying of gold and silver.

11   Presumably a kinsman of Pirckheimer's and AD's friend Ulrich Varnbühler (BI; see 94, 170, 262).

12   Not identified.

13   Possibly either the brother of the woodcarver Jost de Negker, with whom AD dined in Brussels (note 403), or of Jobst Planckfelt, with whom AD lodged in Antwerp. Such contacts on the journey are unlikely to have been fortuitous and suggest that the itinerary and overnight stops were carefully planned.

14   Ehrenfels belonged to the Count Palatine of the Rhine, with whom the bishop of Bamberg had no customs toll treaty. This is the only one of thirty-four toll stations on the journey to Cologne where his pass did not secure him exemption. He was lucky at Boppard to get away with the contention that he was not carrying merchandise.

15   The customs man may have known Agnes Dürer from her travels selling AD's prints. A 'can' of wine was in Germany, as also in northern Britain, a measure, often a quart (DWb V, 164–6 and SOD).

16   For Nikolaus Dürer or Unger (from his Hungarian origin), son of AD's uncle Ladislaus, see the Family Chronicle (1). He had trained with AD's father as a goldsmith in Nuremberg, where he was a citizen from 1481, and he worked there at least until 1505.

17   Hieronymus Fugger (1499–1538), youngest son of Ulrich Fugger of the Augsburg trading and banking dynasty. Jan Chroserpeck has not been identified.

18   *ein collation*: the term originally referred metonymically to the frugal supper given to the friars on fast days, preceded by a reading from the *Collationes* – 'discourses, sermons' of St John Cassian.

19   *ein faczalet*: AD uses a form close to Italian *fazzoletto* which he may have picked up in Venice. However, variants such as *facilet, fatzenet, facenetlein*, are also found in this period (DWb III). The oldest occurrence of *Schnupftuch* (from *schnupfen*, related to English 'sniff, snuffle, snuff') given in DWb IX is from 1538. Modern *Taschentuch* is early nineteenth century (Paul 995). A handkerchief was clearly a more prestigious gift in 1520 than might appear, and not to be sneezed at.

20   The same unidentified person written as Jan Chroserpeck (note 17)?

21   *das pürschlein*: either the diminutive form of *der bursch*, 'boy, young chap, serving lad', or of *die bursch* or *bursche*, 'purse', then 'group of mates who when eating and drinking together pooled their money as a common kitty'. The turn of phrase used here suggests the latter (DWb II, 546–9; Paul 184, *Börse* and 197, *Bursche*).

22   At Cologne the travellers switched from river to road.

23   With few exceptions, AD's place names can be identified on modern maps. However, he often wrote them down from hearing. In this instance, the differing forms in the two source manuscripts have not been identified and my form is conjectural.

24   Planckfelt owned the Engelenborch, 'Angels' Castle', a hostelry and stabling at 19 Wolstraat, also called Engelschestraat – where the English merchants had their wool warehouse, between the port and the market place in Antwerp. So perhaps *pace* Pope Gregory the Great, *non angeli sed angli?*

25   Stecher had been the Fugger company's administrator in Antwerp since 1513. On the Fuggers in Antwerp see Häberlein 2012, 53f.

26   Staber was evidently the carter from Cologne to Antwerp. The sum paid is left blank.

27   Arnold van Liere (died 1529), who was also dean of the guild of painters. His house was in the Prinsestraat.

28   This was the guildhall known as de Bontemantel on the Great Market.

29   The lawyer Adrian Herbouts (died 1546), legal counsel and public orator to the city authorities.

30   Peter Teels (1467–after 1543), sculptor and carpenter to the city and the cathedral chapter.

31   Quentin Massys, or Matsys/Metsys (1466–circa 1530), born in Louvain, settled in Antwerp in 1491. His house, called 'The Ape', was in the street of the tanners. He was a painter of both religious works (major altars in Louvain and Antwerp) and secular subjects. He was a friend of Peter Gilles (note 75), Thomas More, and Erasmus, of whom he painted a portrait and engraved a medallion (see also 255).

32   Lorenz Staiber, from a wealthy Nuremberg family, married to the patrician Magdalena Rummel. In the imperial service, he was on his way back from England, where Henry VIII had conferred a knighthood on him. He was also a renowned organist.

33   João Brandão, from 1514 to 1521 agent of the King of Portugal.

34   This is the pen drawing W 747, S D 1520/8, inscribed 'This is my landlord in Antwerp Jobst Planckfelt 1520'. The gift of a branch of coral is the first of a series of exotica which AD collected in the Netherlands. The seaport of Antwerp was an ideal place to acquire objects brought from parts of the world being opened up by maritime discovery and trade in this period.

35   Called De Eekhof, where the city's painters could stockpile materials and carry out large commissions.

36   Emperor Charles V (BI), grandson of Emperor Maximilian I, brought up in the Netherlands by his aunt, Archduchess Margareta of Austria (notes 73 and 363–5) and Adrian of Utrecht, later Pope Hadrian VI. Elected German king in 1519, he was proceeding to Aachen for his imperial coronation on 23 October 1520.

37   *kammerspiehl*: from the Netherlandish word *kammerspel*, 'play performed inside, in a room' – *kammer* is English 'chamber'. Its sense in seventeenth-century occurrences is usually 'farce, low comedy', but this is clearly not what AD understands by it. See also notes 65, 129, 311.

38   Son of Veit Imhoff, presumably working for the family business in Antwerp.

39   Judging by the range and quantity of his purchase, Fischer was an art dealer as well as, or as part of, his post as factor in Antwerp for the Nuremberg trading company of Hillebrant. On prices and AD's pricing policy, see Landau/Parshall 1994, 351–3, and the notes on Money, Coinage and Currency. Fischer buys copies of the *Small Woodcut Passion* and the *Engraved Passion*. The 'large books' (see Arnulf 2004) are the book-format editions of the *Apocalypse*, the *Life of Mary* and the *Great Passion*. The remainder consists of mixed prints classified and priced according to whether they were printed on half (301 × 205 mm), quarter (174 × 124 mm) or full-size sheets (359 × 277 mm).

40   Not as Anzelewsky 1988b, 'a woven linen wall-hanging', rather (Heydenreich 2007, 245) this is AD's term for a painting on fine canvas, executed in a water-based medium on a 'cloth' coated with size and a thin pigmented wash.

41   Felix Hungersberg, imperial captain and an outstanding lute player. He was one-eyed. The first or second of the two drawings referred to here will be W 749, S D 1520/10, with the inscription 'This is Captain Felix the exquisite lutenist'. The third, done in late November 1520, is W 819, S D 1520/28, which shows Felix kneeling with sword and (unfinished) coat of arms, and is inscribed 'Felix Hungersperg. The exquisite and highly accurate lute-player'. See note 195, fig. 50, and texts 163.4/15.

42   Perhaps Alexander von Bruchsal, goldsmith and medallist, active in Antwerp from 1505 and a member of the Guild of St Luke.

43   Joachim Patenier or Patinir (circa 1475/80–1524), from Dinant, a friend of Quentin Massys, became particularly close to AD during his stay in the Netherlands. In his biography of Netherlandish painters (1604) Carel van Mander attributes a riotous, drunken lifestyle to Patinir. See notes 305, 309f., 345.

44   A design, presumably for the triumphal arch, using ink and tinted washes.

45   AD's 'new' engravings from 1519 to 1520 were *St Anthony* (S E 89, SMS 87), *Peasant and Wife at Market* (S E 90, SMS 88), *Madonna Nursing* (S E 91, SMS 86), *Madonna Crowned by an Angel* (S E 93, SMS 92), *Madonna with the Swaddled Infant* (S E 94, SMS 91). Peter Wolfgang is not identified.

46   The apprentice may have ground colours for an oil painting AD had under-taken. He got similar help from a young apprentice when painting his portrait of King Christian of Denmark in July 1521 (note 398).

47   The Bombelli brothers from Genoa were silk merchants. Tommaso was also paymaster of Archduchess Margareta. 'Tomasin' is AD's version of the diminutive pet-name Tommasino (compare note 223).

48   At such points as this AD left spaces and entered a stroke for each meal he sub-sequently ate with the person named.

49    Lorenz Sterk, from 1514 to 1525 treasurer and administrator of the revenues of Brabant and Antwerp. AD painted his portrait in oils (note 317).

50    Calicut or Kozhikode was a trading port in the modern state of Kerala in southwest India. But the name was used generically for countries in the 'New World' (Massing 2007c, 367; Kleinschmidt 2008, 188f.). The hollow wood is most likely a bamboo stick.

51    *ein geflochten hut von holder kernen*: the translation is conjectural. No conclusive interpretation of this mysterious hat has emerged. See Rupprich I, 181, note 134.

52    Erasmus of Rotterdam was lodging at this time with his friend Peter Gilles (note 75).

53    Agostino Scarpinello, from Naples, though AD calls him 'the Lombard' (*Lumbarth*), was secretary to Bishop Aloisius Marliano, the emperor's theological advisor. The *Imagines* are the two woodcuts of the star-charts of the Northern and Southern Hemispheres, which AD made for Johannes Stabius (S W 171/72, SMS 243–4, texts 102.5–6).

54    Presumably an Italian merchant.

55    This is the great Gothic cathedral of Antwerp which in its pre-Reformation form is said to have housed over fifty altars.

56    The Premonstratensian abbey of St Michael, which no longer exists, had a chapel which AD calls *porkirche*, the modern German architectural term *Empore* (*empor*, 'upper'). It was in the triforium gallery above a vaulted side aisle and was visible from the nave through a tracery arcade.

57    Nikolaus Kratzer (1486–1550), professor of mathematics at Oxford and court astronomer to King Henry VIII since 1517, with whom AD was in contact again in 1524 (199). He was a friend of Erasmus and Peter Gilles. Cuthbert Tunstall, English envoy in Brussels, had proposed Kratzer as a useful man to collect information on Charles V's German territories and on the Lutheran controversy. He was in Antwerp to visit Erasmus and present when AD did one of his portrait sketches of Erasmus, as he recorded in an inscription on a print of the engraving AD eventually produced in 1526 (226.2). Winkler tentatively identified the charcoal or chalk drawing W 808, S D 1521/34 as AD's portrait of Kratzer, on the grounds of facial resemblance to Holbein's oil painting of him.

58    *jungfrau Suten*: Zoetje was a girl's name in Flemish. Its derivation from Middle Dutch *soete/sute*, 'sweet', suggests that it might have been a nickname, 'Sweetie'. Either way, it is perhaps surprising that she should have had a Flemish rather than an Italian name. Perhaps Tommaso Bombelli had a Flemish wife. For other suggestions, see Unverfehrt 2007, note 25, 231. The silverpoint drawing of a young woman with hair let down (W782, S D 1521/46), on the left-hand part of a page in AD's sketchbook, has been suggested as the portrait referred to here.

59    Pfaffrot is recorded in Riga in 1519, and in August 1520 he had just returned from Danzig (Gdansk), where he had been acting for the Portuguese factor Francisco Pesão to obtain release of Portuguese merchants' goods confiscated by the authorities

there. The ink drawing W 748, S D 1520/11, headed 'Hans Pfaffrot of Danzig 1520 a strong man', is obviously connected with the charcoal sketch referred to here.

60   *schlecht gulden*: coins either worn, clipped or defectively minted, thus worth less than their nominal value.

61   Presumably AD had wished to have the wings of an altar opened for him to see the central panel.

62   See Rupprich 1955. AD also saw, but does not describe, the two other great annual processions in Antwerp, on Trinity Sunday and at Corpus Christi (26 and 30 May 1521). On this occasion, it becomes clear, he watched the event from the window of his lodgings.

63   The hierarchical sequence gave precedence to the orders of monks, then to friars and finally to the chapters of regular canons, who lived by a rule of life but were not enclosed in a monastic house.

64   Widows who lived as beguines (from a Middle Dutch verb for 'mutter (prayers)'), living in lay sisterhoods, though they did not take formal vows and were not formally supervised by the Church. They did charitable work and sustained themselves by spinning, weaving and lace-making. The mantle sketched at the end of the Journal (texts A, B and the BM folio) is called 'the beguines' mantle' in A.

65   *viel wagen, spiel auff schiffen und andern pollwerck*: the 'ships', Flemish *punten*, are the 'landships' or boat-like structures on wheels which regularly figure in contemporary accounts of processions in this period. They are associated with the 'ship of fools' in satirical folly literature circa 1500, and come ultimately out of ancient carnival traditions attested in many different parts of Europe. The *pollwerck* are wheeled stages for the performance of plays, often recorded also in descriptions of Passion and mystery plays.

66   The sequence AD rather unclearly summarises is, firstly, a group of those Old Testament prophets who foretell the Gospel history of salvation, then scenes from the biblical and apocryphal life of Mary (the culmination of which is her assumption into heaven and coronation there, which the feast day commemorates), and finally the figures of the associated legends of St Margaret and the dragon-slaying St George.

67   The Fugger house, which incorporated the business premises, was in the Steenhowersvest. AD mentions no members of the Fugger family resident in Antwerp, and it is not clear who 'he' is who had built the house, unless their factor had done so on their behalf.

68   *haraß*, from Arras in Picardy, was a finely woven blend of silk, wool and linen yarn. It was the preferred material for women's cloaks and mantles. Agnes Dürer's cloak was to be a heavy-duty, expensive winter garment. See Zander-Seidel 1990, Glossary. AD calls it a *höcke* (variously written in the period as *hoike, heike, huke*, Flemish *huike*). Originating in France it was a bell-shaped cape, pulled on over the head. It seems to have been very similar to the *husecke* AD had in Venice (29.9, note 8). The 'half-atlas'

of the lining was a cheaper linen or wool cloth. See AD's sketch patterns for a 'Netherlandish mantle' appended to the Journal (see Sources and note 64).

69   *signor Ruderisco* was Rodrigo Fernandez d'Almada, at first secretary to the factor João Brandão, then himself factor from 1521 to 1550. He lived in the house called Immerseele in the Lange Nieuwstraat. The sugary delights reflect the exotic trade of Portuguese ships with the Canary and Cape Verde islands. Nuremberg merchants bought large consignments of Portuguese spices and sugar for transmission to South Germany and beyond (Harreld 2004, 128–39).

70   *goldstain*: the shafts of the traceried gallery of the chapel (see note 56) were made of single lengths of high-quality yellow-veined marble from Portovenere. AD does use the older word-forms *marmel*, *marmelstein* (see note 249), borrowed into German from Greek/Latin in the ninth century, but not the reborrowing *Marmor* – sixteenth-century, widespread only from the eighteenth (DWb VI, 1659–61). See also *porfit* and *gossenstein*, note 147.

71   Gilles van Apfenauwe, a German nobleman and royal usher, is listed in the salary register of the English court for 1517 as 'Gilles l'Allemand, varlet servant'.

72   Konrad Meit (circa 1485–circa 1550), from Worms, sculptor (*maistre tailleur de pierres*) at the regent's court. He specialised in small-scale work in alabaster, wood and marble. He carved Margareta's tombstone effigy in Bourg-en-Bresse.

73   Margareta (BI), archduchess of Austria, daughter of Emperor Maximilian I and Mary of Burgundy, was thus Charles V's aunt. She had been regent of the Netherlands since 1507.

74   *St Jerome* (S E 77, SMS 70), *Melencolia* (S E 79, SMS 71), the three engravings of the *Madonna* (S E 91, 93, 94, SMS 86, 91–2), *St Anthony* (S E 89, SMS I, 89). '*Veronica*' is presumably the engraving *Sudarium displayed by two Angels* (1513, S E 69, SMS 68), rather than the etching, *Sudarium spread out by an Angel* (1516, S E 83, SMS 82).

75   Peter Gilles, or Petrus Aegidius in humanist circles (BI), was city clerk of Antwerp. He was a close friend of Erasmus, who was staying with him at the time. In 1517 Quentin Massys had painted a diptych of portraits of Erasmus and Gilles, intended as a gift to their mutual friend, Sir Thomas More.

76   *St Eustace* (1501, S E 34, SMS 32) and *Nemesis* or *The Large Fortuna* (1501/1502, S E 37, SMS 33). The latter, based on the Virgilian poem *Manto* by Angelo Poliziano, was particularly appropriate as a gift to a humanist. The presence in AD's baggage of prints of these much earlier major engravings shows how ambitious his plans were for selling and disseminating his work in the Netherlands (see 14.3).

77   However, AD then dates his departure for Mechelen on the Sunday after St Bartholomew, the day before he here claims the new agreement with his landlord was arrived at. Rupprich overrides the text of the two manuscripts and amends the text to read 'on the 20th August, which was the Monday before St Bartholomew'. I have preferred to let the discrepancy stand.

78   Rupprich suggests this was an example of the small carved wooden figures produced for domestic devotional use in the Netherlands in this period.

79   A further set of AD's most prestigious earlier prints comprising: *Adam and Eve* (1504, S E 42, SMS I, 39), *Hercules at the Crossroads* (1498, S E 24, SMS 22), *Nativity* (1504, S E 41, SMS 40), *Crucifixion* (1508, S E 50, SMS 61).

80   Hans Ebner, Leonhard Groland and Niklas Haller, the deputation of the Nuremberg Council who were conveying the imperial insignia to the coronation at Aachen.

81   Jakob Banisius (1467–1532), royal counsellor, former secretary to Maximilian I and friend of Willibald Pirckheimer. AD or his associate Hans Springinsklee drew a woodblock of his coat of arms (S W 195, SMS A25).

82   The Franconian Margrave Johann of Brandenburg (1493–1525), nephew of AD's patron Cardinal Albrecht, had been a courtier in the Netherlands since 1508, accompanied King Charles to Spain, and returned with him in 1520.

83   *die 4 gemalten materien*: the Latin borrowing *materie* became part of the specialised vocabulary of craftsmen, denoting the material of which an artefact is made, initially in the specific sense of the material to be used in making a 'masterpiece', the work which qualifies a master-craftsman (DWb VI, *Materie* 2).

84   Rogier van der Weyden (1399/1400–1464) decorated the Golden Chamber with four monumental panels of *The Justice of Trajan* and *Herkinbald*. They were extraordinarily famous and admired, and their destruction in the bombardment of the city by Louis XIV's besieging French army in 1695 removed what was probably Rogier's finest work. They are known now only in tapestry copies from the mid-fifteenth century (Nash 2008, 16f.).

85   The residence of the dukes of Brabant which stood near the present royal castle. AD drew a quick sketch of the scene from a window (W 822, S D 1520/15).

86   AD's submission to Charles V, requesting the confirmation and renewal of the liferent granted him by Maximilian I. It was accompanied by two drafts of a suggested form of words for the imperial chancery to use (165.1–2). The Nuremberg delegation took the final document back with them on their return home (165.3). Erasmus Strenberger (BI), from the Austrian Tyrol, was secretary and confidant of Banisius, after whose death he became a canon of Trento in Hapsburg Northern Italy. His will specified that he be buried in the same grave as Banisius.

87   Smith 2004, 75–7.

88   Ms A has *mein herr wirt*, 'my lord host'. The B text *meiner herren wirth* is more plausible.

89   Johannes, son of Dr Gregor Lamparter, imperial and Württemberg chancellor, appears to have been employed by the Austrian authorities in the Netherlands. The drawing is possibly W 806, S D 1520/14. The landlady may be the woman in Netherlandish costume W 746, S D 1520/13.

90   In the palace in Brussels were displayed gifts which Hernan Cortéz (1485–1547), the Spanish conquistador, was given by the Mexican Emperor Montezuma, and which Charles V brought with him from Spain to the Netherlands. They were in part stage properties from cult festival performances and ceremonies in pre-Columbian Mexico, and were also presented as gifts to distinguished visitors. The dramatic action in which the objects were used involved the sun, the moon and the morning star, as well as gods (Rupprich III, 441). Some of the objects are still in the Hapsburg treasury in Vienna. By curious chance, Ferdinand Columbus, son of Christopher Columbus, was in Brussels at this very moment in the entourage of Charles V, and he and AD could also have crossed paths in Aachen and Cologne, later even in Nuremberg where he spent a month in the winter of 1521–2. He amassed a large print collection in which AD's works were well represented (Schiffauer 1965, 67; Neuhaus 2002, 22; McDonald 2004a, 155; Parshall 2004, 181; Feest 2013, 367–71). On Nuremberg's contribution to the Iberian voyages of discovery in Columbus's 'quasi "New World"' (Christoph Scheurl writing to Sixt Tucher in 1506), see Schultheiß 1955.

91   Neither of the two manuscripts of the Journal attempts to reproduce this drawing.

92   The residence of Count Hendrick III of Nassau (1483–1538), tutor of Charles V, Stadtholder of Holland, Seeland and Frisia. The house was close to the ducal palace. Hendrick was an art collector and patron of Netherlands Renaissance artists such as Jan Grossaert, Baerent van Orley and Jan Scorel.

93   Regent Margareta's counsellor and treasurer, the general revenue collector of the Netherlands.

94   A ring made from buffalo horn, worn to ward off falling sickness, or epilepsy (Baumann 1996, 44).

95   Rogier van der Weyden's painting (circa 1440) of St Luke making a silverpoint drawing of the *Virgin and Child*, in preparation for his legendary portrait (Schaefer 1986; Smith 2004, 16–19; Nash 2008, 157f., 172). It hung in the chapel of the painters' Guild of St Luke and may originally have been the central panel of an altar, so that AD would have paid a gratuity to have the wings of the altar unlocked and opened. Several versions of the painting are known.

96   Probably the altar painting of the *Seven Sacraments*, recorded as being in the Nassau house in a seventeenth-century inventory. Hugo van der Goes (circa 1440–1482) also painted St Luke drawing the Virgin with a metalpoint on paper (circa 1480; Nash 2008, 205). AD does not mention Hieronymus Bosch's *Garden of Earthly Delights* which also hung in the Nassau house.

97   Allegedly the bed was built for the Count's drunken guests to fall into.

98   Baerent van Orley (BI), painter, designer of tapestries and stained-glass windows, since 1518 court painter to Archduchess Margareta.

99   Jehan de Metenye, also burgomaster of Bruges from 1517 to 1520.

100   Gillis van Busleyden, counsellor and chief accountant of Brabant, treasurer of the church of St Gundula in Brussels.

101   The charcoal sketch W 810, S D 1521/31, is probably of Baerent van Orley but is dated 1521 and cannot be the one referred to here.

102   Although AD had already received gifts from Erasmus in Antwerp (note 52), no portrait is mentioned at that point. The charcoal sketch W 805, S D 1520/16, is the only one preserved from 1520–21. In his letter of 19 July 1522, Erasmus tells Pirckheimer that AD had begun to 'paint' him in Brussels, though the Latin verb *pingere* also does duty for other media, including charcoal. AD's engraving of 1526, seemingly based on the sketch or sketches done in the Netherlands, shows a left-facing profile of Erasmus, not the almost full-face pose of W 805. It is not impossible that AD actually based the engraving on Quentin Massys's medallion of 1519, with the same profile view. But it seems unlikely that W 805 can have been the Brussels drawing.

103   *meiner wirthin gefatterin*: on *gefatterin* as 'neighbour', see Family Chronicle (1). The drawing is possibly W 746, S D 1520/13, which is headed in AD's hand, 'Done in Brussels 1520'.

104   The collection of scurrilous anecdotes, forming a 'life' of the picaresque anti-hero Till Eulenspiegel, became a best-seller in sixteenth-century Germany and, later, England. The earliest surviving version was printed in Strasburg in 1515, but the material comes from the Low German area of Brunswick. A second surviving edition was produced in Cologne (circa 1520) and a Low German version was printed in Antwerp some time after 1519 (see Rupprich 1970, 124–7). However, two copies of this copiously illustrated, sought-after book would have cost much more than one stuiver (see the prices AD paid for Reformation pamphlets, note 140), and Rupprich (III, 442) argues that what AD bought was copies of a single-leaf woodcut picture of Eulenspiegel or possibly one of Lukas van Leyden's copperplate engravings of episodes in the book.

105   Evidently AD lodged with the Nuremberg Council delegates (see note 80).

106   Son of the Nuremberg patrician Martin Geuder and Juliana, a sister of Pirckheimer.

107   She appears to have been a lady-in-waiting of Archduchess Margareta.

108   João Brandão, whose house was at Kipdorp, on the way to Antwerp, and his secretary Rodrigo Fernandez d'Almada. The Indian feathers and the porcelain bowls, which would have been traded from China to India, will have been cargo from a Portuguese merchant ship. AD's *porcolona* looks like a transcription from a heard, not written word. The earliest occurrence of the word in German is in the 1477 translation of Marco Polo's *Marvellous Journeys*. AD is likely to have heard Italian *porcellana* in Venice where the earliest imports arrived in the fifteenth century. Compare *porzelona* (note 261). See Massing 2007d. The Italian word may derive from the milky white colour of breeds of pig, Latin *porcella*, feminine diminutive of *porcus*.

109   Susanna's *höcken* – the same cape as Agnes had (note 68) – was quite an expensive one, whereas Agnes does not receive a gift. The parakeet acquires a cage.

Susanna (1502/6–1562) appears to have been something of a surrogate daughter to the childless Dürers. She married Georg Schlenk, an assistant in AD's workshop, in 1524. From 1533 he is recorded in a minor city function as excise-man at the Frauentor. Susanna's death is recorded in the necrology of St Laurence's Church.

110  A coconut, clearly a novelty.

111  Wilhelm and Wolfgang von Rogendorf, Austrian noblemen. Wilhelm (1481–1541) was Stadtholder of Friesland. Wolfgang (1483–1543) was marshal of the region of Austria below the Enns. The surviving, damaged copy of the woodcut of their coat of arms is in the GNM (S W 193, SMS 253). On journeys these were hung up outside inns and lodgings to advertise the presence of their bearer.

112  Member of an Augsburg trading family and nephew of Ambrosius Höchstätter (see notes 281/283).

113  Frederick II, prince elector and count palatine of the Rhine (1482–1556), a patron of AD, whose portrait of the prince, dated 1522, was noted by Joachim von Sandrart (1675) in the castle at Heidelberg. The silverpoint drawing W 903, S D 1523/8, of 1523 was the basis for a medallion.

114  That is, the *vera icon* of the face of Christ, on the cloth held out for him by Veronica to wipe his sweating face, as he carried his cross to Calvary. A favourite subject of AD – see the drawings W 272, 608 and 609, S D 1503/16, XW 608–9, the engraving S E.68, SMS 68 (meant here) and the etching S E 82, SMS 82.

115  Marc de Glasere, active in Bruges circa 1516–33, later at Archduchess Margareta's court in Mechelen. Despite AD's designation of Marc as goldsmith, Rupprich identifies him as glazier or glass-painter (hence his name!).

116  Perhaps Hennen Doghens, pupil of Dirk Vellert (see note 118).

117  Probably varieties of mineral coal and brown-coal (lignite) for sketching. What AD calls *steinkohle* is a soft chalk with very high carbon content and is first recorded as a sketching tool in his writings.

118  Dirk Vellert or Felart van Staar, glass-painter and copperplate engraver (BI), recorded as member of the Guild of St Luke in 1511 and its dean in 1518 and 1526. Ground brick dust may have been used as an admixture in vermilion pigment.

119  Master Jakob is later described (September 1520) as the Rogendorfs' painter (note 111).

120  Probably Messire Jehan Marie de Bonisiis, named in the archduchess's will in 1532 as physician in ordinary.

121  Perhaps W 812, but the watermark suggests a much earlier date: S D 1507/2.

122  He was one of the musicians of Phillip the Fair of Burgundy and later of Charles V.

123  From an old, originally Austrian noble family. His father Georg (died 1512) had emigrated from the Steiermark to Nuremberg in 1493. Georg the younger married the daughter of Hans Imhoff the elder in 1521, and AD was the godfather of their first child. The 'walking cane' (*meer ruten*) may alternatively have been a dried exotic

fish, another contribution to AD's cabinet of curiosities. See Rupprich I, 185, notes 238f., and Unverfehrt 2007, 84.

124 Wolf II Haller (1492–1559), financier, of the Netherlands branch of the Nuremberg patrician family, was agent of the Fuggers from 1519 but had become a courtier of Charles V.

125 Dene has not been identified.

126 Jan Provost or Prévost (BI). In Bruges he was an office-bearer in the Guild of St Luke between 1501 and 1526. His best known work is the *Last Judgement* in the Groeningemuseum, painted for the Town Hall of Bruges.

127 *angesicht*: literally 'face', it can denote 'portrait'. Hans Schwarz, the Augsburg medallist, worked in Nuremberg in 1519–20. AD had done a preparatory sketch for the inscription of a medal of himself in 1519 (W 720, S D 1519/17, see 143.4), but after Schwarz had been expelled from Nuremberg he seems to have produced only a one-sided boxwood model which he has now sent to AD in Antwerp. This model for the obverse survives in the Herzog Anton Ulrich Museum in Braunschweig, and the GNM has a bronze cast from it. It is inscribed ALBERTVS DVRER PICTORTS [sic] GERMANICVS. AD must have provided the fine portrait of himself, with its noble profile and flowing hair. See Ex. Cat. New York/Nuremberg 1986, 417, 474; Mende 1983, 57–68 & 182–6; Ex. Cat. Osnabrück 2003, 22f. The medal is the only known commission by AD (Smith 2011, 2).

128 Rupprich suggests these were penny-whistles made of clay for giving as presents to children!

129 Charles V's carefully staged royal progress through Bruges, Ghent and Ypres to Antwerp was a demonstration of his power, leading up to his coronation. A printed programme of the triumphal entry into Antwerp was sold to spectators. Peter Gilles and Cornelius Grapheus directed the thirteen allegorical plays (*pegmata*), performed on mobile stages, and wrote a Latin verse commentary on them. In the first, the Spirit of Antwerp bade the king welcome and the Three Graces proffered him their golden apples. In the rest, gods, goddesses and heroes, virtues and vices, and continents apotheosised the young monarch.

130 On the bashful monarch's embarrassment, and the painter AD's delight, at seeing naked young women in these tableaux, see 337.2.6. Philip Melanchthon recounted the description of the same tableaux which AD gave him, probably during his visits to Nuremberg in 1525–6. Grafton 2000, 149.

131 Rupprich's note (I, 186, 257) is incorrect. See Unverfehrt 2007, 94. The foundation myth of the city of Antwerp tells of the giant Druoon Antigoon, who imposed a toll on all who wished to cross the river Schelde, which consisted of cutting off their right hand. The young hero Brabo, allegedly a kinsman of Julius Caesar and founder of Brabant, slew the giant and cut off *his* right hand. On the spot where Brabo threw the cut-off hand, the town grew up. Thus the popular etymology of the name Antwerp: 'hand' and 'throw' (Middle Netherlandish *werpen*). The real origin is *aan de werf*, 'at the wharf'. The 'old book' is in the city archive.

132   *des Raphaels von Vrbins ding*: Raphael had died on 6 April 1520. *ding* can refer to engravings, in particular, but here seems to denote Raphael's artworks in general which his will stipulated should be dispersed among his pupils. AD's visitor was Tommaso di Andrea Vincidor (died 1536) who had come to Flanders in 1520, at the behest of Pope Leo X, to supervise the manufacture, by Peter van Aelst in Brussels, of Raphael's tapestries for the Sistine Chapel in the Vatican. See Nesselrath 1993.

133   *antiga*: see note 5 to AD's letter 29.2 to Willibald Pirckheimer from Venice (1506).

134   *ein calacut*: cotton fabric from Calicut (see note 50). But it could also mean 'Calicut hen' – a turkey!

135   Margareta was in fact Charles V's aunt.

136   See note 120.

137   Ziegler (died 1534) was imperial vice chancellor. He signed the letter confirming AD's annuity from the emperor (165.3). AD's associate Hans Schäufelein painted an altar of the *Lamentation* in 1521 for the chapel Ziegler endowed in the principal church of his native town Nördlingen.

138   Either another curiosity of nature or, when pulverised, a medicine for fever.

139   Adrian Herbouts (note 29).

140   *die Condemnatzen und dialogos*: both publications must relate to the Lutheran controversy. The former may be the pamphlet with denunciations of Luther's teachings by the universities of Louvain and Cologne (published without date or printer's name). Dialogue was a favoured medium and genre of Reformation controversy, and the proliferation of pamphlets in dialogue form, often anonymous and without publication details, makes it difficult to identify which works might have been available to AD. His use of the Latin word suggests that they were not in the vernacular.

141   A chalk stick coloured with ferric oxide, first used by Italian artists around 1500. However, no drawing by AD done with red chalk survives. He may have used it as a ground.

142   Presumably Tomasin's servant.

143   *des Raphaels ding*: here is meant the engravings based on works by Raphael carried out under his supervision, mainly by Marcantonio Raimondi. According to Giorgio Vasari (1568), it was to seek legal protection against the plagiarism of his graphic work, and the abuse of his trademark monogram, that AD went to Venice in 1505. See 29.2 and 29.5.

144   The portrait has not survived, but there are putative engraved copies extant from the seventeenth century. See Unverfehrt 2007, 89f.

145   The Augsburg trading firm of Meuting had a branch in Antwerp run by Georg Meuting who had married and settled locally.

146   Pine nuts were nutritious, but also often used as rosary beads, which AD continued to acquire despite Luther's rejection of the efficacy of mechanical prayer.

147   AD's account of Charlemagne's palace chapel at Aachen, where by long tradition German kings, later emperors, were crowned, shows a grasp both of the antique roots of the political ideology of the medieval empire and of the extent to which

Carolingian art and architecture inform the Northern Renaissance of the sixteenth century (see Bullough 1980, 149–53; McClendon 2005, 108–27; McKitterick 2008, 147–55). His description draws on a sharply observed vocabulary of Latin- and Italian-derived words. He confines his description of the Carolingian octagonal palace chapel to the pillars and capitals of the gallery. These, he recognises, are accurately proportioned, with correct Corinthian capitals, according to the *De Architectura* (books 3–4) of the Roman architect Vitruvius (active 46–30 BC). AD discovered this classical core text soon after 1500 and read how Vitruvius, 'who writes a little about the proportions of the human body', had derived from these the symmetry of the classical temple. He paraphrased passages of *De Architectura*, and studied and sketched the antique orders. He observed and drew classical buildings during his visits to Venice (see 20, 34, 51.1, 182.5; W 93 & III, 20, S D 1495/4 & 25; S AS 1508/1–2, 1509/3–4 & 7–16). His adjective *proportionirt* may well derive from his reading of Vitruvius. AD was aware, directly or indirectly from Einhard's *Vita Karoli*, the contemporary biography of Charlemagne written between 817 and 830, perhaps from the German translation printed in Cologne in 1512, that the columns and capitals of the chapel were *spolia*, salvaged from the ruins of Rome and Ravenna. Additional new columns and capitals were carved locally to supplement the originals. The *De Architectura* was still known circa 800, so that not only the Roman but also the Carolingian craftsmen followed Vitruvius's pattern. In 1511 AD had painted a large-scale portrait of *Karolus Magnus* on the panels made as doors for the shrine in which the imperial regalia and relics were housed in Nuremberg (64.7–11). In Aachen for the coronation of Charles V, he appears well versed in the historical and ideological significance of the Carolingian chapel and its Roman artefacts and the continuities it embodies, back to the Roman Empire and forward to the Hapsburg imperial present and the Renaissance revival of the scientific learning of Antiquity. He connects the material of Roman architecture, through its Carolingian Christian reuse, to the contemporary Holy Roman Empire which, in the person of his imperial patrons Maximilian I and – as he hopes – Charles V, sponsored the revival of classical art and learning in Germany. The ancient columns in Aachen are made, he observes, of *porfit*, 'porphyry' (in the sense 'red marble'). His form of the word derives from an Italian variant *porfido*. AD seems also to realise that not all the porphyry columns of the octagon came from Theoderic the Great's palace in Ravenna. Some of them, and their capitals, were local additions to the Roman *spolia*, whether newly quarried or recovered from Roman Cologne or Trier, and whether carved by Frankish or Italian masons (Stalley 1999, chapter 3; McClendon 2005, 112). The columns, he says, are *von porfit grün und rot und gossenstein*. The word *gosse* means 'gutter/drain', and *Goßstein*, *Gußstein* or *gossenstein* (DWb IV, I, 5, 985) is the hard, impermeable stone needed for channelling waste drainage from a kitchen or latrine. Most commonly this would be a kind of basalt. German *Basalt* is not recorded before the seventeenth/eighteenth century and AD perhaps fell back on the synecdoche *gossenstein*, 'drain-stone'. In fact the supplementary columns in Aachen are

of fine-grained local granite. The word *Granit* is likewise not found in German until the mid-eighteenth century (DWb IV, I, 5, 1862–4; Pfeifer 1989), and if AD realised that the columns were granite, it may be that he had also encountered granitic stone used as 'drain-stone'.

148    *verbadet und…vertruncken*: the prefix *ver-* attached to both verbs can connote indulgence, excess, using up or wasting money. From Roman times Aachen was famous for (and named after) its thermal springs.

149    AD drew the fourteenth-century Town Hall in his sketch book (W 764, S D 1520/20), and through the window of the state chamber, where later medieval coronations took place, he drew the church of St Mary, now Aachen Cathedral (W 763, S D 1520/22).

150    A local tavern.

151    Christoph (1508–1561) was the eldest son of Leonhard Groland who had evidently brought him along on the diplomatic mission.

152    Peter von Enden or Inden had been the previous year's burgomaster of Aachen.

153    Topler (1456–1544) and Pfinzing (1490–1552) were both from Nuremberg. The drawing of the venerable Topler and the youthful Pfinzing (W 761, S D 1520/19) is the first and one of the finest in AD's silverpoint sketchbook.

154    What AD saw must have been the late medieval arm reliquary of Charlemagne, since the remains of Emperor Henry II were preserved in Bamberg. 'Other relics' will have included the swaddling clothes of the infant Jesus.

155    Kaspar Sturm (1475–1548), in the service of Cardinal Albrecht of Mainz in 1515, then from later in October 1520 Imperial Herald. He escorted Luther from Wittenberg to the Diet of Worms in 1521, and was probably the author of the first pamphlet describing Luther's interrogation there. The silverpoint portrait (W 765, S D 1520/21) is on the reverse of AD's silverpoint of the town hall in Aachen (see note 149).

156    Presumably an oil painting, but not identified.

157    Jakob Köpfinger from Ulm had been a legal official in Nuremberg from 1506 to 1509. Rupprich's reference (R I, 188, note 297) to W 769, S D 1520/29, as the metalpoint portrait is mistaken. It depicts a young man against an Antwerp townscape.

158    AD must have in mind the account of the coronation by Hermann Mohr, published in Latin in Cologne in 1520 and Nuremberg in 1523, and in German in 1521. Mohr was present at the ceremony as counsellor to the archbishop of Cologne. As the Nuremberg delegates reported to the city council, the crush in the chapel was such that of the insignia they had taken to Aachen only the imperial mantle actually reached King Charles, and 'at this coronation the electoral lords spiritual had no notion of what was appropriate'. See Bühler 1971, 158f.

159    It is tempting to read this as documentation of an encounter with Mathis Gothart Nithart (circa 1480–1528), generally known in modern times as Matthias Grünewald, the other outstanding painter of early sixteenth-century Germany. They had both contributed to Jakob Heller's Frankfurt altar in 1508–9, but not in direct

co-operation, and there is no other evidence of a meeting between them. Grünewald could have attended the coronation in the retinue of his patron Cardinal Albrecht of Mainz. However, a more likely identification is with Matthes Püchler, registrar in the imperial chancery, who witnessed Charles V's instruction to resume the payment of AD's liferent (165.4).

160  Etienne (or Stephan) Lullier was also in charge of the archduchess's library in Mechelen.

161  *ein zeter paum paternoster*: a rosary – cedarwood beads threaded on a string, for use in private devotions, counting off the repeated recitation of the Lord's Prayer (*pater noster*) and Hail Mary. Despite his incipient Lutheran zeal, AD still clings to this characteristic practice of late medieval Catholic piety. However, rosaries were also valued as necklaces.

162  A place name is missing.

163  On the journey to Seeland AD buys a further pair of glasses.

164  A cheap – stamped not cast – silver medallion, which AD concludes is a waste of money (*verspielt*).

165  The manuscripts have *Lewern* (B) and *Löwen* (i.e. Louvain), but it must be *Düren* that is meant, where the church had a fragment of a skull alleged to be that of St Ann, stolen from Mainz in 1500 but kept in Düren by papal consent and by 1520 a popular pilgrimage goal.

166  It is impossible to guess which of Luther's writings this might have been. For the *Condemnatio Lutheri*, see note 140. His recognition of the Reformer as a godly man does not deter AD from buying another rosary, having given the one made of cedarwood beads to Hans Ebner.

167  Perhaps this skull and the ivory skull bought in Cologne were for use as models in the painting of *St Jerome* (A 162) and the preparatory drawings (W 792, S D 1521/6).

168  *enspertelle*: these are additions to the pair of shoes referred to immediately above. By *ens* is meant the strap or bar which forms the heel of the shoe, and *pertelle* is a diminutive form of *borte*, 'braid trimming' (R I, 188, note 313).

169  The daughter of AD's cousin Nikolaus Unger. See R I, 188, note 315, on this Nuremberg Hallowe'en custom.

170  The reference here to a *maister Steffan zu Cöln*, as the painter of an altar panel, taken to be the great retable of the *Virgin Enthroned* and the *Adoration of the Magi*, then in the chapel of the town hall, now on the high altar of Cologne Cathedral, led to the identification in 1850 of Stephan Lochner (active in Cologne from 1447 to his death in 1451) as the artist concerned. Matthias Quad von Kinckelbach in 1609 tells an anecdote of how AD was aghast to hear that the artist had died a miserable death in poverty and neglect. Neither the assumption that AD saw this panel nor its attribution to Stephan Lochner has gone unchallenged. Corley 2000, 133f., rejects both. But see also Smith 2004, 26–9; Nash 2008, 23, 239.

171  Not identified.

172 The Gürzenich hall, built circa 1440, destroyed in an air raid in the Second World War.

173 There are three versions of the coat of arms (see S W 194, SMS 254f.). See the reference in the Journal to a second woodblock in Antwerp in January 1521.

174 Duke Frederick the Wise, Luther's protector and AD's earlier patron, had an attack of gout in Cologne and could not proceed to the coronation in Aachen.

175 The portrait, presumably done in return for the Nuremberg envoy's hospitality, has not survived.

176 A legend, much elaborated over centuries, told how St Ursula and her companions, including Pope Cyriacus and 11,000 virgins (originally eleven but multiplied by the misreading of a manuscript) were slaughtered at Cologne by Attila's Huns. The church stood on the site of a Roman cemetery, the bones of which (belonging to both sexes) were piously misinterpreted. See also note 295.

177 Johann Ferenberger, royal secretary, had cordial links with Nuremberg. In 1523 he entered the service of Archduke Ferdinand for whom AD wrote his *Instruction on Fortification* (1527).

178 AD or a copyist mixes up Leonhard Groland and Nikolaus Haller.

179 Not identified. AD presumably needed her as a model.

180 With this *confirmacia* of his liferent (see 165.3), which the envoys could now take back to the council in Nuremberg, the most urgent purpose of the journey had been achieved. But there is no suggestion that AD might himself return.

181 Not identified.

182 The church of St Stephan and the imperial palace, the Valkhof, originally set up by Charlemagne.

183 In fact, the river Waal.

184 AD uses the two verbs *verfahren* (for the river voyage) and *verreiten* (for the horse-ride). See note 148.

185 *Bosch* – 's-Hertogenbosch – was at this date the third largest city of the Netherlands after Antwerp and Brussels. Sint-Janskerk was a huge church in French Gothic style from the later fourteenth century. Among its treasures (many later destroyed by Calvinist iconoclasts) were three paintings by the city's greatest artist, Hieronymus van Acken or Bosch.

186 's-Hertogenbosch was a major centre of goldsmith work. AD's host may have been one of them, Arnoldus die Leeuwe (Unverfehrt 2007, 112).

187 The Assumption of the Virgin Mary had been 15 August. It must have been the feast of the Presentation of Mary in the Temple, on 21 November.

188 Not identified.

189 Mentioned for the first time here is the engraving *The Sea Monster* (S E 23, SMS 21) and the six etchings he made between 1515 and 1518. AD was one of the very first artists to experiment with etching, invented around 1500 by Daniel Hopfer in Augsburg.

190   *schon loth*: Netherlandish *lood*, 'lead'. An ounce of fine white lead, used as a pigment by painters since antiquity. However, to give three of AD's large books of prints for an ounce of this is exceedingly poor value. Unverfehrt 2007, 116f., suggests that AD is bartering for solder (also termed *lood*) alloyed with silver or gold and copper, as used by goldsmiths.

191   *mit einer großen Fortuna*: in medieval Latin, *fortuna maris* referred to the hazards of sea voyages. In Italian, *fortuna di mare* came to mean specifically 'storm, tempest' (Battaglia 6, 226). From Italian seafarers it entered German descriptions of Mediterranean travel and pilgrimage in the later fifteenth century. See Niermeyer 2002, I & Rupprich III, 442.

192   *viel mehr dann hundert klaffter lang*: both German *klafter* and English 'fathom' originally meant the span of both arms outstretched. As a fixed measure for commercial purposes it varied regionally but was on average around six feet or 1.8 metres. At 100 fathoms, the creature would have been a good six times the size of any known species of whale. No wonder it turned out to be, in fisherman's parlance, 'the one that got away'.

193   Stephan Capello was a jeweller and goldsmith who worked in particular for Archduchess Margareta. Perhaps the 'goldsmith from Mecheln' portrayed in the pen drawing W 745, S D 1520/9, and the chalk sketch W 812, S D 1507/2 (the latter dating is based on the watermark of this sheet). The acquisition of yet a further cedarwood rosary suggests that AD may have collected them as jewellery or objects of value. In 1569 Willibald Imhoff paid 12 gulden for a rosary of thirty-two coral pearls that had been AD's property.

194   *kesselbraun*: Rupprich takes this as a scribe's error for *kesterbraun*, 'chestnut brown'. But see DWb V, 623: a painter's pigment associated with the colour of a copper cauldron (*Kessel*); the term is well attested in the fifteenth and sixteenth centuries. On the competing theories about the composition and origin of the colour, see Heydenreich 2007, 159–61.

195   The drawing has the soldier and lutenist Felix von Hungersberg kneeling and supporting his (unfinished) coat of arms (W 819, S D 1520/28). While the manuscript text of the journal says in 'his' book, the original may have said in 'my' book (*mein* rather than *sein*). Otherwise the survival of the drawing is hard to explain. See also note 41.

196   *100 ostria*: German *auster*, from Low German *uster*, is not found until the sixteenth century. The Netherlandish word was *oester*. AD cannot have been used to eating oysters in Nuremberg, dangerously far from the sea for the safe consumption of shellfish. But in Venice in 1495 he did a pen drawing of a lobster and a crab (W 91f., S D 1495/21f.), and it appears that he still thought of oysters as Italian (*ostria/ostrea/ostrica* from Latin *ostrea* – Battaglia 12, 263f.). On a much later visit, in 1786, Goethe was equally fascinated by the crustaceans on Venetian fishmongers' slabs: 'What a precious, glorious thing a living creature is! How adapted to its condition, how true, how *being*!' (*wie wahr, wie seiend*).

197    Lazarus Ravensburger from Augsburg, factor of the Höchstetter mercantile family in Lisbon since 1515, is portrayed in AD's silverpoint book (W 774, S D 1520/35).

198    Presumably Hennik or Hennen Doghens (see notes 116/118).

199    Jan de Haas was his host in Bergen op Zoom. The drawing of the maid and 'old woman' appears in the silverpoint sketchbook (W 771, S D 1520/31).

200    The Markiezenhof, residence of the Marquis of Bergen. AD drew a view of the town in his sketchbook (W 768, S D 1520/30) and a silverpoint of the choir of the Groote Kerk, still under construction (W 772, S D 1520/33).

201    Imhoff, a member of the major Nuremberg dynasty, had been a friend of AD at least since 1506.

202    She is the right-hand figure in the silverpoint W 770, S D 1520/32.

203    *Johann de Abüs*: Jan Gossaert or Mabuse (BI), painter and engraver, His greatest work, the altarpiece of the *Deposition of Christ* in the Premonstratensian abbey in Middelburg had just been completed when AD saw it. It perished in a fire in 1568. Carel van Mander describes AD's visit. By *hauptstreichen*, the painting of heads, AD has in mind no doubt the proportional construction of human heads which he demonstrates at length in his *Four Books of Human Proportion* and its preliminary drafts.

204    Veere op Walcheren.

205    One of three brothers of an old Nuremberg family.

206    *lechst*: superlative adverb from the adjective *lech*, *leck*, English 'leaking, leaky'. It came also metaphorically to mean 'drained of strength'. See DWb VI, 471f. & 475f.

207    None of AD's drawings of it survives. The town hall had a similar design to that in Brussels. Begun in 1452, it had been rebuilt in 1512 by Rombout Keldermanns. The newly completed abbey, with its late Gothic woodcarving and *porkirche* (triforium chapel: see note 56), was destroyed by fire in 1568 and the old town suffered severely from bombing in the Second World War.

208    Rupprich's note 410 (I, 191), which indirectly identifies 'Meister Hugo' as Hugo van der Goes, should be ignored. He had died in 1482.

209    Friedrich Kraussberger was factor for the Nuremberg trading house of the Hirschvogel brothers (Bernhard was a friend of AD) which had branches in Venice and Antwerp.

210    See Unverfehrt 2007, 128f. Tulips and hyacinths were not yet known in Europe. Narcissi were available by circa 1530. The sprouting bulb was most likely a Mediterranean autumn- and winter-flowering sea onion (*urginea maritima*), which had medicinal uses in treating dropsy.

211    AD did manage to sketch a walrus, though he fails to mention it. See fig. 51.

212    *ein koczen*: either *kotze* (masc. or fem.), a rough-textured, shaggy or felted woollen bed or horse blanket, a garment worn particularly by a peasant or pilgrim, formerly common across the German dialects, now restricted and archaic in South German and Austrian, or *kötze* (fem.), basket, usually of wicker. See DWb V, 1901–5. The erosion of grammatical inflexions in AD's German allows either possibility.

213  *den Schnabhannen*: robber knight or highwayman. The word occurs in Sebastian Brant's *Ship of Fools*, in Hans Sachs, and other popular literature. Who or what AD meant by it is a puzzle.

214  The son of Jan de Haas in Bergen op Zoom.

215  There is much doubt and confusion about four names, *maister Bernhart* (note 98, Bernhard/Baerent van Orley?), *Bernhart von Castell* (note 247), *Bernhart von Resten* (= Bernhart van Reesen? – see note 279), and (here) *Bernhart von Breßlen*. Perhaps all are to be read as 'Bernhard of Brussels', that is the painter Baerent or Bernhard van Orley? Or as Bernhard van Reesen? Frustratingly, in the oil painting known as 'Bernhard van Reesen' (note 279), the subject holds a letter, but obscures with his fingers most of the inscription 'To Bernhar...at...'. See R I, 194, note 538.

216  *Kamrich*: from the Flemish form, *Kamerijk*, of French *Cambrai*. See Zander-Seidel 1990, glossary: *Kammerleinwand* or *-tuch*.

217  Bernhard Kerpen, steward of the Count of Nassau.

218  *zwo zichen*: modern German *Zieche*, cover for pillows, feather beds and quilts (Zander-Seidel 1990, glossary).

219  *soilir*: AD uses his version of Venetian Italian *zoieler*. See 29.5, note 1.

220  All of these objects are presumably items for AD's cabinet of exotica. The fish scale may have been a shark's fin.

221  *latwerge*: electuary or conserve of fruit, syrup or honey into which one could stir medicinal powders such as theriac to make them palatable. The German word is a corruption of Latin *electuarium*.

222  *mehr käczlein*: small African mongoose (*meerkat* is Netherlandish for 'sea-cat').

223  *Gerhart Pombelly*: AD customarily refers to him by the German equivalent of his name Gherardo, and the surname too suffers from its transcription into Nuremberg phonology.

224  She was Gherardo's fiancée, or so Rupprich assumes.

225  Francesco Pesão, 'the little factor', successor to consul Brandão.

226  Ulrich Hanolt or Haunolt from Augsburg was married to Felicitas Meuting, from another Augsburg family; the Meuting here is probably her relative Georg. Kaspar Lewenter has not been identified.

227  This may be the ninety-three-year-old man who was the model for the drawings W 788f., S D 1521/2f., and for the painting of *St Jerome*. See note 267 and text 163.23.

228  Rupprich I, 191f., note 448, discusses at length whether 'Master Jakob' is the physician referred to on further occasions in 1521 or Provost Jakob, prior of the Antwerp house of the Augustinian Hermit Friars. But these are not even the only two whom AD names in this way.

229  *ein pisem knopff*: the strong-smelling substance secreted from a gland of the male musk deer was used as an ingredient in perfumes (the word derives from Sanskrit *muska*, 'scrotum'). The dried gland, enclosed in a decorative, pierced container, called a musk-apple or musk-ball, was carried as a specific against the plague.

230    Agnes Dürer had evidently become godmother to the Planckfelts' baby. The gulden inserted into its swaddling clothes was a contribution to its upbringing, while the small change would help towards drinks shared by mother, midwife and woman friends. See the woodcut of women celebrating the birth of Mary (*Life of Mary*, S W 78, SMS 170). Putting money into a pram, 'to wet the baby's head', is a neighbourly custom still practised in Scotland.

231    *meister Dietrich*: the glass painter Dirk Vellert. The *Six Knots* are the woodcuts S W 100–105, SMS 142–7 and pp. 148–57, printed on Italian paper such as AD used in Venice in 1506. They are free copies of six copperplate engravings, related to Italian quattrocento patterns for embroidery and ceiling designs, some of which have in their centre the inscription *Academia Leonardi Vi[n]ci*. AD omits this, and there is in fact no documentary evidence for such an institution. The designs are not really 'knots' but exceedingly elaborate, symmetrical circular systems. It may be that they were conceived as expressions of artistic virtuosity in the near-infinite extension of pure line, perhaps prompted by Pliny the Elder's story of the competition between Apelles and Protogenes as to who could draw the finest freehand line (*NH* 35, 81; McHam 2013, Plinian Anecdote 8). AD may have set out to outdo Leonardo by copying his engraved designs in the still more demanding medium of woodcut.

232    A picture of a putto painted in gouache on a canvas cloth.

233    *doctor Loffen*: Rupprich suggests (I, 192, note 460) Dr Luppin, formerly physician to Emperor Maximilian I.

234    Sute Bombelli might possibly be the left-hand figure on the silverpoint leaf W 782, S D 1521/46, but the identification is disputed.

235    *ein herczog angesicht*: Frederick the Wise of Saxony and Frederick II, the Count Palatine, have been suggested as subject. But it is strange that AD does not give a name. Perhaps the head of a Roman general (*dux* is the Latin equivalent of *herzog*).

236    *Der Ruderigo, scriban de Portugal*: see note 69. AD's word for 'secretary' here is not German, though the nouns *Schreiber* and *Secretary* were both available. *Schreiber* is what he calls his friend Lazarus Spengler, town clerk of Nuremberg (63.6). He calls Peter Gilles and Cornelius Grapheus *secretary*, often synonymous with *Schreiber* but perhaps more prestigious in implication and as a Latinate word (see note 257). Martin Luther appears to have coined *Skribent*, 'writer, author', from Latin *scribens*, but it can scarcely have entered AD's active vocabulary from that source as early as 1520 (DWb X, I, 1331f.). *scriban* might reflect the title Rodrigo himself used. Modern Portuguese has *escrevente*, and *escriba* from Latin *scriba*, 'scribe, clerk, notary' (see Niermeyer 2002, II, 1235). But it is possible that here again AD recalls the Venetian form of Italian *scribano* or *scrivano* (Battaglia 18, 304f.).

237    Ms A has *zweÿ calacutisch töchter*, but the collator/corrector has emended *töchter*, 'daughters, girls' to *tücher*, 'cloths'. It does seem unlikely that Agnes Dürer would have tolerated two dusky slave-girls in the household.

238    *mirabulon*: Myrobalan, plum from the East Indies, with alleged medicinal properties of strengthening the heart and liver. The increasing prominence of therapeutic

substances among the gifts from his friends may indicate their concern about his health, which AD confirms in his entries in April 1521. See notes 302, 306, 315 and subsequent references.

239   The Fugger employees were preparing for the coming carnival.

240   The *sudarium* or cloth with which Veronica wiped the sweating face of Christ on the way to Calvary, and which then for ever bore the imprint of his face.

241   *futrall*: cases shaped for specific objects – as, here, pictures – to fit into.

242   The next Sunday before the Lenten fast (Quinquagesima).

243   Gerhard van der Werwe.

244   Florent Nepotis or Fleurequin Neefs.

245   Thomas Lopez was the former factor of Portugal, later knighted and promoted to royal ambassador.

246   No wonder, since AD had designed his mask!

247   No member of the great noble family of the Counts of Castell had this Christian name at that time. He possibly came from the place called Castell in Franconia. But see note 215.

248   Gherardo Bombelli's betrothed.

249   *den guten marmelstain hauer, maister Jan*: Jean Mone (circa 1485/90–1548/9), from Metz, who later entered the service of Charles V, had just been working in Barcelona on the sculptures of the cathedral of St Eulalia. Christoph Coler (BI) was a Nuremberg patrician and friend of AD.

250   *Jan Türcken*: according to Rupprich I, 192, note 485, Jan or Jakob Tierik, painter and art dealer (died 1567). But see Unverfehrt 2007, 239, note 34.

251   On the supply and value of ultramarine, see 47.3–4, 47.7, 85.2 and Burmeister/ Krekel 1998.

252   Hans Schäufelein (1480/85–1538/40) had been AD's pupil from 1503 to 1510 and began to sign his own work as early as 1504.

253   Perhaps ivory saltcellars imported by the Portuguese from Sierra Leone. See Smith 2011, 27.

254   Not identified.

255   The engraving *Knight, Death and Devil* (1513. S E 71, SMS 69).

256   Margareta, wife of Christoph Coler (see note 249).

257   Peter Gilles or Aegidius. AD gives him the title *secretary*, a later fifteenth-century German loan-word from Latin *secretarius*. Used in ecclesiastical and secular contexts in the sense 'confidential advisor, privy counsellor, private secretary', it is often synonymous with *schreiber*, particularly *stadtschreiber*, 'town clerk', but eventually largely supplants it. Compare notes 236, 270 and 276, and see DWb X, I, *Sekretär*, and Pfeifer 1989, 3, 1611.

258   In fact, the recently completed north tower of the church of Our Lady is 123m high, that of the cathedral in Strasburg 143m.

259   His fiancée, one would hope.

260 A specially made case for his portrait.

261 *porzelona*: compare the *porcolona* given him earlier by Consul Brandão (note 108).

262 The *Meersche* guild of mercers (dealers in silk and fine fabrics) had a hall called The Black Eagle on the great market place and an altar of St Nicholas in the church of Our Lady. The *Seated St Nicholas* was a design for a mass vestment for the priests serving the altar. Two designs by other artists had been rejected. The guild's payment to AD is recorded in its accounts as 18 stuivers and 9 pence. The silverpoint drawing of an enthroned bishop W 776, S D 1521/10, may have some connection with this commission but is not the design as such.

263 Peter Teels? See note 30.

264 It seems that already in mid-March 1521, AD is preparing for the return journey. The contents of the small bale (*pellein*) are protected against damage and breakage in a barrel (*stübich*) and no doubt included the gifts to Nuremberg friends detailed a little later (see notes 271–5). The Hesslers were freighters.

265 Compare note 208. This is the *Meister Hugo* AD met and did a likeness of in Middelburg. See also note 147, where AD comments on the antique porphyry columns of Charlemagne's chapel in Aachen. The *porfido steinlein* sounds like a geological rather than an archaeological fragment.

266 It is not clear whether these were designs for the interior or exterior decoration of the Bombelli house. Mural designs for rooms are found in AD's drawings. W 921, S D 1521/62 is dated 1521, when on his return to Nuremberg AD began work on elaborate plans for the redecoration of the town hall (168). Two earlier drawings, W 710f., S D 1506/27f., are clearly meant for house façades. They belong in a line of adaptation from the North Italian examples which Tommaso Bombelli may have had in mind, best exemplified by Hans Holbein's decoration of the House of the Dance in Basel and by painted house fronts in Augsburg.

267 The painting (A 162, see 163.23) is in Lisbon. On the preparatory studies which survive (W 788–92, S D 1521/2f.), see note 227. Numerous copies of the painting testify to its popularity. See Price 2003, 217–20; Ex. Cat. Bruges 2010, 430.

268 It was customary to give an offering to a confessor, especially at Easter.

269 *tärtschlein*: a small round or oval shield, archaic English 'targe'. In German the word has died out. Modern English 'target' has greatly extended meanings. See DWb XI, I, 1, 146f. *Tartsche*; SOD 'targe/target'. Gilbert is not identified.

270 Cornelius Grapheus, *der von Antorff secretary*, musician and poet (BI and notes 236, 257). His letter to AD in 1514 (188) demonstrates his strong commitment to the Reformation. On rock- or stone-chalk (*stain kraide*) see *steinkohle* note 117.

271 See note 264. The recipients of gifts are the wives of AD's friends: Klara Nützel, Felicitas Imhoff and Barbara Straub (both daughters of Willibald Pirckheimer), Ursula and Juliana Spengler (wives of the brothers Lazarus and Georg), Katharina Löffelholz (Agnes Dürer's aunt).

272 The silver coronation medallion of Charles V.

273   For Kaspar Nützel, Jakob Muffel and Hieronymus Holzschuher, see BI.

274   Ursula, widow of Hans Kramer, and Pirckheimer's neighbour. Her present of *zendeldort* was silk cloth known in Italy as *zendale*, woven of *seta torta*, 'twisted silk yarn'.

275   Katharina, wife of Hans Lochinger who had tried to persuade the imperial court to resume payment of AD's liferent in November 1519 (149).

276   Adrian Herbouts, whose designation here, as *secretary*, may allude to his role as attorney-general. The panel of *Lot and his Daughters* is the work of Joachim Patinir and may be the landscape painting of the burning of Sodom now in Rotterdam (Boijmans van Beuningen Museum). It has an eighteenth-century inscription on the back which makes that claim. It might be the panel of this subject attributed to AD himself which was sold to Emperor Rudolf II out of the Imhoff collection some time after 1580. See Unverfehrt 2007, 138–40.

277   AD had also brought stocks of prints by his former associate Hans Baldung, known as Grien or Grün, to sell in the Netherlands.

278   Powdered sandalwood in precipitation with rose- or endive-water was held to alleviate fever.

279   Presumably the portrait of Bernhard van Reesen, merchant from Danzig (Gdansk). See note 215 and Ex. Cat. Bruges 2010, 428f.

280   The Swiss War of 1499 was fought between the Swiss Confederation and an alliance of Emperor Maximilian I with the Swabian League, to which Nuremberg contributed a contingent of troops led by Willibald Pirckheimer. The war featured among the exploits celebrated on the *Triumphal Arch* (1512–15, see 97.1). In 1520 Pirckheimer was writing an account of the war. The price AD paid suggests that what he bought was a broadsheet with woodcut and text or a set of engravings of the war (R I, 194, note 539).

281   The model ship designed and given to him by Ambrosius Hochstätter (see note 283).

282   Also known as *lignum gualacum* and in German as *franzosenholz* ('French wood'), it was imported from the West Indies from circa 1512 and used, in finely grated form, particularly in the treatment of syphilis, the *morbus gallicus* or 'French disease'. The German humanist Ulrich von Hutten attributed his recovery from syphilis to its properties. AD expresses his own fear of contracting syphilis in his letters from Venice. However, his purchase is undoubtedly connected with the other evidence in this part of the Journal of his search for treatments for the malarial fever he had contracted in Zeeland (see Johnson 2008, 159–62, and note 302).

283   Ambrosius Hochstätter (died 1534), from Augsburg, resident as a merchant in Antwerp. His family business, along with the Fugger and Welser companies, had fitted out three ships which sailed with the king of Portugal's fleet to the East Indies in 1505. The Hochstätter firm failed in 1529 and Ambrosius died in prison.

284   *sein morin*: the silverpoint drawing W 818, S D 1521/8, see 163.24.

285    *schamlot*, or *camelot*, was a high-quality woollen weave, preferably of camel or goat hair, used for women's outer garments (Zander-Seidel 1990, glossary).

286    Neither sitter nor portrait has been identified.

287    Hans Lüber or Lieber (died 1554) belonged to a patrician family in Augsburg, but himself lived in Ulm.

288    For Jan Provost, see note 126. He was not born in Bruges but in Bergen (Hainaut).

289    *Pol, die reiche abteÿ*: wrongly corrected to 'Sint Paul' by Rupprich, this is AD's mishearing of the name Boudelo, where the wealthy Cistercian abbey of Our Lady was situated (Unverfehrt 2007, 152).

290    See note 115.

291    The *Prinsenhof*, palace of the counts of Flanders, then of the dukes of Burgundy.

292    The palace and its chapel no longer exist and there is no record of such paintings by Rogier van der Weyden. Nor is AD's other 'old master' identifiable.

293    A late Gothic parish church. No works of either Rogier or Hugo are known to have been here, though there was a triptych with a deposition of Christ by Robert Campin, Rogier's teacher.

294    *das alawaser Marienbildt*: the white marble Madonna and Child of circa 1500 was bought from Michelangelo by the Mouscron family for their funerary chapel in the church of Our Lady. AD takes it to be alabaster.

295    By *Johannes* AD could mean either Jan van Eyck, whose *Madonna of Canon Joris van der Paele* was in the cathedral of St Donation, or Hans Memling, three of whose altars and the *Shrine of St Ursula* are in the chapel of the Hospital of St John. Dieric Bouts, whose *Martyrdom of St Hippolytus* was in St Salvator's, might well be one of 'the rest'.

296    The chapel of the guild of painters, saddlers and glaziers, built in 1450. It is impossible to reconstruct what out of its large collection of paintings AD could have seen.

297    St Bavo's Cathedral, then a parish church dedicated to St John the Evangelist and St John the Baptist.

298    The Ghent Altar of the *Adoration of the Lamb*, locally attributed to Hubert and Jan van Eyck, although their role in its painting is still unresolved. 'Our first comment by a northern artist on a northern work' (Nash 2008, 11–14, 36; see also Smith 2004, 165–8).

299    The silverpoint drawings W 777, 779 and 781, S D 1521/11–13.

300    In 1371 a father and son were condemned to death for an insurrection against the count of Flanders. To find out which was stronger, a father's love for his child, or the child's for its father, the count promised to spare the one who cut off the other's head. The father insisted that he should die, since the son had his whole life still before him. But when the son came to behead his father, the sword shattered, and the count

pardoned them both. The Hoofdbrug was indeed the city's place of executions from 1371 to 1585 (Unverfehrt 2007, 160/63).

301  These are the rivers Schelde, Leie and Lieve, and the Moere canal.

302  AD now acknowledges the reason for his strong interest in remedies for fever evident in the Journal since his return from the coastal areas of Holland. Low-lying Zeeland was notorious for agues and malarial infections, although mosquitoes should not have been a danger in December. The fever was apparently intermittent but acute, and there is little doubt that it at least contributed to his ill health in the following years and his relatively early death just seven years later. It is possible that he had suffered similar infections at earlier stages of his life and that a new infection aggravated a chronic condition. The sketch of himself pointing to his spleen as the seat of a pain, usually assumed to have been done for the guidance of a physician (W 482, S D 1519/2, text 46), may date from soon after his return from Venice in 1507. A painful spleen is one symptom of malaria, and it is entirely possible that AD could have first contracted the disease in mosquito-ridden Venice. At the same date he blames his lack of progress on Jakob Heller's altar on a fever that has lasted several weeks.

303  Book-binding was a common way for monks to fulfil the requirement of the monastic rule of life that they should perform tasks involving physical labour. Books for the community's library needed binding, and when done for outsiders it brought income for everyday expenses. The only books AD mentions having acquired in the Netherlands are Reformation pamphlets. Perhaps one of the Augustinian friars, sympathetic to the Lutheran cause, was prepared to do the job of binding 'heretical' material.

304  Anna Frey, who died on 18 August 1521.

305  The silverpoint portrait has not survived, nor is it clear what the second portrait, done for but not necessarily of Patinir, may have been. Carel van Mander claims that AD did a likeness of Patinir with an engraver's burin on a slate, and that the silverpoint was the model for an engraved portrait of Patinir by Aegidius Sadeler (R I, 195, note 588, and III, 442).

306  Rupprich suggests that Jakob, perhaps AD's regular physician in Antwerp, may have been Jacques de Moore who, along with Jan de Marnix, Etienne Lullier and Florequin Nepotis, was a member of the Guild of St Sebastian at the court of Archduchess Margareta.

307  At a total cost of more than thirty-three gulden, this was an extraordinarily luxurious garment. It may have been intended in the first instance for wearing at Patinir's wedding.

308  *Cruce*, see also *creutzwoche*: Rogation week, the week in which Ascension Day falls, was a time for penitence and a term for financial settlements.

309  *maister Joachim der gut landschafft mahler*: while the use of 'landscape' as a term in painting is first attested in German in 1518, this is the earliest known occurrence of the compound 'landscape-painter' (DWb VI, 131 & 134; Paul 2002, 586). Italian

*tavolette de paesi* is also first recorded in 1521, in the context of a Venetian collection which contained works of Patinir (Unverfehrt 2007, 171).

310 It was Patinir's second marriage, to Johanna Noyts.

311 Theatrical performances had a part in festive culture, both public and private, to an extent that would have been unfamiliar to AD in Nuremberg. The first play, with a serious theme, perhaps based on a biblical story (Susanna and the Elders or the Marriage at Cana suggest themselves), will have been followed by a comedy or farce.

312 See note 115.

313 Member of a Nuremberg merchant family.

314 These and other domestic purchases during the latter stages of AD's stay in Antwerp go together with less frequent dining out, and show that he and Agnes had their own household quarters in the Planckfelt hostelry.

315 *dem frembden arczt*: his identity is unclear, since *fremd* can mean that the doctor was either 'foreign' or merely a 'stranger'. It suggests that AD was concerned to have a second opinion on his illness.

316 Compare note 235.

317 Anzelewsky identifies this portrait of Lorenz Sterk as the badly repainted picture in the Isabella Stewart Gardner Museum, Boston (there is an early copy in the Royal Collection, Windsor). Ludwig Grote believed that to be the portrait of Rodrigo Fernandez d'Almada, and Norbert Wolf accepts this attribution (A 164, Wolf K 48). The identification of the sitter remains uncertain.

318 The manuscript phrase is elliptical, but the sense is clearly that Planckfelt reciprocated AD's portraits with an appropriate rebate of charges for board and lodging.

319 What AD could not know at this juncture was that Duke Frederick the Wise of Saxony had staged a mock abduction of Martin Luther, to protect him from any breach of the imperial safe-conduct he had been granted for his journey back to Wittenberg from the Imperial Diet at Worms, where he had been declared an outlaw by Charles V for refusing to recant the theological opinions for which the pope had excommunicated him. Frederick's troops took him instead to the Saxon stronghold of the Wartburg near Eisenach, where he remained hidden until 1 March 1522.

320 *der do war ein nachfolger Christij*: the phrase echoes Jesus' calling of the disciples to 'follow after' him in the four gospels. In other books of the New Testament, and in medieval theology and devotional literature, the summons to follow or imitate Christ is extended metaphorically to all Christians. To follow Christ to the end and to die for his faith would qualify Luther as a martyr. AD's command of biblical idiom, at a point when Luther is yet to begin his German translation of the New Testament during his confinement at the Wartburg, is one of the remarkable features of this passage. The theme of Luther's 'Passion', put to death at the behest of the pope, like Christ at the prompting of the high priest, appears in pro-Lutheran propaganda immediately after the rumours of his death began to spread in April–May 1521. Around 1525 AD did two drawings with biblical inscriptions, perhaps for Lazarus

Spengler, of Christ carrying the Cross and the Christian following after him, bearing his own (W 925f., S D 1525/7f. and 211.3.2–3).

321    AD's condemnation of the Roman Church suggests that he had some knowledge of Luther's first major attacks on the papacy and on late medieval Catholicism published in 1520: *To the Christian Nobility of the German Nation*; *The Babylonian Captivity of the Church*; and *The Freedom of the Christian*. At this early stage of Reformation controversy, AD's humanist friends, not least Willibald Pirckheimer, made common cause with Luther in their anti-clericalism.

322    Here AD oversimplifies Luther's teaching. Although *sola scriptura*, 'Scripture alone' should be the ultimate authority in matters of faith, Luther respected and often cited the teaching of the early Christian Fathers of the Church, above all St Augustine. In fifteenth- and early sixteenth-century Germany the prohibition on making vernacular bible translations available to the laity was rarely enforced. AD knew the pre-Lutheran printed German bible, of which his godfather Anton Koberger had published the eleventh edition in 1483. He took from the Koberger bible the text of Revelation which accompanies his woodcut series of the *Apocalypse* (1498).

323    The call to reunite the Church, the sundered Body of Christ, and a little further on to convert all unbelievers, sets off an accumulating apocalyptic tone in the lament.

324    This idea of the last 140 years as an age of evangelical awakening, or of heresy in the Roman Church's view, shows a remarkable historical awareness on AD's part. While 140 years takes in quite precisely the lifetimes of the English reformer John Wyclif and the Bohemian Jan Hus, and the activities of their Lollard and Hussite followers, it also includes the revival in Germany of the older Waldensian movement. AD may have in mind also the pietistic lay spirit of the 'Modern Devotion' and the Brethren of the Common Life, the Beguines and the Friends of God, in the late medieval Netherlands. See Cameron 1991, 61–4, 70–78.

325    AD's precise, step-by-step recapitulation of the Passion of Christ in the betrayal and assumed martyrdom of Martin Luther extends to the assurance that God will 'restore him to life', that is to eternal life. The German verb *erquicken* strongly connotes 'resurrection' (compare in liturgical English 'the quick and the dead').

326    See Christ's prophecy of the destruction of Jerusalem, Luke 19:41–4, and John's vision of the New Jerusalem, Revelation 21:1–5.

327    The clarity and transparency of Luther's style and his theological exposition is a common theme in the writings of his lay followers, notably Hans Sachs who allegorises him as the sweet and clear voiced 'Wittenberg nightingale'. It is possible that AD is playing here, as other contemporaries do, on the near homonym *lauter*, older and dialectal *luter*, 'pure, clear'. Luther himself in 1517 had changed his name from the original Luder, probably to bring it closer to the humanist Greek form Eleutherius with which he signs letters in that year (modelled on Greek *eleutherios*, 'worthy of a free man' or 'one who sets free', Leppin 2006, 124f.). He may also have wished to free himself from the German homonym *luder*, 'cadaver, carrion', also 'despicable person', an association which Catholic polemicists nonetheless continued to exploit.

328   The edict of the Diet of Worms dated 8 May 1521, outlawing Luther as a heretic, ordered his books to be publicly burned. Earlier, when the Church excommunicated him and his books were burned in Cologne and Louvain, Luther had responded on 10 December 1520 by himself burning the pope's bull and works of canon law. He justified his action in the pamphlet *Why the Pope's and his Disciples' Books have been burned* (Wittenberg, December 1520).

329   Luther declares in *The Babylonian Captivity of the Church* that the teachings of the Fathers and medieval theologians, unless grounded in Scripture, are mere 'opinions', not doctrinal authorities. See also 151.1, note 25.

330   *diesen gott geistigen menschen*: the adjective formation *gott geistig* is remarkable in two respects. Firstly, *geistig* is found in the writings of the mystic Meister Eckhart (circa 1260–1327), as a synonym of *geistlich*, but only in an obscure and specialised theological sense. It reappears in the seventeenth century, in the sense 'ingenious, witty'. Only in the eighteenth century does it acquire its modern polysemic meanings, 'spiritual, intellectual, mental' (DWb IV, I, 2, 2771–5). Secondly, the formation of a compound adjective *gottgeistig* appears to be unique, with no entry in DWb. However there are parallel formations in sixteenth-century German, often sparsely attested, like *gottähnlich, gottförmig, gottgefällig, gotthaftig, gottselig* (DWb IV, I, 5) which arise characteristically in Luther's or his adherents' writings, and in a few cases can be traced back to late medieval mystical texts, which influenced Luther's spirituality and theological expression. The word appears to be AD's original coining. It testifies to his stylistic resourcefulness and to the way in which the Reformation was a creative, linguistically emancipatory force at often unexpected cultural levels. See also note 336.

331   *O Erasme Roderadame*: Gerhard Gerhards, illegitimate son of the intended priest Gerhard, constructed for himself the humanist cognomen Desiderius Erasmus out of Latin and Greek equivalents for the etymological interpretation of his Dutch name (*Gerhard*: 'desire strongly'). He added the adjectival form of his birthplace Rotterdam, then a small fishing port. AD here apostrophises him with his Latin title, in its correct vocative case, and addresses him with the familiar second-person singular pronoun *du* (archaic English 'thou') as was customary among humanist colleagues and friends, whereas he invariably writes to Willibald Pirckheimer, with whom he was infinitely better acquainted, using the formal, respectful second-person plural pronoun *ir* appropriate to a Nuremberg senator.

332   AD paraphrases Paul's Epistle to the Ephesians 6:12: 'For we wrestle not against flesh and blood, but against rule, against power, and against worldly rulers of the darkness of this world.'

333   Now, in the spirit of Ephesians 6, AD casts Erasmus as the 'soldier of Christ' who puts on 'the whole armour of God...the helmet of salvation and the sword of the Spirit'. The metaphorical *militia Christi* ('warfare of Christ') characterised as 'soldiers of Christ' the early Christian martyrs who refused to fight for heathen Roman emperors, then the monks cast as spiritual warriors in the Rule of St Benedict, and also the medieval crusaders who fought simultaneously Christendom's external battle

against the heathen and the individual's inner struggle against the devil. Erasmus revived the original Pauline conception in his *Enchiridion Militis Christiani*, the 'handbook' (in Greek also 'little sword') of the 'Christian Soldier', intended as a 'form of life' for lay Christians in general. First published in 1503, it was only with the third edition, published in 1518, that it became widely known and read. The first German translation came out in 1520. Whether AD had had access through humanist friends to the Latin original, or had had time to read it in German, it is impossible to tell. He had recently met Erasmus in Antwerp and Brussels, and it seems quite likely that the *Enchiridion* is being evoked in this passage. See also notes 342, 362, and text 90.5.

334  *Du bist doch sonst ein altes meniken*: the ideal of the Christian warrior is abruptly undercut by this image of Erasmus – 54 years old in 1520, a notorious hypochondriac, and the epitome of the thin stooped scholar, who has himself confessed to AD that he might have at best a couple more years of usefulness in him (in fact he outlived AD by eight years). AD compounds the ironical contrast of spiritual heroism and physical frailty by using the Dutch diminutive, 'little old guy'.

335  Quoting Matthew 16:18.

336  *ob du hie gleich förmig deinem maister Christo würdest*: AD paraphrases Paul's Epistle to the Romans 8:29 and the idea expressed in William Tyndale's 1534 New Testament of the Christian being 'like fashioned unto the shape of [Christ]', in Luther's New Testament *gleich…dem Ebenbilde* [Gottes] *Sons*. Created by God 'in his own image' (Genesis 1:27), the human being through the imitation of Christ, the God-made-man, strives to recover the 'equal form', his likeness to the divine, lost through sin. The word *gleichförmig* appears in late medieval German mystical texts and is very frequently found in Luther's writing, for instance in *The Freedom of the Christian* (1520) which AD had probably read by the time he wrote this passage.

337  *so wirstu doch ehe aus dem todt ins leben kommen und durch Christum clarificirt*: see John 5:24, 'He that heareth my words…shall not come into damnation, but is scaped from death unto life.' AD's *clarificirt* is another remarkable word to find in a piece of spontaneous lay vernacular writing. It is a loan-word from Middle Latin *clarefacere* (participle *clarefactum*) and conveys the idea of the purification or transfiguration of the earthly body in the resurrection of the dead. Luther is not the source in this instance. He uses in such contexts the verb *verklären* (from *klar*, 'clear'). The Transfiguration of Christ (Matthew 17:1–9), the physical manifestation of his divinity, is similarly in Luther's New Testament *Verklärung*, in the Latin Vulgate *transfiguratio*. The form *clarificirt* derives from the translation of Latin theological vocabulary by writers of mystical texts in the fourteenth to fifteenth centuries. AD is likely to have heard and assimilated it from hearing it used in sermons or reading it in a devotional work (DWb V, 986 and XII, I, 651–4).

338  Matthew 26:39.

339  I Samuel 17.

340  The sentence is problematical. The clause 'as indeed he can be found among the Romans' (*wie er ja unter den Römischen stehet*) is missing in manuscript B and has

been regarded by some commentators as an interpolation. Given the careful copy-editing and collation that manuscript A has undergone, that seems unlikely. The sense is presumably that God still 'stands by' the Roman Church, despite its errors, in so far as his divine will permits. See also note 323 and the earlier plea to Christ to reunite all the sheep of his flock, of whom the Roman Church forms only a part.

341 See Matthew 23:34–6, Revelation 6:9–11 and 16:4. Consistent with the expectation of imminent Last Judgement, characteristic of late medieval lay piety and expressed in his woodcut narrative of the *Apocalypse* (1498), AD takes the presumed betrayal and death of Luther as the latest in a long history of the shedding of the blood of prophets and martyrs, 'slain for the word of God' (Revelation 6:9), and as a new portent of the Second Coming of Christ, who will judge his enemies and avenge the blood of the fallen.

342 AD's outburst of emotion and fervour is by far his most extended and unequivocal utterance on Martin Luther and the early Reformation to have survived. It is a response, immediate but by no means unreflected, to the particular and brief moment in which it appeared that Luther had been abducted and even put to death by the forces of Roman Church and Empire, who had condemned and outlawed him at the Diet of Worms. Its vivid language and controlled passion, and its grasp of the immediately current themes and issues, have often fed doubts as to its spontaneous composition around Whitsun 1521, indeed as to its very authenticity – whether AD edited or elaborated it in a later revision of his Journal, or whether it was interpolated by another hand in a subsequent, posthumous attempt to claim AD as a 'Lutheran'. The notion that AD was not capable of such accomplished and powerful rhetoric is refuted by the ample evidence in his writings of his linguistic resourcefulness and virtuosity. The idea that the passage's religious fervour and grasp of theological controversy might be counterfeit ignores the degree to which it so exactly fits the situation of May 1521, not least the position of Erasmus.

AD presses Luther's assault on the moral corruption of the Papacy and Curia, their exploitation of the laity through financial exactions and teaching based on medieval theological doctrine not sanctioned by scripture. This challenge to the Church's moral and theological authority took up grievances of long standing, antipathy to the wealth and power of Rome, the age-old tensions between Papacy and Holy Roman Empire, and the legacy of the Great Schism of the Church from 1378 to 1417. German humanists of AD's acquaintance like Ulrich von Hutten and Willibald Pirckheimer saw Luther as a recent recruit to their rejection of Roman anti-intellectualism and obscurantism. Erasmus in his *Praise of Folly* had deployed savagely ironical anti-clericalism and satire of the superstitious, materialistic religiosity foisted by the Church on the common laity. In the dedicatory letter to Paul Volz in the *Enchiridion* he anticipated Luther's criticisms of indulgences and the externalisation of faith, and Luther had thanked Erasmus warmly for this, as the 'younger brother of yours in Christ', in his first letter to him of 28 March 1519 (*ECorr* 6, 283, letter 933; Luther, WA, Briefe I, 163). At the Diet of Worms, the representatives of German cities and territories had, as often before, presented a

catalogue of grievances, *gravamina*, to be redressed. But Luther's eschatological vision of Rome as the new Babylon of the Book of Revelation, incapable of reform and ripe for final Judgement, went far beyond humanist critique. AD depicts him, entirely as Luther saw himself, as the Angel of the Apocalypse in terminal struggle with the Papal Antichrist. If Luther has suffered Passion and martyrdom in imitation of Christ, it must have been ordained by divine will. Hence AD prays to Christ now to unleash the apocalyptic process, gathering the scattered Christian flocks into one ecumenical fold, dispelling error and revealing evangelical truth, as the Last Judgement approaches.

Martin Luther, 'doctor of Holy Scripture, adversary of the Pope', as he characterises himself in his table-talk, had by 1521 set out key positions of his new theology in German-language treatises, with some of which AD was familiar. But it is the scourge of Rome rather than the illuminator of the 'holy clear Gospel, not obscured by human doctrine' who dominates AD's lament. When he appeals to Erasmus to replace Luther as guide to scriptural truth, he does so knowing him as the author of the renewed text of the Greek New Testament, even though he is unaware that for Luther at the Wartburg this was about to become a key source for his own renewed German New Testament. Erasmus too had pleaded for all Christians to have access to the Bible in their own language, and he shared many of Luther's criticisms of the Church's institutional and pastoral practices (*Erasmus Werke* I, *Enchiridion* 14–15; III, *Paraclesis* 12–14; II, *Laus Stultitiae* 92–9, 165–73). Yet he looked for incremental internal reform and from the start distanced himself from Luther's confrontational stance and his uncompromising theological radicalism (in letter 1191 of early 1521 he describes himself navigating between the Scylla of Luther and the Charybdis of militant Catholics), though he was slow to voice his typically nuanced differences explicitly. In 1520–21 contemporaries still largely assumed that Erasmus was in general terms a Lutheran sympathiser, and as such he was coming under hostile fire from conservative theologians in the Netherlands. AD records having met Erasmus three times by the early months of 1521. It is difficult to imagine that the Lutheran controversy was not a topic of conversation between them, for all that AD was no humanist intellectual, and that Erasmus was reluctant to encourage the uneducated laity to involve themselves in doctrinal matters. Even so, AD had imbibed his reformed theology from Johann Staupitz and came to Erasmus with the recommendation of Willibald Pirckheimer.

Be that as it may, when AD cast Erasmus in the role of soldier of Christ, storming the gates of hell, alias the portals of the Vatican, he could not have miscalculated more drastically. In advance of the imperial assembly in Worms, Erasmus had pleaded for moderation and compromise between the opposed parties. More and more he distanced himself from Luther. He feared that Luther's German nationalism, and his involvement of the laity in religious controversy through the publication of his treatises in German, would endanger the European community of humanist learning and politicise the quest for reform. Erasmus saw himself as a philologist and a moral philosopher, not as a theologian, especially not a dogmatist of Luther's stamp, and as suited

to the contemplative, not the active life. In a letter of 5 July 1521 to Richard Pace he rejected the martyr's crown, which AD – unbeknown to him – was at that moment offering him. Determined not to be manoeuvred into partisanship by the Lutherans, he declares that, while Luther said and wrote everything with conviction, 'mine was never the spirit to risk my neck for the truth. Not everybody has the strength to be a martyr. I fear that if it comes to a trial of strength, I shall behave like Peter [thrice denying Christ]. I obey popes and emperors when they make good decisions, for that is godly. If they make bad ones, I put up with it, for that is only safe' (*ECorr* 8, 259, letter 1218).

At this traumatic moment in the early Reformation AD reacts not as a vernacular humanist but as an exceptionally articulate evangelical layman, schooled in the Staupitz Society (108, 120, 130) in Nuremberg, and fired by his reading of Luther's works for the common man and by his radical contacts in the Netherlands like Cornelius Grapheus and the Antwerp Augustinians. No further written evidence remotely as revealing survives that might allow us to plot more clearly the evolution of his religious convictions in the remaining years of his life. The letter of Willibald Pirckheimer to Johann Tschertte (290) written after AD's death, purports to show him in his final years as disillusioned in his once ardent faith. The quite sparse evidence of his artworks in the 1520s neither bears that out nor definitively refutes it.

[Rupprich I, 197–9, note 642; Moeller 1959; Lutz 1968, 32–4; Gerlo 1983, 11–14; Cameron 1991; Reinhard 1991; Sahm 2002, 171–81; Leppin 2006, esp. chapters 4–5; Price 1994 & 2003, 231–5, 243f.; Chadwick 2001, 136–7; Ribhegge 2010, esp. chapter 5]

343  *canonicus*: not identified.

344  Konrad Meit.

345  Celebrated as a landscape artist (see note 309), Joachim Patinir was said to have difficulties drawing people. Quentin Massys apparently did the large figures for him on his *Temptation of St Anthony*. AD may have done the four figure-drawings of St Christopher, which have not survived, as a thanks for his invitation to Patinir's wedding and perhaps also as a model for him to practise from. Patinir's own *St Christopher* was possibly influenced by the drawing W 802, SD XW 802. AD's leaf W 800, S D 1521/14, monogrammed and dated 1521, with nine sketches of St Christopher in different poses, is likely to have had some connection with the four drawings for Patinir. Another large pen drawing of St Christopher in the BM Sloane volume (W 801, S D 1521/15, Rowlands 1988, 77), on paper with a violet ground and highlighted in white, clearly belongs in close proximity to the costume studies on the same paper, W 820 and 835, S D 1521/23–4, both of which are dated 1521 (see also note 355). Winkler concludes that this is the same paper AD describes here in the Journal, and that W 801 belonged to the same series as the drawings for Patinir. A further drawing (W 802, S D XW.802), with forged monogram and false date (1515 or 1517) may be a preparatory study for the second of two engravings of St Christopher (S E 95f., SMS 93f.) done immediately after AD's return to Nuremberg later in 1521, possibly as a votive image to the patron

saint of travellers, at whose shrine in Vierzehnheiligen he and Agnes had prayed when they set out in July 1520.

346  21 May was AD's fiftieth birthday.

347  The unnamed Englishman is presumed to be the same one for whom AD a little later drew a coat of arms, a sketch for which (W 829, S D 1521/21) is preserved on the reverse of the drawing of *Christ's Agony on the Mount of Olives* (W 798, S D 1521/20, see note 354). The arms are those of the Abarrow family of North Charford, Hampshire. The sketch is annotated with directions for colouring the arms (see Rupprich I, 199, note 660). John Abarrow was possibly exiled in the Netherlands, having been convicted of murder (for which he was later pardoned by Henry VIII). See Levey 1971/2, 157.

348  Gerhard Horenhout of Ghent (circa 1465–1540) was the most important book illuminator of the time and worked for Archduchess Margareta and for Charles V. He had created a prayer book for Maximilian I, and between 1528 and 1531 worked in England for Henry VIII, who also held his daughter Susanna (fl. circa 1520–50) in high regard. She later married the royal treasurer John Parker. Women artists are quite frequently named in the Netherlands, and catered for in guild regulations from the later fifteenth century (Nash 2008, 77f.). AD's remark betrays a prejudice of his time, but at least he finds the picture well done, even though he is surprised to find it done at all (and is thus less dismissive than Samuel Johnson's comment 250 years later on a woman's preaching and a dog's walking on his hinder legs).

349  The Circumcision Procession was an elaborate celebration of the holiest of the relics preserved in Antwerp, the *praeputium* or foreskin of Christ. It fell victim to iconoclasm, when the Calvinist preacher Herman Moded hung it round his neck and purported to work magic tricks with it (Unverfehrt 2007, 174).

350  Probably Jan van de Perre, active as goldsmith between 1515 and 1551. He became court goldsmith to Charles V.

351  AD had earlier given *Veronica* paintings to Jakob Banisius and João Brandão. The 'true icon' of the face of Christ is among his most frequent subjects, and was one of the sources for his self-portrait of 1500. For those he produced in the Netherlands, see Anzelewsky 1971, 126 K, 152 V, 158 V, 160 V.

352  No convincing identification of the artist or the work has been established.

353  The jacinth or zircon is a transparent gemstone regarded in earlier times as an aid against poor eyesight. The agate engraved with the suicide of Lucretia could possibly have been an antique Roman piece.

354  Of these five drawings, two are those of *Christ being led away to Golgotha* (W 793f., S D 1520/37f.), two are those of *Christ's Agony in Gethsemane* (W 797–8, S D 1520/39, 1521/20). The sketch of the Abarrow coat of arms on the reverse of W 798 establishes the proximate date of these. Rupprich suggests that the two pairs (and the paired drawings of the *Entombment* W 795f., S D 1521/17f.) were prompted by street drama scenes which AD witnessed as part of the Trinity Sunday Circumcision procession.

355   The *Three heads of Children* (W 862–4, S D 1521/75–7), the drawing of a *Woman in Flemish Costume*, and the rear view of another costume (W 820 and 835, S D 1521/23f.), all conform to the same unusual medium, half-sheets with a dark ground and white highlighting as used in the *St Christopher* W 801 (note 345). However, the studies of children seem more plausibly to belong to the preparatory drawings for the unfinished engraving *Crucifixion with Many Figures*, which AD started after his return from the Netherlands.

356   See above, note 347.

357   Andreas of Cracow has not been identified. The children's heads W 865–9, S D 1521/73f., 78–80 are more likely to be further studies for the uncompleted *Crucifixion* of later 1521 (note 355).

358   Both manuscripts have 2 fl., but that price would be absurd.

359   Not identified.

360   Perhaps a member of the Rehlinger or Rechlinger family of Augsburg. AD drew Anna Rehlinger in 1523 (W 910, S D 1523/20).

361   Hendrik Keldermans belonged to a celebrated family of architects and sculptors, responsible for a number of the major public buildings AD had seen in the Netherlands, for example the church of Our Lady in Antwerp, the Great Church and the Marquis's Palace in Bergen op Zoom, the town hall in Ghent, and the Regent's Palace and town hall in Mechelen.

362   Johann Poppenruyter or Poppenreuter (died before 24 January 1534), from Nuremberg, had settled in Mechelen by 1498. The foundry he built up there won a Europe-wide reputation. By 1503 he is recorded as senior ordnance-master to the archduke of Austria, Burgundy and Brabant, and in 1515 as court foundry-master to Charles V. His brother Sebald was a priest in Nuremberg and his widowed sister also lived there. AD's drawing of a mortar (W 783, S D 1521/25) may be connected with this visit. His interest in artillery had led already in 1518 to his etching of the Great Cannon (S E 86, SMS 85). It was Poppenruyter's first wife, Katharina van Osseghem, who in 1501 encouraged Erasmus to write the *Handbook of the Christian Soldier* – the first, 1503 edition of which is dedicated to Poppenruyter – in the hope that it would reform her husband from his 'immoderate, whore-mongering, adulterous' lifestyle. Erasmus in the letter to Paul Volz which prefaces the 1518 edition concedes that the book has had no effect on his 'uneducated' friend. The dedication sheds light on the title of Erasmus's work. *Enchiridion* means in Greek both 'handbook' and 'sword'. With it Erasmus offers the armaments manufacturer a spiritual weapon to arm him against his own sins. (Welzig 1990 I, viii–xi & 1f.; *Erasmus Works* 60, introduction; Rupprich III, 442).

363   See Unverfehrt 2007, 182. Presumably not the 1519 oil painting of Maximilian I now in the GNM, since AD shortly afterwards gave it to Tommaso Bombelli's son-in-law in return for a white English cloth. Possibly one of the portrait woodcuts of Maximilian (S W 90, SMS 252) on which his jacket and insignia were printed in gold, or even the silver medallion of Charles V, designed by AD, which the Nuremberg authorities planned to present to the new emperor. Unfortunately the medal showed

Charles, politically incorrectly, as a beardless youth, and the city had to abandon the presentation, while the Regent Margareta also spurned it, for this or some other reason. AD as a result did not get the reciprocal gift he had counted on. (See 143.1, 158).

364 Contemporary inventories detail her impressive collection. One particular treasure was the *Book of Hours* of the Duc de Berry. The forty small panels included thirty-two component parts of Juan de Flandes's *Politychon*, created for Margareta's mother-in-law Isabella of Castile. By Jan (*Johannes*) and Jacob the Italian (*Jacob Walch*) are meant Jan van Eyck and Jacopo de'Barbari. Other painters represented in the collection included Rogier van der Weyden, Hans Memling, Dirk Bouts and Hieronymus Bosch (Grebe 2013, 36–9).

365 AD had met the Venetian painter Jacopo de'Barbari (BI), perhaps in Venice in 1494/5, certainly around 1500 in Nuremberg. He describes how he tried without success to persuade Jacopo to share his knowledge with him. Although AD writes dismissively about Jacopo from Venice in 1506 (29.2, note 10), and soon realised that he was himself a vastly superior artist, he was still anxious to get hold of the Italian's notebook in 1521. Margareta claimed to have given it to her current court painter, Baerent van Orley. AD had cordial relations with Baerent and might have got hold of it directly from him, though it was probably by now no great loss to him. AD resented Margareta's evident disfavour.

366 Konrad Meit.

367 Etienne Lullier.

368 The Augustinian priory had been established by monks from Saxony in 1513. They were expelled from Antwerp as heretics in 1523. See the letter by Cornelius Grapheus (188).

369 Presumably AD's physician.

370 Lukas van Leiden (1494–1533), Dutch painter and engraver, had already come under AD's artistic influence, though Vasari's notion of them as continuing rivals is a fiction. Carel van Mander's account of their meeting is similarly overstated. AD's silverpoint portrait has been identified as W 809, S D 30, but the inscriptions on it are spurious. The more plausible candidate is W 816, S D 1521/26, on which the engraved version in the *Portraits of Celebrated Painters in Low Germany* (Antwerp 1572) is based.

371 Sitters and portraits are unidentified.

372 Jan van de Perre (see note 350)?

373 *mein dodten*: godson (medieval German *tote*) – Hieronymus Imhoff.

374 Anton Hanolt or Haunolt was successor to Bernhard Stecher as the Fuggers' factor in Antwerp.

375 *calamar*: either a species of squid with a long horny shell, in which case AD will have taken his word from Italian *calamaro*, or a pen-case in the shape of or made from a squid shell (Middle Latin *calamarius* from Latin *calamus*, a reed or a pen made from it), or an inkwell (Middle Latin *calamaris*).

376 *ein schilt krott puckeln*: a further item for AD's collection of exotica.

377   *des Grünhanßen ding*: a set of prints by Hans Baldung Grün, AD's former assistant and associate.

378   Presumably the son of Hene Doghens, the glass-painter Vellert's pupil.

379   Aert van Ort, member of the guild between 1513 and 1531, or Arnold Sundert, another Antwerp glass-painter.

380   Jean Mone.

381   Cornelius Grapheus. AD had previously given him a copy of the *Small Woodcut Passion*, which Grapheus inscribed: 'Albertus Dürer, the greatest of painters, gave this with his own hands to Cornelius Grapheus, 7 February in the year 1521'.

382   It had appeared at the beginning of October 1520. Luther published it in Latin only, unlike his other major works in that year. However, the Strasburg printer Johann Prüß reprinted it along with a German translation by Thomas Murner, the Franciscan friar and moral satirist, who emerged as one of Luther's bitterest Catholic opponents.

383   An Utrecht merchant, Peter Pot, had founded almshouses at the beginning of the fifteenth century administered by Cistercian monks.

384   *ein ausgestrichen calacut*: a smooth printed or self-coloured cotton weave from Calicut, which ranged in weight from calico to batiste.

385   The word is a puzzle. Manuscript A has the equally curious *posthohn*. Rupprich I, 201, note 715, suggests *persian* in the sense of 'cotton material', or a scribal error for 'yellow shoes/slippers'.

386   *kützen tuch zu einer kappen*: heavy, rough-textured woollen cloth, suitable for a cape, and perhaps intended for wearing on the journey home.

387   Borax is the mineral salt sodium borate, which in purified form had a range of uses, in glass-making, as an antiseptic, and in medicinal applications. It is quite unclear why AD should have wanted 5 lb of it. However the name was also used to designate pine and fir resins which AD could have used in making varnishes (Unverfehrt 2007, 194).

388   See Unverfehrt 2007, whose appendices 1–6 give an exhaustive analysis of the feasible artistic, economic and financial profit-and-loss accountancy of the Netherlands journey, including 'value-added' aspects and other items impossible to quantify precisely. Clearly AD himself was disappointed with the return, especially with his failure to secure new Hapsburg patronage, though he does not seem to add the renewal of his liferent into the positive column of the equation. See the further discussion of the financial aspects of the Journal in the introductory commentary.

389   Rupprich suggests this was Henri met de Bles (circa 1500/1510–after 1550), an Antwerp landscape painter, probably the nephew of Joachim Patinir. On a panel of St Christopher he copied one of AD's engravings of the saint (see also Unverfehrt 2007, 90f.).

390   Capers were held to be beneficial for pain in the spleen, a symptom of malarial infection.

391   The portrait which Archduchess Margareta had disdained.

392   A universal remedy, consisting of an electuary of plant essences and opium.

393   King Christian II of Denmark (1481–1559) had married Isabella, daughter of Philip of Burgundy, granddaughter of Maximilian I and sister of Charles V. He was on his way to Brussels (see below) to press the emperor to pay the remaining portion of his wife's dowry. The charcoal drawing W 815, S D 1521/33, is in the BM Sloane collection (Rowlands 1988, 75).

394   Anton von Metz, Danish envoy to the German principalities.

395   Wenzeslaus Linck (1483–1547) became in August 1520 vicar-general of the Augustinian congregation in Germany, to which the Antwerp priory also belonged. He was conducting a visitation of his province. AD had come to know him as a member of the Staupitz group in 1517–18 (129–30).

396   The collection in the print cabinet in Copenhagen, in an inventory of 1859, comprised twenty-four leaves: SMS 7, 16, 19, 20, 22, 23, 25, 30, 32, 33, 34, 35, 37, 39, 41, 61, 62, 68, 69, 70, 71, 72, 86, 92. It shows the size and range of the stock of prints AD took to the Netherlands, and it gives an insight into his own valuation of his graphic works.

397   Christian II had re-established the triple monarchy of Denmark, Norway and Sweden, but his coronation in Stockholm on 8 November 1520 had been marred by a massacre of eighty-two of his opponents, which earned him the nickname 'Nero of the North' and turned Sweden and Denmark into his 'enemies' lands'.

398   Anton von Metz pays AD an advance for expenses. It was most likely the painter Baerent van Orley who provided the panel and the services of Bartholomäus van Coninxloo, the apprentice who ground AD's colours.

399   The queen of Spain was Joanna 'the Mad', mother of the as yet unmarried Charles V, but she was locked up in the fortress of Tordesillas in Spain. Charles's sister Eleanor was queen of Portugal. The queen present in Brussels must have been Germaine de Foix, widow of King Ferdinand of Aragon and Charles's step-grandmother.

400   Remarkable are both the handsome fee and the speed with which AD painted – in all he spent only nine days in Brussels, two of which he describes as 'idle'.

401   *des maisters Jannen puben*: Rupprich assumes this is Jan van de Perre, and that is borne out by the following references to 'Master Jan the goldsmith'. But it is quite unclear why Rupprich in his note 748, R I, 202, states that Jan had 'deceived' AD.

402   Tommaso Vincidor, Raphael's pupil.

403   *schneuder*: tailor, wood-carver, or woodblock cutter. Rupprich suggests the wood-carver Jost de Negker of Antwerp, who had worked for Emperor Maximilian in Augsburg from 1508 to 1510 and had also copied woodcuts by AD.

# 163 Inscriptions on Works of Art 1520–21

### 163.1 *Arnold of Seligenstadt*. **Pen sketchbook. W 752, S D 1520/7**

Inscription:

Master Arnold of Seligenstadt 1520

Shown leaning half-asleep against a coil of ship's rope. Arnold Rucker (1480–1538/9) was owner of the hostelry of the Great Star in Seligenstadt and an organ builder. He was also a friend of the painter Matthias Grünewald. See 162, note 7.

### 163.2 *Jobst Planckfelt*. **Pen sketchbook. W 747, S D 1520/8**

Inscription:

This is my landlord in Antwerp, Jobst Planckfelt

AD, his wife and maid boarded at Planckfelt's house, the Engelenborch, for the whole of their stays in Antwerp and he is frequently mentioned in the Journal. AD also did portraits in oil paints of Planckfelt and his wife, in part settlement of the bill for the lodgings before he left Antwerp (162, note 318 and Anzelewsky 1991, 269f.).

### 163.3 *Goldsmith from Mechelen*. **Pen sketchbook. W 745, S D 1520/9**

Inscription:

A goldsmith from Mechelen, done at Antwerp 1520

This is not likely to be Stephan Capello, Margareta of Austria's court goldsmith, whom AD also drew but whom he would have referred to by name.

### 163.4 *Felix von Hungersberg*. **Pen sketchbook. W 749, S D 1520/10**

Inscription:

This is Captain Felix, the exquisite lutenist, done at Antwerp 1520

The drawing picks out his hairnet and rakish beret, his blind left eye and his waxed and twirled moustache. AD clearly thought him a great character. He dined with him, sold him prints and was given a hundred oysters by him. On his music, see the second portrait drawing 163.15 and 229.

[Ex. Cat. Vienna 2003, 490]

### 163.5 *Hans Pfaffroth*. **Pen sketchbook. W 748, S D 1520/11**

Inscription:

Hans Pfaffroth of Danzig 1520, a strong man

AD got a Philip's gulden for the drawing. Pfaffroth had been trying to release goods confiscated in Danzig (Gdansk) belonging to the Portuguese merchants in Antwerp.

### 163.6 *Park of the Royal Palace in Brussels*. **Pen drawing in brown ink. W 822, S D 1520/15**

Inscription:

This is at Brussels, the menagerie and the pleasure grounds, seen looking down from the castle

In the Journal AD writes, 'Behind the King's House in Brussels, I saw the fountains, the maze and menagerie, and have never seen anything more entertaining and pleasing, quite like a Garden of Eden.'

### 163.7 *Desiderius Erasmus*. **Charcoal drawing. W 805, S D 1520/16**

Inscription:

Erasmus of Rotterdam

AD refers to the drawing of Erasmus he did on 1 September 1520 in Brussels as his second portrait sketch, but it is the only one that survives. It is not highly finished and may be the drawing Erasmus refers to in his letter of 14 March 1525 which was interrupted by the arrival of three dignitaries from Nuremberg (207). It was not the basis for AD's portrait engraving of Erasmus of 1526 (226.2). See 162, note 102.

[Ex. Cat. Vienna 2003, 494]

### 163.8 *Paul Topler and Martin Pfinzing*. **Silverpoint sketchbook. W 761, S D 1520/19**

Inscriptions:

Paul Topler 1520, 61 years old
Martin Pfinzing, 30 years old
Done at Aachen

Topler (1456–1544) and Pfinzing were both members of prominent Nuremberg families. See 162, note 153.

### 163.9 *Aachen Town Hall*. Silverpoint sketchbook. W 764, S D 1520/20

Inscription:

The town hall at Aachen

AD visited the town hall, saw the coronation chamber, and sketched the cathedral from one of its windows.

### 163.10 *Kaspar Sturm, River Landscape*. Silverpoint sketchbook. W 765, S D 1520/21

Inscription:

1520 Caspar Sturm, 45 years old. Done at Aachen

The first part of the inscription is in classical capitals. The river landscape background seems to have been added later. It is labelled *tiell* or *toll* but has not been convincingly identified.

Sturm (1475–1548) was appointed Imperial Herald in 1520 and was deputed to escort Martin Luther to the Diet of Worms in 1521. See 162, note 155.

### 163.11 *Aachen Cathedral*. Silverpoint sketchbook. W 763, S D 1520/22

Inscription:

At Aachen, the minster

See 163.9. The drawing is revealing for the architectural history of the cathedral, showing the octagonal chapel of Charlemagne with a Gothic spire in place of the later dome.

### 163.12 *Woman from the Burgenland*. Pen sketchbook? W 751, S D 1520/25

Inscription:

A Turkish Woman

or

A Woman from the Burgenland

AD's writing allows either the reading *ein türgin* or *ein bürgin*. The drawing seems to have been copied from the right-hand figure in the silverpoint drawing of two women (W766, S D 1520/24), adding another head with a different version of the curious hat. Ephrussi (1882) related the drawings to the studies of Livonian women (1521, see 163.28–30), and he cast doubt on the idea that the women's costume could have been

Turkish. Much more recent research points to similarities with traditional costume in the Austrian Burgenland (see S D 4, 1952).

### 163.13   *Coat of Arms of Lorenz Staiber with Alphabet*. Pen drawing. S D 1520/26

Inscriptions:

> Abcdefghiklmnr
> For Jobst
> Albrecht Dürer of Nuremberg
> My lords' Dürer

The sheet has the sketch of a helmet and to the right of it two more sketches for the coat of arms of Lorenz Staiber (S W 194, SMS 254/255) which AD drew on wood-blocks in two states in August and November 1520. Staiber, from Nuremberg, was in imperial service and was knighted by Henry VIII of England in 1520. Jobst could be the woodblock cutter Jobst de Necker or AD's landlord in Antwerp, Jobst Planckfelt. See R I, 192, note 461.

### 163.14   *Metzgen at the Age of Thirty-Nine*. Black chalk drawing. S D 1520/27

Inscriptions:

> Metzgen
> Aged 39

The name is written in small script above the note of her age which like the date 1520 and AD's monogram is in large capitals. There have been a number of interpretations of the name. Strauss (S D 4, 1956) points to the form *Mätzchen*, used in the same way as English 'thingy, thingamy, thingamabob, thingamyjig', but also as a pet-name for small animals and young children (DWb VI, 1768–70), and suggests that Metzgen was the familiar name of Nikolaus Dürer's daughter in Cologne. On the provenance of the drawing, Strauss relates: 'Lord Seymour presented "Portrait of Metzgen" to the celebrated opera singer Pauline Viardot, who later sold it…in order to acquire Mozart's manuscript score of *Don Giovanni*'.

### 163.15   *Felix von Hungersberg*. Pen and brown ink. W 819, S D 1520/28

Inscription:

FELIX HVNGERSPERG
The exquisite and highly accurate lutenist

To the right of the head:

> These are the best
> Felix, Adolf, Samario

Captain von Hungersperg is shown kneeling, supporting a round shield with his arms (two quartered double-headed eagles). AD records that it was done in the last week of November 1520. Felix von Hungersperg gave him a gift of 100 oysters in return. This is the second drawing AD did of him – see 163.4, and 162, notes 195f. On AD's interest in lute music, see 229. Adolf is likely to be Adolf Blindhammer, lutenist to Maximilian I in 1503, who gained Nuremberg citizenship in 1514 and was paid by the city to teach the lute in 1515. Samario is unidentified; the name suggests he might have been one of the 'good lute-players' AD came across in Venice in 1506 (29.2).

### 163.16  *Young Man aged Twenty-Four, St Michael's Church, Antwerp.* **Silverpoint sketchbook. W 769, S D 1520/29**

Inscriptions:

> 1520, XXIIII
> St Michael's, Antwerp

Whether the subject is a young man or woman is difficult to determine. The church impressed AD greatly (see 162, note 56).

### 163.17  *Girl and Old Woman.* **Silverpoint sketchbook. W 771, S D 1520/31**

Inscription:

> At Bergen op Zoom, feast day

The drawing shows a young and an older woman in similar costume. The feast day will have been the feast of St Nicholas on 6 December 1520.

### 163.18  *Woman from Bergen and Woman from Ter Goes.* **Silverpoint sketchbook. W 770, S D 1520/32**

Inscription:

> At Bergen, at Ter Goes in Zeeland

Two women in contrasting folk head-dresses, the latter added on 8 December 1520, according to the Journal entry.

**163.19**   *Choir of the Church at Bergen op Zoom*. **Silverpoint sketchbook.**
**W 772, S D 1520/33**

Inscription:

This is the new choir at Bergen

Probably done around 10 December 1520, on AD's return from Zeeland. The choir is shown at a half-built stage, but without scaffolding. AD had earlier drawn a more general view of the town (W 768, S D 1520/30), where he visited the castle (*Markiezenhof*).

**163.20**   *Marx Ulstatt, Young Woman*. **Silverpoint sketchbook. W 773,**
**S D 1520/34**

Inscriptions:

Marx Ulstatt, I drew his picture at sea
18
18
The beautiful girl at Antwerp, 1521

Ulstatt was probably a fellow voyager to Zeeland. It has been suggested that the 'beautiful girl' was Gerhard Bombelli's fiancée, to whom AD refers in the Journal. '18' may be her age.

**163.21**   *Lazarus Ravensburger, Tower of the Mayor's House in Antwerp*.
**Silverpoint sketchbook. W 774, S D 1520/35**

Inscription:

Ravensburger, done at Antwerp

Lazarus Ravensburger was factor for Augsburg merchants at Lisbon. AD saw him frequently in Antwerp and exchanged prints and his portrait for exotic objects. He visited and admired the house of Arnold van Liere just two days after his arrival in Antwerp.

**163.22**   *Agnes Dürer*. **Metalpoint on violet-grounded paper. W 814,**
**S D 1521/1**

Inscription:

This likeness of his wife in Netherlandish costume was drawn by Albrecht Dürer at Antwerp in the year 1521, when they had been married to each other for twenty-seven years

If the drawing indeed marked their wedding anniversary, it will have been done around 14 July 1521. However, the Roman numeral has also been read as indicating twenty-six and a half, thus placing it in January 1521. See Anzelewsky/Mielke 1984, 109f.

### 163.23  Old Man aged Ninety-Three. Brush on violet-grounded paper, white heightening. W 788, S D 1521/3

Inscription:

The man was 93 years old and healthy and competent. At Antwerp

This version shows him with eyes closed, another (W789, S D 1521/2) with eyes open. With another sketch of arm and shoulder (W 790, S D 1521/4), these are preparatory drawings for the painting St Jerome (A 162). On its history, see Anzelewsky 1991, 263f.

[Ex. Cat. Vienna 2003, 503–10]

### 163.24  The Moorish Woman Katherina. Silverpoint. W 818, S D 1521/8

Inscription:

Katerina aged 20 years

The young black woman was the servant of João Brandão, royal Portuguese factor in Antwerp and one of AD's closest friends there. In a draft for the third of his Four Books of Human Proportion (1528), from circa 1513/15, AD wrote: 'A large difference can be observed between white and Moorish people. They are still human beings and many of the proportions of these black people are usable [that is, as models for artistic portrayal] for their beauty, although black people's faces are rarely beautiful to look at' (R II, 459). In the Aesthetic Discourse in the printed text of the Four Books, he writes: 'Moors' faces are rarely beautiful because of their squashed noses and thick lips…But I have seen some of them whose whole bodies were so well shaped and pleasing that I have neither seen nor can imagine any better formed' (R III, 295).

### 163.25  Chandelier and Coat of Arms of the Abarrow Family. Pen drawing. W 829, S D 1521/21

Inscription:

The coat blue and, where it is slit, lined with gold, yellow, white, black, black-white, red, black, white

The instructions are on the verso of a drawing of Christ's Agony in Gethsemane. Along with sketches of a chandelier, AD sketches the arms of the Abarrow family and indicates where the colours are to be applied. See 162, note 347.

**163.26** *Walrus*. **Pen and brown ink. W 823, S D 1521/27** [see fig. 51]

Inscription:

> This animal of those parts, whose head I have drawn here, was caught in the Netherlands sea and was twelve Brabant ells long with four feet

Presumably AD saw the walrus in Zeeland and subsequently worked up the sketch into this finished drawing. To read *Das dosig thyr* as 'dozy animal' (see e.g. Strauss 4, 2048) is attractive but unlikely. It is not Middle Dutch/Low German *dösig*, but AD's dialect form of *dasig*, 'belonging there', as opposed to *hiesig*, 'belonging here' (though Zeeland is far to the south of the normal latitude of the walrus). The Rhinoceros is also described as *das dosig Thier* in the inscription of AD's 1515 woodcut (102.2.2).

[Massing 2007c, 363; Ex. Cat. Bruges 2010, 433]

**163.27** *Irish Warriors and Peasants*. **Pen and brown ink and watercolour. W 825, S D 1521/36**

Inscription:

> This is how warriors go around in Ireland, the other side of England
> 1521
> This how peasants go around in Ireland

Three warriors are shown, with long swords, spear and bow and arrows, one is wearing chain-mail. Two peasants are barefoot and carry hoes and a horn. It is quite improbable that AD saw and drew them from life. More likely he copied them from an unknown source. See Anzelewsky/Mielke 1984, 111f.; Massing 2007b, 87–91.

**163.28** *Latvian Woman*. **Pen and watercolour. W 826, S D 1521/37**

Inscription:

> 1521 This is how rich women are dressed in Livonia

AD's version of sixteenth-century *Lifland* is *Eiffland* or *Eyflant*. In this case too, we cannot tell whether AD saw his models in the flesh or copied them from other drawings. This and the following two studies were themselves copied in a book of women's costume printed in Nuremberg in 1577.

**163.29  *Two Latvian Women*. Pen and watercolour. W 828, S D 1521/38**

Inscription:

   In Livonia ordinary women are dressed like this

See 163.28. Even 'ordinary women' have fur-trimmed cloaks and dresses.

**163.30  *Three Latvian Women*. Pen and watercolour. W 827, S D 1521/39**

Inscription:

   1521 This is how in Latvia the women of the powerful dress

See 163.28. The three women have heavy fur cloaks and two have head-gear which largely conceals their faces.

**163.31  *Six Animals and two Landscapes*. Pen, partly watercoloured. Dated 1521. S D 1521/40**

Inscription:

   An extraordinary animal which I...
   Large, one-and-a-half hundredweight
   heavy...

It is assumed that AD drew the animals in the zoological garden in Brussels during his brief stay in the city, from 3 to 12 July 1521, before he left on his journey home. The drawing shows a lynx, then to the right in three tiers, a lioness and a dog-faced baboon, a lion and a chamois, a large recumbent lioness. On the left are two landscapes. The inscription is in the top right-hand corner, above the baboon. It was curtailed when the sheet was trimmed.

**163.32  *Girl with Cologne Headdress, Agnes Dürer*. Silverpoint on pink-grounded paper. W 780, S D 1521/57**

Inscription:

   Cologne hair-banding
   On the Rhine, my wife near Boppard

Done separately, the two bust-length figures are juxtaposed to form a contrasting pair, young and old with their different headgear. The girl has the hairstyle characteristic of Cologne costume, with the hair in a net bound with complex ribbon-work (*gebende*). Agnes Dürer has her customary rather stern, pursed-lipped mien.

[Ex. Cat. Vienna 2003, 496–8]

**163.33** *Model for Sorrowing Virgin Mary?* **Pen and brown ink. W 744,
S D 1521/58**

Inscription:

Done on the Rhine, 1521

Perhaps not a portrait sketch, in view of the extraordinarily complex drapery of the
female figure. It compares closely with W 759, S D 1521/56, *Virgin Mary with Halo*,
and Panofsky took it to represent a model posing as *mater dolorosa*.

**163.34** *Male Figure, Landscape near Andernach.* **Silverpoint on
pink-grounded paper. W 778, S D 1521/60**

Inscription:

At Antwerp
Near Andernach on the Rhine

The male subject is not identified. Since the other side of the sheet has on it the drawing
of two lions, done in Ghent in April 1521, it is likely that the portrait was drawn before
AD left Antwerp on 6 April. The river landscape, showing the Krahnenberg, above
Andernach (south of Cologne), is the last extant drawing of the Netherlands journey.

# 164 Resolution of the City Council 1520

*Fourth day after Michaelmas [5 October] 1520:*
Famous foreign painter to be registered as citizen, fee waived, as compliment
to Albrecht Dürer.

In the Register:

Albrecht Dürer, painter, given citizenship free of charge

[1520, VII, 5b]

In the Register of Citizens:

*Sabbath after St Francis [6 October] 1520:*
Hanns Hofman, painter, paid nil, swore [oath of citizenship]

The clerk who wrote the entry in the register of resolutions made a careless error (AD
had had citizenship since 1493). The 'famous painter' (*berümbten maler*) is categorised as

*frembd* – 'foreign' – but the term includes those from other parts of the German lands. Hans Hofmann was evidently imported to work on the Town Hall murals, hence the waiver of a citizenship fee. He left Nuremberg again once his commission was finished. In 1530 he was recorded as father-in-law of Georg Pencz, often assumed to have played a key role in the project, though this is nowhere documented.

[Mende 1979, 80]
  Hampe, Ratsverlässe 1520, VII, 5b
  R I, 242

## 165  Documents Relating to Albrecht Dürer's Imperial Liferent 1520–21

### 165.1  Draft of Emperor Charles V's Mandate to the Nuremberg Council Authorising the Payment of the Liferent

*[Brussels, late August 1520]*
This is a copy of how the mandate of the royal administration to those in Nuremberg, concerning Albrecht Dürer's hundred gulden, which he is to collect yearly, should sound. Charles by the grace of God King elect of the Romans and future Emperor et cetera.

Honourable well-beloved subjects! As our royal letter of confirmation given at *[place]* on *[date]*, which he has received from us, makes plain, we have graciously renewed and confirmed to our painter and the Empire's well-beloved subject Albrecht Dürer, for good, proper and weighty reasons, the assurance and deliverance, which the most serene prince, our dear lord and grandfather, Emperor Maximilian of esteemed memory, formerly gave him, concerning the one hundred Rhenish gulden which he is to receive annually from us and out of the customary city tax of Nuremberg for the duration of his life. And since we are persuaded that the same our dear lord and grandfather, in recognition of Albrecht Dürer's faithful service, manifested when His Majesty commissioned his Triumphal Chariot and his Gate of Honour, and variously in many other ways, commanded that on a single occasion, out of the same customarily due city tax, which you are obliged to pay into our and the Empire's treasury, the said Albrecht Dürer was to receive two hundred gulden from you, for which reason His Majesty had letters sent to you requiring this; and since we are credibly informed that upon the death of the same our dear lord and grandfather of esteemed memory, and until we might issue a further mandate, you have however refused to hand over this sum, we accordingly earnestly require you,

on receipt of this letter, that by virtue of the written provision issued by our dear lord and grandfather and accepted and confirmed by us, you now henceforward pay out and deliver to Albrecht Dürer, for the duration of his life and no longer, in return for his due quittance, annually at the appointed time and due date, these one hundred gulden out of the aforesaid our and the Empire's city tax, and in addition pay the other outstanding two hundred gulden, likewise in return for his quittance, and do not let yourselves in any way be confused or deterred in this matter by others of our orders and commands such as may be issued in future. Accordingly, the annual one hundred gulden and also the payment of two hundred gulden shall be deducted from the customary city tax hitherto due and due in the future, in the same way as if it were being paid into our hands and in return for our quittance. This arrangement shall be wholly without infringement of or prejudice to the privileges, favours and freedoms, which our predecessors as imperial rulers have bestowed upon you, namely that you are obliged to remit the aforesaid city tax to no one other than to our own hands, and these in no less a way remain in force. In this whole matter you shall be carrying out our earnest wish. Given...

<div style="text-align:right">To the citizens, masters, and Council of Nuremberg</div>

In Brussels at the end of August 1520, AD had Erasmus Strenberger draw up for him a submission to Charles V, requesting the confirmation and renewal of the liferent granted him by Maximilian I, along with two drafts of a suggested form of words for the imperial chancery to use (see also 165.2). The Nuremberg delegation took the final document back with them on their return home (165.3).

This draft survives in AD's autograph, now in the Print Cabinet, Berlin.

R I, 88f.

## COMMENTARY

On Erasmus Strenberger, see BI and 162, note 86.

In late August 1520, in Brussels, AD had made contact with 'my lords of Nuremberg', the delegation of senators who were to represent the city at the coronation of Charles V and who were escorting the imperial regalia, which were in the city's safe-keeping, for their use in the ceremony at Aachen. It was no doubt at their suggestion and with their help that the draft documents 165.1–2 were composed and written by Strenberger and handed over to the Nuremberg envoys, having first been copied by AD himself for his own records.

## 165.2 Draft of Emperor Charles V's Confirmation of the Privilege granted to Albrecht Dürer by Maximilian I

*[Brussels, late August 1520]*

This is a copy of how the confirmation which King Charles is giving to Albrecht Dürer shall be framed, in the matter of the one hundred gulden, which Emperor Maximilian conferred on him at Nuremberg for the duration of his life, and of the further two hundred gulden to be received on a single occasion.

We Charles, by the grace of God elected King of the Romans and future Emperor et cetera declare publicly with this letter for ourselves and our successors as imperial rulers: Whereas the most serene prince, our dear lord and grandfather, the lord Maximilian, Roman Emperor of esteemed memory, made provision and arrangements, and gave written instruction, for our painter and loyal subject of the Empire Albrecht Dürer, in recognition of his art, skill and understanding, further the willing, loyal and useful service that the same Dürer rendered and performed for many years to the aforesaid our dear lord and grandfather, annually to receive one hundred Rhenish gulden for the duration of his life and no longer, from and out of the customary city tax which the honourable our and the Empire's well-beloved loyal citizens, burgomasters and Council of Nuremberg are obliged to pay into our royal treasury annually and every year on St Martin's Day; and whereas also letters were issued to the aforesaid citizens, burgomasters and Council of Nuremberg, requiring this payment to be handed over each year, as the instruction of our dear lord and grandfather of esteemed memory on this matter, sealed and despatched, now laid before us, dated at Innsbruck on the sixth day of the month of September of the year now past fifteen hundred and fifteen, sets forth in full; we have accordingly, and in consideration of the zealous loyal service which the same Albrecht Dürer has likewise hitherto shown and henceforth obediently proffers, graciously renewed and confirmed these our dear lord's and grandfather's written instructions in all their points, clauses and provisions, renew and confirm to him also, in virtue of our supreme sovereignty as Roman King, for our self and our successors on the throne, publicly and on the authority of this document, that the said Albrecht Dürer shall and may receive the same one hundred gulden out of the aforementioned city tax of Nuremberg from the burgomasters and Council there, annually and on each and every coming St Martin's Day in return for his quittance. The same sum shall also be accounted to the said burgomasters and Council and subtracted from the same customary city tax, just as if they had paid it into our hands and received our quittance for it as paid and discharged, without any hindrance or impediment of any kind to them and their successors from us and our successors on the throne. And should there be or subsequently be discovered any omission or flaw in these arrangements and provisions of our dear lord and grandfather, each and every one we shall herewith hold to have

been wholly and completely repaired and made good, just as if such omissions and flaws had occurred generally and been removed. And if henceforth, in the near or distant future, out of negligence or rash insistence or some other cause, the aforesaid arrangements and provisions, and this our royal confirmation and reinforcement should be cancelled by any other order, mandate, decree or other such, which might contradict them, however this may be or appear to be the case, but is not intended to be so, these shall however not be binding on the said Albrecht Dürer, but on the contrary he shall remain at all events covered by this provision, act of grace and confirmation, for we now, then, and then as now, withdraw, derogate and annul those same in virtue of our royal sovereignty, in true knowledge, and of our own resolve. Furthermore we shall neither revoke nor abrogate the aforesaid our predecessor's provision, confirmed by us, but allow it to remain in force and validity.

Witness this document et cetera.

given at...

AD's autograph copy. In 1969 this was in private ownership. The second of the draft documents drawn up by Erasmus Strenberger (see 165.1).

R I, 89f., III, 436

### 165.3  Emperor Charles V confirms Albrecht Dürer's Liferent

*[Cologne, 4 November 1520]*
Albrecht Dürer.
We Charles V, by the grace of God elected Roman Emperor Augustus, ever extending the bounds of Empire, King in Germany, in Hapsburg, both Sicilies, Jerusalem, Hungary, Dalmatia, Croatia et cetera, Archduke of Austria and Duke of Burgundy et cetera, Count of Habsburg, Flanders and Tirol et cetera, make known:

As formerly the most serene prince, Emperor Maximilian, our dear lord and grandfather of esteemed memory, made provision and gave written instruction for Albrecht Dürer, our and the Empire's loyal subject, in recognition of his art and well-deserving faithful service, to receive one hundred Rhenish gulden every year for as long as he lives from and out of our and the Empire's customary city tax, which the honourable our and the Empire's well-beloved loyal burgomasters and councillors of the City of Nuremberg are obliged to pay annually into our imperial treasury, as contained in His Imperial Majesty's letter sent out in this matter and dated on the sixth day of the month of September in the year past fifteen hundred and fifteen, so accordingly we have granted our favour and consent to His Imperial Majesty's grace and provision and have likewise graciously provided and made available to the same Albrecht Dürer the said one hundred

Rhenish gulden from and out of the aforementioned city tax for the duration of his life. We give therefore our favour and consent, provide and authorise for him the appointed one hundred Rhenish gulden as liferent from the Imperial Majesty publicly in virtue of this letter, such that these same one hundred Rhenish gulden from now henceforward yearly for as long as he lives shall be paid and delivered to him by the forenamed burgomasters and councillors of the City of Nuremberg on receipt of his due quittance and with no shortfall and therefore we earnestly request the same burgomasters and councillors of Nuremberg with this letter, and express our will, that they now pay and deliver to the above named Albrecht Dürer the aforesaid one hundred Rhenish gulden every year for as long as he lives in return for his appropriate quittance; the sum shall be drawn annually on their customary city tax in the same way as if they had paid it into our own hands and received our quittance for it. Witness this document sealed with our attached Imperial seal. Given in our and the Empire's city of Cologne, on the fourth day of the month of November, in the five hundred and twentieth year after Christ's birth, in the second year of our Imperial reign and in the fifth year of all other dominions.

Carolus

> Signed:
> Albrecht Cardinal of Mainz
> Archchancellor.
> N. Ziegler.

The original is lost. The copy in the Staatsarchiv, Nuremberg (S. 1, L, 73, No. II, fol. 15) is the one sent to the city government by the Nuremberg delegates to Charles V's coronation.

   R I, 90

## Covering Letter to the Nuremberg Authorities:

Albrecht Dürer has succeeded in obtaining from His Imperial Majesty, a renewed consent, as per enclosed copy, in respect of the 100 gulden which Your Graces are to pay him annually, also a sealed missive to Your Honours, and has entrusted these same to us for security's sake, for us to bring home. It is also his urgent request that you should take gracious thought of him, and should Your Graces receive meantime any request with regard to the outstanding money, its validity should not be recognised.

COMMENTARY

However, the following confirmation of the privilege (165.4) reiterates AD's entitlement to receive the unpaid instalments of his liferent. Neither the draft of Charles V's

confirmation of Maximilian's privilege (165.2), nor this final confirmation, deals with the issue of the additional 200 gulden granted by Maximilian in September 1518 (127). AD apparently fears the money might be claimed by some other and paid out in his absence. However, there is reason to believe that overdue regular payments and the additional 200 gulden had been paid out or at least authorised in 1519 (see 165.5–6).

### 165.4 Emperor Charles V to the Burgomasters and Council of the City of Nuremberg

*[Cologne, 4 November 1520]*
To the honourable our and the Empire's well-beloved loyal Burgomasters and Council of the City of Nuremberg.

Charles, by the grace of God elected Roman Emperor Augustus, ever extending the bounds of Empire et cetera.

Honourable well-beloved subjects. In that formerly the most serene prince Emperor Maximilian, our dear lord and grandfather of esteemed memory, made provision and gave written instruction for our and the Empire's well-beloved subject Albrecht Dürer to be paid every year for the duration of his life one hundred Rhenish gulden from and out of our and the Empire's customary city tax, which you are obliged to pay annually into our imperial treasury, and since we as Roman Emperor have graciously consented thereto and have authorised this liferent anew, as contained in the letter sent out on this matter, we earnestly request and state our will that you pay and deliver to the same Albrecht Dürer the aforesaid liferent of one hundred Rhenish gulden, to the full extent that it has remained unpaid since Emperor Maximilian's instruction, and henceforward every year as long as he lives, from and out of the already specified city tax on receipt of his due quittance, and allow nothing to hinder or impede this. Thereby you shall do our earnest will. Given in our and the Holy Empire's City of Cologne, on the fourth day of the month of November, anno et cetera fifteen twenty, in the second year of our Roman and the fifth year of our other dominions.

Carolus

> Signed:
> Albrecht Cardinal of Mainz
> Archchancellor.
> Registered:
> M. Püchler

Original in the State Archive, Nuremberg (S. I, L. 79, No. 15, Fasc. 4). Beneath the address, in the hand of a chancery clerk: 'To give Albrecht Dürer for the duration of his life 100 fl. from the city tax'.
  R I, 91–2

## 165.5 Nuremberg City Tax Account 1519–20

Item in the year 1519 was paid:

| | | |
|---|---|---|
| To the Provost of Nuremberg as he has previously paid out and loaned | 200 | Rhenish gulden |
| For a stained glass window previously ordered by Emperor Maximilian for St Sebald's Church | 200 | Rhenish gulden |
| To Albrecht Dürer | 300 | Rhenish gulden |
| To aforesaid Sixt Ölhafen | 200 | Rhenish gulden |
| To said Georg Vogel | 100 | Rhenish gulden |
| Again to same Albrecht Dürer on receipt of a quittance from said Imperial Majesty | 200 | Rhenish gulden |
| Total | 1200 | Rhenish gulden |

Item in the year 1520 was paid:

| | | |
|---|---|---|
| To said Sixt Ölhafen | 200 | Rhenish gulden |
| To Georg Vogel aforesaid | 100 | Rhenish gulden |
| To same Albrecht Dürer | 100 | Rhenish gulden |
| Thus previously in 1520 too much has been committed and paid out | 100 | Rhenish gulden |
| To aforementioned Stabius | 200 | Rhenish gulden |
| To Niklas Ziegler in payment of his stipend until he entered the Chancery with Our Gracious Lord the Cardinal of Mainz | 400 | Rhenish gulden |
| Total | 1100 | Rhenish gulden |

State Archive, Vienna, Cod. Suppl. 414/1, fol. 94f., 'Payments from the Nuremberg City Tax'
  R I, 248f.

## 165.6 Summary of Expenditure from the Nuremberg City Tax Monies 1520

Paid 1100 gulden at imperial currency rate for 1000 gulden at city rate to Our Most Gracious Lord Charles, Roman King and future Emperor, for our customary city tax due at Martinmas this year 1520. Of this we paid:

200 fl. to Sixt Ölhafen
Plus 100 gulden to Georg Vogel
Plus 400 gulden imp. to Niklas Ziegler

Plus 200 gulden imp. to Johann Stabius
Plus 200 gulden imp. to Albrecht Dürer
as per imperial donation, namely for the years 1519 and 1520.
These he received himself on the Sabbath after St Peter in Chains anno 1521.

In the bottom margin:

The quittances for all the city tax expenditure are filed with the other imperial
quittances

State Archive Nuremberg, City Account No. 25 for the year 1525, fol. 211: Imperial Tax
  R III, 453

### COMMENTARY

The imperial mandate for AD's liferent is dated 6 September 1515. It is not stated
whether the annual payments of 100 gulden were to apply to the year 1515 or to start
in 1516. The Nuremberg tax accounts for the years 1516, 1517 and 1518 contain no
mention of AD, so that we cannot know whether he was paid the instalments in these
current years. If he were not paid, it is surprising that there is no record of him
reminding the city council of his entitlement. On 27 April 1519 he points out (138)
that the extra grant of 200 gulden authorised by Emperor Maximilian in September
1518 (127) is still outstanding. Since the death of Maximilian in January 1519 the legal
basis of his liferent had become questionable. The city authorities were reluctant to
make payments authorised in the previous reign unless and until they were recon-
firmed by the new monarch Charles V (see 138, 153–4). However, the city tax accounts
for 1519 and 1520 do not straightforwardly square with this picture. In 1519 AD is said
to have been paid sums of 300 gulden and 200 gulden, the latter specified as being
in accordance with a quittance issued by Maximilian. Neither payment is dated. The
second of them could well relate to Maximilian's request of September 1518 and AD's
reminder in April 1519 (127, 138). The (earlier?) payment of 300 gulden does not
include the liferent instalment of 100 gulden for 1519 and, as Rupprich (I, 249, note)
seems to imply, is most readily explicable as outstanding instalments for three previous
years, surprising though such a delay in meeting clear obligations may seem. It is not
impossible that the emperor's quittance was not sent in these instances and the pay-
ments were therefore not made at the appropriate time.

  The summary account of 1520 (165.6) specifies quite explicitly that the 200 gulden
paid to AD are the liferent instalments for 1519 and 1520. This account is clearly written
retrospectively, since it dates the payment for those two years on the sabbath (Saturday)
after the feast of St Peter ad Vincula (3 August) 1521. In this instance we have clear
evidence that annual payments could be quite drastically in arrears. However, the 1521

liferent instalment was paid promptly, as AD's quittance is dated 12 November 1521 (165.8), and this becomes the consistent pattern for the remaining years of AD's life.

On the payments to Ölhafen, Vogel, Stabius and Ziegler in the accounts for 1519–20, see 165.7.

## 165.7 Letter of Anton Tucher to Duke Frederick of Saxony

*[12 October 1521]*

Most gracious Lord,

I have taken note in humble submission that Your Princely Grace has written to me now on the matter of the city tax, which my colleagues the honourable councillors are obliged to pay annually to each and every Roman Emperor and King, and has sent under seal therewith His Roman Imperial Majesty's our most gracious lord's assignment, which Your Princely Grace has extended to six years, also His Majesty's order, instruction and quittance, and that Your Princely Grace has requested me to expedite the matter, so that the same city tax will be paid over by my colleagues at the time indicated, reckoned from the immediately approaching St Martin's Day onwards. It is indeed the case that the envoys of my colleagues the councillors at Worms had orders to oblige Your Princely Grace by meeting your expectations with the annually recurring customary city tax, or as much of it as had not been otherwise disposed of or granted elsewhere by our erstwhile Emperor Maximilian of most esteemed memory or by His present Imperial Majesty, our most gracious lord. My colleague Kaspar Nützel has further informed me, that he intimated to Your Princely Grace at Worms this humble submission of my lordships, the honourable Council, in the form I have indicated; Your Princely Grace has on the other hand allowed and approved the annual payment out of the yearly city tax of two hundred gulden to Sixt Ölhafen and one hundred gulden to Albrecht Dürer in Nuremberg, which they were awarded by Emperor Maximilian for their faithful service and largely unpaid work, full confirmation of which has been received from the present Imperial Majesty. However in the case of Georg Vogel, erstwhile Imperial Majesty's valet, who was also awarded one hundred gulden by Emperor Maximilian of esteemed memory, out of the yearly city tax, my colleagues are not aware of any recent imperial confirmation, for which reason they have let the matter drop, on the assumption that the original instruction has been terminated with the death of Emperor Maximilian. Even so, the one hundred gulden due on the approaching St Martin's Day have been made over to the said Vogel at his urgent pleading, and my colleagues the councillors have it in mind as appropriate to deduct the sum from the city tax. And my colleagues

shall not fail to make payment to Your Princely Grace of the surplus which remains over and above Ölhafen's, Dürer's and Vogel's allotments, giving a total of seven hundred gulden at Martinmas now approaching, and the next year after that, insofar as Georg Vogel does not submit a new instruction from His present Imperial Majesty, annually eight hundred gulden…Dated Saturday after St Denis, 12th October 1521.

State Archive, Nuremberg, Briefbuch LXXXII, fol. 266
  R I, 267f.

COMMENTARY

In 1516, when Kaspar Nützel was negotiating the terms on which the Nuremberg city tax might be diverted to the direct payment by the city council of the debts incurred by Maximilian I in his artistic commissions (109–110), it was Duke Frederick of Saxony, then imperial chancellor, whose financial machinations bothered the council. Although no longer in that office, Duke Frederick is still taking responsibility for working out with Anton Tucher how the complex arrangements should be managed under the new reign of Emperor Charles V. The city accepts that Sixt Ölhafen and, of course, AD are legitimate recipients of money otherwise destined for the imperial purse (the reframing of the terms of Nuremberg's disbursement of the city tax in 1530 shows that part of it was still being paid to Ölhafen – see 244). It is reluctant to commit itself to continuing subsidy of Georg Vogel, since he was a personal servant of the late Emperor Maximilian. That Johannes Stabius is also being paid by the stratagem of diverting money from the Nuremberg city tax is first recorded in the accounts for 1519, though his crucial role in the conception of projects like the Triumphal Arch and Procession make it entirely understandable. He left the imperial court in 1521 and hence no longer figures in Tucher's letter. That Nikolaus Ziegler should have been receiving 400 gulden annually in 1519–20 'in payment of his stipend until he entered the Chancery with Our Gracious Lord the Cardinal of Mainz' is more difficult to explain. Ziegler belonged to an eminent Nuremberg family, but he had been in imperial service since soon after 1500, as the highly efficient head of the chancery, and he is not known to have had a specific role in Maximilian's cultural ideological schemes. It is possible that after Maximilian's death his salary was paid in this way until, with Charles V's accession and the appointment of Cardinal Albrecht of Mainz as archchancellor, his position was regulated in 1521.

The creative accounting which was devised in 1516 clearly continued to vex the Nuremberg city council. It has an air of subterfuge and manipulation and was evidently used as a convenient way of tapping funds to meet ad hoc needs, as in the case of Ziegler. However, it cost the city nothing since the money involved would otherwise have gone to the imperial treasury in any case. But it does seem to have irritated a

city administration accustomed to more scrupulous and transparent procedures. The prolonged dispute with the imperial authorities documented in 244 shows that these frictions were still acute in 1528–30 and bedevilled the long-running issue of AD's liferent even after his death.

### 165.8 Albrecht Dürer's Quittance to the Burgomasters and Council of the City of Nuremberg

*[Nuremberg, 12 November 1521]*
I Albrecht Dürer, citizen of Nuremberg, acknowledge publicly with this document:
As heretofore the Most Illustrious Mighty Lord, Emperor Maximilian, our most gracious lord of esteemed memory, in consideration of my faithful service to His Majesty, allotted and granted to me in writing one hundred Rhenish gulden yearly for the duration of my life out of the customary city tax of the corporate City of Nuremberg, the which allotment the present Roman Imperial Majesty, our most gracious lord, having of his grace confirmed, the prudent, honourable and wise Burgomasters and Council of the City of Nuremberg, my well-disposed lords, have paid and delivered to me these one hundred gulden on St Martin's Day now past. For that I pronounce them and the corporate City of Nuremberg hereby wholly quit, free and discharged. In testimony I have printed my customary personal seal at the end of this text on this document. – Given on the Tuesday after St Martin's Day, in the year fifteen hundred and twenty one since the birth of Christ our dear Lord.
[on the back of the sheet]
1521 Albrecht Dürer pro 100 fl. set against the city tax q.° 6.°

Original, written by a scribe, but with AD's seal. State Archive, Nuremberg, S. 1, L. 79, No. 15, Fasc. 6. In all future years up to 1527 AD copies this template letter of receipt.
R I, 93